THE COMPLETE ENCYCLOPEDIA OF ILLUSTRATION

THE COMPLETE ENCYCLOPEDIA OF ILLUSTRATION

BY J. G. HECK

TRANSLATED BY SPENCER F. BAIRD, A.M., M.D.

Containing all the original illustrations from the 1851 edition of The Iconographic Encyclopaedia of Science, Literature, and Art with editorial revisions for easy reference

MATHEMATICS AND ASTRONOMY NATURAL SCIENCES MILITARY SCIENCES NAVAL SCIENCES ARCHITECTURE

GEOGRAPHY HISTORY AND ETHNOLOGY MYTHOLOGY AND RELIGION FINE ARTS TECHNOLOGY

FOREWORD BY PAUL BACON

Special material copyright © 1979 by Crown Publishers, Inc.
All rights reserved under International and Pan-American
Copyright Conventions.

No part of this book may be reproduced or transmitted in any form or by any means electronic or mechanical including photocopying, recording, or by any information storage and retrieval system, without permission in writing from the publisher.

This 1996 edition is published by Gramercy Books, a division of Random House Value Publishing, Inc., 40 Engelhard Avenue, Avenel, New Jersey 07001. Web address: http://www.randomhouse.com

Gramercy Books and colophon are trademarks of Random House Value Publishing, Inc.

Random House
New York • Toronto • London • Sydney • Auckland

Printed and bound in the United States of America

Library of Congress Cataloging-in-Publication Data

Heck, Johann Georg.

The complete encyclopedia of illustration.

Reprint of the 2 vols. of plates originally published by
R. Garrigue, New York, in 1851 as part of the author's

4-vol. work entitled: Iconographic encyclopedia of science, literature, and art.

1. Illustration of books. I. Title.

1. Illustration of books. 1. 11tle. NC960.H4 1979 769 79-8486 ISBN 0-517-18340-4

10 9 8 7 6 5 4 3 2 1

Editor's Note. Certain characterizations, descriptions, and names in this book should be viewed as arising from the context of the time in which the original publication was compiled. Any offense to modern sensibilities is unintended and does not reflect the attitudes of the editor or publisher of this current edition.

FOREWORD

The idea of using old engravings as a basis for current design—whole, in fragments, whatever—is probably as old as design itself. I first became aware of the process in the late 1940s, especially because of Bradbury Thompson's work in *Inspirations for Printers*, a publication of the West Virginia Pulp and Paper Company. At first, it didn't occur to me to wonder about where exactly Thompson got those things, but the stuff looked good, with a strange harmony: in the abstract and transparent color shapes that Thompson used, the old steel engravings looked peculiarly at home.

The designer I was then apprenticed to, Hal Zamboni, had a collection of old illustrated encyclopedias, I discovered, and we pored over them occasionally for some apt application; there were jealous mentions (in precisely the style of record collectors) of the lucky so-and-so who had this or that crumbling but priceless set. I thought then, and still think, that the craftsmanship and the sheer output of those steel engravers were sobering to contemplate. Sometimes completely straightforward, sometimes romantic, they showed what was known about the appearance of things: real, mystical, practical, ancient, new, preposterous, scientific, or sacred. And, in the case of this book, encyclopedic in the truest sense.

These images are wonderful to look at and to think about; so many of the extraordinarily detailed engravings show us the things that were obsolete before the Civil War—yet here they are, awesome devices we can't even imagine in operation, in flawless detail.

In the Naval Sciences plates, for instance, note the quality of the seas and skies; they are only there as background, but they are done with a painter's eye, so that a ship's rigging is seen in its own environment. And there are innumerable other examples: faint buildings in the distance behind depicted animals, buildings which suggest college or church spires and are not necessary, but which are there because the engraver wanted them to be.

You want to know what *Corvus corax*, the raven, looks like? Well, here is what he looks like—and what a bevel gear looks like, and a nasal cleft, and the *Arc de Triomphe*—lovingly detailed, cross-hatched, and, luckily for us, splendidly reproducible.

ACKNOWLEDGMENTS

The publisher wishes to acknowledge, with gratitude, the help of Andrew Yockers in researching and securing the captions to the plates, and the cooperation of Mrs. Martha C. Slotten, of the Library at Dickinson College, Carlisle, Pennsylvania in providing that material, and, most of all, thanks are due to Doug Anderson, who found and lent the original volumes of illustrations. Catherine Riley created plate titles from figure captions where they were missing from the original edition.

INTRODUCTION

In the mid-nineteenth century, when this book was first published, a man was not considered fully educated unless he had a broad, deep, and detailed knowledge of all areas of culture and human endeavor. This was expected to include a solid grounding in the scientific disciplines, an appreciation of art in all its manifestations, a store of mythological references and tales, considerable knowledge of geological wonders and oddities, plus curiosity about technological developments that were changing the face of society at that time.

To such a many-faceted man, this encyclopedia could well have been his greatest treasure. He would have spent hours browsing through its richly adorned pages, expanding his knowledge and increasing his perception of every area of human achievement by coming in contact with illustrations of such realism, beauty, and detail that their impact would be lasting. Today this work can be viewed with that same fascination, expecially since it emphasizes how we have to place much of scientific knowledge and instrumentation in historic context.

Originally published in 1851 as *The Iconographic Encyclopaedia of Science, Literature, and Art,* this work was based on the famed *Bilderatlas*, by Friedrich Arnold Brockhaus, one of the finest encyclopedias of its day. Spencer Baird translated the captions and text from the original German, and those captions have been included here, although the text has not, since it would now be thoroughly outdated.

This edition, at the most modern level, reproduces the entire body of plates by means of fine-line offset lithography, which will enable their most successful use by artists, designers, and others; and this is also the only edition to place complete captions and translations of all German terms for convenient reference within the same section as their respective plates.

The physical and intellectual world of the nineteenth century has been captured and categorized in this volume in ten major divisions representing the various areas of scientific knowledge and artistic achievement of the age.

In *Mathematics and Astronomy*, the extraordinarily complex mathematical and geometrical drawings are painstakingly precise, and the astronomical illustrations give the views of the planets and the heavens a startling beauty.

In the *Natural Sciences*, graphic representations of the principles and instruments of Physics, Meteorology, and Chemistry provide a virtual history of these sciences; in the subsection on Mineralogy, there are drawings of minerals in exquisite crystalline forms.

Geognosy and Geology spread before the viewer the interior of the earth, its many strata and substrata, and the earth's exterior formations from the Coral Islands of the Pacific to the grottoes of France, to a volcanic crater in Iceland. The Meteorology section includes diagrams and displays of nature's climatic phenomena—the common as well as the more unusual, such as air hurricanes, mirages at sea, or the aurora borealis. In the sections on Botany and Zoology, the scientific accuracy of the drawings is rivaled only by the diversity and beauty of the subjects. Depicted in their natural habitats, whether jungle, desert, seashore, or countryside, the birds, animals, fish, and snakes have a lifelike quality and power that make them seem ready to spring off the page. The surgical drawings in the Anthropology and Surgery section, with the expertise and comprehensiveness of a classical anatomy text, can instruct or simply please the eye.

Geography and Planography: An immense range of subject exists in this section—from atlases of the continents to maps of mountain and river systems, from a map of the world according to Ptolemy to a plan of Paris in the nineteenth century.

History and Ethnology: Of the divisions, this is one of the most variegated and informative of all areas of culture, containing drama, tragedy, surprising facts, and a multitude of costumes and customs. Scenes of antiquity include a terrifying view of the Roman Coliseum with lions and an elephant attacking the Christian martyrs; there are numerous plans, drawings, and diagrams of catacombs, early churches, and chapels. Illustrations of medieval life cover the range of emotions, from the ceremony bestowing knighthood, an exhilarating scene, to plates portraying the horrors of the Inquisition. Crowns and shields appear in rich profusion, followed by histories, in graphic form, of the various religious orders and communities. The nineteenth century section presents life in every area of the world, from earthy scenes of Russian peasant life to the pomp and splendor of an Oriental court, from views of the Brazilian slave trade to an elegant masked ball in Paris.

Military and Naval Sciences: The review of Military Sciences begins with the simple hand-held weapons of the Egyptians, Medes, and Persians; advances through the growing complexity of instruments and armor of the Middle Ages; then proceeds to a complete study of all aspects of military life in the nineteenth century: cavalry, infantry, officer dress, fencing positions, tactics and battle formations, medals and military orders, and finally, military structures, engines, and fortifications.

Naval Sciences contains some of the most beautiful plates in the book. The artistry of the engravers captured the lilting movement of the ships at sea almost in three dimensions, and the excitement of the era of the immense sailing ships. Ships of all nations are shown: cutters, frigates, fishing smacks, barques, coasters, sloops, schooners, and steamships. There are quaint scenes of shipboard life, of naval officers and sailors in full dress and at ease.

Architecture: In pictures of extraordinary clarity garnered from every corner of the globe, we marvel at the Egyptian pyramids, the purity of line of the classic Greek and Roman styles, the intricacies of pre-Columbian temples in Central America, the ornate-

ness of Islamic architecture, and some of the most stunning examples of European cathedrals built through the centuries: the magnificent Cologne and Rouen Cathedrals, the Minster at York, the gloomy but intriguing interior of the Cathedral at Milan. This tour ends with a review of the architecture of palaces.

Mythology and Religious Rites: This is not only a comprehensive survey of religious customs, ceremonies, deities, and artifacts through the ages, but also an assemblage of many intriguing curiosa: penitents, ascetics, and fanatics, statues of Indian idols, the funeral of the Dalai Lama, Persian Magi, and the amazing plethora of gods and symbols that the Egyptians worshiped.

The Fine Arts section is a treasure trove of painting, sculpture, and other decorative arts from ancient, classical, Renaissance, Baroque, Mannerist, and Neoclassic periods. There are numerous illustrations on the theory of drawing, including life studies and the graphic arts, and the section ends with an intriguing collection, "Alphabets of Various Languages for the Use of Engravers."

Technology documents the rapid industrialization of the 1850s incorporating all the new and exciting technological innovations that were then radically changing the nature of life. Although it illustrates innumerable constructions—streets, tunnels, dams, bridges, canals, aqueducts, cranes, pumps—the highlights inevitably are those inventions or processes that were to have the greatest repercussions on society: the locomotive, the cotton gin, the industrial weaving looms, and the minting, mining, and metal-mill equipment.

In this extraordinary compilation, with the completeness and variety of its subject matter, the delicacy and precision of the engravings, and the authoritativeness of the treatment, we see mirrored the meticulously cultivated mind of the nineteenth century. In fact, it is a cultural ideal for all times, but even more so today, when technological advances give man the impression that he can forsake the meticulous and leave those details to machines. This volume demonstrates to the modern reader the importance of delving knowingly and lovingly into the past to discover, preserve, and re-create the art and artifacts of old.

These illustrations are the realizations, in every sense, of an earlier age, which will gratify the appetite of people in our society for information, history, and the craftsmanship of another day.

CLAIRE BOOSS

NOTE: On certain of the plate titles, only the principal elements have been named, as the subjects are sometimes too many and too diverse to enumerate. Complete descriptions can be found in the figure captions that procede each major section of the book. There are some figures that have no captions, these having been omitted from the original edition, and there the reader must rely on the general information provided by the plate titles.

TABLE OF CONTENTS

TRANSLATIONS OF GERMAN NAMES AND TERMS USED IN THE PLATES WILL BE FOUND IN THE GLOSSARIES IN EACH CAPTION SECTION.

FOREWOR	P D	AGE
INTRODUC	CTION	i
	MATHEMATICS AND ASTRONOMY	
CAPTIONS	TO THE PLATES	2
PLATES 1 A	AND 2. MATHEMATICAL AND GEOMETRICAL PROBLEMS	. 5
PLATE 3.	MATHEMATICAL AND GEOMETRICAL PROBLEMS	. 6
PLATE 4.	PROBLEMS IN GEODESY OR SURVEYING, AND PROJECTION IN	
DI 4000 6	VERTICAL AND HORIZONTAL PLANES	. 7
PLATE 5.	MATHEMATICAL AND SURVEYING INSTRUMENTS	. 8
PLATE 6.	ILLUSTRATING THEORIES, FORCES, AND PHENOMENA OF THE SOLAR SYSTEM	0
PLATE 7.	VARIOUS PLANETARY SYSTEMS	
PLATE 8.	CELESTIAL BODIES	11
PLATE 9.	SEASONS AND OTHER PHENOMENA OF THE SPHERES	12
PLATE 10.	ILLUSTRATING PHASES OF THE EARTH'S MOON AND ORBITS OF THE EARTH AND VARIOUS MOONS	
PLATE 11.	BEER AND MADLER'S MAP OF THE MOON	
PLATE 12.	MAP OF THE NORTHERN HEAVENS	
PLATE 13.	MAP OF THE SOUTHERN HEAVENS	
PLATE 14.	PLANET SIZES AND VARIOUS PHENOMENA	10
PLATE 15.	ASTRONOMICAL INSTRUMENTS	1/
	TIOTHORICAL MOTROWENIS	18

NATURAL SCIENCES

CAPTIONS T	TO THE PLATES	21
	PHYSICS AND METEOROLOGY	
PLATE 16.	THEORIES OF FORCE AND GRAVITY: DEMONSTRATIONS OF THESE AND OTHER PHYSICAL LAWS	37
PLATE 17.	ILLUSTRATING THEORIES OF DYNAMICS AND OTHER PHYSICAL LAWS	38
PLATE 18.	THEORIES AND INSTRUMENTS OF HYDRAULICS AND AERODYNAMICS	
PLATE 19.	THEORIES AND INSTRUMENTS OF MECHANICS, THERMODYNAMICS, AND ACOUSTICS	
PLATE 20.	THEORIES AND INSTRUMENTS OF ELECTRICITY AND MAGNETICS	41
PLATE 21.	THEORIES AND INSTRUMENTS OF OPTICS	42
PLATE 21.	PHENOMENA AND APPARATUS OF ELECTRICITY AND MAGNETICS	43
PLATE 23.	TANKS OF THE PROPERTY OF THE P	
FLATE 23.	PHENOMENA PHENOMENA	44
PLATE 24.	PHENOMENA OF CONDENSATION AND AIR CURRENTS	45
PLATE 25.	CLOUD FORMATION AND LIGHT REFRACTION	46
PLATE 26.	PHENOMENA OF CLOUDS AND LIGHT	47
PLATE 27.	METEOROLOGICAL ELEMENTS AND INSTRUMENTS	48
PLATE 28.	CLIMATE AND WEATHER CHARTS	49
PLATE 29.	RAINFALL AND TEMPERATURE MAP; TEMPERATURE CHARTS	5(
	A STATE OF THE STA	
	CHEMISTRY, MINERALOGY, AND GEOLOGY	
PLATE 30.	CHEMICAL LABORATORY, APPARATUS, AND EQUIPMENT	5
PLATE 30. PLATE 31.	CHEMICAL APPARATUS AND EQUIPMENT	52
PLATE 31.	FORMS OF CRYSTALLIZATION; VARIOUS INSTRUMENTS	53
PLATE 32.	MINERALS AND THEIR CRYSTALLINE FORMS	54
PLATE 34.	MINERALS AND THEIR CRYSTALLINE FORMS	5.
PLATE 34.	MINERALS AND THEIR CRYSTALLINE FORMS	50
PLATE 35.	MINERALS AND THEIR CRYSTALLINE FORMS	5
PLATE 37.	FOSSILS AND REPRESENTATION OF ANIMALS OF THE LIAS	5
PLATE 38.	SECTION OF THE WIRKSWORTH CAVE AND FOSSILS	5
PLATE 39.	FOSSILS, A SKELETON, AND VEINS OF ORE	6
PLATE 40.	FOSSILS AND SKELETONS	6
PLATE 41.	FOSSILS, SKELETONS, AND TRACKS	6
PLATE 42.	FOSSILS FROM VARIOUS PERIODS	6

PLATE 43.	ROCK AND VALLEY FORMATIONS AND STRATIFICATION	64
PLATE 44.	STRATIFICATION IN MOUNTAINS AND BASINS; FISSURES AND CRATERS	
PLATE 45.	VOLCANOES AND VOLCANIC FORMATIONS	66
PLATE 46.	SPECIAL GEOGNOSY	67
PLATE 47.	VOLCANIC AND HURRICANE CHARTS; MOUNTAIN PROFILES; CRATERS; AND ANTARCTICA	
PLATE 48.	BORING EQUIPMENT; STRATIFICATION AND ARTESIAN WELLS	60
PLATE 49.	NOTABLE GEOLOGICAL FORMATIONS	70
PLATE 50.	VOLCANOES, GEYSERS, AND WATER FALLS	71
PLATE 51.	FORESTS, LAKES, CAVES, AND UNUSUAL ROCK FORMATIONS	72
PLATE 52.	CAVES, ICEBERGS, LAVA, AND ROCK FORMATIONS	73
PLATE 53.	CAVES AND ROCK FORMATIONS	74
	BOTANY	
PLATE 54.	REPRESENTATIVES OF THE ALGAE, FUNGI, BRYOPHYTA, POLYPODIOPHYTA AND OTHER NONFLOWERING PLANTS	75
PLATE 55.	FIG TREE, AQUATIC FLOWERING PLANTS, AND REPRESENTATIVES OF THE FAMILIES GRAMINEAE AND CYPERACEAE	
PLATE 56.	HABITAT GROUPING AND REPRODUCTIVE PARTS OF VARIOUS WOODY MONOCOTS, ESPECIALLY PALMS AND CYCADS	
PLATE 57.	REPRESENTATIVES OF THE MONOCOT ORDER LILIALES	78
PLATES 58	AND 59. AROMATIC PLANTS	79
PLATES 60	AND 61. CULTIVATED PLANTS FROM DIVERSE FAMILIES: ORNAMENTAL, EDIBLE, OR MEDICINAL	
PLATE 62.	MEMBERS OF THE ACANTHUS, OLIVE, VERBENA, MINT, FIGWORT AND NIGHTSHADE FAMILIES	
PLATE 63.	PLANTS OF SEVERAL FAMILIES WHICH CONTAIN TOXIC COMPOUNDS, ESPECIALLY OF THE ORDER POLEMONIALES	
PLATE 64.	PLANTS WITH A RESINOUS OR MILKY SAP	02
PLATE 65.	PLANTS BREWED AS TEAS AND REPRESENTATIVES OF THE UMBELLIFERAE, SOME POISONOUS	
PLATE 66.	CULTIVATED PLANTS OF THE RANUNCULACEAE AND OTHER FAMILIES	
PLATE 67.	VARIOUS PLANTS OF ECONOMIC IMPORTANCE, INCLUDING TEA, WINE GRAPE, COTTON AND CACAO	
PLATE 68.	CULTIVATED PLANTS OF MANY FAMILIES, MOSTLY ORNAMENTAL	
PLATE 69.	PLANTS INDIGENOUS TO SANDY OR ROCKY SOIL, A SANDALWOOD, AND REPRESENTATIVES OF THE ORDER MYRTALES	
PLATE 70.	LYTHRUM AND REPRESENTATIVES OF THE ORDER ROSALES	58
PLATE 71.	VARIOUS PLANTS, INCLUDING MEMBERS OF THE SUMAC, SPURGE	59
	AND GOURD FAMILIES	90

PLATE 72.	CONIFEROUS GYMNOSPERMS, AND ANGIOSPERMS OF THE MULBERRY, PEPPER, BEECH AND WITCH HAZEL FAMILIES	91
PLATE 73.	MAPS AND CHARTS OF PLANT DISTRIBUTION	92
	ZOOLOGY	
		02
PLATE 74.	CLASSIFICATION	73
PLATE 75.	REPRESENTATIVES OF THE PHYLA PROTOZOA, PORIFERA, COELENTERATA, AND MOLLUSCA	94
PLATE 76.	REPRESENTATIVES OF THE PHYLA MOLLUSCA, ECHINODERMATA, CTENOPHORA, AND ARTHROPODA	
PLATE 77.	REPRESENTATIVES OF THE PHYLA COELENTERATA, CHORDATA, MOLLUSCA, PLATYHELMINTHES, AND ARTHROPODA	
PLATE 78.	REPRESENTATIVES OF THE PHYLUM ARTHROPODA: CLASSES CRUSTACEA AND ARACHNIDA	
PLATE 79.	INSECTS OF THE ORDERS HYMENOPTERA, DIPTERA, LEPIDOPTERA, AND ODONATA	
PLATE 80.	INSECTS OF THE ORDERS LEPIDOPTERA, ORTHOPTERA, AND HEMIPTERA	
PLATE 81.	MEMBERS OF THE INSECT ORDER COLEOPTERA; AND THE CHORDATE CLASSES CHONDRICHTHYES, OSTEICHTHYES, AMPHIBIA, AND REPTILIA	
PLATE 82.	CHORDATES OF THE CLASSES CHONDRICHTHYES AND OSTEICHTHYES	
PLATE 83.	OSTEICHTHIES OSTEICHT	102
PLATE 84.	MEMBERS OF THE CLASSES CHONDRICHTHYES AND OSTEICHTHYES	
PLATE 85.	REPRESENTATIVES OF THE CLASSES CHONDRICHTHYES AND OSTEICHTHYES	104
PLATE 86.	REPTILES OF THE SUBORDERS SAURIA AND SERPENTES	105
PLATE 87.	REPTILES OF THE SUBORDERS SAURIA AND SERPENTES	106
PLATE 88.	AMPHIBIANS OF THE ORDER URODELA AND REPTILES OF THE ORDERS SOUAMATA AND CROCODYLIA	
PLATE 89.	AMPHIBIANS OF THE ORDER URODALA AND REPTILES OF THE SUBORDER SAURIA	108
PLATE 90.	MEMBERS OF THE CLASSES REPTILIA AND AMPHIBIA	109
PLATE 91.	AVES OF THE ORDERS PODICIPEDIFORMES, PELECANIFORMES, SPHENISCIFORMES AND GAVIIFORMES	110
PLATE 92.	MEMBERS OF THE ORDERS ANSERIFORMES, PELECANIFORMES, CHARADRIIFORMES, AND SPHENISCIFORMES	
PLATE 93.	MEMBERS OF THE ORDERS CICONIIFORMES, GRUIFORMES, AND CHARADRIIFORMES	
PLATE 94.		

PLATE 95.	AVES OF THE ORDERS CASUARIIFORMES, ANSERIFORMES,
PLATE 96.	CHARADRIIFORMES, GALLIFORMES, AND GRUIFORMES
PLATE 97.	MEMBERS OF THE ORDERS GALLIFORMES AND COLUMBIFORMES
TEATE 77.	AND TROGONIFORMES
PLATE 98.	MEMBERS OF THE ORDERS PSITTACIFORMES, PICIFORMES, AND
	PASSERIFORMES
PLATE 99.	MEMBERS OF THE ORDERS APOPODIFORMES AND
PLATE 100.	PASSERIFORMES
PLATE 101.	
PLATE 102.	REPRESENTATIVES OF THE ORDERS PASSERIFORMES AND
	APOPODIFORMES
PLATE 103.	MEMBERS OF THE ORDERS PASSERIFORMES, CORACIIFORMES, AND CAPRIMULGIFORMES
PLATE 104.	MEMBERS OF THE ORDERS STRIGIFORMES AND FALCONIFORMES
PLATE 105.	MEMBERS OF THE ORDER FALCONIFORMES
PLATE 106.	CHART OF THE MIGRATIONS OF FISHES AND BIRDS
PLATE 107.	MAMMALS OF THE ORDER CETACEA: SUBORDERS ODONTOCETI AND MYSTECETI
PLATE 108.	REPRESENTATIVES OF THE ORDERS ARTIODACTYLA, LAGOMORPHA, AND RODENTIA
PLATE 109.	REPRESENTATIVES OF THE ORDER ARTIODACTYLA: SUBORDERS TYLOPODA AND RUMINANTIA
PLATE 110.	MEMBERS OF THE ORDERS ARTIODACTYLA AND PERISSODACTYLA
PLATE 111.	MEMBERS OF THE ORDER PERISSODACTYLA: FAMILY EQUIDAE
PLATE 112.	REPRESENTATIVES OF THE ORDERS ARTIODACTYLA, PERISSODACTYLA, HYRACOIDEA, AND PROBOSCIDEA
PLATE 113.	REPRESENTATIVES OF THE ORDERS EDENTATA, MARSUPIALIA, PHOLIDOTA, CARNIVORA, AND MONOTREMATA
PLATE 114.	REPRESENTATIVES OF THE ORDERS INSECTIVORA, CARNIVORA, RODENTIA AND LAGOMORPHA
PLATE 115.	REPRESENTATIVES OF THE ORDERS RODENTIA AND CARNIVORA
PLATE 116.	MEMBERS OF THE ORDER CARNIVORA: FAMILY FELIDAE
PLATE 117.	REPRESENTATIVES OF THE ORDER CARNIVORA: FAMILIES CANIDAE, URSIDAE, AND MUSTELIDAE
PLATE 118.	REPRESENTATIVES OF THE ORDERS CHIROPTERA AND PRIMATES
PLATE 119.	REPRESENTATIVES OF THE ORDERS PERISSODACTYLA
	AND PRIMATES
	ANTHROPOLOGY AND SURGERY
DI ATE 100	VARIETIES OF MANUALD
DI ATE 121	VARIETIES OF MANKIND
LAIE 121.	ILLUSTRATING THE PSYCHOLOGICAL RELATIONS OF THE BRAIN (PHRENOLOGY)
	140

PLATE 122.	THE BONES OF THE HEAD
PLATE 123.	ANATOMY OF THE BONES
PLATE 124.	ANATOMY OF THE BONES
PLATE 125.	ANATOMY OF THE LIGAMENTS AND MUSCLES 144
PLATE 126.	ANATOMY OF THE LIGAMENTS AND MUSCLES
PLATE 127.	ANATOMY OF THE LIGAMENTS AND MUSCLES
PLATE 128.	ANATOMY OF THE MUSCLES
PLATE 129.	ANATOMY OF THE MUSCLES
PLATE 130.	ANATOMY OF THE FASCIAE, INTEGUMENTS, AND ORGANS OF MASTICATION AND RESPIRATION
PLATE 131.	ANATOMY OF THE ORGANS OF DIGESTION
PLATE 132.	ANATOMY OF THE EYE
PLATE 133.	ANATOMY OF THE EAR AND NOSE
PLATE 134.	ANATOMY OF THE VASCULAR SYSTEM
PLATE 135.	ANATOMY OF THE VASCULAR SYSTEM
PLATE 136.	ANATOMY OF THE VASCULAR SYSTEM
PLATE 137.	ANATOMY OF THE VASCULAR SYSTEM
PLATE 138.	ANATOMY OF THE BRAIN AND NERVES
PLATE 139.	ANATOMY OF THE NERVES
PLATE 140.	VARIOUS SURGICAL OPERATIONS
PLATE 141.	VARIOUS SURGICAL INSTRUMENTS
	GEOGRAPHY AND PLANOGRAPHY
	TO THE GEOGRAPHICAL MAPS
PLATE 142.	PHYSICAL MAP OF EUROPE
PLATES 14	3 AND 144. MOUNTAIN AND RIVER SYSTEMS OF CENTRAL EUROPE
PLATE 145.	PHYSICAL MAP OF ASIA
PLATE 146.	PHYSICAL MAP OF AFRICA
PLATE 147.	PHYSICAL MAP OF NORTH AMERICA
PLATE 148.	PHYSICAL MAP OF SOUTH AMERICA
	MAPS OF THE WORLD ACCORDING TO: HERODOTUS (I), STRABO (II), PTOLEMY (III), THE ANCIENTS (IV)
PLATE 150.	THE KINGDOM OF ALEXANDER THE GREAT
PLATE 151.	ROMAN EMPIRE UNDER CONSTANTINE THE GREAT
PLATE 152.	EUROPE IN THE TIME OF CHARLEMAGNE
PLATE 153	EUROPE AT THE TIME OF THE CRUSADES
PLATE 154	EUROPE BEFORE THE FRENCH REVOLUTION OF 1789
PLATE 155	EUROPE IN THE NINETEENTH CENTURY
DY ACTE 0 15	6 AND 157. THE RAILROADS OF CENTRAL EUROPE

PLATE 158.	THE AUSTRIAN EMPIRE
PLATE 159.	PRUSSIA
PLATE 160.	SWEDEN, NORWAY, AND DENMARK
PLATE 161.	GREAT BRITAIN AND IRELAND
PLATE 162.	SPAIN AND PORTUGAL 191
PLATE 163.	FRANCE
PLATE 164.	SWITZERLAND
PLATE 165.	ITALY
PLATE 166.	RUSSIA
PLATE 167.	THE TURKISH EMPIRE
PLATE 168.	GREECE
PLATE 169.	ASIA
PLATE 170.	AFRICA
PLATE 171.	NORTH AMERICA
PLATE 172.	SOUTH AMERICA
PLATE 173.	AUSTRALIA
PLATE 174.	LONDON 203
PLATE 175.	PARIS AND ENVIRONS
PLATE 176.	FORTIFICATIONS OF PARIS
PLATE 177.	CONSTANTINOPLE
PLATE 178.	ST. PETERSBURG AND WARSAW
PLATE 179.	BERLIN
PLATE 180.	VIENNA
PLATE 181.	LISBON AND NAPLES
PLATE 182.	ROME AND MILAN
PLATE 183.	MADRID, SARAGOSSA, AND BARCELONA
PLATE 184.	COPENHAGEN, STOCKHOLM, ANTWERP, AND AMSTERDAM
PLATE 185.	LEGHORN, FLORENCE, ANCONA, AND MODENA
	HICTORY AND DELINION OF THE
	HISTORY AND ETHNOLOGY
CAPTIONS T	O THE BLATES
CAPTIONS I	TO THE PLATES
	ANCIENT TIMES AND MIDDLE AGES
PLATE 186	EGYPT
	ANCIENT MIDDLE EAST AND THE ORIENT
	TOMBS AND FUNERARY OBJECTS
2/112 107.	VARIOUS PEOPLES OF ANTIQUITY

PLATE 190. SCENES OF GERMANS AND GAULS	228
PLATE 191. TOMBS AND FUNERARY OBJECTS	229
THE AREA CONTRACTOR OF THE CON	
PLATE 192. GRECIAN COSTUMES	230
	231
	232
	233
	234
PLATE 197. ROME	235
PLATE 198. ROME	236
PLATE 199. DETAILS FROM THE CIRCENSIAN GAMES	237
PLATE 200. SCENE IN ROMAN COLISEUM AND ROMAN COINS	237
PLATE 201. ROMAN FURNITURE AND TOOLS	
PLATE 202. ROMAN TOMBS, SARCOPHAGI, AND ARTIFACTS	239
PLATE 203. SCENES AND ARTIFACTS FROM GAUL AND VARIOUS MONUMENTS	240
PLATE 204. CATACOMBS, CHURCHES, AND CHAPELS	241
PLATE 205. THE TRIBES OF THE MIGRATION	242
PLATE 206. COSTUMES OF CENTRAL EUROPE	243
PLATE 207. SCENES AND ARTIFACTS FROM THE TIME OF CHARLEMAGNE AND THE FRANKS	244
PLATE 208. SCENES OF FRENCH MEDIEVAL LIFE	245
PLATE 209. GERMAN AND ENGLISH ARMOR AND TOURNAMENTS	246
PLATE 210. DIFFERENT MODES OF COMBAT	247
PLATE 211. BECOMING A KNIGHT	248
PLATE 212. CROWNS AND SHIELDS	249
PLATE 213. COATS OF ARMS	250
PLATE 214. COATS OF ARMS	251
PLATE 215. THE INOUISITION	252
PLATE 216. THE INQUISITION	253
THE PROPERTY OF MARIOUS MONACTIC	
INSTITUTIONS	254
PLATE 218. REPRESENTATIVES OF RELIGIOUS COMMUNITIES	255
PLATE 219. MEMBERS OF VARIOUS RELIGIOUS AND MILITARY ORDERS	250
PLATE 220. FREEMASONRY	25
PLATE 221. HAWKING AND CRUSADERS	258
PLATE 222. CRUSADERS	259
PLATE 223. KNIGHTS RETURNING FROM CRUSADE AND AT TOURNAMENT	260
PLATE 224. CHURCH OF THE HOLY SEPULCHRE AND CHURCH OF ST. MARY OF	26
THE MANGER	20
ETHNOLOGY OF THE NINETEENTH CENTURY	
PLATE 225. THE FIVE PRINCIPAL RACES	26

PLATE 226.	GERMANIC PEOPLES
PLATE 227.	GERMANIC AND AUSTRIAN PEOPLES
PLATE 228.	GYMNASIUM AND ACROBATICS
PLATE 229.	EQUESTRIAN FEATS
PLATE 230.	RACES AND A BALL
PLATE 231.	
PLATE 232.	OUTDOOR CELEBRATIONS
PLATE 233.	SPANISH AND SARDINIAN SCENES
PLATE 234.	RUSSIAN AND CAUCASIAN TRIBES
PLATE 235.	SCENES OF RUSSIAN LIFE
PLATE 236.	SCENES OF RUSSIAN LIFE
PLATE 237.	EASTERN PEOPLES AND COSTUMES
PLATE 238.	SCENES FROM MIDDLE EASTERN LIFE
PLATE 239.	PERSIANS AND OTHER EASTERN PEOPLES
PLATE 240.	SCENES OF EASTERN LIFE
PLATE 241.	SCENES OF PERSIAN LIFE
PLATE 242.	SCENES OF THE ENGLISH EAST INDIES
PLATE 243.	EAST INDIAN AND ARABIAN SCENES
PLATE 244.	SCENES FROM INDIAN, ARABIAN, AND PERSIAN LIFE
PLATE 245.	HINDOO SCENES
PLATE 246.	ORIENTAL PEOPLES
PLATE 247.	SCENES FROM CHINESE LIFE
PLATE 248.	CHINESE ENTERTAINMENT AND PUNISHMENT
PLATE 249.	
PLATE 250.	AFRICAN SCENES AND PEOPLES
PLATE 251.	ARABIAN AND EGYPTIAN SCENES
PLATE 252.	PEOPLES OF AFRICAN TRIBES
PLATE 253.	SPORTS OF INDIAN TRIBES
PLATE 254.	PEOPLES AND COSTUMES OF MEXICO AND SOUTH AMERICA
PLATE 255.	BRAZILIAN SCENES
PLATE 256.	VARIOUS SOUTH AMERICAN PEOPLES
PLATE 257.	LIFE IN BRAZIL AND PATAGONIA
PLATE 258.	BRAZILIAN SLAVE TRADE
PLATE 259.	SCENES FROM GREENLAND, BRAZIL, AND PATAGONIA
PLATE 260.	SPORTS AND DUELS OF VARIOUS SOUTH AMERICAN INDIANS
PLATE 261.	RITES AND CEREMONIES OF MEXICAN AND SOUTH AMERICAN INDIANS
PLATE 262.	SCENES OF THE PACIFIC
PLATE 263.	SCENES OF AUSTRALIAN AND POLYNESIAN NATIVES
PLATE 264.	NATIVES OF THE SOUTH PACIFIC
PLATE 265.	RITES AND CEREMONIES OF THE PACIFIC

	MILITARY SCIENCES	
CAPTIONS T	TO THE PLATES	307
PLATE 267.	WEAPONS OF THE EGYPTIANS, MEDES, AND PERSIANS	309
PLATE 268.	GREEK AND ETRUSCAN WARRIORS	310
PLATE 269.	WEAPONS OF THE GREEKS, ETRUSCANS, AND ROMANS	311
PLATE 270.	GREEK AND ROMAN TROOP MOVEMENTS	312
PLATE 271.	SCENES OF ANCIENT WARRIORS	313
PLATE 272.	CEREMONIAL PROCESSIONS	
PLATE 273.	RANKS AND ALLIES OF THE ROMAN ARMY	315
PLATE 274.	SOLDIERS AND OFFICERS OF ROMAN TIMES	316
PLATE 275.	ANCIENT AND MEDIEVAL WEAPONS AND ARMAMENTS	
PLATE 276.	MILITARY TRAPPINGS OF ANCIENT ROME	
PLATE 277.	MILITARY CEREMONIES AND PROCESSIONS OF ROME	
PLATE 278.	MILITARY LIFE OF THE GERMANIC TRIBES	320
PLATE 279.	ROMAN AND CARTHAGINIAN MILITARY FORMATIONS	
PLATE 280.	MEDIEVAL WAR SCENES	322
PLATE 281.	WEAPONS OF THE GERMANS, NORMANS, ANGLO-SAXONS, AND	
	DANES	323
PLATE 282.	ARMOR OF THE MIDDLE AGES	
PLATE 283.	MEDIEVAL ARMOR AND TOURNAMENTS	
PLATE 284.	MILITARY DIGNITARIES AND WAR CAMPS	
PLATE 285.	PRUSSIAN AND FRENCH INFANTRY	
PLATE 286.	PRUSSIAN AND FRENCH CAVALRY	
PLATE 287.	AUSTRIAN AND BRITISH INFANTRY	
PLATE 288.	BRITISH AND BELGIAN CAVALRY	
PLATE 289.	TURKISH TROOPS	
PLATE 290.	SCENES FROM TURKISH MILITARY LIFE	332
PLATE 291.	ILLUSTRATING THE VARIOUS KINDS OF ARMS OF THE MID-NINETEENTH CENTURY	
PLATE 292.		
PLATE 293.	ILLUSTRATING MILITARY FENCING	
PLATE 294.		
PLATE 295.	MILITARY TACTICS AND FRENCH TROOPS IN ALGIERS	
PLATE 296.	AUSTRIAN AND PRUSSIAN ORDERS	
PLATE 297.		
PLATE 298.	MILITARY ORDERS OF MANY LANDS	34

PLATE 299.	ANCIENT MILITARY ENGINES
PLATE 300.	MILITARY ENGINES OF THE MIDDLE AGES
PLATE 301.	MILITARY STRUCTURES, ENGINES, AND FORMATIONS OF ANCIENT AND MEDIEVAL TIMES
PLATE 302.	ILLUSTRATING MODERN ARTILLERY
PLATE 303.	ILLUSTRATING ARTILLERY CARRIAGES
PLATE 304.	ILLUSTRATING ARTILLERY AND PONTOON CARRIAGES
PLATE 305.	ILLUSTRATING THE FABRICATION OF ARTILLERY AND PROJECTILES, BALLS AND BOMBS
PLATE 306.	ILLUSTRATING MILITARY PYROTECHNY
PLATE 307.	ROMAN MILITARY STRUCTURES AND TECHNIQUES
PLATE 308.	
PLATE 309.	WALLS OF GREECE AND ROME
PLATE 310.	CASTLES OF THE MIDDLE AGES
PLATE 311.	THE GREAT WALL OF CHINA; VARIOUS TOWERS AND BATTLEMENTS
PLATE 312.	VARIOUS FORTIFIED STRUCTURES
PLATE 313.	ILLUSTRATING FIELD FORTIFICATION
PLATE 314.	ILLUSTRATING PERMANENT FORTIFICATIONS
PLATE 315.	ILLUSTRATING ATTACK AND DEFENCE OF FORTIFIED PLACES
PLATE 316.	ILLUSTRATING ATTACK AND DEFENCE OF FORTIFIED PLACES
PLATE 317.	ILLUSTRATING THE PIONEER AND PONTOON SERVICE
	NAVAL SCIENCES
	NAVAL SCIENCES
CAPTIONS	TO THE PLATES
	SEA VESSELS OF ANCIENT TIMES AND THE DARK AGES
PLATE 319.	ANCIENT VESSELS AND NAVAL TRAPPINGS; A ROMAN NAVAL SPECTACLE
DI ATE 220	SHIPS OF SEVERAL NATIONS
PLATE 320.	SHIPS OF SEVERAL NATIONS
PLATE 321.	SHIPS OF EUROPE
	SHIPS OF THE ORIENT
PLATE 323. PLATE 324.	ILLUSTRATING THE THEORY OF SHIPBUILDING
PLATE 324. PLATE 325.	CONSTRUCTION AND MAINTENANCE OF A SHIP
PLATE 326.	BASIC STRUCTURE OF A SHIP
PLATE 327. PLATE 328.	FRENCH SHIP OF THE LINE AND EQUIPMENT
	VARIOUS VIEWS OF FRENCH SHIPS
TLAIE 329.	VARIOUS VIEWS OF FRENCH SHIPS

PLATE 330.	FLAGS OF VARIOUS NATIONS
PLATE 331.	EUROPEAN SHIPS OF VARIOUS FUNCTIONS
PLATE 332.	TRADING AND FISHING SHIPS 381
PLATE 333.	STEAMSHIPS AND SAILING SHIPS OF VARIOUS RIGS
PLATE 334.	FRENCH STEAM-PROPELLED SAILING SHIPS: EUROPEAN SAILING
	SHIPS OF WAR
PLATE 335.	ILLUSTRATING THE CONSTRUCTION OF STEAMSHIPS
PLATE 336.	ILLUSTRATING THE CONSTRUCTION OF STEAMSHIPS
PLATE 337.	NAVAL OFFICERS AND SAILORS
PLATE 338.	SCENES FROM SHIPBOARD LIFE
PLATE 339.	SCENE ON A FRENCH FRIGATE
PLATE 340.	SAILORS ON DECK DUTY
PLATE 341.	INCIDENTS ABOARD SHIP
PLATE 342.	SHIPS ON PARADE AND SHIPBOARD LIFE
PLATE 343.	SHIP MANOEUVERS
PLATE 344.	SHIPS AT SEA
PLATE 345.	ILLUSTRATING MANOEUVERS OF FLEETS
PLATE 346.	SHIPS AT WAR
PLATE 347.	SHIPS IN DRYDOCK AND IN PORT
PLATE 348.	ROADSTEADS AND HARBOR EQUIPMENT
PLATE 349.	LIGHTHOUSES AND DOCKS
	ARCHITECTURE
CAPTIONS	TO THE PLATES
CAPTIONS	TO THE PLATES
DI ATE 250	ANCIENT INDIAN TEMPLES AND PAGODAS
	INDIAN TEMPLES AT ELLORA AND ELEPHANTA
PLATE 331.	ANCIENT ARCHITECTURE AND SCULPTURE
PLATE 352.	EGYPTIAN TEMPLES AND TOMBS
	TEMPLE, PALACE, AND CATACOMBS
	PYRAMIDS AND MONUMENTS
	ILLUSTRATING GENERAL CONSIDERATIONS ON ARCHITECTURE
PLATE 356.	ANCIENT ARCHITECTURE
PLATE 357.	ARCHITECTURE OF CLASSICAL GREECE
PLATE 358.	CLASSICAL GREEK TEMPLES
PLATE 359.	GREEK AND ROMAN TEMPLES
PLATE 360.	GREEK TEMPLES IN SEVERAL EUROPEAN COUNTRIES
PLATE 361.	
PLATE 362.	RUMAN AND MIDDLE EASIERN ARCHITECTURE

PLATE 363.	ROMAN FORUM AND VARIOUS AMPHITHEATRES
PLATE 364.	GREEK AND ROMAN TEMPLES
PLATE 365.	TEMPLE AT BAALBEC AND OTHER GREEK AND ROMAN ARCHITECTURE
PLATE 366.	
PLATE 367.	ROMAN MEMORIAL AND CEREMONIAL ARCHITECTURE
PLATE 368.	GREEK AND ROMAN CAPITALS AND BASES
PLATE 369.	CLASSICAL COLUMNS, DOORS, AND BALUSTERS
PLATE 370.	CLASSICAL COLUMN ARRANGEMENT AND ORNAMENTATION
PLATE 371.	CLASSICAL CAPITALS AND BASES
PLATE 372.	CLASSICAL ARCADES
PLATE 373.	PRIMITIVE STANDING STONE ARCHITECTURE OF WESTERN EUROPE
PLATE 374.	TRADITIONAL CHINESE ARCHITECTURE431
PLATE 375.	PRE-COLUMBIAN ARCHITECTURE OF CENTRAL AMERICA
PLATE 376.	EARLY CHRISTIAN ARCHITECTURE
PLATE 377.	BYZANTINE ARCHITECTURE
PLATE 378.	BYZANTINE ARCHITECTURE
PLATE 379.	BYZANTINE AND EARLY ROMANESQUE ARCHITECTURE
PLATE 380.	ISLAMIC ARCHITECTURE
PLATE 381.	ISLAMIC ARCHITECTURE
PLATE 382.	ISLAMIC, INDIAN, AND EARLY ROMANESQUE ARCHITECTURE 439
PLATE 383.	COLOGNE CATHEDRAL; MEDIEVAL ARCHITECTURE
PLATE 384.	VARIOUS ARCHITECTURAL STYLES OF THE MIDDLE AGES
PLATE 385.	VARIOUS ARCHITECTURAL STYLES OF THE MIDDLE AGES
PLATE 386.	MEDIEVAL CATHEDRALS AND ARCHITECTURAL DETAILS
PLATE 387.	MEDIEVAL CATHEDRALS AND ARCHITECTURAL DETAILS 444
PLATE 388.	CATHEDRAL OF ROUEN; ARCHITECTURAL DETAILS OF THE MIDDLE AGES
PLATE 389.	ROMANESQUE AND GOTHIC ARCHITECTURE 446
PLATE 390.	SCENES AND DETAILS OF GOTHIC CATHEDRALS AND ABBEYS 447
PLATE 391.	ECCLESIASTICAL AND SECULAR ARCHITECTURE OF THE RENAISSANCE
PLATE 392.	RENAISSANCE CHURCHES AND ARCHITECTURAL DETAILS
PLATE 393.	SAINT PETER'S IN ROME
PLATE 394.	ITALIAN CHURCHES OF THE MIDDLE AGES AND RENAISSANCE 451
PLATE 395.	EUROPEAN CHURCHES OF VARIOUS ARCHITECTURAL STYLES
PLATE 396.	EUROPEAN CHURCHES OF THE SIXTEENTH AND SEVENTEENTH CENTURIES
PLATE 397.	EUROPEAN CHURCHES OF THE SEVENTEENTH AND
	EIGHTEENTH CENTURIES
	MAJOR EUROPEAN CATHEDRALS
PLATE 399.	EUROPEAN CHURCHES OF VARIOUS ARCHITECTURAL PERIODS 456

PLATE 400.	SECULAR ARCHITECTURE OF THE RENAISSANCE AND BAROQUE ERAS
PI ATE 401	PALATIAL ARCHITECTURE OF VARIOUS PERIODS
PLATE 402.	DAY ATTAL AND MONIMENTAL ADOLUTEOTHER OF FRANCE AND
TEMPE 402.	GERMANY
PLATE 403.	NEO-CLASSICAL ARCHITECTURE IN FRANCE AND ROME
PLATE 404.	NEO-CLASSICAL ARCHITECTURE IN GERMANY AND HOLLAND
PLATE 405.	PUBLIC BUILDINGS IN THE NEO-CLASSICAL STYLE
PLATE 406.	MONUMENTAL AND PUBLIC ARCHITECTURE OF VARIOUS PERIODS 463
PLATE 407.	COMMERCIAL ARCHITECTURE 464
PLATE 408.	VARIOUS EUROPEAN PRISONS
PLATE 409.	THE ARCHITECTURE OF BRIDGES
	MYTHOLOGY AND RELIGIOUS RITES
CAPTIONS	TO THE PLATES
PLATE 410.	HINDOO AND BUDDHIST SYMBOLS AND RELIGIOUS IMPLEMENTS
PLATE 411.	HINDOO PENITENTS, RELIGIOUS FIGURES AND PARAPHERNALIA; MONGOLIAN IDOLS; FIGURES OF BUDDHA
DI ATE 410	RELIGIOUS SCENES AND FIGURES OF INDIA AND CENTRAL ASIA
PLATE 412.	RELIGIOUS SCENES AND FIGURES OF INDIA AND CENTRAL ASIA
PLATE 413.	DITES AND DELICIOUS EICHDES AND DADADHEDNALIA OF THE
PLATE 414.	FAR EAST
PLATE 415.	RELIGIOUS SCENES, SYMBOLS, AND FIGURES OF CHINA, JAPAN, AND INDONESIA
DI ATE 416	RELIGIOUS SCENES AND SYMBOLS OF THE ANCIENT NEAR EAST
PLATE 416. PLATE 417.	EGYPTIAN GODS AND RELIGIOUS SYMBOLS
PLATE 417.	EGYPTIAN RELIGIOUS SYMBOLS AND TABLEAUX
PLATE 419.	SACRIFICE TO ISIS; RELIGIOUS AND MYTHOLOGICAL FIGURES OF
PLATE 419.	EGYPT
PLATE 420.	SCENE OF CHINESE WORSHIP; ANCIENT MIDDLE EASTERN DEITIES AND IDOLS; NORSE GODS
PLATE 421.	FIGURES AND SCENES OF NORSE AND GERMANIC MYTHOLOGY 484
PLATE 422.	DEITIES AND RELIGIOUS RITES OF THE NORSE, GAULS, AND CELTS 485
PLATE 423.	AZTEC AND MAYAN RELIGIOUS RITES, FIGURES, AND ARTIFACTS 486
PLATE 424.	RELIGIOUS RITES AND FIGURES OF ANCIENT GREECE AND ROME 487
PLATE 425.	SACRED RITES, RELIGIOUS AND MYTHOLOGICAL FIGURES, AND RELIGIOUS PARAPHERNALIA OF GREECE AND ROME
PLATE 426.	LEGENDARY SCENES AND FIGURES FROM GREEK AND
	ROMAN MYTHOLOGY

PLATE 427.	CLASSICAL DEITIES AND MYTHOLOGICAL CHARACTERS
PLATE 428.	GREEK AND ROMAN GODS AND RELIGIOUS PARAPHERNALIA
PLATE 429.	GREEK FESTIVAL AND MYTHOLOGICAL FIGURES AND SCENES
PLATE 430.	CLASSICAL LEGENDS AND MYTHOLOGICAL FIGURES
PLATE 431.	GODS AND MYTHOLOGICAL CREATURES494
PLATE 432.	GODS AND MYTHOLOGICAL CHARACTERS495
PLATE 433.	GODS AND MYTHOLOGICAL CREATURES AND FIGURES
PLATE 434.	GODS AND MYTHICAL CHARACTERS
PLATE 435.	THE MUSES AND OTHER LEGENDARY FEMALE FIGURES; APOLLO AND DIONYSUS
PLATE 436.	APHRODITE AND OTHER GODDESSES AND GODS
PLATE 437.	APOLLO; SACRIFICE TO MARS; OTHER MYTHOLOGICAL FIGURES 500
PLATE 438.	A SACRIFICE IN ROME; GODS AND MYTHOLOGICAL CHARACTERS
PLATE 439.	LEGENDARY AND MYTHOLOGICAL SCENES AND FIGURES OF
	GREECE AND ROME
	THE FINE ARTS
CAPTIONS 7	TO THE PLATES
PLATE 440.	ANCIENT SCULPTURE
PLATE 441.	ANCIENT SCULPTURE
PLATE 442.	GREEK AND ROMAN SCULPTURE AND COINS
PLATE 443.	GREEK AND ROMAN SCULPTURE
PLATE 444.	CLASSICAL SCULPTURE 513
PLATE 445.	CLASSICAL AND CLASSICAL REVIVAL SCULPTURE 514
PLATE 446.	RENAISSANCE SCULPTURE 515
PLATE 447.	RENAISSANCE, MANNERIST, AND NEOCLASSIC SCULPTURE
PLATE 448.	NEOCLASSIC SCULPTURE 517
PLATE 449.	HEROIC AND MEMORIAL SCULPTURE AND MONUMENTS
PLATE 450.	NINETEENTH-CENTURY MEMORIAL AND CEREMONIAL SCULPTURE 519
PLATE 451.	ANCIENT WALL AND VASE PAINTING
	ANCIENT DECORATIVE ARTS 521
PLATE 453.	ANCIENT AND EARLY MEDIEVAL PAINTING AND MOSAICS
PLATE 454.	ITALIAN PAINTING OF THE RENAISSANCE 523
PLATE 455.	
PLATE 456.	PAINTING OF THE SIXTEENTH AND SEVENTEENTH CENTURIES
PLATE 457.	BAROQUE AND MANNERIST PAINTING
PLATE 458.	
PLATE 459.	ILLUSTRATIONS OF THE THEORY OF THE ART OF DRAWING

PLATE 460.	ILLUSTRATIONS OF THE THEORY OF THE ART OF DRAWING
PLATE 461.	ILLUSTRATIONS OF THE GRAPHIC ARTS 530
PLATE 462.	ALPHABETS OF VARIOUS LANGUAGES FOR THE USE OF ENGRAVERS 531
PLATE 463.	ALPHABETS FOR ENGRAVERS
PLATE 464.	DETAILS ILLUSTRATING THE CONSTRUCTION OF THEATRICAL BUILDINGS
PLATE 465.	DETAILS ILLUSTRATING THE CONSTRUCTION OF THEATRICAL BUILDINGS
	THEATRICAL BUILDINGS
	TECHNOLOGY
CAPTIONS 7	TO THE PLATES
PLATE 466.	CONSTRUCTION OF STREETS AND ROADS; THE THAMES TUNNEL
PLATE 467.	ILLUSTRATING THE CONSTRUCTION OF RAILROADS
PLATE 468.	RAILROAD CONSTRUCTION; LEIPSIC STATION
PLATE 469.	MOTIVE POWER; CONSTRUCTION OF INCLINED PLANES
PLATE 470.	CONSTRUCTION OF LOCOMOTIVES AND RAILWAY CARS
PLATE 471.	ILLUSTRATING THE CONSTRUCTION OF ATMOSPHERIC RAILROADS 544
PLATE 472.	ILLUSTRATING THE CONSTRUCTION OF STONE BRIDGES
PLATE 473.	ILLUSTRATING THE CONSTRUCTION OF WOODEN BRIDGES
PLATE 474.	ILLUSTRATING THE CONSTRUCTION OF IRON BRIDGES
PLATE 475.	CONSTRUCTION OF CANALS AND DAMS
PLATE 476.	CANALS AND AQUEDUCTS
PLATE 477.	ILLUSTRATING THE CONSTRUCTION OF WINDLASSES AND CRANES 550
PLATE 478.	PUMPING DEVICES
PLATE 479.	FIRE-FIGHTING EQUIPMENT
PLATE 480.	CONSTRUCTION OF WATER-WHEELS
PLATE 481.	ILLUSTRATING THE CONSTRUCTION OF AN AMERICAN GRINDING-MILL
PLATE 482.	
PLATE 483.	WOOL PROCESSING EQUIPMENT
PLATE 484.	WEAVING EQUIPMENT
PLATE 485.	MINTING EQUIPMENT
PLATE 486.	MINTING559
PLATE 487.	COINS OF VARIOUS NATIONS
PLATE 488.	MINING
PLATE 489.	MINING
PLATE 490.	MINING
PLATE 491.	MINING 564

DI ATE 402	METAL MILLING	5
	METAL MILLING	
PLATE 494.	AGRICULTURE	7
PLATE 495.	AGRICULTURE	8
PLATE 496.	HUSBANDRY	9
PLATE 497.	AGRICULTURE	0
	HUNTING	
	FISHING	
PLATE 500.	FISHING	3

THE COMPLETE ENCYCLOPEDIA OF ILLUSTRATION

Captions to the Mathematics and Astronomy Plates, 1-15

PLATES 1 and 2. Mathematical and Geometrical **Problems**

Figures 1-91.

PLATE 3.

Mathematical and Geometrical **Problems**

Figures 1-142.

GLOSSARY

Milchstrasse, Milky Way

PLATE 4.

Problems in Geodesv or Surveying, and Projection in Vertical and Horizontal Planes

Figures 1-68.

PLATE 5. Mathematical and Surveying **Instruments**

Figure

- 1, 2. Hair compasses
- 3. 4. Proportional compasses
- 5. Proportional compasses with micrometer screw
- 6, 7. Beam compasses
- 8, 8a. Triangular compasses
- 9, 10. Elliptograph
- 11-13. Farey's elliptograph
- 14. Excentric compasses
- 15. Pantograph
- 16. Wallace's eidograph
- 17. Spring compasses
- 18, 19. Parallel ruler
- 20. Lehman's plane table
- 21. Mayer's plane table
- 22. Mayer's fork and plummet
- 23, 24. Tubular level
- 25. Diopter ruler
- 26. Diopter ruler with telescope
- 27. Measuring chain
- 28. Measuring staff
- 29. Arrow or picket
- 30. Zollman's instrument for measuring angles
- 31. Astrolabe

- 32. Hadley's sextant
- 33, 34. Compass and telescope
- 35, 36. Schmalkalder's prismatic compass
- 37. Graphometer
- 38. Theodolite
- 39. Borda's reflecting circle
- 40, 41. Water level and movable diopter
- 42-44. Keith's mercurial level
- 45. Level and compass
- 46. Levelling telescope
- 47. Levelling compass
- 48. Levelling circle
- 49, 50. Explanation of the vernier
- 51, 52. Levelling staves
- 53, 54. Target of levelling stave
- 55. Plate compasses
- 56. Mason's level
- 57. Application of plane table
- 58-60. Lehman's method of topographical drawing

GLOSSARY

- a = der Projection desBergstriches, a = Projection of the mountain tract
- b = der Höhe der horizontalen Schicht, b = Height of the horizontal stratum
- c = wahre Länge des Bergstriches, c = True length of the mountain tract

PLATE 6.

Illustrating Theories, Forces, and Phenomena of the Solar System

Figure

- 1, 2. The armillary sphere
- 3. Illustrating the properties of the circle
- Illustrating the properties of the ellipse
- Illustrating the parallax
- Illustrating the centrifugal force of the earth
- Illustrating the rotation of the earth

- 8, 9. Illustrating the proof of the earth's being of spherical shape and an elliptical spheroid
- 10. Illustrating the local variation of gravity
- 11. The parallelogram of forces
- 12. Illustrating the points, circles, and terms of the terrestrial sphere
- 13. Illustrating the apparent rotation of the celestial sphere
- 14. Illustrating the heliocentric and geocentric place of the planets
- 15. Illustrating the perihelion distance
- 16, 17. Illustrating refraction
- 18. Illustrating the theory of eclipses of the sun and moon
- 19. Illustrating the phases of the moon
- 20. Illustrating the moon's nodes
- 21. Illustrating the apparent course of Venus
- 22. Illustrating the theory of twilight
- 23. Illustrating the theory of ebb and flow
- 24, 25. Illustrating the apparent course of superior and inferior planets
- 26. Illustrating the resistance of the ether

PLATE 7.

Various Planetary Systems

- 1. Planetary system of Ptolemy
- Planetary system of the **Egyptians**
- Planetary system of Tycho de Brahe
- 4, 5. Planetary system of Copernicus
- Illustrating the velocity of planets
- 7. Illustrating the inclination of

the planetary orbits to that of the earth

PLATE 8. **Celestial Bodies**

Figure

- 1. Group of stars in Hercules
- 2. Group of stars in Aquarius
- 3. 4. Group of stars fan shaped
- Nebula in Ursa
- Nebula in Gemini
- 7. Nebula in Leo Major
- 8, 9. Nebulæ in Monoceros
- 10. Nebula in Canes Venatici
- 11. Nebula in Sagittarius
- 12, 13. Nebula in Auriga
- 14. Nebula in Andromeda
- 15. Comet of 1819
- 16, 17. Comet of 1811
- 18. Surface of Mars
- 19. Surface of Jupiter
- 20. Surface and rings of Saturn

PLATE 9.

Seasons and Other Phenomena of the Spheres

Figure

- 1. Illustrating the seasons 2, 3. Daily and yearly motion of the earth
- Illustrating the parallel sphere
- Illustrating the right sphere
- Illustrating the 13 transits of Mercury in the 19th century
- 7, 8. Illustrating the phenomena of the transit of Mercury. May 4, 1786
- 9-13. The sun's spots

PLATE 10.

Illustrating Phases of the Earth's Moon and Orbits of the Earth and **Various Moons**

Figure

- 1. Illustrating the determination of longitude and latitude
- Illustrating the theory of the elliptical orbit of the earth

- Illustrating the duration of a revolution of the moon
- Illustrating the daily revolution of the moon around the earth
- Illustrating the phases of the
- Orbits of the moons of Jupiter
- Orbits of the moons of Saturn
- Orbits of the moons of Uranus
- Orbit of the earth's moon
- 10. Serpentine projection of the moon's course on the plane of the earth's orbit

GLOSSARY

Abend. Evening: —stern.

Evening star Abnehmender Mond, Decreasing

Aphelium, Aphelion Apsidenlinie, Line of Apsides Aufsteigender Knoten, Ascending

node Austritt beim Aufgang der Sonne, Emersion at sunrise; —beim Untergang der Sonne.

Emersion at sunset Axe der Ekliptik, Axis of the **Ecliptic**

Bahn des Merkur, Orbit of Mercury; —der Venus, Orbit of Venus

Colur des

Frühlings-Æquinoxiums, Colure of the vernal equinox; —des Herbst-Æquinoxiums, Colure of the Autumnal equinox; —der Nachtgleichen, Colure of the equinoxes: —des Sommersolstitiums, Colure of the Summer solstice: —des Wintersolstitiums.

Colure of the Winter solstice

Comet von 1811 vor seiner Erscheinung. Projectirt auf die Ekliptik am 25 März 1811. Neigung der Bahn 75° 5', Comet of 1811 before its

appearance. Projected on the ecliptic March 25, 1811, Inclination of the orbit 75° 5'.—von 1811 nach seiner Erscheinung b am 1 März 1812, Comet of 1811 after its appearance until March 1, 1812

Dauer der längsten Nächte,
Duration of the longest nights;
—des längsten Tages,
Duration of the longest day
Dichteres Medium, Denser

medium

Drei Uhr Morgens, 3 o'clock A.M.; —Nachmittag, 3 o'clock P.M.

Dritter Octant, Third octant
Dünneres Medium, Rarer medium
Ebene der Pallas, d. Juno, etc.,
Planes of the orbits of Pallas,
Juno, etc.

Eintritt beim Aufgang der Sonne, Entrance at sunrise; —beim Untergang d. Sonne, Entrance at sunset

Ekliptik, Ecliptic
Erdaxe, Axis of the earth
Erdbahn, Orbit of the earth
Erde, Earth
Erster Octant, First octant
Erstes Viertel, First quarter
Excentricität, Eccentricity
Frühling, Spring
Frühlingsnachtgleiche, Vernal
equinox

Gemässigte Zone, Temperate zone

Grosse Axe, Axis of the heavens Halley'scher Comet v. 1759 u. 1835, Neigung seiner Bahn, Halley's Comet of 1759 and 1835, inclination of its orbit

Heisse Zone, Torrid zone Herbst, Autumn Herbstnachtgleiche, Autumnal

Herbstnachtgleiche, Autumna equinox

Horizont, Horizon
Kalte Zone, Frigid zone
Kometenbahn, Orbit of a comet
Letztes Viertel, Last quarter
Millionen Meilen, Millions of
miles
Mittag, Noon

Mittag, Noon Mittelkraft, Mean force Mitternacht, Midnight Monate, Months

Mond, Moon; — -bahn, Orbit of the moon; — -finsterniss, Eclipse of the moon

Morgen, Morning; — -stern, Morning star

Neumond, New moon Neun Uhr Abends, 9 P.M.; —Morgens, 9 A.M.

Niedersteigender Knoten, Descending node

Nord, North; — -pol, Northpole Nördliche Declination der Sonne, Northern declination of the sun

Nördlicher Polarkreis, Arctic circle

Obere Conjunction, Superior conjunction

Estliche Digression, East digression

Ost, East
Perihelium, Perihelion
Polarstern, Polar star
Polhöhe über dem Horizont,
Elevation of the pole above
the horizon

Richtung des Schattens um Mittag, Direction of the shadow at noon

Rotationsaxe, Axis of rotation Scheinbarer Himmelsbogen, Apparent arch of the heavens; —Horizont, visible horizon

Sechs Uhr Abends, 6 P.M.;
—Morgens, 6 A.M.

Solstitial oder Wendepunktlinie, Solstitial colure

Sommer, Summer;

— -Sonnenwende, Summer solstice

Sonne, Sun; —Sonnen-Æquator, Sun's equator; — finsterniss, Eclipse of the sun; — -scheibe im Grössenverhältniss zu den Planeten, The sun's disk; its size compared to the diameters of the planets

Stunden, Hours; —Entfernung, Hours' distance; — -ring, Hour-circle

Süd, South; — -pol, South pole Südliche Declination der Sonne, Southern declination of the sun Südlicher Polarkreis, Antarctic circle

Südwestlicher Sonnenrand, Southwestern edge of the sun

Trabanten des Jupiter; —des Saturn; —des Uranus, Satellites of Jupiter, Saturn, and Uranus

Untere Conjunction, inferior conjunction

Vierter Octant, Fourth octant Vollmond, Full moon

Vom Pol bis zum Zenith, From pole to zenith; —Zenith biz zum Æquator, From zenith to equator

Wahrer Horizont, True horizon Wendekreis des Krebses, Tropic of Cancer; —des Steinbocks, Tropic of Capricorn

Westliche Digression, West digression

Winter-Sonnenwende, Winter solstice

Zoll, Digit, inch

Zunehmender Mond, Increasing moon

Zweites Octant, Second octant

PLATE 11.

Beer and Mädler's Map of the Moon

PLATE 12.

Map of the Northern Heavens

PLATE 13. **Map of the Southern Heavens**

PLATE 14.

Planet Sizes and Various
Phenomena

Figure

1-11. Relative sizes of the planets with respect to the sun's diameter

12-15. Positions of Saturn and its ring with respect to the earth

16-35. Apparent size of the planets in their perigee and apogee

36–45. Apparent size of the sun as seen from the planets

46-54. Comparison of the diameters of the moon and the planets to the diameter of the earth

55. Mode of observing a transit of Venus

56. Total eclipse of the sun

57. Aurora borealis

58. Aurora australis

59. Mock suns

GLOSSARY

Anfang bei Sonnenaufgang,
Beginning at sunrise; —bei
Sonnenuntergang, beginning at
sunset

Arabien, Arabia
Atlantischer Ocean, Atlantic
Ocean

Azorische Inseln, the Azores Berberey, Barbary

Berührung des Sonnen-, und Mondrandes, Contact of the edges of sun and moon

Canarische Inseln, Canary Islands

Capverdische Inseln, Cape Verd Islands

Centrale oder totale
Verfinsterung, Central or total
eclipse

Drei Zoll Verfinsterung, Three digits eclipsed

Ende bei Sonnenaufgang, End at sunrise; —bei Sonnenuntergang, End at sunset

Grönland, Greenland Grossbritanien, Great Britain Grosser Ocean, Pacific Ocean Indisches Meer, Indian Sea Island, Iceland

Mittel bie Sonnenaufgang, Middle at sunrise; —bei Sonnenuntergang, Middle at sunset

Mittelländisches Meer, Mediterranean Sea Mongolei, Mongolia Neun Zoll Verfinsterung, Nine digits eclipsed Nordpol, North pole Norwegen, Norway Nubien. Nubia Ost Indien, East Indies Russland, Russia Sechs Zoll Verfinsterung, Six digits eclipsed Sibirien, Siberia

PLATE 15. Astronomical Instruments

Figure

Herschel's reflecting telescope

2. Fraunhofer's achromatic refractor at Dorpat

3-10. Meridian circle at Pulkowa

11, 12. Meridian circle at Hamburg

13. Roemer's transit instrument

14. Dollond's repeating circle

15-17. Repsold's Equatorial at Hamburg

18. Troughton's quadrant

19. Tycho's mural quadrant

20. Clockwork of Fraunhofer's refractor

21. Ptolemy's triquetrum

22. Portable transit instrument

23. Reflecting sextant

24. Reflecting sector

25-34. Repsold's small transit instrument at St. Petersburg

35–37. Ertel's theodolite

38. Henderson's planetarium

39. Henderson's explanation of the seasons

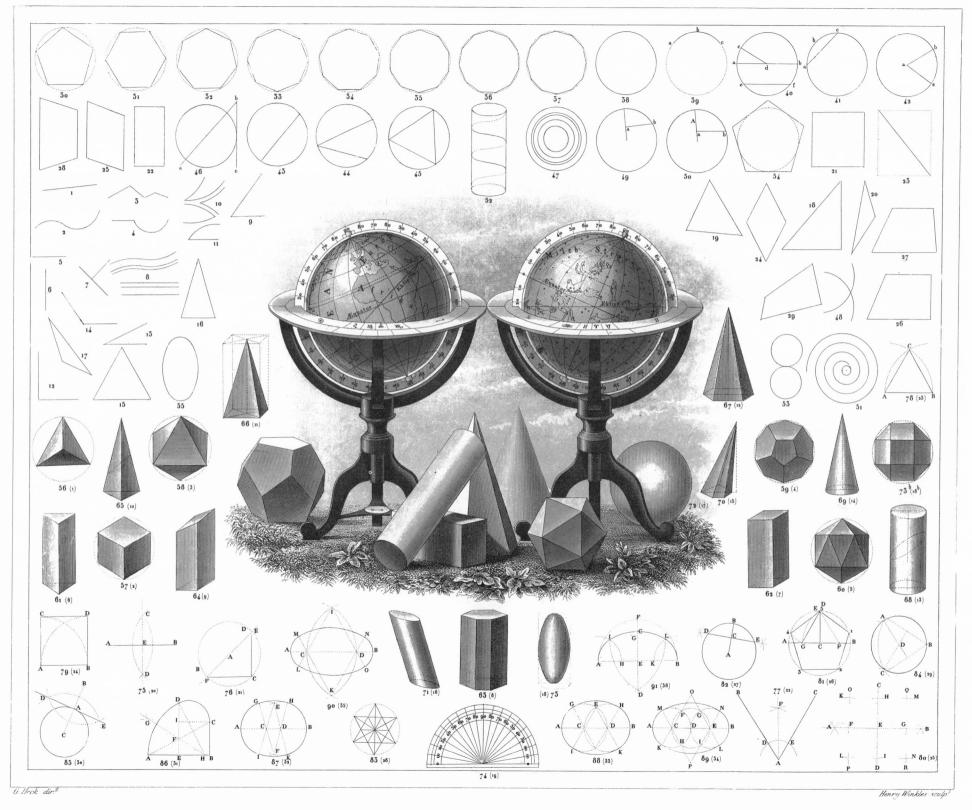

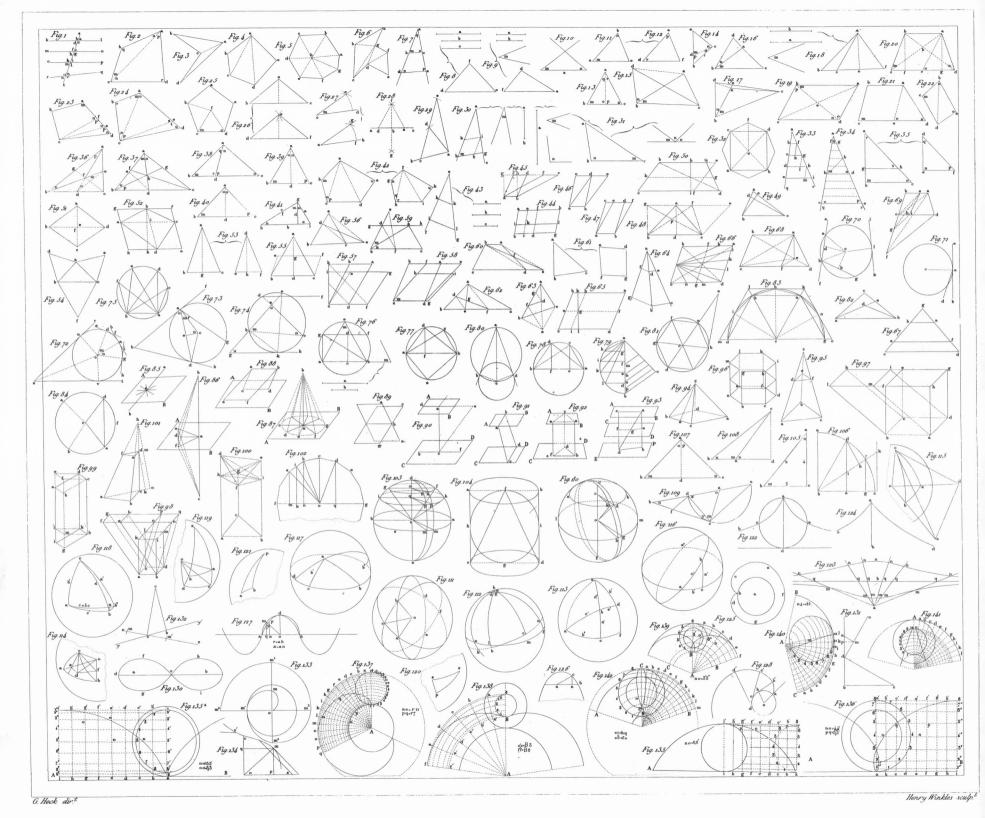

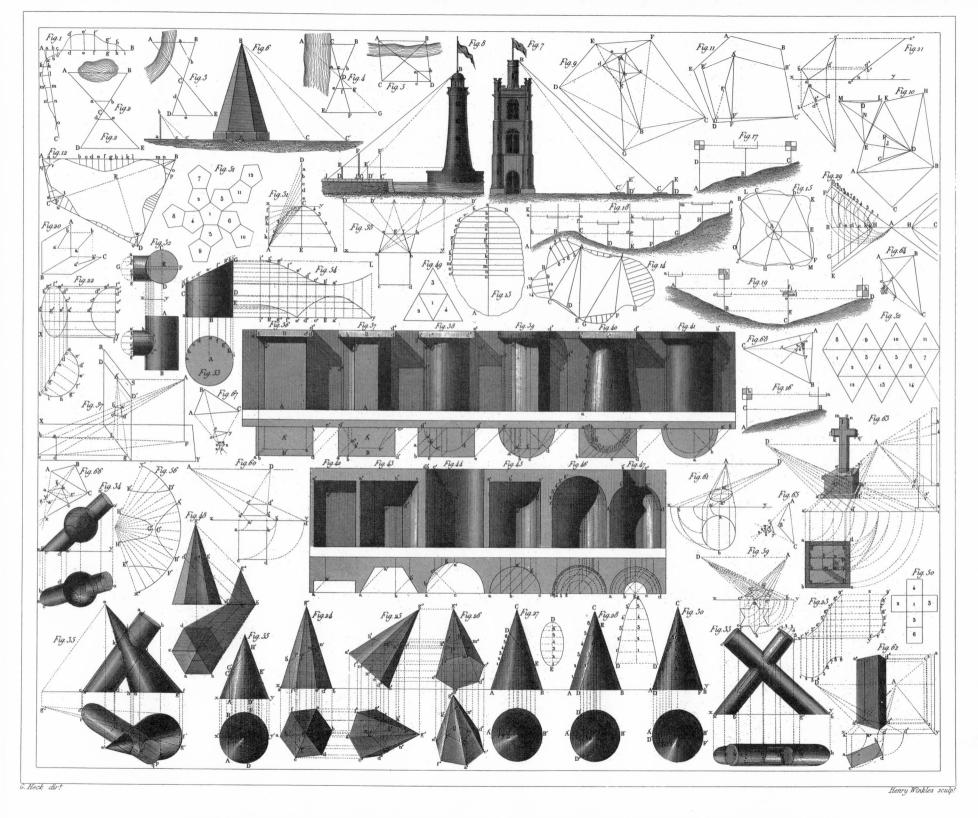

PLATE 4. PROBLEMS IN GEODESY OR SURVEYING, AND PROJECTION IN VERTICAL AND HORIZONTAL PLANES

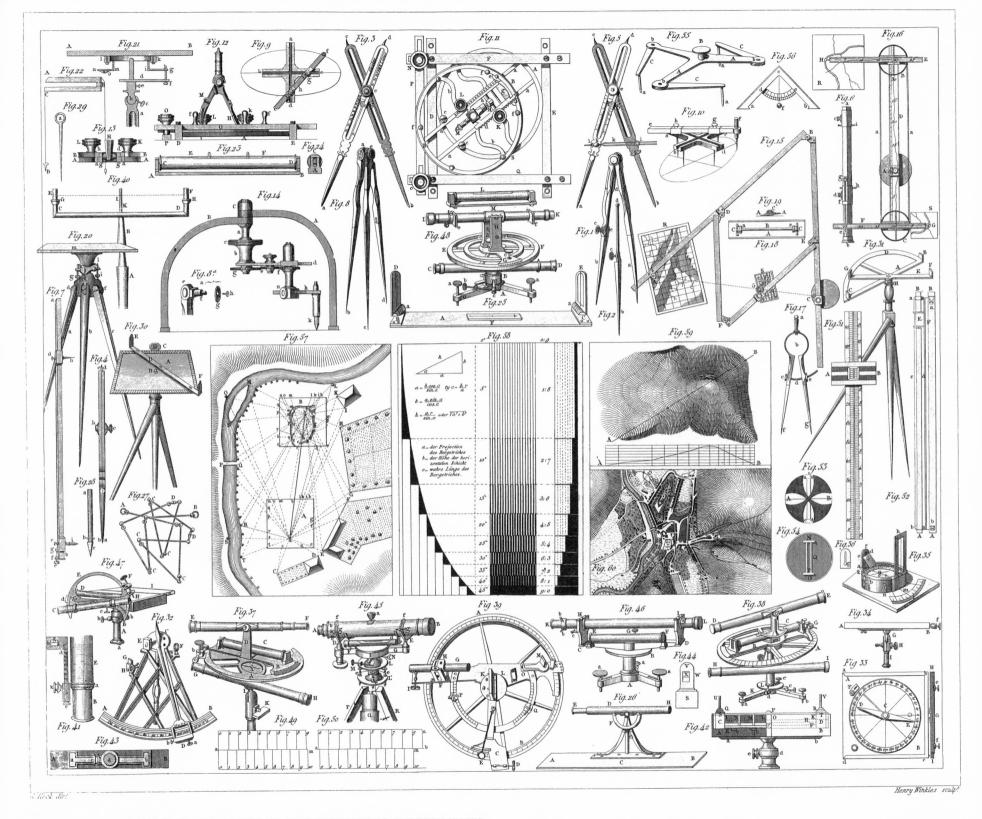

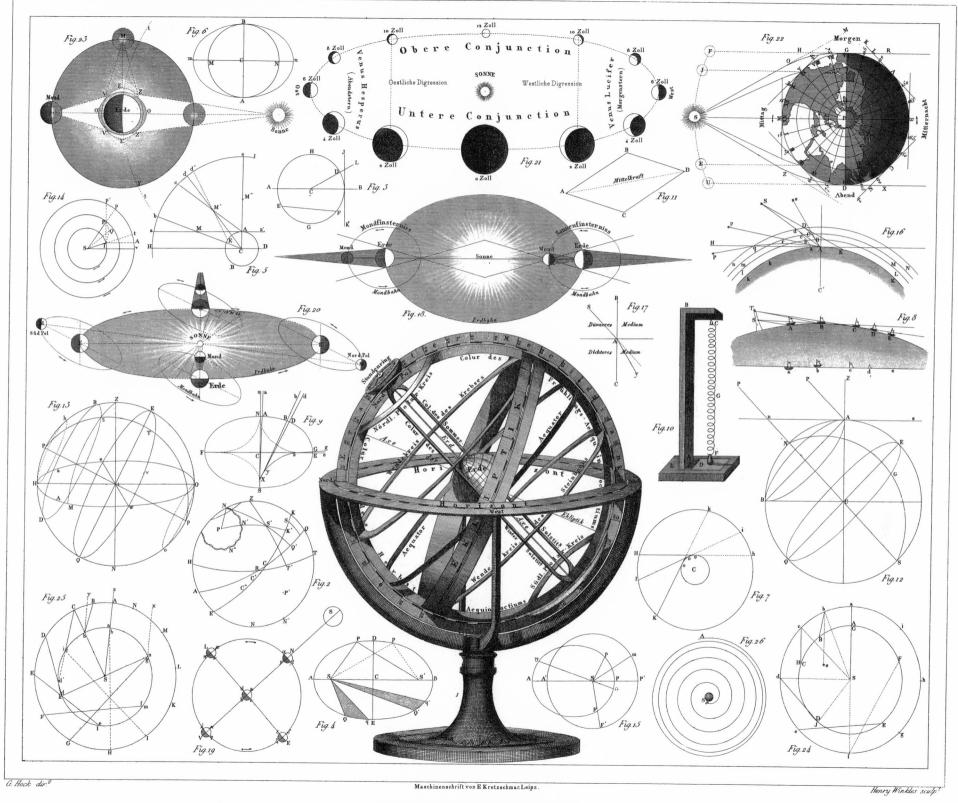

PLATE 6. ILLUSTRATING THEORIES, FORCES, AND PHENOMENA OF THE SOLAR SYSTEM

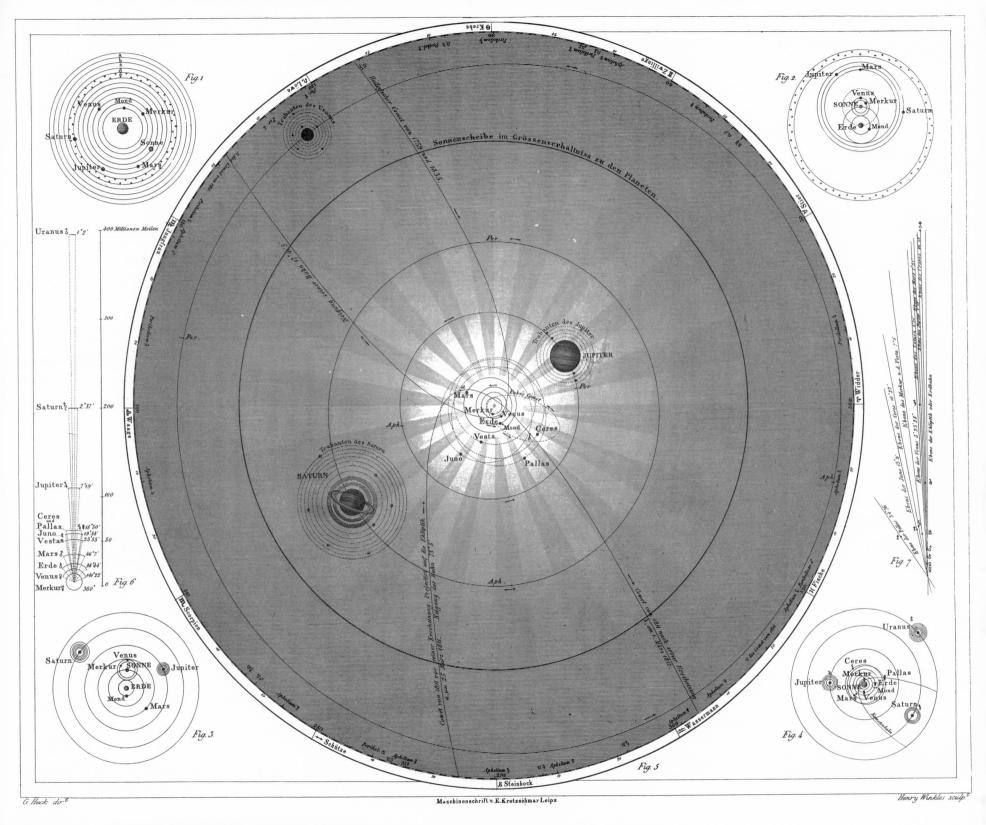

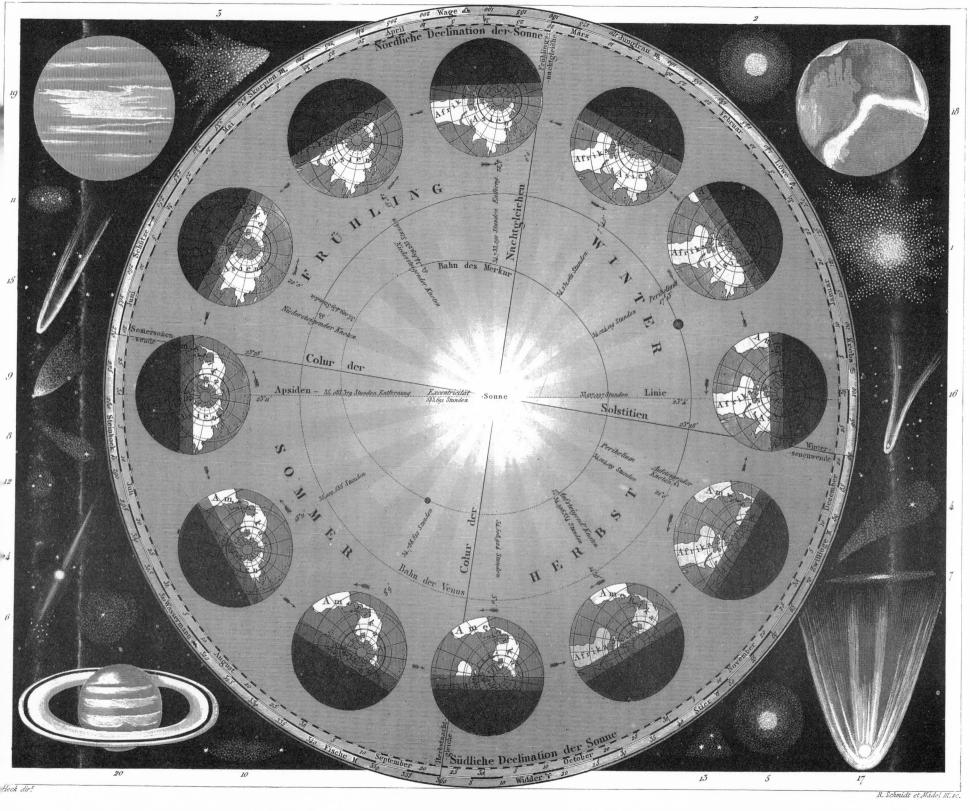

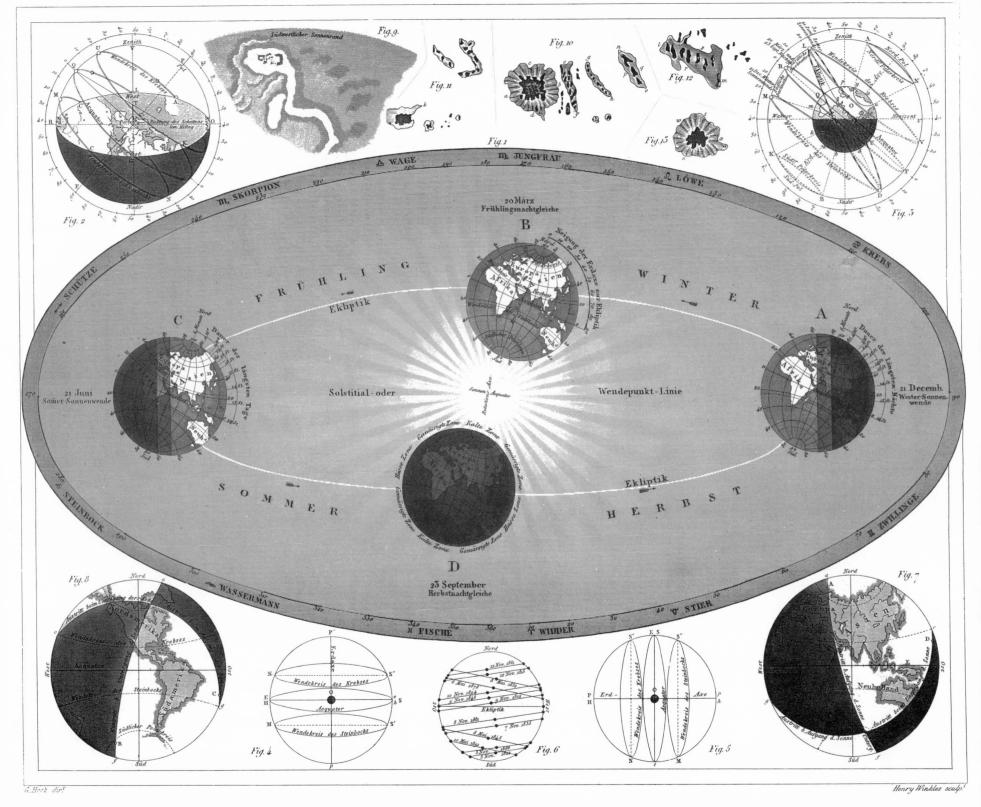

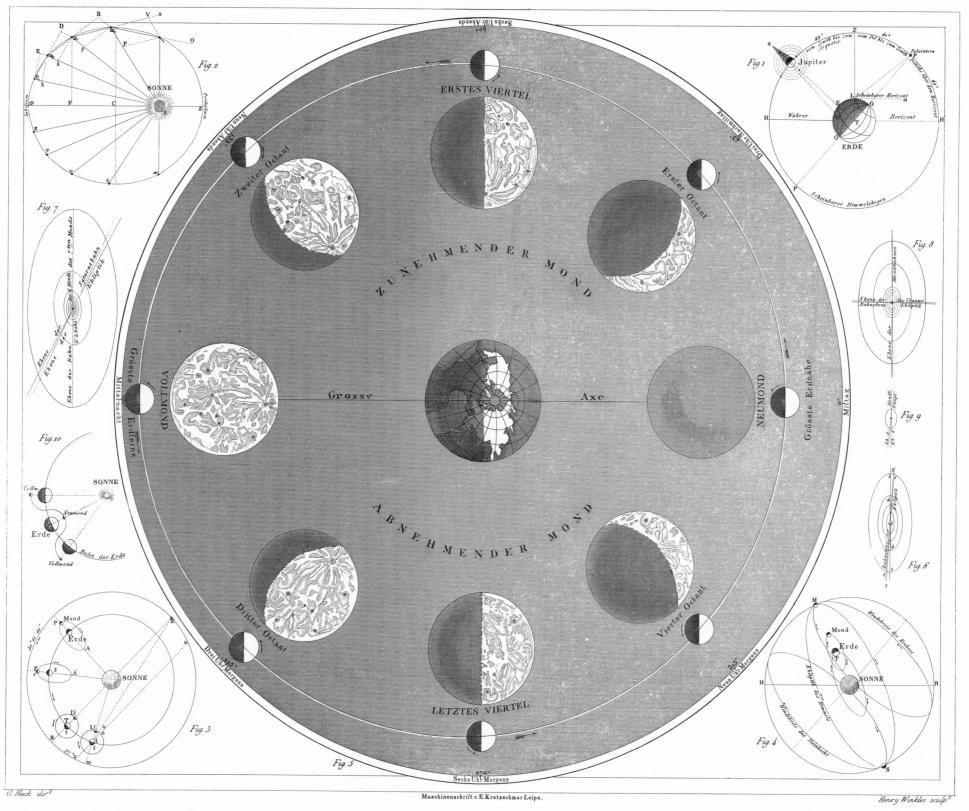

PLATE 10. ILLUSTRATING PHASES OF THE EARTH'S MOON AND ORBITS OF THE EARTH AND VARIOUS MOONS

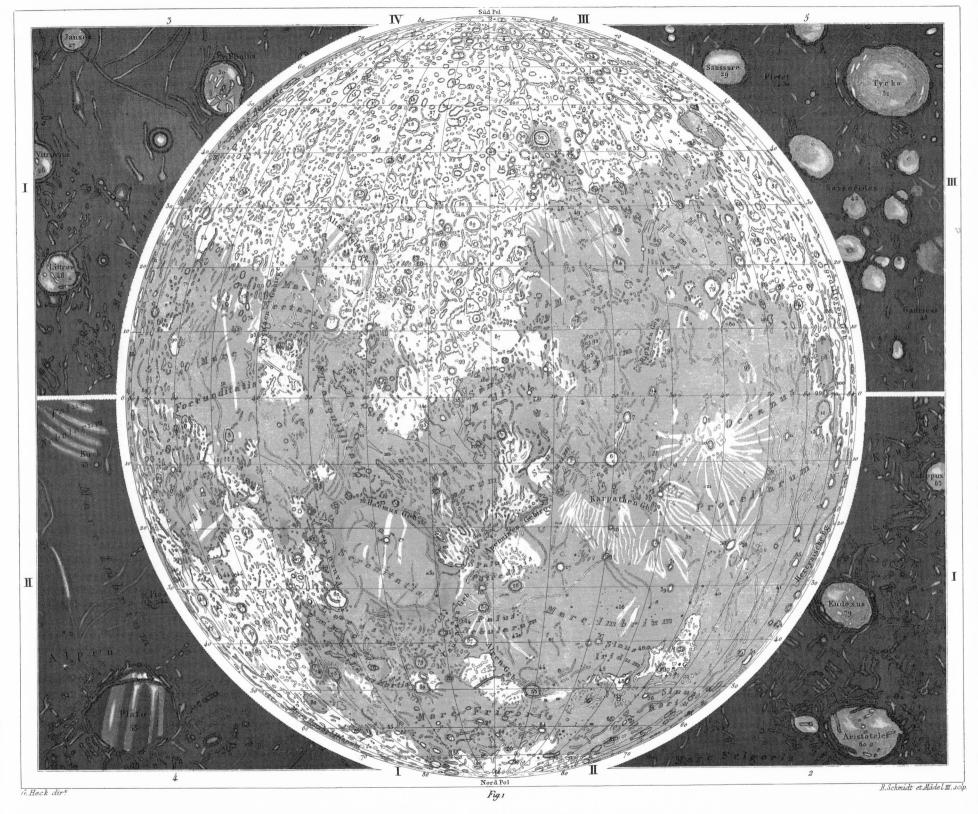

PLATE 11. BEER AND MÄDLER'S MAP OF THE MOON

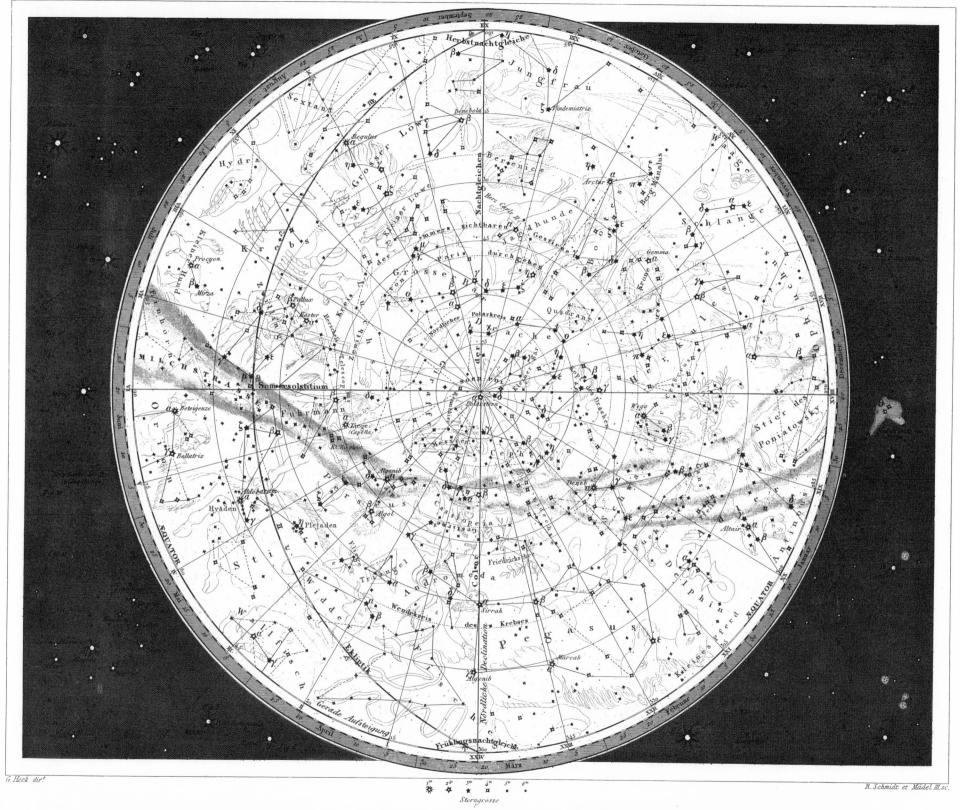

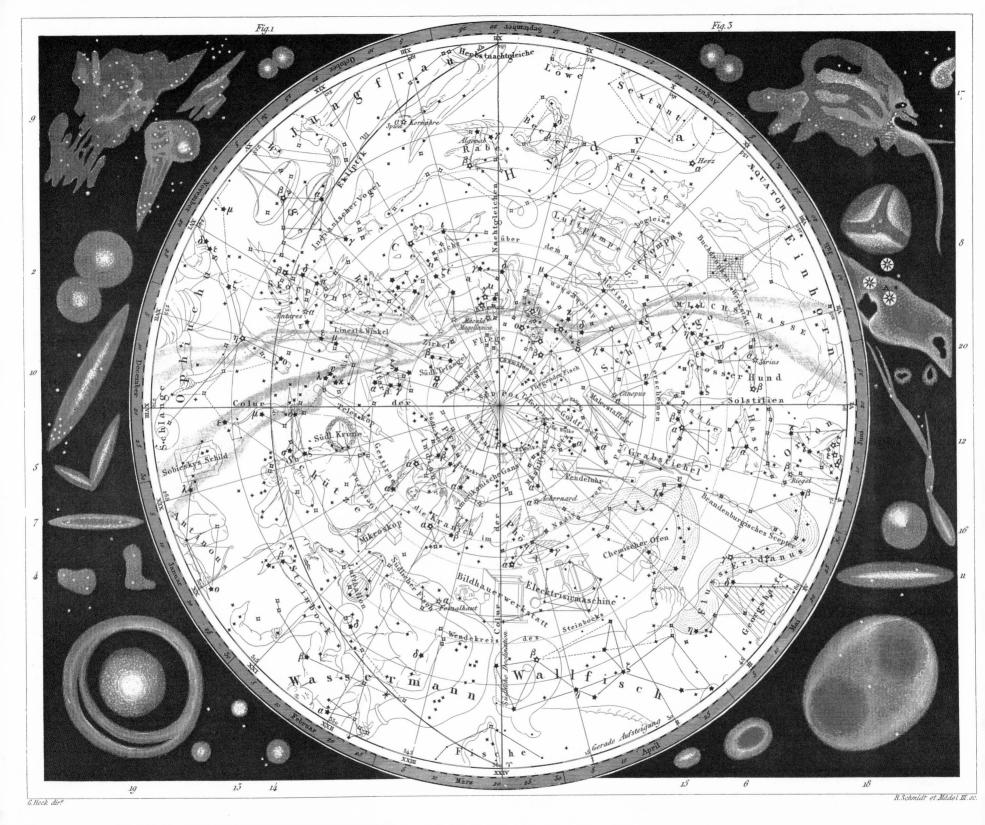

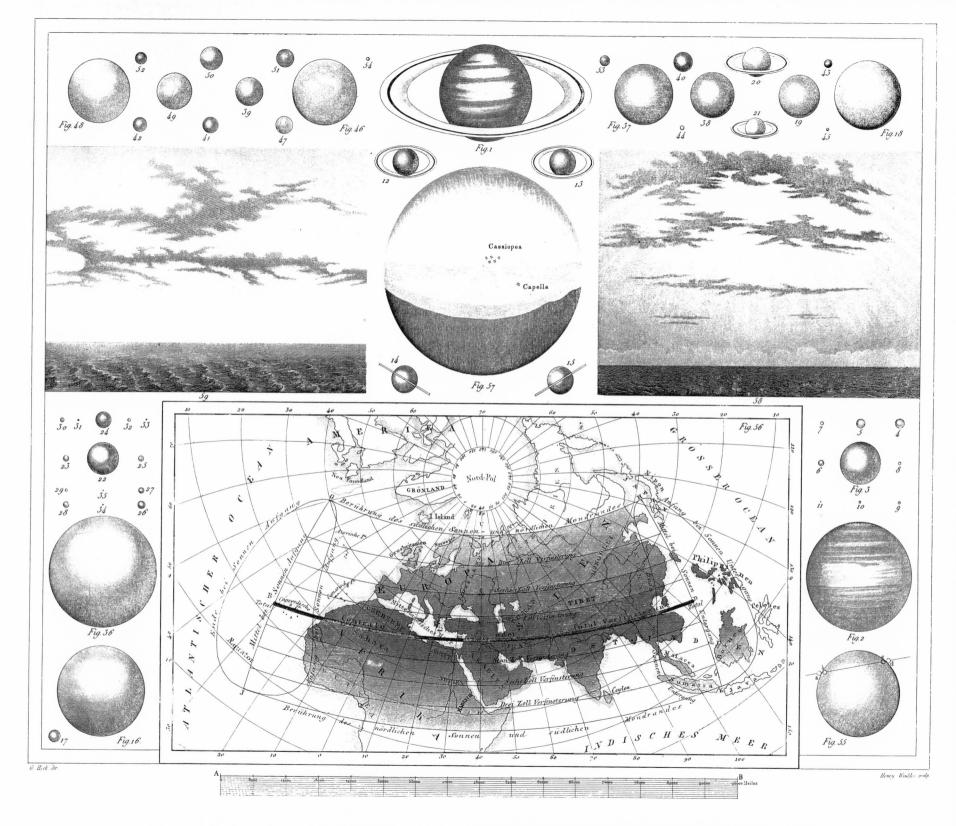

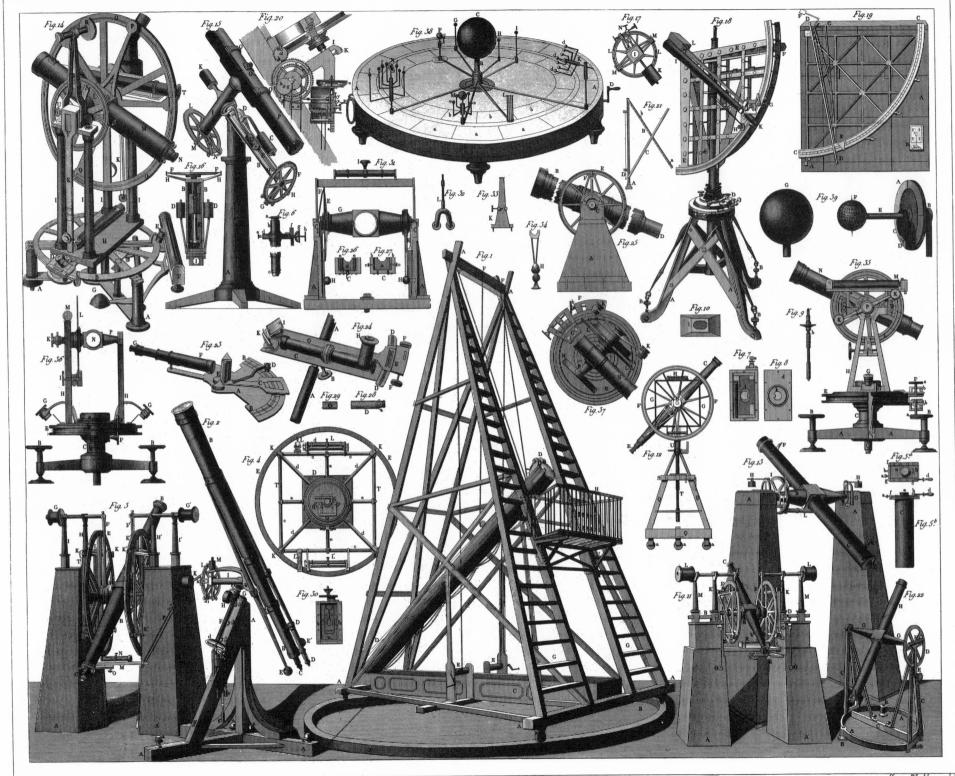

Henry Winkles sculp.t

NATURAL SCIENCES COMPRISING PHYSICS AND METEOROLOGY, CHEMISTRY, GEOGNOSY AND GEOLOGY, BOTANY, ZOOLOGY, AND ANTHROPOLOGY.

Captions to the Natural Sciences Plates, 16-141

PHYSICS AND METEOROLOGY

PLATE 16.

Theories of Force and Gravity; Demonstrations of These and Other Physical Laws

Figure

- 1. Parallelogram of forces
- 2. Triangle of forces
- 3. Polygon of forces
- 4. Parallelopipedon of forces
- 5. Center of gravity of a line
- 6. Center of gravity of a triangle
- Center of gravity of a polygon
- Center of gravity of a parallelogram
- Center of gravity of irregular surfaces
- 10. Center of gravity of a cube
- 11. Center of gravity of a parallelopipedon
- 12. Center of gravity of a pyramid
- 13. Center of gravity of two different bodies
- 14. Illustrating Varignon's funicular machine
- 15, 16. Illustrating the theory of the pulley
- 17, 18. Atwood's machine for demonstrating the laws of freely falling bodies
- 19. The fixed pulley
- 20. Illustrating the oscillation of the pendulum
- 21. The gridiron pendulum
- 22. The mercurial pendulum
- 23. Lever of the first class
- 24. Application of the same in the steelyard
- 25. Lever of the second class
- 26. Lever of the third class
- 27, 28. Illustrating the theory of equilibrium
- 29. Lever and pulley
- 30. Bent lever

- 31. Compound lever
- 32, 33. Wheel and axle
- 34. Endless screw attached to windlass
- 35. Wheel and axle with pulley
- 36-40. Movable pulleys
- 41, 42. White's pulley
- 43. Pulley with cords working obliquely
- 44-46. Inclined plane
- 47, 48. The wedge
- 49-52. Illustrating theory of strength and stress of materials

PLATE 17.

Illustrating Theories of Dynamics and Other Physical Laws

Figure

- 1–3. Illustrating the theory of the screw
- 4. Hunter's differential screw
- 5-21. Illustrating the theory of strength and stress of materials
- 22. Illustrating the theory of uniformly varying motion
- 23. Illustrating the theory of unequably accelerated motion
- 24. Illustrating the influence of gravitation on the motion of projectiles
- 25-28. Illustrating the theory of projectiles
- 29. Illustrating the centrifugal force
- 30. Illustrating the lateral pressure of moving liquids
- 31–33. Illustrating the velocity of efflux
- 34. Illustrating the forcing pump
- 35. Prony's swimmer, a contrivance to regulate the velocity of efflux
- 36. Illustrating the hydraulic ram
- 37, 38. Illustrating the ballistic pendulum
- 39, 40. Valve and parachute of

the Hampton balloon

- 41. Henson's flying machine
- 42–48. Illustrating the pneumodrome of Partridge

PLATE 18.

Theories and Instruments of Hydraulics and Aerodynamics

Figure

- 1-8. Illustrating the pressure of liquids
- 9, 10. Illustrating the law of Archimedes
- 11. The Cartesian devils
- 12-14. Hydrostatic balance
- 15. Nicholson's areometer
- 16. The scale areometer
- 17–19. Illustrating capillary attraction
- 20-30. Illustrating phenomena of attraction of liquids and solids
- 31. Dutrochet's endosmometer
- 32. Common barometer
- 33-35. Gay Lussac's syphon barometer
- 36-38. Fortin's barometer
- 39–41. Arago and Dulong's apparatus for proving Mariotte's law
- 42. Kopp's differential barometer
- 43. Kopp's volumeter
- 44. Gay Lussac's hand air-pump
- 45, 46. Larger air-pump
- 47. Two-cylindered air-pump
- 48-50. Babinet's cock for obtaining the greatest rarefaction
- 51-53. The condensing pump
- 54-56. The syphon
- 57, 58. Apparatus involving the theory of the syphon
- 59. Cup of Tantalus
- 60. Fountain involving the syphon
- 61. Hero's ball
- 62. Intermitting spring
- 63, 64. Hero's fountain
- 65-71. Hydraulic press

- 72. Apparatus to measure the pressure of falling water
- 73. Ordinary air balloon
- 74. Marey Monge's copper balloon
- 93 see 43. [The figure is marked 93 by mistake of the engraver.]

PLATE 19.

Theories and Instruments of Mechanics, Thermodynamics, and Acoustics

- 1. Gasometer
- 2. 3. Cylindrical blower
- 4. Water regulator
- 5. Wind measurer
- 6. Common bellows
- 7. Mercurial thermometer
- 8. Apparatus for measuring the expansion of solids
- 9–11. Apparatus for measuring higher temperatures
- 12. Metal or quadrant thermometer
- 13. Breguet's thermometer
- 14. Air thermometer
- 15. Pneumatic apparatus
- Illustrating the relative expansion of mercury, water, and alcohol
- 17. Illustrating the laws of vaporization
- 18. Illustrating the tension of vapor in unequally heated places
- 19, 20. Apparatus for measuring the elasticity of vapor
- 21. Apparatus for ascertaining the density of watery vapor
- 22. Apparatus for mixing vapors with gases
- 23. Apparatus for measuring the tension of this mixture
- 24. Apparatus for boiling water by the condensation of vapor
- 25. Papin's digester26. Papin's first steam-engine

- 27-34. Watt's steam-engine
- 35. Illustrating the transmission of heat
- 36. Rumford's differential thermometer
- 37, *a*, *b*. Melloni's thermo-multiplier
- 38-40. Locatelli lamp, etc.
- 41. Illustrating the refraction of heat rays
- 42. Apparatus for ascertaining the laws of cooling
- 43. Calorimeter of Lavoisier and Laplace
- 44, 45. Apparatus for determining the specific heat of bodies
- 46. Apparatus for determining the specific heat of gases
- 47. Cooling tube
- 48. Cooling tube
- 49. Apparatus for measuring
- latent heat
 49, a. Illustrating the transmission of sound
- 50. Savart's monochord
- 51. 52. Vibration of strings
- 53–58. Illustrating the construction of organs
- 59-61. Cagniard de la Tour's system of determining the number of vibrations in a
- 62. Apparatus for causing plates to vibrate
- 63-90. Figures produced by the vibration of plates, bells, etc.
- 91. Apparatus for producing tones by the combustion of
- hydrogen gas 92. Illustrating the manner of communicating vibrations to
- 93. Illustrating the echo in arched rooms
- 94. Hearing tube
- 95. Illustrating the metal tongue
- 96, 97. Tongue work of the organ
- 98. Illustrating the nature of the human voice

PLATE 20.

Theories and Instruments of **Electricity and Magnetics**

Figure

- 1. Attraction of a natural magnet
- Attraction of an artificial magnet
- Curves of filings over a magnet
- Influence of a magnet on an iron rod
- The same without contact
- Magnetic needle
- The various poles of a magnet
- Compass
- Variation of the compass
- 10. Inclination of the compass
- 11. Action of the earth upon the magnetic needle
- 12. Intensity compass of Gambey
- 13, 14. Coulomb's torsion balance
- 15. Coulomb's determination of the strength of the magnet at various distances from its pole
- 16. 17. Duhamel's method of preparing artificial magnets
- 18. Œpinus's method of doing the
- 19. Horse-shoe magnet
- 20, 21. Armature of natural magnets
- 22. Electrical pendulum
- 23. Coulomb's electroscope
- 24. Pith ball electroscopes
- 25. Electric pistol
- 26. Volta's straw electrometer
- 27, 28. The electrophorus
- 29. Plate electric machine
- 30, 30a. Rubbers of the same
- 31. Van Marum's electric machine
- 32. Nairne's electric machine
- 33. Franklin plate
- 34. Discharging rod
- 35, 36. Leyden jars
- 37. Electrical battery
- 38. Henley's universal discharger
- 39. Electrical mortar
- 40. Kinnersley's thermometer
- 41. Leyden jar with movable coatings

- 42. Lightning plate
- 43. Lightning tube
- 44. Electrical light
- 45. Wheatstone's apparatus for determining the velocity of electricity
- 46. Electric wheel [By mistake of the engraver this figure is numbered 76. It stands in the center of the plate.1
- 47. Influence of Galvanism
- 48. Volta's galvanic double plate
- 49. Voltaic pile
- 50, 51. Fechner's improvement of Bohnenberger's electrometer
- 52. Trough apparatus
- 53-55. Wollaston's battery
- 56. Volta's simple galvanic series
- 57. Hare's calorimeter
- 58. Becquerel's constant battery
- 59, 60. Daniel's constant battery
- 61. Grove's battery
- 62, 63. Bunsen's carbon battery
- 64, 65. Apparatus for decomposing water
- 66. Apparatus for decomposing
- 67. Becquerel's galvanoplastic apparatus
- 68. Influence of the galvanic current on the magnetic needle
- 69. Schweigger's galvanometer
- 70. Nobili's improved galvanometer
- 71-74. Tangent compass
- 75. Sine compass
- 76. [See 46.]
- 76-78. Magnetic action of the galvanic current
- 79-81. Electro-magnets
- 82. Rotation of the magnet under the influence of the galvanic current
- 83-85. Ampère's apparatus for determining the influence of terrestrial magnetism on the galvanic current
- 86. Neutralization of terrestrial magnetism
- 87. Rotation of vertical currents
- 88. De la Rive's apparatus showing that feeble currents are affected by magnetism
- 89, 90. Disconnecting and

severing of magnetic currents

PLATE 21.

Theories and Instruments of **Optics**

Figure

- 1. Refraction of light in its passage from water into air
- 2. 3. Full shadow and half shadow
- Inverted image caused by a ray of light entering a dark room through a small aperture
- Angle of reflection of light
- Apparatus to prove the equality of the angles of reflection and of incidence
- Proof of the symmetry of images reflected by plane mirrors
- Construction of reflected images
- 9. Mirrors placed together at an
- 10-12. Wollaston's reflecting goniometer
- 13. Gambey's goniometer
- 14, 15. Reflecting sextant
- 16-18. Concave mirror
- 19, 20. Nature of images formed in concave mirrors
- 21. Spherical convex mirror
- 22. Image formed on the same
- 23. Caustic curve
- 24. Angle of refraction
- 25. Laws of refraction
- 26. Total reflection
- 27. Prism stand
- 28. Solar spectrum
- 29. Prismatic refraction
- 30. Hollow prism
- 31. Dulong's apparatus for determining the refractive powers of gases
- 32. The six kinds of lenses
- 33. Refraction by lenses
- 34. Focus of lenses
- 35. Divergence of rays in concave lenses
- 36. Secondary axis of lenses
- 37-39. Images formed in lenses
- 40. Aperture of the lens necessary to unite all rays in one point

- 41, 42. Fresnel's polyzonal lens
- 43, 44. Decomposition of light into various colored rays
- 45. Composition of white light from various colored rays
- 46. Decomposition of the natural colors of bodies by the prism
- 47. Achromatic prism
- 48. Achromatic lens
- 49. Mosaic composite eve
- 50. Simple human eye
- 51. Illustrating double sight
- 52. Illustrating the possibility of seeing various objects at once
- 53, 54, Irradiation
- 55. The phenakistoscope
- 56. Wollaston's camera lucida
- 57, 58. Camera obscura
- 59. Solar microscope
- 60, 61. Compound microscope
- 62. Gregorian telescope
- 63. Cassegrainian telescope 64. Newtonian telescope
- 65. Galilean telescope
- 66. Astronomical telescope
- 67. Determination of the magnifying power of telescopes
- 68. Fresnel's apparatus for determining the interference of light
- 69. Nörremberg's polariscope
- 70. Angle of polarization
- 71, 72. Rochon's micrometer
- 73. Soleil's apparatus for measuring the rings of polarization
- 74–76. Daguerreotype apparatus
- 77. Reflexion by spherical concave mirrors
- 78. Refraction in water
- 79. Common prism
- 80. Refraction by prisms 81. Construction of the hollow
- prism 82. The direction of emerging rays shown to be parallel
- with that of entering ones 83. Divergence of rays emerging from lenses
- 84. Convergence of rays emerging from lenses 85. Angle of vision
- 86. Vanishing of small objects on the punctum cœcum

- 87. Apparatus for exhibiting the duration of an impression on the retina
- 88. Apparatus for experiments on the interference of light
- 89. Undulation of rays
- 90. Illustrating the theory of interference
- 91. Illustrative of the explanation of reflexion by the undulatory theory
- 92. The law of refraction similarly illustrated
- 93–99. Fraunhofer's spectra
- 100, 101. Polarization of light
- 102, 103. The magic lantern
- 104. Camera lucida
- 105, 106. Brewster's kaleidoscope

PLATE 22.

Phenomena and Apparatus of **Electricity and Magnetics**

- 1. Apparatus for observing the action of terrestrial magnetism on vertical
- currents 2, 3. Faraday's apparatus for observing the rotative action of terrestrial magnetism on
- horizontal currents 4. Action of parallel currents
- upon each other 5, 6. Apparatus to show the action of crossing currents
- upon each other 7. Apparatus for determining the plane of the terrestrial currents
- 8. Declination spiral wire
- 9, 10. Ampère's apparatus for explaining the rotation of the magnet
- 11. Thermo-electric currents
- 12. Thermo-electric multiplier
- 13. Apparatus to show the development of electricity by combustion
- 14. Illustrating induction currents
- 15-17. Neef and Wagner's induction coil 18. Apparatus to show the
- production of electrical currents by magnetism

- 19. Induction coil in connection with magnets
- 20-22. Ettinghausen's magneto-electric rotating machine
- 23-27. Stöhrer's triple magneto-electric machine
- 28. Differential galvanometer 29. Apparatus for determining the
- conducting powers of metals
 30. Apparatus for determining the
- requisite qualities of conducting wires
- 31, 32. Apparatus for obtaining an unalterable thermo-electric current
- 33-35. Thermo-electric pile
- 36-38. Stöhrer's improvement of Daniel's electro-magnetic machine
- 39. Ritchie's improved machine
- 40. Wheatstone's telegraph
- 41, 42. Steinheil's telegraph
- 43-47. Illustrating Ampère's theory of the rotation of magnets
- 48, 49. Astatic multiplier
- S1. Weber's apparatus for demonstrating the laws of magnetism
- 52, 53, 53a. Arago's apparatus for investigating phenomena in rotation magnetism
- 54. Illustrating the intensity of electricity in combined elements
- 55-58. Clarke's magneto-electric machine
- 59. Henley's quadrant electrometer
- 60. Apparatus for proving that free electricity is confined to the surface of bodies
- 61. Gold leaf electrometer
- 62. Buff's apparatus for determining the kind of electricity in a body
- 63. Apparatus to show the separation of the combined electricities when an electrified body is brought near
- 64. Apparatus to show that the connection of two similar electroscopes by an insulated

- conductor will separate their electricities
- 65. Construction of the electrometer
- 66, 67. Different windings around the electro-magnet
- 68. Rotation of the magnet around its own axis
- 69. The voltaic pile
- 70. Illustrating the action of electrical currents
- 71. Production of electric light in a vacuum
- 72. Electric dance
- 73-75. Eisenlohr's hydro-electric machine

PLATE 23.

Sun Rays, Winds, Precipitation, and Condensation Phenomena

Figure

- Howard's diagram to elucidate the action of the sun's rays on the earth
- 2. Illustrating the snow line
- 3. Curvature of the Alpine snow line
- 4-23. Forms of snow crystals
- 24-35. Forms of hailstones
- 36-38. Illustrating the amount of dew on trees and herbs
- 39, 40. Illustrating the amount of dew on differently inclined surfaces
- 41-43. Illustrating the greatest deposit of dew on the highest points of an object
- 44–47. Illustrating the increase of dewdrops
- 48. Illustrating that an object rolled up in a ball receives less dew than if spread out flat
- 49-52. Illustrating that gilt paper is bedewed only when its unmetallic side is in contact with wood
- 53, ab. Zone of dew deposited in the cavity of a watch-glass
- 54. Regular deposit of dew *around* wafers on a glass plate, not *on* them
- 55. Deposit of dew on a window
- 56, 57. Deposit of dew on spiders' webs

- 58. Perpendiculars from the widest boughs of a tree marking the limits of the formation of frost
- Curious formation of frost on the chiselled star of a tombstone
- 60, 61. Curious formation of frost on leaves
- 62. Illustrating the theory of winds
- 63. Illustrating the theory of whirlwinds
- 64. Rain gauge

GLOSSARY

Februar, February Fische. Pisces Frühling 90 Tage, Spring 90 days Heisseste Temperatur, Hottest temperature Herbst 90 Tage, Autumn 90 days Januar, January Juli, July Jungfrau, Virgo Juni. June Kälteste Temperatur, Coldest temperature Krebs. Cancer Löwe, Leo Mai, May März, March Mittlere Temperatur, Medium temperature Schütze, Sagittarius Skorpion, Scorpio Sommer 93 Tage, Summer 93 days Steinbock, Capricornus Stier, Taurus Waage, Libra Wassermann, Aquarius Widder, Aries Winter 93 Tage, Winter 93 days

PLATE 24.

Phenomena of Condensation and Air Currents

Zwillinge, Gemini

Figure

- 1. Peculiar crystallization on the window of a drug store
- 2. Two trees trained on a wall, only in part exposed to frost

- 3-6. Ice flowers
- 7. Formation of fog over rivers
- 8. Overtopping of trees by fog
- 9. Formation of fog over rivers enclosed by hills
- Illustrating the different appearance of clouds to observers at different places
- Illustrating the difference of shape of clouds according to their elevation
- 12. Illustrating the difference of currents of air at different heights
- 13-18. Different formations of fog near the harbor of Plymouth (England)
- 19. Mirage in Lower Egypt
- 20, 21. Mirages at sea
- 22. Theory of mirages
- 23. Mirage on the lake of Geneva

PLATE 25.

Cloud Formation and Light Refraction

Figure

- 1-8. Forms of clouds
- 9. Halo around the sun
- 10, 11. Haloes around the moon
- 12. Halo and colored ring
- 13-20. Mock suns

PLATE 26.

Phenomena of Clouds and Light

Figure

- 1-9. Illustrating phenomena in clouds
- 10-12. Rainbows
- 13. Aurora borealis
- 14. Midnight sun in the polar regions

PLATE 27.

Meteorological Elements and Instruments

Figure

- 1. Whirlwind and waterspout
- 2, 3. The sun behind clouds
- 4. The drawing of water
- 5. Converging in the east, of the shadow of the setting sun
- Illustrating that objects on earth can throw shadows into space

- 7. Shadows thrown on a bank of fog
- 8, 9. Coloring of clouds by the
- 10, 11. Phenomena of the sun's apparent contact with clouds
- 12. Apparent contact of clouds
- 13. Zodiacal light
- 14-19. Lightning rod
- 20-26. Magnetic observatory at Greenwich

PLATE 28.

Climate and Weather Charts

Figure

- 1, ab. Inclination charts
- 2, ab. Isodynamic charts
- 3 (center). Chart of magnetic declinations
- 4. ab. Barometrical wind rosettes
- 5, ab. Thermometrical wind rosettes [For Glossary see after Plate 29.]

PLATE 29.

Rainfall and Temperature Map; Temperature Charts

Figure

- Map of Humboldt's
 isothermal lines showing the
 distribution of heat and rain
 on the earth
- 2. Diagram of the mean annual temperature at various places
- 3. The mean decennial temperature of various places
- 4. Comparison of temperature

GLOSSARY

Ægypten, Egypt
Æquator-Grenze des Schneefalls,
Equatorial boundary of the
snow region
Aleuten, Aleutian Islands
Arabien, Arabia
Asien. Asia

Barometer steigt,—fällt, Barometer rises,—falls

Berberei, Barbary

Beständiger Regen, Perpetual

C. der guten Hoffnung, Cape of Good Hope

Canarische Inseln, Canary Islands Capverdische Inseln. Cape Verd Islands Deutschland, Germany Erd-Æguator, Terrestrial equator Europa, Europe Frankreich. France Freundschafts Inseln, Friendly Islands Gebiet der Monsun Regen, Region of the Monsoons Gesellschafts Inseln, Society Islands Grönland, Greenland Grossbritanien. Great Britain Grosser Ocean, Pacific Ocean Herbst und Winter Regen, Autumn and winter rains Indisches Meer, Indian Sea Italien. Italy Kopenhagen, Copenhagen Kurve von Leith, Br., Curve of Leith, latitude Kurve von Padua, Br., Curve of Padua, latitude Linie ohne Inclination. Line without inclination Magnetischer Æquator, Magnetic equator Manschurei, Mandshoo territory Maximum der magnet, Kraft, Maximum of magnetic power Mittlere Tageswärme, Medium daily temperature Mongolei, Mongolia N. O., N. E. Neufundland, Newfoundland Neu Guinea, New Guinea Neu Sealand, New Zealand Niedrige Inseln, Low Islands Nord Amerika, North America Nördlicher Gürtel der beständigen Niederschläge, Northern zone of perpetual deposits Nördliche Hemisphäre, Northern Hemisphere Nördlicher Polarkreis, Arctic Circle Nördliches Eismeer, Arctic Sea Nordpol, North pole

Oceanien. Oceania Ost Indien, the East Indies Ostseite. East side Persien. Persia Provinz des Herbstregens:—des Sommerregens: —des Winterregens, Region of autumnal, of summer, and of winter rains Regenloses Gebiet, Rainless region Russland, Russia Schwacher Sommerregen, Light summer rain Sibirien. Siberia S. O., S. E. S. O. Monsun im Apr.-Oct., N. W. Monsun im Oct.-Apr., S. E. Monsoon from April to October, N. W. Monsoon from October to April Spanien, Spain Süd Amerika, South America Südpol, South pole Südlicher Continent, Southern continent Südlicher Gürtel der beständigen Niederschläge, Southern zone of perpetual deposits Südliche Hemisphäre, Southern Hemisphere S. W. Monsun im Apr.-Oct., N. O. Monsun im Oct.-Apr., S. W. Monsoon from April to October, N. E. Monsoon from October to April Thermometer steigt, —fällt, Thermometer rises,—falls Turkei, Turkey Vereinigte Staaten, United States Wärme-Æquator, Equator of heat Wendekreis des Krebses: -des Steinbocks, Tropic of Cancer; —of Capricorn West Indien, the West Indies Westseite, West side Winterregen, Winter rains Wüste Schamo oder Gobi, Desert of Shamo, or Gobi Zone häufiger, fast beständiger Niederschläge, stets mit electrischen Explosionen, Zone of frequent, nearly perpetual

deposits, always accompanied

by electrical explosions

CHEMISTRY, MINERALOGY. AND GEOLOGY

PLATE 30. Chemical Laboratory, Apparatus, and Equipment

Figure

- 1. Ground-plan of the chemical laboratory at Giessen
- 2. Perspective view of part of the analytical laboratory at Giessen
- 3. 3a. Portable wind furnace
- 4, 5. Portable distilling apparatus
- 6, 7. Fixed furnace
- 8, 9. Sand bath furnace
- 10. Small table for raising or lowering receivers
- 11, 12. Small alembic
- 13. Pharmaceutical steam apparatus
- 14-20. Pharmaceutical steam apparatus with its utensils
- 21, 22. Crucible furnace
- 23. Tongs for handling hot crucibles
- 24. Splitting iron
- 25, 26, Retorts
- 27-29. Globes or matrasses
- 30-34. Hessian crucible
- 35, 36. Evaporating dishes
- 37-41. Thermometers
- 42. Separating funnel
- 43. Bent tube with bulb
- 44, 45. Walter's safety tube
- 46. Filtering funnel
- 47. Separating funnel
- 48. Special funnel
- 49. Washing bottle
- 50. Measure
- 51-54. Florentine flasks
- 55. Pneumatic tub
- 56, 57. Wolff apparatus
- 58, 59. Gasometer
- 60, 61. Davy's apparatus for investigating earths
- 62. Apparatus for generating
- prussic acid. 63. Apparatus for producing
- small quantities of illuminating gas from various substances
- 64. Argand's oil lamp

65-68. Pharmaceutical extract presses

69-73. Chemical balance

PLATE 31.

Chemical Apparatus and **Equipment**

Figure

- 1, 2. Oxy-ethereal lamp
- 3. Distilling apparatus
- 4, 5. Gasometer
- 6, 7. Apparatus for rendering carbonic acid liquid
- 8. Apparatus for obtaining phosphorus
- Furnace for obtaining caustic
- 10. Furnace for heating matrasses
- 11. Berzelius lamp
- 12. Triangle of iron wire
- 13. Apparatus for obtaining the gaseous elements
- 14. Apparatus for obtaining chlorine
- 15-23. Drying apparatus
- 24. Air pump
- 25. Calcium tube
- 26. Chloride of calcium tube
- 27-29. Combustion tubes
- 30-32. Combustion furnace
- 33. Apparatus for elementary analysis with application of
- 34-38. Apparatus for determining the nitrogen in organic substances
- 39. Apparatus for filling the potash apparatus
- 40, 41. Apparatus for determining the specific gravity of vapor
- 42. Muffle furnace
- 43. Cupel
- 44. Muffle
- 45, 46. Apparatus for generating carbonic acid gas
- 47. Two-branched tube for washing precipitates
- 48, 49. Washing bottles
- 50-52. Filtering apparatus
- 53. Suction tube
- 54. Washing bottle
- 55. Galley furnace
- 56. Gas generator
- 57. Crucible
- 58. Apparatus for ascertaining

- the amount of pure metal in oxvdes
- 59. Davy's safety lamp
- 60. Apparatus for procuring oxvgen
- 61. Safety tube
- 62, 63. Blowpipe
- 64. Iron pincers for handling heated vessels
- 65. Apparatus for obtaining nitrogenous substances from organic matter
- 66. Eudiometer

PLATE 32.

Forms of Crystallization: Various Instruments

Figure

- 1. Blowpipe
- 2. Attenuated point of flame caused by the blowpipe
- 3. Forceps
- Berzelius blowpipe
- 5. Nicholson areometer
- Magnetic needle
- 7, ab. Instrument for detecting electricity in minerals
- Common goniometer
- Gambay's goniometer
- 10. Wollaston's goniometer

Forms of Crystallization

- 11, 12. Regular octahedron
- 13. Octahedron abbreviated to a six sided plate
- 14. Cube
- 15. Relation of the cube and octahedron
- 16, 17. Cubic octahedron
- 18. Rhombic dodecahedron
- 19. Relation of the rhombic dodecahedron and cube
- 20. Pyramidal cube
- 21, 24. Cube with dodecahedral faces replacing its edges
- 22. Octahedron with dodecahedral faces
- 23. Octahedron passing into a dodecahedron
- 24. See 21
- 25. Combination of cube faces and those of the pyramidal cube
- 26. Tetrahedron

Nord See. North sea

Norwegen, Norway

Nubien, Nubia

- 27. Octahedron passing into a tetrahedron
- 28. Cube with its edges replaced by three faces
- 29. Pentagonal dodecahedron
- 30. Trapezohedron
- 31. Octahedron passing into a trapezohedron
- 32. Obtuse square octahedron
- 33. Acute square octahedron
- 34. Square octahedron with two corners truncated
- 35. Right square prism
- 36. Regular eight sided prism
- 37. Right square prism with its corners truncated
- 38. Square octahedron with truncated basal edges
- 39. Square octahedron with truncated lateral edges
- 40. Eight sided pyramid
- 41. Twelve sided prism
- 42. Six sided prism with bevelled edges
- 43. Right square prism with basal edges truncated
- 44. Rectangular octahedron
- 45. Rectangular octahedron truncated
- 46. Square octahedron with bevelled lateral edges
- 47, a. Obtuse rhombic octahedron
 - b. Acute rhombic octahedron
 - c. Rectangular octahedron
- 48. Rhombic octahedron with two corners bevelled
- 49. Octahedron with the corners of the vertical axis replaced by four plane faces
- 50. Right rhombic prism
- 51. Right rhombic prism with obtuse edges truncated
- 52. Irregular eight sided prism
- 53-55. Combination of prisms belonging to the trimetric system
- 56. Rectangular prism
- 57, 58. Modified octahedrons
- 59, 60. Oblique six sided prism
- 61. Octahedron with half the edges truncated
- 62. Prism with half the basal edges truncated
- 63–65. Oblique rhomboidal prism

- 66. Oblique six sided prism
- 67. Double six sided pyramid
- 68. Pyramidal six sided prism
- 69. Modified rhombic octahedron
- 70. Regular six sided prism71. Regular six sided prism with
- truncated basal edges
 72. Regular six sided prism with truncated corners
- 73. Obtuse double six sided pyramid
- 74. Scalene octahedron
- 75. Rhombohedron
- 76. Six sided prism with four edges bevelled
- 77, 78. Natural situation of two rhombohedrons
- 79. Grouping of crystallizations
- 80-87, 90, 91. Forms of ground jewels
- 88, 89. Crystalline formations
- 90, 91. See 80, etc.
- 92, 93. Crystalline structure

PLATE 33.

Minerals and Their Crystalline Forms

Figure

- 1. Meteoric iron
- 2. Iron pyrites
- 3, 4. Sulphur
- 5-10. Native bismuth
- 6-11. Galena
- 7. Weidmannstedtian figures
- 8. Sulphate of lead
- 9. Native silver
- 10. See 5
- 10. See 5
- 12. Arborescent native silver
- 13. Native copper
- 14. Native gold
- 15. Pyrites in calcareous spar
- 16. Filiform native silver
- 17. Galena on quartz
- 18. Arsenical pyrites
- 19. Galena on calcareous spar
- 20. Galena in cubes
- 21. Selenid of mercury
- 22. Crystallization of iron pyrites
- 23. Molybdenite
- 24. Native copper
- 25. Native antimony 26–29. Sulphur
- 30. Native silver
- 31. Antimony

- 32-36. Gold, galena, etc.
- 37. Sulphuret of copper
- 38. Antimony
- 39, 47. Antimonial silver
- 40-45. Gold, 40 and 42, Silver, 42, 43, Diamond
- 46. Diamond
- 47. See 39
- 48. Copper pyrites
- 49, 50. Glance cobalt
- 51. Diamond, Grey copper ore
- 52, 53, 56, 59. Grey copper ore
- 54, 55. Glance cobalt
- 56. See 52
- 57, 58, 60. Glance cobalt
- 59. See 52
- 60. See 57
- 61-63. Native mercury
- 64. Glance cobalt

PLATE 34.

Minerals and Their Crystalline Forms

Figure

- 1. Micaceous iron ore
- 2, 3. Quartz
- 4. Tourmaline
- 5. Hematite
- 6. Datholite
- 7. Pyrolusite
- 8. Tin ore
- 9. Fibrous brown hematite
- 10. Rutile
- 11. Scaly hematite
- 12. Andalusite
- 13. Asbestos
- 14. Stilbite
- 15. Analcime
- 16. Mesotype17. Apophyllite
- 18. Chabazite
- 19. Tin ore in granite
- 20. Reniform hematite
- 21, 22. Silica
- 23, 25. Oxyde of iron
- 24. Manganite
- 25. See 23 26. Braunite
- 27. Red copper ore
- 28. Apophyllite
- 29. Hausmannite
- 30. Sapphire31. Oxyde of iron32. Anatase
- 33. Red copper ore

- 34. Tourmaline
- 35. Augite
- 36. Quartz
- 37. Oxyde of tin
- 38. Corundum
- 39, 40. Arsenious acid
- 41. Picrosmine
- 42. Oxyde of tin
- 43. Rutile
- 44. Oxyde of copper
- 45. Nepheline
- 46. Scapolite
- 47. Staurotide
- 48, 53. Idocrase 49. Bervl
- 50. Thomsonite
- 51. Silica
- 52. Augite 53. See 48
- 54. Chondrotite
- 55. Humboldtite
- 56. Various silicates
- 57. Emerald58. Euclase
- 59. Natrolite
- 60. Dichroite
- 61. Oxyde of copper
- 62. Prehnite
- 63. Epistilbite
- 64. Garnet
- 65. Albite66. Chabazite
- 67. Pyroxene
- 68, 69. Beryl
- 70. Staurotide71. Iolite
- 71. Tonte 72. Silica
- 73. Datholite
- 74. Olivine
- 75. Hornblende76. Feldspar

PLATE 35.

Minerals and Their Crystalline Forms

Figure

- 1. Spodumene
- 2. Feldspar twin crystal
- Sphærosiderite
 Natrolite
- 5. Harmotome
- 6. Green garnet7. Strontianite
- 8, 10, 11, 14, 16–22, 24, 25, 27–29, 31–37, 40, 41, 43–47,

- 49. Various forms of arragonite and calcareous spar
- 9. Topaz
- 10, 11. See 8 12, 30, 38, 39, 42, 48. Boracite
- 13. 23. Stalactite
- 14. See 8
- 15. Opake beryl
- 16-22. See 8
- 23. See 13
- 24, 25. See 8
- 26. Feldspar
- 27-29. See 8
- 30. See 12 31–37. See 8
- 38, 39. See 12
- 40, 41. See 8 42. See 12
- 43–47. See 8
- 48. See 12 49. See 8

PLATE 36. Minerals and Their Crystalline Forms

- Figure 1, 2, 4, 6, 8–10, 13. Sulphate of
- baryta
- 3. Double spar4. See 1
- 5. Wavellite
- 6. See 1 7. 20. Strontianite
- 8–10. See 1
- 11. Thorns coated with salt
- 12. Gypsum 13. See 1
- 14. Spathic iron15. Wolfram
- 16, 24, 25. Alum 17. Sulphate of soda
- 18. Sulphate of ammonia 19, 34, 35. Copperas
- 20. See 7
- 21. White lead ore 22. Yellow lead ore
- 23. Sulphate of zinc 24, 25. See 16
- 26, 36, 41, 43, 47, 48. Saltpetre 27. Green vitriol
- 28. Sulphate of potassa 29, 37. Calcareous spar
- 30. Rocksalt

- 31. Karstenite
- 32. Fluor spar
- 33, 40. Sulphates of alkalies
- 34, 35, See 19
- 36. See 26
- 37. See 29
- 38, 39, 42, 44, 46, 49. Phosphates of alkalies
- 40. See 33
- 41. See 26
- 42. See 38
- 43. See 26
- 44. See 38
- 45 Sulphate of iron
- 46. See 38
- 47, 48. See 26
- 49. See 38

PLATE 37.

Fossils and Representation of Animals of the Lias

Figure

- 1-59. Fossils of the transition slate
- 60-72. Fossils of the carboniferous period
- a-f. Buckland's representation of animals of the Lias

PLATE 38.

Section of the Wirksworth Cave and Fossils

Figure

- 1, 2. Fossils of the Copper Slate Formation
- 3-11. Fossils of the Rock Salt Formation
- 12-67. Fossils of the Jura
- 68. Section of the Wirksworth cave

PLATE 39.

Fossils, a Skeleton, and Veins of Ore

Figure

- 1-45. Fossils of the Cretaceous System
- 46–50. Fossils of the Tertiary Period
- 51-80. Skeleton of Hydrarchos harlani
- 81–87. Illustrating the formations of veins of ores

PLATE 40. Fossils and Skeletons

Figure

- 1-3, 11-22. Fossils of the Tertiary Period
- 4-9. Fossils of the Rock Salt Formation
- 10. Plesiosaurus macrocephalus (Jura)
- 11-22. See 1

PLATE 41.

Fossils, Skeletons, and Tracks

Figure

- 1-10. Fossil remains of Arachnida, etc. (Tertiary)
- 11-27. Fossils of the Jura
- 28. Fossil Irish elk (Tertiary)
- 29. Dinotherium giganteum (Tert.)
- 30. Missourium theristocaulodon (Tert.)
- 31, ab. Batrachoid tracks (Rock Salt)
- 32. Birds' tracks in Connecticut (Rock Salt)
- 33. Skull of Hyæna spelæa (Tert.)
- 34. Skull of Ursus spelæus (Tert.)
- 35. Pterodactylus crassirostris (Jura)
- 36. Human skeleton from Guadaloupe (fossil in Limestone)

PLATE 42. Fossils from Various Periods

Figure

- 1-12. Fossils of the Tertiary
- 13–23. Fossils of the Cretaceous
- 24-31. Fossils of the Jura
- 32-40. Fossils of the Rock Salt
- 41–56. Fossils of the Carboniferous
- 57-66. Fossils of the Transition Slate

PLATE 43.

Rock and Valley Formations and Stratification

Figure

- 1-3. Illustrating the formation of valleys
- 4-6. Illustrating the formation of rock beds

- 7-9, 12. Illustrating stratification
- 10, 11. Penetration of various rocks in volcanic regions
- 12. See 7.
- 13-15. Illustrating the relation of stratification to mountain masses
- 16-19. Illustrating subordinate strata
- 20, 21. Illustrating disseminated and imbedded ores
- 22-25. Illustrating the cleavage of rocks
- 26. Table mountain at the Cape of Good Hope

PLATE 44.

Stratification in Mountains and Basins; Fissures and Craters

Figure

- 1. The valley of Pyrmont
- 2-5, 12-14. Illustrating the relation of stratification to mountain masses
- 6, 7. Tertiary basin of Paris
- 8. Dunes on the sea shore
- 9. Section of a volcanic cone
- 10. Mont Blanc chain
- 11. Mountains in the vicinity of Bärschwyl
- 12-14. See 2
- 15. Fissures in the earth in Calabria
- 16. Circular cavities in the plain of Rosarno
- 17. Crater of the Geyser in Iceland
- 18. Volcano of Eyafiël in Iceland

PLATE 45.

Volcanoes and Volcanic Formations

Figure

- 1. Illustrating valleys of disruption
- 2. Extinct volcanic district in Auvergne
- 3. Section of Judæa and the Dead Sea
- 4. Vesuvius in the time of Pliny
- 5. Vesuvius as seen at present
- 6. Mount Etna
- 7. Campi Phlegræi near Naples
- 8. Chart of the Bay of Naples9. Volcanic chart of Etna

- 10. Volcanic chart of Iceland
- 11. Map of the vicinity of Lake Titicaca, in Peru
- 12. Section of the mountains around the lake

GLOSSARY

Basalt Boden, Basaltic soil Bugt. Bay Busen von Neapel, -von Salerno, Bay of Naples, -of Salerno Cyclopen Inseln, Cyclops Islands Die Flegreischen Felder, The Phlegræan fields Fiorden, the inlet Island, Iceland Längenthal im Trachyt, Long valley in the trachyte formation Lava Ströme, Lava streams Neapel, Naples Nord Cap, North Cape Œ. Island Passhöhe. Height of the pass Polarkreis. Arctic circle See. Lake

PLATE 46. Special Geognosy

Figure

1-3. Silurian system

Vesuv, Vesuvius

- 4–6. Devonian system
- 7, 8. Carboniferous group
- 9, 10. Copper slate formation
- 11. Rock salt formation
- 12–16. Jura formation
- 17. Cretaceous system18. Upper tertiary
- 19. Erratic boulder

GLOSSARY

Aufgeschw. Land, Deposited ground
Braunschweig, Brunswick
Bunter Sandstein, Variegated sandstone
Donau, Danube
Ebbe Geb., Ebbe Mountains
Egge Geb., Egge Mountains
Geb. v. Charolais, Mountains of

Charolais

Harz Gebirge, Hartz Mountains;

 —und Thüringer Wald, Hartz and Thuringian Mountains
 Hochwald, High forest (mountain

tract)

Jura Gebirg, Jura Mountains;

 --- kalk, Jurassic Limestone Kohlengebirge, Carboniferous formation

Kohlenkalk, Carboniferous limestone

Kohlensandstein, Carboniferous sandstone

Kreide, Chalk Laacher See, Lake Laach Porphyr, Porphyry

Quadersandstein, Freestone Rhein, Rhine

Rheinisches Uebergangsgebirg,

Rhenish transition rock Rothhaar Geb., Rothhaar Mountains

Schuttland, Conglomerate Steink. Gebilde, Carboniferous

formation Tertiär, Tertiary

Teutoburger Wald, Teutoburg forest

Todtliegendes, Red sandstone Trias, Rock salt formation Trier, Treves

Uebergangskalk, Transition limestone

Vogel Geb., Vogel Mountains Vogesen sandstein, Vosges sandstone

Vulcan Gebilde; —Gerölle, Volcanic formation; —rubble Weser Geb.. Weser Mountains

PLATE 47.

Volcanic and Hurricane Charts; Mountain Profiles; Craters; and Antarctica

- Volcanic chart of the world, [Also chart of the winds; Glossary at Plate 29.]
- Chart of European volcanoes
 Volcanic chart of Lower Italy
- 4. Crater of Kirauea
- 5. Crater on the Island of Hawaii
- 6. Landscape from the Southern Continent

- 7. Profile of mountains in the Old World
- 8. Profile of mountains in the New World
- 9. 10. Charts of hurricanes

GLOSSARY

Ægatische In., Ægatian Islands Atlantischer Ocean, Atlantic Ocean

Canal von Malta, Maltese Channel

Deutschland, Germany

Frankreich. France

Grosse Antillen, The larger West India Islands

Indischer Ocean, Indian Ocean Kleine Antillen, the smaller West India Islands

Liparische In., Liparian Islands Lissabon, Lisbon

Meerb. v. Taranto, Bay of **Taranto**

Mittelländisches Meer. Mediterranean Sea

Mozambique Kanal, Mozambique Channel

Neapel, Naples

Nord Amerika, North America Sicilien, Sicily

Spanien, Spain

Str. von Messina. Strait of

Messina Türkei, Turkey

Tyrrhenisches Meer, Tyrrhenian Sea

Venedig, Venice

Vesuv. Vesuvius

Wien. Vienna

PLATE 48.

Boring Equipment; Stratification and Artesian Wells

Figure

- 1. Coup d'æil of the normal masses
- Illustrating the theory of springs and Artesian wells
- Section of the Artesian well of Grenoble
- Interior of a boring shed
- 5-14. Boring tools

PLATE 49.

Notable Geological Formations

Figure

- 1. Interior of the crater on the Island of Hawaii
- Coral island in the Pacific Ocean
- 3. Rock groups on the Faroe Islands
- 4. Natural bridge of Icomonzo in Columbia
- Glacier sources of the Rhine
- Trachyte columns in the Siebengebirge
- Basaltic groups on the Island of Staffa
- Fissured clay slate on the Lahn
- Cleft variegated sandstone near Kreuznach, Germany

PLATE 50.

Volcanoes, Gevsers, and Water Falls

Figure

- 1. The Geyser of Iceland
- Submarine volcanic eruption
- Air volcano of Turbaso in Columbia
- The volcanic Island of Ferdinandea
- Crater of the same
- Crater of the Krabla in Iceland
- Crater of Etna in Sicily
- Niagara Falls
- The Dal Elf Fall in Sweden

PLATE 51.

Forests, Lakes, Caves, and **Unusual Rock Formations**

Figure

- 1. Primitive forest of Brazil
- 2. Lake of Keswick. Cumberland, England
- Arch of rock on Cape Parry
- The fresh water cave. Isle of Wight, England
- 5. The Blackgang cave on the Isle of Wight
- Basalt rocks on the Island of **Tahiti**

- 7. The Grotto del Cane near Naples
- The grotto of Jupiter on the Island of Naxos, Greece

PLATE 52.

Caves, Icebergs, Lava, and Rock **Formations**

Figure

- 1. Icebergs of the Antarctic regions
- Sandstone cave in Sicily
- Lava arch in Iceland
- Burning mountain near Duttweiler
- 5. Cascade of Teverone near Tivoli
- 6. Basalt columns on the Island of Staffa
- Upright tree stems found in 7. carboniferous formations
- Island of Staffa with Fingal's cave
- Section of the cavern of Gailenreuth in the Hartz

PLATE 53.

Caves and Rock Formations

Figure

- 1. The Grotte des Demoiselles in France
- 2. The Dunold Mill Cave. Lancashire, England
- 3. The cave of Montserrat in Catalonia, Spain
- Porphyry mountain near Kreuznach, Germany
- The Lurley rock on the Rhine
- The Rhonetrichter (Perte du Rhone), France
- Serpentine rocks near Lizard Point, Cornwall, England
- Clay slate strata on the coast of Scotland
- 9. Submarine section of the Straits of Gibraltar
- 10. Submarine section between Tarifa and Alcazar, Spain 11–13. Illustrating the cleavage
- of rocks 14. Illustrating subordinate beds

BOTANY

PLATE 54.

Representatives of the Algae, Fungi, Bryophyta, Polypodiophyta and Other Nonflowering Plants

- 1-15. Jussieu's Classification of Plants, types of classes
- 16. Ustilago segetum
- 17. Uredo phaseoli
- 18. Tuber cibarium, truffle
- 19. Bovista gigantea
- 20. Morchella esculenta, morel
- 21. Polyporus perennis
- 22a. Boletus umbellatus
- 22b. Boletus edulis, edible mushroom
- 23. Hydnum auriscalpium
- 24. Cantharellus cibarius
- 25. Agaricus fimetarius
- 26. Agaricus campestris, champignon
- 27. Agaricus procerus
- 28. Agaricus muscarius, toadstool
- 29. Cladonia pyxidata
- 30. Parmelia parietina
- 31. Cetraria islandica, Iceland moss
- 32. Rochella tinctoria
- 33. Usnea florida
- 34. a, Conferva bombycina; b, C. rivularis; c, C. flaccida; d, C. glomerata
- 35. Sphærococcus coronopifolius
- 36. Laminaria digitata
- 37. Laminaria saccharina
- 38. Fucus vesiculosus
- 39. Spagnum acutifolium, Peat-moss
- 40. Polytrichum juniperinum
- 41. Climacium dendroides
- 42. Anthoceros punctatus
- 43. Gymnoscyphus repens 44. Marchantia polymorpha
- 45. Pilularia globulifera
- 46. Salvinia natans
- 47. Marsilea quadrifolia 48. Ceterach leptophylla
- 49a. Polypodium vulgare 49b. Ceterach officinarum
- 50. Aspidium filix mas
- 51. Asplenium trichomanes
- 52. Scolopendrium officinarum
- 53. Lomaria spicans

- 54. Adiantum capillus veneris
- 55. Osmunda regalis
- 56. Botrychium lunaris
- 57. Ophioglossum vulgatum
- 58. Lycopodium clayatum
- 59. Equisetum limosum

PLATE 55.

Fig tree, Aquatic Flowering Plants, and Representatives of the **Families Gramineae and** Cyperaceae

Figure

- Potamogeton natans
- Arum maculatum, wake robin
- 3. Zostera marina
- Acorus calamus
- Typha latifolia, cat-tail
- Eriophorum angustifolium
- Cyperus officinalis 7.
- 8. Saccharum officinale, sugar
- Oryza sativa, rice
- 10. Bambusa arundinacea. bamboo-cane

Center figure: Musa sapientum, banana tree (German:

Banana oder Feigenbaum)

PLATE 56. **Habitat Grouping and** Reproductive Parts of Various Woody Monocots, Especially Palms and Cycads

Figure

- 1. Cocos nucifera, cocoa palm
- Phœnix dactvlifera, date palm
- Sagus farinifera, sago palm Cycas circinalis, sago tree
- 5. Dracæna braziliensis
- 6. Aloë arborescens Areca catechu, areca palm 7.
- Zamia elliptica
- Papyrus antiquorum

PLATE 57.

Representatives of the Monocot **Order Liliales**

- 1. Dracæna draco, dragon's blood
- 2. Luzula pilosa, woodrush
- Commelyna tuberosa

- 4. Colchicum autumnale
- 5. Veratrum album, sneezewort
- 6. Fritillaria imperialis, crown imperial
- 7. Erythronium dens canis, dog's tooth
- 8. Agave americana, century plant
- 9. Phormium tenax, New Zealand flax
- 10. Scilla maritima, squill

PLATES 58 and 59. **Aromatic Plants**

Figure

- Amaryllis formosissima, daffodil lily
- Narcissus pseudo-narcissus, daffodil
- 3. Crocus sativus, saffron
- 4. Iris germanica, iris
- 5. Musa paradisiaca, plantain
- 6. Curcuma zedoaria, turmeric
- 7. Zingiber officinale, ginger
- 8. Vanilla aromatica, vanilla
- 9. Nymphæa lotus
- 10. Aristolochia clematis, birthwort
- 11. Aristolochia sipho, Dutchman's pipe
- 12. Aristolochia serpentaria, Virginia snake root
- 13. Elæagnus angustifolia
- 14. Daphne mezereum, mezereon
- 15. Camphora officinarum, camphor tree
- 16. Cinnamomum zeylanicum, cinnamon tree
- 17. Laurus nobilis, victor's laurel
- 18. Cinnamomum cassia, cassia tree

PLATES 60 and 61. Cultivated Plants from Diverse

Families: Ornamental, Edible, or Medicinal

Figure

- 1. Protea speciosa, sugar-bush
- 2. Banksia serrata
- 3. Myristica moschata, nutmeg
- 4. Rheum palmatum, rhubarb
- 5. Beta vulgaris, common beet
- 6. Celosia cristata, cock's comb
- 7. Plantago major, common plantain

- 8. Mirabilis longifolia
- 9. Plumbago europæa, toothwort
- 10. Anagallis arvensis, pimpernel
- 11. Dodecatheon integrifolium, American cowslip
- 12. Cyclamen europæum, sow-bread
- 13. Lysimachia vulgaris, loose-strife
- 14. Veronica officinalis, speedwell
- 15. Pedicularis palustris, lousewort
- 16. Lathræa squamaria, tooth-wort

PLATE 62.

Members of the Acanthus, Olive, Verbena, Mint, Figwort and Nightshade Families

Figure

- 1. Ruellia formosa
- 2. Acanthus mollis, bear's claw
- 3. Olea europæa, olive
- 4. Jasminum officinale
- 5. Vitex agnus castus
- 6. Betonica officinalis, betony
- 7. Galeopsis tetrahit, hemp nettle
- 8. Digitalis purpurea, purple foxglove
- 9. Calceolaria corymbosa, slipperwort
- 10. Verbascum thapsus, mullein
- 11. Nicotiana tabacum, tobacco

PLATE 63.

Plants of Several Families Which Contain Toxic Compounds, Especially of the Order Polemoniales

Figure

- 1. Hyoscyamus niger, henbane
- 2. Datura stramonium, jimson weed
- 3. Atropa belladonna, belladonna
- 4. Solanum dulcamara, climbing nightshade
- 5. Capsicum annuum, cayenne pepper
- 6. Borago officinalis, borage
- 7. Exogonium purga, jalap plant

- 8. Polemonium cœruleum, Jacob's ladder
- Jacaranda tomentosa
- 10. Bignonia leucoxylon
- 11. Gentiana pneumonanthe, common gentian
- 12. Spigelia marilandica, pinkroot
- 13. Nerium oleander, oleander

PLATE 64.

Plants with a Resinous or Milky Sap

Figure

- Cynanchum vincetoxicum, celandine
- 2. Asclepias cornuti, swallowwort
- 3. Mimusops dissecta
- 4. Styrax benzoin, benzoin tree
- 5. Ledum palustre, marsh tea
- 6. Erica filamentosa, cape heath
- 7. Campanula trachelium
- 8. Lobelia fulgens
- 9. Lactuca virosa, poison lettuce
- 10. Cynara scolymus, artichoke
- 11. Carthamus tinctorius, safflower
- 12. Serratula tinctoria, saw wort
- 13. Tanacetum vulgare, tansy

PLATE 65.

Plants Brewed as Teas and Representatives of the Umbelliferae, Some Poisonous

Figure

- 1. Artemisia absinthum, wormwood
- 2. Dipsacus fallonum, cardoon
- 3. Rubia tinctoria, madder
- 4. Coffea arabica, coffee
- 5. Lonicera caprifolium, woodbine
- 6. Aralia nudicaulis, sarsaparilla
- 7. Œnanthe fistulosa, dead tongue
- 3. Cicuta virosa, water hemlock
- Æthusa cynapium, fool's parsley
- Chærophyllum temulum, cow parsley
- 11. Conium maculatum, hemlock
- 12. Sium latifolium, water parsley

PLATE 66.

Cultivated Plants of the Ranunculaceae and Other Families

Figure

- 1. Clematis erecta, creeping climber
- 2. Anemone hortensis, garden anemone
- 3. Pulsatilla fratensis, pasque flower
- 4. Ranunculus acris, crowfoot
- 5. Adonis vernalis, bird's eve
- 6. Helleborus niger, black hellebore
- 7. Aquilegia vulgaris, columbine
- 8. Aconitum stærkianum, helmet flower
- Papaver somniferum, poppy
- 10. Chelidonium majus, celandine
- 11. Sinapis alba, white mustard
- 12. Capparis spinosa, caper plant
- 13. Reseda luteola, dyer's rocket
- 14. Paullinia pinnata, paulinia15. Æsculus pavia, small buckeye

PLATE 67.

Various Plants of Economic Importance, including Tea, Wine Grape, Cotton and Cacao

Figure

- Acer pseudo-platanus, white maple
- 2. Malpighia urens
- 3. Hypericum perforatum
- 4. Garcinia cambogia
- 5. Citrus medica, citron
- Thea chinensis, tea plantSwietenia mahogoni,
- mahogany tree 8. Vitis vinifera, wine grape
- 9. Geranium sanguineum, cranesbill
- 10. Oxalis acetocella, wood-sorrel
- 11. Gossipium herbaceum, cotton plant
- 12. Theobroma cacao, cacao tree

PLATE 68.

Cultivated Plants of Many Families, Mostly Ornamental

Figure

- 1. Magnolia grandiflora
- 2. Illicium anisatum, star anise
- 3. Anona squamosa, anona

- 4. Cocculus lacunosus
- 5. Berberis vulgaris, barberry
- . Tilia grandiflora, lime tree
- 7. Bixa orellana, arnotto tree
- 8. Helianthemum vulgaris
- . Guaiacum officinale
- 10. Diptamus albus, white dittany
- 11. Dianthus caryophyllus, carnation
- 12. Saponaria officinalis, soapwort
- 13. Camellia japonica, camelia

PLATE 69.

Plants Indigenous to Sandy or Rocky Soil, a Sandalwood, and Representatives of the Order Myrtales

Figure

- 1. Sedum acre, stone crop
- 2. Saxifraga granulata,
- stone-break
 3. Cereus hexagonus, six-edged
- cactus
- Tamarix germanica, tamarisk
 Mesembryanthemum
- rubrocinctum, fig-marigold Enothera biennis, evening
- primrose
 7. Epilobium angustifolium,
- willow-herb
- 8. Santalum myrtifolium9. Melaleuca cajeput, cajeput
- tree 10. Melaleuca fulgens, fiery
- cajeput
- 11. Eugenia pimenta, allspice12. Caryophyllus aromaticus,
- clove-tree
 13. Melastoma malabathricum

PLATE 70.

Lythrum and Representatives of the Order Rosales

- 1. Lythrum salicaria
- 2. Mespilus germanicus, medlar
- 3. Rosa moscata, musk rose
- 4. Potentilla anserina, silver weed5. Amygdalus communis, sweet
- almond
 6. Acacia vera, gum arabic tree
- 7. Cassia lanceolata, senna

- 8. Tamarindus indica, tamarind
- 9. Hæmatoxylon campechianum, logwood
- 10. Coronilla varia, sicklewort
- 11. Phaseolus vulgaris, kidney bean
- 12. Genista tinctoria, dyer's greenwood
- 13. Indigofera anil, anil
- 14. Glycyrrhiza glabra

PLATE 71.

Various plants, Including Members of the Sumac, Spurge and Gourd Families

Figure

- 1. Anacardium occidentale, cashew nut
- Rhus cotinus, smoke tree
- 3. Pistacia terebinthus, turpentine tree
- Juglans regia, English walnut
- Euonymus europæus, spindle
- Ilex aquifolium, European holly
- Rhamnus catharticus, buckthorn
- Euphorbia cyparissias, wolf's
- Euphorbia officinarum, spurge
- 10. Siphonia elastica, caoutchouc
- 11. Cucumis citrullus, water melon
- 12. Momordica balsamina. balsam apple
- 13. Bryonia alba, white bryony
- 14. Carica papaya, West Indian pawpaw
- 15. Cucumis melo

PLATE 72.

Coniferous Gymnosperms, and Angiosperms of the Mulberry, Pepper, Beech and Witch Hazel **Families**

Figure

- 1. Ficus carica, fig tree
- Artocarpus incisa, breadfruit
- Morus nigra, black mulberry
- Humulus lupulus, hops
- 5. Cannabis sativa, hemp
- Piper nigrum, black pepper
- 7. Castanea vesca, chestnut

- 8. Quercus tinctoria, black oak
- Liquidambar styraciflua, sweet gum
- 10. Taxus baccata, European yew
- 11. Juniperus communis, common juniper
- 12. Cupressus sempervirens, European cypress
- 13. Larix cedrus, European cedar

PLATE 73.

Maps and Charts of Plant **Distribution**

Figure

- Botanical chart
- 2. Chart of the Chinese and Indian cotton region
- Chart of the American region of the sugar cane, coffee, etc.
- Chart of the vertical distribution of plants in Asia
- The same of America
- 6. The same of Europe
- The same of the Canary Islands
- The same of the frigid zone of Europe

GLOSSARY

Ægypten, Egypt Aleuten, Aleutian Islands Algerien, Algeria Amazonenstrom, Amazon River Anden Gebirge, the Andes Arabien, Arabia Aral S., Lake Aral Asien, Asia Atlantischer Ocean. Atlantic Ocean Australian, Australia Azorische In., the Azores Bahama In., Bahama Islands Baumwolle, Cotton Bonin In., Bonin Islands Brasilien, Brazil Californien, California Canarische In., Canary Islands Cap der guten Hoffnung, Cape of Good Hope Cap Horn, Cape Horn Cap Verdische In., Cape Verde Islands

Caraibisches M., Caribbean Sea

Carolinen In., Caroline Islands

Caspisches M., Caspian Sea

Chinawälder. Bathbark forests Deutschland, Germany Falklands In., Falkland Islands Feuerland, Terra del Fuego Frankreich. France Freundschafts In., Friendly **Islands** Gallopagos In., Gallopagos Islands Gerste u. Hafer, Barley and oats Gewürznelken, Cloves Grönland, Greenland Grossbritannien, Great Britain Grosser oder Stiller Ocean. Pacific Ocean Habesch, Habesh Himmalaya Geb., Himmalaya **Mountains** I. Island, Iceland I. Karafta oder Sachalin, Island of Karafta or Sachalin Indisches Meer, Indian Ocean Irland, Ireland Kaffee, Coffee Kaschmir. Cashmere Kurilen. Kurile Islands Ladronen In., Marian Islands Mais. Indian corn Malediven In., Maldive Islands Mandschurei, Manchooria Marañon od. Amazonenstrom. Amazon River Marianen od. Ladronen In., Marian Islands Mb. v. Mexico, Gulf of Mexico Mendana's Arch., Mendana's Archipelago Mittel Amer, Central America Mittellündisches Meer. Mediterranean Sea Mongolei, Mongolia Moskau, Moscow Muscatbaum, Nutmeg tree N. Gran., New Grenada Neufundland. Newfoundland Neu Guinea. New Guinea Neu Seeland, New Zealand Nord Amerika, North America Norwegen, Norway Nubien. Nubia Ost Indien, East India Patagonien, Patagonia Pfeffer, Pepper

Reis, Rice

Roggen, Rye

Russisches Amerika, Russian America Russland, Russia Sandwichs In., Sandwich Islands Schiffer In., Navigators' Islands Schwarzes M., Black Sea Schweden, Sweden Sibirien. Siberia Sklaven S., Slave Lake Spanien, Spain Süd Amerika, South America Thee, Tea Toisen, Toises (1t. = 6 feet.) Türkei. Turkey Vanille, Vanilla Vereinigte Staaten, United States Vulc. v. Aconcagua, Volcano of Aconcagua Weitzen, Wheat West Indien, West Indies Wüste Sahara, Desert of Sahara Wüste Schamo oder Gobi, Desert of Shamo or Gobi Zeichenerklärung für fig. 1, 2, u. 3, Explanation of the marks in figs. 1, 2, and 3 Zimmt, Cinnamon Zucker, Sugar **ZOOLOGY**

NOTE: The names used in the plate titles are the currently used scientific names for the groups of animals recognized in 1979. Many of the names for the species (figure captions) are out of date, some for over 100 years. Many of the common names are also out of date or are names used for groups of species.

PLATE 74. Classification

- Monas, animalcule 1.
- Monocerca, animalcule 2.
- 3. Spongia, sponge
- Hydra, naked polypi 4.
- 5. Diphies, medusa
- 6. Velella, nautilus
- Sipunculus, tube worm 7.
- 8. Holothuria, sea jelly
- Ligula, strapworm
- 10. Nemertes, cordworm

- 11. Botryllus, sea grape
- Ostrea, oyster
- 13. Chiton, sea cockroach
- Fissurella, fissure shell
- 15. Vermetus, worm shell
- 16. Strombus, screw shell
- Carina, keel shell 17.
- Bulla, wood digger 18.
- 19. Phyllidium, leaf shell
- 20. Tritonium, triton
- 21. Limnæus, mud shell
- 22. Clio, whale louse
- Octopus, polypus 23.
- Hirudo, leech 24.
- 25. Aphrodite, sea mouse
- **Amphitrite** 26.
- Anatifa, duck mussel 27.
- 28. Cancer, crab
- 29. Squilla, shrimp
- 30.
- Talitrus, sea flea
- 31. Cyamus, whale louse
- Oniscus, cheslip 32.
- 33. Cyclops, water flea
- 34. Caligus, fish louse
- Aranea, spider 35.
- 36. Chelifer
- 37. Scolopendra
- Lepisma, book worm 38.
- 39. Pediculus, louse
- 40. Pulex, flea
- Carabus, ground beetle 41.
- Forficula, earwig
- 43. Cimex, bedbug
- Libellula, dragon fly
- 45. Tenthredo, tailed wasp
- 46. Vanessa, butterfly
- Stomoxys, autumn fly 47.
- Petromyzon, lamprey eel 48.
- 49. Squalus, shark
- 50. Raja, ray
- Acipenser, sturgeon
- 52. Orthagoriscus, moon fish
- 53. Hippocampus, sea horse
- 54. Anguilla, eel
- Pleuronectes, sole 55.
- Merlangus, whiting
- 57. Cyprinus, chub
- Xiphias, swordfish
- Salamandra, salamander
- 60. Rana, frog
- Vipera, viper 61.
- Boa, boa constrictor
- Anguis, adder
- **Ophisaurus**
- Chirotes

66, 6	67. Chalcides
68.	Bipes
69.	Anolis
70.	Scincus
71.	Tilicua
72.	Chamæleo, chameleon
73.	Ptyodactylus
74.	Basiliscus, basilisk
75.	Iguana, guana
76.	Draco, dragon
77.	Agama
78.	Stellio, stellion
79.	Lacerta, lizard
80.	Tejus
81.	Crocodilus, crocodile
82.	Plesiosaurus
83.	Ichthyosaurus
84.	Chelonia, sea tortoise
85.	Testudo, land tortoise
86.	Anas, duck
87.	Sula, dodo
88.	Pelecanus, pelican
89.	Procellaria, petrel
90.	Podiceps, diver
91.	Phœnicopterus, flamingo
92.	Rallus, water rail
93.	Scolopax, snipe
94.	Ardea, heron
95.	Grus, crane
96.	Otis, bustard
97.	Struthio, ostrich
98.	Gallus, cock
99.	Crax, curassow
100.	Columba, pigeon
101.	
102.	Picus, woodpecker
103.	Buceros, rhinoceros bird
	Merops, bee-eater
105.	Sitta, nut-pecker
106.	Alauda, lark
	Cypselus, sea swallow
108.	Pica, magpie
109.	Otus, owl
	Vultur, vulture
	Milvus, kite
112.	Balæna, whale
	Cervus, deer
	Bos, ox
115.	Camelus, camel
116.	Equus, horse
	Sus, hog
	Elephas, elephant
119.	Ornithorhynchus, duckbilled
	platypus
120.	Manis, pangolin
30	

21.	Bradypus, sloth
22.	Lepus, rabbit
23.	Sciurus, squirrel
24.	Castor, beaver
25.	Mus, mouse
26.	Didelphys, kangaroo
27.	Phoca, seal
28.	Mustela, marten
29.	Viverra, civet
30.	Felis, cat
31.	Hyæna, hyena
32.	Canis, dog
33.	Ursus, bear
34.	Erinaceus, hedgehog
35.	Vespertilio, bat
36.	Pteropus, rousset
37.	Lemur, maki
38.	Hapale, ouistiti
39.	Simia, monkey
40.	Homo, man
	PLATE 75.
	Representatives of the Phyla
	Representatives of the Phyla tozoa, Porifera, Coelenterata,
	Representatives of the Phyla
	Representatives of the Phyla tozoa, Porifera, Coelenterata, and Mollusca
Pro Figu 1.	Representatives of the Phyla tozoa, Porifera, Coelenterata, and Mollusca are Monas lens
Pro Figu 1. 2.	Representatives of the Phyla tozoa, Porifera, Coelenterata, and Mollusca are Monas lens Proteus diffluens
Pro Figu 1. 2.	Representatives of the Phyla tozoa, Porifera, Coelenterata, and Mollusca are Monas lens Proteus diffluens Bursaria vesiculosa
Pro Figu 1. 2. 3.	Representatives of the Phyla stozoa, Porifera, Coelenterata, and Mollusca are Monas lens Proteus diffluens Bursaria vesiculosa Cryptomonas ovata
Figu 1. 2. 3. 4.	Representatives of the Phyla stozoa, Porifera, Coelenterata, and Mollusca see Monas lens Proteus diffluens Bursaria vesiculosa Cryptomonas ovata Trachelocerca olor
Figu 1. 2. 3. 4. 5.	Representatives of the Phyla stozoa, Porifera, Coelenterata, and Mollusca see Monas lens Proteus diffluens Bursaria vesiculosa Cryptomonas ovata Trachelocerca olor Trachelocerca viridis
Figu 1. 2. 3. 4. 5.	Representatives of the Phyla stozoa, Porifera, Coelenterata, and Mollusca re Monas lens Proteus diffluens Bursaria vesiculosa Cryptomonas ovata Trachelocerca olor Trachelocerca viridis Vibrio anguillula
Figu 1. 2. 3. 4. 5. 6. 7.	Representatives of the Phyla stozoa, Porifera, Coelenterata, and Mollusca are Monas lens Proteus diffluens Bursaria vesiculosa Cryptomonas ovata Trachelocerca olor Trachelocerca viridis Vibrio anguillula Cyclidium glaucoma
Figu 1. 2. 3. 4. 5. 6. 7.	Representatives of the Phyla stozoa, Porifera, Coelenterata, and Mollusca are Monas lens Proteus diffluens Bursaria vesiculosa Cryptomonas ovata Trachelocerca olor Trachelocerca viridis Vibrio anguillula Cyclidium glaucoma Paramecium compressum
Figure 1. 1. 22. 33. 44. 55. 66. 77. 88. 99. 110.	Representatives of the Phyla atozoa, Porifera, Coelenterata, and Mollusca Tre Monas lens Proteus diffluens Bursaria vesiculosa Cryptomonas ovata Trachelocerca olor Trachelocerca viridis Vibrio anguillula Cyclidium glaucoma Paramecium compressum Chilodon cucullatus
Figure 11. 22. 33. 44. 55. 66. 77. 110. 111.	Representatives of the Phyla atozoa, Porifera, Coelenterata, and Mollusca are Monas lens Proteus diffluens Bursaria vesiculosa Cryptomonas ovata Trachelocerca olor Trachelocerca viridis Vibrio anguillula Cyclidium glaucoma Paramecium compressum Chilodon cucullatus Gonium pectorale
Figure 11. 22. 33. 44. 55. 66. 77. 110. 111. 112.	Representatives of the Phyla atozoa, Porifera, Coelenterata, and Mollusca are Monas lens Proteus diffluens Bursaria vesiculosa Cryptomonas ovata Trachelocerca olor Trachelocerca viridis Vibrio anguillula Cyclidium glaucoma Paramecium compressum Chilodon cucullatus Gonium pectorale Bursaria truncatella
Figure 1. 22. 33. 44. 55. 66. 77. 110. 111. 112. 113.	Representatives of the Phyla atozoa, Porifera, Coelenterata, and Mollusca are Monas lens Proteus diffluens Bursaria vesiculosa Cryptomonas ovata Trachelocerca olor Trachelocerca viridis Vibrio anguillula Cyclidium glaucoma Paramecium compressum Chilodon cucullatus Gonium pectorale Bursaria truncatella Urocentrum turbo
Figure 11. Figure 12. Figure 13. Figure 14. Figure 14. Figure 15.	Representatives of the Phyla atozoa, Porifera, Coelenterata, and Mollusca Tre Monas lens Proteus diffluens Bursaria vesiculosa Cryptomonas ovata Trachelocerca olor Trachelocerca viridis Vibrio anguillula Cyclidium glaucoma Paramecium compressum Chilodon cucullatus Gonium pectorale Bursaria truncatella Urocentrum turbo Trichodina cometa
Figure 1	Representatives of the Phyla atozoa, Porifera, Coelenterata, and Mollusca and Mollusca are Monas lens Proteus diffluens Bursaria vesiculosa Cryptomonas ovata Trachelocerca olor Trachelocerca viridis Vibrio anguillula Cyclidium glaucoma Paramecium compressum Chilodon cucullatus Gonium pectorale Bursaria truncatella Urocentrum turbo Trichodina cometa Volvox globator
Figu. 1. 22. 33. 44. 55. 66. 77. 110. 111. 112. 113. 114. 115. 116.	Representatives of the Phyla atozoa, Porifera, Coelenterata, and Mollusca Tre Monas lens Proteus diffluens Bursaria vesiculosa Cryptomonas ovata Trachelocerca olor Trachelocerca viridis Vibrio anguillula Cyclidium glaucoma Paramecium compressum Chilodon cucullatus Gonium pectorale Bursaria truncatella Urocentrum turbo Trichodina cometa Volvox globator Rotifer vulgaris
Figure 1. 22. 33. 44. 55. 66. 77. 110. 111. 112. 113. 114. 115. 116. 117.	Representatives of the Phyla atozoa, Porifera, Coelenterata, and Mollusca Tre Monas lens Proteus diffluens Bursaria vesiculosa Cryptomonas ovata Trachelocerca olor Trachelocerca viridis Vibrio anguillula Cyclidium glaucoma Paramecium compressum Chilodon cucullatus Gonium pectorale Bursaria truncatella Urocentrum turbo Trichodina cometa Volvox globator Rotifer vulgaris Opercularia articulata
Figu. 11. 22. 33. 44. 55. 66. 77. 111. 112. 113. 114. 115. 116. 117. 118.	Representatives of the Phyla atozoa, Porifera, Coelenterata, and Mollusca Tre Monas lens Proteus diffluens Bursaria vesiculosa Cryptomonas ovata Trachelocerca olor Trachelocerca viridis Vibrio anguillula Cyclidium glaucoma Paramecium compressum Chilodon cucullatus Gonium pectorale Bursaria truncatella Urocentrum turbo Trichodina cometa Volvox globator Rotifer vulgaris Opercularia articulata Stentor mylleri
Figure 1. 1. 22. 33. 44. 55. 66. 77. 88. 19. 111. 115. 116. 117. 118. 119.	Representatives of the Phyla atozoa, Porifera, Coelenterata, and Mollusca Tre Monas lens Proteus diffluens Bursaria vesiculosa Cryptomonas ovata Trachelocerca olor Trachelocerca viridis Vibrio anguillula Cyclidium glaucoma Paramecium compressum Chilodon cucullatus Gonium pectorale Bursaria truncatella Urocentrum turbo Trichodina cometa Volvox globator Rotifer vulgaris Opercularia articulata Stentor mylleri Melicerta ringens
Figu. 11. 22. 33. 44. 55. 66. 77. 111. 112. 113. 114. 115. 116. 117. 118.	Representatives of the Phyla atozoa, Porifera, Coelenterata, and Mollusca Tre Monas lens Proteus diffluens Bursaria vesiculosa Cryptomonas ovata Trachelocerca olor Trachelocerca viridis Vibrio anguillula Cyclidium glaucoma Paramecium compressum Chilodon cucullatus Gonium pectorale Bursaria truncatella Urocentrum turbo Trichodina cometa Volvox globator Rotifer vulgaris Opercularia articulata Stentor mylleri

22.

23.

24.

26.

27.

Hydra fusca

Hydra viridis

Virgularia juncea

Pennatula grisea

28, 29. Tubularia coronata

Pennatula granulosa

Pennatula phosphorea

Sertularia polyzonalis

31.	Sertularia falcata
32.	Thuaria thuia
33.	Sertularia abietina
34.	Sertularia operculata
35.	Corallina rubens
36.	Flabellaria opuntia
37.	Penecillus penecillus
38.	Corallina officinalis
39.	Tubularia sultana
40.	Tubularia campanularia
41.	Acetabulum mediterraneum
42.	Tubularia indivisa
43.	Flustra foliacea
44.	Spongia fistularis
45.	Spongia officinalis
46.	Alcyonium ficiforme
47.	Alcyonium palmatum
48.	Gorgonia flabellum
49.	Gorgonia verrucosa
50.	Gorgonia cerataphyta
51.	Antipathes spiralis
52.	Coralium nobile
53.	Isis hippuris
54.	Flustra
55.	
56.	Pocillopora polymorpha
	Retepora
57. 58.	Eschara
	Oculina virginea
59.	Oculina gemmascens
60.	Madrepora prolifera
61.	Porites porites
62.	Astrea astroites
63.	Explanaria ananas
64.	Meandrina labyrinthica
65.	Fungia fungites
66.	Tubipora musica
67.	Teredo navalis
68.	Sabella ventilabrum
69.	Vermetus lumbricalis
70.	Serpula glomerata
71.	Aspergillum javanum
72.	Serpula arenaria
73.	Dentalium elephantinum
74.	Dentalium politum
75.	Dentalium entalis
76.	Patella granatina
77.	Patella saccharina
78.	Calyptræa sinensis
79.	• •
	Patella laciniosa
80.	Fissurella græca
81.	Ancylus lacustris
82.	Emarginula fissura
83.	Pileopsis hungarica
	(Trochidæ)
84.	Neritina crepidularia

31. Sertularia falcata

Patella vulgata 86. Haliotis tuberculata 87. Neritina fluviatilis 88. Natica canrena 89. Sigaretus haliotideus 90. Melania amarula 91. Limnea auricularia 92. Limnea stagnalis Bulimus decollatus fasciatus 94 Bulimus decollatus albus 95. Paludina vivipara 96. Janthina ianthina 97. Helix memoralis 98. Helix pomathia Turbo nautileus 100. Clausilia perversa 101. Scalaria dathrus 102. Scalaria scalaris 103. Turbo cochlus 104. Delphinula delphinus Telescopium indicator 106. Trochus solaris 107. Trochus magus Solarium perspectivum Cerithium vertagus 110. Pleurotoma babylonia 111. Murex ramosa 112. Murex haustellum 113. Murex tribulus 114. Strombus lentiginosus 115. Pterocera chiragra 116. Rostellaria rectirostris 117. Terebra maculata 118. Purpura lapillus 119. Harpa ventricosa 120. Baccinum undatum 121. Cassidoria echinophora 122. Oliva ispidula 123. Mitra episcopalis 124. Mitra papalis 125. Oliva porphyria 126. Oliva maura PLATE 76. Representatives of the Phyla Mollusca, Echinodermata, Ctenophora, and Arthropoda Figure Auricula midæ 1. 2. Ovula volva

3.

4.

5.

6.

7.

Cypræa moneta

Cypræa arabica

Cypræa mauritiana

13. Spirula spirula Nautilus beccari 15. Nautilus calcar Nautilus pompilius 17. Argonauta argo Pinna obeliscus 19. Pinna rudis 20. Avicula margaritifera Mytilus cygneus Mytilus bidens Terebrata caput serpentis Crania craniolaris 25. Ostrea cristigalli 26. Malleus malleus 27. Pecten corallinus Pecten pallium ducale Pecten maximus Perna ephippium 31. Arca senilis 32. Arca noæ 33. Tridacna gigas Isocardia corallina Spondylus gæderopus 36. Venus mercenaria 37. Cytherea dione 38. Donax rugosa 39. Donax scripta Mactra solidissima 41. Hemicardium cardissa 42. Cardium echinatum 43. Cyclas 44. Tellina radiata Solen vagina Solen siliqua 47. Unio complanatus 48. Mya pictorum Pholas pusillus Pholas dactylus 51. Pollicipes mitella 52. Lepas anatifa 53. Coronula 54. Balanus psittacus Chiton squamosus 56. Holopus rangii 57. Encrinus radiatus Pentacrinus osteria Bulla physis 59. Ovula ovum Oreaster turritus

Conus aurantiacus

Conus summus

Conus textillis

Conus cedo nulli

Conus marmoreus

Asterias aurantiaca

Astrogonium granulare

Ophiolepis scolopendrina

61.

9.

10.

11.

63.	Astrophyton caput medusæ	
64.	Ophiurus asterias	
65.	Stellonia rubens	
66.	Solaster papposa	
67.	Spatangus purpureus	
68.	Clypeaster rosacea	
69.	Echinus cidaris	
70.	Cidaris diadema	
71.	Cidaris esculentus	
72.	Lucernaria quadricornis	
73.	Thaumantias cymbaloidea	
74.	Aurelia aurita	
75.	Octopus octopodius	
76.	Loligo loligo	
77.	Sepia officinalis	
78.	Clio borealis	
79.	Scyllæa pelagica (Tritoniidæ)	
80.	Lernæa branchialis	
81.	Lernæa cyprinacea	
82.	Terebella conchilega	
83.	Porpita nuda	
84.	Velella spirans	
85.	Cucumaria frondosa	
	PLATE 77.	
Representatives of the Phyla		
Coe	lenterata, Chordata, Mollusca,	
Platyhelminthes and Arthropoda		

Platyhelminthes, and Arthropoda

Figure Physalia physalis Thetis fimbria

Salpa maxima Pedicellaria Actinia undata 5. Actinia senilis 6. 7. Ascidia lepadiformis Ascidia venosa 8.

Nais serpentina 10. Nais proboscidea Phyllodoce stellifera 11.

12. Nereis tubicola Amphitrite reniformis 13.

Spio filicornis 14. 15. Aphrodite aculeata

Doris papillosa 16. Doris argo 17.

18. Aplysia depilans Limax agrestis 19.

Limax empiricorum 20.

21. Limax fuscus Malacobdella grossa 22.

23. Nephelis octoculata (Hirudinidæ)

Clepsina complanata 25. Hæmopis vorax

Hirudo officinalis 26. Sipunculus saccatus 27.

28. Sipunculus nudus

Echinococcus veterinorum suis 30. Cysticercus cellulosæ

Tænia cateniformis 32. Bothriocephalus latus

Tænia solium 33. Ligula cingulum 34.

35. Planaria cornuta 36. Distoma hepaticum 37. Lumbricus variegatus

Lumbricus terrestris 38. 39. Echinorhynchus gigas

Trichocephalus dispar 40. Ascaris lumbricoides 41.

42. Oxvuris vermicolaris Filaria medinensis 43.

Lumbricus aquaticus 44. 45. Filaria papillosa

Argas fischeri 46. 47. Argas savignii Chelifer beauvoisii 48.

49. Galeodes phalangium

50. Galeodes araneoides 51. Scorpio europæus

Buthus afer 52.

53. Epeira imperialis 54. Tetragnatha argyra

Theridion denticulatum 55.

Argyroneta aquatica Uloborus walcnærius

Gasteracantha armata

58. Mygale avicularia Epeira diadema 59.

Pallene brevirostris (Pvcnogonidæ)

Chelifer cancroides Phalangium opilio

Phalangium ægyptiacum 63.

64. Hydrachna abstergens

Hydrachna despiciens Ixodes annulatus 66.

Ixodes americanus 67. 68. Sarcoptes scabiei

69. Gamasus coleopterorum

Acarus siro 70.

71. Ixodes orbiculatus

Pulex penetrans Pulex irritans 73.

74, 75. Nirmidæ Phthirius pubis

Pediculus capitis 77. Lodura nivicola

Podura villosa

Smynthurus fimetarius

81, 84. Machilus polypoda 82, 83. Lepisma saccharina

84. See 81

85. Melophagus ovis

Hippobosca equina 86. Bombylius major 87.

88. Dioctria ater

89. Asilus cabroniformis 90. Conops macrocephala

91. Stomoxis calcitrans

92, 93. Empidæ

Anopheles bifurcatus

95. Culex nemorosus 96. Culex pipiens

97. Tabanus tropicus 98. Tabanus bovinus

99-109. Muscidæ 110. Clitellaria ephippium

111. Volucella pellucens

112. Scæva pyrastri

113. Crysotoxum vospiformis

114. Eristalis tenax 115. Helophilus pendulus

116. Leptis vermileo

117. Stratiomys chamæleon

118. Chironomus plumosus

119. Anisomera nigra

120. Ctenophora elegans

121. Psychoda phalænoides 122. Mycetophila cericea

123. Bibio marci

124. Mycetophila mirabilis 125. Cephalemvia ovis

126, 127. Gasterophilus equi

128. Œstrus tarandi 129. Œstrus boyis

PLATE 78.

Representatives of the Phylum Arthropoda: Classes Crustacea and Arachnida

Figure

1, 2. Cancerinæ

3. Thalamita natator

Gecarcinus lateralis 4.

5. Gelasimus annulipes Ocvpoda arenaria 6.

7. Philyra scabriuscula

8. Dorippe sima 9. Ranina serrata

10. Pagurus diogenes

11. Palinurus guttatus

Sevllarus æquinoctialis 12.

Stenopus hispidus

14. Callianassa uncinatta

Squilla maculata 15.

Gonodactylus stylifer 16.

17. Phyllosoma stylicornis

18. Orchestia fischeri

19. Ancylomera hunteri

20. Cymadocea armata 21. Sphæroma serratum

22. Porcellio granulatus

23. Caprella acuminifera

24. Cvamus ovalis

25. Aprus cancriformis

Branchipus pisciformis 26.

27. Cyclops communis 28. Phyllophora cornuta

Ergasilus sieboldi 29. Lernæa polycolpus 30.

31. Achtheres percarum

Pycnogonum litterale 32.

Nymphon gracile 33. Limullus moluccanus 34.

35. Nemesia cellicola

36. Segestria perfida

Lycosa tarentula 37. Lycosa melanogaster 38.

39. Hersilia caudata

40. Chersis savinii

Salticus formicanus 41.

Eripus heterogaster 42.

Arcys lanceolarius 43. Latrodectus malmignatus 44.

Nyssa timida 45.

Tegenaria domestica 46.

Lachesis perversa 47. Uloborus walcnærius 48.

Argyroneta aquatica

PLATE 79.

Insects of the Orders Hymenoptera, Diptera, Lepidoptera, and Odonata

Figure

Mutilla europæa

Apterogyna occidentalis

3-9. Formicidæ

10. Bombus lapidarius 11. Bombus muscorum

Megachile sementaria

Bombus terrestris 14. Xylocopa violacea

15. Nomada variegata

16. Eucera longicornis 17. Megachile centuncularis

18. Apis mellifica

19. Vespa maculata

20. Polistes paritum

21. Vespa vulgaris

22. Vespa crabro 23. Leucospis dorsigera

24. Chrysis cyanea

25. Chrysis aurata

26. Chrysis ignita 27. Pompilus cœruleus

28. Pompilus viaticus

29. Crabro cribarius 30. Pelopæus spirifex

31. Ammophila sabulosa

32, 33, 36-39. Ichneumonidæ

34, 35. Chalcididæ

36-39. See 32

40. Rhyssa persuasoria (Ichneumonidæ)

41. Urocerus spectrum

42. Urocerus gigas

43. Lophyrus juniperi 44. Nematus capreæ

45. Cimbex americana

46. Tenthredinidæ 47. Cimbex variabilis

48-53. Cinipidæ

54. Mantispa pagana

55. Raphidia ophiopsis 56. Termes fatalis

57. Bittacus tipularia

58. Panorpa communis 59. Ascalaphus barbarus

60. Myrmeleon libelluloides

61. Myrmeleon formicarius

62-64. Hermerobiidæ 65. Hydropsyche plumosa

66. Phryganea striata

67. Perla bicaudata

68. Limnophilus rhombica

69. Phryganea grandis

70-72. Ephemeridæ

73. Agrion puella 74. Caleptervx virgo

75. Libellula depressa

76. Æschna grandis 77. Pterophorus pentadactyla

78. Coccvx resinosa

79. Carpocapsa pomonella 80. Hercyna paliotalis

81. Tinea granella

82. Plutella xylostella

83. Gallerea cereana 84. Tinea pellionella

85. Lemmatophila salicella

86. Hyponomeuta evonymella

- 87. Hyponomeuta pedella
- 88. Hypena rostralis
- 89. Botys verticalis
- 90. Sciaphila literata
- 91. Tortrix viridana
- 92. Halias prasinana
- 93-102. Geometridæ
- 103-123, 129, 136. Noctuidæ
- 124. Callimorpha jacobææ
- 125. Arctia fuliginosa
- 126. Arctia matronula
- 127. Arctia dominula
- 128. Pygæra bucephala
- 129. See 103
- 130-135, 137-151. Bombycidæ
- 136. See 103

PLATE 80.

Insects of the Orders Lepidoptera, Orthoptera, and Hemiptera Mantedea, and Hemiptera

Figure

- 1. Lasiocampa quercus
- 2. Dendrolimus pini
- 3. Odonestis potatoria
- 4-7. Bombycidæ
- 8. Zygæna filipendula
- 9. Sesia fuciformis
- 10-21. Sphingidæ
- 22. Hesperia malvarum
- 23-50. Papilionidæ
- 51. Thrips phisapus
- 52. Lecanium illicis
- 53. Lecanium hesperidum
- 54. Coccus cacti
- 55. Psylla alni
- 56. Dorthesia urticea
- 57, 59, Aphidæ
- 58. Chermes ulmi
- 59. See 57
- 60. Pyrrhocoris apterus
- 61. Coryzus hyoscyami
- 62. Cydnus biguttatus
- 63. Pentatoma juniperinus
- 64. Pentatoma baccarum
- 65. Acanthosoma hæmorrhoidalis
- 66. Cimex rufipes
- 67. Acanthia lectularia
- 68. Ranatra linearis
- 69. Nepa cinerea
- 70. Neucoris cimicoides
- 71. Belostoma grandis
- 72. Corixa striata
- 73. Notonecta glauca
- 74. Aphrophora spumaria

- 75. Cicada fraxini
- 76. Fulgora candelaria
- 77. Fulgoria laternaria
- 78. Œdipoda stridula
- 79. Œdipoda cærulescens
- 80. Œdipoda migratoria
- 81. Acridium cristatum
- 82-85. Locustidæ
- 86-88. Gryllidæ
- 89. Phyllium siccifolium
- 90. Mantis religiosa
- 91. Empusa gongylodes
- 92. Cyphocrana gigas
- 93. Blatta orientalis

PLATE 81.

Members of the Insect Order Coleoptera: and the Chordate Classes Chondrichthyes, Osteichthyes, Amphibia, and Reptilia

Upper Division

- **Figure**
- 1-3. Forficulidæ
- 4-6. Brachelytra
- Meloë proscarabæus
- Lytta vesicatoria
- Blaps mortisaga
- 10. Tenebrio molitor
- 11-16. Carabidæ
- 17. Dyticus marginalis
- 18. Hydrophilus piceus
- 19-21. Mordellidæ
- 22. Buprestis mariana
- 23. Euchroma gigas
- 24. Buprestis chrysostigma
- 25. Elaphrus riparius (Carabidæ)
- 26-29. Cicindela
- 30-33. Elateridæ
- 34. Malachius æneus
- 35-38. Cantharis
- 39. Lycus sanguineus
- 40. Pyrochroa coccinea
- 41, 42. Lampyridæ
- 43. Necvdalis cærulea 44-61. Longicornia
- 62-64. Clerida
- 65-76. Rhincophora
- 77-79. Bruchus
- 80-101. Trimera
- 102, 103. Nitidulidæ
- 104. Silpha thoracica
- 105, 106. Necrophorus 107, 108. Anthrenus
- 109. Byrrhus pilula (Byrrhidæ)

- 110. Gyrinus natator
- 111. Ptinus fur
- 112. Anobium pertinax
- 113. Apate capucinus
- 114. Hylesinus piniperda
- 115, 116. Bostrichus
- 117, 118. Dermestes
- 119-123. Hister
- 124. Lucanus
- 125-127. Cetoniadæ
- 128-131. Melolonthidæ
- 132, 136-144. Scarabæidæ
- 133-135. Aphodiidæ
- 136-144. See 132
- 145-148. Dynastidæ

Lower Division

Figure

- 1. Alosa vulgaris, shad
- Clupea harengus, herring
- Engraulisencrasicholus. anchovy
- Harengula sprattus, sprat
- Thymallus vulgaris, greyling
- Cobitis fossilis, mudfish
- Exoglossum barbatula. groundling
 - Rhombus vulgaris, brill
- 9. Platessa flesus, fluke
- 10. Zeus faber, dory
- 11. Lota vulgaris, burbot
- 12. Trachinus draco, sea cat
- 13. Xiphias gladius, swordfish
- 14. Amodytes tobianus, sand-eel 15. Syngnathus ophidion, sea
- serpent
- 16. Syngnathus acus, sea-needle 17. Pegasus draco, sea-dragon
- 18. Lumpus anglorum, lump sucker
- 19. Diodon punctatus, sticklebag
- 20. Tetraodon lagocephalus, star belly
- 21. Centriscus scolopax, trumpet fish
- 22. Aluteres monoceros, unicorn
- 23. Lophius piscatorius, widegap
- 24. Acipenser ruthenus, caviar sturgeon
- 25. Acipenser sturio, sturgeon
- 26. Sphyrna malleus. hammer-headed shark
- 27. Spinax acanthias, thorn-hound

- 28. Petromyzon fluviatilis. lamprey
- 29. Seps chalcides, bronze colored lizard
- 30. Scincus cyanurus, scink
- 31. Plestiodon aldrovandii
- 32. Triton cristatum, eft
- 33. Draco dandini, flying dragon
- 34. Rana temporaria, yellow frog 35. Hyla viridis, tree or green frog
- 36. Bufo calamita, toad
- 37. Bombinator igneus, glistering toad
- 38. Pelobatus fuscus, water toad
- 39. Testudo geometrica, tortoise
- 40. Testudo græca, mosaic tortoise
- 41. Cistudo europæa, European tortoise
- 42. Emys picta, terrapin
- 43. Sphargis coriacea, leather turtle

PLATE 82.

Chordates of the Classes Chondrichthyes and Osteichthyes

- 1. Aspidophorus cataphractus.
- pogge
- Pristis antiquorum, saw fish
- 3. Esox lucius, pike
- Perca fluviatilis, perch
- 5. Anguilla vulgaris, eel Gasterosteus aculeatus,
- stickleback
- 7. Salmo fario, salmon trout
- Holocanthus tricolor, tricolor Synanceia horrida, dragon's
- head 10. Labrax lupus, bass
- 11. Solea vulgaris, sole
- 12. Platessa limanda, dab

PLATE 83. Osteichthyes of the Orders Perciformes, Scorpæinformes, Beryciformes, and

Dactylopteriformes

Figure

- 1. Holocentrum longipinne, red
- Acanthurus gemmatus, gem fish

- 3. Amphacanthus corallinus, coral perch
- Sphyræna spet, barracuda pike
- Scorpæna scropha, dragon's
- Naucrates ductor, pilot fish
- Trigla lyra, piper
- Thynnus vulgaris, tunny
- Scomber vulgaris, mackerel
- 10. Acerina cornua, ruffe
- 11. Cepola rubescens, band fish
- 12. Dactylopterus volitans, flying fish

PLATE 84.

Members of the Classes Chondrichthyes, and Osteichthyes

- **Figure**
- 1. Carcharius verus, shark
- Coryphæna hippuris, dolphin
- Echineis remora, sucking fish Chondrostoma nasus, broad
- snout
- Cottus gobio, bullhead
- Gobio fluviatilis, gresling Alburnus lucidus, bleak
- Acanthurus chirurgus. lancettail
- Chætodon auriga, angel
- 10. Barbus vulgaris, barbel 11. Cyprinus carpio, carp
- 12. Tinca vulgaris, tench 13. Anabas scandens, climbing

PLATE 85. Representatives of the Classes **Chondrichthyes and Osteichthyes**

perch

- **Figure**
- 1. Morrhua vulgaris, codfish Merlangus vulgaris, whiting
- Raia batis, skate 4. Trachinus vividus, weever 5. Blennius viviparus, guffer
- Ophiocephalus striatus. ophidion
- Mullus barbatus, mullet Dipterodon capensis, Cape-dipterodon
- Amphiprion bifasciatus, amphiprion
- 10. Scolopsides vosmari 11. Trachypterus spinolæ,
- trachypterus 12. Cyprinus auratus, gold-fish

PLATE 86. Reptiles of the Suborders Sauria and Serpentes

Figure

- Deirodon nasutus, green snake
- Tropidonotus natrix, ringed snake
- Trigonocephalus lanceolatus, copperhead
- Naia tripudians, cobra di capello
- 5. Boa constrictor
- 6. Phrynosoma cornuta, horned frog

PLATE 87.

Reptiles of the Suborders Sauria and Serpentes

Figure

- 1. Anguis fragilis, slow worm
- 2. Vipera berus, viper
- Cerastes cornutus, horned viper
- Xiphosoma caninum, dog boa
- 5. Crotalus horridus, rattlesnake
- Seps chalcides, scink

PLATE 88.

Amphibians of the Order Urodela and Reptiles of the Orders Squamata and Crocodylia

Figure

- 1. Siren lacertina, siren
- 2. Necturus lateralis, water-puppy
- Chamæleo vulgaris, chamæleon
- Platydactylus guttatus, gecko
- . Uroplatus fimbriatus, flat headed salamander
- . Lophyrus furcata, lophyrus
- . Crocodilus lucius, alligator
- . Crocodilus vulgaris, crocodile

PLATE 89.

Amphibians of the Order Urodela and Reptiles of the Suborder Sauria

Figure

- Salamandra maculata, salamander
- Triton tœniatum, brook salamander

- 3. Draco dandini, flying dragon
- 4. Scincus officinalis, scink
- 5. Basiliscus mitratus, basilisk
- 6. Iguana tuberculata, guana
- 7. Lacerta viridis, lizard

PLATE 90.

Members of the Classes Reptilia and Amphibia

Figure

- 1. Bufo viridis, green toad
- 2. Engystoma ovale, S. Amer. toad
- 3. Dactelythra capensis, Cape toad
- 4. Pipa americana, Guiana toad
- 5. Rana esculenta, frog
- 6. Hyla viridis, tree or green frog
- Achrochordus javanica, Java snake
- 8. Platurus laticaudis, India water snake
- 9. Elaps corallinus, coral snake
- 10. Typhline cuvierii, blind scink
- 11. Chelonia mydas, green turtle
- 12. Cistudo europæa, land tortoise
- 13. Testudo geometrica, India tortoise

PLATE 91.

Aves of the Orders Podicipediformes, Pelecaniformes, Sphenisciformes, and Gaviiformes

Figure

- 1. Podiceps cristatus, crested grebe
- 2. Podiceps minor, little grebe
- 3. Colymbus glacialis, loon
- 4. Sterna nigra, sooty tern
- 5. Larus eburneus, ivory gull
- 6. Pelecanus crispus, hairy pelican
- 7. Cygnus olor, mute swan
- 8. Cygnus ferus, hooper swan
- 9. Oidemia americana, scoter
- 10. Anas crecca, teal
- 11. Procellaria capensis, Cape pigeon
- 12. Diomedia exulans, white albatross
- 13. Aptenodytes patagonica, Patagonian penguin
- 14. Fratercula arctica, puffin
- 15. Alca torda, razor-billed auk

PLATE 92.

Members of the Orders Anseriformes, Pelecaniformes, Charadriiformes, and Sphenisciformes

Figure

- 1. Carbo cormoranus, cormorant
- 2. Eudytes cristatus, crested penguin
- 3. Tachypetes aquilus, frigate pelican
- 4. Phæton æthereus, tropic bird
- 5. Plotus anhinga, snake bird
- 6. Sula bassana, booby
- 7. Anser segetum, bean goose
- 8. Anas boschas, mallard
- Anas galericulata, mandarin duck
- 10. Merges cucullatus, hooded merganser
- 11. Larus argentatus, herring gull
- 12. Sterna hirundo, sea swallow

PLATE 93.

Members of the Orders Ciconiiformes, Gruiformes, and Charadriiformes

Figure

- Charadius auratus, plover
- 2. Vanellus cristatus, lapwing
- 3. Grus cinerea, crane
- 4. Platalea leucorrhodia, roseate spoon-bill
- 5. Ardea purpurea, purple heron
- 6. Egretta candidissima, snowy heron
- 7. Ciconia alba, white stork
- 8. Gallinago major, snipe
- 9. Limosa rufa, rufous godwit
- 10. Recurvirostra avocetta, avocet
- 11. Phænicopterus ruber, scarlet flamingo
- 12. Ardea ralloides, pigmy heron

PLATE 94.

Members of the Orders Struthioniformes, Gruiformes, Ciconiiformes, and Charadriiformes

Figure

- 1. Struthio camelus, ostrich
- 2. Otis tarda, great bustard

- 3. Otis tetrax, smaller bustard
- 4. Balearica pavonina, crowned crane
- 5. Botaurus stellaris, bittern
- 6. Ibis alba, white ibis
- 7. Numenius arcuatus, curlew
- 8. Totanus calidris, sandpiper
- 9. Parra indica, Indian jacana
- 10. Fulica americana, coot
- 11. Porphyrio hyacinthinus, hyacinth gallinule12. Heliornis surinamensis, sun
- Heliornis surinamensis, sur bird
- 13. Totanus ochropus, green sandpiper

PLATE 95.

Aves of the Orders Casuariiformes, Anseriformes, Charadriiformes, Galliformes, and Gruiformes

Figure

- Casuarius galeatus, cassowary
- Palamedea cornuta, horned screamer
- 3. Ibis cristatus, crested ibis
- 4. Tringa rufescens, rufous sandpiper
- 5. Glareola torquata, pratincole
- 6. Himantopus albicollis, stilt
- 7. Cinclus interpras, turnstone
- 8. Rallus aquaticus, dusky rail
- 9. Rallus crex, corn crake 10, 11. Gallus domesticus.
- common fowl
- 12. Meleagris gallopavo, turkey13. Numida meleagris, guinea fowl
- 14. Pterocles alchata, desert grouse
- 15. Turnix dactylisonans, quail

PLATE 96.

Members of the Orders Galliformes and Columbiformes

Figure

- Tetrao urogallus, cock of the woods
- 2. Tetrao tetrix, moor cock
- Perdix cinerea, grey partridge
 Perdix rubra, red partridge
- 5. Pavo cristatus, peacock6. Phasianus colchicus, pheasant

- 7. Phasianus pictus, golden pheasant
- 8. Argus giganteus, argus pheasant
- Tragopan hastingsii, golden breasted horned pheasant
- 10. Crax rubra, red curassow
- 11. Lophortyx californicus, California partridge
- 12. Columba livia, rock pigeon
- Columba œnas, blue-backed dove
- 14. Goura cruenta, ground pigeon
- 15. Columba turtur, turtle dove

PLATE 97.

Representatives of the Orders Psittaciformes, Piciformes, and Trogoniformes

Figure

- Cacatua sulphurea,
 yellow-crested cockatoo
- 2. Psittacus erythacus, grey African parrot
- 3. Palæornis malaccensis,
 Malacca parrot
- Palæornis alexandri, redheaded parrot
- 5. Psittacus melanocephalus,
- black-headed parrot

 6. Trogon curucui, curucui
- 7. Trogon viridis, green curucui8. Bucco macrorhynchus,
- puff-bird
- Monasa tranquilla, S. Amer.
 Capito viridiauranthius, green and orange barbet
- 11. Pogonias sulcirostris, grooved-bill barbet
- 12. Pteroglossus aracari, long-tailed aracari13. Ramphastus tucanus, largebilled toucan

PLATE 98.

Members of the Orders Psittaciformes, Piciformes, and Passeriformes

- Platycercus viridis, green
 parrot
- 2. Ara ararauna, blue and yellow maccaw

- 3. Ara militaris, military maccaw
- 4. Lorius domicellus, lory
- 5. Picus villosus, hairy woodpecker
- 6. Picus cayennensis, Cayenne woodpecker
- 7. Gecinus viridis, green woodpecker
- 8. Picus major, large woodpecker
- 9. Yunx torquilla, wry neck
- 10. Pica caudata, magpie
- 11. Corvus monedula, jackdaw
- 12. Corvus corax, raven
- 13. Corvus cornix, hooded crow

PLATE 99. Members of the Orders Apopodiformes and Passeriformes

Figure

- 1, 3. Garrulus glandarius, jay
- Nucifraga caryocatactus, nutcracker
- 3. See 1
- 4. Paradisea minor, bird of paradise
- Paradisea regia, king paradise bird
- 6. Paradisea superba, superb paradise bird
- Paradisea sexsetacea, six shafted paradise bird
- 8. Trochilus moschitus, ruby topaz hummingbird
- 9a. Trochilus ornatus, magnificent hummingbird
- Trochilus colubris, hummingbird
- 10. Trochilus delalandii, De Lalande's hummingbird
- 11. Trochilus minimus, smallest humming bird
- 12. Trochilus cristatus, crested hummingbird
- 13. Trochilus macrourus, swallow tailed hummingbird
- 14. Buphaga africana, beefeater
- Sturnella ludoviciana, American lark
- 16. Icterus baltimore, Baltimore oriole

PLATE 100. Representatives of the Order Passeriformes

Figure

- 1. Sturnus vulgaris, starling
- 2. Loxia pityopsittacus, parrot crossbill
- 3. Coccothraustes vulgaris, hawfinch
- 4ab. Fringilla canaria, canary bird
- 5. Fringilla cannabina, red poll
- 6. Fringilla domestica, house-sparrow
- 7. Sylvia hippolais, willow wren
- 8. Oriolus galbula, oriole
- 9. Merula vulgaris, blackbird
- 10. Merula saxatilis, rock thrush
- 11. Pastor roseus, rose colored starling
- 12. Merula viscivorus, missel thrush
- 13. Merula iliaca, redwing
- 14. Merula musica, song thrush

PLATE 101. Members of the Orders Passeriformes, and Apopodiformes

1. Trochilus granatinus, garnet humming bird

Figure

- 2. Pyrrhula europea, bullfinch
- 3. Spermophila crassirostris, thick-billed finch
- 4. Coccothraustes chloris, green finch
- 5. Fringilla senegala, senegal finch
- 6. Fringilla amaduva, amaduvat
- 7. Vidua regia, king widow bird
- 8. Vidua erythrorhynchus, red-billed widow bird
- 9. Carduelis spinus, siskin
- 10. Carduelis elegans, goldfinch
- 11. Calliste tatao, seven-colored tanager
- 12. Fringilla cœlebs, chaffinch
- 13. Emberiza hortulana, ortolan
- 14. Emberiza schœniculus, reed bunting
- 15. Emberiza citrinella, vellowhammer
- 16. Rupicola aurantia, cock of the rock

- 17. Muscicapa grisola, grey flycatcher
- 18. Muscicapa albicollis, white-necked flycatcher
- 19. Muscicapa regia, king of the flycatchers
- 20. Ampelis carnifex, scarlet-crested chatterer
- 21. Ampelis cortinga, banded chatterer

PLATE 102.

Representatives of the Orders Passeriformes and Apopodiformes

Figure

- 1. Trochilus albicollis, white-necked humming bird
- Certhia familiaris, brown creeper
- 3. Parus cristatus, crested tit
- 4. Parus major, titmouse
- 5. Alauda calandria, field lark
- 6. Alauda cristata, crested lark
- 7. Alauda arvensis, skylark
- Acanthiza campestris, hedge
 warbler
- 9. Cæreba cyanea, blue creeper
- 10, 11. Phœnicura, redstarts
- 12. Phœnicura suecica, blue throated Swedish redstart
- 13. Erythaca rubecula, robin
- 14. Menura superba, lyre bird
- 15. Dicrurus forficatus, fork-tailed drongo
- Cracticus varius, black and white shrike
- 17. Vauga curvirostris, hooked-bill shrike
- Laniarius barbarus, Barbary shrike
- Laniarius collurio, red-backed shrike
- 20. Laniarius exubitor, butcher bird

PLATE 103.

Members of the Orders Passeriformes, Coraciiformes, and Caprimulgiformes

Figure

1. Buceros erythrorhynchus, red-billed hornbill

- 2. Buceros rhinoceros, rhinoceros hornbill
- 3. Halcyon atricapilla, black capped kingfisher
- 4. Ceryle javanicus, Java kingfisher
- Alcido ispida, common kingfisher
- 6. Caprimulgus europæus, goatsucker
- 7. Hirundo rustica, swallow
- 8. Cypselus melba, black martin
- 9. Tyrannus severus, Cayenne flycatcher
- 10. Milvulus forficatus, South Amer. flycatcher
- 11. Parus ater, pine tit
- 12. Regulus auricapillus, golden crested wren
- 13. Philomela luscinia, nightingale
- 14. Curruca hortensis, garden warbler
- Curruca atricapilla, blackcap warbler
- Phœnicura ruticilla, common redstart
- 17. Motacilla boarula, grey wagtail
- 18. Saxicola œnanthe, wheatear

PLATE 104. Members of the Orders Strigiformes and Falconiformes

Figure

- 1. Strix flammea, European barn owl
- 2. Otus brachyotus, short eared owl
- 3. Otus wilsonianus, long-eared owl
- 4. Bubo maximus, grand duke
- 5. Falco peregrinus, wandering falcon
- 6. Falco œsalon, merlin
- 7. Milvus regalis, kite
- 8. Buteo vulgaris, common buzzard
- 9. Gyps fulvus, griffin vulture
- Sarcoramphus papa, king vulture
- 11. Sarcoramphus gryphus, condor

PLATE 105. Members of the Order Falconiformes

Figure

- Aquila chrysaëtos, golden eagle
- Archibuteo niger, black buzzard
- 3. Pandion ossifragus, osprey
- . Haliaëtus albicilla, sea eagle
- 5. Astur palumbarius, goshawk6. Accipiter nisus, sparrow
- hawk
 7. Falco subutes, hobby
- 8. Falco alaudarius, kestril

PLATE 106.

Chart of the Migrations of Fishes and Birds

GLOSSARY

Aleuten In., Aleutian Islands
Amazonenstrom, Amazon River
Arabien, Arabia
Arabisches M., Arabian Sea
Asien, Asia
Atlantischer Ocean, Atlantic
Ocean
Behringsstrasse, Behring's Straits

Baffins Meer, Baffin's Bay Californien, California Canarische In., Canary Islands Cap der guten Hoffnung, Cape of

Good Hope Capstadt, Capetown Cap Verds In., Cape Verde

Islands

Caspisches Meer, Caspian Sea

Donau, Danube

Felsen Geb., Rocky Mountains

Fensterschwalben, Domestic swallows Feuerland, Terra del Fuego

Freundschafts In., Friendly Islands Gesellschafts In., Society Islands Gr. Bären See, Great Bear Lake Grönland, Greenland

Grossbritannien, Great Britain Grosser Ocean, Pacific Häringe, Herrings

Häringe, Herrings
Hudsons Meer, Hudson's Bay
I. Melville, Melville Island

Indisches Meer, Indian Ocean

Lissabon, Lisbon Makrelen, Mackerel Meerb. v. Bengalen, Bay of Bengal Meerb. v. Mexico, Bay of Mexico Mongolei, Mongolia Neuseeland, New Zealand

Neu Sibirien, New Siberia Nord Amerika, North America Nördliches Eismeer, Arctic Sea Patagonien, Patagonia Raben u. Krähen. Ravens and crows

Rauchschwalben. Barn swallows Russisch Amerika, Russian America

Schiffer In., Navigators' Islands Schleiereulen, Barn owls Schwarzes Meer. Black Sea Sibirien, Siberia Sklavensee, Slave Lake

Stadre u. Amseln, Starlings and blackbirds

Sud Amerika, South America Uferschwalben, Bank swallows Verrinigte Staaten, United States Versammlungs u. Abzugspunkt, Place of meeting and departure

Wachteln, Quails Warschau, Warsaw West Indien. West Indies Wien, Vienna Wüste Sahara, Desert of Sahara

Zeichenerklärung, Explanation of the marks

PLATE 107.

Mammals of the Order Cetacea: Suborders Odontoceti and Mysteceti

Figure

- 1. Balæna mysticetus, Greenland whale
- 2, 3. Physeter macrocephalus, sperm whale
- 4. Delphinus delphis, dolphin

PLATE 108.

Representatives of the Orders Artiodactyla, Lagomorpha, and Rodentia

- 1, 2. Cervus elaphus, stag
- 3. Cervus dama, fallow deer
- 4. Cervus capreolus, roebuck

- 5. Lepus timidus, hare
- 6. Lepus cuniculus, rabbit
- 7, 8. Bos taurus, common ox
- 9. Ovis aries, sheep
- 10. Capra hircus, goat
- 11. Sciurus vulgaris, squirrel

PLATE 109.

Representatives of the Order Artiodactyla: Suborders Tylopoda and Ruminantia

Figure

- 1. Camelus bactrianus, two-humped camel
- 2. Camelus dromedarius. dromedary
- Camelopardalis girafa, giraffe
- Moschus moschiferus, musk
- Antilope dorcas, gazelle
- Antilope redunca, antilope of Senegal

PLATE 110.

Members of the Orders Artiodactyla and Perissodactyla

Figure

- 1. Bison americanus, buffalo
- Bos bubalus, Indian buffalo
- Rupicapra tragus, chamois
- Antilope scripta, Cape-elk
- Auchenia alpaca, paco
- Auchenia lama, lama
- 7. Auchenia vicunna, vicunna 8. 9. Tarandus furcifer, reindeer
- 10. Cervus alces, eland
- 11. Siberian horse

PLATE 111.

Members of the Order Perissodactyla: Family Equidae

Figure

- Equus zebra, zebra
- Equus asinus, ass
- 3. Equus mulus, mule
- Equus caballus, horse 4.
- 5. Norman team horse
- 6. Arabian mare and colt
- 7. Arabian stallion

PLATE 112.

Representatives of the Orders Artiodactyla, Perissodactyla, Hyracoidea, and Proboscidea

Figure

1. Tapir indicus, tapir

- 2. Hyrax syriacus, daman
- Dicotyle labiatus, peccary
- Porcus babyrussa, Asiatic
- Sus domesticus, domestic hog
- Sus scropha, wild hog
- 7. Phacochærus æthiopicus, wart hog
- Hippopotamus amphibius, hippopotamus
- Elephas indicus, Indian elephant

PLATE 113.

Representatives of the Orders Edentata, Marsupialia, Pholidota, Carnivora, and Monotremata

Figure

- 1. Ornithorhynchus anatinus, duck-billed platypus
- Echidna aculeata, porcupine ant-eater
- Manis pentadactyla, pangolin
- Myrmecophaga didactyla, two-toed ant-eater
- Myrmecophaga jubata, great ant-eater
- 6. Chlamydophorus truncatus, Chili armadillo
- 7. Dasypus sexcinctus, six-girdled armadillo
- Dasypus novemcinctus, nine-girdled armadillo
- 9. Bradypus didactylus, sloth
- 10. Bradypus tridactylus, aï
- 11ab. Halmaturus laniger, rufous kangaroo
- 12ab. Halmaturus dorsalis, ashv kangaroo
- 13. Didelphys murina, Brazilian opossum
- 14. Didelphys virginiana, Virginia opossum
- 15. Nasua rufa, brown coati

PLATE 114.

Representatives of the Orders Insectivora Carnivora, Rodentia and Lagomorpha

Figure

- 1. Chinchilla lanigera, chinchilla
- 2a. Cavia cobaya, Guinea pig
- 2b. Lagomys alpinus, pika
- 3a. Cercolabes villosus, Brazil porcupine

- 3b. See 16 [mistake of the engraver]
- Hystrix cristatus, European porcupine
- Halamys caffer, Cape jerboa
- Mus sylvaticus, field mouse
- Mus rattus, black rat
- Mus musculus, common mouse
- Cricetus vulgaris, hamster
- 10. Myoxus glis, dormouse
- 11. Arctomys alpinus, marmot
- 12, 13. Pteromys volucella, flying squirrel
- 14. Sciurus carolinensis, grey squirrel
- 15. Sciurus maximus, Malabar squirrel
- 16. Lutra vulgaris, European otter
- 17. Talpa europæa, European mole
- 18. Erinaceus europæus, European hedgehog

PLATE 115.

Representatives of the Orders Rodentia and Carnivora

Figure

- 1. Castor fiber americanus, beaver
- Phoca vitulina, seal
- 3. Trichechus rosmarus, walrus
- Felis domesticus, cat
- 5. Felis domesticus angorensis, Angora cat
- Hyæna striata, striped hyena
- 7. Canis aureus, jackal
- Canis lupus, wolf
- Canis familiaris pastoreus, shepherd's dog
- 10. Lutra canadensis, Canada otter
- 11. Ursus maritimus, white polar bear

PLATE 116. Members of the Order Carnivora:

Family Felidae

Figure

- 1. Felis leo, lion
- Felis tigris, tiger
- 3. Felis leopardus, leopard
- 4. Felis onca, jaguar

- 5. Felis pardus, panther
- Lvnx europæus, lvnx

PLATE 117.

Representatives of the Order Carnivora: Families Canidae, Ursidae, and Mustelidae

Figure

- Vulpes fulvus, red fox
- Meles vulgaris, badger
- Mustela martes, marten
- Mustela foina, beech marten
- Mustela putorius, polecat
- Putorius furo, ferret
- Putorius vulgaris, weasel
- Putorius erminea, ermine
- 9. Ursus arctos, brown bear
- 10. Ursus americanus, black bear
- 11. Canis familiaris sibericus, Siberian dog
- 12. Canis familiaris, domestic dog
- 13. Canis familiaris molossus, bull dog
- 14. Canis familiaris leporarius, greyhound
- 15. Canis familiaris normanus, chase dog
- 16. Canis familiaris vertagus, badger dog

PLATE 118.

Representatives of the Orders **Chiroptera and Primates**

- **Figure** 1. Galeopithecus rufus, flying
- lemur 2. Plecotus timoriensis,
- long-eared bat 3. Vespertilio noctula, common
- Vespertilio serotinus, serotine
- 5. Vespertilio murinus. European bat
- Rhinolophus ferrum equinum, horse-shoe bat Megaderma lyra.
- broadwinged bat
- 8. Vampyrus spectrum, vampire Pteropus vulgaris, roussette
- 10. Otolicnus senegalensis. galago
- 11. Lemur pusillus, fox-nosed maki

- 12. Lemur macao, maki
- 13. Cynocephalus maimon, mandrill
- 14. Cercopithecus diana, holoway
- 15. Hylobates agilis, agile gibbon

PLATE 119. Representatives of the Orders Perissodactyla and Primates

Figure

- Rhinocerus indicus, Indian rhinoceros
- 2, 3. Cebus capucinus, capucin
- Macacus cynomolgus, hare-lipped monkey
- 5. Cercopithecus ruber, patras
- 6. Cercopithecus griseus, grey patras
- Macacus silenus, maned macaque
- 8. Cynocephalus sphinx, baboon
- 9. Inuus ecaudatus, Barbary ape
- 10. Troglodytes niger, chimpanse
- 11. Pithecus satyrus, orang outang

ANTHROPOLOGY AND SURGERY

PLATE 120. Varieties of Mankind

Figure
1-9. Varieties of mankind
10-12. Facial angles
Center figure. Chart of the five
races of Blumenbach

GLOSSARY

- I. Kaukasische oder Weisse Race, Caucasian or White Race
- II. Mongolische oder Gelbe Race, Mongolian or Yellow Race
- III. Æthiopische oder Schwarze Race, Ethiopian or Black Race
- IV. Amerikanische oder Kupferfarbige Race, American or Copper-colored Race
- V. Malayische oder Olivenfarbige Race, Malay or Olivecolored Race
- F. 1 bis 4. Grundzüge (Typus) der

Kaukasischen Race, Figures 1–4. Types of the Caucasian Race

Figur 5. Grundzüge der Mongolischen Race, Figure 5. Type of the Mongolian Race Figur 6. Grundzüge der Æthiop-

ischen Race, Figure 6 Type of the Ethiopian Race

F. 7, 8. Grundzüge der Kupferfarbigen Race, Figures 7, 8. Type of the Coppercolored Race

Figure 9. Grundzüge der Olivenfarbigen Race, Figure 9. Type of the Olive-colored Race

Afghanen, Afghans Algonkiren, Algonkins Araber, Arabs Azteken, Azteks Berbern, Berbers Birmanen, Birmans Bucharen, Bucharians Caffern, Caffres Californier, Californians Canadier, Canadians Caraiben, Caribbeans Celten, Celts Chaldäer, Chaldæans Chinesen, Chinese Cinbebassen, Cinbebasses Colombier, Colombians Eleuten, Aleutians Eskimos, Esquimaux Ethiopier, Ethiopians Fellatas, Fellatah Finnen. Finns Germanen, Germans Gothen, Goths Hindus, Hindoos Hottentotten, Hottentots Iberier. Iberians Jakuten. Yacoots Japanesen, Japanese Jukaghiren, Youkaghirs Kalmücken, Calmucks Kamtschadalen, Kamskadales Kaukasier, Caucasians Kirghisen, Kirghese Koriälen. Koreans Kosaken, Cossacks Kriks, Creek Indians Lappen, Laplanders

Letten, Lethonians

Madagassen, Madagassees Mandschus, Manchoos Mauren, Moors Mongolen, Mongols Neger, Negroes Negritos, Negritoes Neuseeländer, New Zealanders Osagen, Osages Osmanen, Osmanli Ostiaken, Ostiaks Patagonen, Patagonians Pelasger, Pelasgians Perser, Persians Samojeden, Samoeids Sius. Sioux Indians Slaven, Slavonians Sovten, Sovetes Tibetaner, Thibetans Tschucktschen, Tchoukches Tungusen, Tungus Wogulen, Voguls

PLATE 121.

Illustrating the Psychological Relations of the Brain (Phrenology)

Figures 1–21.

PLATE 122.

The Bones of the Head

Figures 1–19.

PLATE 123.

Anatomy of the Bones

Figures 1–31.

PLATE 124.

Anatomy of the Bones

Figures 1-50.

PLATE 125.

Anatomy of the Ligaments and
Muscles

Figure 1-14. Anatomy of the ligaments 15-17. Anatomy of the muscles

PLATE 126.

Anatomy of the Ligaments and Muscles

Figure 1–18. Anatomy of the ligaments 19, 20. Anatomy of the muscles

PLATE 127.

Anatomy of the Ligaments and

natomy of the Ligaments and Muscles

Figure

1-19. Anatomy of the ligaments 20, 21. Anatomy of the muscles

PLATE 128.

Anatomy of the Muscles
Figures 1–15.

PLATE 129.

Anatomy of the Muscles
Figures 1–19.

PLATE 130.

Anatomy of the Fasciae,
Integuments, and Organs of
Mastication and Respiration

Figure
1-22. Anatomy of the fasciæ
23-26. Anatomy of the
integuments

27–30. Organs of mastication and deglutition

31–38. Organs of respiration and voice

PLATE 131.

Anatomy of the Organs of Digestion

Figures 1–21.

PLATE 132.

Anatomy of the Eye
Figures 1–45.

PLATE 133.

Anatomy of the Ear and Nose
Figure
1–25. Anatomy of the ear
26–45. Anatomy of the nose

PLATE 134.

Anatomy of the Vascular System
Figures 1–13.

PLATE 135.

Anatomy of the Vascular System
Figures 1–13.

PLATE 136.

Anatomy of the Vascular System
Figures 1–17.

PLATE 137.

Anatomy of the Vascular System
Figures 1–16.

PLATE 138.

Anatomy of the Brain and Nerves
Figures 1–21.

PLATE 139.

Anatomy of the Nerves
Figures 1–14.

PLATE 140.

Various Surgical Operations
Figures 1–35.

PLATE 141.

Various Surgical Instruments
Figures 1–90.

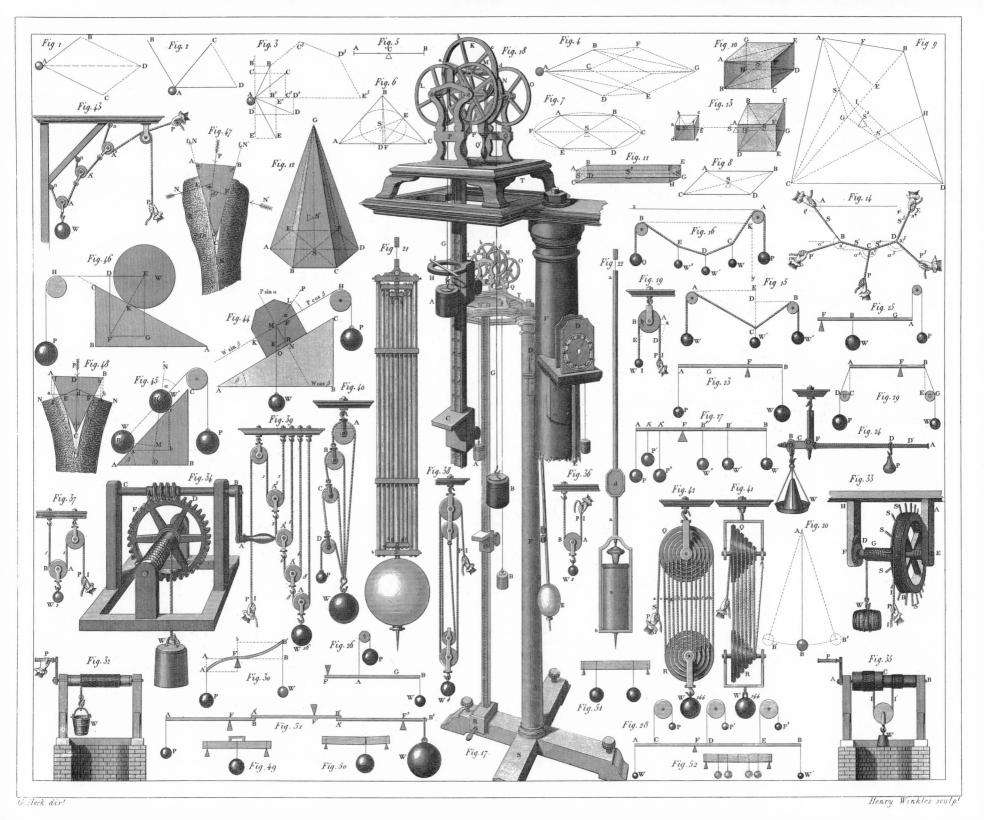

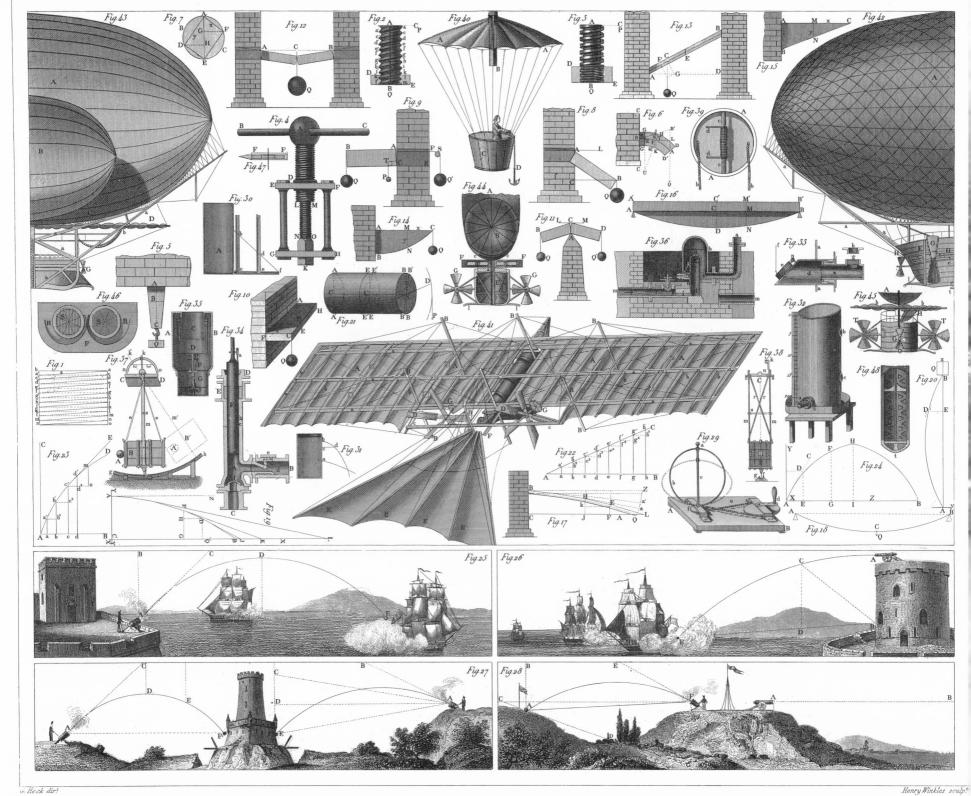

38

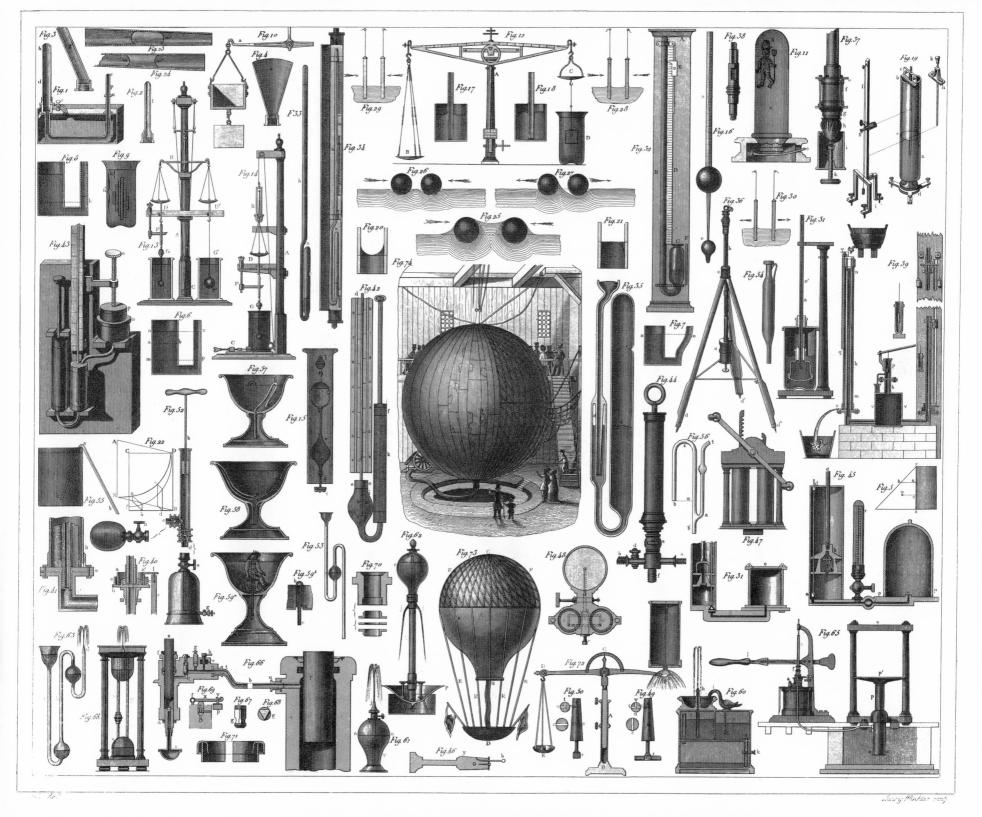

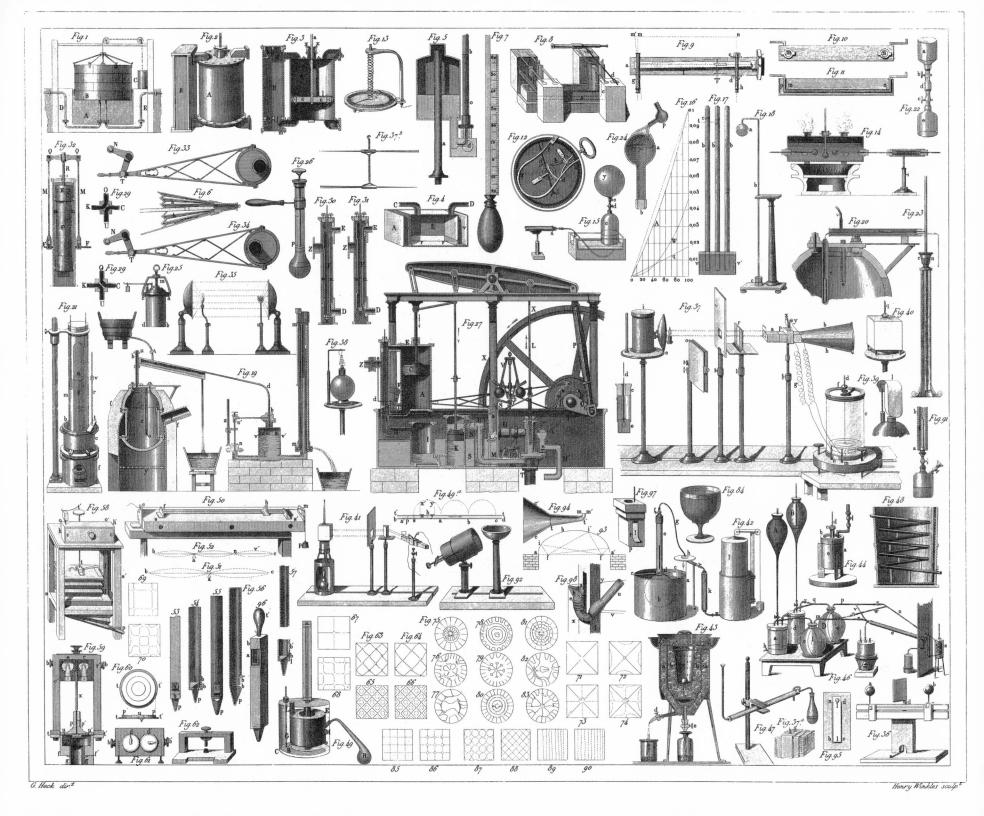

PLATE 19. THEORIES AND INSTRUMENTS OF MECHANICS, THERMODYNAMICS, AND ACOUSTICS

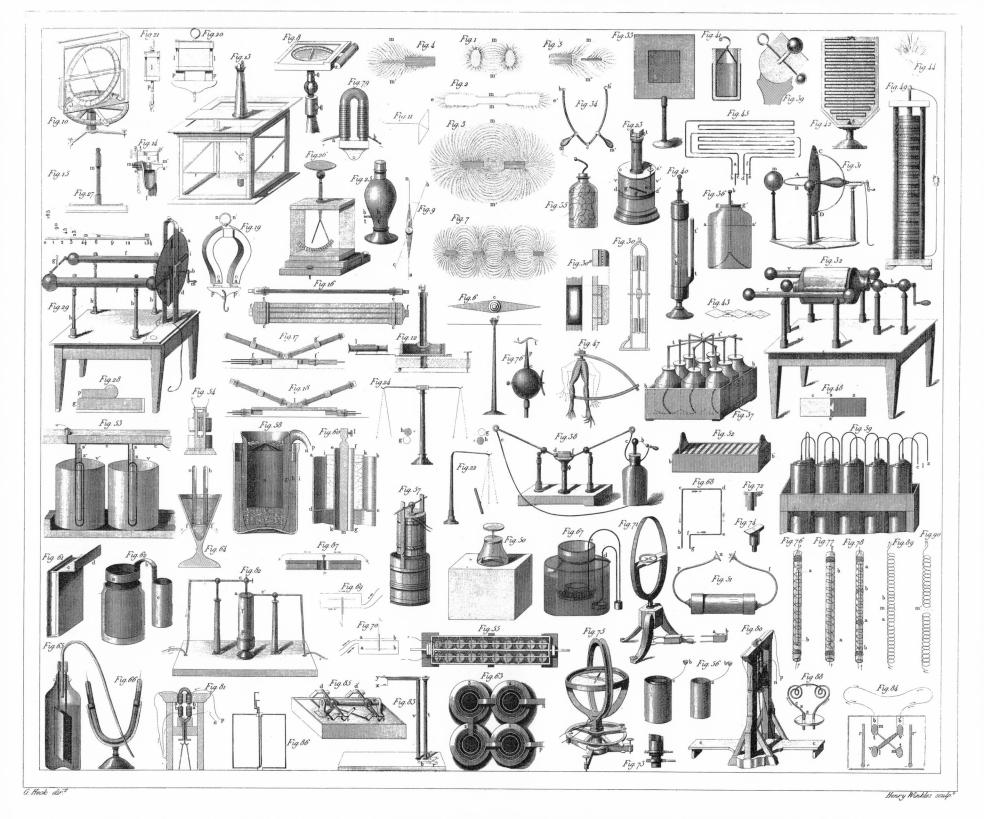

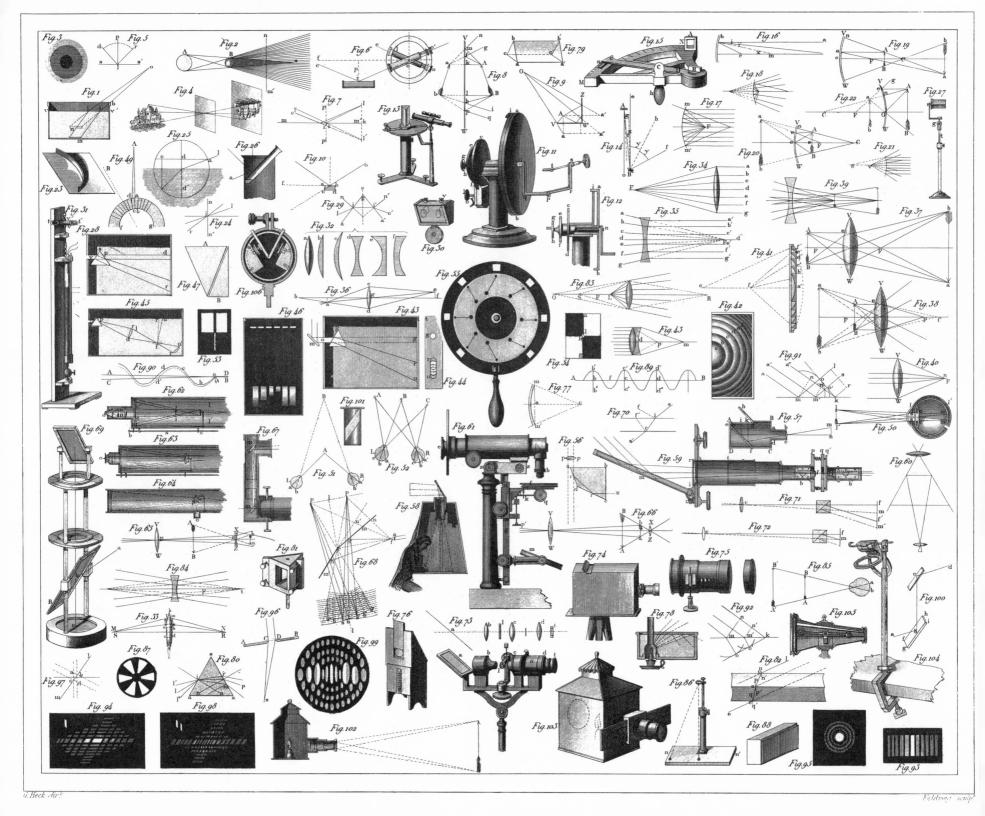

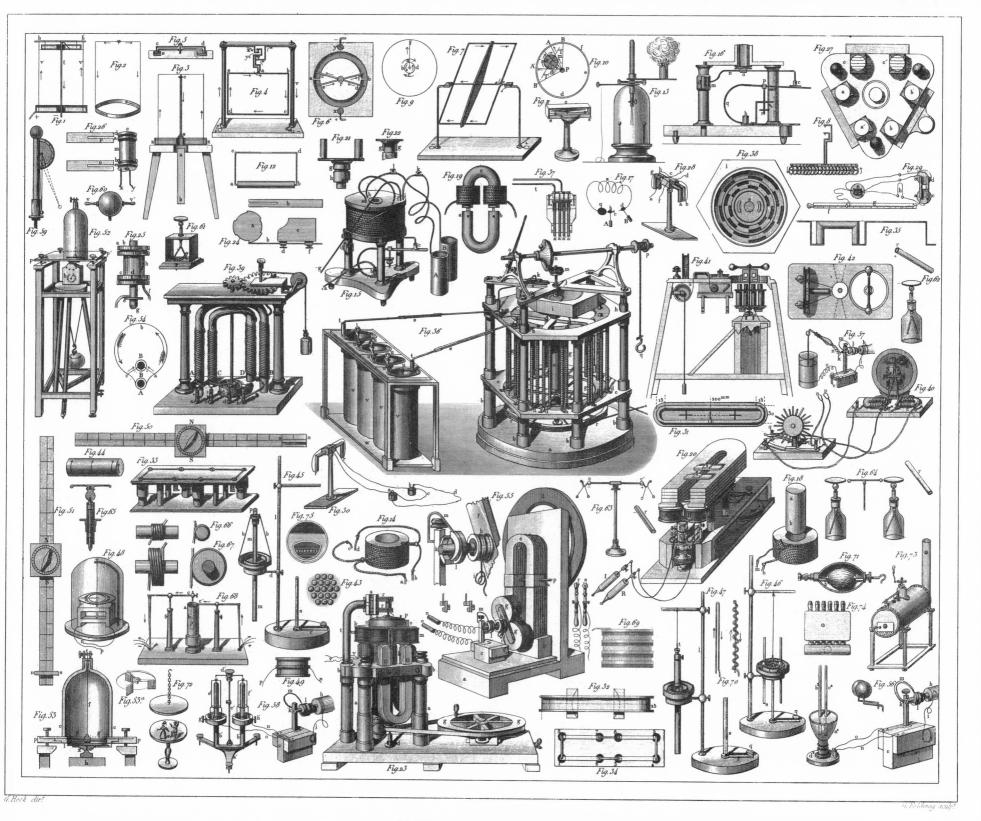

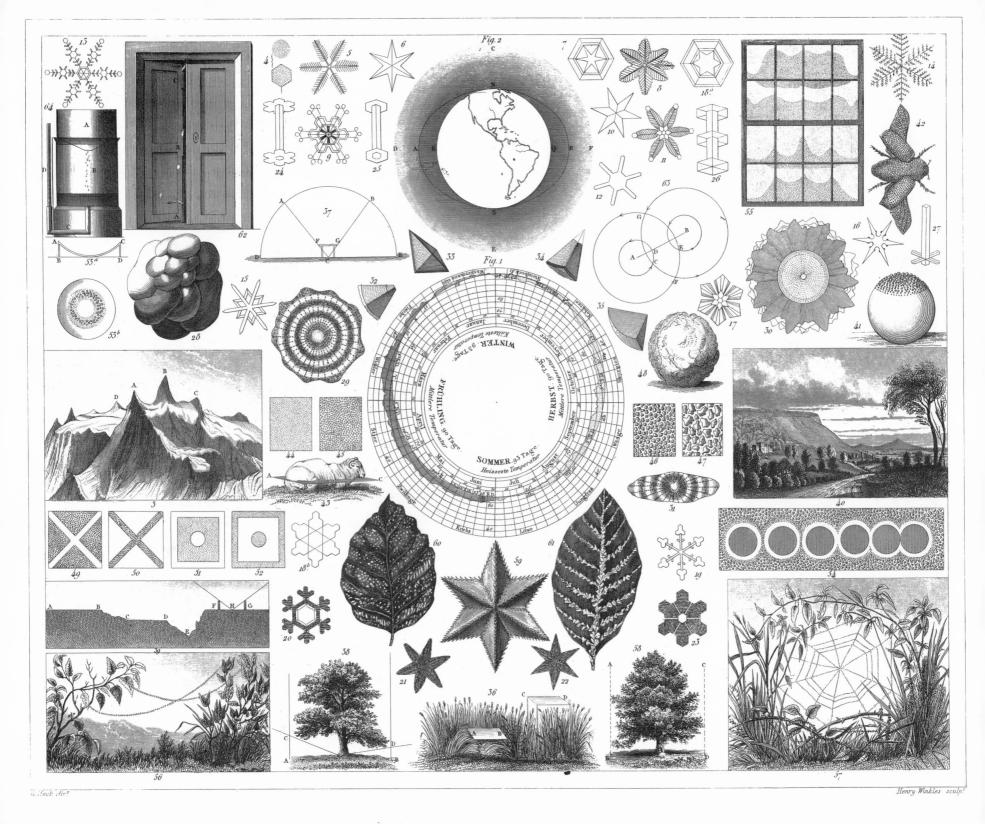

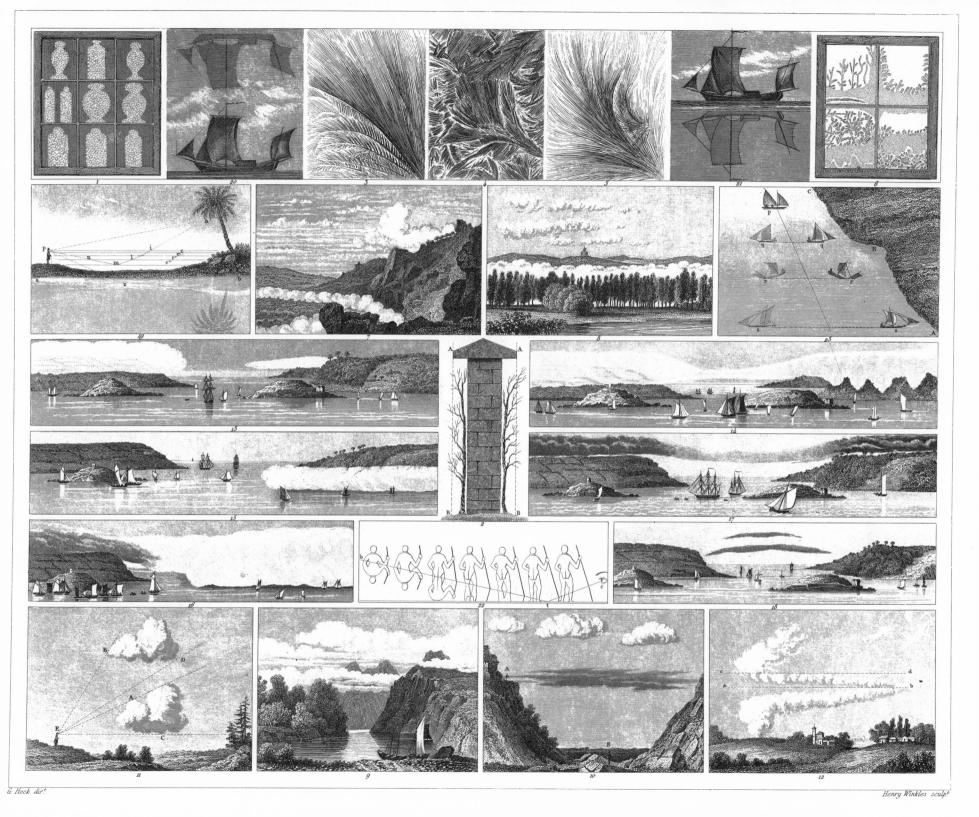

PLATE 24. PHENOMENA OF CONDENSATION AND AIR CURRENTS

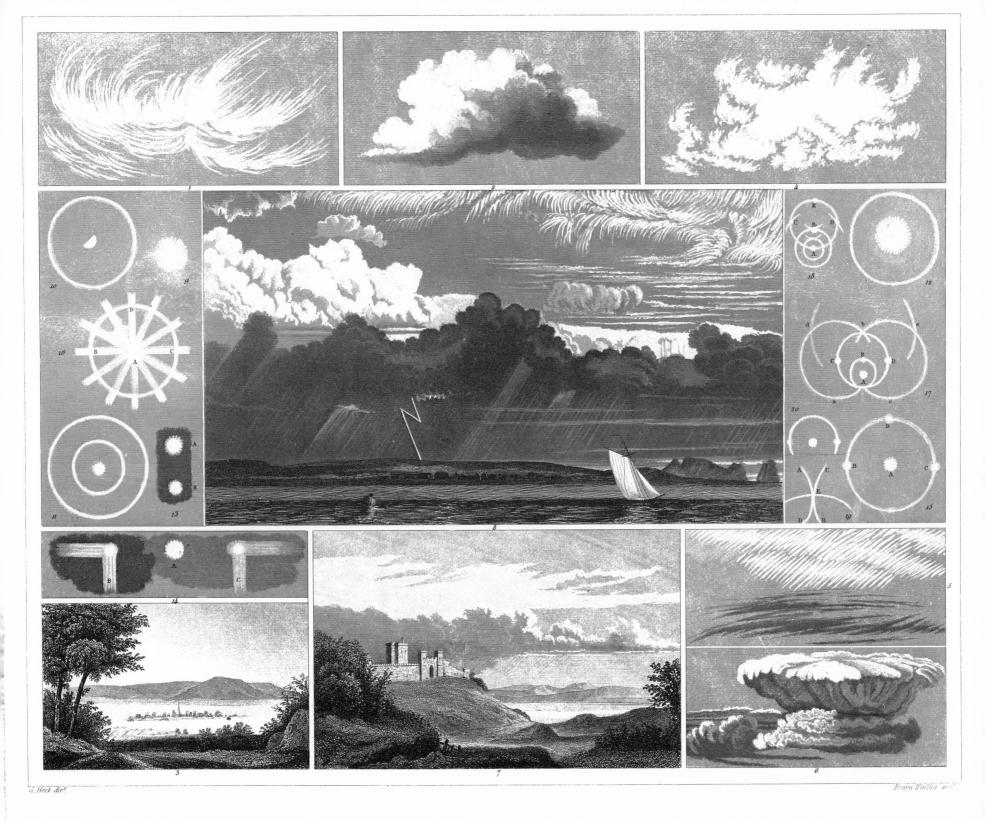

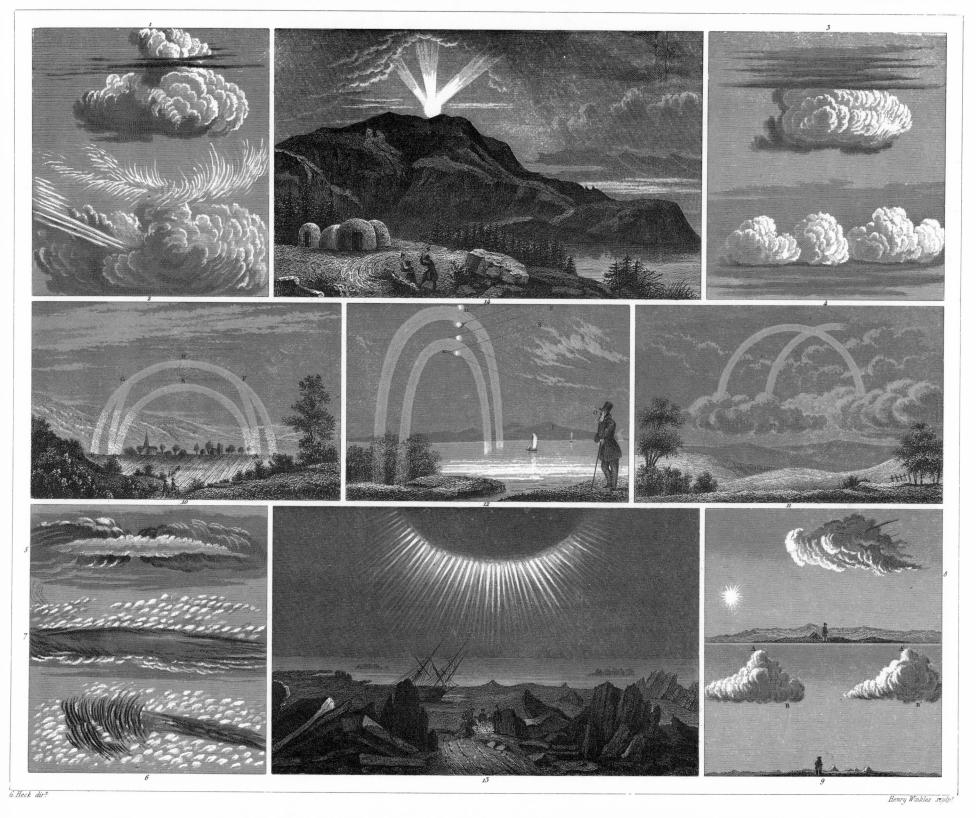

PLATE 26. PHENOMENA OF CLOUDS AND LIGHT

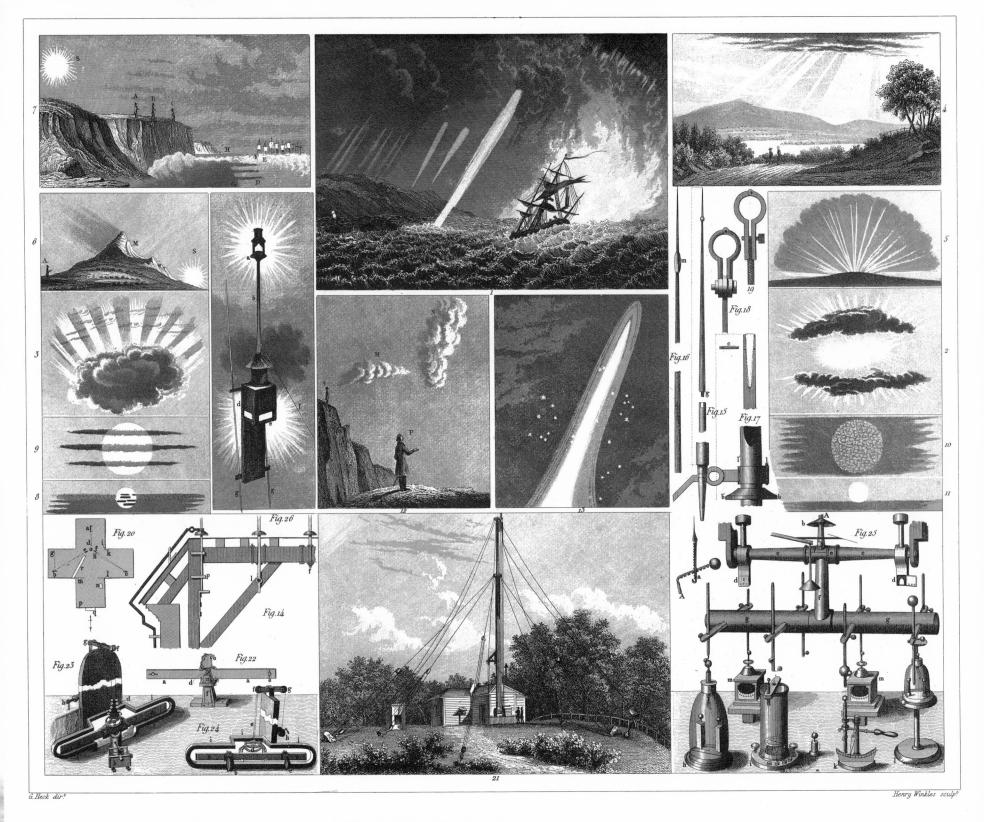

PLATE 27. METEOROLOGICAL ELEMENTS AND INSTRUMENTS

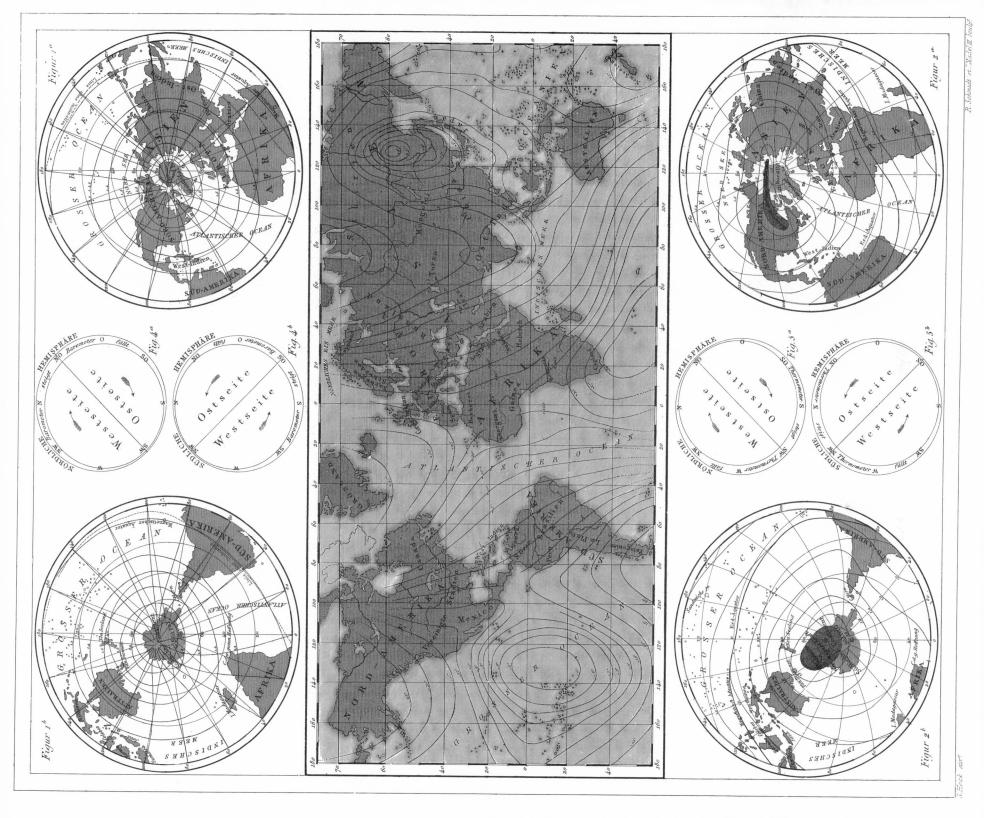

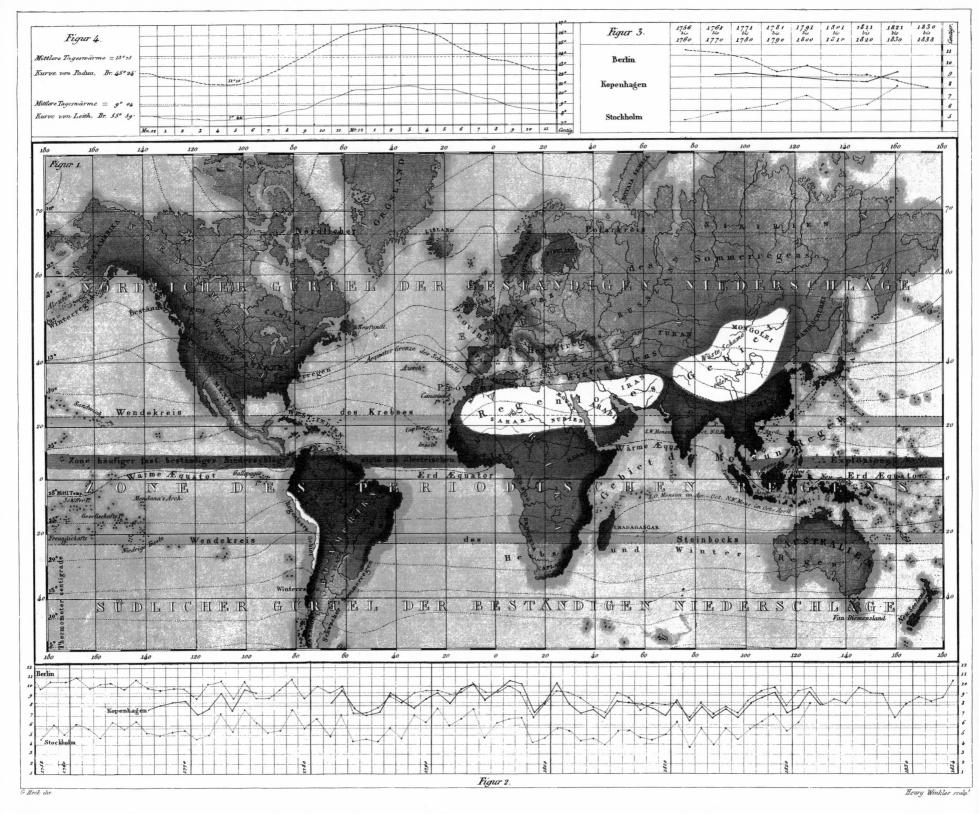

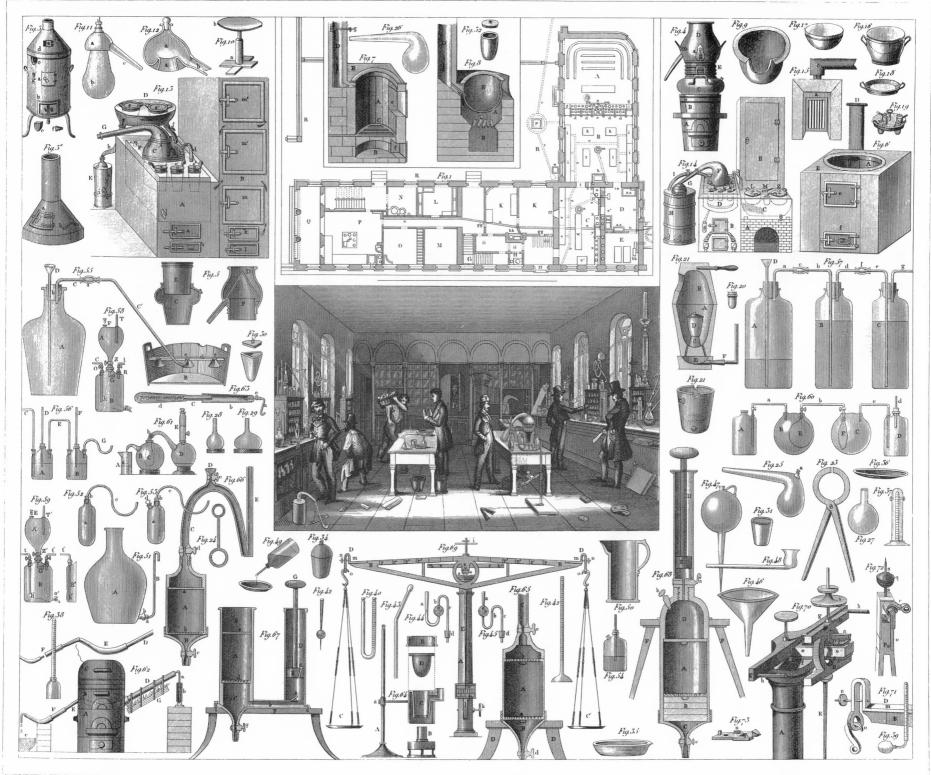

Fenry Wirking sayp

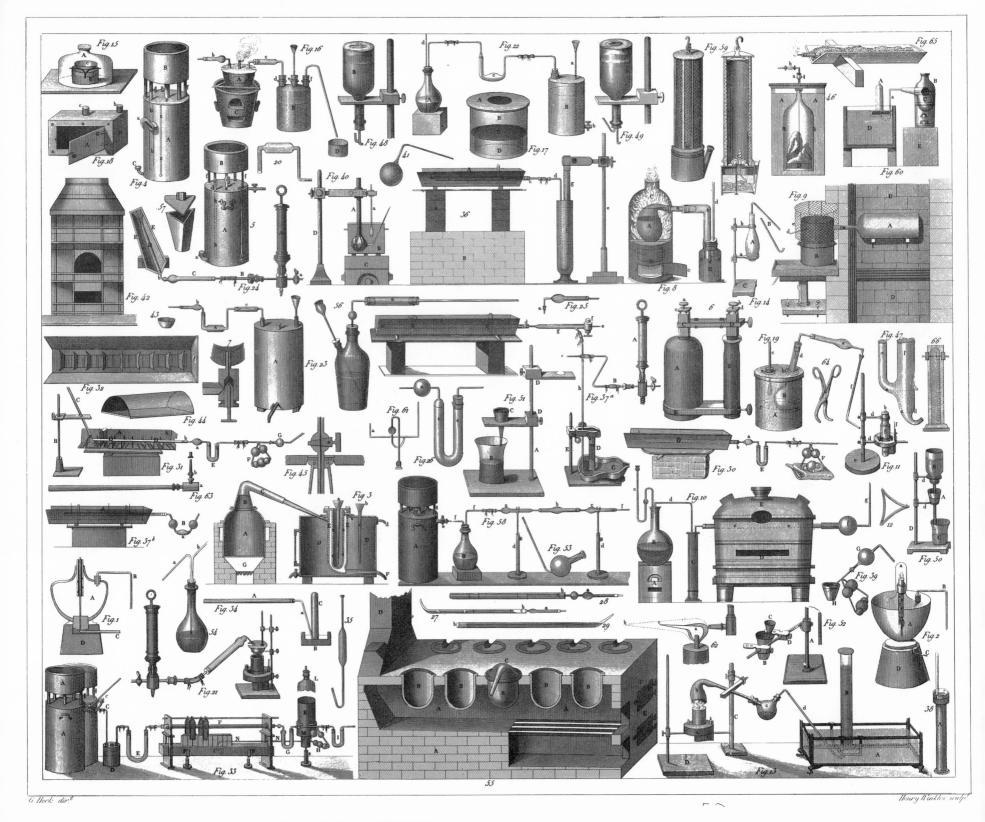

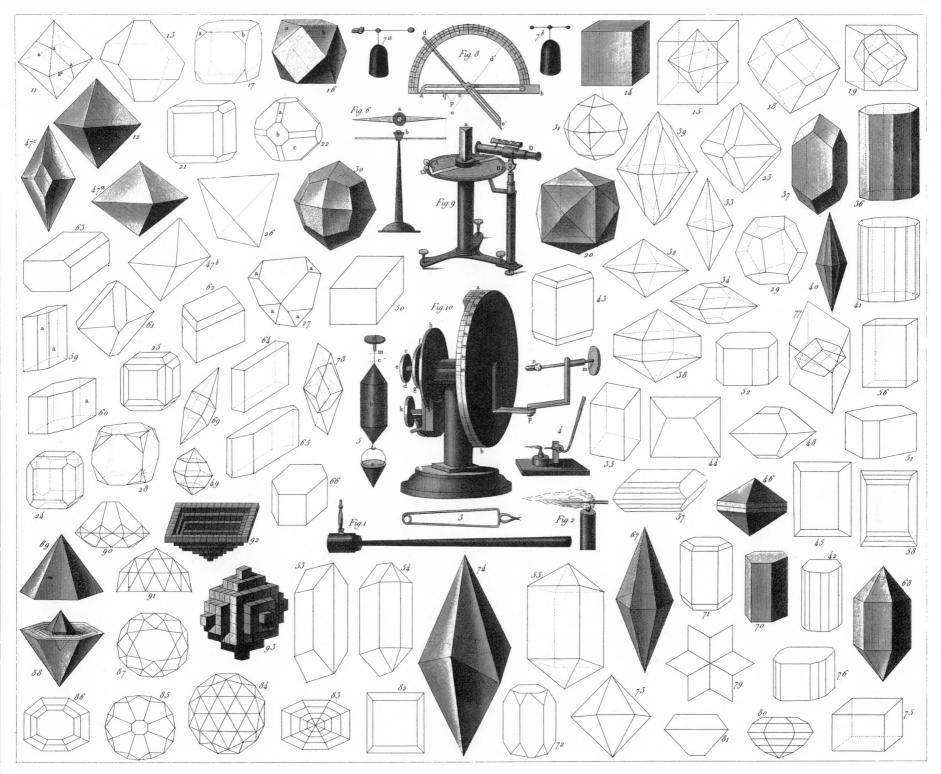

G. Neck dur!

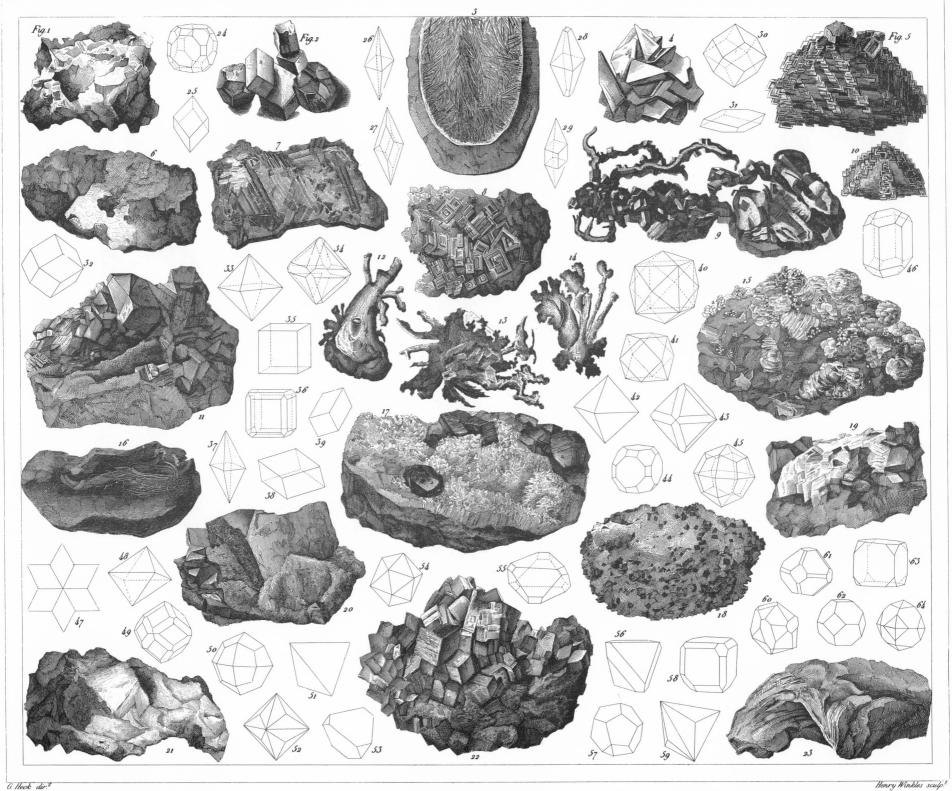

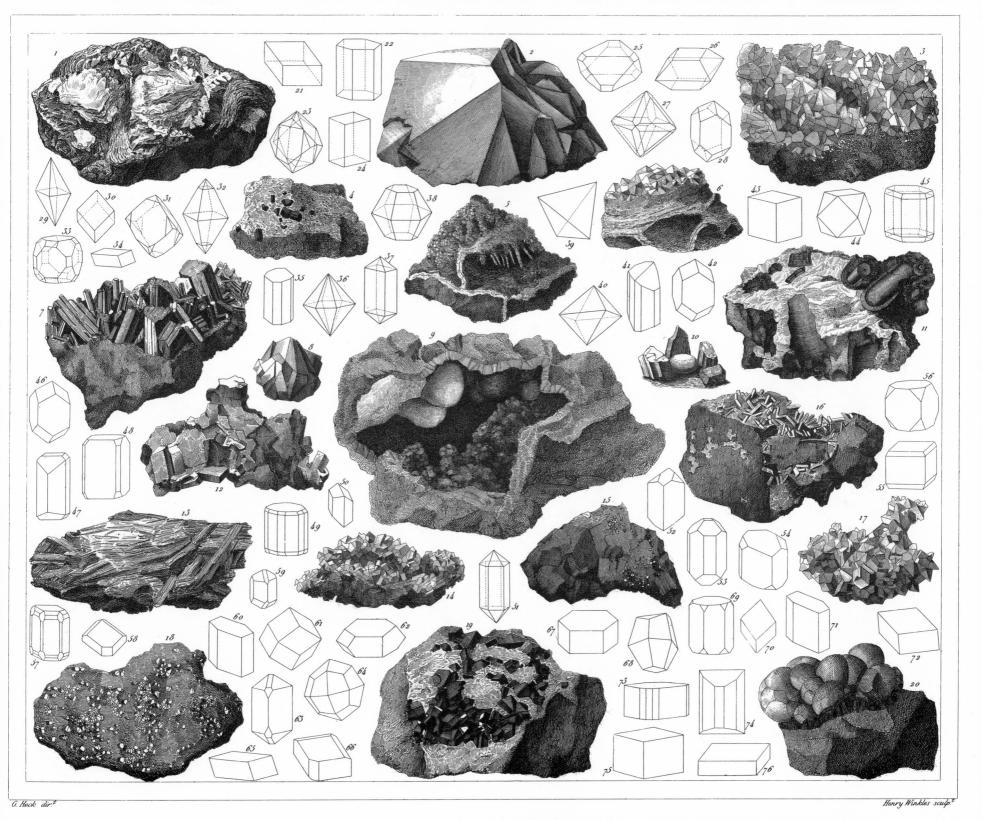

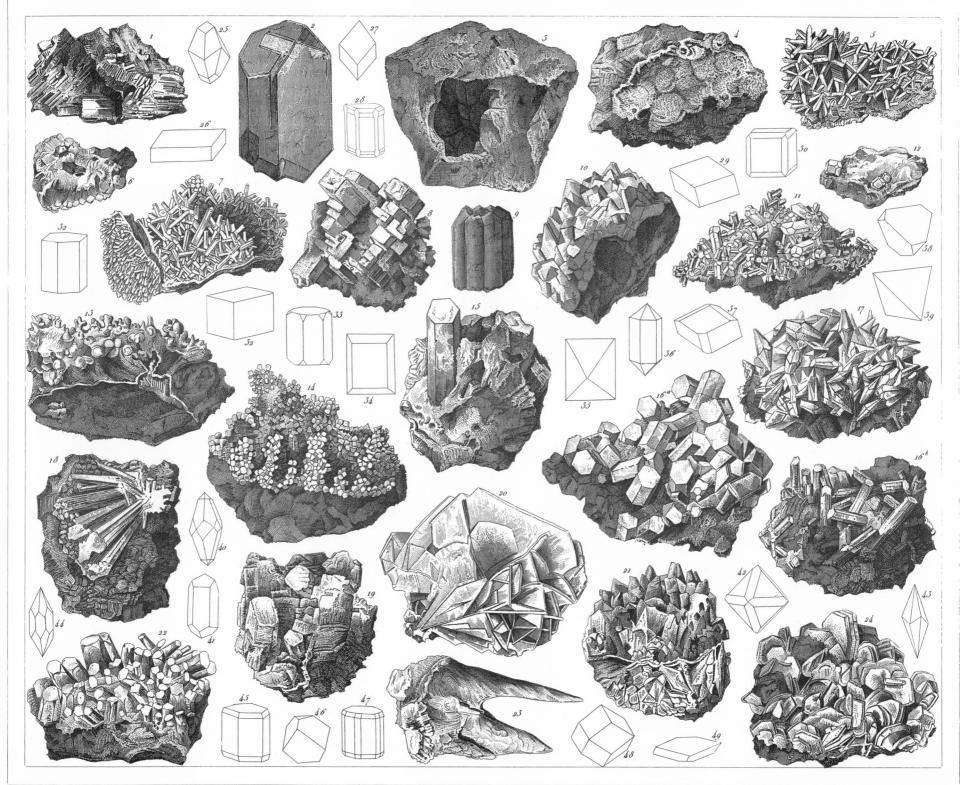

G. Heck dir.

Henry Winkles sculp.

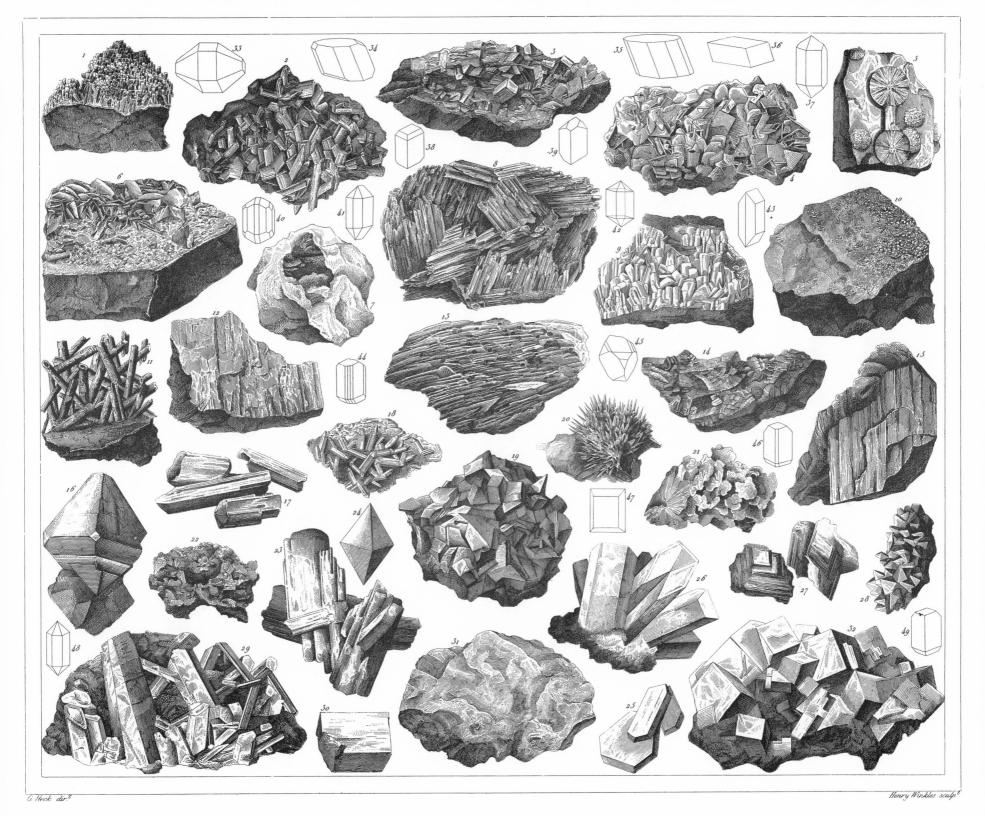

.

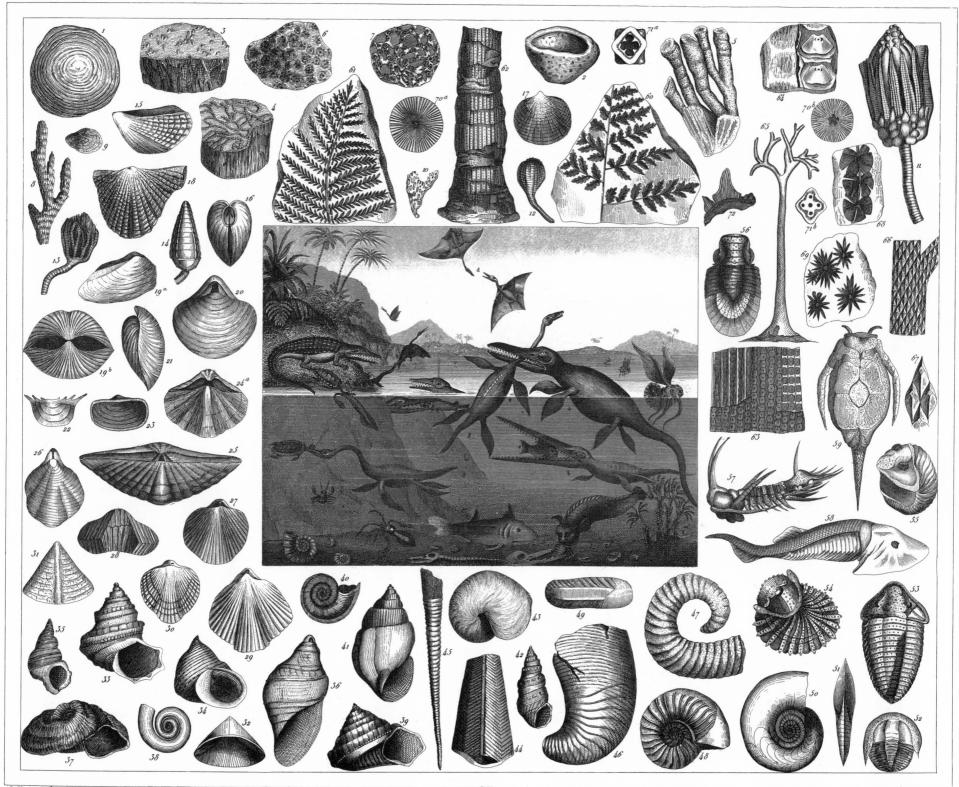

G. Heck dir.

Henry Winkles sculp.t

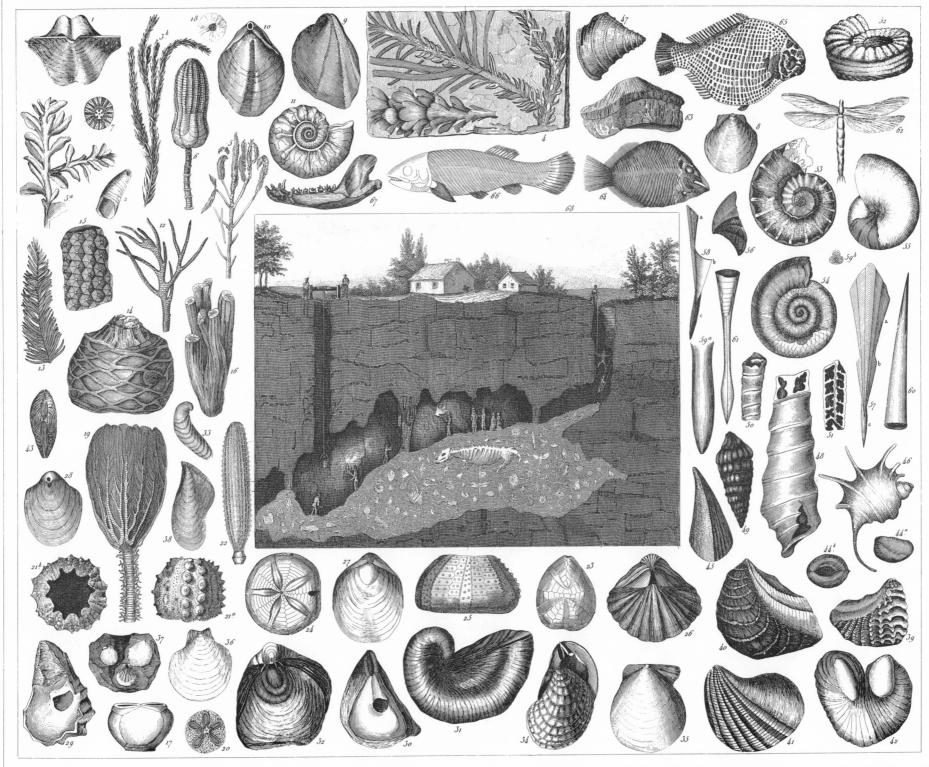

Henry Winkles sculp!

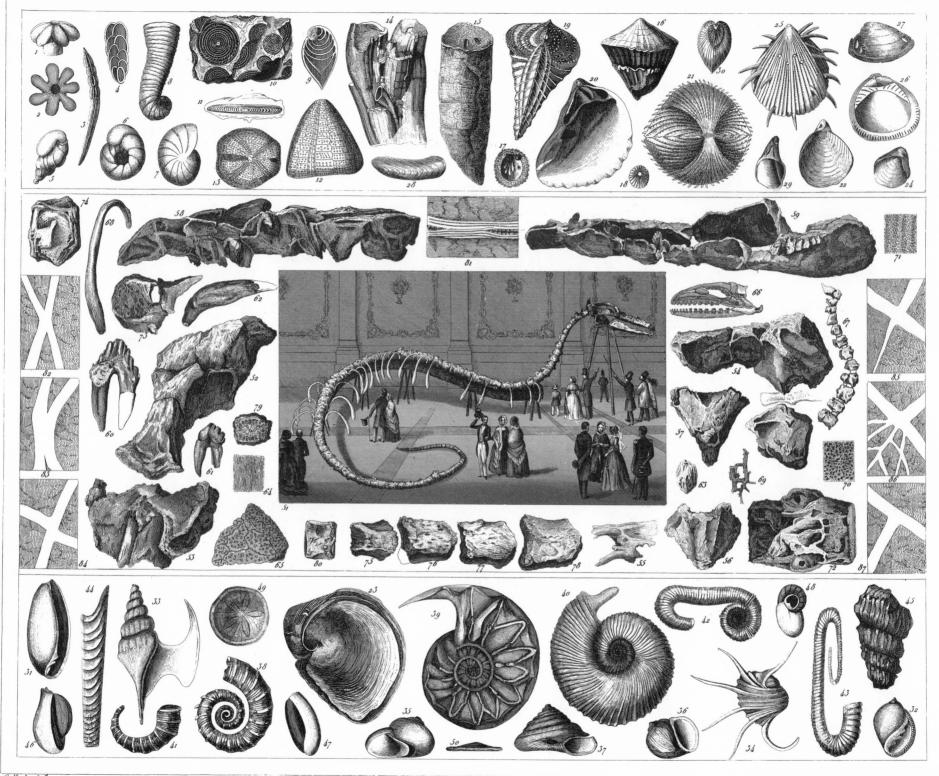

Henry Winkles sculp.t

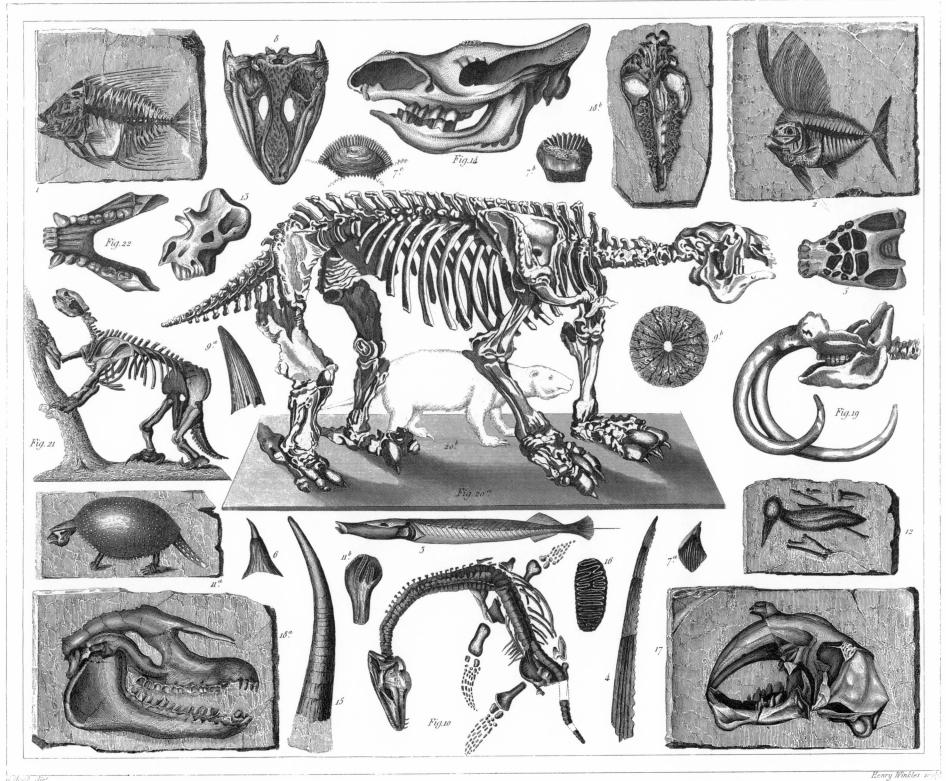

none y

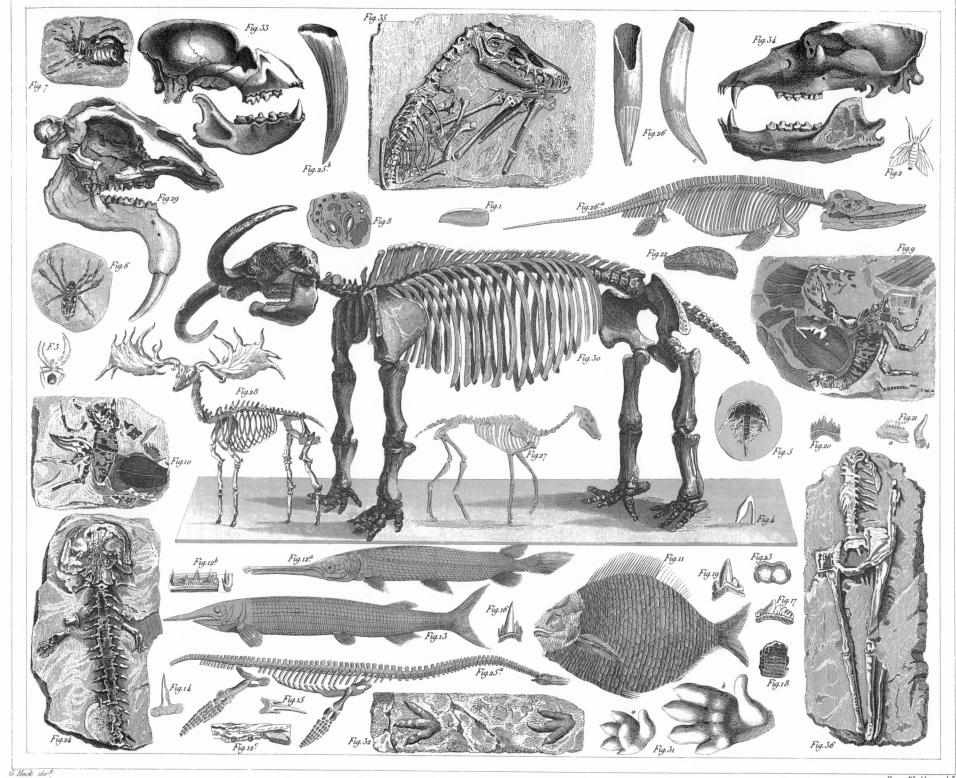

Henry Winkles soulp.t

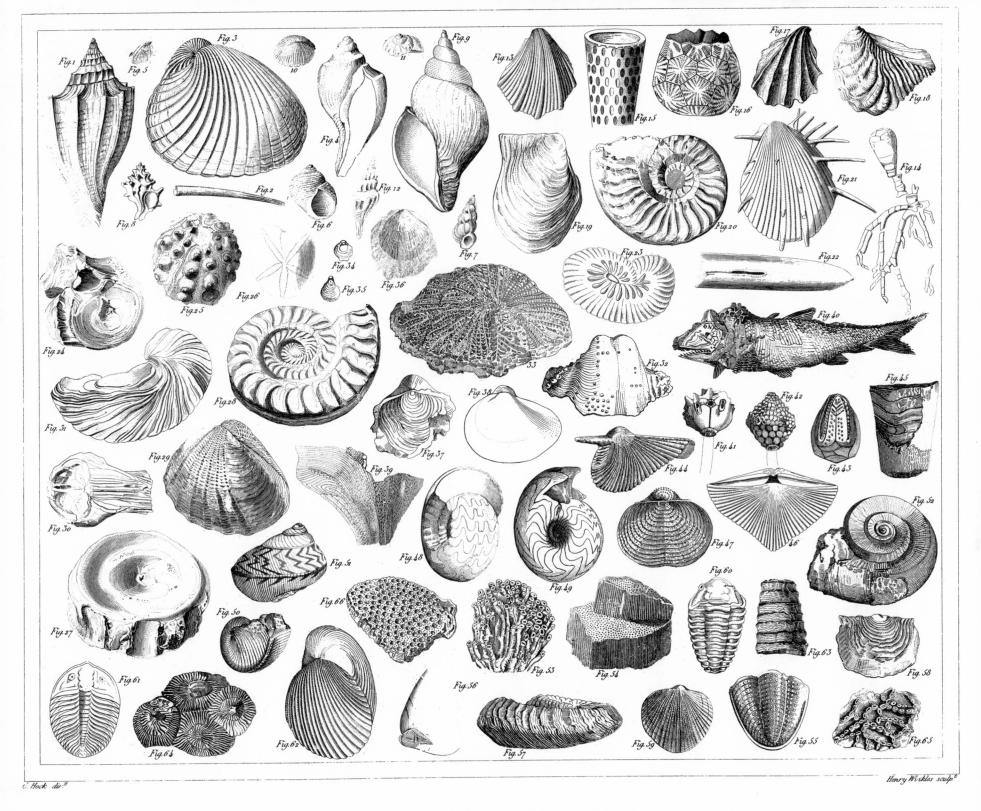

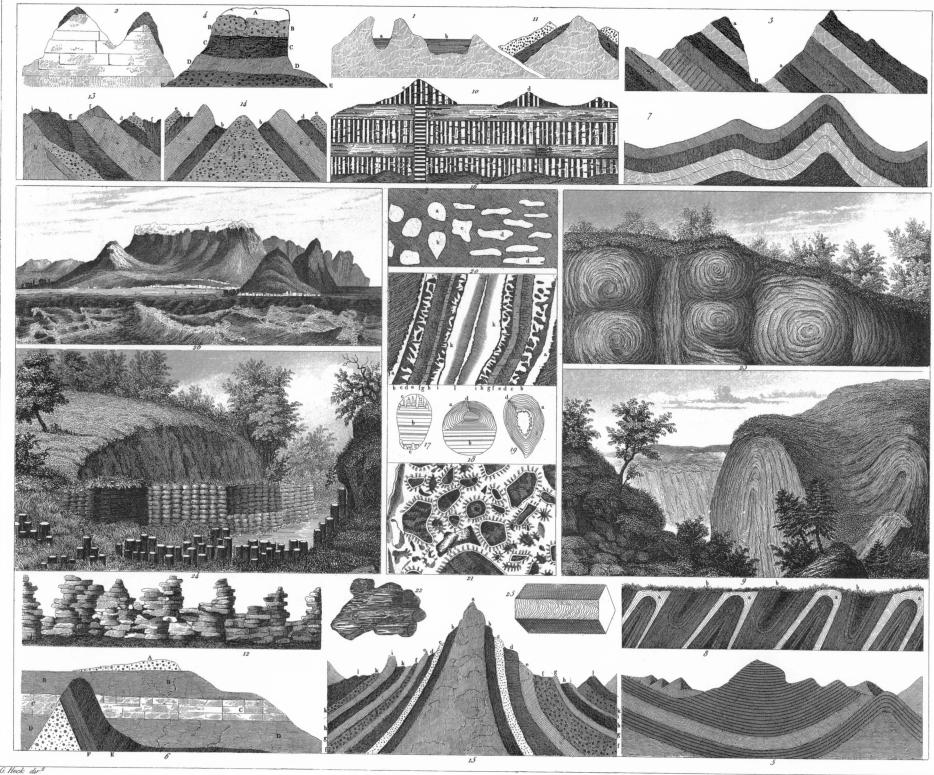

Henry Winkles sculp.

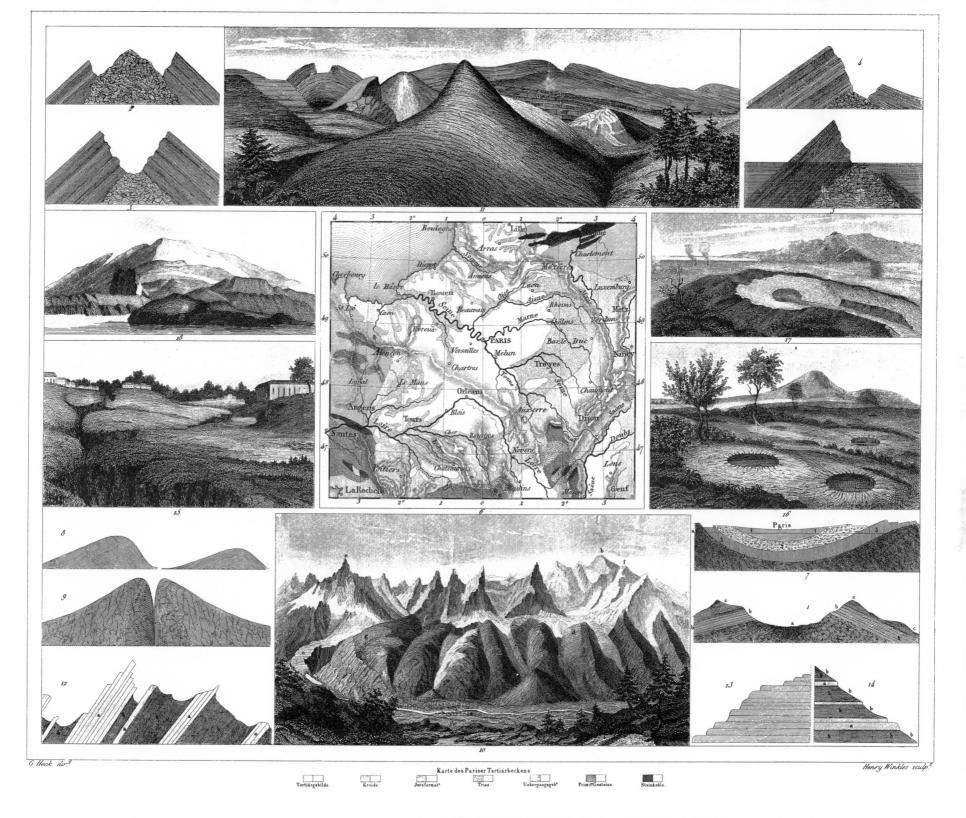

PLATE 44. STRATIFICATION IN MOUNTAINS AND BASINS; FISSURES AND CRATERS

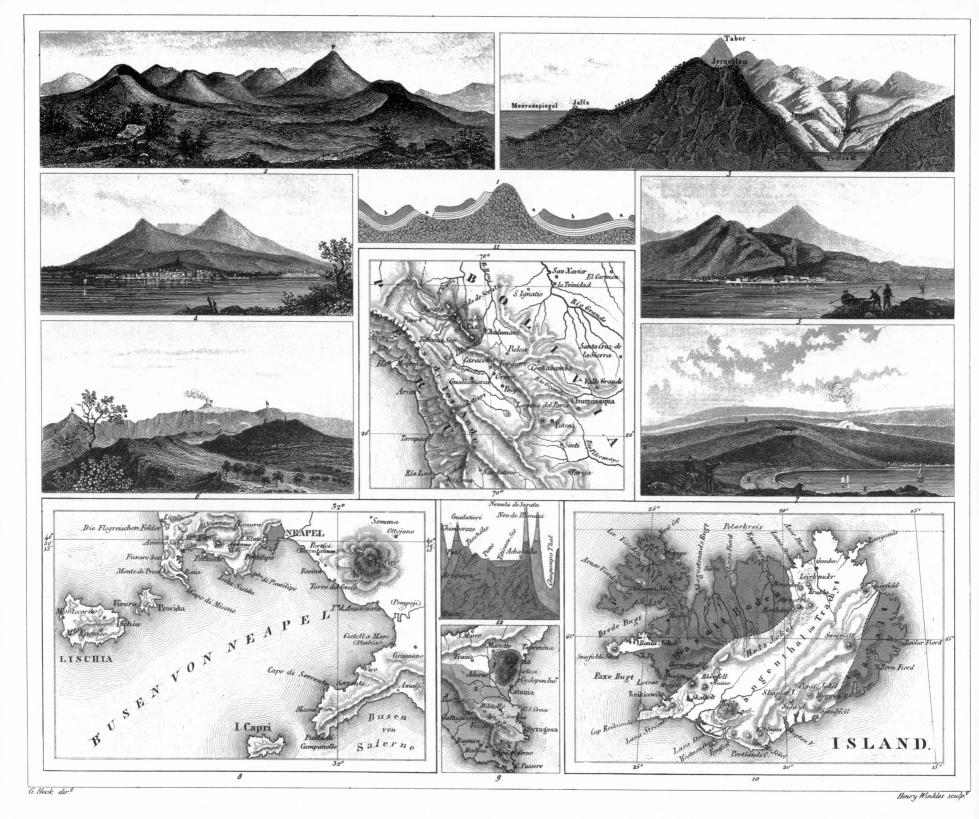

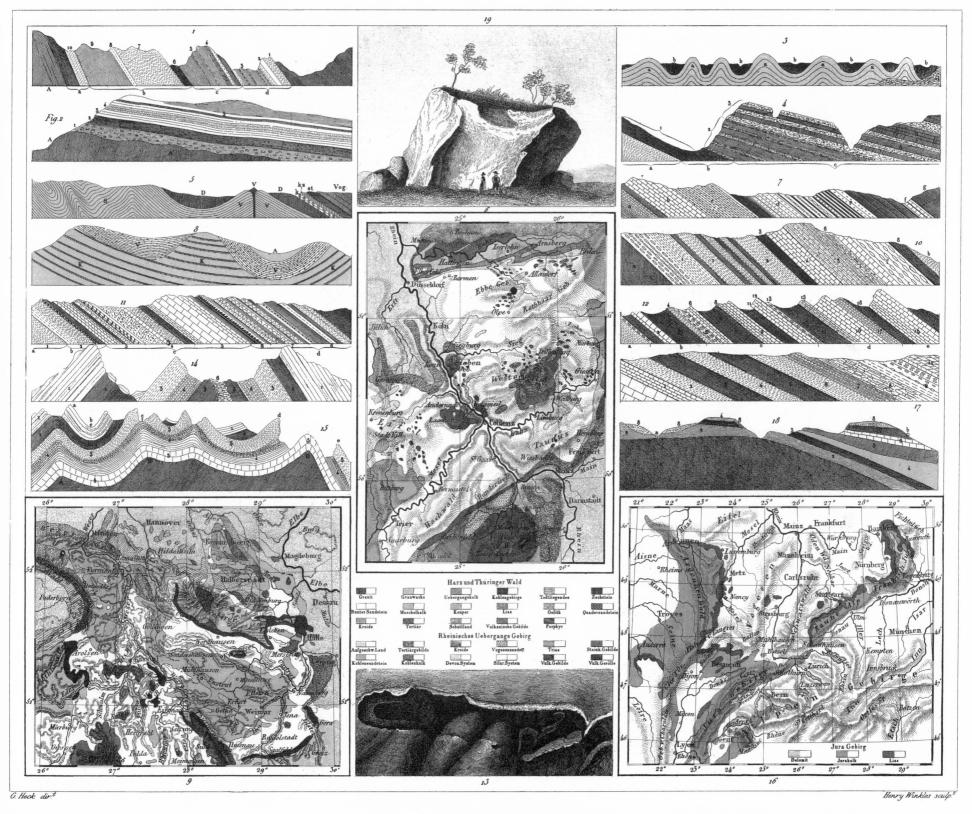

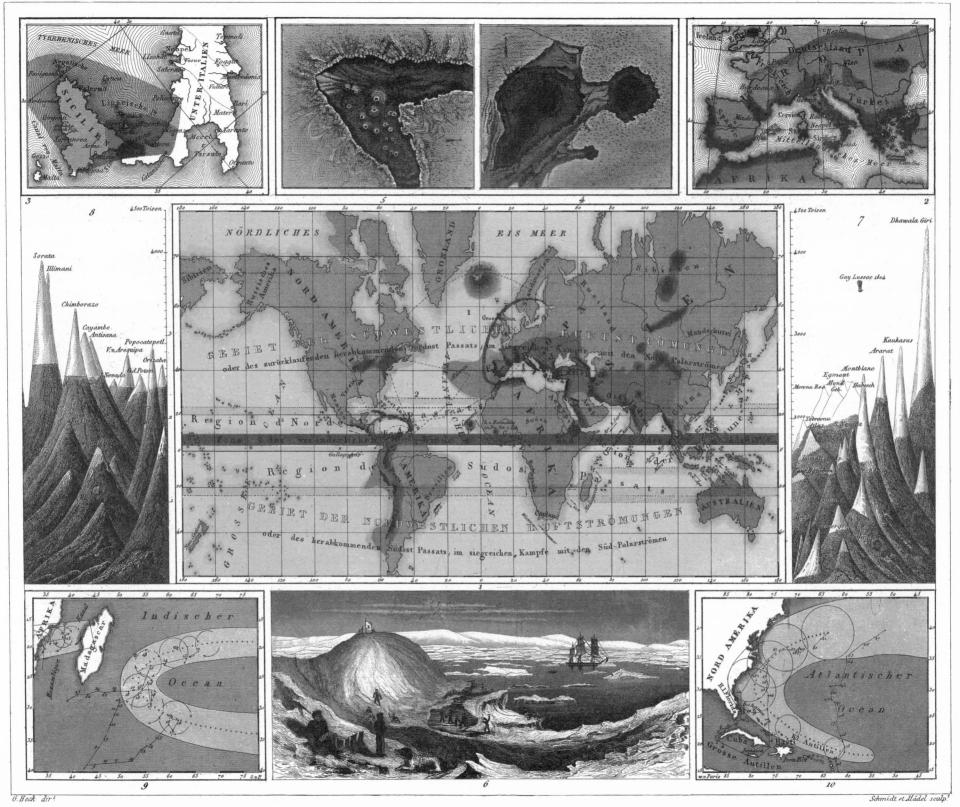

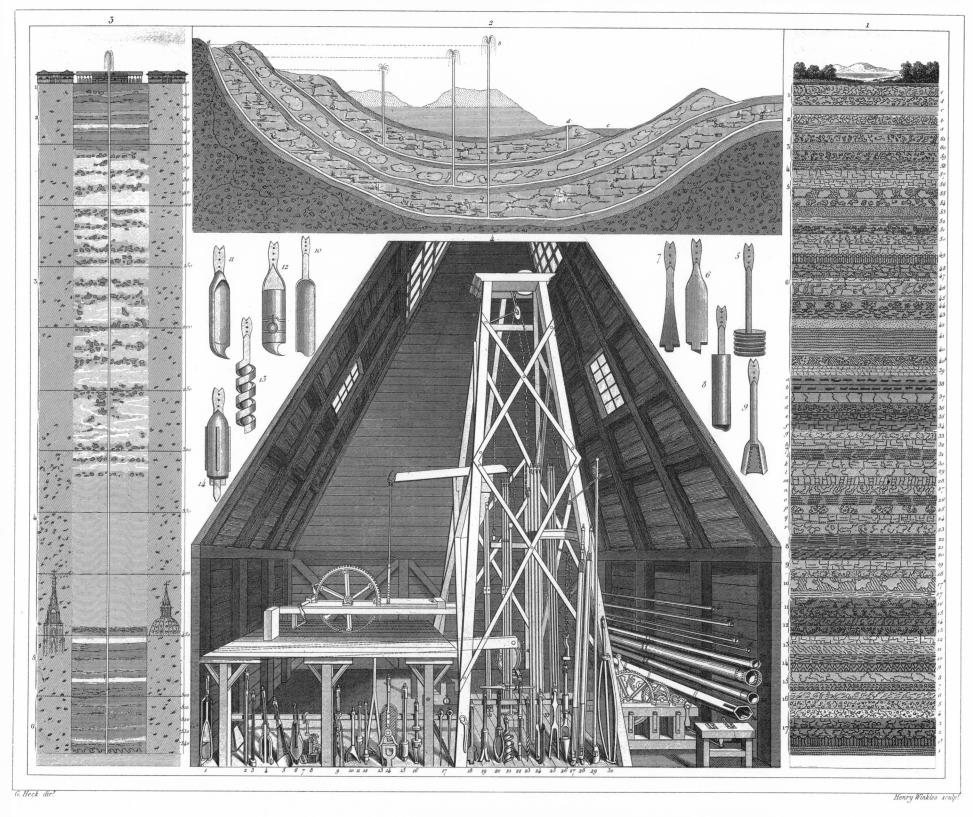

PLATE 48. BORING EQUIPMENT; STRATIFICATION AND ARTESIAN WELLS

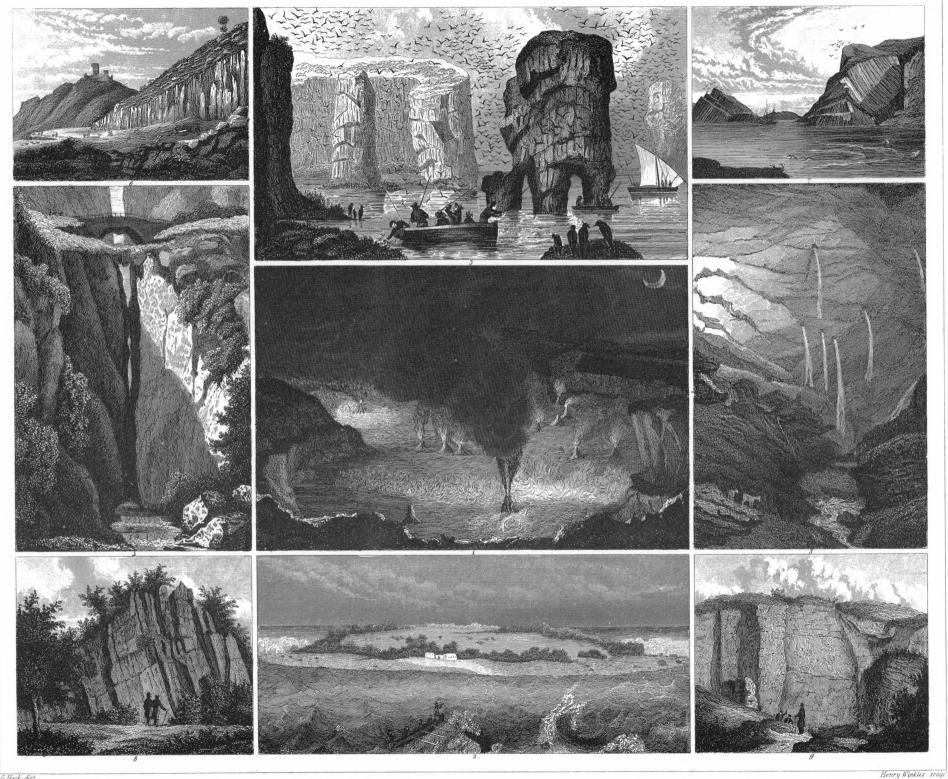

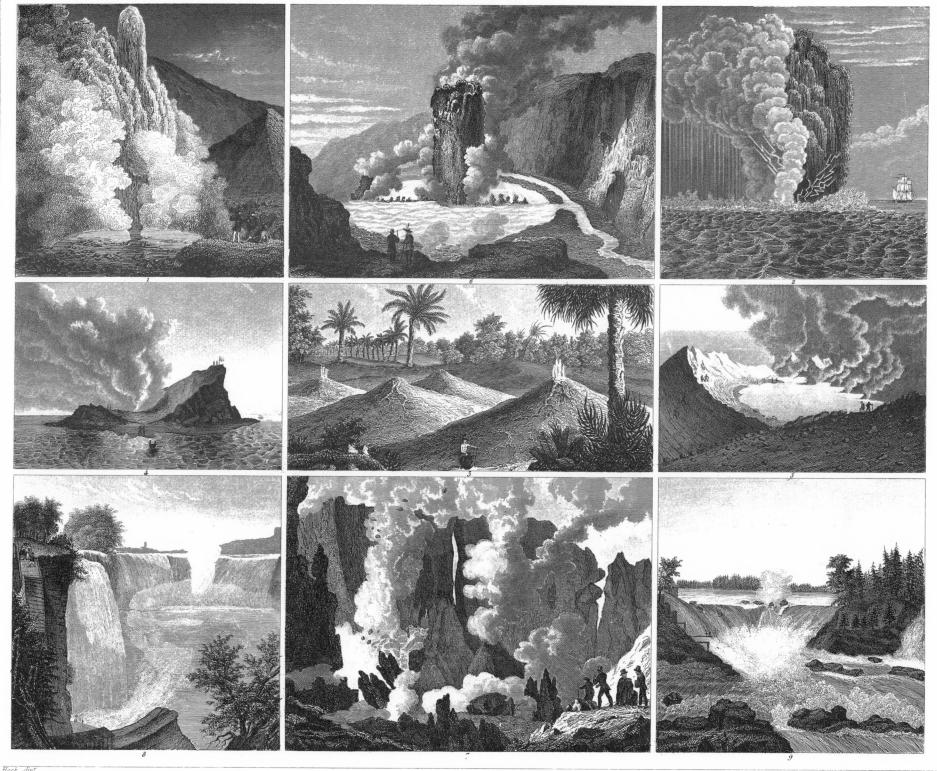

Henry Winkles scuin!

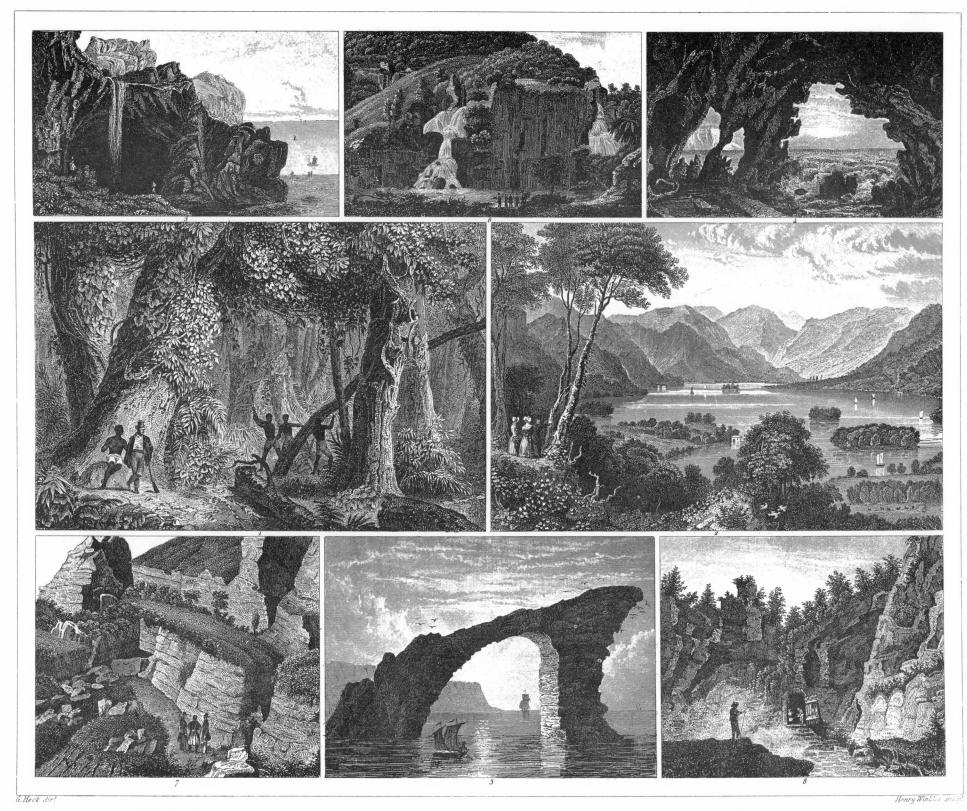

PLATE 51. FORESTS, LAKES, CAVES, AND UNUSUAL ROCK FORMATIONS

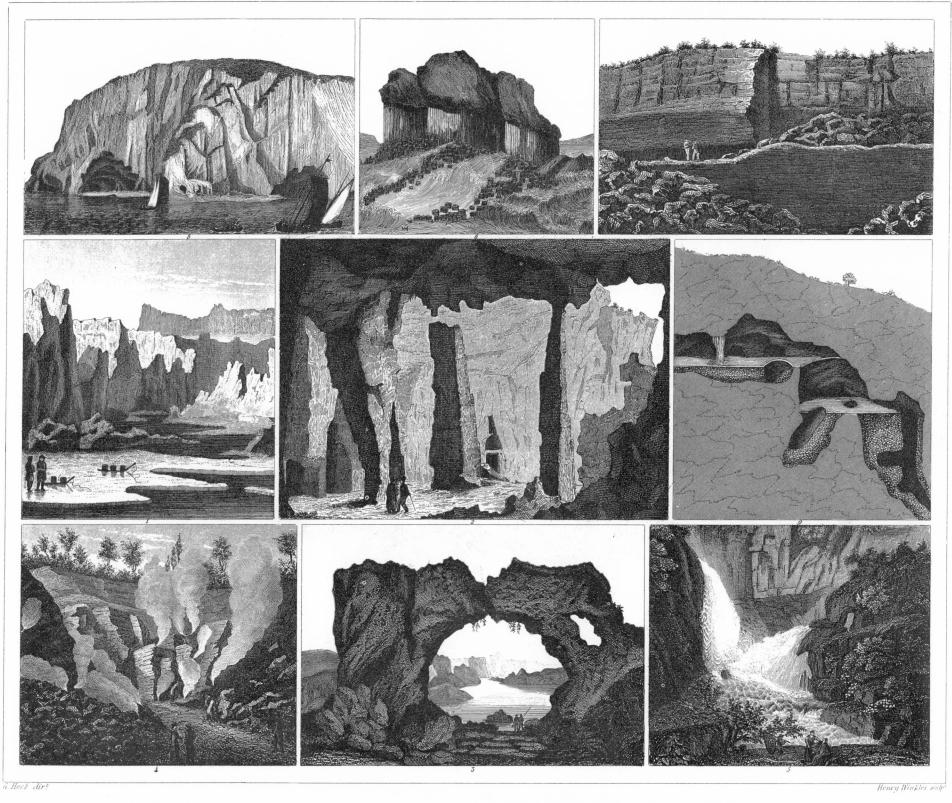

PLATE 52. CAVES, ICEBERGS, LAVA, AND ROCK FORMATIONS

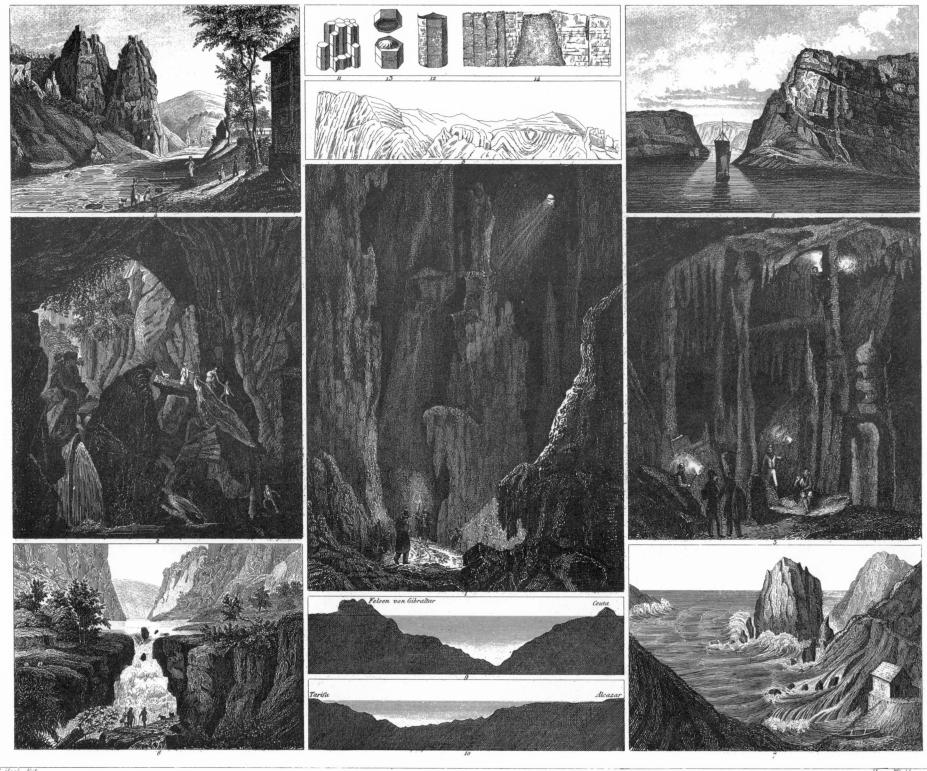

ir. Heck dir

Henry Winkles souli'

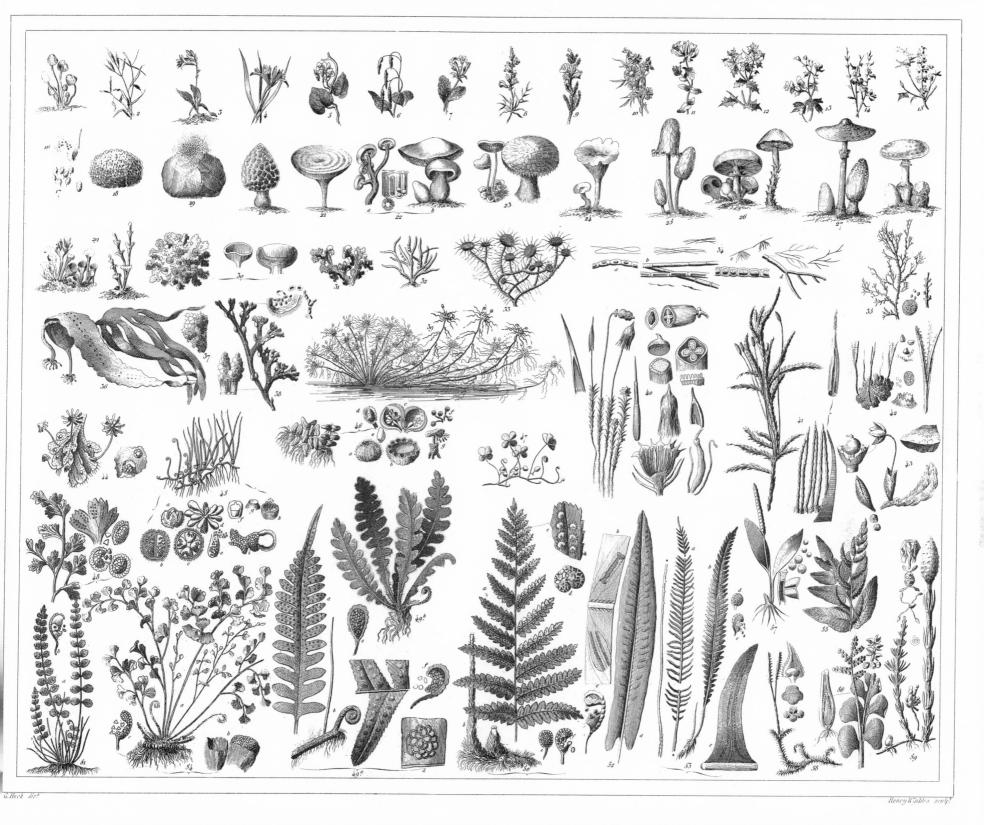

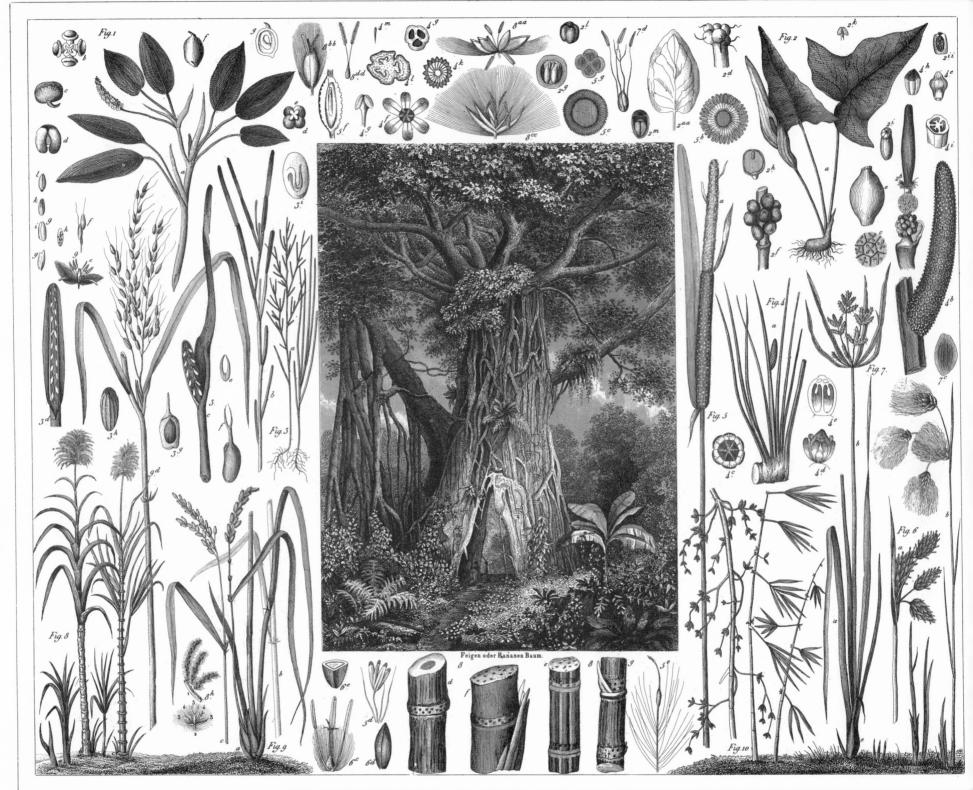

G. Heck dirt

Henry Winkles scuy

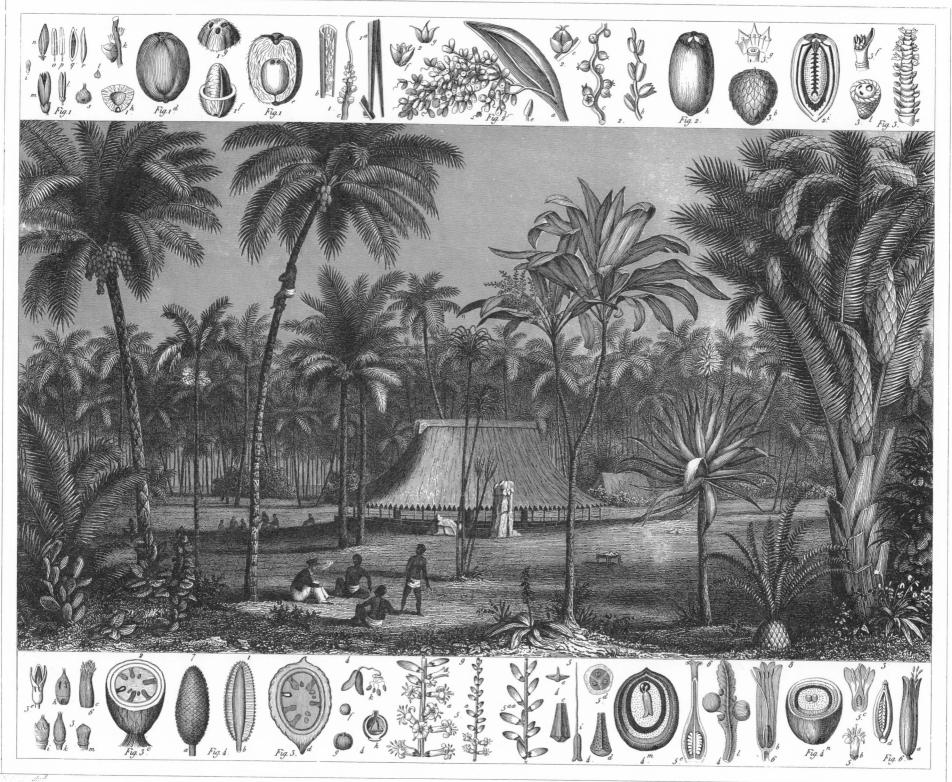

Schmidt sculp Dresden

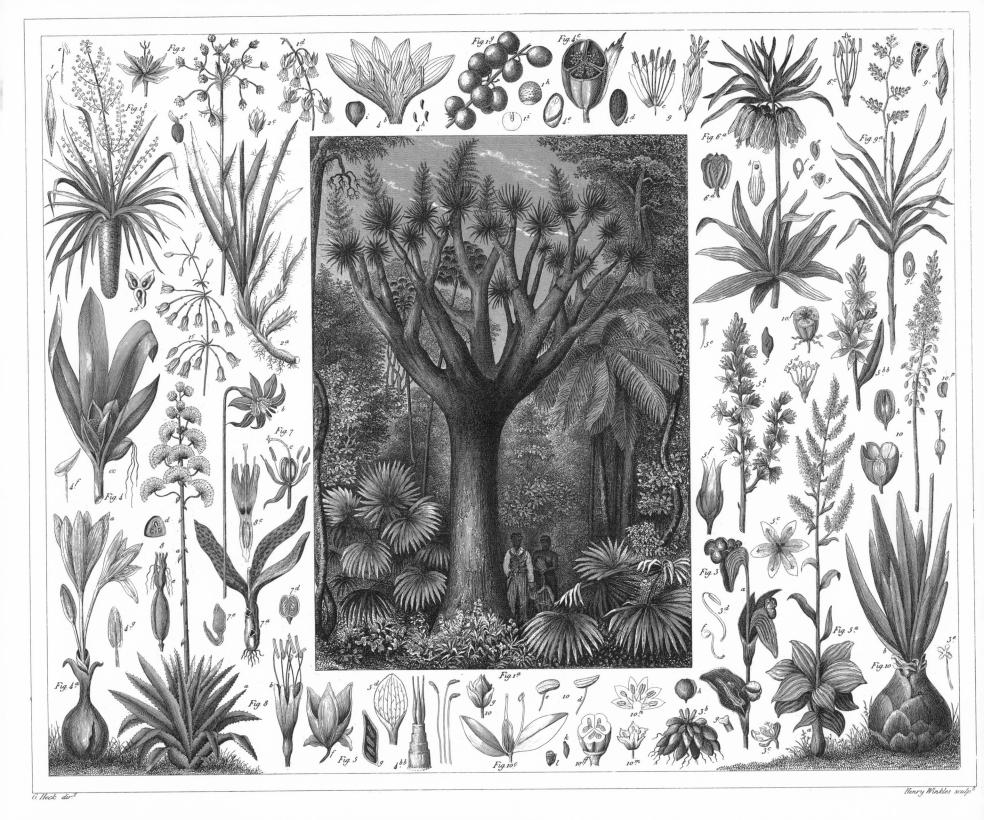

PLATE 57. REPRESENTATIVES OF THE MONOCOT ORDER LILIALES

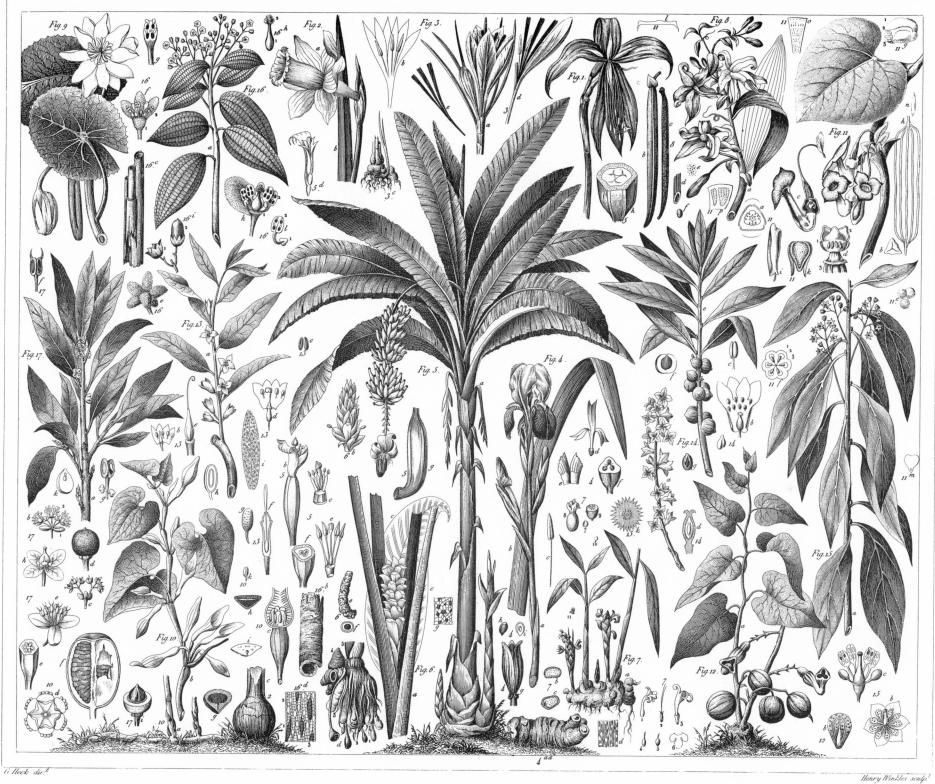

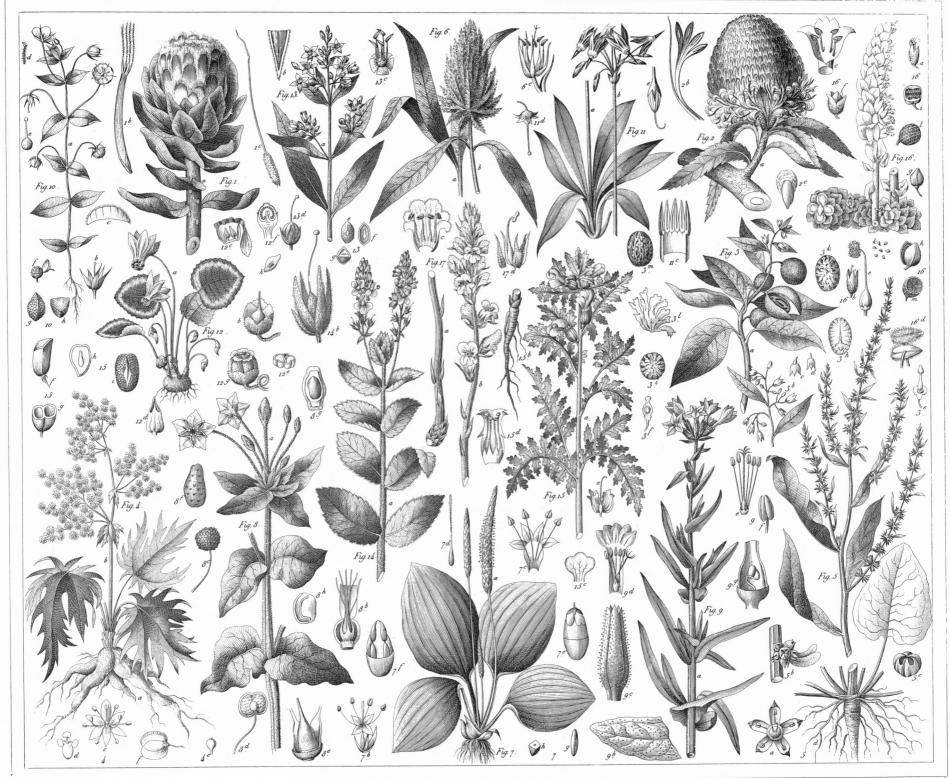

Henry Winkles sculp!

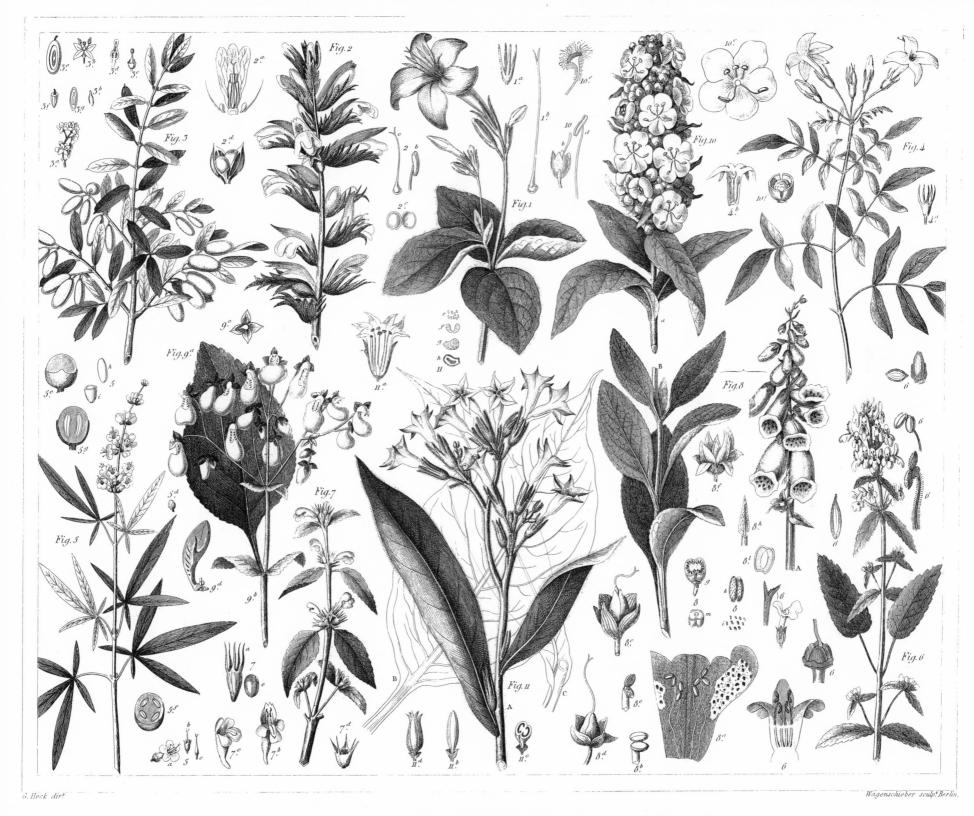

PLATE 62. MEMBERS OF THE ACANTHUS, OLIVE, VERBENA, MINT, FIGWORT AND MIGHTSHADE FAMILIES

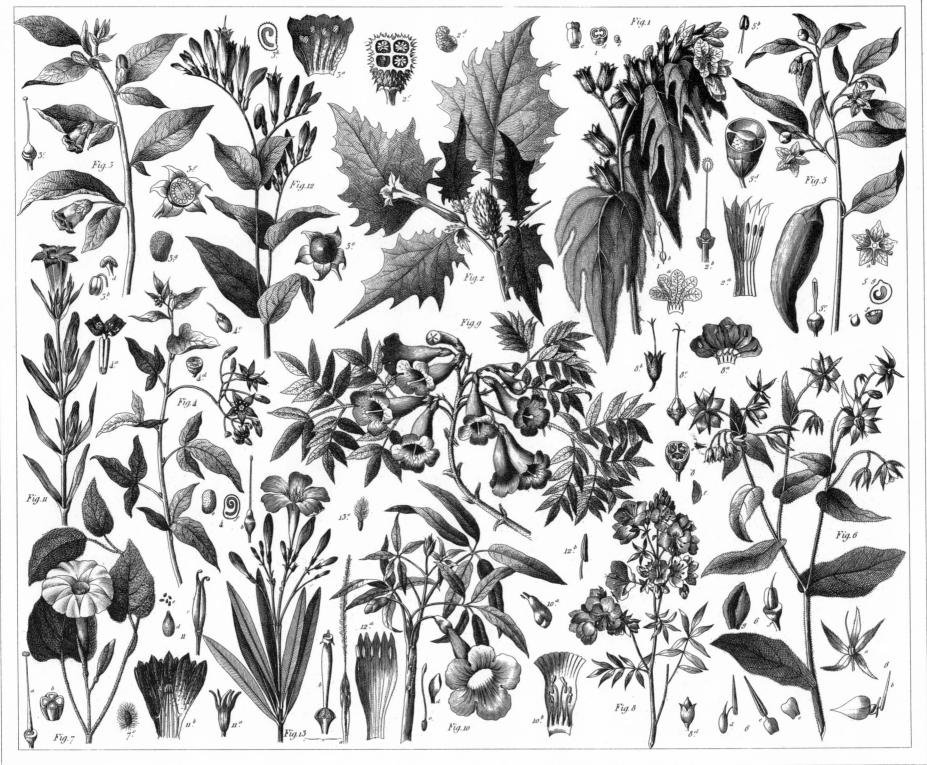

Henry Winkles scuip!

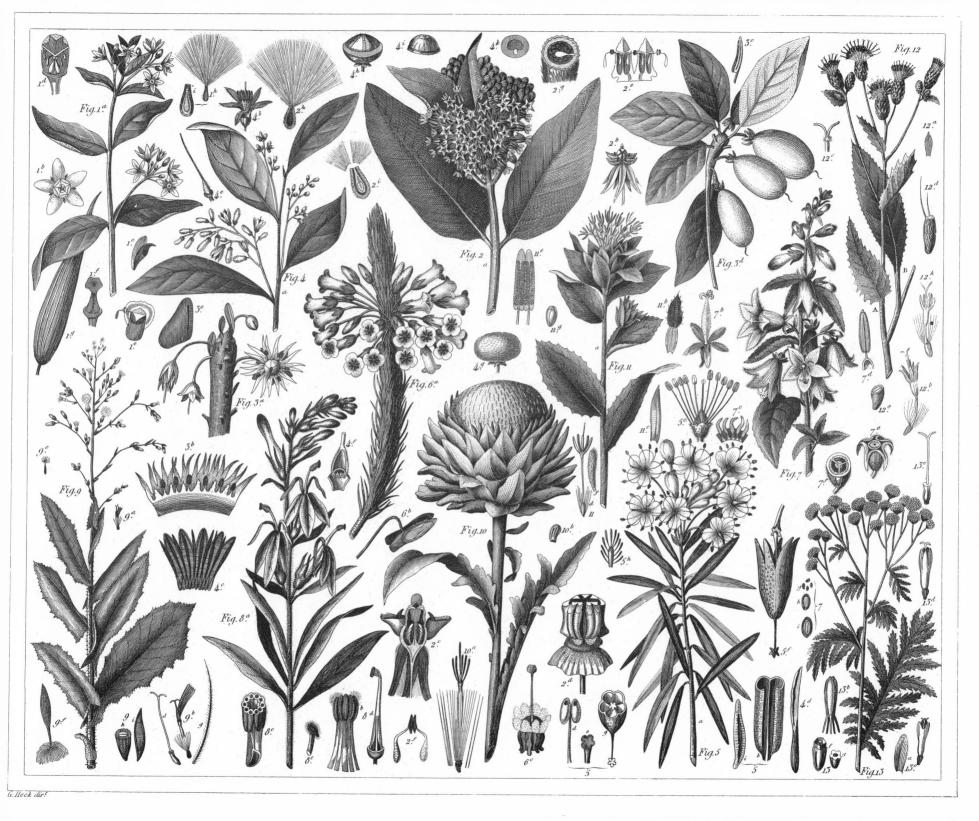

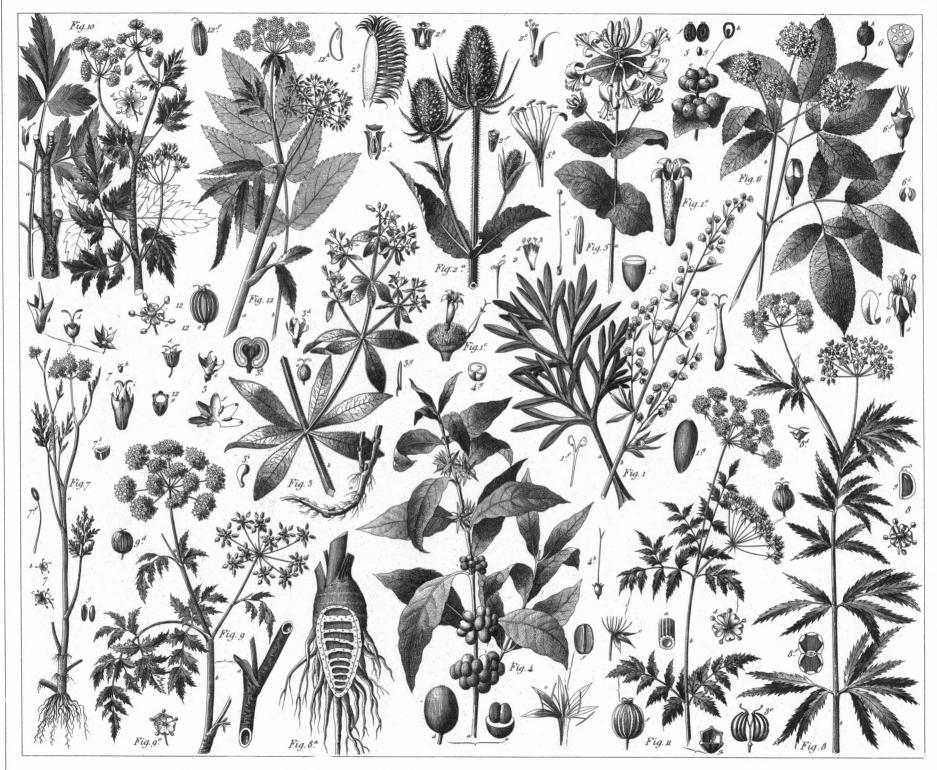

G. Heck dirt

Henry Winkles sculp!

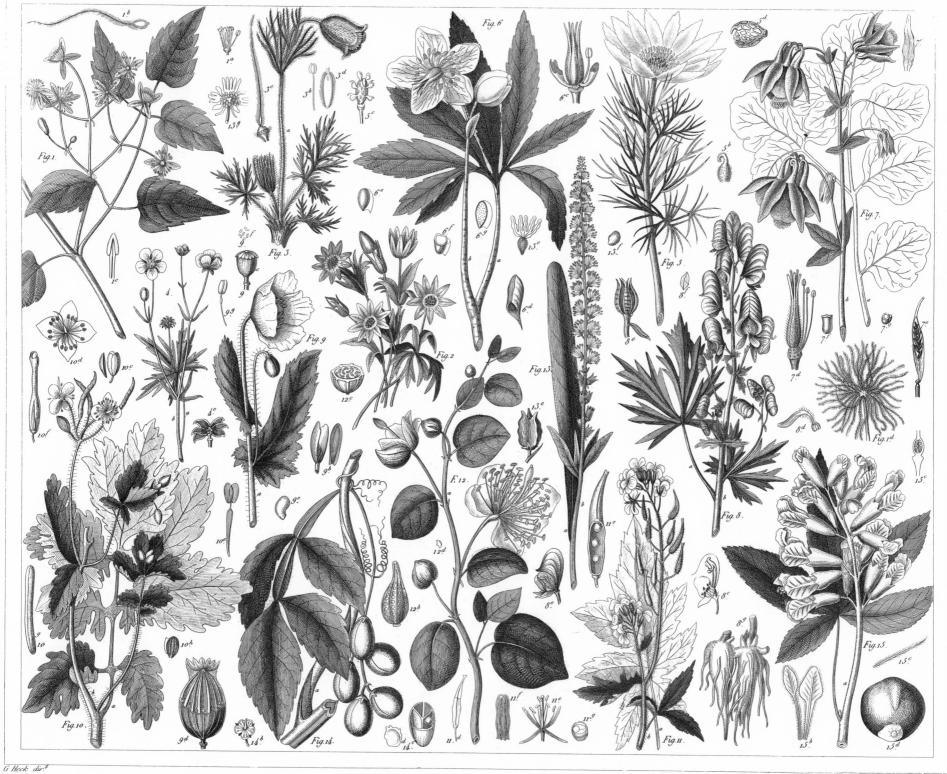

Wayenschieber sculp Berlin

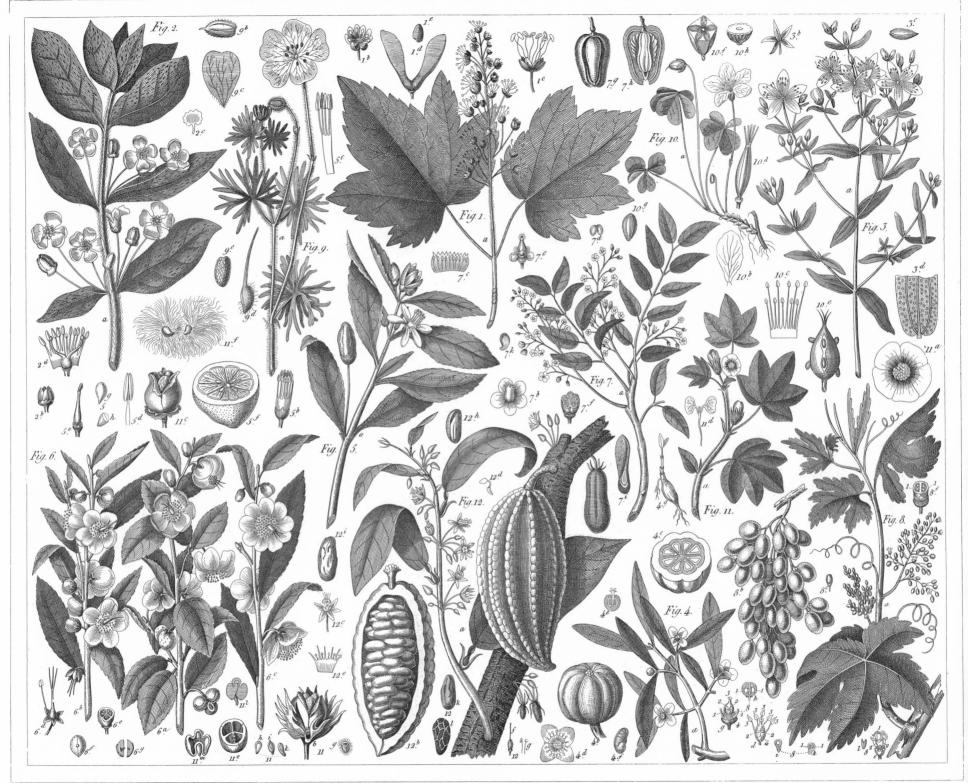

G. Heck dir.t

Wagenschieber south Bert

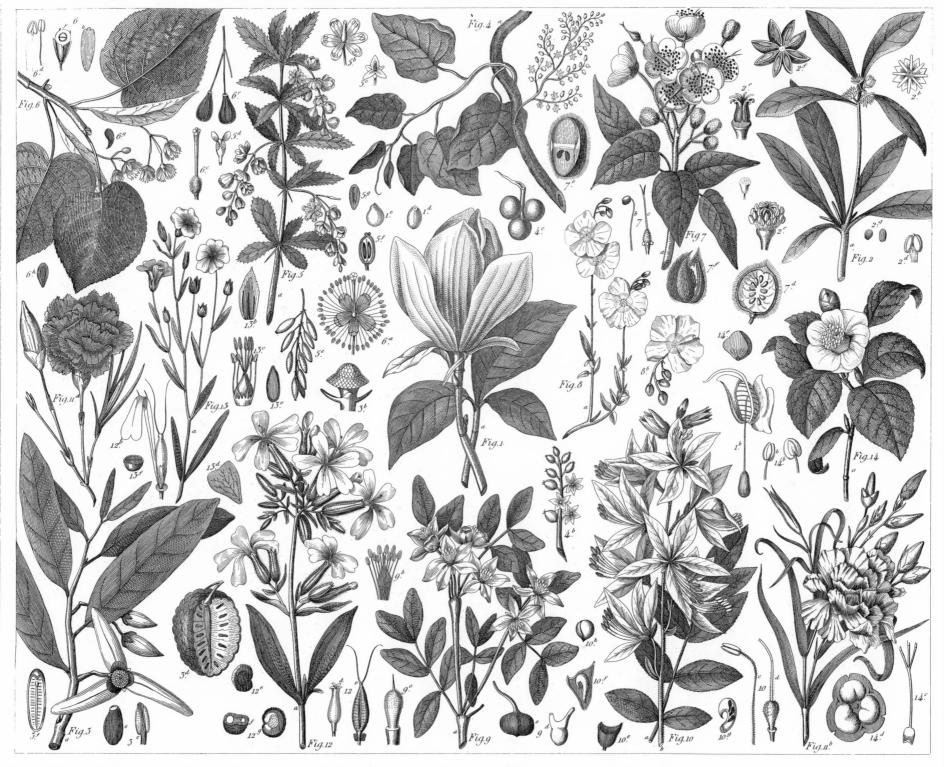

G. Heck dir!

Wagenschieber sculp! Berlin.

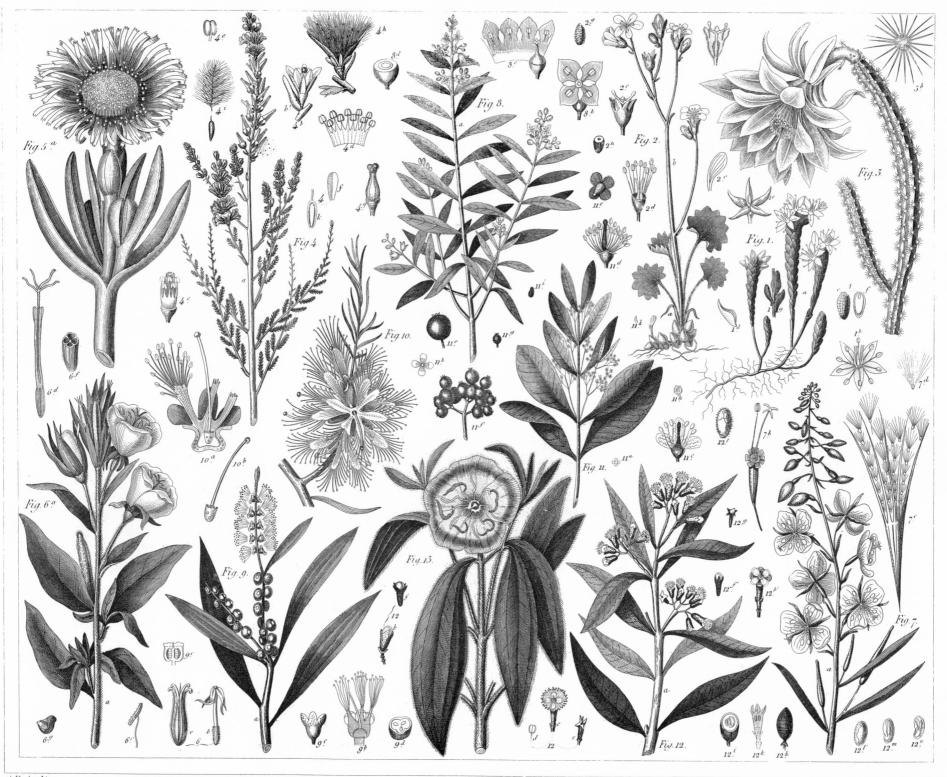

6. Hech dir.

Wagenschieber sculp. Rerlin.

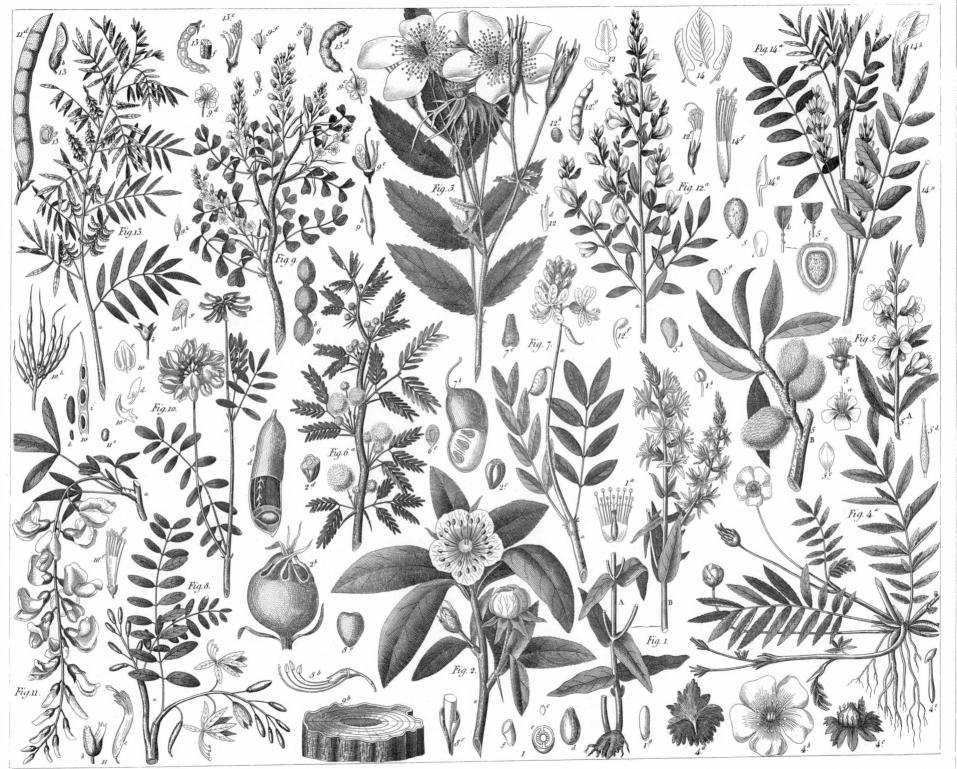

Wagenschieber sculp. Berlin.

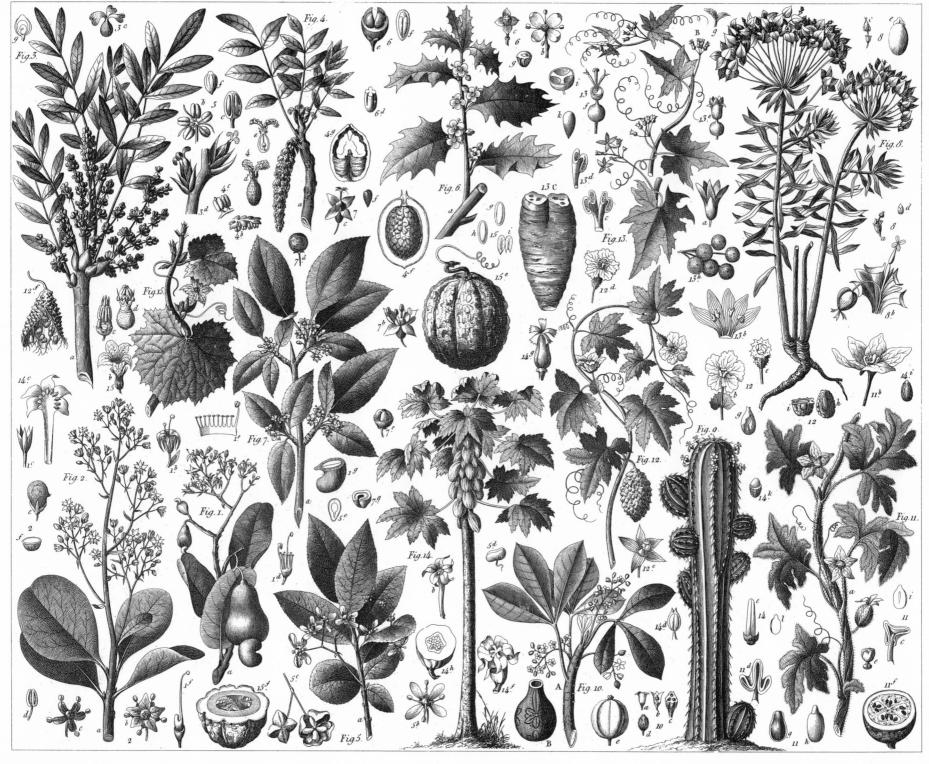

G. Heck dir.

Henry Winkles sculps.

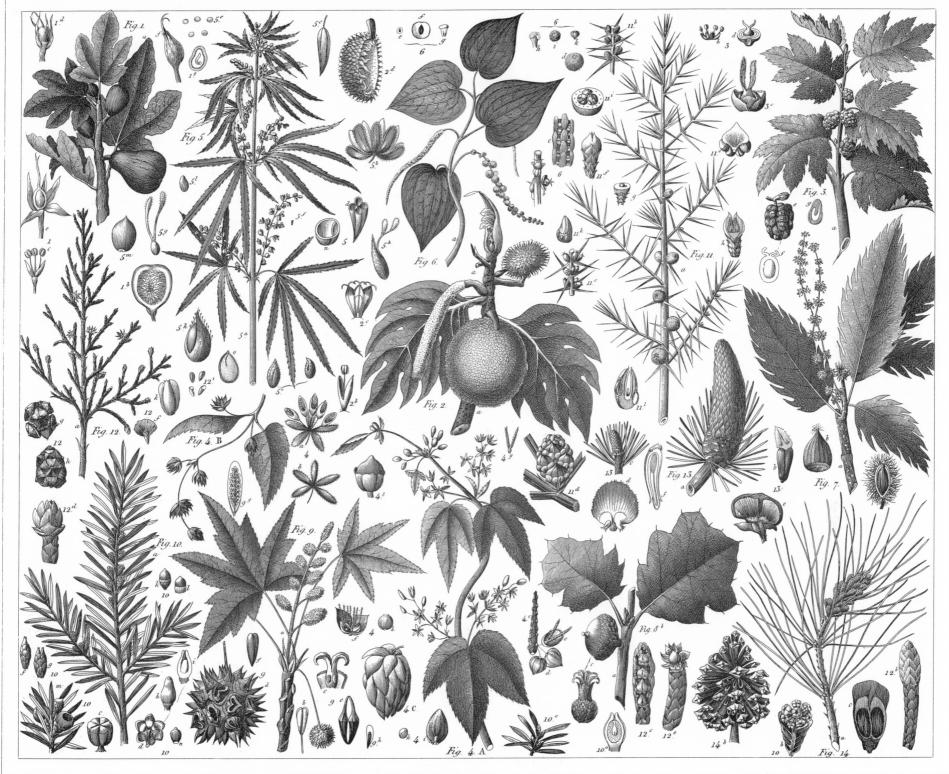

Henry Winkles soulpt

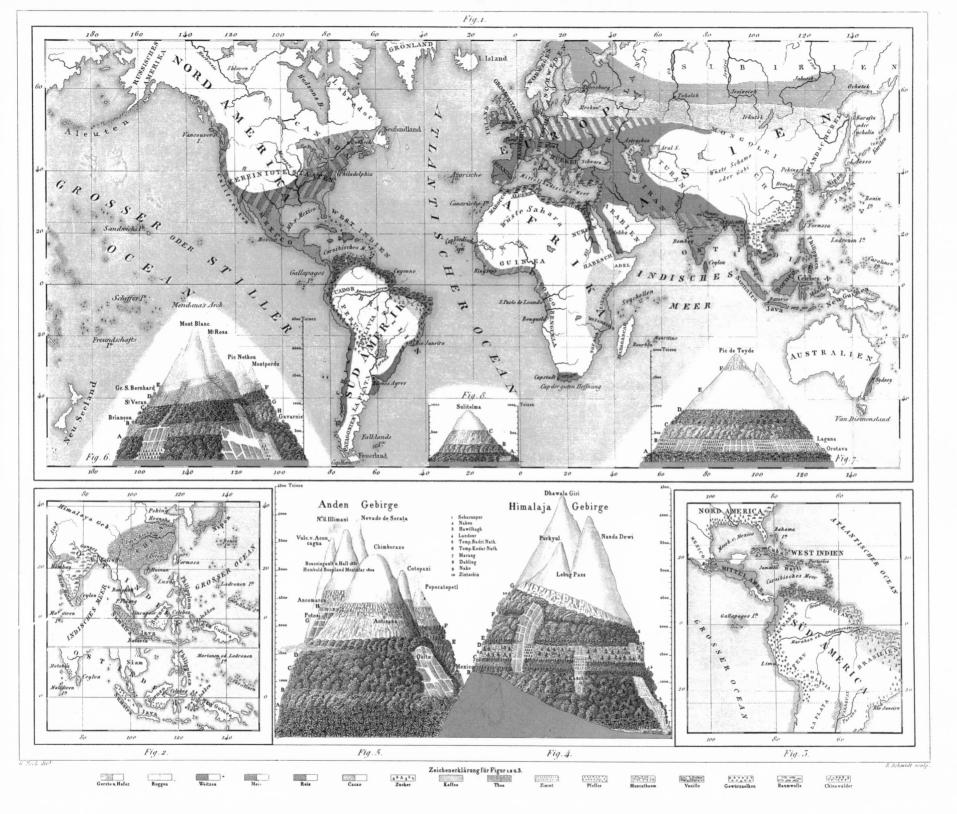

PLATE 73. MAPS AND CHARTS OF PLANT DISTRIBUTION

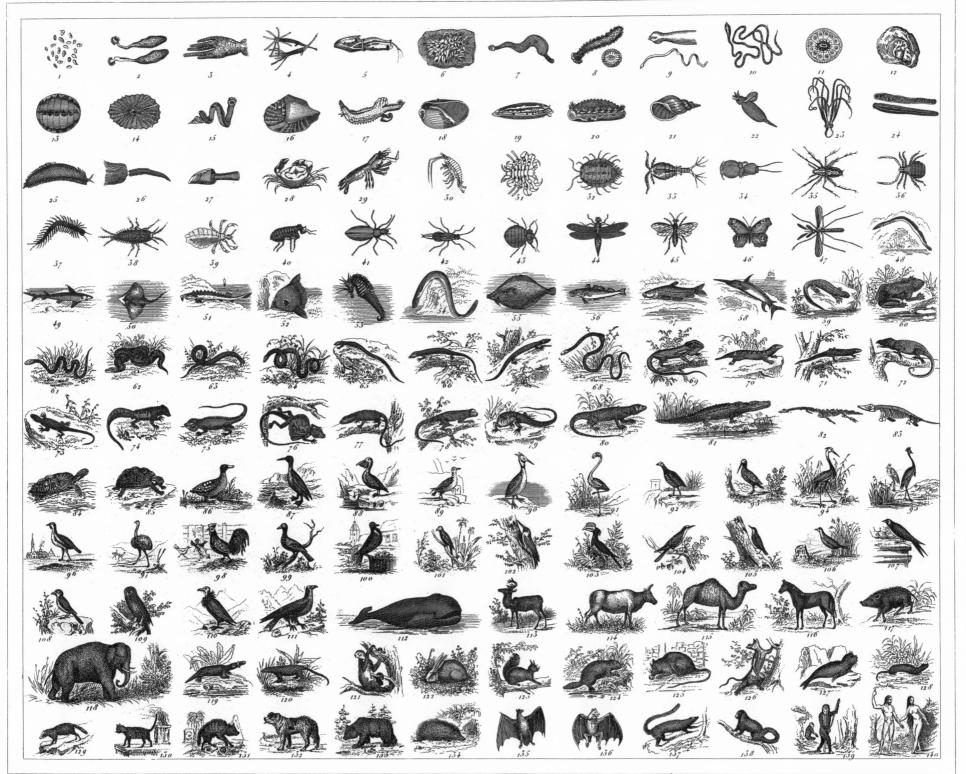

G. Heck dir.

Henry Winkles sculp!

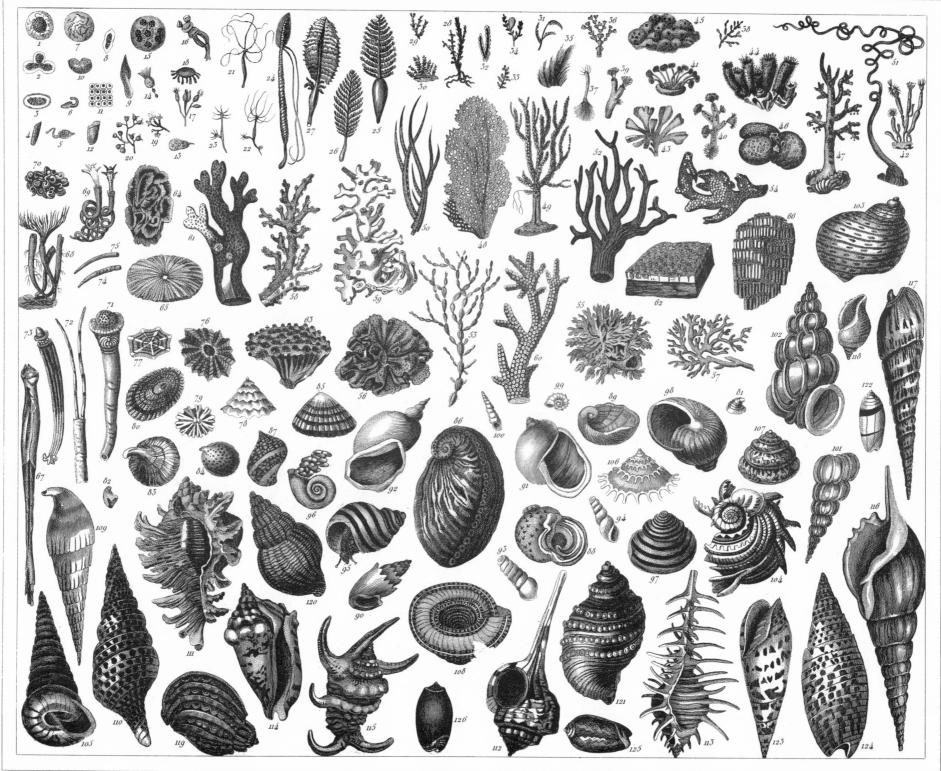

Henry Winkles sculp!

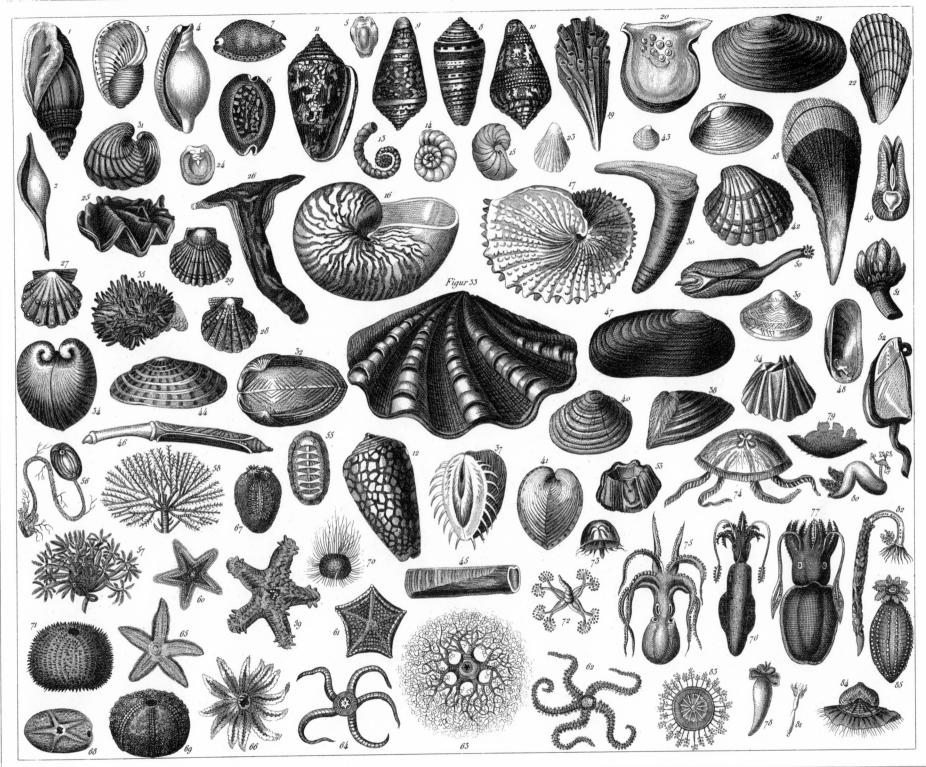

G. Heck dir!

Henry Winkles sculpt

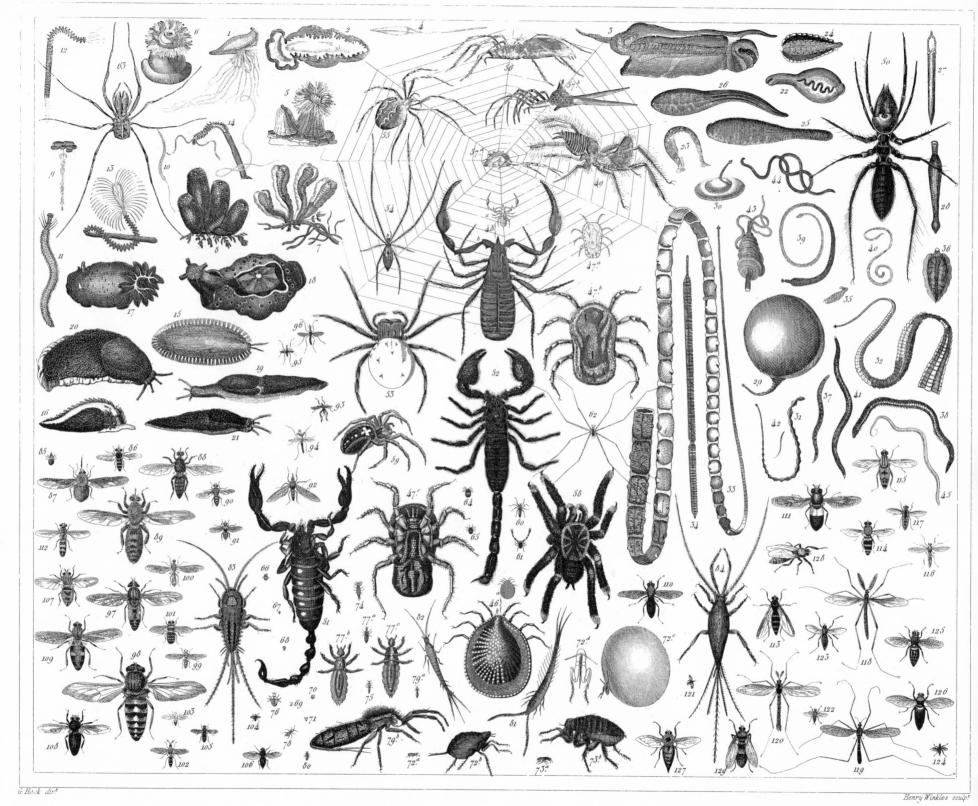

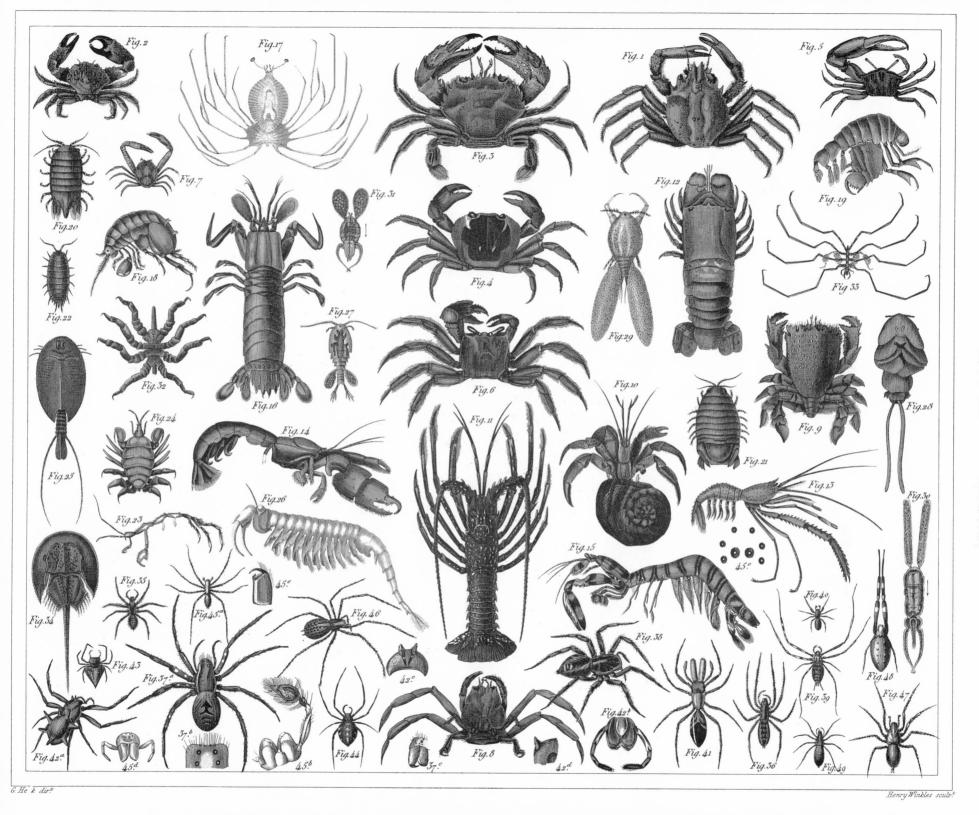

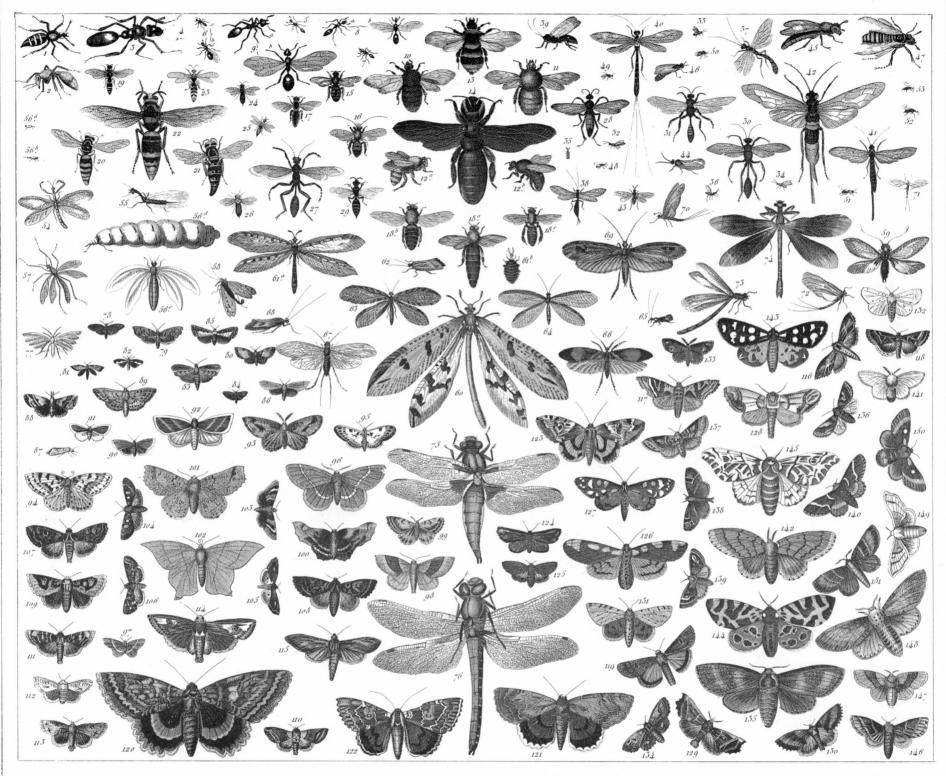

i. Heck dirt

Henry Winkles Sor

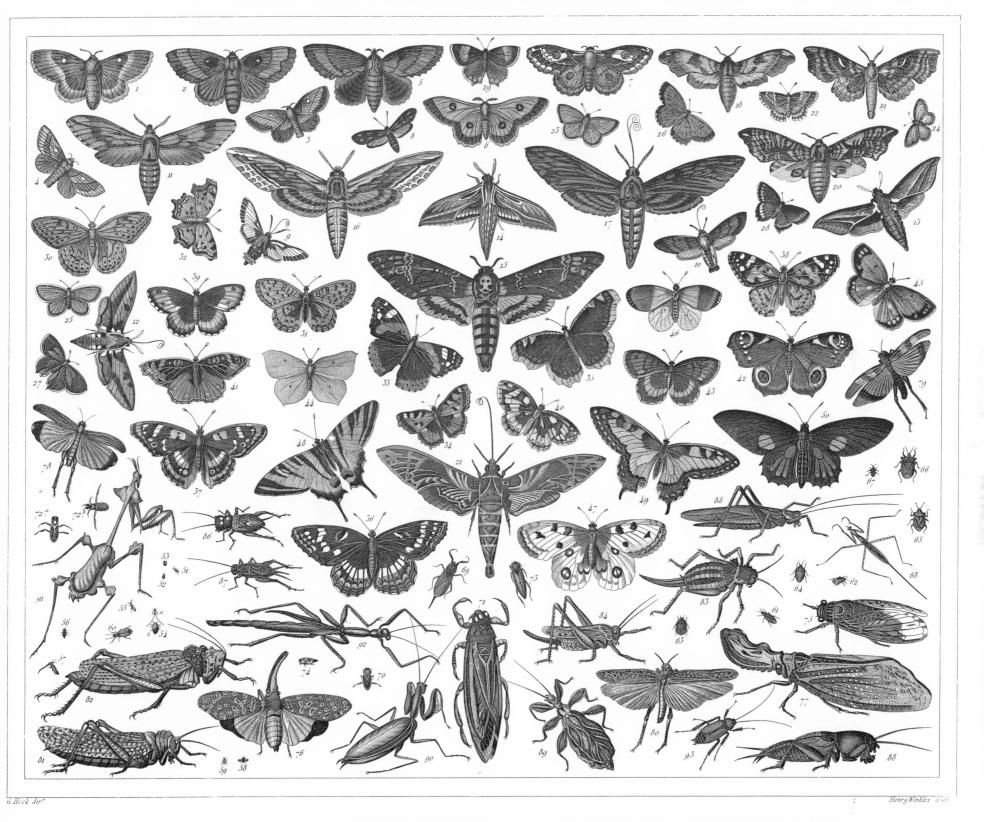

PLATE 80. INSECTS OF THE ORDERS LEPIDOPTERA, ORTHOPTERA, AND HEMIPTERA

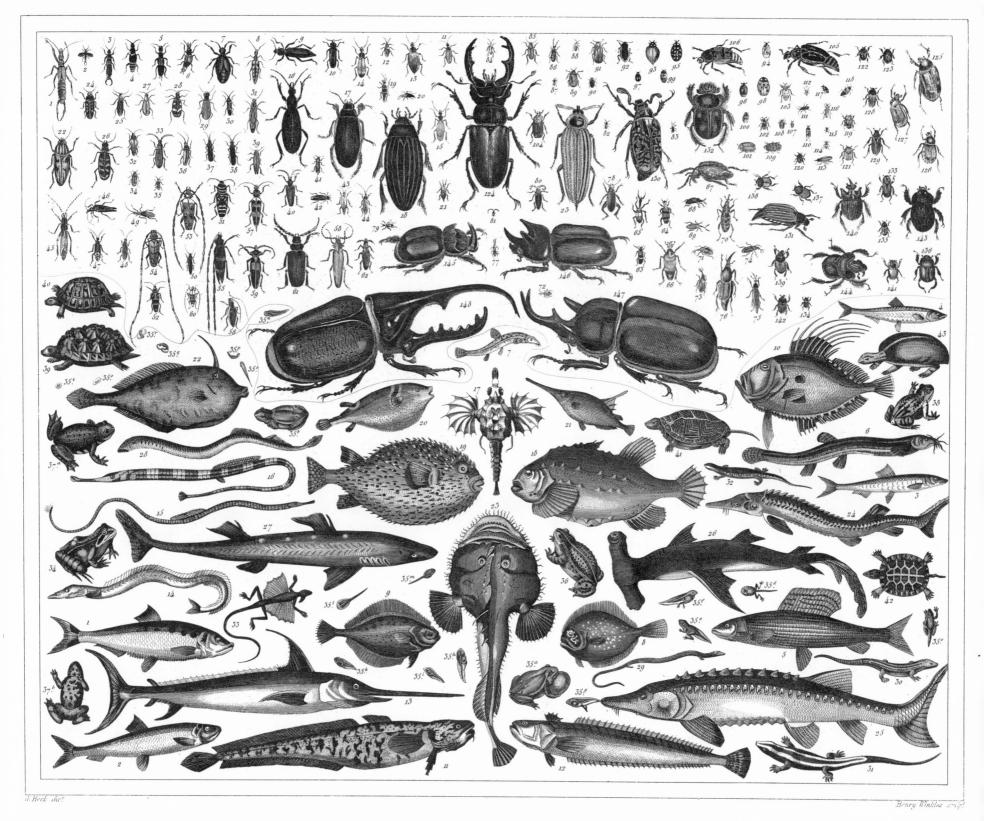

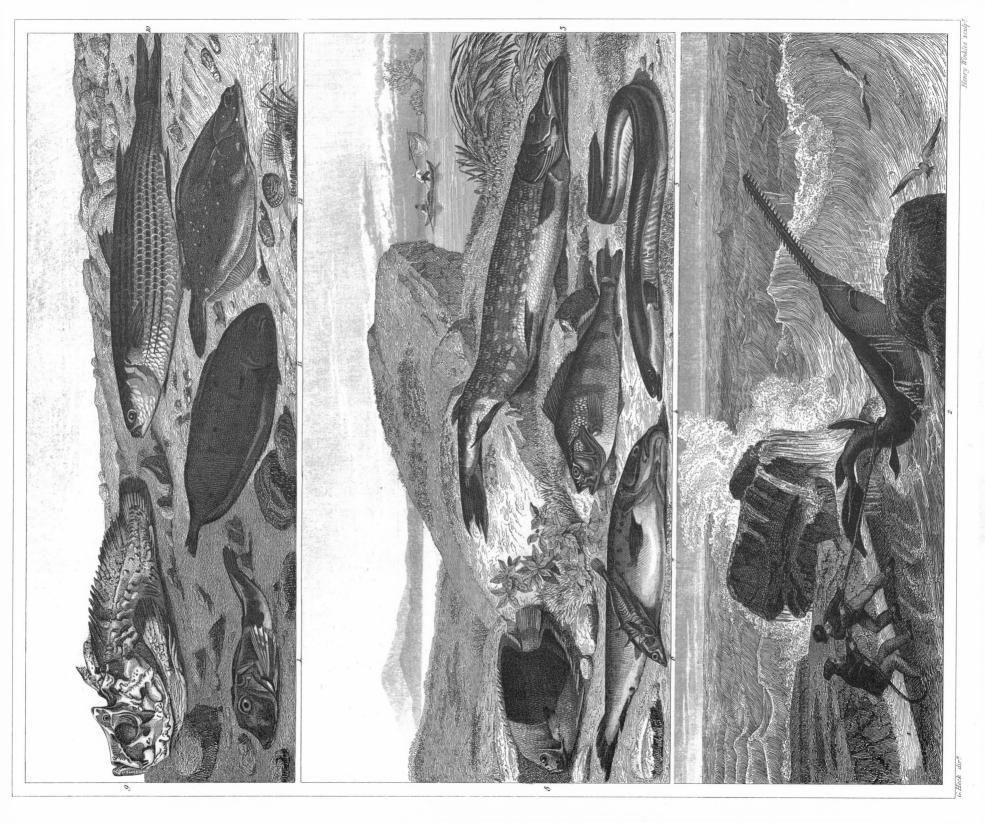

PLATE 82. CHORDATES OF THE CLASSES CHONDRICHTHYES AND OSTEICHTHYES

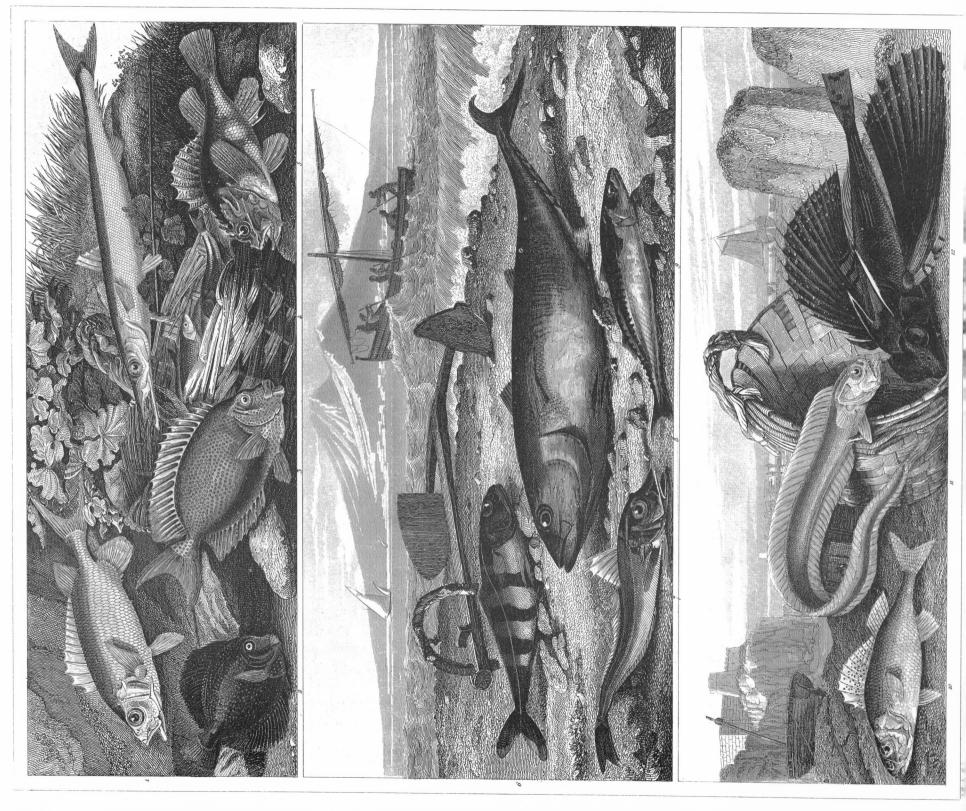

PLATE 83. OSTEICHTHYES OF THE ORDERS PERCIFORMES, SCORPAEINFORMES, BERYCIFORMES, AND DACTYLOPTERIFORMES

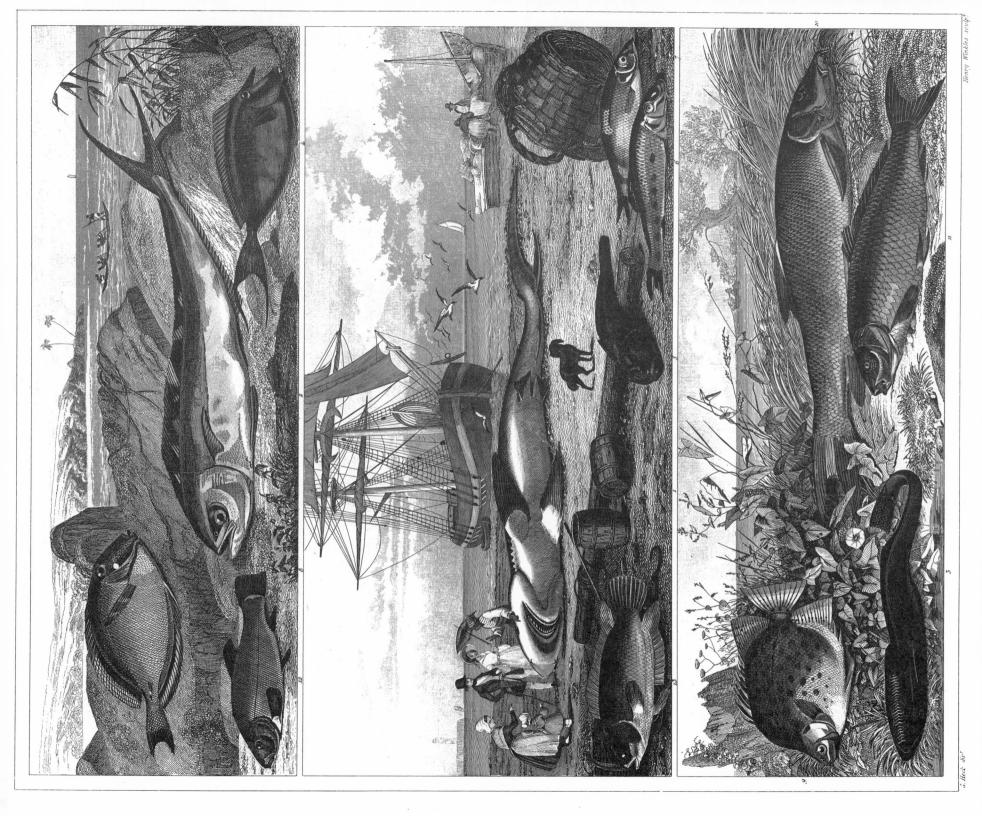

PLATE 84. MEMBERS OF THE CLASSES CHONDRICHTHYES, AND OSTEICHTHYES

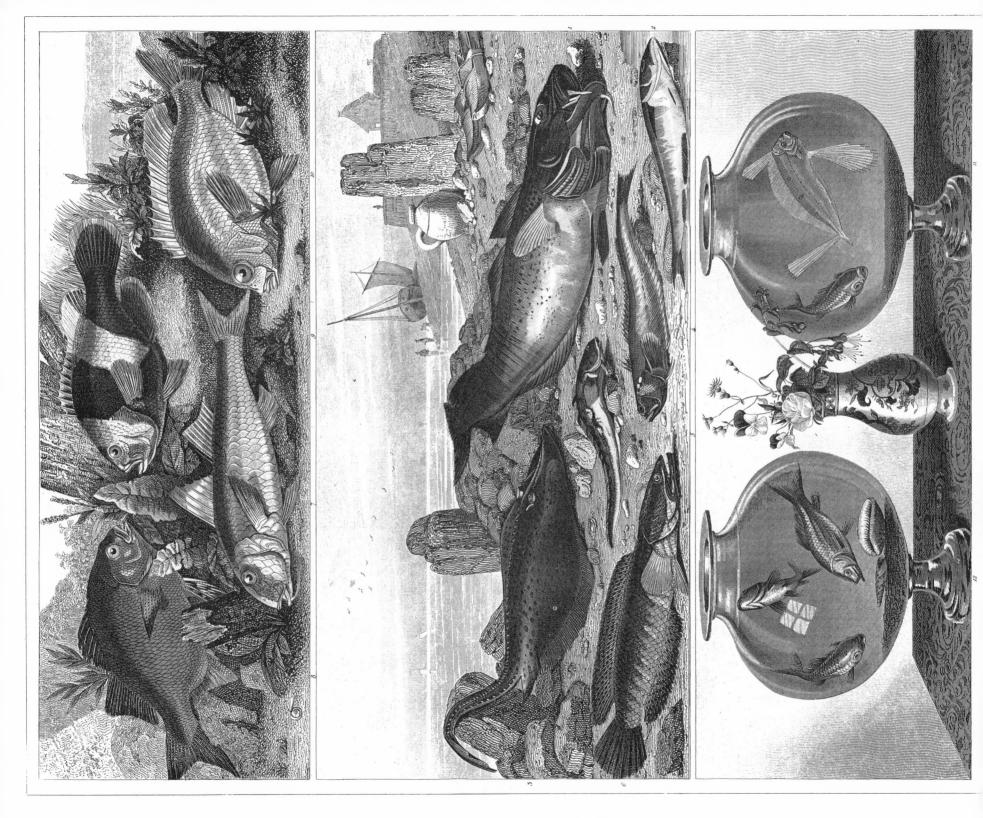

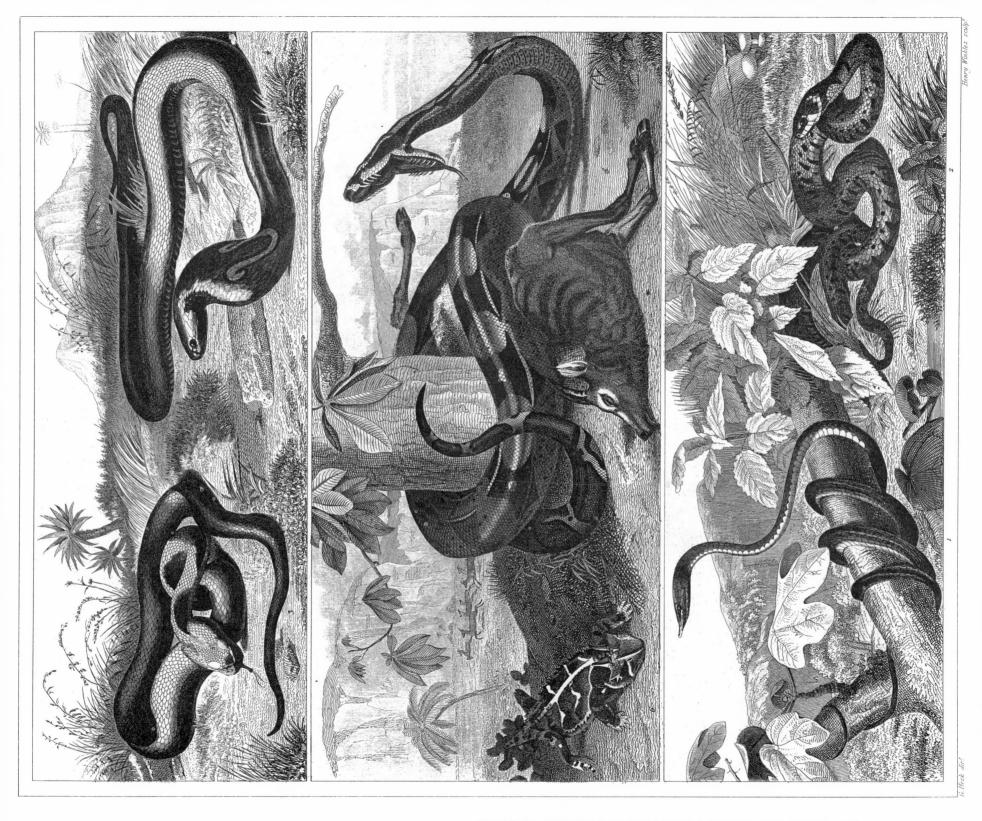

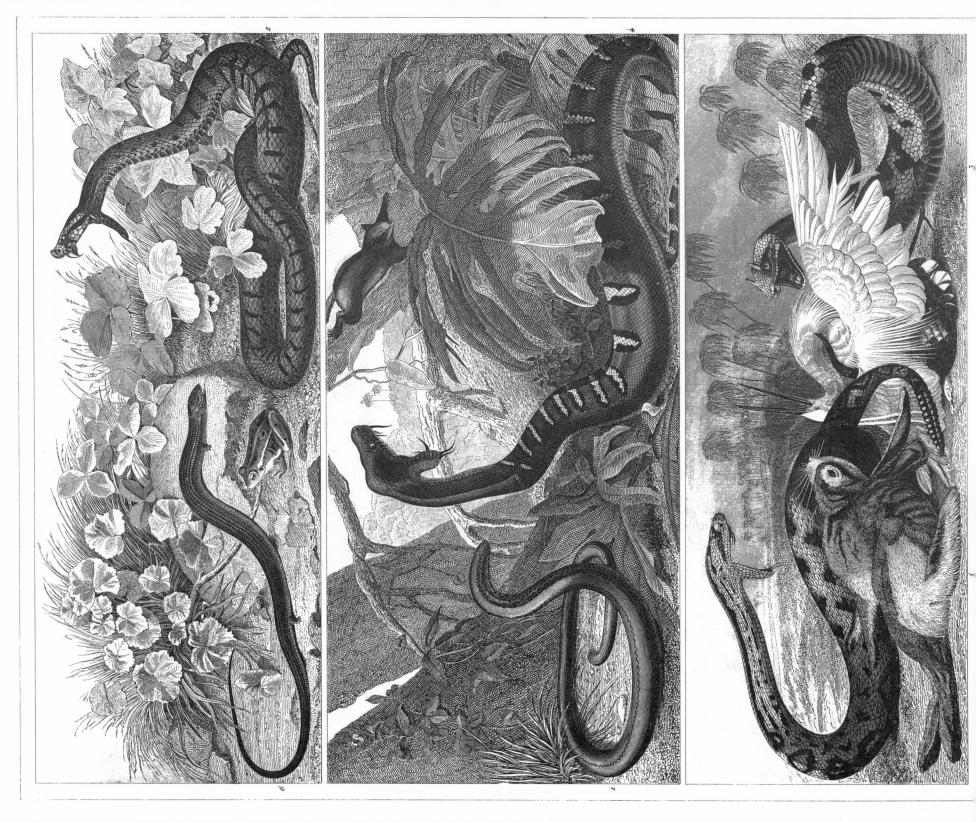

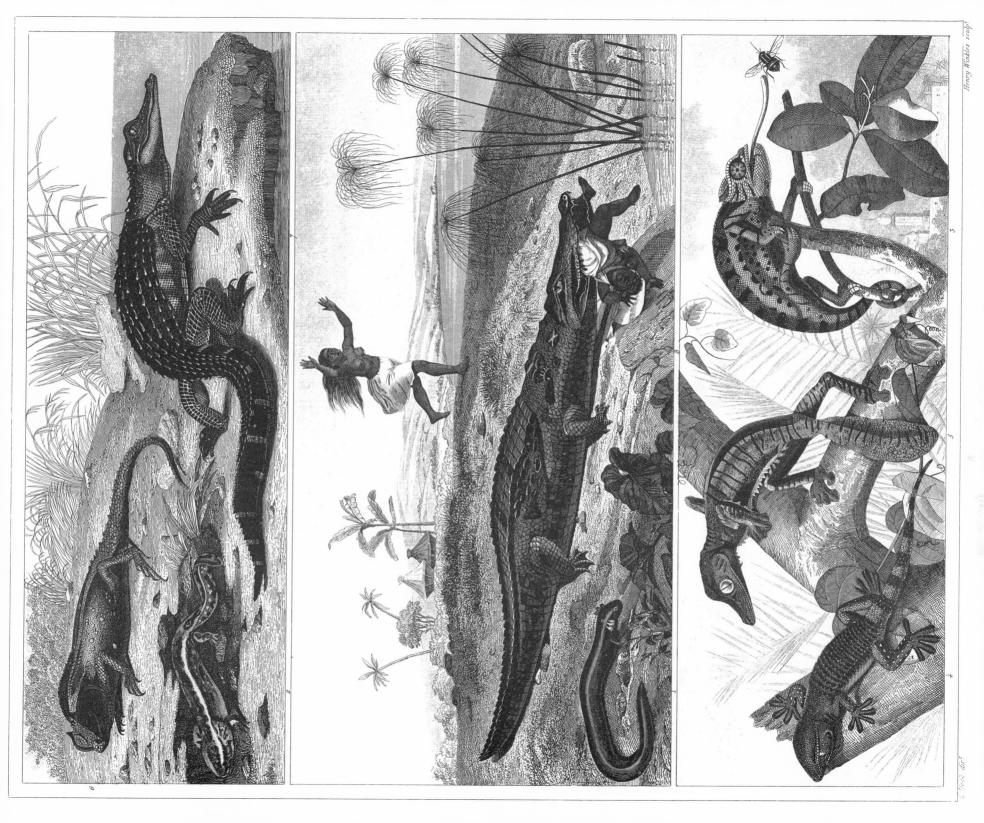

PLATE 88. AMPHIBIANS OF THE ORDER URODELA AND REPTILES OF THE ORDERS SQUAMATA AND CROCODYLIA

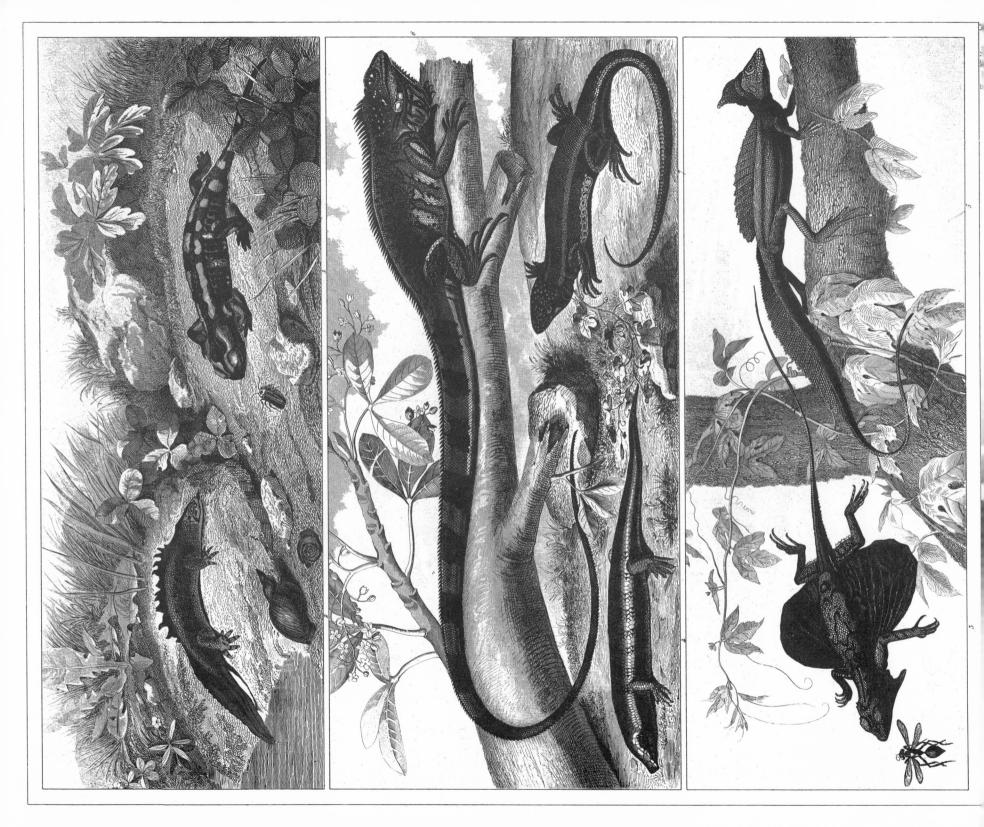

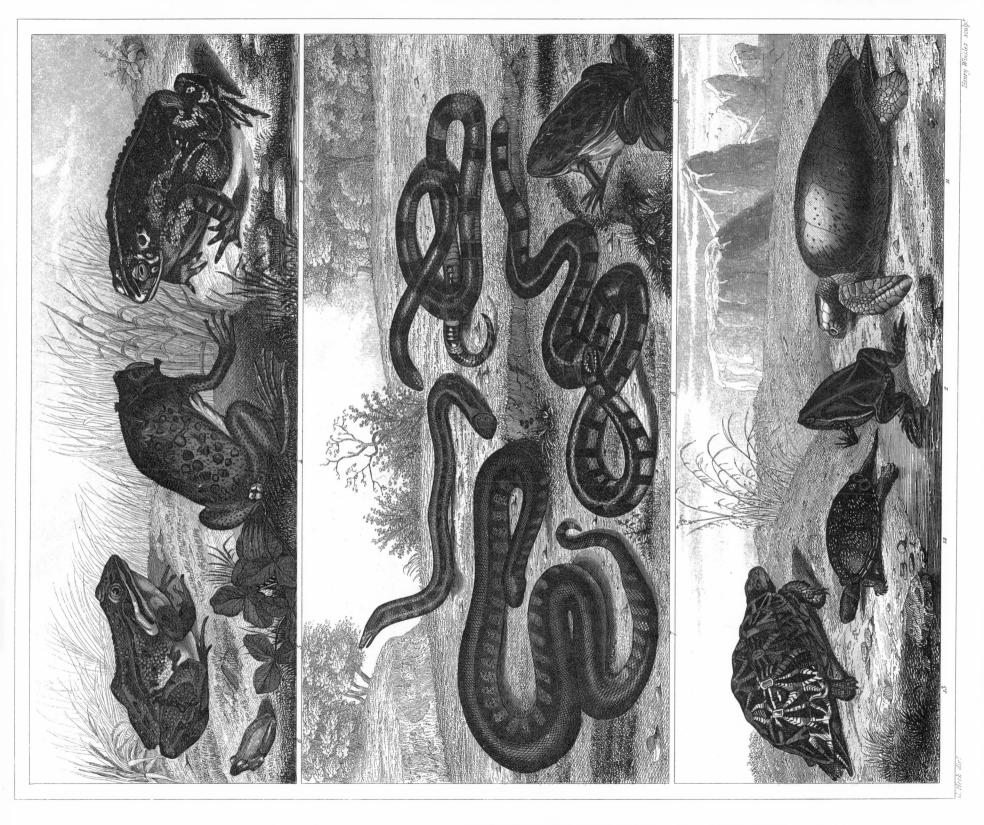

PLATE 90. MEMBERS OF THE CLASSES REPTILIA AND AMPHIBIA

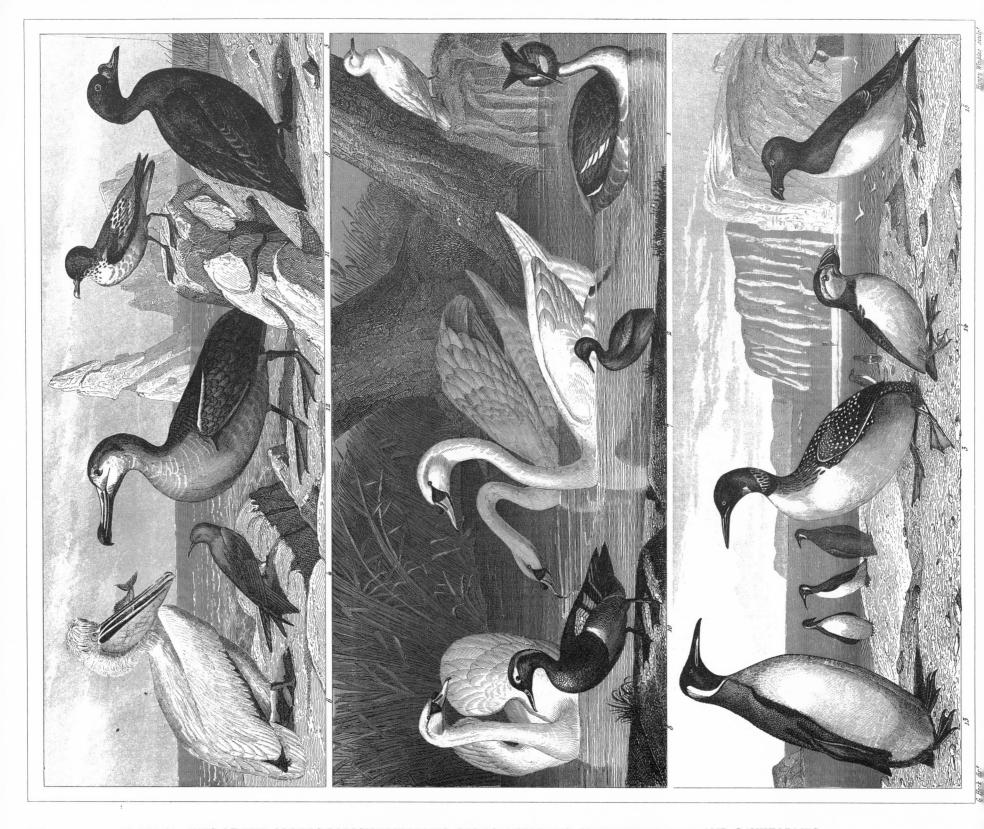

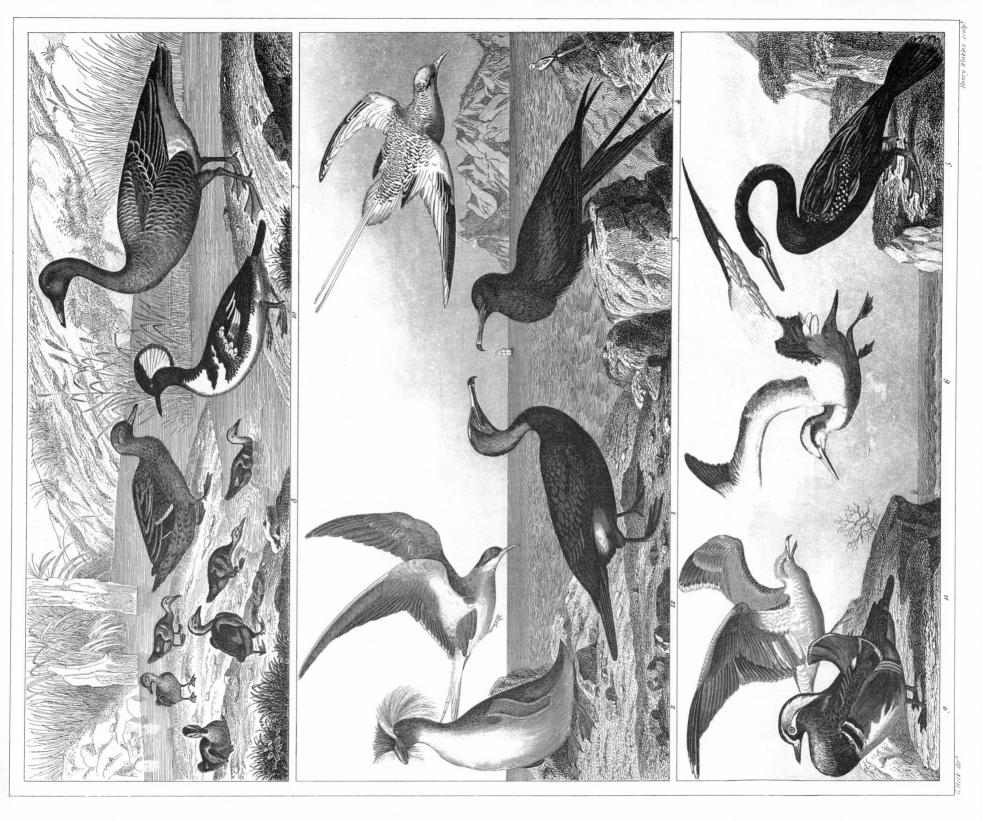

PLATE 92. MEMBERS OF THE ORDERS ANSERIFORMES, PELECANIFORMES, CHARADRIIFORMES, AND SPHENISCIFORMES

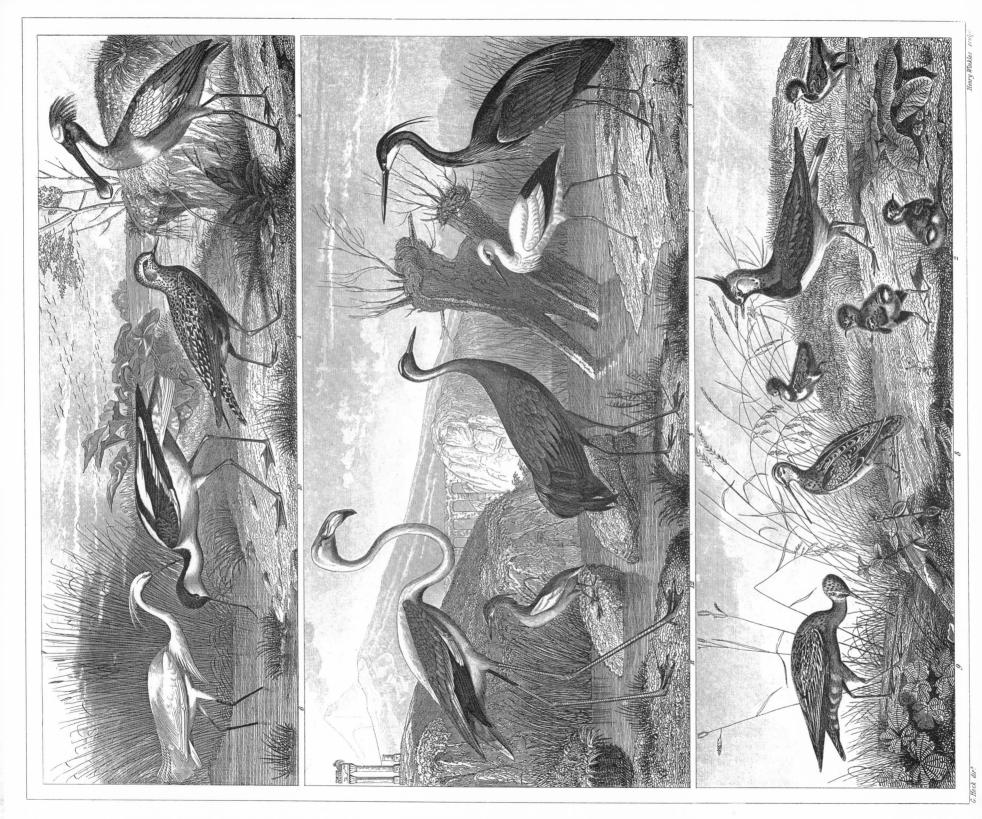

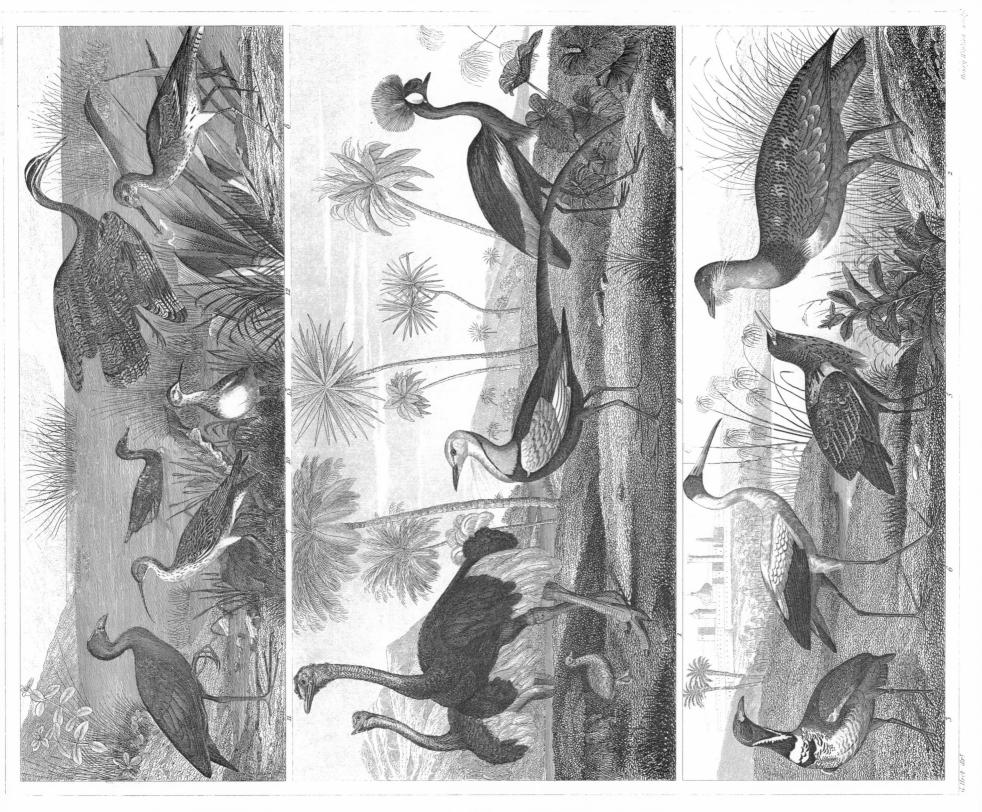

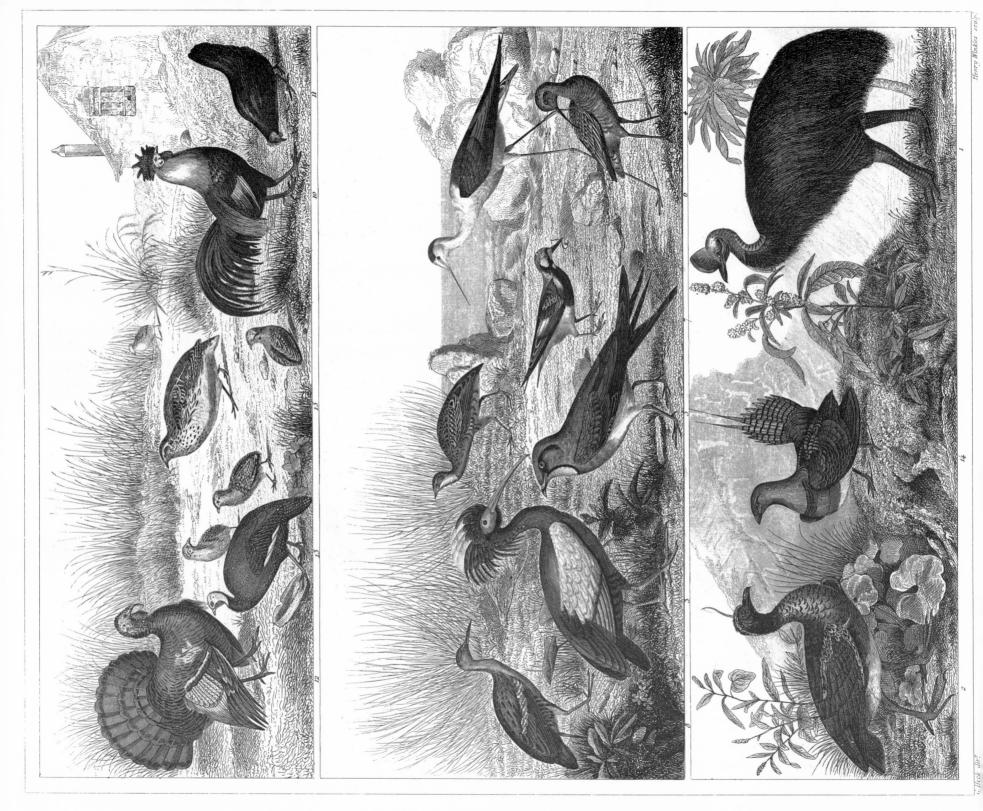

PLATE 95. AVES OF THE ORDERS CASUARIIFORMES, ANSERIFORMES, CHARADRIIFORMES, GALLIFORMES, AND GRUIFORMES

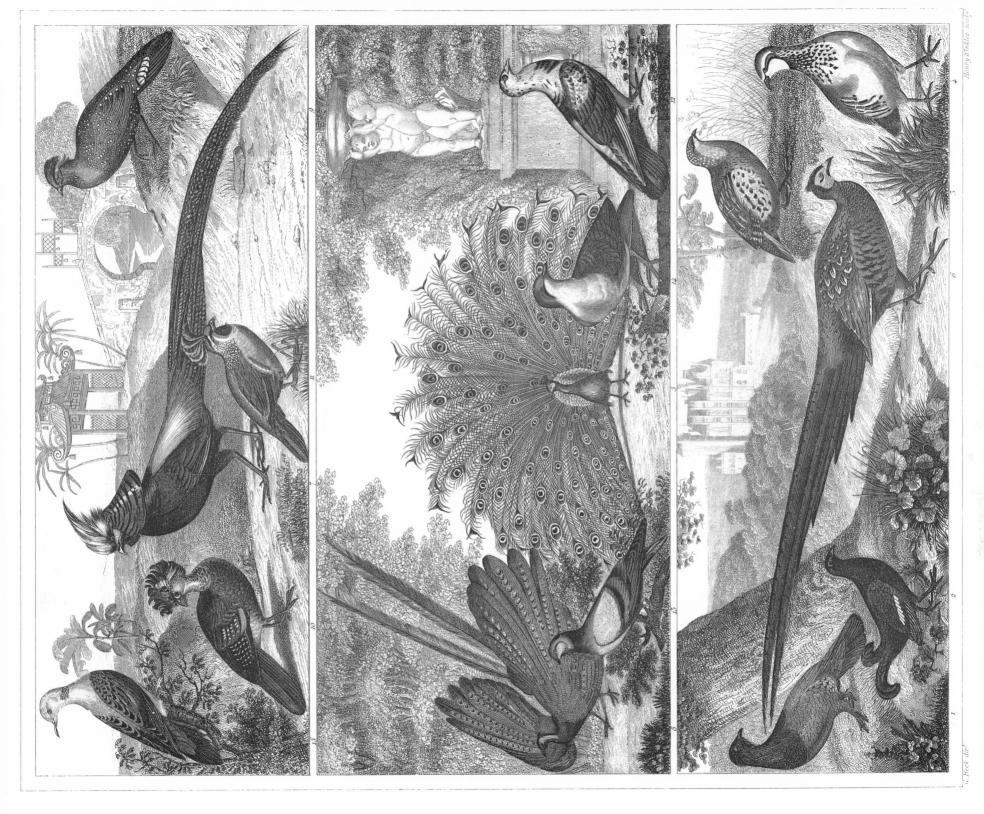

PLATE 96. MEMBERS OF THE ORDERS GALLIFORMES AND COLUMBIFORMES

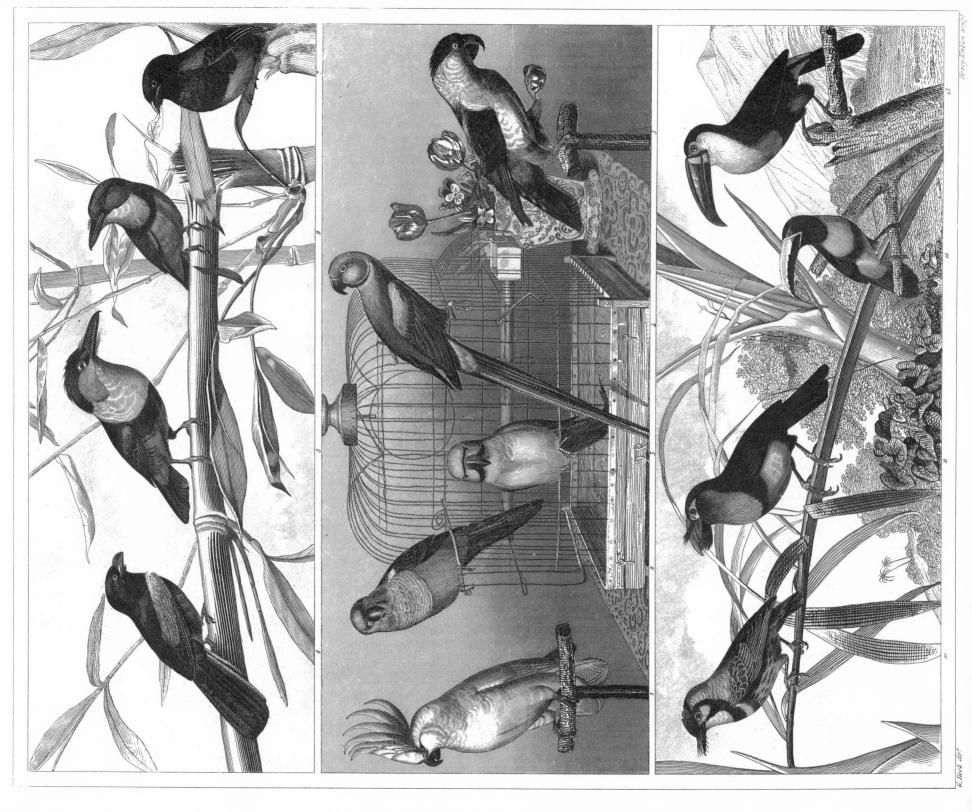

PLATE 97. REPRESENTATIVES OF THE ORDERS PSITTACIFORMES, PICIFORMES, AND TROGONIFORMES

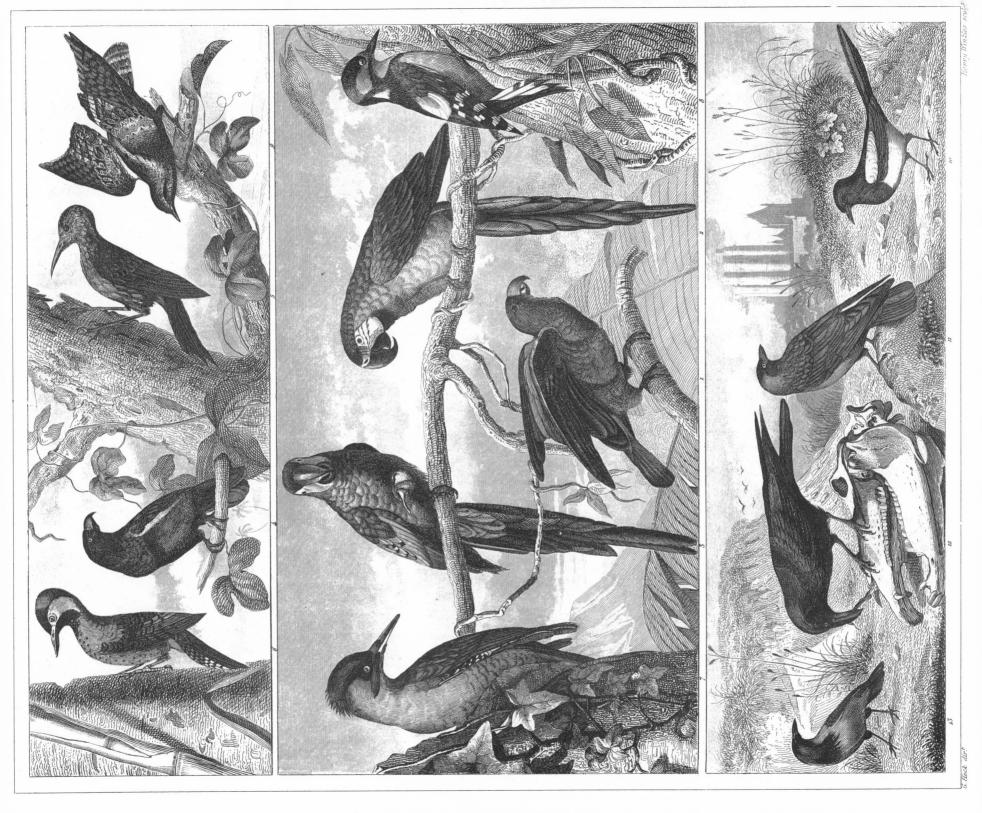

PLATE 98. MEMBERS OF THE ORDERS PSITTACIFORMES, PICIFORMES, AND PASSERIFORMES

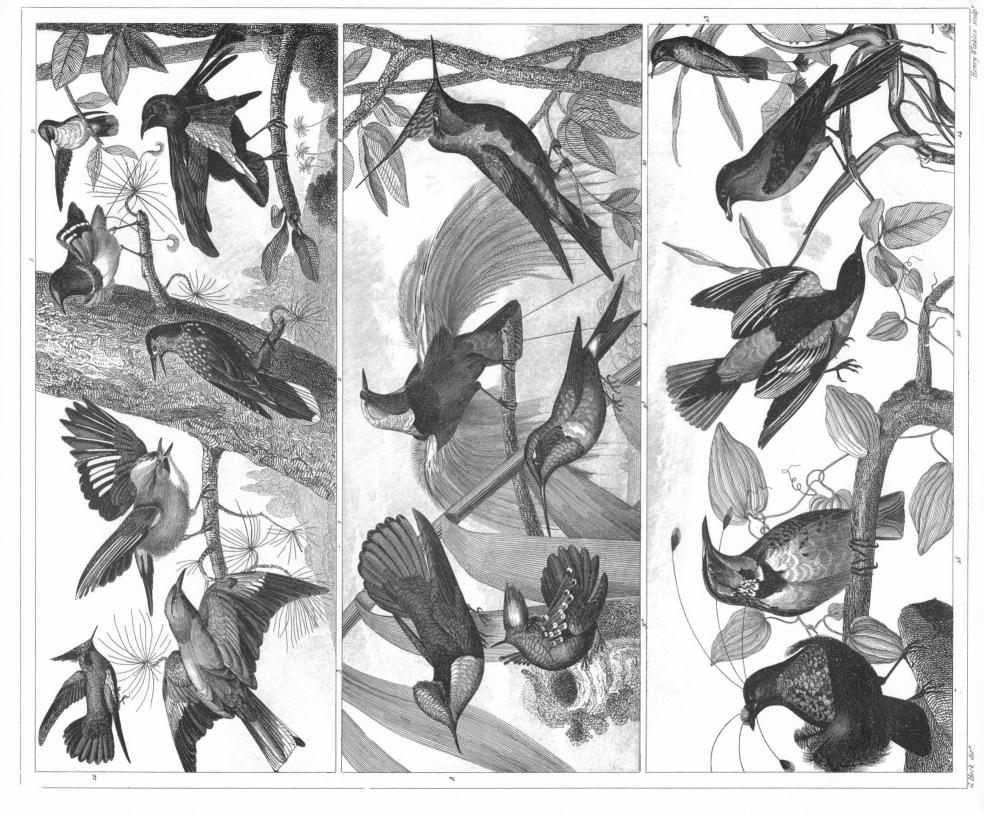

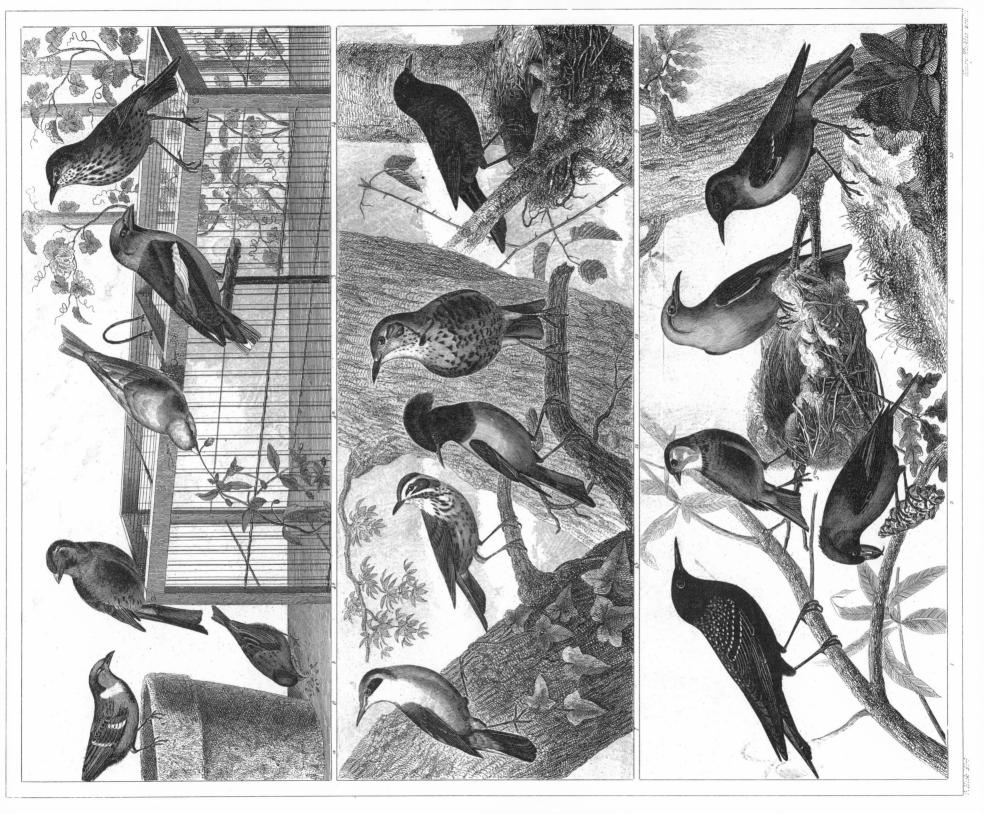

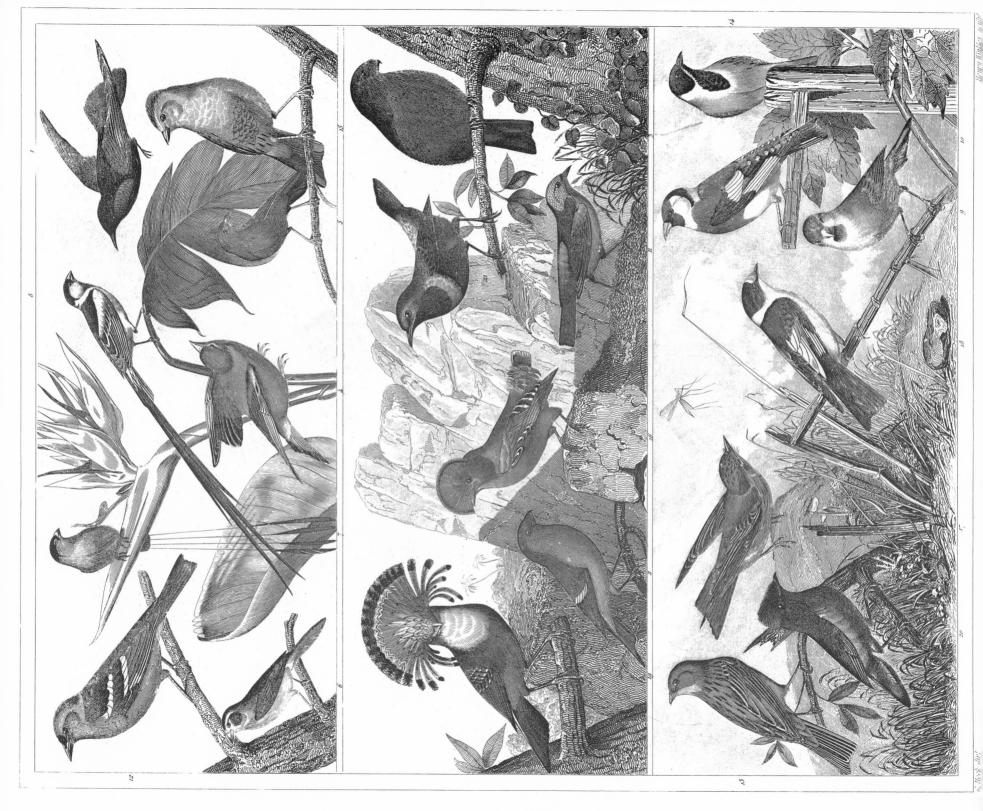

PLATE 101. MEMBERS OF THE ORDERS PASSERIFORMES, AND APOPODIFORMES

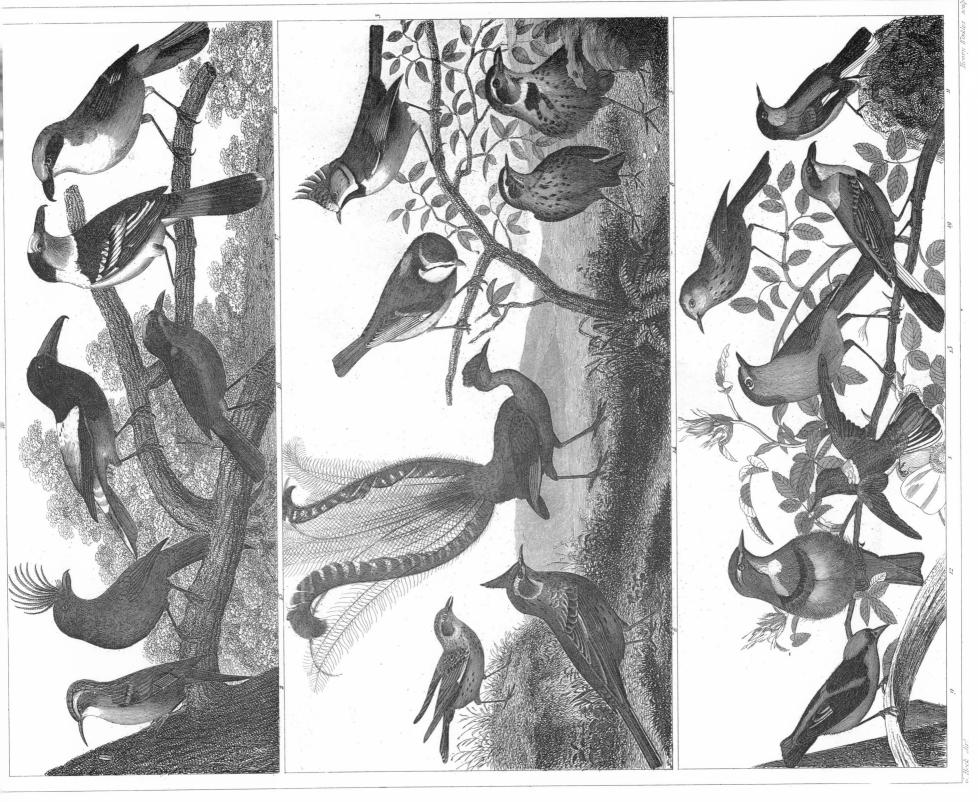

PLATE 102. REPRESENTATIVES OF THE ORDERS PASSERIFORMES AND APOPODIFORMES

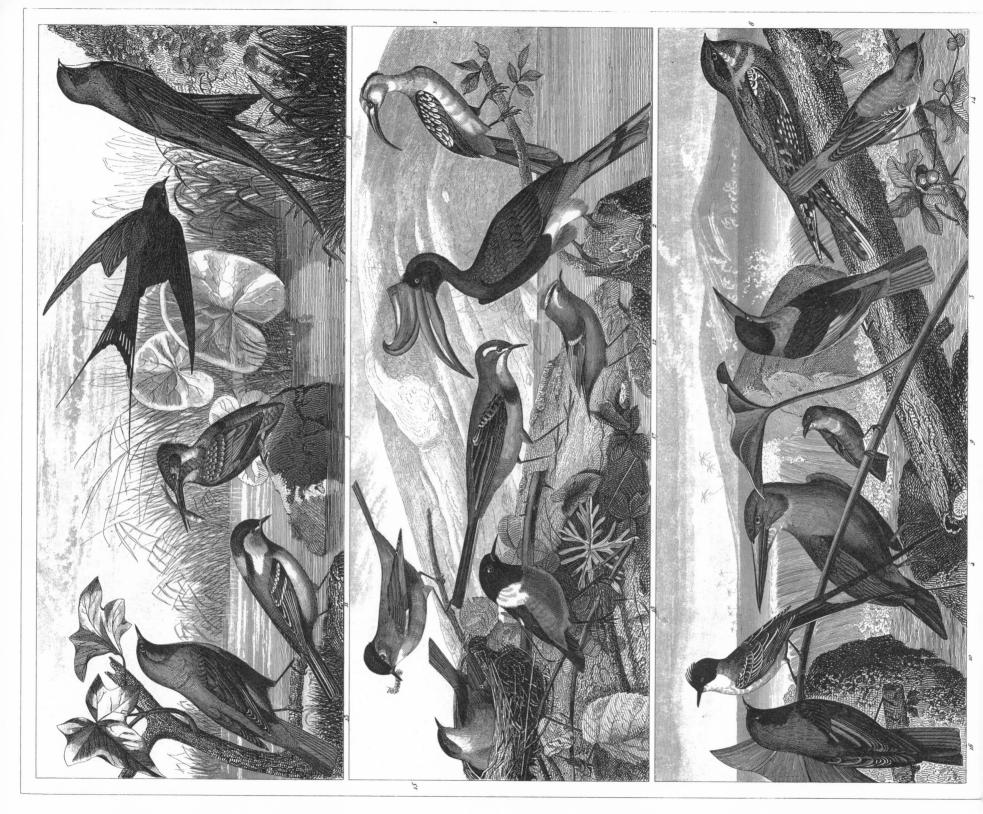

PLATE 103. MEMBERS OF THE ORDERS PASSERIFORMES, CORACIIFORMES, AND CAPRIMULGIFORMES

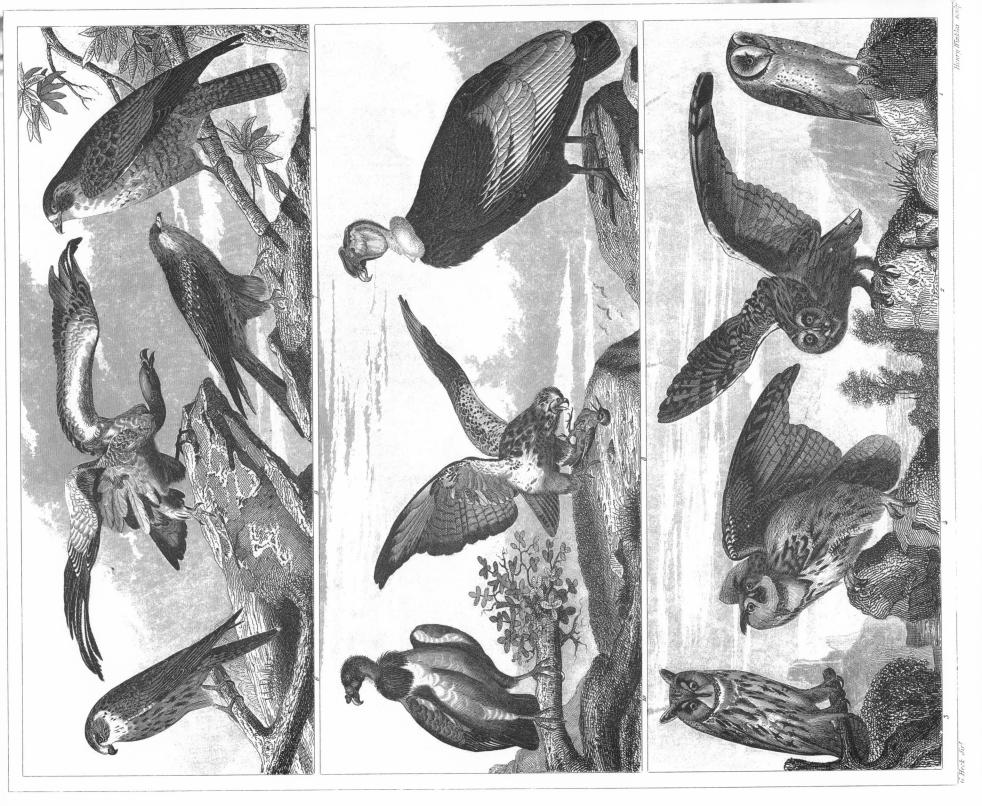

PLATE 104. MEMBERS OF THE ORDERS STRIGIFORMES AND FALCONIFORMES

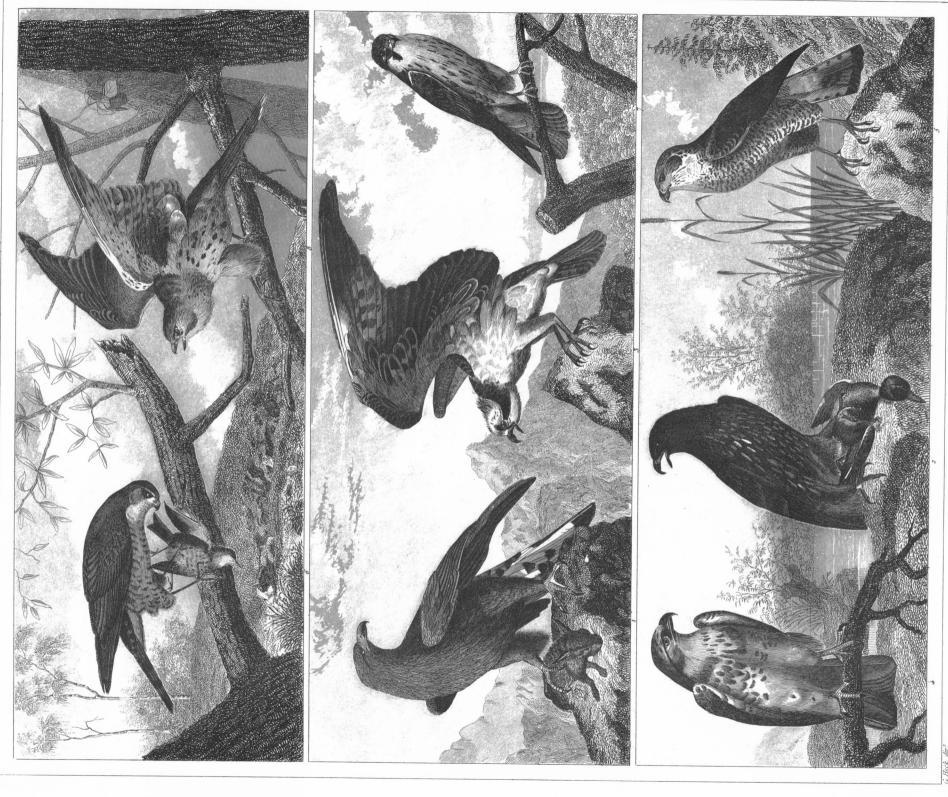

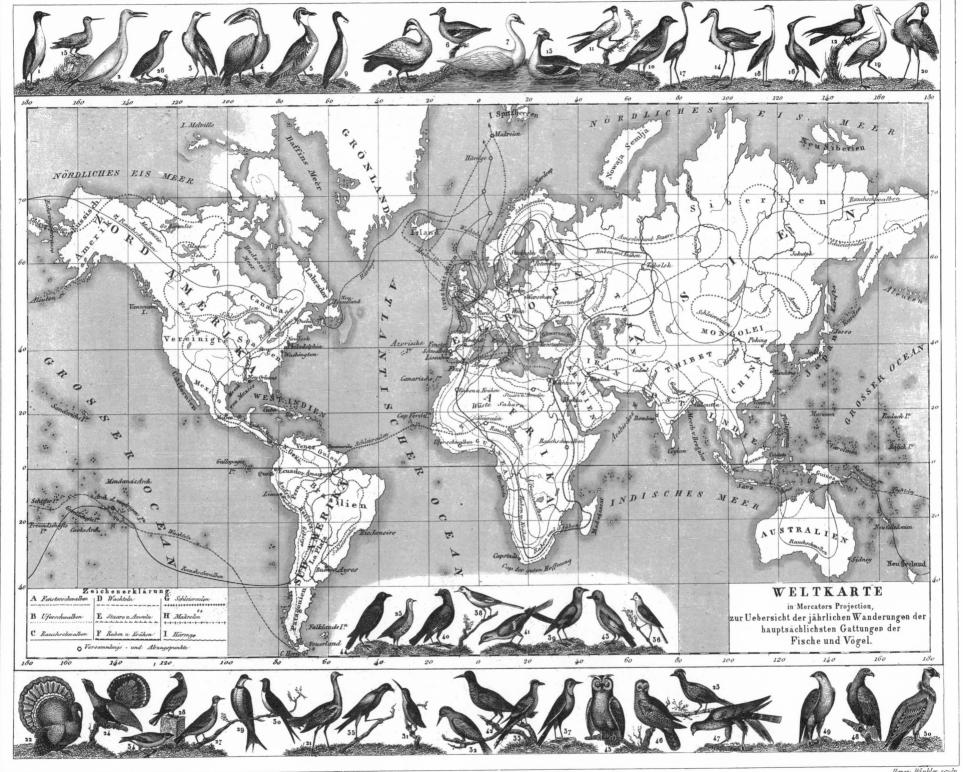

Henry Winkles sculp.

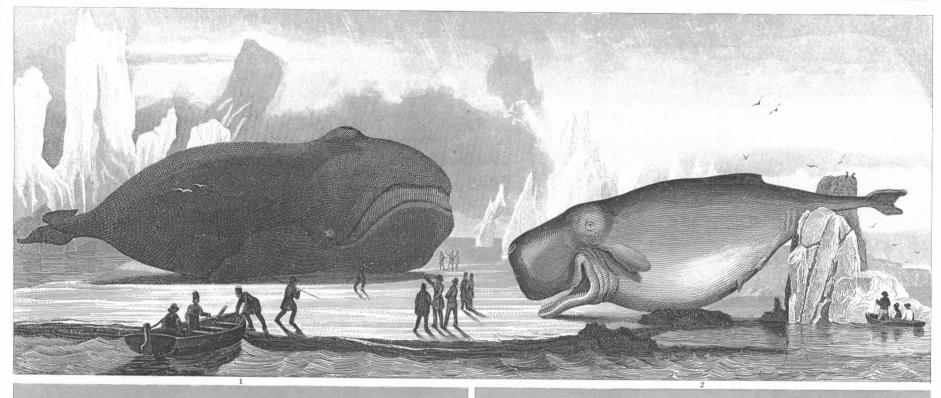

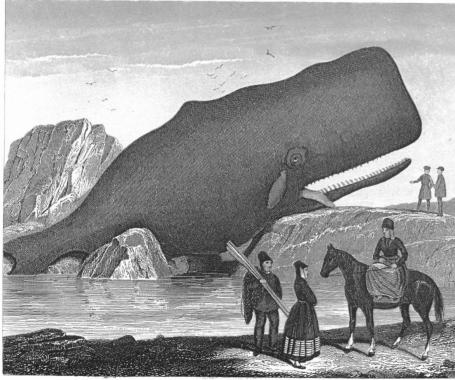

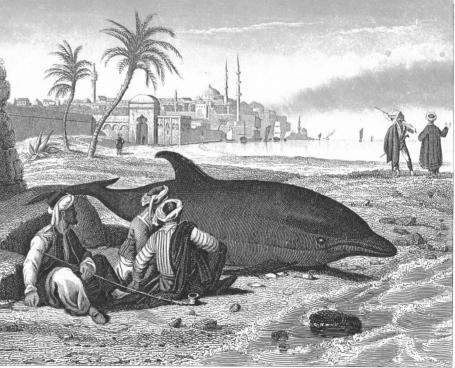

Winkles et Lehmann sculp!

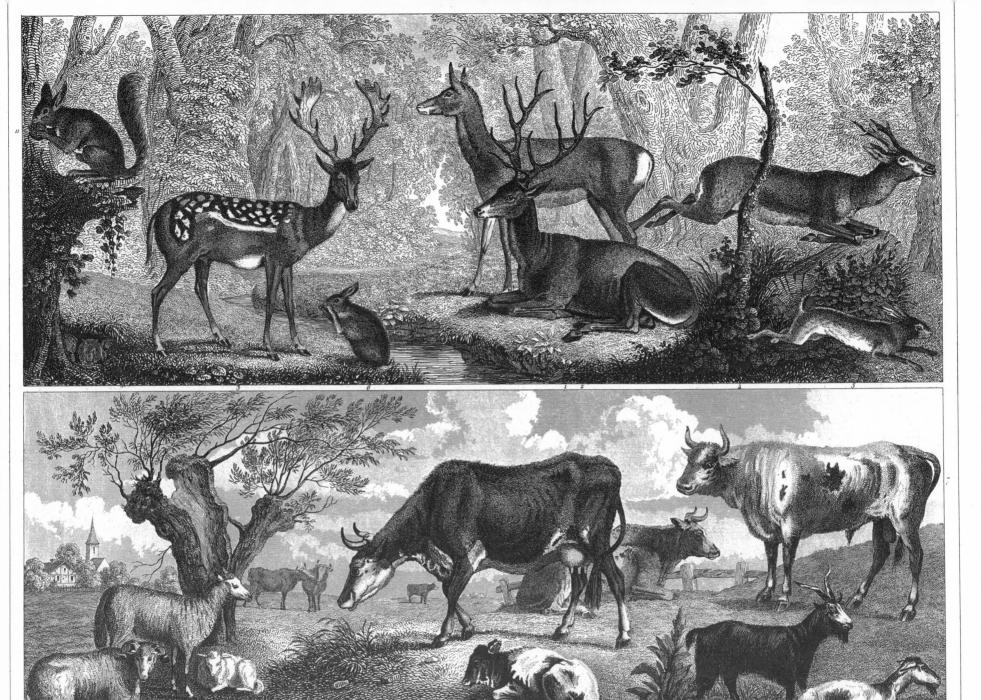

Henry Winkles sen

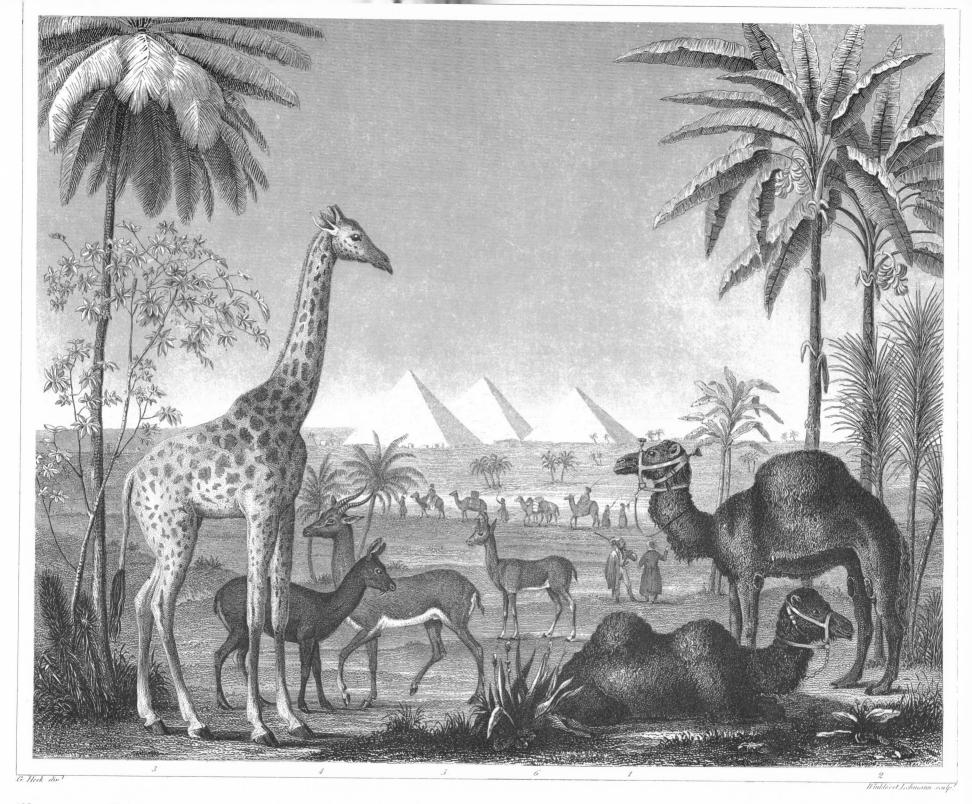

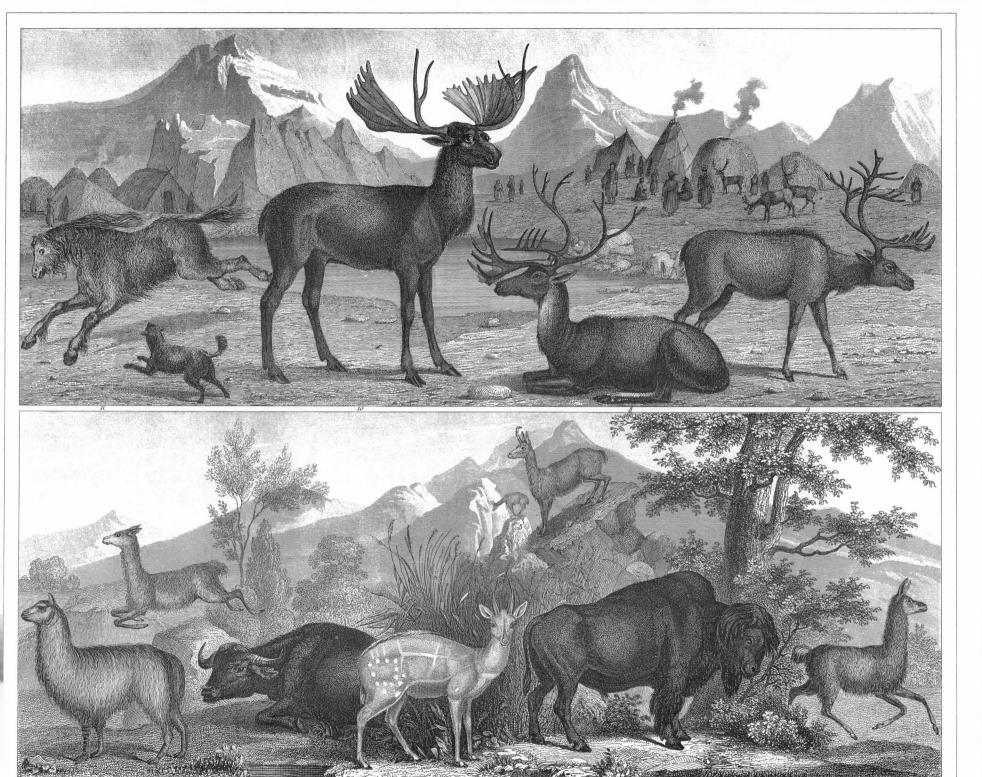

H mm Wintel or coule

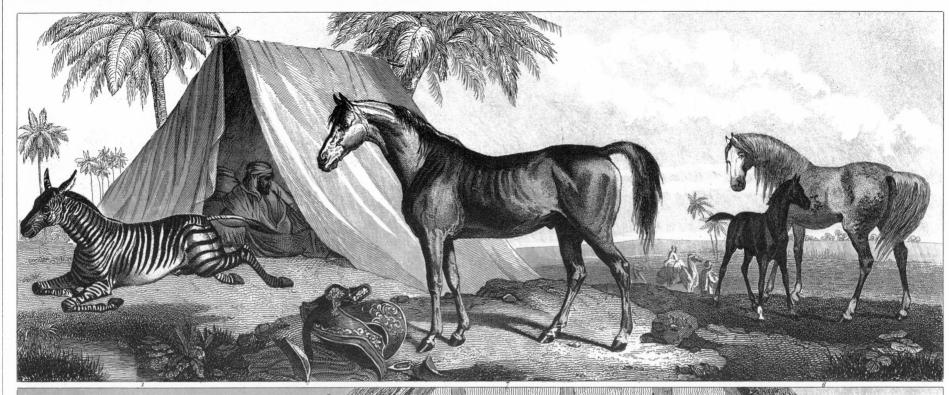

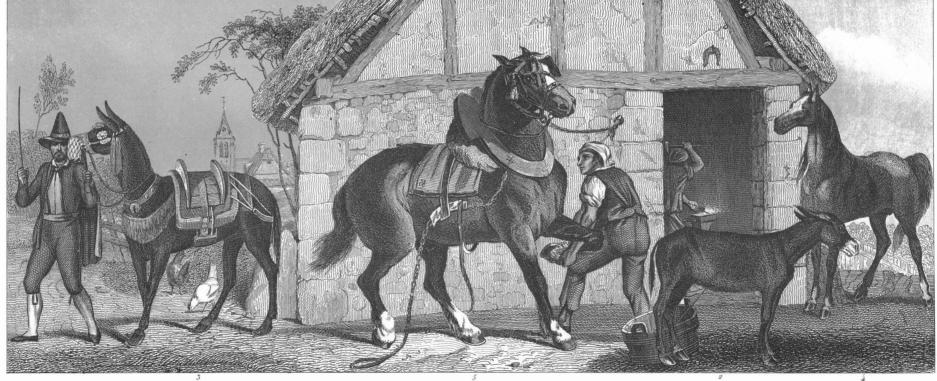

Henry Winkles seul

D. 7.

130

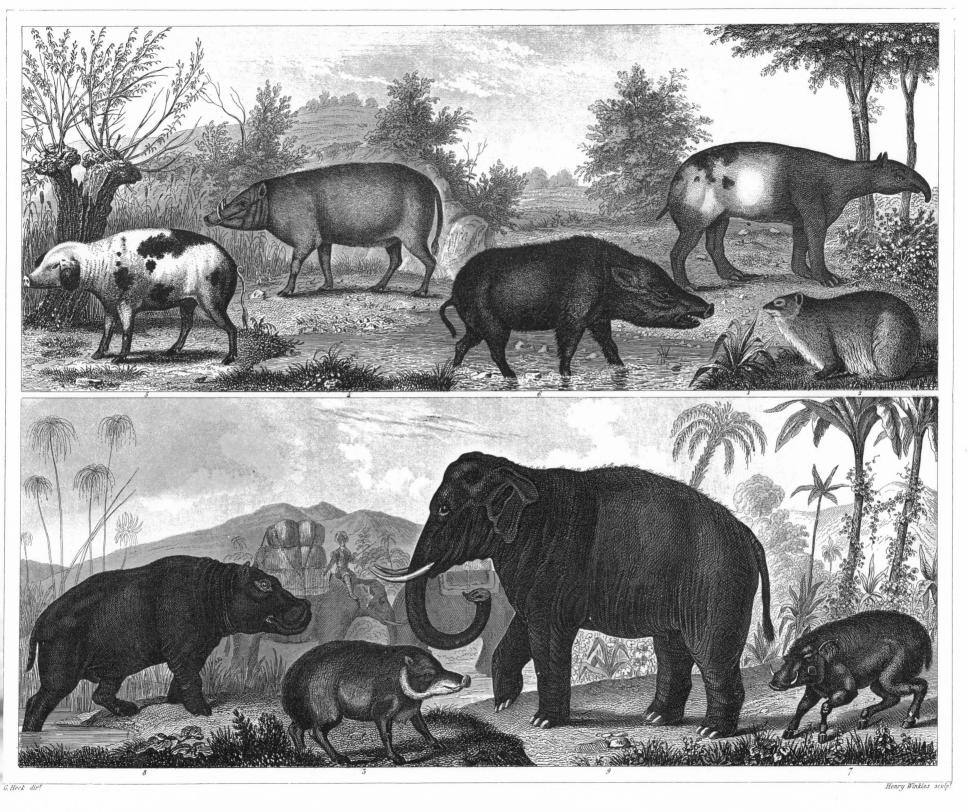

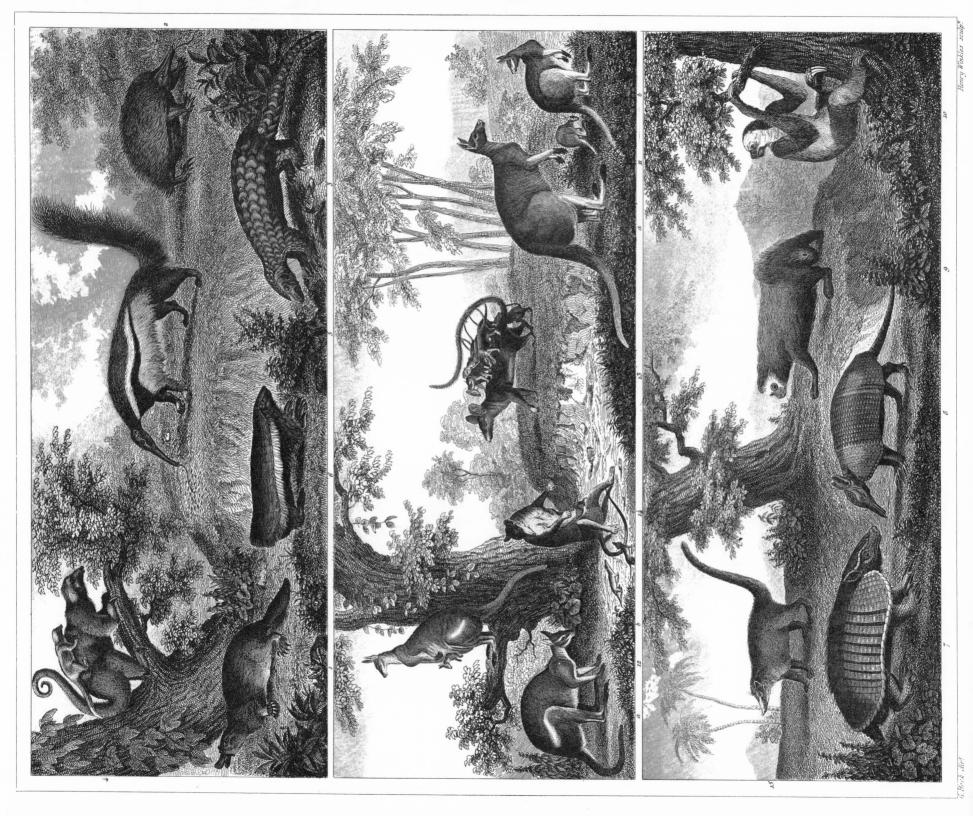

PLATE 113. REPRESENTATIVES OF THE ORDERS EDENTATA, MARSUPIALIA, PHOLIDOTA, CARNIVORA, AND MONOTREMATA

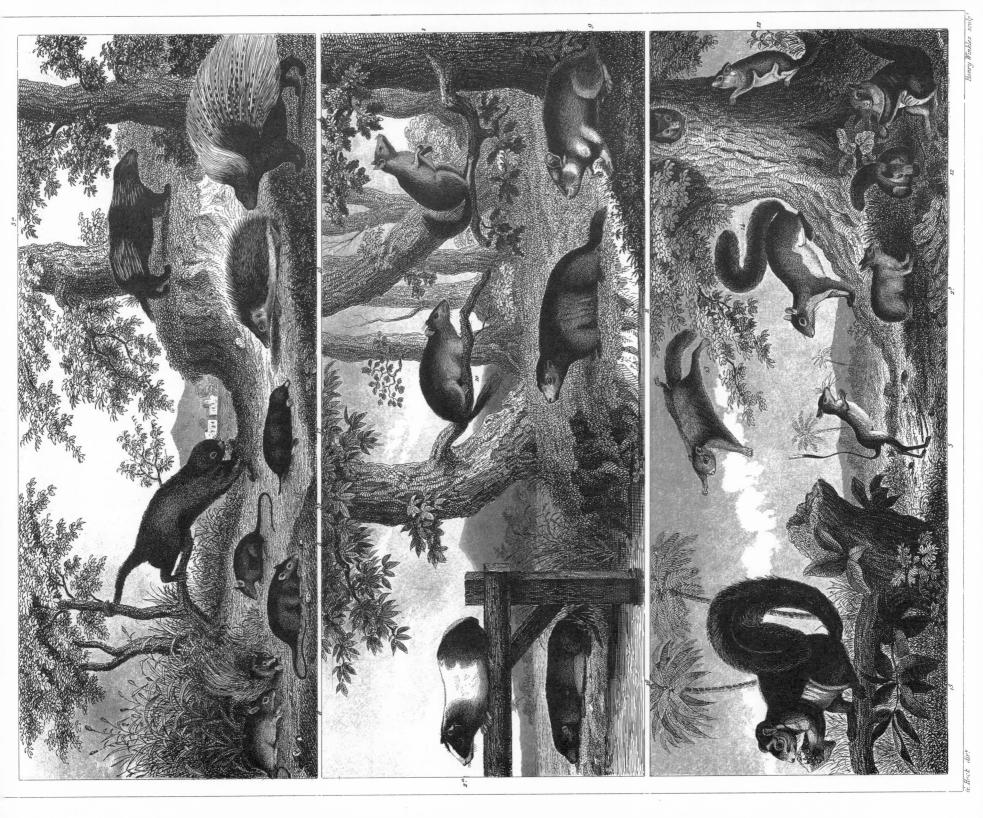

PLATE 114. REPRESENTATIVES OF THE ORDERS INSECTIVORA CARNIVORA, RODENTIA, AND LAGOMORPHA

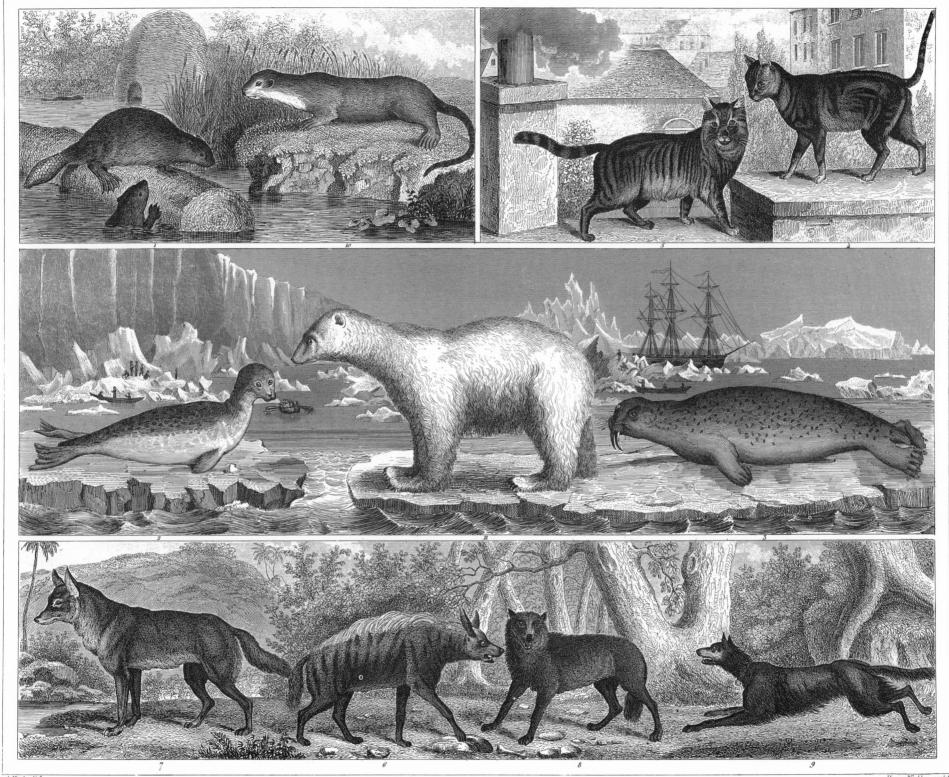

Henry Winkles sculpt

134

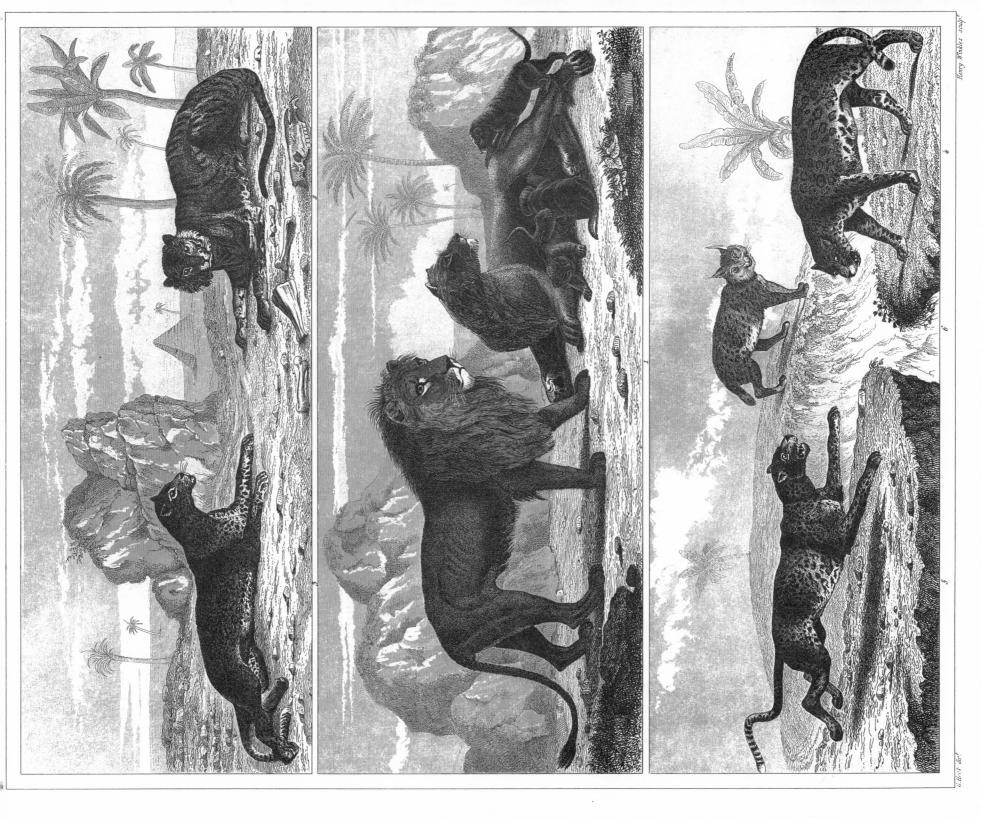

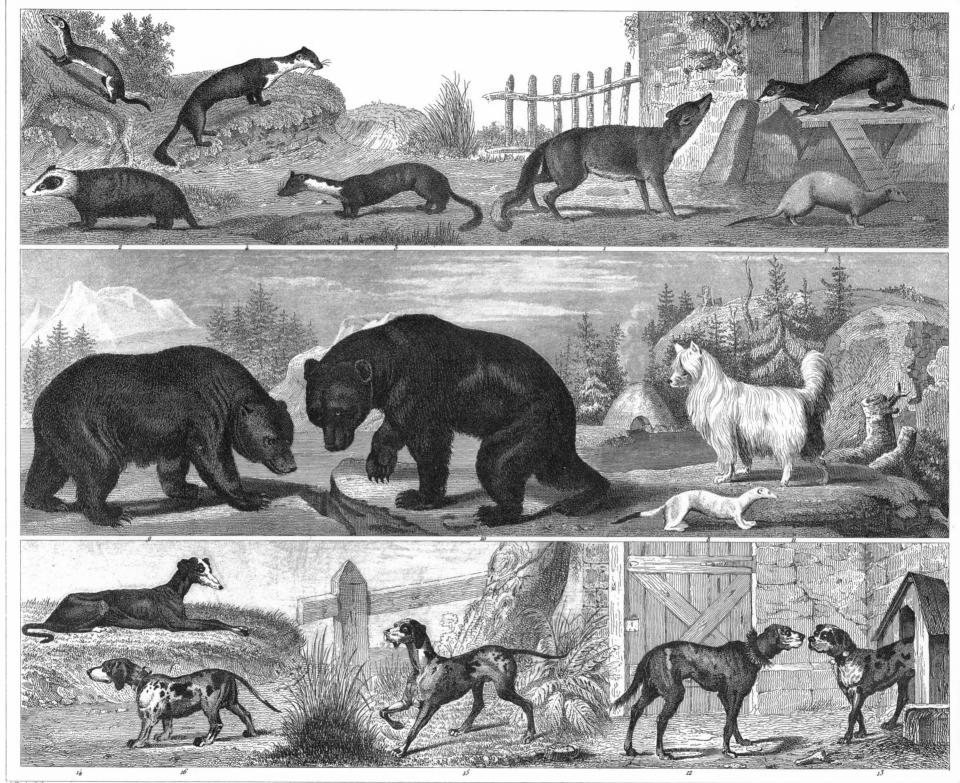

136

Henry Winkles si

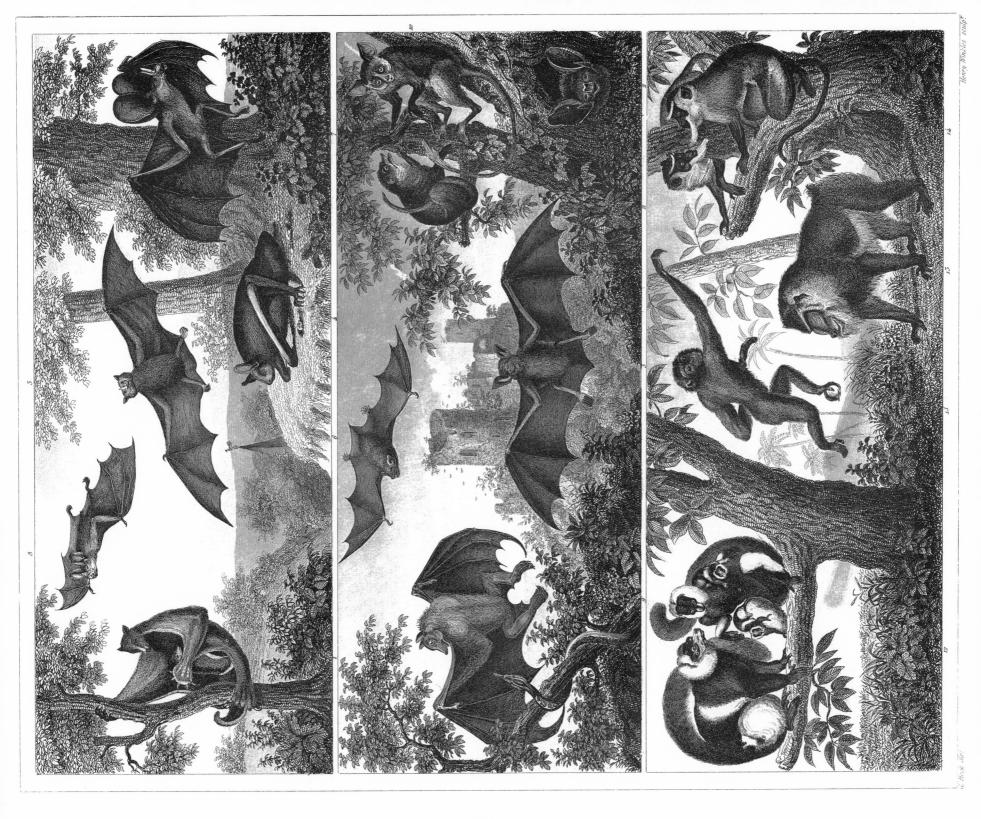

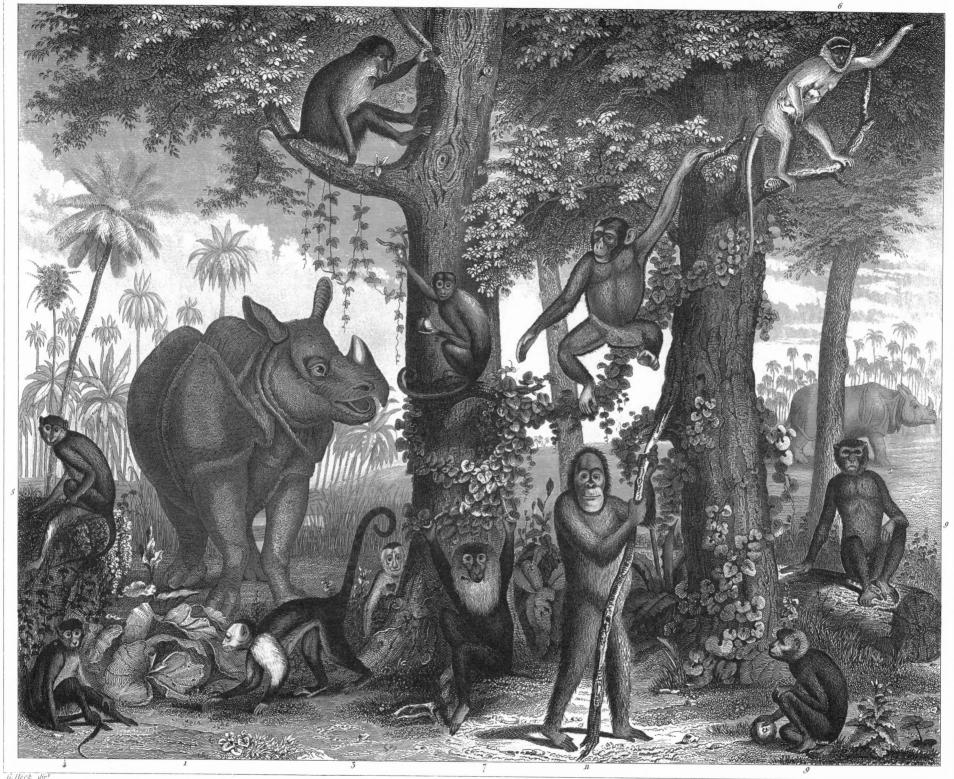

Henry Winkles sculy!

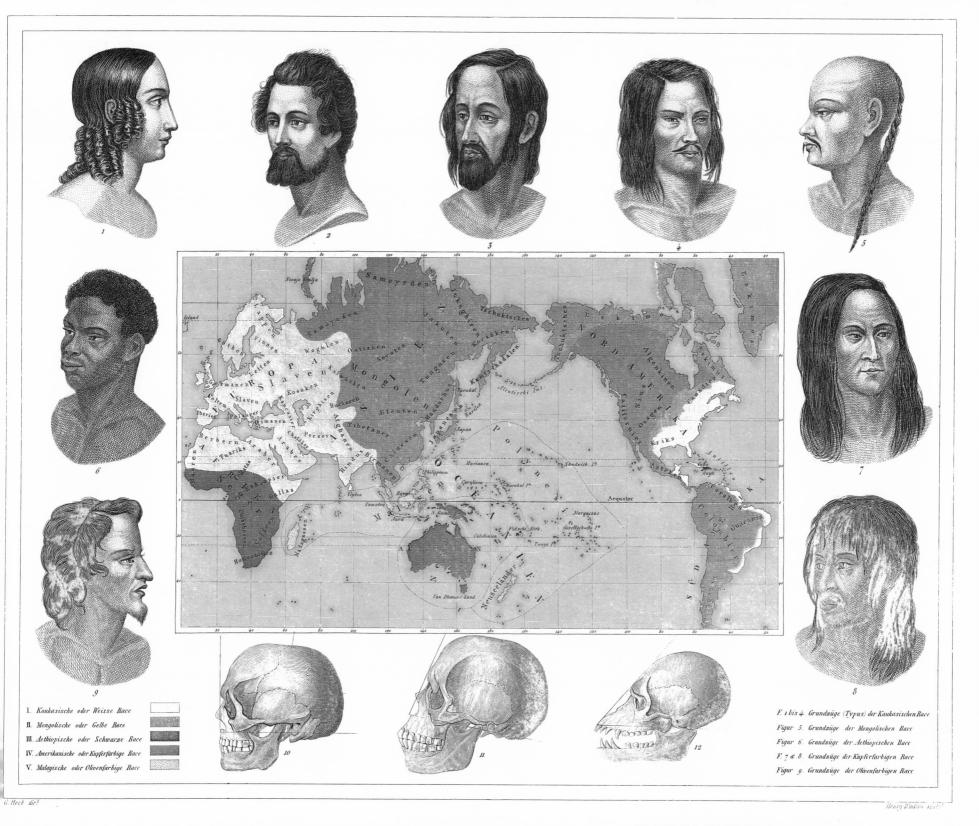

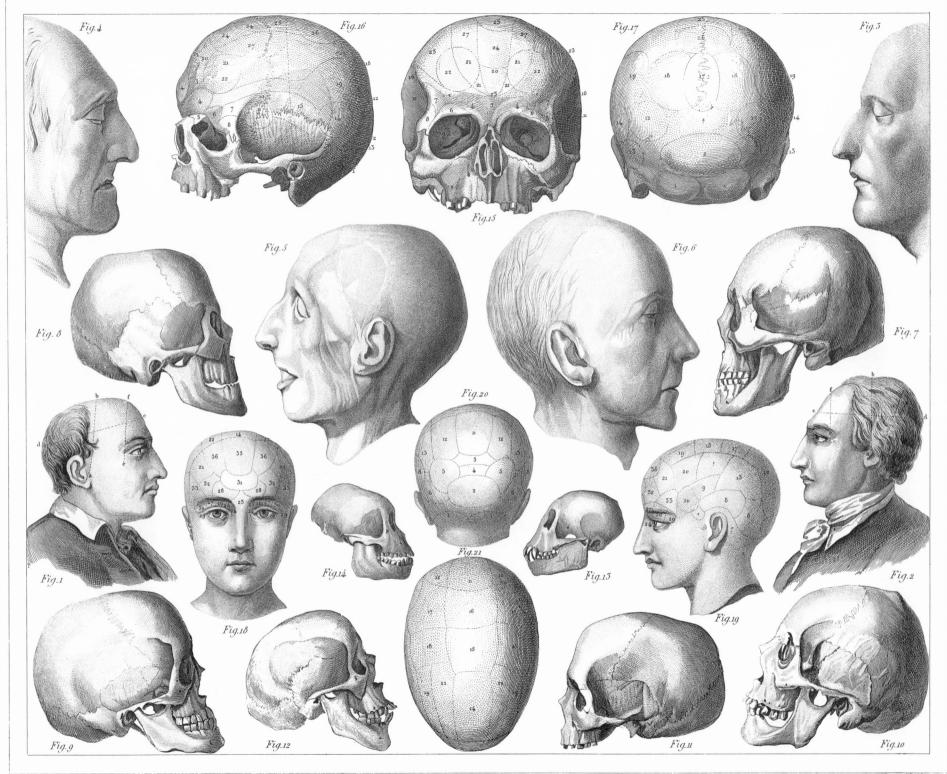

Henry Winkles sould

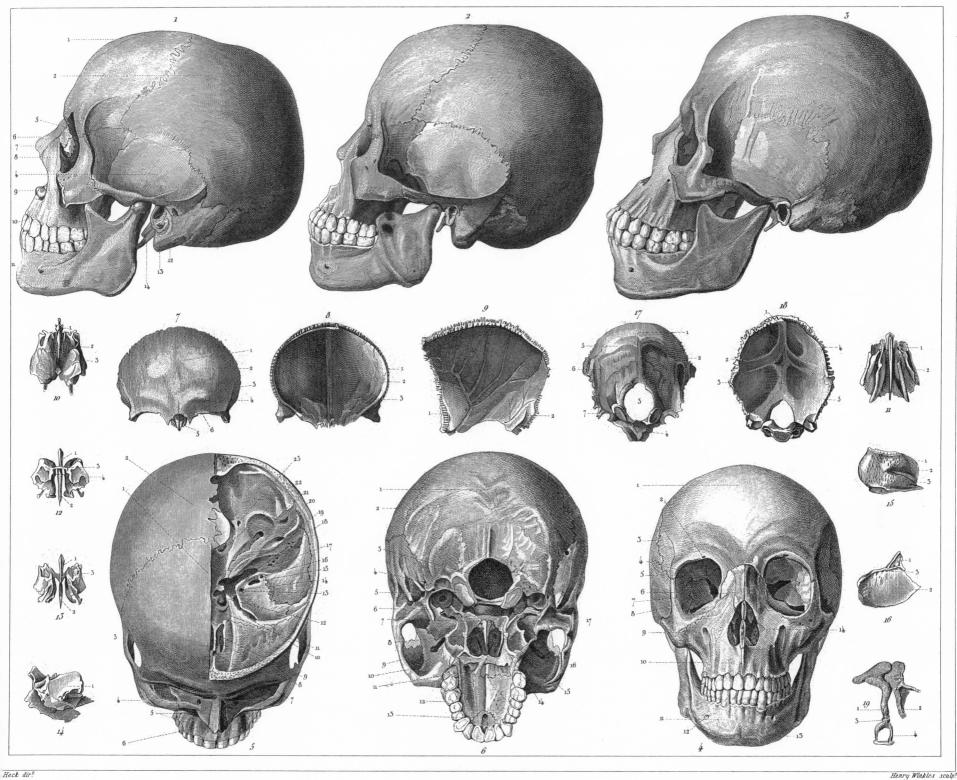

Henry Winkles sculpt

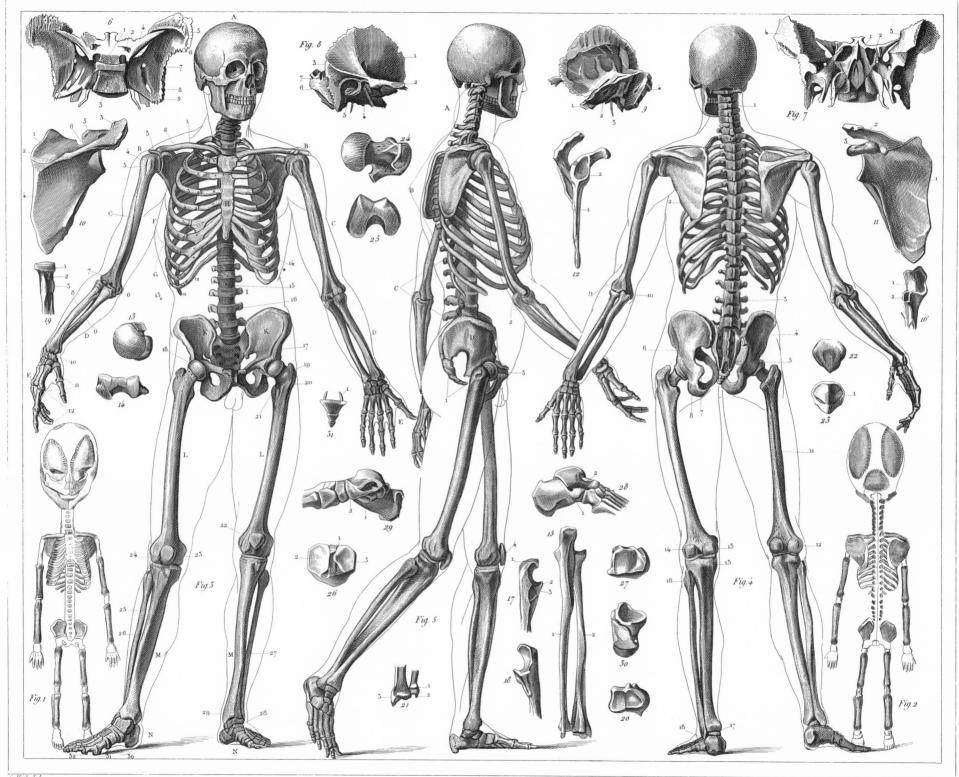

Henry Winkles sculp!

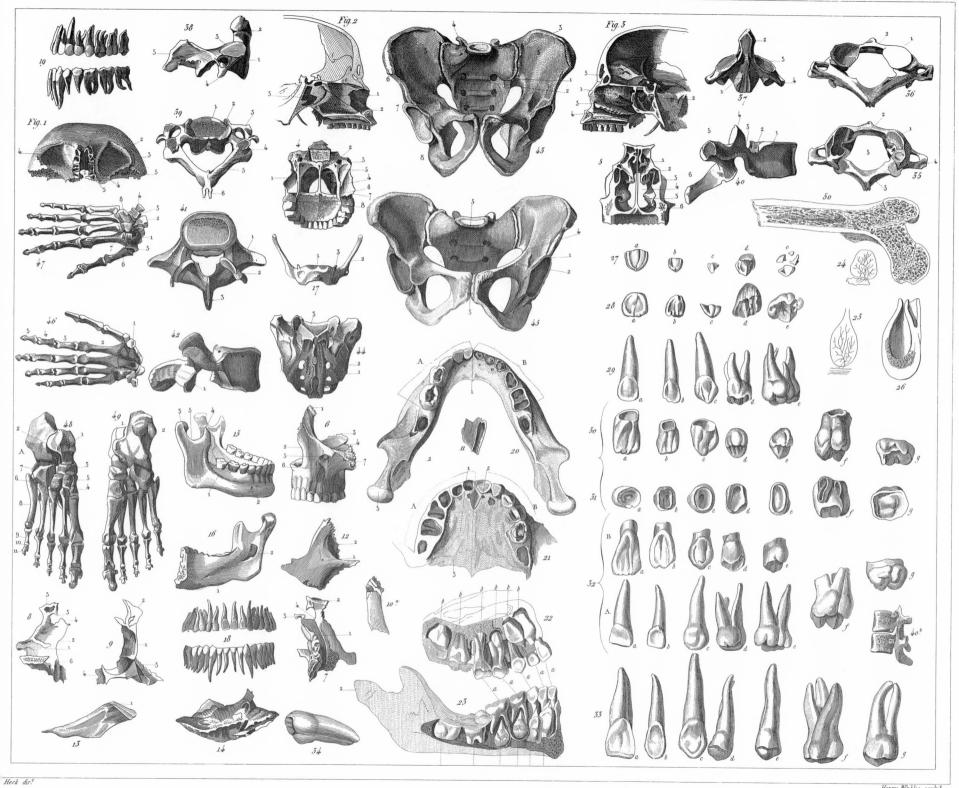

Henry Winkles sculp!

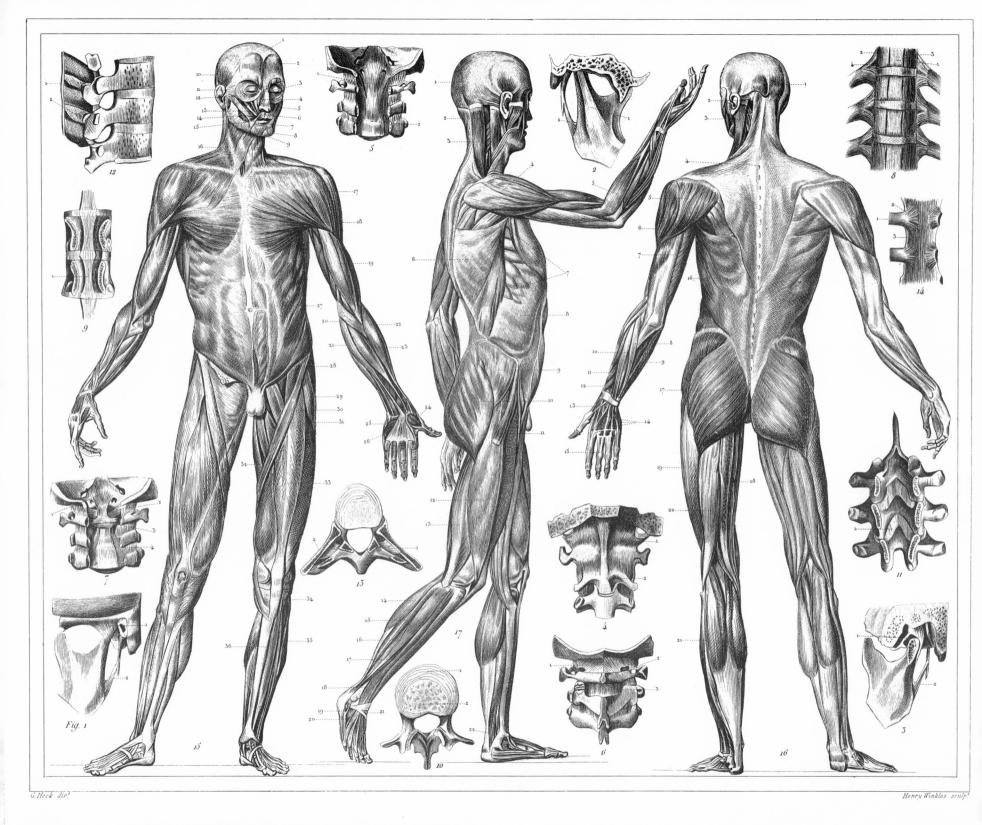

PLATE 125. ANATOMY OF THE LIGAMENTS AND MUSCLES

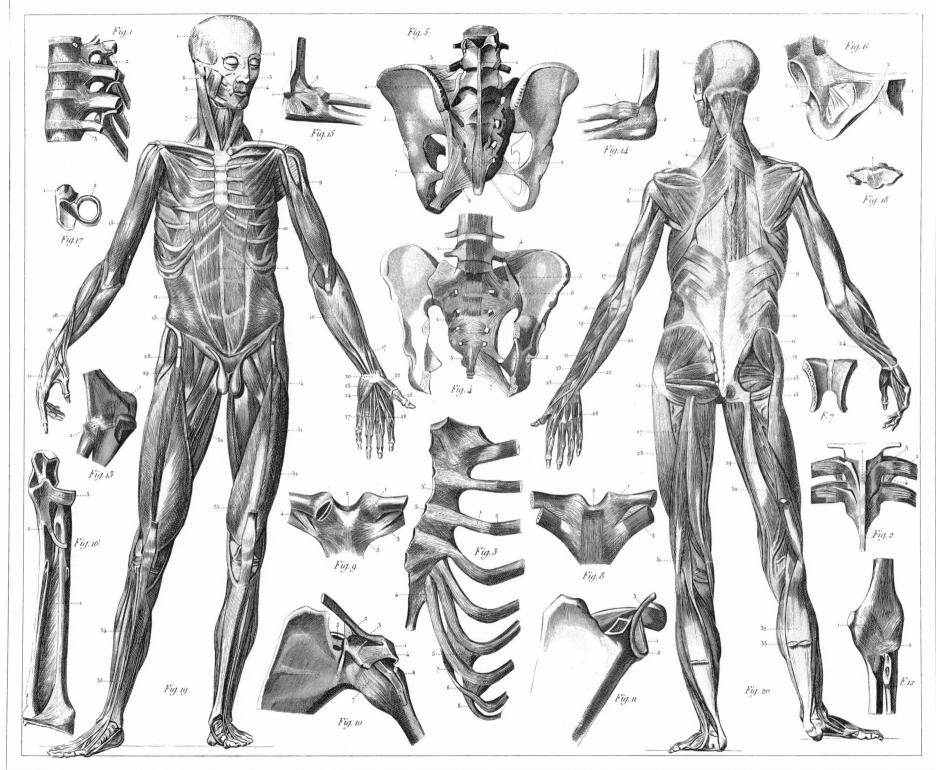

Henry Winkles sculp!

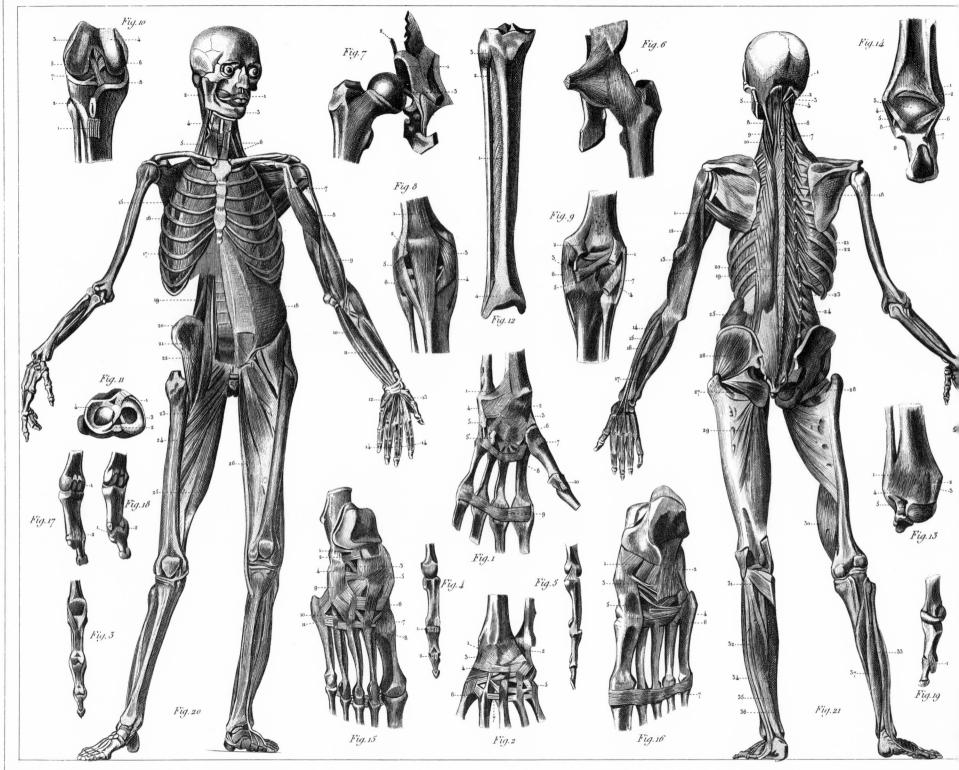

ir. Heck dir!

Hanry W

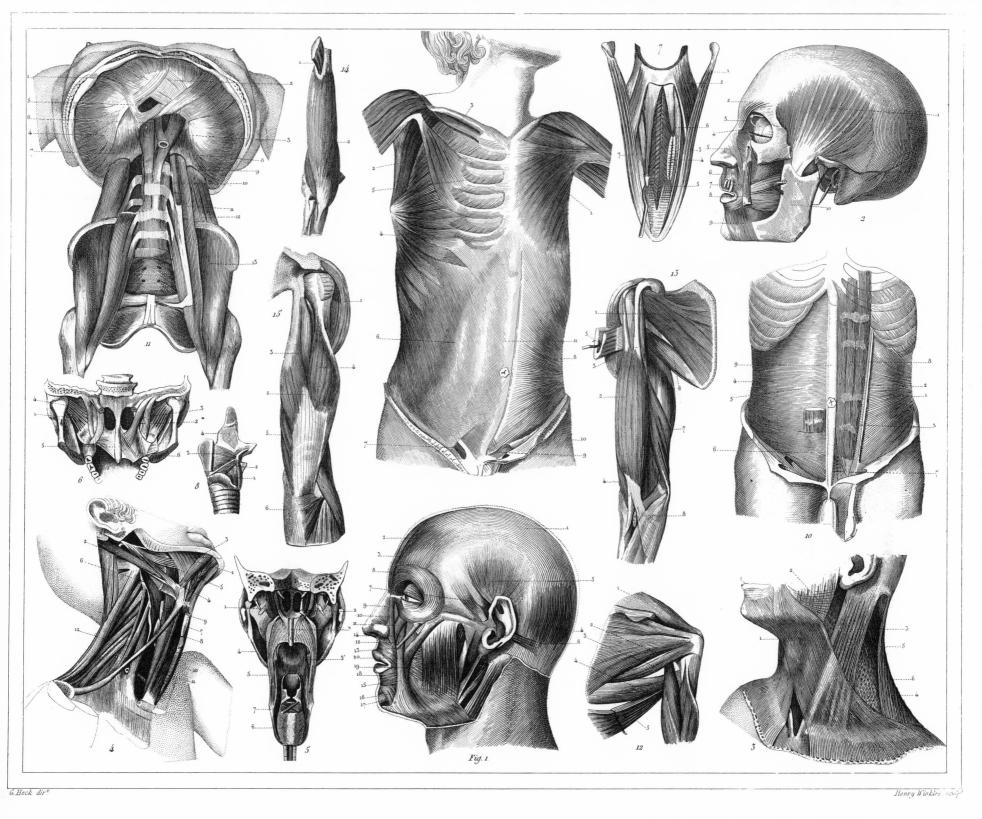

PLATE 128. ANATOMY OF THE MUSCLES

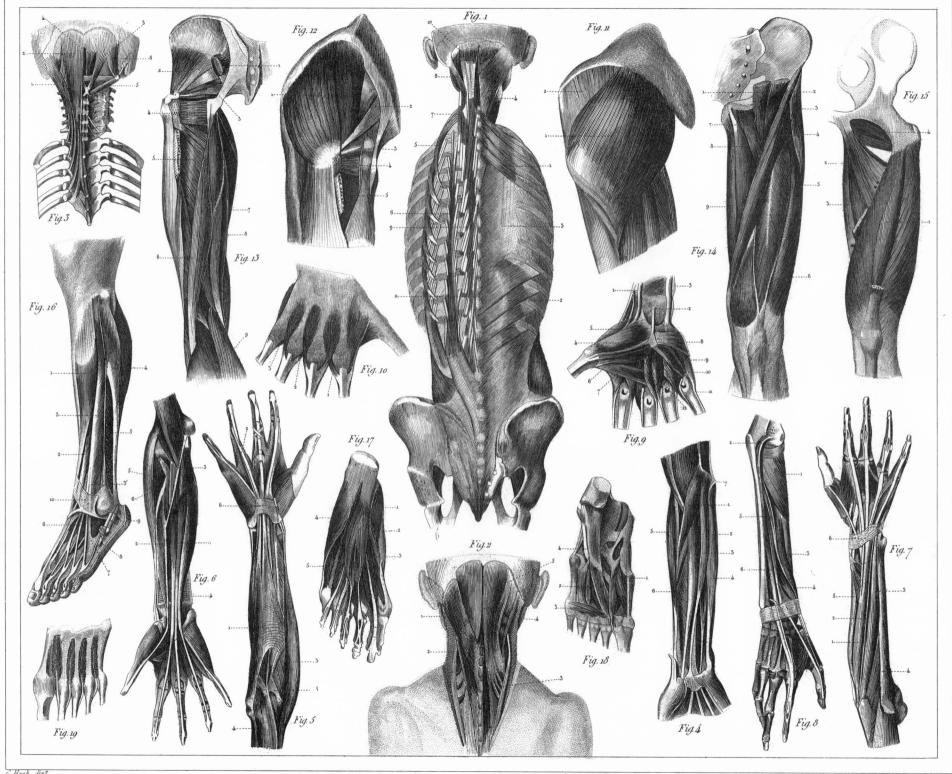

Henry Winkles sculp!

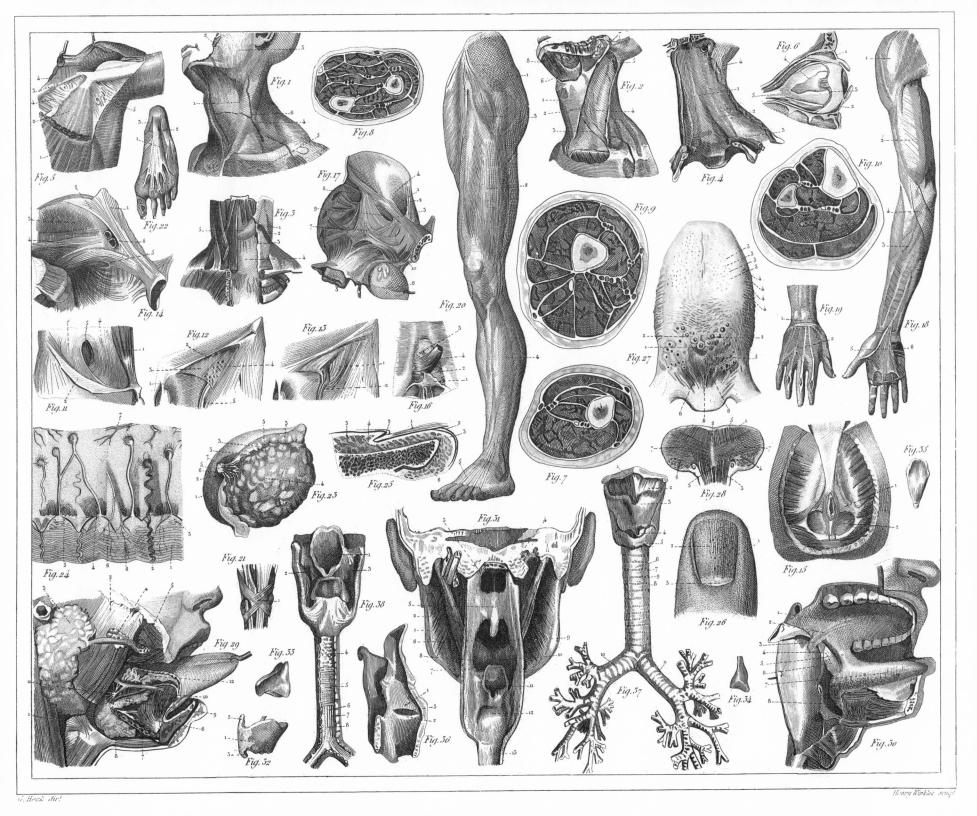

PLATE 130. ANATOMY OF THE FASCIAE, INTEGUMENTS, AND ORGANS OF MASTICATION AND RESPIRATION

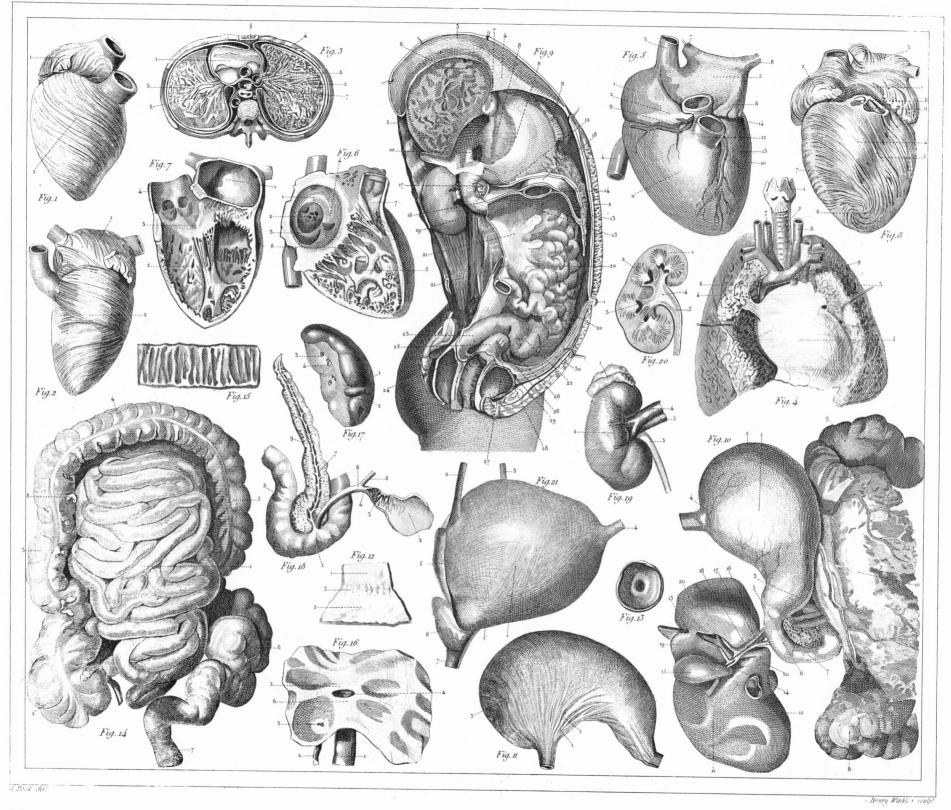

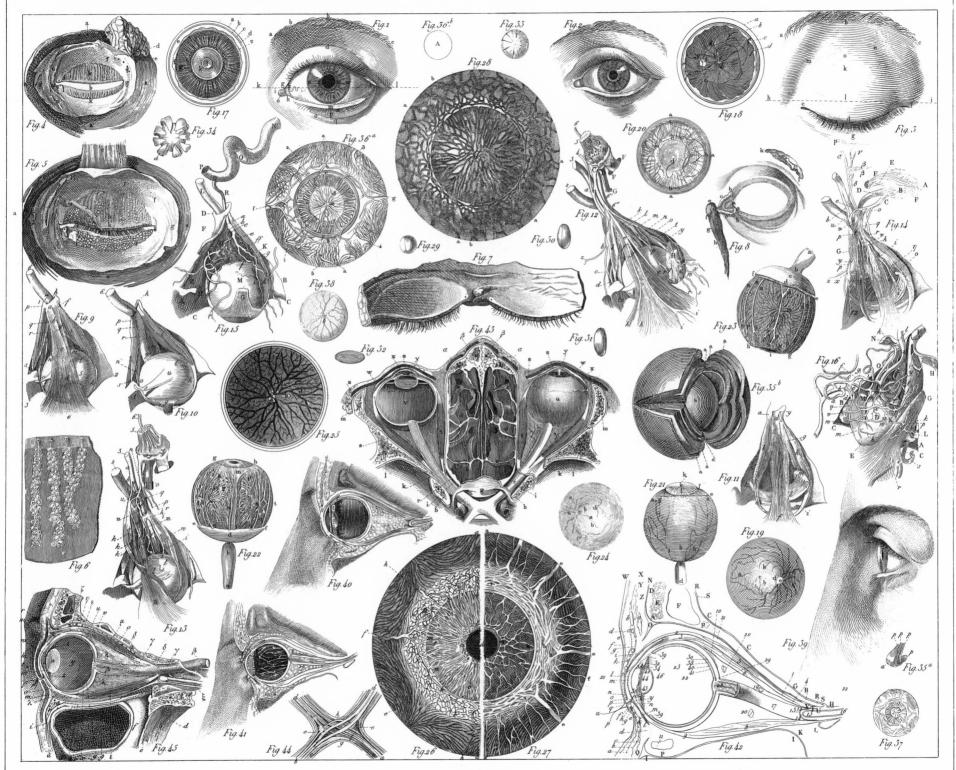

Henry Winkles souls

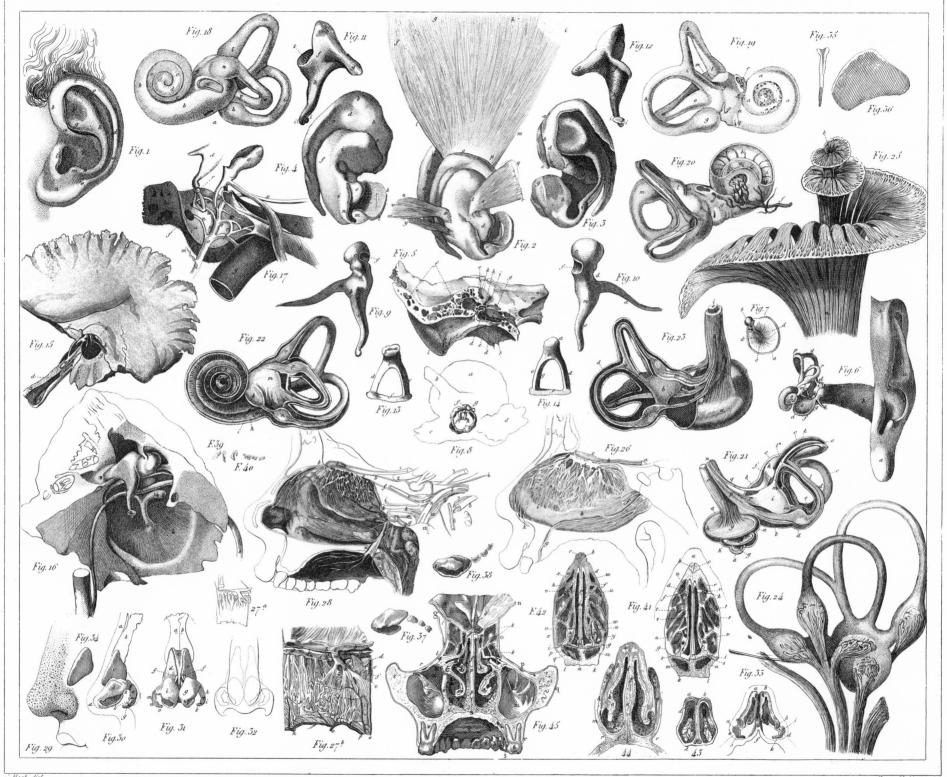

Henry Winkles sculp'

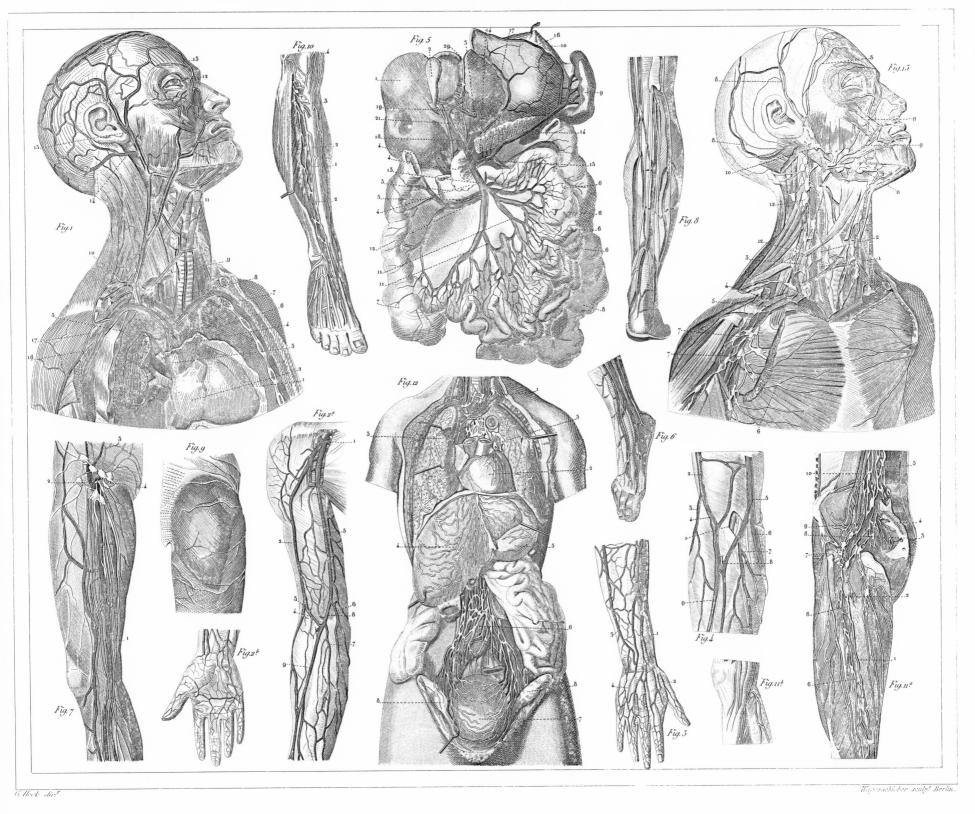

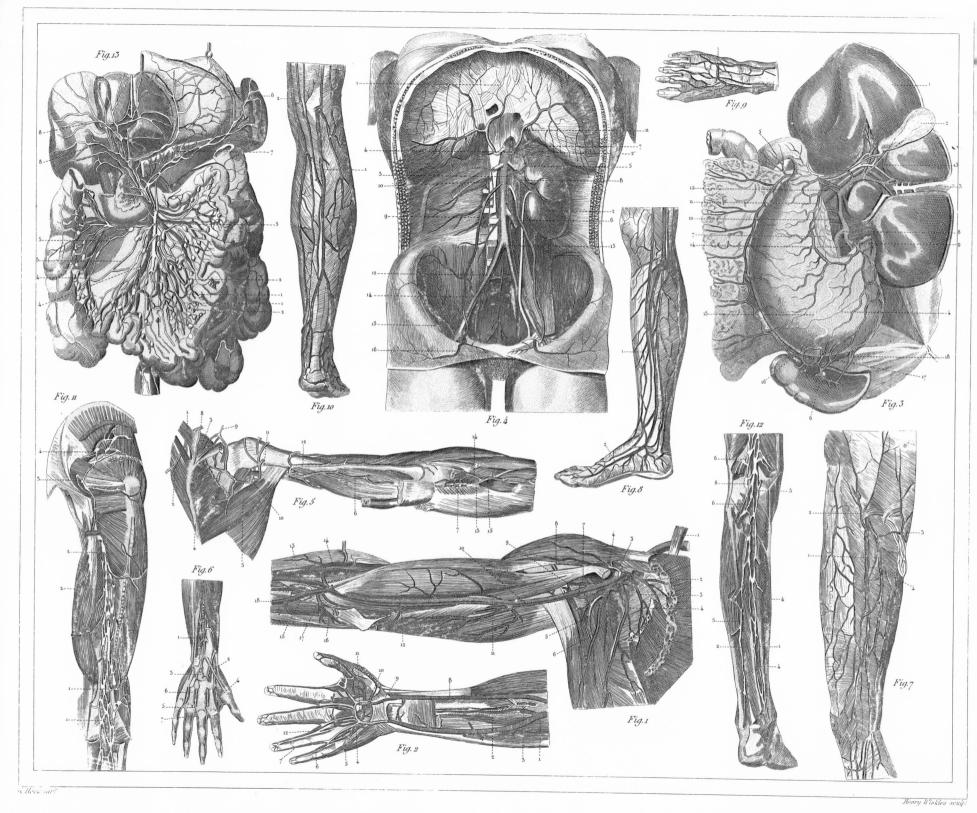

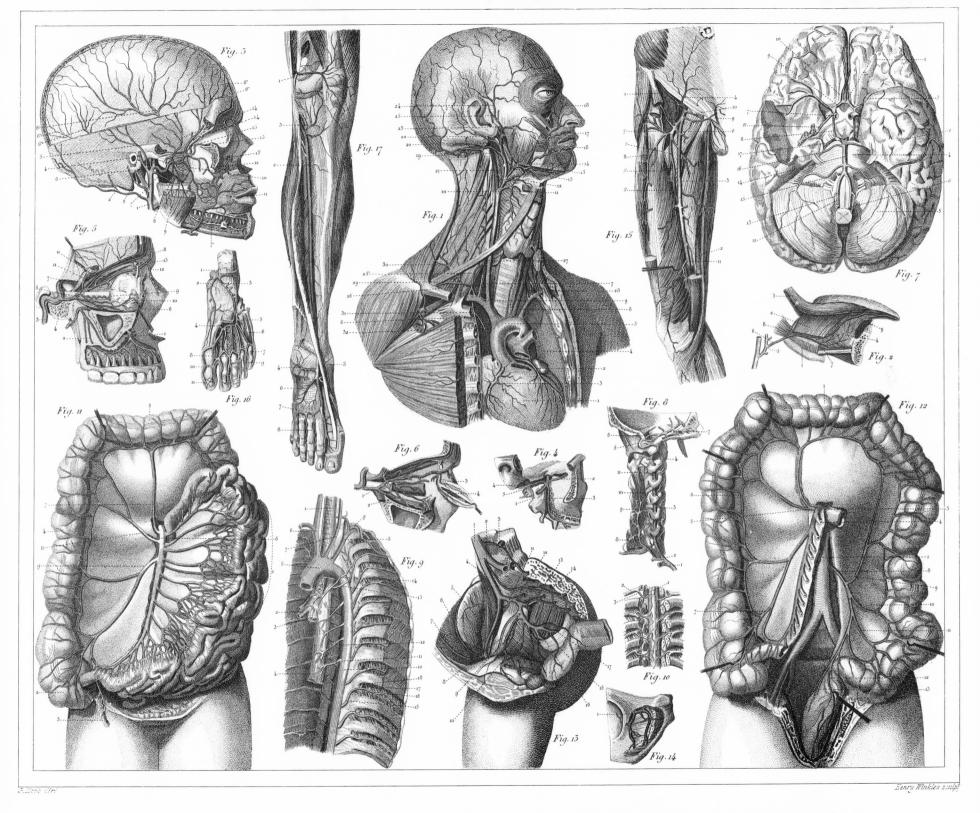

PLATE 136. ANATOMY OF THE VASCULAR SYSTEM

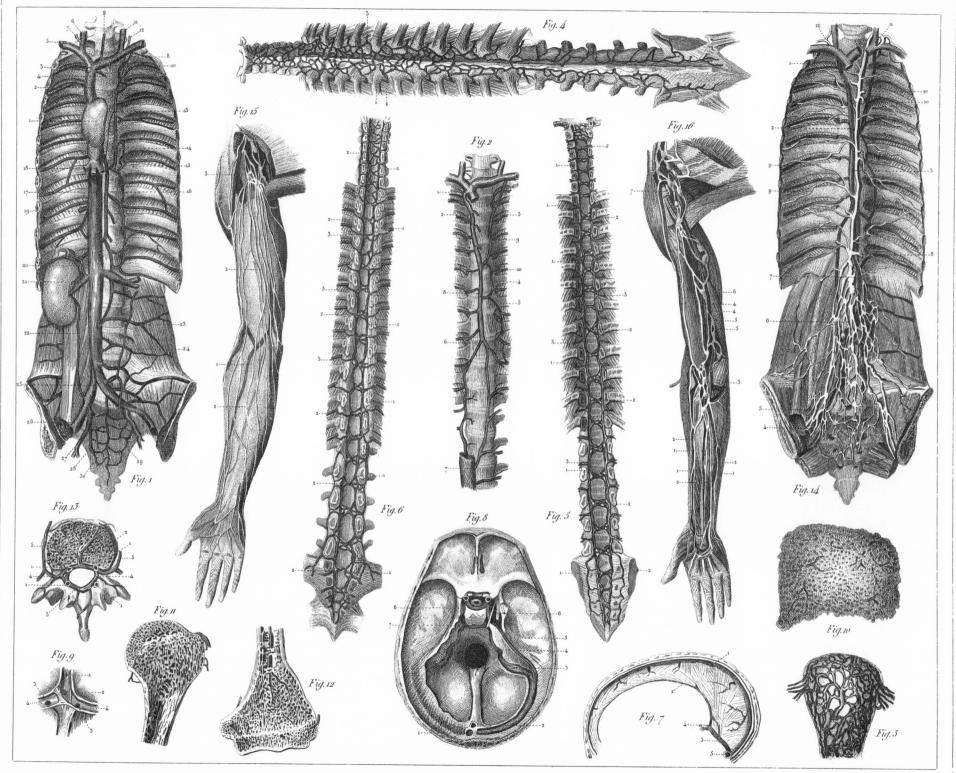

6. Heck dir!

Henry Winkles sculpt

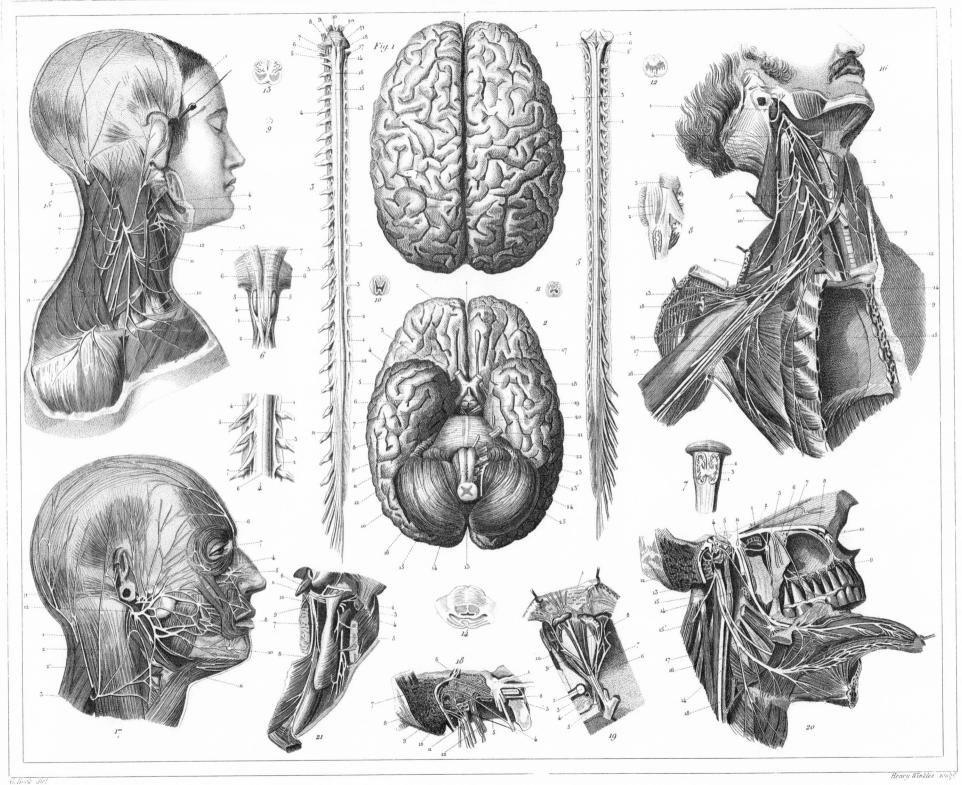

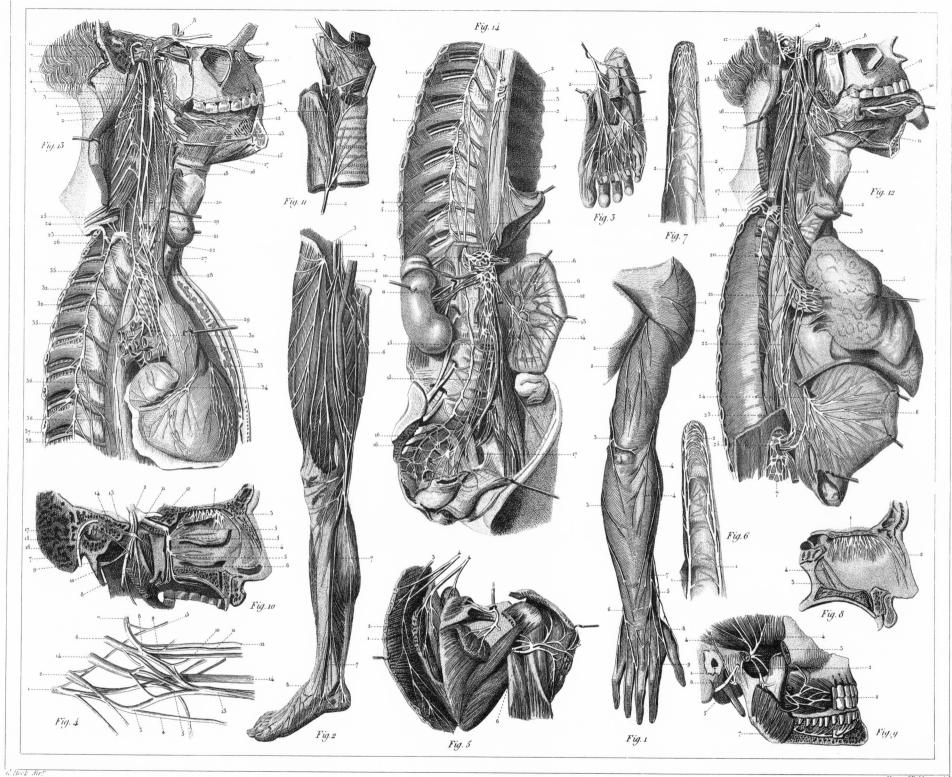

Henry Winkles sculpt

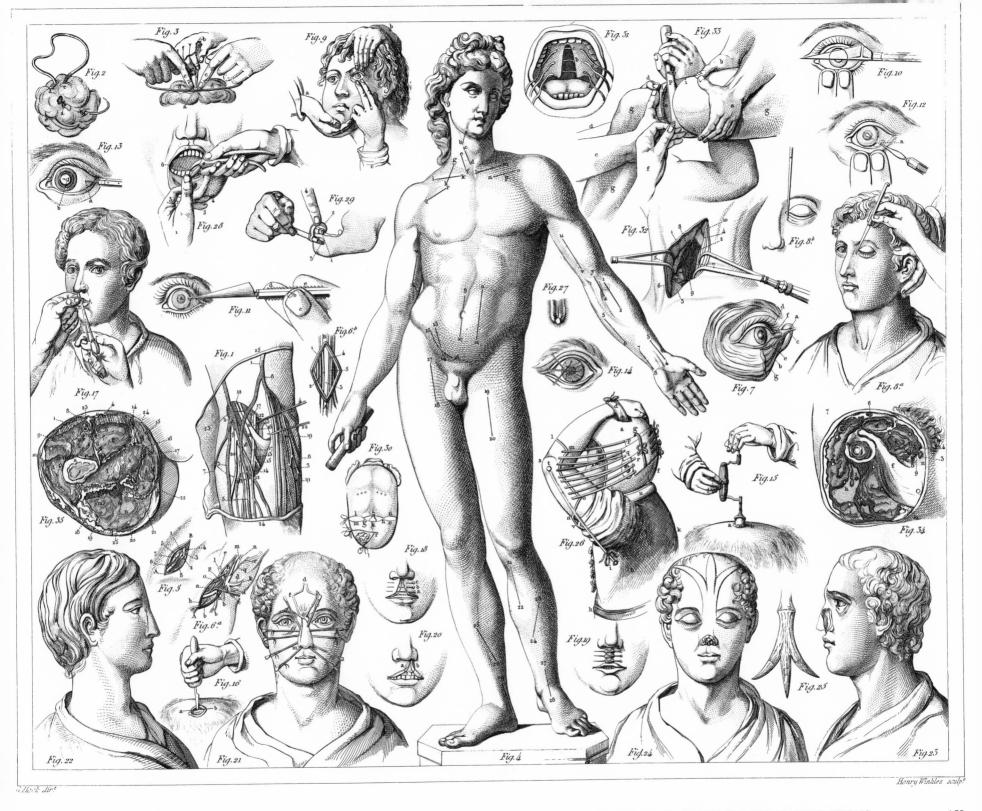

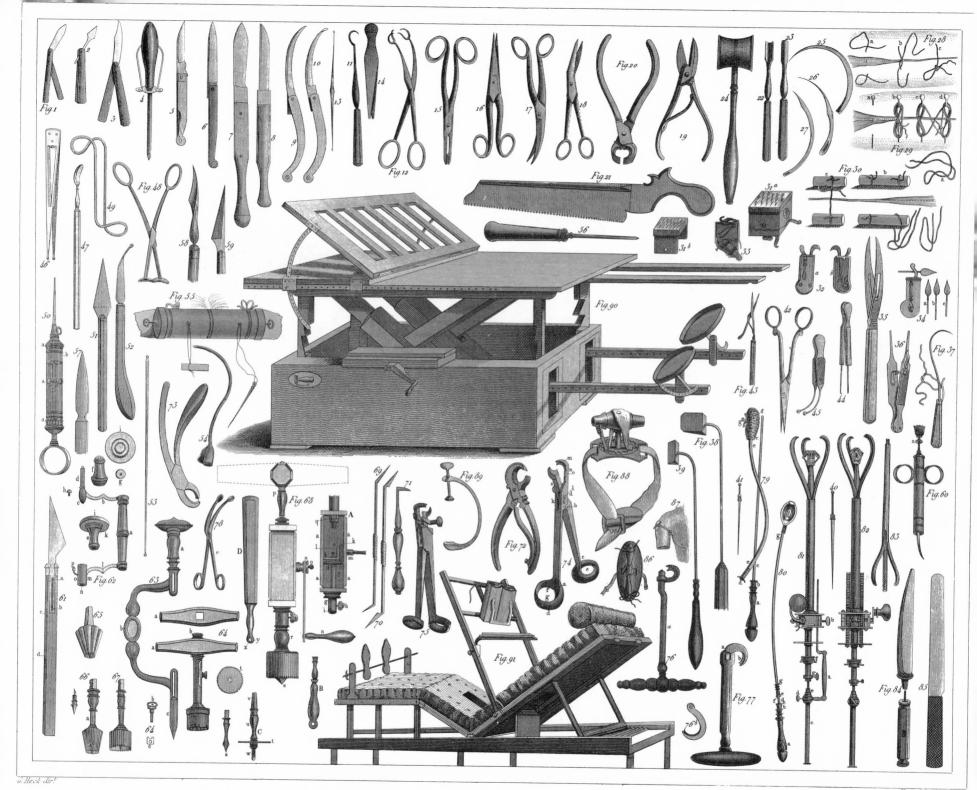

Henry Winkles sculp.

Glossary to the Geographical Maps, Plates 142–185

The Longitude in the Maps is eckoned from the meridian of 'erro. To reduce it to the meridian f Greenwich, add 18° 10′ for W. ong., and subtract the same for E. ong.]

basgia, Abkhas bassien. Abassi (tribe in North Africa) bbitibes. Abbitibbe River bdera, Adra brincate, Abrincafui byssinien, Abyssinia cci, Gaudix chalziche, Akalzike chen, Aix la Chapelle cincum, Buda Pest dagk, Island Adack dmiralitäts Is., Admiralty Islands drianopel. Adrianople driatisches Meer. Adriatic Sea dulis, St. Gothard

dulis, St. Gothard

Egadische In., the islands of
Levanso, Favignana, and Maritimo (the ancient Ægades)

Egäisches Meer, Archipelago
egypten, Egypt

Egyptische Schöne wovon 184/s a.d. Gr., Egyptian miles 184/s to a degree

Elana, Akaba
 Emona, Laybach
 Equat. d. ewigen Schnees, Equator of perpetual snow
 Equatorgrenze d. Schneefalles, Equatorial boundary of snow
 Equatorialgrenze d. europ. tropn.

Getreides, Equatorial boundary of European tropical grain Equatorialgr. des ewigen Schnees,

Equatorial gr. des ewigen Schnees,
Equatorial boundary of perpetual snow

Ethiopien, Ethiopia

ithiopisches Meer, Ethiopian Sea Anten, Antæ (Sarmatian tribe)

Agrigentum, Girgenti Aguja Sp., Cape Aguya Akjerman, Akerman Alands In., Aland Islands Alanen, Alani Albanien, Albany Albaracin, Albarracin Albersche, Alberche River Albis. Elbe River Albufeira, Albufera Albufera See. Lake Albufera Alemannen, Alemanni Aleschki, Aleshki Aleuten Inseln. Aleutian Islands Alexandrien, Alexandria Algesiras, Al Gezira Algier, Algiers Alpen 1200 t. mittlere Höhe, Alps 1200 toises mean height Alpen Gebirge, the Alps Alpes Bastarnicæ, Lower Alps Alpes Rhætiæ, Rhætian Alps Alsen, Isle of Als Alt Californien, Upper California Alter Molo, Old pier Amassera, Amasserah Amboser Hochland, Ambose Highlands Amenis, Ameni Island Amiranten I., Amirante Islands Amisia, Ems River Ammonia, Hargiah Ancyra, Angora Andalusien, Andalusia Andamanen, Andaman Islands Andes von Peru, the Andes of Peru

Andes von Quito, the Andes of

Andros mit Hafen, Andros with

Andöe. Island of Andoen

Anemurium, Cape Anamour

Quito

port

Angeln, Angli

Antinoe, Enseneh Antwerpen, Antwerp Anurigrammum, Anurajapoera Aornus, Ohund Aosta Thal. Aosta Valley Apeliotes (Ost). Southeast tradewind Apenninen Geb, the Apennines Apulien, Apulia Aquæ Sextiæ, Aix Aquitanien, Aquitania Arabien, Arabia Arabische Wüste, Arabian Desert Arab. Mb., Arabian Gulf Arabisches od. Persisches Meer, Arabian or Persian Sea Arachosia, S. E. Cabul Arachotus, Lora River Aral See, Aral Sea Aran, Karabagh Araxes. Aras River Arbela, Arbay Archangelsk, Archangel Archipel von Neu Britannia, Archipelago of New Britain Archipel der Niedrigen Inseln, Low Islands Archipelagus, Archipelago Ardennen, Ardennes Arelate, Arles Argolische In., Archipelago of Nauplia Argelis, Argellez Argentoratum, Strasbourg Argonnen Wald, the Argonne For-Aria, Khorasan Aria See, Lake of Zarrah Ariaspæ, Ariaspes (inhabitants of

Aria, in ancient Drangiana, in

Aquitania

Persia)

Ariminum, Rimini

Armenier, Armenians

Armoricum, ancient

(S. W. France) Arnheim. Arnhem Aroe. Patras Arsanus, Murad River Arsinoe, Suez Art. Magazin, Artillery Arsenal Aru In., Aroo Islands Arvernum, Auvergne Asiatisches Russland, Asiatic Russia Asiatisches Sarmatn., Asiatic Sar-Asow, Azov Asowsches Meer. Sea of Azov Assomtion, Asuncion Assyrn., Assyria Asta, Asti Asturica, Astorga Asturien, Asturias Athabasca S., Lake Athapescow Athen. Athens Athenæ. Athens Athribis. Tel Atrib Atlantischer Ocean, Atlantic Ocean Atschin, Acheen Attalia, Adalia Attici, Inhab. of Attica Augila, Augela Aug. Turinorum, Turin Aug. Vindelicorum, Augsburg Augustodunum, Autun Aulona, Valona Auster (Süd), South Wind Australian. Australia Austral. Busen, Gulf of Australia Austrasien. Empire of Chlodwig Avalites, Zevla Avalitischer G., Bay of Zeyla Aventicum, Avenche Avernum. Lake Averno Azania, Ajan Azorische Inseln, Portugiesisch, the Azores, Portuguese

Azowsches Meer. Sea of Azov B. von Athen od. v. Ægina, Bay of Athens or of Ægina B. von Nauplia od. v. Argos, Bay of Nauplia or of Argos Babadagh, Baba Dag Bagistanus, Beesitoon Bagous Geb., Bagous Mountains Bahama Inseln. Bahama Islands Bai u. Dorf Catalan. Bay and village of Catalan Baiern, Bavaria Baikal S. u. Geb., Baikal Lake and **Mountains** Baireuth, Bayreuth Bairischer Wd., Bavarian Forest Baktrien, Bactriana Balearen. Balearic Islands Baleares, Balearic Islands Balearischer Canal, Balearic Channel Balkan Geb., Balkan Mountains Balkasch S., Lake Balkash Baltica, Sweden Banasa, Meheduma Banater Geb., Banat Mountains Banater Milit. Grenge. Military frontier of the Banat Banks Land, Banks' Island Barcelonnetti, Barceloneta Barcino, Barcelona Baschkiren, Bashkirs Bass Strasse, Bass's Strait Bassistis, Bashnia Baumwolle, Cotton Baumwolle u. Reis, Cotton and rice Bayrische Alpen, Bayarian Alps Bayrisches Hochland, Bavarian **Highlands**

Behrings Meer, Behring's Strait

or Kamtschatkian Sea

Behrings Meer od. Meer von

Kamtschatka, Behring's Strait

Belgien, Belgium Belice, Belici River Belochrobaten, Belochrobati (Slavonian tribe) Belzoi See, Lake Belzoi Berenike, Bengazi Berg Andros, Mount Andros Berkley Sund, Berkeley Sound Bermudas od. Sommer I., Bermudas or Somers Islands Berner Alpen, Bernese Alps Bernstein Küste. Amber Coast Bessarabien, Bessarabia Bieler S., Lake of Biel Bielos See, Lake Biellos Biled-ul-gerid, od. Dattelland, Biled-ul-gerid, or Land of Dates Biscayscher Meerbusen, Bay of **Biscay** Bithynien, Bithynium Blaue Bge., Blue Mountains Bodensee. Lake of Constance Böhmische Höhe, Bohemian Highlands Böhmischer Kessel, Bohemian Basin Bogen Indianer, Strongbow Indians (tribe of the Chippeways) Bolzoi, oder Grosser See, Bolzoi or Large Lake Boreas (Nord), North Wind Borysthenes, Pripet River Borysthenes (Danapris), Dniepr River Bosnien, Bosna Bostra, Boszra Bothnischer Busen, Gulf of Botnia Bracara, Braga Brasilien, Brazil Brasilische Gebirge, Brazil Moun-Brasilische Strömung, Brazil Current Brasilisches Guyana, Brazil Guyana Braunschweig, Brunswick Brede Bugt, Bay of Brede Brienzer S., Lake of Brienz

Britisches Guyana, British Guyana Brivates Haf, Bay of Brest Brüssel, Brussels Brundisium, Brindisi Brundusium, Brindisi Bucephala, Ihylum Bucharest, Bukarest Bucharien. Bokhara Buchweitzen, Buckwheat Bucinarische In., Buccinarian Islands Bulgaren, Bulgari (tribe on the lower Danube) Burdigala, Bordeaux Burgunder, Burgundians Busen von Bengalien, Bay of Ben-Busen von Cadix, Bay of Cadiz Busen Carpentaria, Bay of Carpentaria Busen v. Danzig, Bay of Dantzig Busen von Lepanto oder von Korinth, Gulf of Lepanto or of Corinth Busen v. Lion, Gulf of Lyons Busen v. Lübeck, Bay of Lubeck Tehuantepec

Busen von Panama, Bay of Panama Busen von Taranto, Gulf of Taranto Busen von Tehuantepec, Gulf of Tehuantepec Busen von Triest, Gulf of Trieste Busen von Venedig, Bay of Venice Byblos, Djebail Byzacium, Tunis Byzant., Constantinople

C. d. guten Hoffnung, Cape of Good Hope
C. Horner Strömung, Cape Horn current
Cabillonus, Chalons
Cæsar Augusta, Saragossa
Cætobriga, Setobal
Cajeta, Gaeta
Caledonien, Caledonia
Caledonischer Canal, Caledonian
Canal
Calvadosfelsen, Calvados Rocks
Canal oder La Manche, the British

Channel Canal u. Strömung v. Mozambique, Channel and current Chile, Chili of Mozambique Canal von Yucatan, Channel of Yucatan Canarische Inseln, Canary Islands Candriaces, Nugor River Canopus, Aboukir Cantabrisches Geb. 600 t., Santillanos Mountains 600 toises Cantal G., Cantal Mountains Cap Strom, Cape current Cap u. Ins. Breton, Cape and Island of Breton Cappadocien, Cappadocia Capsa, Wataras Capstadt, Cape Town Capverdische Inseln, Cape Verde Islands Caraibisches Meer. Caribbean Sea Caralis, Cagliari Carenisches Gebirg, Sutherland Highlands Carmania, Kerman Carpathus, Scarpanto Carteia, Ocana Carthaginiensis Sinus. Gulf of **Tunis** Carthago, Carthage Carthago nova, Cartagena Casp. Engpässe, Caspian or Caucasian passes Caspisches Meer, Caspian Sea Caspisch. See liegt 33 t. unter d. Niveau d. Oceans, Caspian Sea. lies 33 toises lower than the level of the ocean Caspische See, Caspian Sea Cassiterides Ins., Scilly Islands Catalonien, Catalonia Celænæ, Dingla Cerasus, Keresoun Cevennen, Cevennes Mountains Chalifat der Abassiden, Caliphate of the Abassides Charolais Geb., Charolles Mountains Chemnis, Ekhmin

Cherson, Kherson

Chersonesus, Cape Razatin Cheviot Gebirge, Cheviot Hills China Wälder. Bathbark Forests Chinesisches Meer. Chinese Sea Chios. Scio Choco Kette, Choco Mountain Chain Chorasmia See. Lake Kharasm Chorasmii. Kharasm Churhessen, Electoral Hesse Cibalis. Palanha Cilicia, Itshili; Die Cilicischen Thore, the Passes of Itshili Cimbrische Halb I.. Cimbrian Peninsula (Jutland) Clearwater See. Clearwater Lake Cnossus, Macritichos Colchis, Mingrelia Colchischer G., Gulf of Mingrelia Colonia, Cologne Comana, Bostan Comer S., Lake of Como Comum, Como Conimbriga, Coimbra Constantinopel, Constantinople Constantinopolis, Constantinople Constanz, Constance Cooks Strasse. Cook's Strait Cophas. Guadel Cophes, Ghizni River Coptos, Ghouft Corcyra, Corfu Cordofan, Kordofan Corduba, Cordova Corps unter Hephæstion, Corps under Hephæstion Croatien, Croatia Croatische Militair Grenze, Croatian military frontier Curene, Kuren Curland. Courland Cvdonia. Canea Cynopolis, Nesle Sheik Hassan Cypern, Cyprus Cyrene, West Barca Cyropolis, Enzellee Cyrus, Politica Cythere. Citria Cyzicus, Kyzik

Dacia, Hungary and Transylvania Daenemark, Denmark Dakien, Dacia (Hungary) Dalmatien, Dalmatia Dampfschiffe von Triest der Œstn. Lloyd Ges., Steamers of the Austrian Lloyd Company from Trieste Dänen, Danes Danubius, Danube River Danzig, Dantzig Daphne, Daia Dardanellen Schlösser, Palaces at the Dardanelles Dardanellen Str., Dardanelles Darnis, Derna Das Alpen Gebirge, the Alps Das Po Thal, the Po Valley Daurisches Alpenland, the Da Oural Alps (branch of the Oural Mountains) Davis Strasse, Davis's Strait Delphi, Castri Dembo Hochland, Dembo Highlands D'Entrecasteaux Spitze, Point d'Entrecasteaux Der Normannen Reiche, the Norman Empires Der Spiegel des todten Meeres liegt 220 t. tiefer als der Ocean, the surface of the Dead Sea lies 220 toises below the level of the ocean Der Wash, the Wash Dergh See, Lake Derg Dertosa, Tortosa Deutsche Meilen 15 auf den Grad, German miles 15 to the degree Deutsche unter Kaiser Friedrich II., Germans under Emperor Frederick II Deutsches Kaiserreich, German **Empire** Deva, Ayas Die Aleuten od. Catharinas Archipel, the Aleutian Islands or Catharine's Archipelago

Die Aleutischen Inseln, the Aleu-

tian Islands

Brigantium, Briançon

Britannien, Gr. Britain

Die Azoren, the Azores
Die bekannte Welt des Alterthums,
the world known to the Ancients
Die Carolinen, the Caroline Islands
Die 3 Oder Mündn., the three
mouths of the Oder
Die Eols Grotten, the Grottoes of
Æolus
Die grosse osteuropäische Ebene
in welcher kein Punkt die Höhe
von 180 t. erreicht, the large

in welcher kein Punkt die Höhe von 180 t. erreicht, the large East-European plain, in which no point reaches the height of 180 toises Die Nord See oder das deutsche

Meer, the North Sea or the German Sea Die Ostsee, oder das Baltische

Meer, the Baltic

Die Philippinen, the Philippine Islands

Die Schweiz, Switzerland
Die sieben Kuhfirsten, the Seven
Cowridges

Diemtiger Th., Diemtig Valley
Dinarisches Alpen Gebirg, Dinarian Alps (on the lower Danube)

Dio Adelphi (Die 2 Brüder), Dio Adelphi (The Two Brothers)

Dioscorides I., Island of Socotra Dioscurias, Iskuria

District diesseits der Donau, District north of the Danube

District diesseits der Theiss, District west of the Theiss

District jenseits der Donau, Dis-

trict beyond the Danube

District jenseits der Theiss, District
beyond (east of) the Theiss

Dobrudscher, Dobrodje

Donau, Danube

Donaumündungen, Mouths of the Danube

Donauwörth, Donauwerth

Donische Kosaken, Cossacks of the Don

Dora Baltea, Doria Baltea River Drapsaea, Bamian

Drontheim, Trondheim

Dschebil el Kamar od. Mond Geb., Gebel Komri, or Mountains of the Moon

Düna, Dvina River Dünkirchen, Dunkirk Durius, Douro River

Durovernum, Canterbury

Eblana, Dublin
Eboracum, York
Ebro Mündung, Mouth of the Ebro
Ebusus, Iviza
Eisenbahnen, Railroads
Eisenbahnkarte von Mitteleuropa,
Railroad chart of Central
Europe

Eismeer, Arctic Ocean
Eisstarre Sand u. Morast Fläche,
Frozen Sand and Swamp Plain
Elusa, Eauze
Emerita Aug., Merida

Emirat v. Cordova, Emirate of Cordova

Enara See, Lake Enara
Engländer unter Richard Löwenherz, the English under
Richard Cœur de Lion

Engl. Colonien am Schwanflusse, K. Georg's Sund und N. S. Wales, English Colonies on Swan River, King George's Sound, and New South Wales

Englische Meilen 69 ²²/₁₀₀ auf den Grad, English miles, 69 ²²/₁₀₀ to the degree

Engpass v. Kaipha, Pass of Kaipha Ephesus, Ayasaluk Epidaurus, Ragusa Vecchia Epirus, Albania Eregli, Erekli Erklärung der Zahlen, Explanation of the figures

Erne See, Erne Loch
Erymanthus, Mount Olonos
Eskimos, Esquimaux

Esthland, Esthonia Euböa, Negropont

Euphrat, Euphrates

Europa vor der Französischen

Revolution, Europe before the

French Revolution
Europa zur Zeit der Kreussüge,

Europa zur Zeit der Kreussuge, Europa zur Zeit Karls des Grossen, Europe at the time of Charlemagne

Europäisch Sarmatien, European Sarmatia

Europäische Besitzungen in Nord Guinea, European possessions in North Guinea

Europäisches Russland, European Russia

Europäisches Scythien, European Scythia

Fadejewski, Fadevskoi
Fær Œer, Faro Islands
Falklands Ins., Falkland Islands
Falsche Bai, Bay of Falso
Faltschi, Faltsi
Fan Œ., Fano I.
Favonius (West), West Wind
(Zephyr)
Feuerland, Terra del Fuego

Finnischer Busen, Gulf of Finland Fischereien von Agoutinitza,
Fisheries of Agoutinitza

Fittre See, Bahr Fittre Flachs u. Hanf, Flax and Hemp Flandern, Flanders Flavia Cäsariensis, Central En-

Flavia Cäsariensis, Central England

Flaviobriga, Bilbao

Flavionavia, Laviana Flevus, Flevo, Zuyder Zee Florentia, Florence

Florenz, Florence Franken, Franconia

Frankfurt, Frankfort

Fränkisches Italien, Frankish Italy Fränkisches Plateau, Franconian

plateau Frankreich, France

Französ. Guyana, French Guyana Französische Lieues 25 auf den Grad, French leagues 25 to the

degree
Franzosen unter Philipp August,

The French under Philip Augustus

Franzosen unter Ludwig IX., The French under Louis IX

Freiburg, Freeburg

Freie Indianer, Free Indians
Freundschafts oder Tonga In.,

Friendly or Tonga Islands
Friedens Fl., Peace River

Frobischer Str., Frobisher's Strait Fuchs Ins., Fox Islands

Fünen, Fyen

Füglæ, Bird Island

Fürstm. Benevent, Principality of Benevento

Fürstenthum Neuenburg, Principality of Neuenburg

Gabæ, Chavos Gades, Cadiz

Gaditanum, Gibraltar

Galætia, Anadolia Galicien, Galicia

Galizien, Galicia

Gallien, Gallia (France)

Gallische Wegestunden wovon 50 auf den Grad, Gallic miles 50 to the degree

Gangischer oder Indischer Golf, Bay of Bengal

Garamantes, Fezzaneers and Tibboo (tribe)

Garda See, Lake of Garda Gaugamela, Kamalis Gaulos, Island of Goza

Geb. v. Granada, Granada Mountains

Gebirge von Auvergne, Mountains of Auvergne

Gedros, Mekran

Gelbes Meer, Yellow Sea

Genf, Geneva

Genfer See, Lake of Geneva Gent. Ghent

Genua, Genoa

Geographen B., Geographer's Bay Geogr. Meilen 15 auf den Grad, Geographical miles 15 to the degree

Gepiden, Gepidæ (tribe)

Germanen, Germans Germanien, Germany

Germanien, Germany Germanische Meer, North Sea Germanische Tiefebene, German

Low Plain Gerste, Barley

Gerste, Hafer, Roggen, Barley, Oats, Rye

Gerste, Roggen, Kartoffeln und Buchweitzen, Barley, rye, potatoes, and buckwheat

Gesellschafts In., Society Islands Gesoriacum, Boulogne

Geten, Getæ (tribe)

Gletscher, Glacier

Glückliches Arabien, Arabia Felix Gogana, Congoon

Gogana, Congoon
Göksschai See, Lake Gokshai
Goldener Chersonesus, Golden

Khersonesus (Malaya)

Gordium, Sarilar

Gordium, Sarilar Gorsynia, Atchicola Gothen, Goths

Gr. Bären See, Great Bear Lake

Gr. Minsh oder Caledonisches Meer, Great Minsh or Caledonian Sea

Gr. Scleven S., Great Slave LakeGrampian Gebirge, GrampianMountains

Graubündner Alpen, Grison Alps Griechenland, Greece

Griechisches Italien, Greek Italy Grönland, Greenland

Gross Britannien und Ireland, Great Britain and Ireland

Gross Phrygia, Phrygia Major Gross Russland, Great Russia

Grosse Antillen, the larger Antilles (West India Islands) Grosse Eskimos, Great Esquimaux

Grosser Atlas, Mount Atlas Grosser oder Stiller Ocean, Pacific Ocean

Grossherz. Hessen, Grand Duchy of Hesse

Grüne Berge, Green Mountains Grünes Vorgebirge, Cape Verde Gürtel des Getreides, Zone of the grains Gürtel ohne Cultur, Zone without Herzogthum, Duchy cultivation Guräus, Kamah River

H. l. or Halbinsel stands for "Peninsula" before the respective names Haag, the Hague Habesch, Habesh Hadrianopolis, Adrianople Hæmus, Balkan Mountains Haf. v. or Hafen von stands for

"Port of" before the respective

names Hafer, Oats Hafer u. Gerste, Oats and barley Hafer u. Weitzen, Oats and wheat Halbinsel Methana, Peninsula of Dara (Methana) Halicarnassus, Boodroom

Haliez oder Galizien, Galicia Han Hai (Südl. Meer), South Sea Harz Gb., Harz Mountains Hasen Ind., Hare Indians Haupt Æquatorial Strömung, Principal equatorial current Haupstadt, Capital

Hebräische Stadien wovon 750 a. d. Gr., Hebrew stadia 750 to the degree

Hebriden oder Western Inseln, Hebrides or Western Islands Hecatompylos, Danghan

Hedschas, Hedias

Heiliges Vgb., Promontorium Sac-

Heliopolis, Baalbec Hellas, Greece

Hellespontus, Dardanelles Helsingör, Elsinore

Heniochi, Tribe in Armenia

Hermopolis, Eshmounein Hermunduren, Hermunduri (tribe

in central Germany) Herodots Erdtafel. Herodotus's Map of the World

Heruler, Heruli (tribe in North Germany)

Herzogl. Sächsische Länder, Saxon Duchies

Hibernien. Hibernia

Hinter Rhein, Hind Rhine (one of the rivulets tributary to the Rhine)

Hippo Regius, Bona Hispalis, Seville Hispanien, Spain Hoch Alp, High Alp Hoch Sudan, Soudah Mountains Hochland von Africa, Highlands of Africa

Hohe Tatarei, Tartar Highlands Hoher Atlas, Mount Atlas

Hügelgruppe v. Sandomir. Group of Hills of Sandomir

Hunds Ribben Ind. Dogrib Indians Hunigaren oder Ungrier, Hungarians

Hydraotes, Ravee River Hypanis, Kuban River Hyphasis, Bevah River Hyrcania, Gyrgaun

Hyrkanisch. Meer, Caspian Sea

I., Ia., Ins., or Insel stands for "Island" before the respective names

I. Helgoland, Island of Heligoland I. Kängurah, Kangaroo Island

I. u. Stadt Cavenne. Island and

Town of Cavenne Ibenes. Ebro River Iberia, Georgia Ichthyophagen, Fish-eaters

Iconium, Konia Illyricum, Illyria

Illyrien, Illyria

Im Sommer 15°, In the summer 66 degrees F.

Im Winter 5°, In the winter 43 degrees F.

Imandra See, Lake Imandra Imaus Geb., Altai Mountains Indischer Ocean, Indian Ocean Indsche Burun, Cape Indjeh Indus Mündn., Mouths of the Indus Ins. d. günen Vorgebirges, Cape Verde Islands

Ins. unter d. Winde, Caribbean Is-

lands

Ipsus, Ipsilihissar Irgis, Irghiz River Irische See, Irish Sea Irland, Ireland Irtisch, Irtish River Is. Hit

Isca, Exe River

Island, Iceland Issedones, Mongolian tribe Ister (Donau), Danube

Ister Mündn., Mouths of the Danube

Italien, Italy

Jacobs Thal, Jacob's Valley Jadera, Zarah

Japanisches Meer, Sea of Japan Jasygien, Jassygia

Jaxartes, Sihon River

Jazygen (Sarmaten), Sarmatians Jenseits d. Ganges, Beyond the

Ganges

Jenseits d. Imaus, Beyond the Altai Jernis, Dunkerrin

Jomanes, Jumna River

Jonische Inseln, Ionian Islands Joppe, Yaffa

Joux See, Lake Joux

Jülich, Juliers

Juliobriga, Revnosa

Julische Alpen, Carnic or Julian Alps

Jura Geb., Jura Mountains Jura Sund, Jura Sound

Jüten, Jutlanders Juvavia, Saltzburg

K. Charlotte S., Queen Charlotte's Sound

Kärnthen, Carinthia

Kaiser Canal, Emperor's Canal Kaiserthum Œsterreich, Empire of Austria

Kalmüken, Calmucks

Kamische Bulgaren, Kama Bulgarians

Kanäle, Canals

Kanal von Bristol, Bristol Channel Kaptschak, Cabjak (tribe in Bokhara)

Karafta oder Sachalin, Caraphta or Sachalin

Karazubazar, Kara Soo Karchedon, Carthage

Karischer B., Bay of Caria Karmanien, Kerman

Karolinen. Caroline Islands

Karpathen 2000 t. mittl. Höhe. Carpathian Mountains 2000 toises mean height

Karpathen Geb., Carpathian **Mountains**

Karpathisches Waldgebirge, Carpathian Forest

Kartagena, Cartagena Karthago, Carthage

Kartoffeln u. Hafer, Potatoes and

Kartoffeln u. Buckweitzen, Potatoes and buckwheat

Kaspisches Meer, Caspian Sea

Kattegat, Cattegat

Kaukasien, Caucasia

Kaukasus Gebirge, Caucasian **Mountains**

Kaukasische Steppe, Caucasian Steppes

Keine Bäume ab. Graswuchs, No trees but grass

Kelten, Celts

Kemi See, Lake Kemin

Kgn. Charlotte I., Queen Charlotte's Island

Kimbrischer Cherson, Cimbrian Chersonesus (Jutland)

Kjölen Gebirge, Koelen Mountains Kirchenstaat, Papal States Kirgisen Horde, Kirghis Horde Kirghisen Steppe, Kirghis Steppes

Kizil Ermak, Kizil Irmak River Kl. Antillen, Little Antilles (Carib-

bean Islands) Kl. Karpathen, Little Carpathians

Kl. Kumanien, Kis Kunsag Klein Phrygia, Phrygia Minor

Klein Russland, Little Russia (Russian Province)

Kleinasien, Asia Minor

Kleine Kirgisen Horde, Little Kir-

ghis Horde

Koblenz, Coblentz Köln. Cologne

Kön. Georg Sund. King George's

König. Georg's I., King George's Islands

Königin Charlotte Sund, Queen Charlotte's Sound

Königreich stands for "kingdom" before the respective names

Konäguen, Tribe of Esquimaux Kong Gebirge, Mountains of Kong

Kopenhagen, Copenhagen

Kosaken, Cossacks

Krakau, Cracow Krym, Crimea

Kuba, Cuba

Kupfer Ind., Copper Indians

L. I. Sund, Long Island Sound Ladoga See, Lake Ladoga Lakeneig, Lakeneigh Laminium, Alambra

Lamose, Lamusa River

Lampsacus, Lamsaki

Lanai, Tribe in North Germany Lancerote, Lancerota Island Land der Finnen, Land of the Finns

Land der kleinen Eskimos, Land of the dwarf Esquimaux

Larice, Lack

Lauriacum, Lorch Lausitzer Gebirg, Lusatian

Mountains

Leba See, Lake Leba Leman S., Lake Leman

Leptis, Lebida

Lerdalsöer, Lerdals Islands Lesbos, Mytilene

Lessöewerk, Lessoe forge

Leucas, Amaxiki

Leuce, Island of Adasi

Ljæchen, Bohemians Libven, Africa

Libysche Wüste, Libyan Desert

Lieukieu In., Loo Choo Islands

Ligeris, Loire River Liguria, Genoa

Ligurisches Meer, Gulf of Genoa

Likeio In., Loo Choo Islands Lilybæum, Boe Lindum, Lincoln Liptauer Alp, Liptau Alps Lissus. Allessio Lithauer, Lithuania Litus Saxonum, Coast of Sussex Litwanen, Lithuania Livadien, Livadia Liviner Thal, Livin Valley Livland, Livonia Livorno, Leghorn Lixus. Luccos River Loja, Loxa Lombardei, Lombardy Lomond S., Lake Lomond Londinum, London Longobarden, Longobardi (Lombards) Lucentum, Alicante Luceria, Lucera Lüneburger Heide, Luneburg Heath Lüttich, Liège Lugdunensis, North West France Lugdunum, Levden Lugovallum, Carlisle Lugumkloster, Lugum Convent Lulea See, Lake Lulea Lumnitz B., Mount Lomnitz Lusitania, Portugal Lutitschen, Luititsi or Wilzi (Tribe in North Germany) Luzern, Lucerne Lycaonia, N. W. Karamania Lyon, Lyons Lystra, Illisera Maas, Meuse River Maasstäbe, Scales Macedonien, Macedonia Mackenzie In., Mackenzie's Islands Macquarie In., Macquarie's Island Madgyaren, Magyars Mähren, Moravia Mährische Höhe, Moravian Highlands Mælar See. Lake Mælar Maeotis See, Sea of Azov

Magelhaens Strasse. Straits of Magellan Mahadia. Mahedia Mahrah, Mahran Mailand, Milan Mainz, Mayence, Maynz Mais und Weitzen, Indian corn and wheat Makariew. Makariv Mal Ström. Malstrom Malaca, Malacca Malmö, Malmo Malmysch, Malmish Malouinen, Falkland Islands Mandeln, Almonds Mandschurei, Manchooria Manytsch, Manich River Maraniten. Maranites, tribe in Arabia Felix Marcomannen, Marcomanni, tribe in S. E. Germany Mare Adriaticum, Adriatic Sea Mare Caspium, Caspian Sea Mare Erythræum (Indisches Meer), Indian Ocean Mare Hyrcanum oder Caspium, Caspian Sea Mare Internum (Mittelländisches Meer), Mediterranean Sea Marea, El Khreit Margaret In., Margaret's Island Margus, Murghab River Marianen od. Ladronen, Marian Islands Marinestunden 25 auf den Grad, Marine leagues 25 to the degree Marisus, Maros River Marmara Meer, Sea of Marmora Marschall Inseln, Mulgrave Islands Marseille, Marseilles Martyropolis, Meia Farekin Mascarenen Inseln. Mascarenhas Islands (Mauritius, Bourbon, etc.) Massaga, Massa Massilia, Marseilles Mater, Matter Mauritania, Algiers

Mauritanien, Algiers

Maxima Cæsariensis. Northern England Mb. v. Issus (Sinus Issilicus), Bay of Iskenderoon Meder. Medes (nation) Mediolanum, Milan Medus, Abkuren River Meer Alpen, Maritime Alps Meer von Ochotsh. Sea of Okotsk Meer von Tarrakai, Gulf of Tartary Meerb. v. Californien, Gulf of California Meerb. v. Sues, Gulf of Suez Meerbusen von Mexico. Gulf of Mexico Meiningen, Meinungen Melgig Sumpf, Melgig Swamp Melitene, Malatia Memel od. Niemen, Meman River Memel Niederung, Tilsit Lowlands Memnis. Korkor Baba Memphis, Mangel Mousa, or Mit Raheni Meninx. Jerba Island Mergui In., Mergue Archipelago Meroe, Gibbainy Mesagna, Mesagne Mesembria, Missivri Mesopotamia, Al Gezira Messana, Messina Mettis. Metz Mexicanische Küstenströmung, Mexican Coast current Miletus, Palatia Militär Colonien, Military colonies Militair Grenze, Military boundary Minius, Minho River Mië See. Lake Mice Mioritz See, Lake Mioritz Mississippi Mündüngen, Mouths of the Mississippi Mittelländisches Meer, Mediterranean Sea Mittlere Kirgisen Horde, Middle Kirghis Horde Mittlere Temperatur nach Celsius, Mean temperature according to Celsius

Mittlere Temperatur nach

Reaumur, Mean temperature

according to Reaumur Mogontiacum, Maynitz Molukken, Molucca Islands Molukken Str., Molucca Passage Mond Gebirg. Mountains of the Moon Mongolei, Mongolia Monreale, Monreal Montagnes Noires, Black Mountains (Black Forest) Mordwinen, Mordwines (tribe in Asiatic Russia) Moreton C. u. B., Moreton Cape and Bay Moscha. Morebat Mosel, Moselle River Moskenasö, Mosken Island Moskau. Moscow Moskwa, Moskow Mosyneoci (tribe on the Black Sea) Mozyr, Mozir Mühlhausen. Mulhouse München, Munich Mündung des Amazonen Stroms, Mouth of the Amazon River Mündung der Elbe, Mouth of the Elbe Mündung des Tajo, Mouth of the **Tagus** Murray Busen, Murray Firth Muthmassliche Grenze der den Alten bekannten Binnenländer von Afrika nach den Geographen Walkenaer und Gosselin. Probable boundary of the African inland known to the Ancients according to the geographers Walkenaer and Gosselin Mutina, Modena of the equatorial current

N. Schottl., North Scotland N. W. Ausflüsse des Æquatorial Stroms, Northwest termination Nabathæer, Nabathæi (nation in Arabia) Nadel Banck, Cape Agulhas Naissus. Nissa Namadus, Nerbuddah River Napeta, Mograt

Narbona, Narbonne Narbonensis, Narbonne Nasamonen, Nasamones (tribe in West Barca) Natal Küste, Natal Coast Navusa mit Hafer, Nausa, with Nazareth Bank und Ins., Nazaret Bank and Island Neagh S., Lake Neagh Neapel (Neapolis), Naples Nelson Canal. Nelson Channel Nemausus, Nismes Nerbudda, Nerbuddah River Neu stands for "New" before the respective names Neu Californien, New California Neu Georgien, New Georgia Neu Helvetien, New Helvetia Neu Karthago, New Carthage Neu Scotia. Nova Scotia Neu Sibirien, New Siberia Neue Hebriden. New Hebrides Neue Saline. New Saltwork Neuenburg, Neufchatel Neuenburger S., Lake of Neufchatel Neustrien, Neustria (the part of France lying between the Meuse, Loire, and the Atlantic Ocean) Nicasia, Island of Karos Nicobaren. Nicobar Islands Nicomedia, Izmid Nieder Canada. Lower Canada Nieder Ungarische Ebene, Lower Hungarian Plain Niederl. Guyana, Dutch Guyana Niederlande, Netherlands Niger, Niger River Nil. Nile River Nil Mündungen. Mouths of the Nile Nilus, Nile River Nîmes. Nismes Niphates Geb., Sepan Mountains Nizza, Nice Norba Cæsaria, Alcantara Nördlicher Oceanus, Arctic Ocean Nördlicher Polarkreis, Arctic Circle Nördlicher Wolga Rücken, Northern Volga Ridge Nördliches Eismeer, Arctic Ocean Nord stands for "North" before the respective names Nord Afrikanische Strömung, North African current Nord Albinger, North Albingians (tribe in Holstein) Nord Georgien, North Georgia Nord Georgien I., North Georgia Island Nord See. North Sea Noricum, Styria, Salzburg, etc. Norische Alpen, Noric Alps Normanische Inseln. Normandv Islands (Guernsey, Jersey, Alderney, Sark) Northlined S., Northlined Lake Norwegen, Norway Notium Vgb., Mizen Head Nuba See. Nuba Lake Nuba Sumpf, Nuba Swamp Nubier, Nubians (tribe) Nubische Wüste, Nubian Desert Numidien, Numidia (East Algiers) Nursa. Norcia Nymegen, Nimegue

Obdorisches Gebirge, Obdorsk Mountains (Northern extremity of the Oural Mountains) Ober See, Lake Superior Obi, Oby Island Obotriten, Obotrites (Vandal tribe in North Germany) Oceanus Atlanticus. Atlantic Ocean Oceanus Germanicus. North Sea Ochus See, mit dem Kaspisches Meere früher wahrscheinlich zusammenhängend, Ochus Sea (Aral Sea), probably formerly connected with the Caspian Sea Odessus, Odessa Odyssus, Odessa Œ. L. v. Ferro, East longitude from

the Island of Ferro

Œ. L. v. Paris, East longitude from

Œca, Tripoli Œlbäume. Olive trees Æsterreich. Austria Æsterreichische Alpen, Austrian Alps Esterreichische Landestheile, Austrian dependencies Æstl. Gats, Eastern Ghauts Æstliche Länge von Ferro, East longitude from the Island of Ferro Æstliche Länge von Paris, East longitude from Paris Offene B., Open Bay Olisibon (Olisipo), Lisbon Olite, Olitte Olivenza, Olivenca Olympia, Miracca Olympische Stadien wovon 600 a. d. Grad, Olympic stadia, 600 to the degree Onega See, Onega Lake Ophiusa, Island of Formentera Orange od. Gariep, Orange or Gariep River Orangen, Oranges Orbelus, Mt. Gliubotin Orchoe, Bassora Oregon oder Felsen Gebirge. **Rocky Mountains** Oregon od. Columbia, Columbia River Orinoco Münd., Mouth of the Orinoco Orkaden, Orkney Islands Orscha, Orsha Orsowa, Orsoya Ortles Sp., Ortler Spitz Ortospanum, Kandahar Osca, Huesca Osmanisches Asien, Ottoman Asia Osmanisches Reich, Ottoman Empire Ossa, Mount Kissovo Ossadiæ (tribe in India) Ost stands for "East" before the respective names Ost Küste von Brasilien. East Coast of Brazil

Ost Preussen, East Prussia

Ost Pyrenäen, East Pyrenees Ost See, Baltic Ost Römisches Kaiserreich. East Roman Empire Ostphalen, Eastphalians (tribe of the Saxon nation) Ostracine. Ras Straki Ostrogothen, Ostrogoths Othrys Gebirg, Othrys (Hellovo) Mountains Ottomaken, Ottomak Indians Oxus, Amoo River Oxyrynchus. Behenese Oxydraces, Oxydracæ (tribe in Moultan) Ozark Gebirg, Ozark Mountains P. Gr. d. Getreides u. d. Zone d. Regens, Polar boundary of grain and of the zone of rain P. Gr. d. Weines u. d. europäisch. tropen. Getreides. Polar boundary of the grape vine and of European tropical grain Padua, Padova Padus. Po River Pæstum, Pesto Palästina. Palestine Palibothra (Palimbothra), Patna Palks Strasse, Palk's Straits Palmyra oder Tadmor, Palmyra or Tadmor Palus Mæotis, Sea of Azov Pamphylia, S. E. Anadolia Pandosia, Mendicino Pannonia, Hungary Pannonien, Hungary Panormus, Raphti Panticapæum, Kertch Paphlagonia, N. E. Anadolia Paphos, Baffa Parætonium, Al Bareton Parisii, nation in North France Paropanusus Geb., Hindoo Koosh Parthia, Province in Khorasan and N. E. Irak Parthiscus (Tibiscus), Theiss River Pasargadæ (Persepolis), Istakar Pastona, Pasten Patagonien, Patagonia

Patagonische Kette, Patagonian Cordilleras Pax Julia, Beja Pella, Allahkilissia Pelopones, Morea Pelusium, Tineh Penninische Alpen, Pennine Alps Pentapolis, Chittagong Pentland Strasse, Pentland Firth Pergamus, Pergamo Pers. Golf, Gulf of Persia Persien. Persia Persische Parasangen, wov. 25 a. d. Gr., Persian parasangs, 25 to the degree Persischer M. B., Gulf of Persia Peruanische Strömung, Peruvian current Petschenegen, Petshenegs (Tartar tribe) Peucetia. Terra di Bari Peuciner, Peucini (tribe in Galicia, etc.) Phanagoria, Tmutarakan Pharsalus, Pharsala Pharselis. Tekrova Phazania, Fezzan Philippi, Filibah *Philippinen*, Philippine Islands Philippopel, Philippopolis Phocæa, Fokies Phryger, Phrygians (nation in Anadolia) Physikalische Karte von Europa (—Afrika, —Asien, —Nord America, —Süd Amerika), Physical map of Europe (—Africa, —Asia, —North America, —South America) Pictavi (nation in Gallia Aquitania) Picten, Picts (nation in Scotland) Pielis See, Lake of Pielis Pindus Mn., Agrafa and Smocovo Mountains Pisidia, S. E. Anadolia Pithyusen (Pityusæ), Islands of Iviza, Formentera, etc. Pitvus. Soukoum Pitkarainen, Pitcairn's Island Plateau v. (or von) stands for

"Plateau of" before the respective names Plateau von Ost Galizien, Plateau of East Galicia Plattkopf Indr., Flathead Indians Podolien, Podolia Polænen, Polænæ (Slavonic tribe) Polargr. d. Bäume, Polar boundary of trees Polargr. d. Moose u. Beeren, Polar boundary of mosses and berries Polargr. d. Obstbaumes. Polar boundary of fruit trees Polargr. d. Œlbaumes. Polar boundary of the olive tree Polargr. d. Weinstocks, Polar boundary of the grape vine Polargrenze, Polar boundary Polargrenze d. Banane u.d. tropischen Getreides. Polar boundary of the banana and of the tropical grain Polargrenze des Getreides, Polar boundary of grain Polargrenze d. Palmen, Polar boundary of palm trees Polargrenze d. Weinstocks u. d. europäisch. trop. Getreides, Polar boundary of the grape vine and of the European tropical grain Polar Kreis, Arctic (or Antarctic) Circle Polen, Poland Polesiens Urwälder u. Sümpfe, Primitive forests and swamps of Polesia (now Minsk in Russia) Pommern, Pomerania Pompelo, Pampeluna Pont. Eux. (Pontus Euxinus), Black Sea Pontinische In., Ponza Islands Pontus, N. E. Bulgaria Pontus Euxinus (Schwarzes Meer), Black Sea Porata, Pruth River Portland Sp., Portland Point Prag, Prague Prairien. Prairies Premnis, Cas. of Ibrim

Paris

Pr. Holland, Prussian Holland (district in East Prussia) Preussen, Prussia Preussische Landestheile. Prussian districts Preussische Höhe, Prussian Plateau Prophtasia (Prophthasia), Dook-Propontis, Sea of Marmora Pskow. Pskov Psyllen. Psylli (tribe in N. Africa) Ptolemäische Erdtafel, Map of the world according to Ptolemy Ptolemäische Stadien wovon 700 auf den Grad, Ptolemæan stadia 700 to the degree Pudosh, Pudog Pura. Pureg Purpur Ins., Purpureæ Insulæ (probably Salvage Islands) Putea, Fuentes Putziger Wiek, Bay of Putzig Pyrenæi, Pyrenees Pyrenäen. Pyrenees Pyreneos Geb., Pyrenees Quaden, Quadi (nation in Hungary) Quadra u. Vancouvers I., Vancouver's Island Querimbe, Querimba Rathenow, Rathenau Ratiaria, Arcer Palanka Rauhe Alp, Rauhe Alpe Rauraci. Tribe in Alsace Rch. d. Picten, Kingdom of the **Picts** Ree See, Lake Ree Regen Fluss, Rain River Regen S., Rain Lake Regenloses Gebiet, Rainless territory Regensburg, Ratisbon Reich der Aglabiten, Kingdom of the Aglabites (dynasty of Ibrahim ben Aglab) Reich Alexanders des Grossen, Empire of Alexander the Great Reich der Bulgaren, Empire of the

Bulgarians Reich der Chazaren, Empire of the Chazares (nation in East Russia) Reich Karls d. Gr., Empire of Charlemagne Reich des Porus, Kingdom of Porus (in India) Reich der Seleuciden, Kingdom of the Seleucidæ (dynasty of Seleucus) Reich der Slaven. Empire of the Slavonians Reiche d. Angelsaxen, Anglo-Saxon possessions Reiche d. Briten. Possessions of the **Britons** Reiche d. Dänen. Possessions of the Danes Reiche d. Scoten. Possessions of the Scots Reis und Kaffee, Rice and coffee Reis und Mais, Rice and Indian corn Republik Genua. Republic of Genoa Republik Venedig. Republic of Venice Reus. Reuss Reval. Revel Rha (Wolga), Rha (Volga) Rhätische Alpen, Rhætian Alps Rhagæ, Rha Rhein. Rhine River Rhein Bayern, Rhenish Bavaria Rhegium, Reggio Rheims. Reims Rhenus, Rhine Rhoda, Rosas Rhodanus, Rhone River Rhodus, Rhodes Rhön Gb.. Hohe Rhæne Mountains Rhoxolanen, Rhoxolani (Sarmatian tribe) Römisch Deutsches. Kaiserreich, Romano-Germanic Empire Römische Meilen wovon 75 auf den Grad, Roman miles 75 to the degree

Römisches Reich, Roman Empire

Römisches Reich zur Zeit Constan-

tins des Grossen. Roman Empire in the time of Constantine the Great Roggen, Gerste, Weitzen, Rve. barley, wheat Roggen u. Gerste, Rye and barley Roggen und Weitzen, Rye and wheat Rom. Rome Roma, Rome Rothes od Erythräisches Meer. Red Sea Rothes Meer od. Arabischer Meerb, Red Sea Rotomagus, Rouen Roxolanen, Roxolani (Sarmatian tribe) Rückkehr der Flotte unter Nearch, Return of the fleet under Near-Rücklaufende Strömung, Counter current Ruinen v. Babylon, Ruins of Baby-Ruinen von Carthago, Ruins of Carthage Ruinen v. Palmyra. Ruins of Palmyra Ruinen v. Susa. Ruins of Susa Rumanier, Rumini (tribe in Bulgaria, Moldavia, and Moravia) Rusadir, Melilla Rusicada, Stora Ruspæ. Sbea Russische Werste 104.3 auf den Grad. Russian Wersts 104.3 to the degree Russisches America, Russian America Russlands beste Kornfelder, Russia's best grainfields Rusucurrum, Koleah Saas Thal, Saas Valley Sabier, Sabians (St. John the Baptist's disciples; sect in Persia) Sachalites Golf, Bay of Seger

Sachsen, Saxony

Switzerland

Sächsische Schweiz, Saxonian

Saguntum, Murviedro Saima S., Lake Saim Saker, Sakr Salamis, Coulouri Salmantica, Salamanca Salomons Ins.. Solomon Islands Saloniki, Salonica Salz Seen, Salt Lakes Salz Wüste, Salt Desert Sambus, Chumbul River Samoieden, Samovedes Samoa oder Schiffer In., Navigators' Islands Samosate, Samisat Samsun, Samsoun Sandw. Cobi od. Hanhai. Desert of Cobi Sand Wüste, Sandy Desert Sangarius, Sakariah River Sarazenen. Saracens or Moors Sardes, Sart Sardica, Sophia Sardinien, Sardinia Sariphi Geb., Shar Mountains Sarmatæ, Sarmatians Sarmatien, Sarmatia Sarmatische Tiefebene, Sarmation Lowland (East Prussia, Poland, and part of Russia) Sarmatisches Meer, Sarmatian Sea (part of the Baltic) Sarnia, Island of Guernsey Satala, Shaygran Sauromaten, Sarmatians Saxen, Saxony (Saxonians, Saxons) Scandinavisches Meer, Scandinavian Sea Schetland In., Shetland Islands Schlangen Indr., Snake Indians Schlesien, Silesia Schloss v. Romelli, Romelli Castle Schnee Alp, Snowy Alps Schotland, Scotland Schwäbische Alp, Suabian Mountains Schwarzes Meer 52 t. tief, Black Sea 52 toises deep Schwarzw. (ald), Black Forest Schweden, Sweden

Schweden, Norwegen und Dänemark, Sweden, Norway, and Denmark Schwedische Landestheile, Swedish districts Schweiz, Switzerland Sclaven K. (üste), Slave Coast Scodra, Scutari Scordisci, tribe in Slavonia Scythopolis, Bysan Scupi. Uskup Scylacium, Squillace See, Sea or Lake See Alpen, Maritime Alps See Alpen von Californien, Maritime Alps of California See Alpen der Nord West Küste, Maritime Alps of the N. W. Coast See Arsissa. Lake Van See Küsten Kette v. Venezuela. Sea coast mountain chain of Venezuela See Likari, Lake Likaris Seehunds B., Seal's or Shark's Bay Seeland, Zealand Seemeilen 20 auf den Grad, Sea miles 20 to the degree Segobriga, Segorbe Seliger S., Lake Seligero Selinus, Vostizza River Senegambien, Senegambia Senogallia (Lugdunensis quarta), Isle of France and Champagne Senus, Shannon River Septentrio (Nord), North Septimanen, Septimani (tribe in Languedoc) Serbien, Servia Sesamus, Amasserah Setuval. Setubal Sevennen. Cevennes Mountains Seyschellen Ins., Seychelle Islands Shetland Inseln. Shetland Islands Shin See, Shin Lake Sicilia, Sicily Sidodona, Shenaas Sidon, Sayda Siebenbürgen, Transylvania Siebenbürgisches Plateau, Plateau

of Transylvania Siena, Sienna Siga, Takumbreet Signia, Segni Sil. Sile River Simferopol. Taurida Simmen Thal, Simm Valley Singaglia, Sinigaglia Singara, Sinjar Singidunum, Belgrade Sinione, Sinub Sinus Arabicus. Red Sea Sirmium, Alt Schabacz Siscia, Sziszek Sitacus, Sita Rhegian River Sitife, Seteef Skagerak, Skager Rack Skagestrandsbugt u. Handelsted, Skager Beach Bay and commercial town Skandien (Scandia), Sweden Skythen, Scythians (nation) Skythini (Scythini), probably Saracens in Armenia Slaven, Slavonians Slavonische Militair Grenze, Slavonian military frontier Slowenen, Wends (Slavonic nation) Sogdiana, Great Bukaria Sogdianien (Sogdiana), Great Bukaria Solanus (Ost), East Soledad od. Ost I., Soledad or Eastern Island (Falkland Islands) Soli. Mezetlu Soraben, Sorbi (Slavonic tribe) Span. Mark, Spanish mark (modern Catalonia, Navarre, and part of Arragonia) Spanien, Spain Speier, Speyer Spoletum, Spoleto St. Georgs Kanal, St. George's Channel St. Johann, St. John Staaten der Mexicanischen Union, States of the Mexican Union Staaten der Nordamerikanischen Union, States of the North

170

American Union Stattenland, Staten Island (S. A.) Stadt der Getæ, City of the Getæ Stalaktiden Grotte, Stalactite grotto Stevermark, Styria Str. v. (Strasse von) stands for "Straits of" before the respective names Strabo's Erdtafel, Map of the World according to Strabo Strasse v. Calais, the British Channel Strom und Gebirgs-System von Mitteleuropa, River and Mountain System of Central Europe Südamerika, South America Süd Atlantische Strömung, South Atlantic current Süd Cap, South Cape Süd Georgien, South Georgia Südl. Continent, Southern Continent Südl. Grenze des Weinstocks. Southern boundary of the grape Südliche Verbindungs Strömung, Southern Connecting current Südlicher Polarkreis, Antarctic Circle Süd oder Neu Georgien, South or New Georgia Süd Schetland, New South Shetland Süd West. South West Sümpfe in gleicher Höhe m. d. Ocean, Swamps on a level with the ocean Sumpf, Swamp Sund, Sound Sunda See. Sea of Sunda Sunda Strasse. Straits of Sunda Susiana, Khuzistan and Louristan Swilly See, Lake Swilly Sybaris, Cochyle River Syracusa, Syracuse Syrdaria. Sir River

Arabian Desert Syrische Wüste, Syrian Desert Syrtes. Gulf of Sidra Syrtika (Seli or Psylli), in Tripolis Tabor, Mt. Tor Tabraca. Tabarca Tacape, Cabes Tafelland von Armenien 250 t... Armenian Plateau 250 toises Tafelland von Iran 650 t. üb. d. Meere. Plateau of Iran 650 toises above the level of the sea Tafelland v. Mexico od. Anahuac. Plateau of Mexico or Anahuac Taifalen. Taifalæ (tribe on the Danube) Tajo, Tagus River Tambow, Tambov Tamesis. Thames River Tanais (Danaber). Don River Tape, Bostam Tapes Ind., Tappe Indians Taprobana, Ceylon Tarnowitzer Höhe, Plateau of Tarnowitz Tarsus. Tersoos Tarum. Tarem Tatra Gebirg, Tatra Mountains (part of the Carpathian Mountains) Taurica, Crimea Taurien, Tauria Taurischer Cherson, Crimea Taxila, Attock Tay Mündung, Firth of Tay Teate, Chieti Telmissus, Macry Tenerifa, Teneriffe Termessus, Schenet Teufels Inseln, Devil's Islands Thapsacus, Der Thebais, Upper Egypt Theben. Thebes tribe)

Thrakien (Thracia), Rumilia Thuner See. Lake of Thun Tiberis. Tevere River Tief Sudan. Low Soudan Tiefland von Afrika. Lowlands of Africa Tingis, Tangiers Tischit. Tisheet Titianus, Tezzano Titicaca See. Lake Titicaca Todtes Meer, Dead Sea Toletum. Toledo Tomi. Tomisvar Torneo See u. Elf, Tornea Lake and River Torres Strasse, Torres' Strait Toscana, Tuscany Toskanisches Hochland. Tuscan Highlands Transylvanische Alpen, Transylvanian Alps Trapezunt, Trebisonde Trapezus, Trebisonde Tremitische In., Tremiti Islands Tridentum, Trento Trier, Treves Triest, Trieste Trileucum, Ortegal Troglodyten, Troglodytes (tribe on the Red Sea) Tschad See. Lake Tchad Tscheremissen, Tchermisses (Finnish tribe in Russian Asia) Tscherkessien, Circassia Tschernomorische Kosaken, Cirnomorian Cossacks Tschuktschen. Tchookches (tribe in N. E. Asia) Türkei, Turkey Türkisch Croatien, Turkish Croatia Tunes. Tunis Tungusen, Tungouski (nation in Asia) Turini, Turin Verschiedene Ind. Stämme, Varitribe)

Tyroler Alpen, Tyrol Alps Tyrrhenen, Tyrrheni (Pelasgian tribe) Tyrrhenisches Meer, Tyrrhenian Sea (part of the Mediterranean) Tyrus, Soor Umgebung von Neu York, Vicinity of New York Unerforschte Alpengebirge, Unexplored mountain region Ungarisches Erzgebirge, Hungarian Erzgebirge Ungarn, Hungary Unterirdische Wasserleitung, Subterranean Aqueduct Unzugängliche Felsenküste, Inaccessible rocky coast Ural Gebirge, Oural Mountains Uralische Kosaken. Oural Cossacks Urumija See, Lake Uromija Usa, Ouse River Ursprung der Peruanischen Küsten Ström, kalten Wassers, Origin of the Peruvian cold water current Uzen, Cumanen oder Polowzer, Utses Camanes or Polovzi (Mongolian tribe) Vandalen, Vandals (Gothic tribe) Vanille u. Cacao, Vanilla and Cacao Vaterland des Kaffeebaumes. Country of the coffee tree Veldidena, Wilden Venedicus Sinus, Gulf of Venice Venedig, Venice Venetæ, Venetes (tribe in Britany) Veneten, Venetes (tribe in Britany) Venetia, Venice Vereingte Staaten, United States

'iadrus, Oder River liennensis, Dauphiny 'ierwaldstädter See, Lake of Lu-Vindhy Kette, Vindhya Mountains 'indobona, Vienna 'irunum, Waren 'isurgis, Weser River Vogesen, Vosges Mountains 'olhynien, Volhynia 'olubilis, Pharaoh's Castle 'order Rhein, Fore Rhine (one of the rivulets tributary to the Rhine) Vorgeb Aromata, Cape Guardafui Yorgeb Simylla, Cape Simylla Votiaken, Wotyaks (Finnish tribe)

Wälder S., Lake of the Woods
Wahabiten, Wahabites (Mahomedan sect)
Walachei, Walachia

Valdai Geb., Waldai Mountains Valfisch B., Whale Bay Vallachisches Tiefland. Wallach-

ian Lowlands
Vallenstädter See, Lake of Wal-

lenstadt
Wan See, Lake Van

Wanger Oge, Wanger Oog Warasdiner Geb., Warasdin Mountains

Warschau, Warsaw Weichsel, Vistula River Weichsel Niederung, Vistula Lowlands

Weisse Bai, White Bay
Weisse Berge, White Mountains
Weisse Bulgaren, White Bulgarians
Weisses Meer, White Sea
Weisses Vorgeb., Cape Blanc
Weitzen, Gerste w. Hafer, Wheat

Weisses Vorgeb., Cape Blanc
Weitzen, Gerste u. Hafer, Wheat,
barley and oats

Weitzen, Mais und Baumwolle, Wheat, Indian corn and cotton Weitzen u. Baumwolle, Wheat and cotton

Weitzen u. Reis, Wheat and rice Vendekreis des Krebses, Tropic of Cancer Wendekreis des Steinbocks. Tropic of Capricorn Wenden, Wends (Slavonic tribe) Wenern See. Lake Wenern Wesegothen, Visigoths (nation) Weser Gb.. Weser Mountains West Gats. West Ghauts West Indien. West Indies West Preussen, West Prussia West Pyrenäen, West Pyrenees West Russland, West Russia Wester W., Wester Wald Westliche Länge von Paris, W. Longitude from Paris Westphalen, Westphalia Wettern See, Lake Wettern Wien, Vienna Wilde Völker, Savage nations Windtafel der Griechen nach Aristoteles, Windchart of the Greeks according to Aristotle Windtafel der Römer nach Vitruvius, Windchart of the Romans according to Vitruvius Winipeg S., Winnipeg Lake Winipigoos S., Lake Winnipigoos Wogulen, Woguls or Uranfi (Finnish tribe) Wolga, Volga River Wüste al Ahkaf, Desert Al Ahkaf Wüste Hochebene, Sandy Plateau Wüste Kharasm, Desert of Kharasm

Zacynthus, Zante
Zadracasta, Goorgaun
Zagrus Geb., Aiagha Mountains
Zahn u. Elfenbein K., Ivory Coast
Zalissa, Tiflis
Zana See, Lake Zana
Zembre S., Lake Zembe
Zariaspa später Baetra (Zariaspa,
later Baetra), Balkh
Zeiton, Zeitoun
Zenobia, Zelebi
Zephyros (West), West wind
Zerstückelung des Reiches, Dis-

Wüste Sahara, Desert of Sahara

Wüstes Arabien, Arabia Deserta

Wüste Sahel, Desert of Sahel

membering of the Empire

Zimmt, Muskatnuss u. Gewürznelke, Cinnamon, nutmeg, and
clove

Zoromba, Dustee River Zucker, Sugar

Zucker, Kaffee, Thee, Sugar, coffee, tea

Zucker u. Kaffee, Sugar and coffee Züricher See, Lake of Zurich

Zug unter Gottfried von Bouillon, Crusade under Godfrey of Bouillon

Zug unter Conrad III. u. Ludwig VII., Crusade under Conrad III and Louis VII

Zug unter Ludwig IX. v. Frankr., Crusade under Louis IX of France

Zug unter Friedrich Barbarossa, Crusade under Frederick Barbarossa

Zug unter Kaiser Friedrich II., Crusade under Emperor Frederick II

Zug unter Richard I u. Phil. August, Crusade under Richard I and Philip Augustus

Zuyder See, Zuyder Zee Zwarte Bge., Black Mountains Zweibrücken, Bipont

Zwischen 0° und 10°, Between 0° and 10°

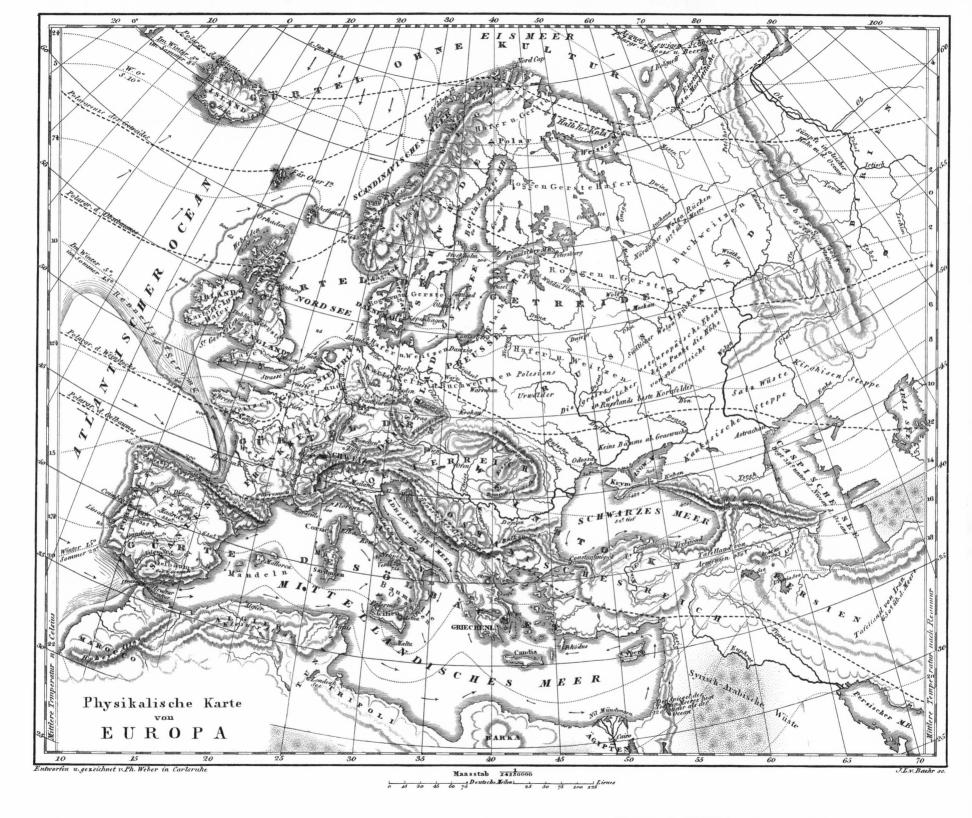

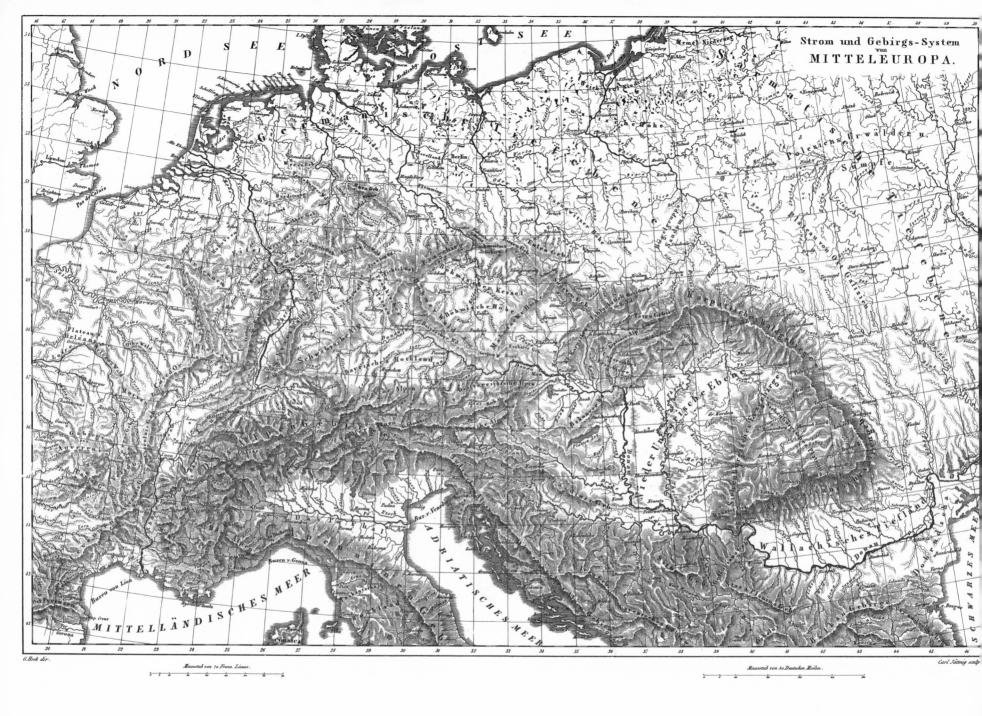

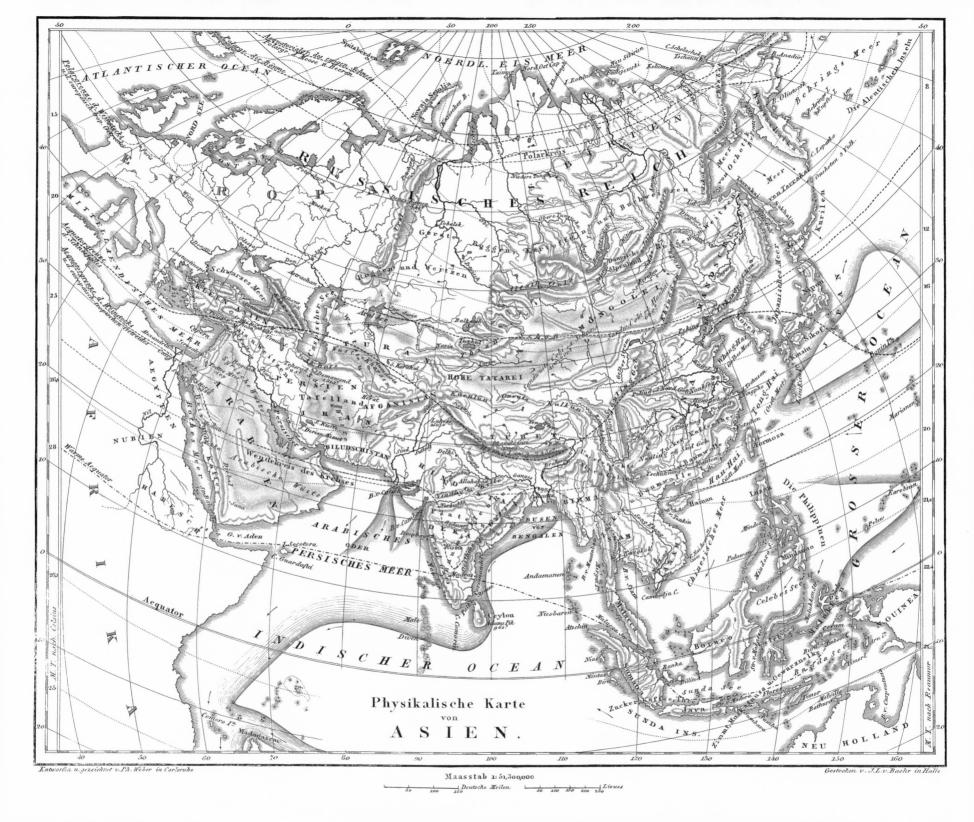

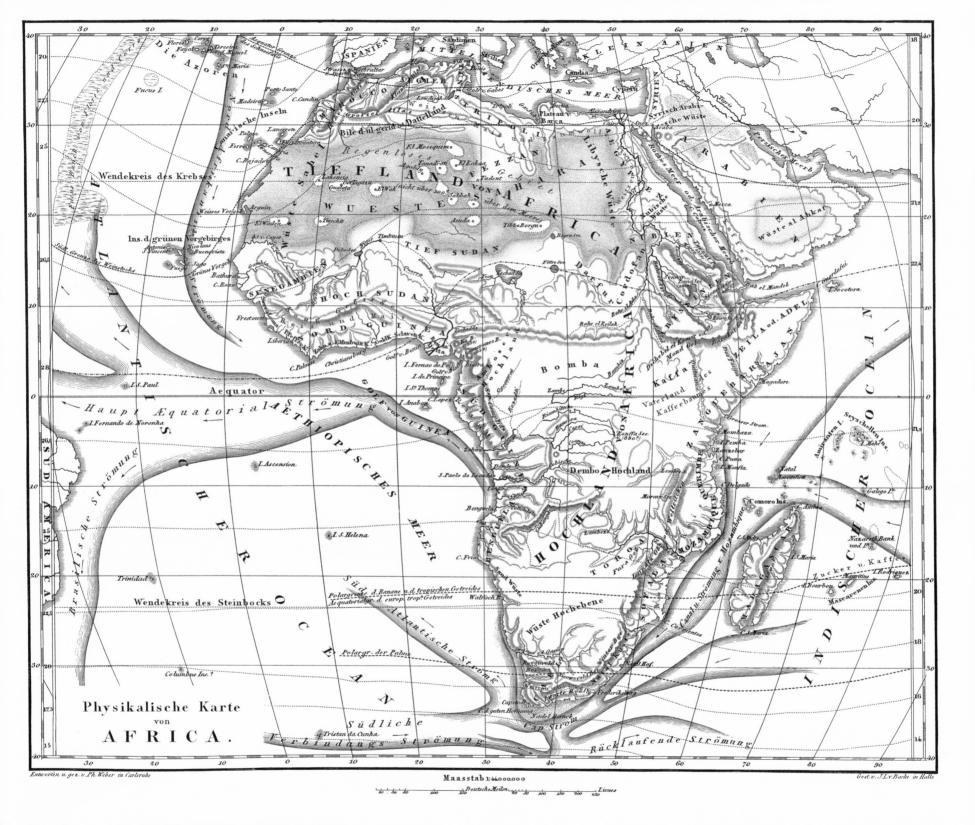

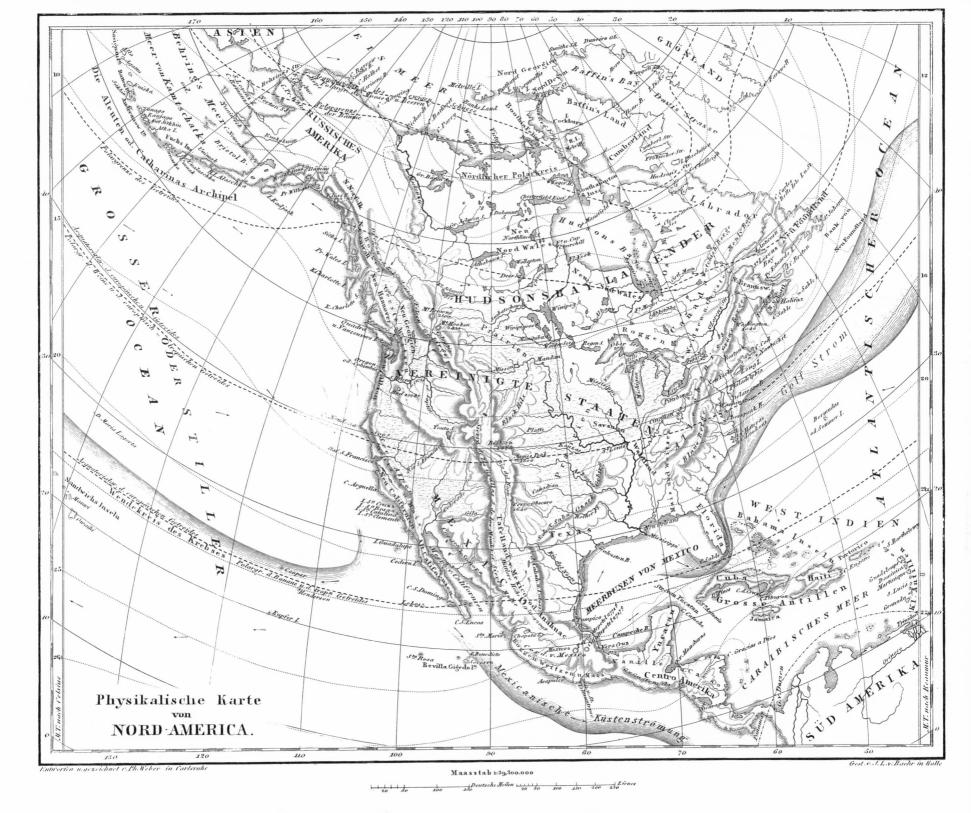

PLATE 147. PHYSICAL MAP OF NORTH AMERICA

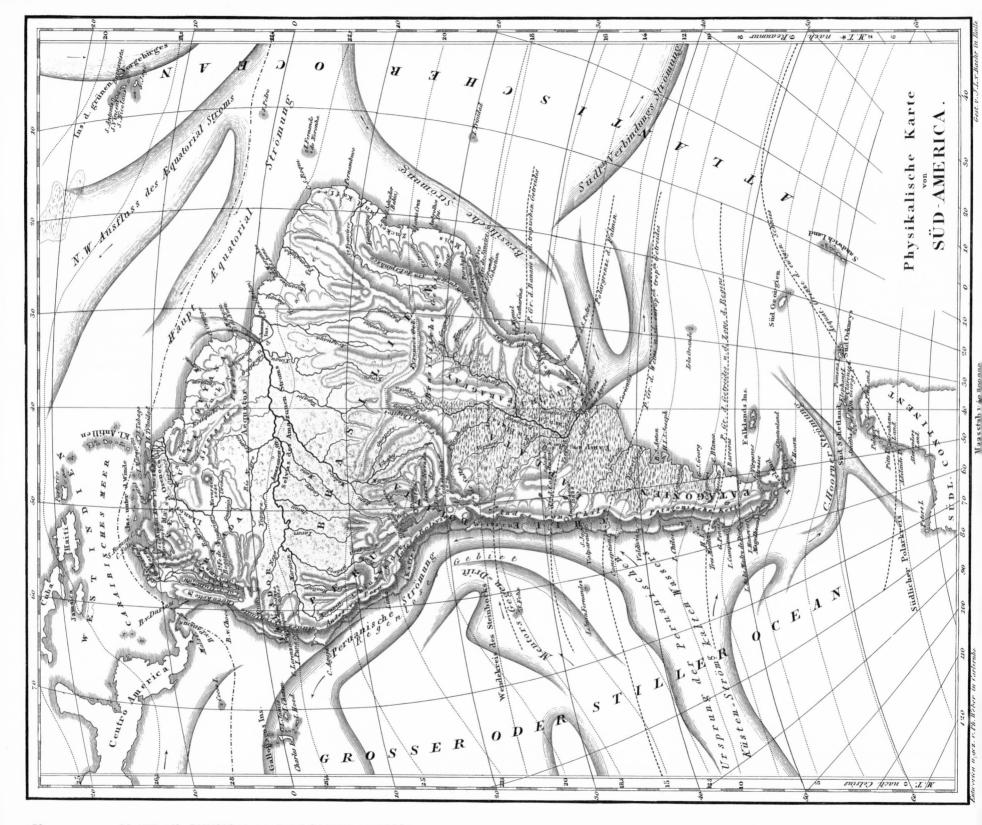

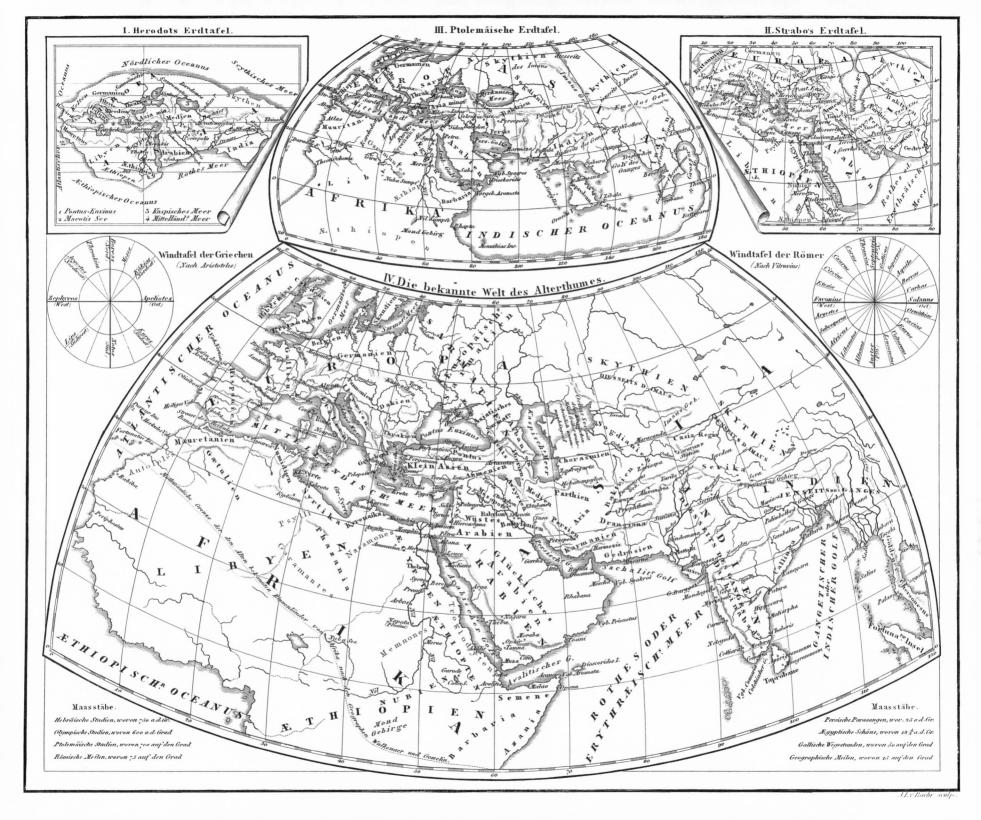

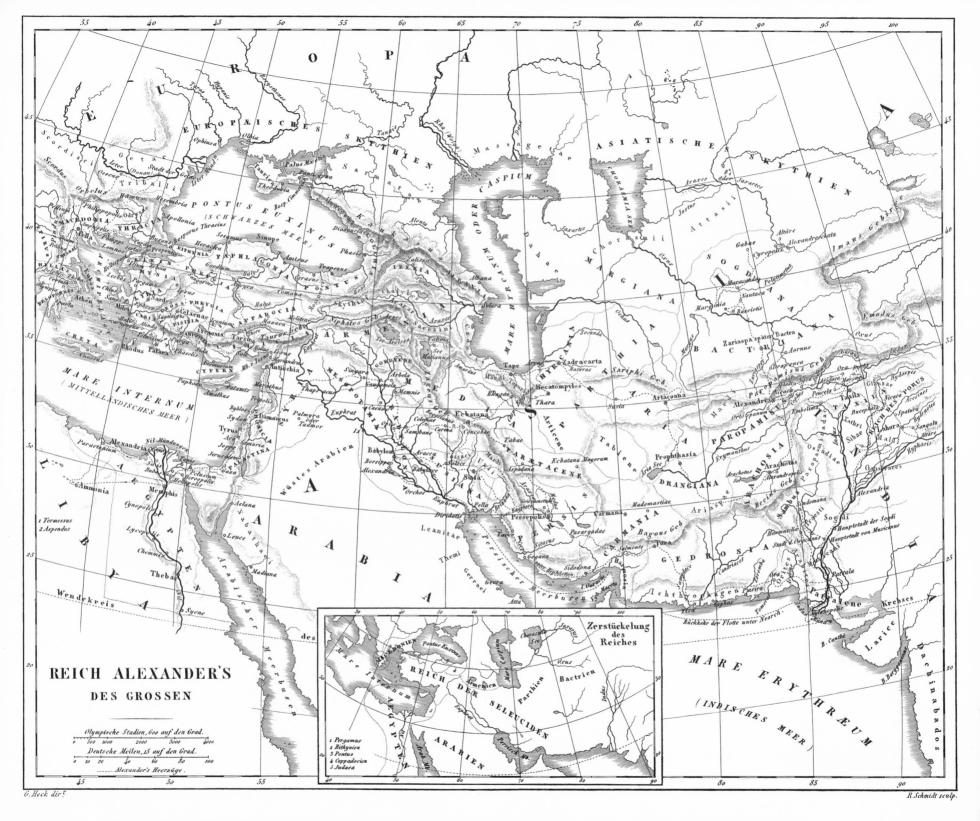

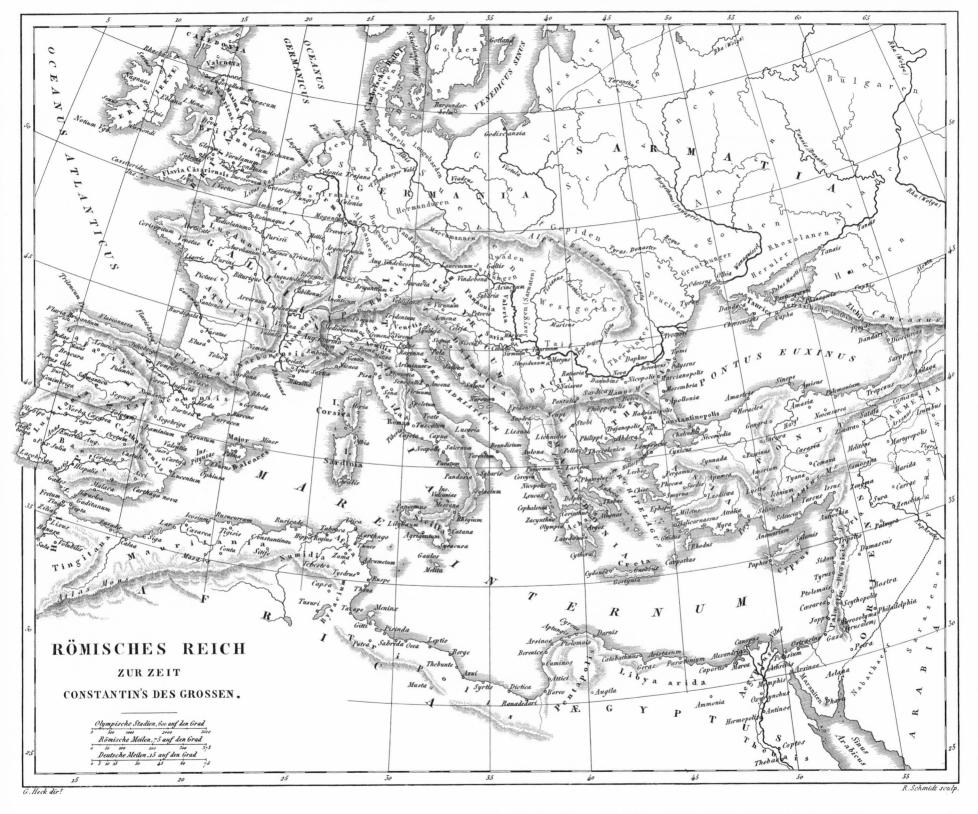

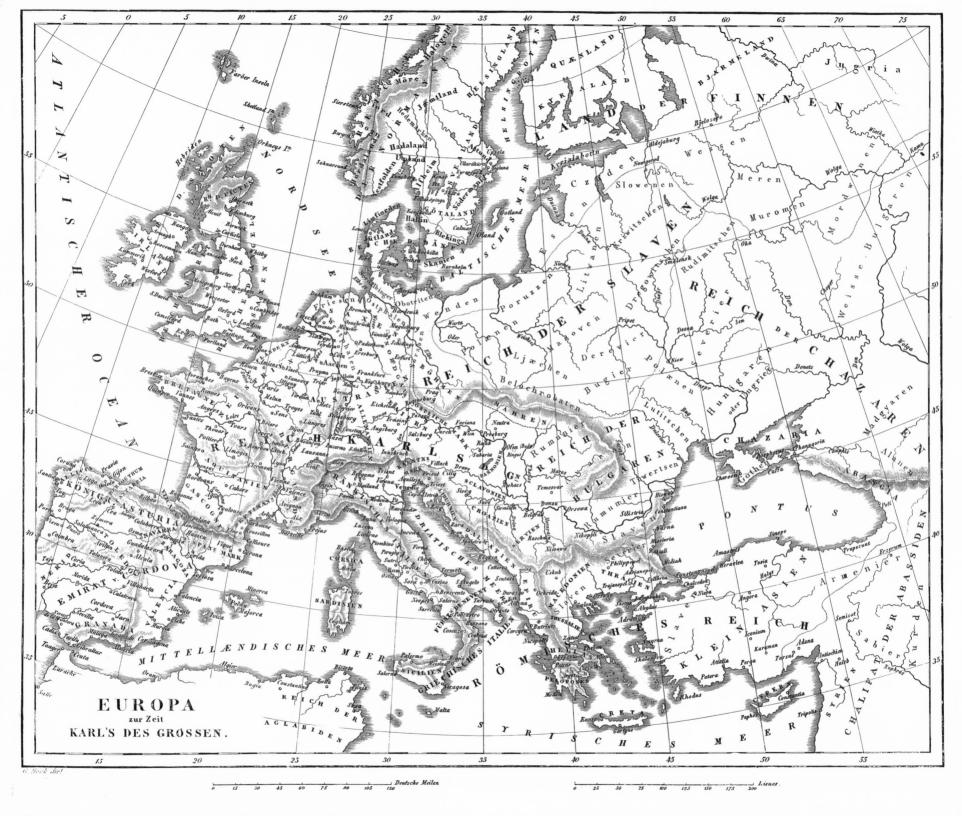

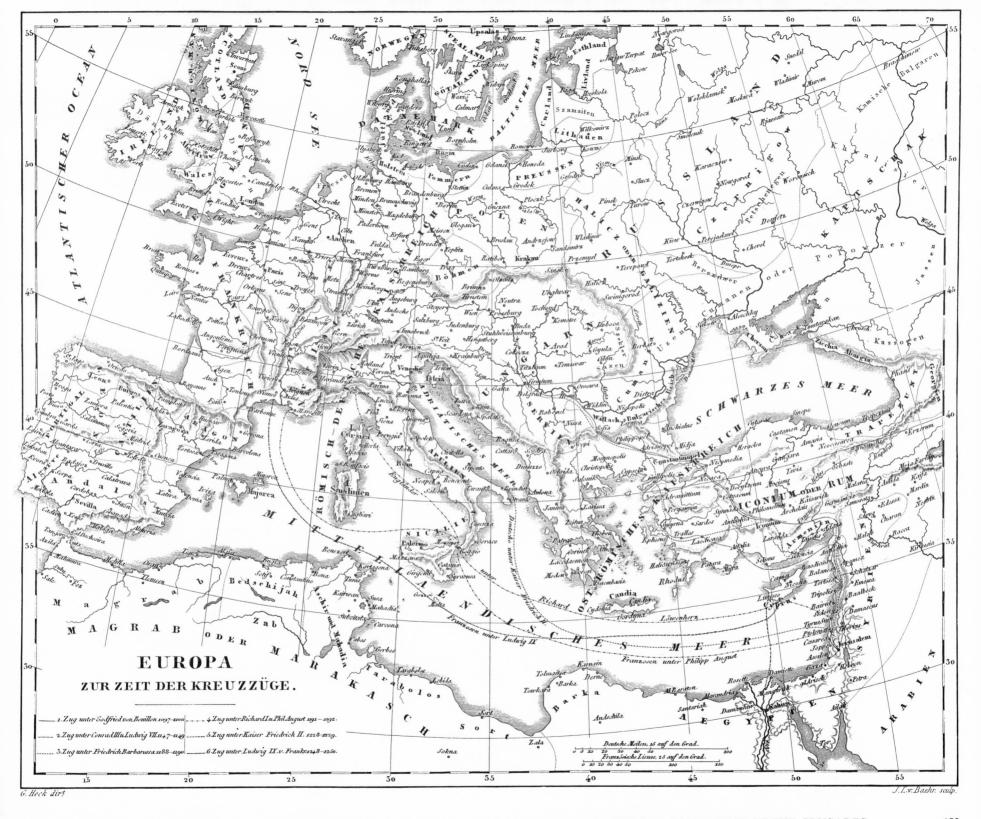

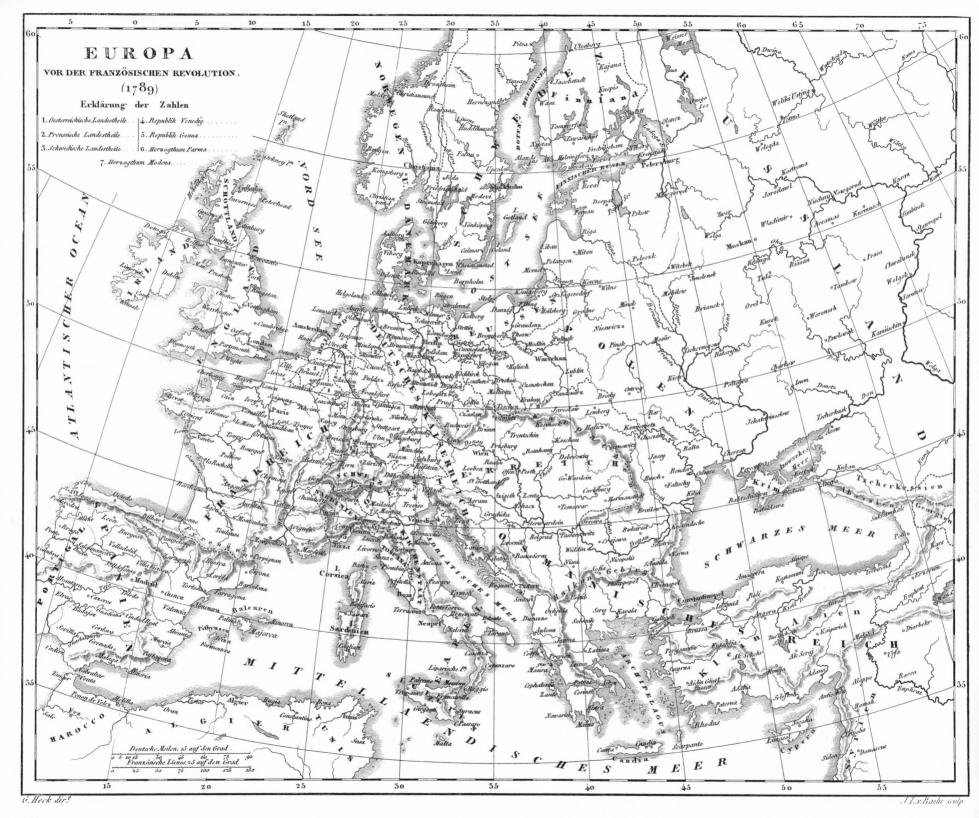

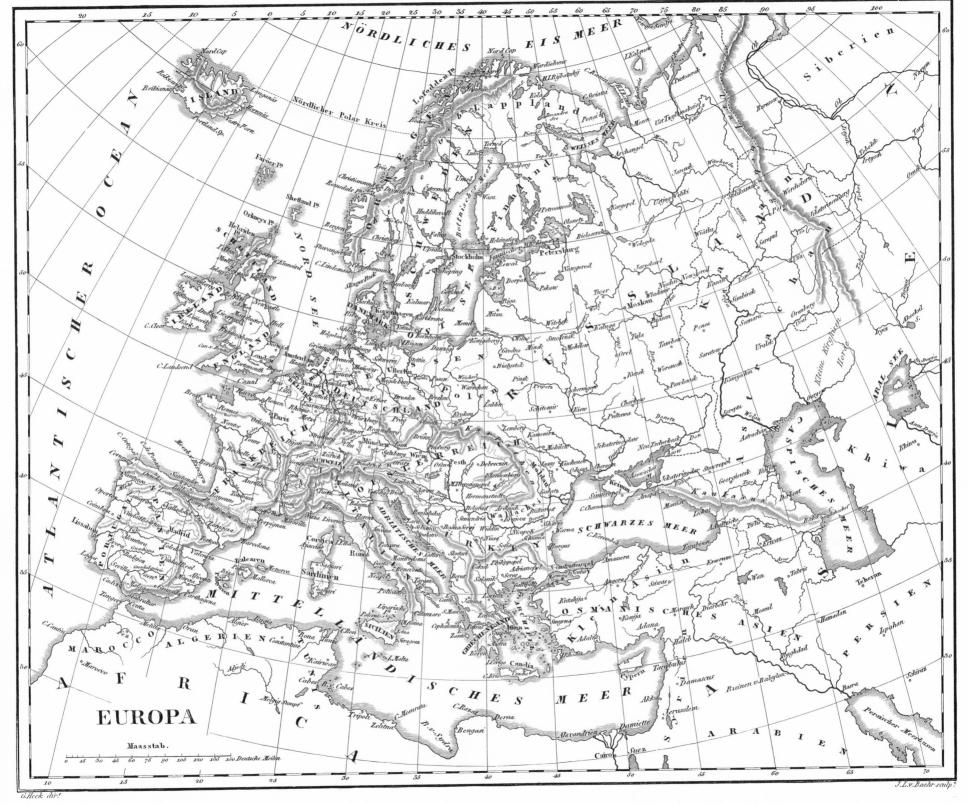

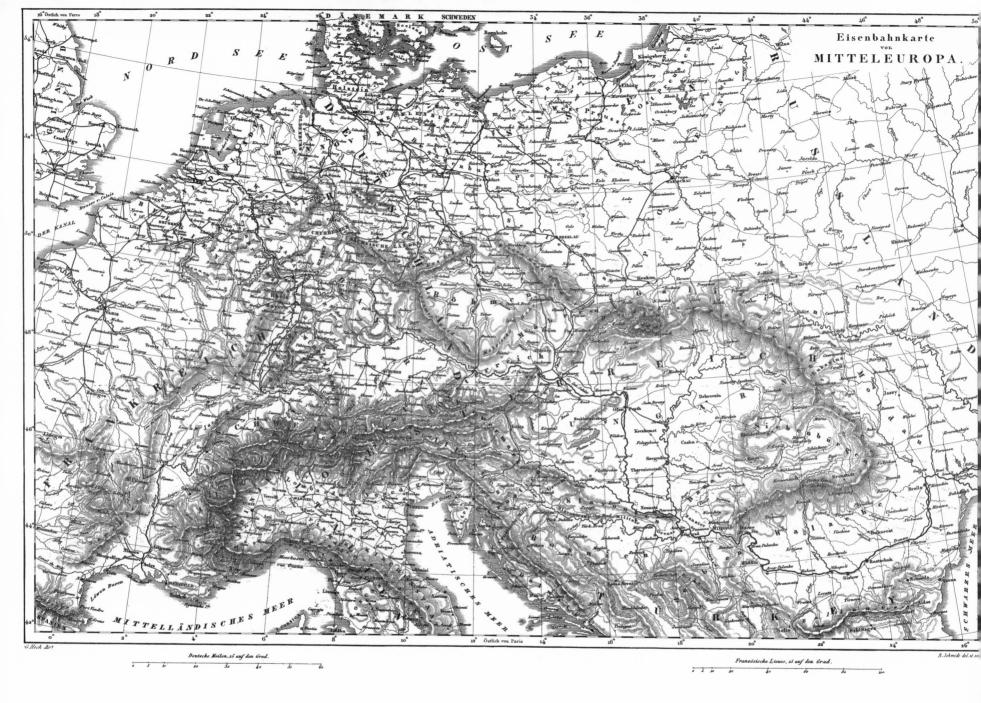

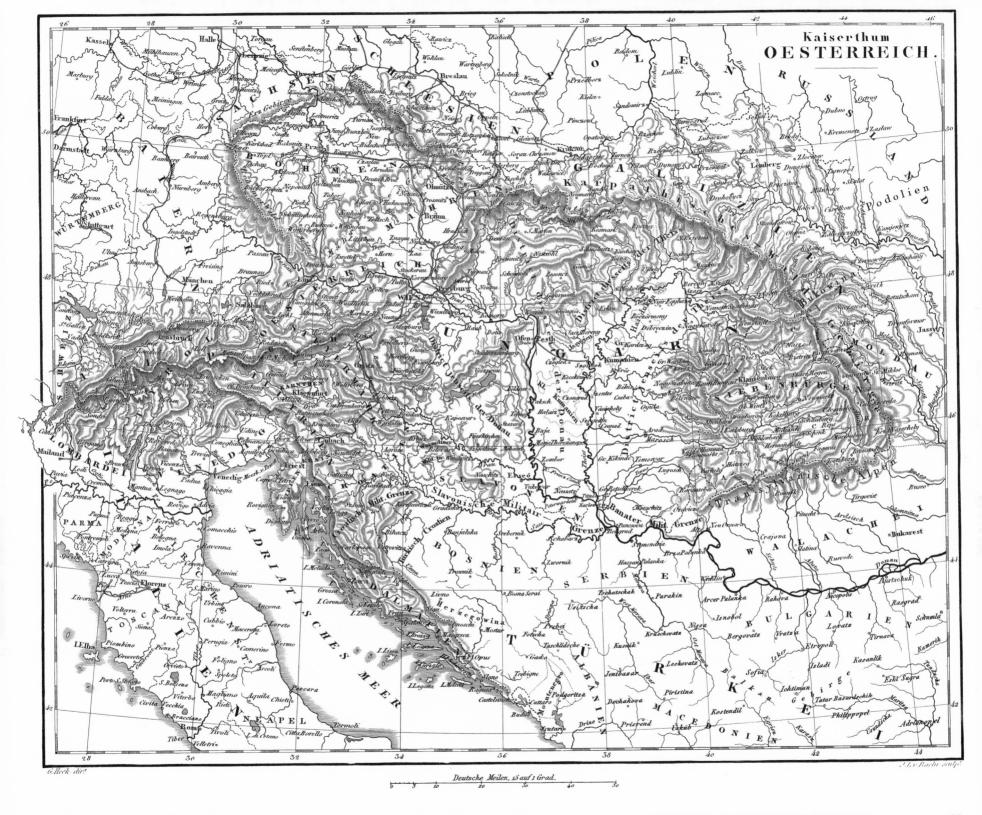

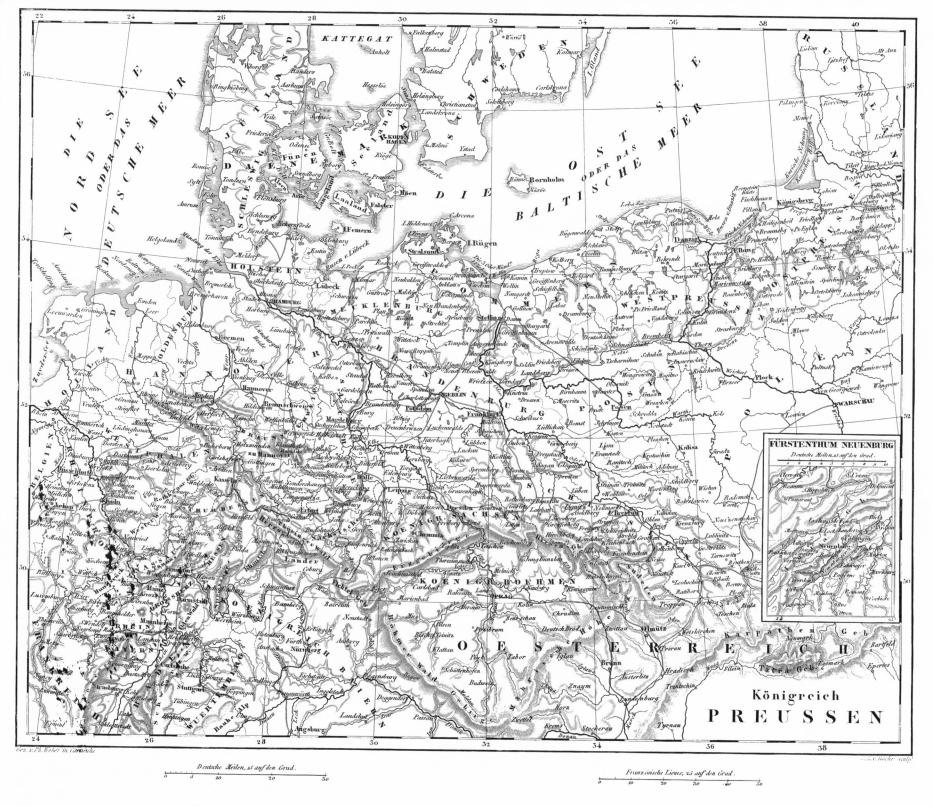

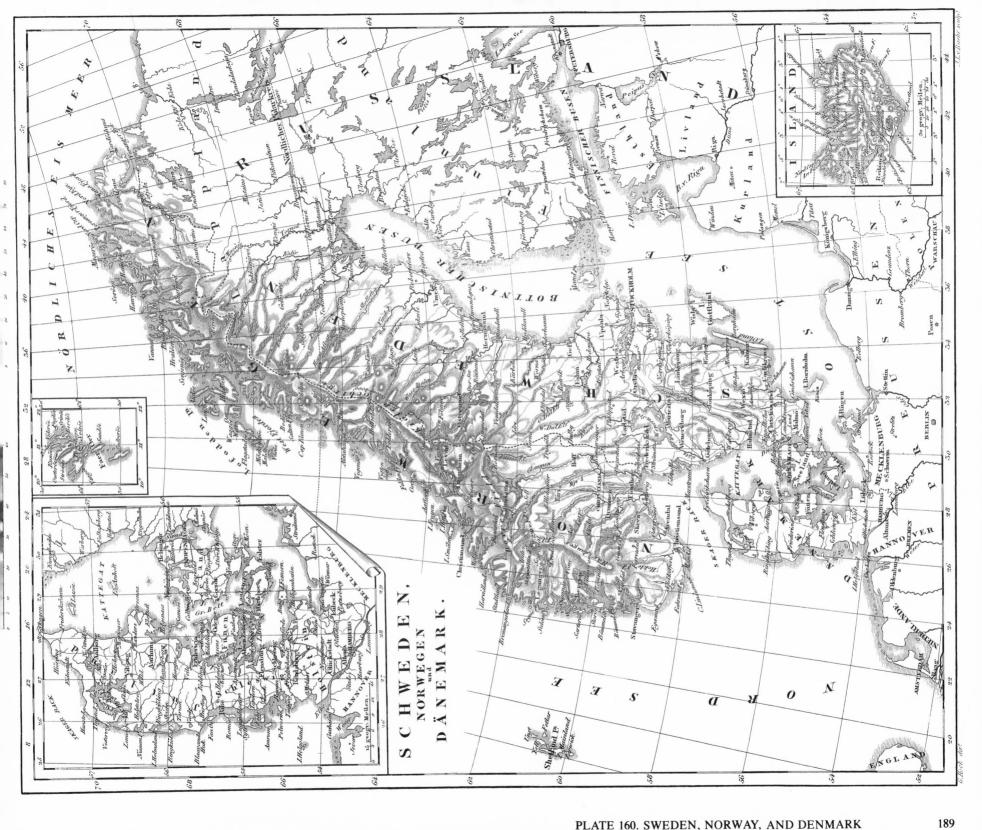

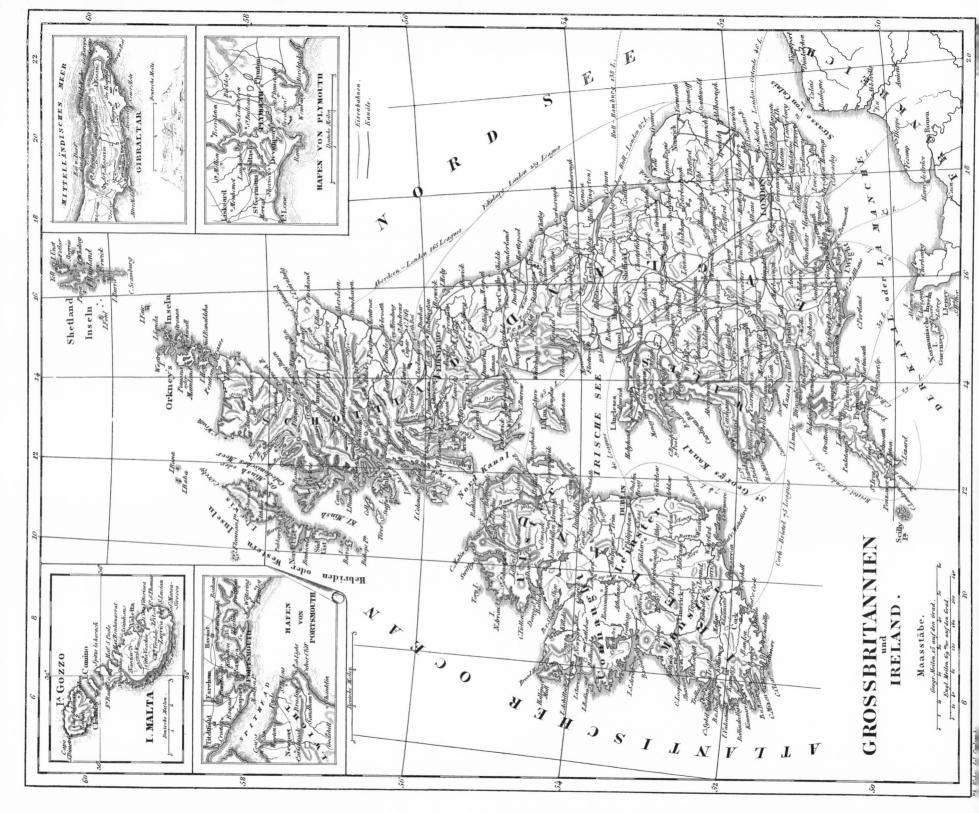

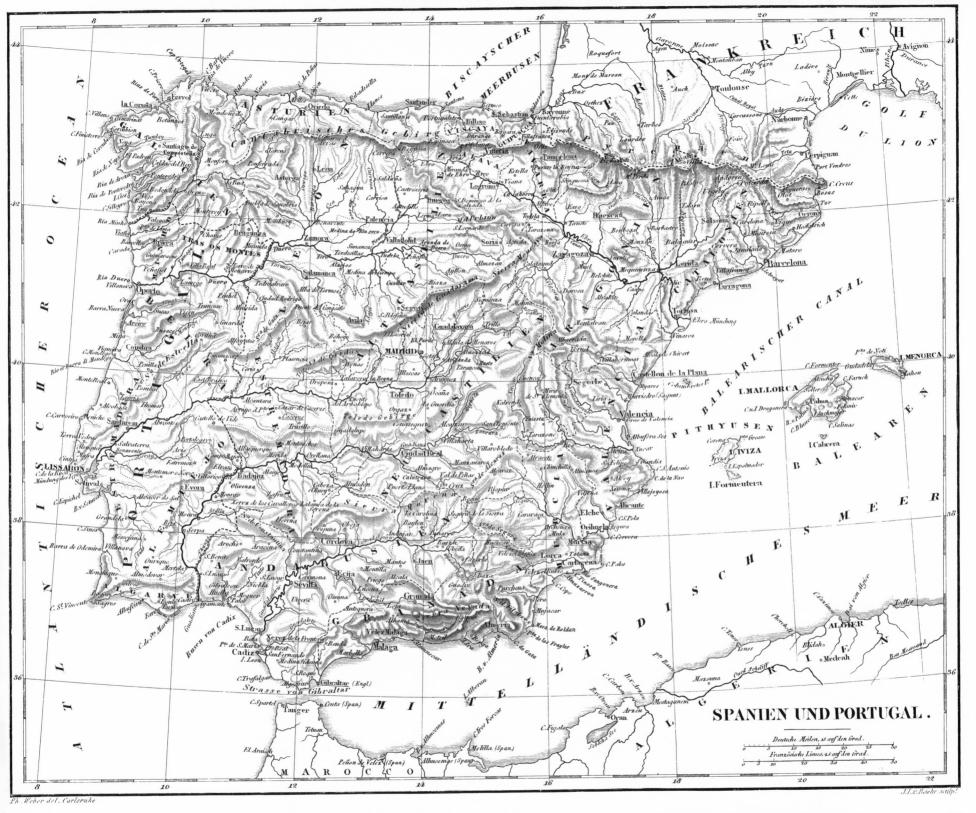

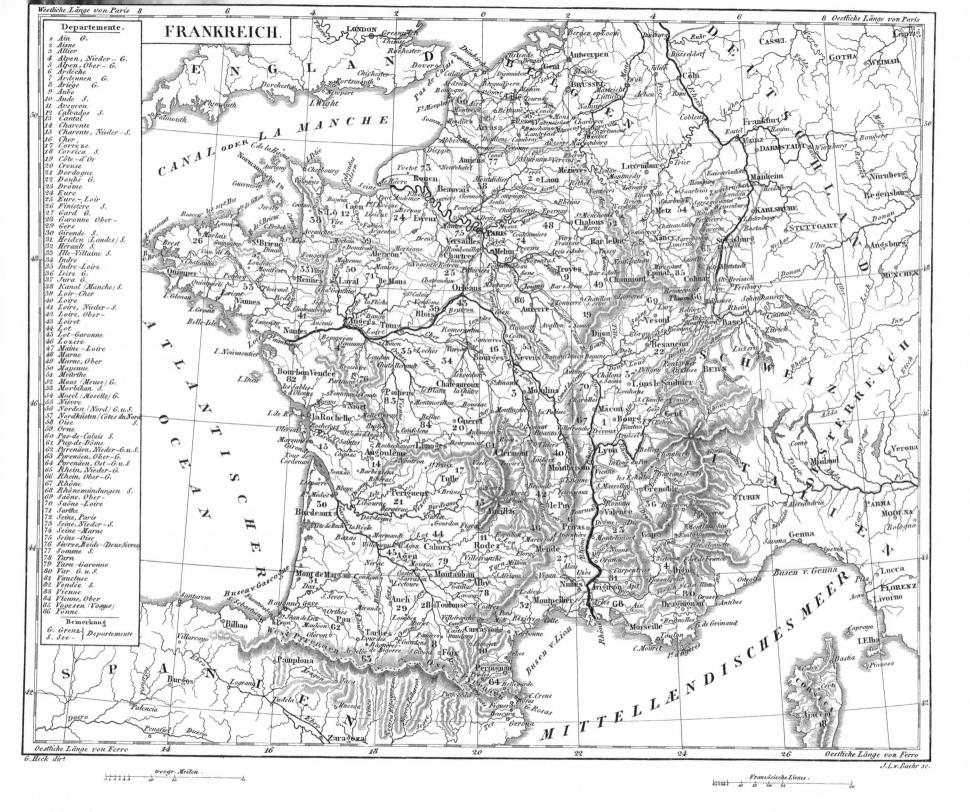

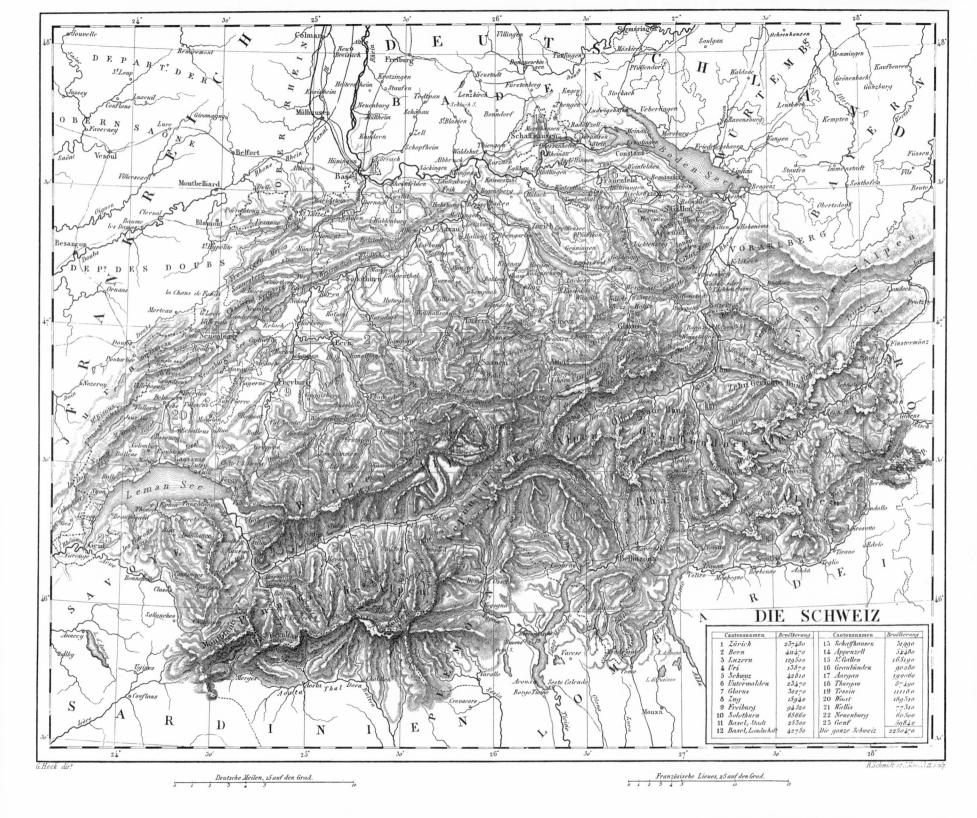

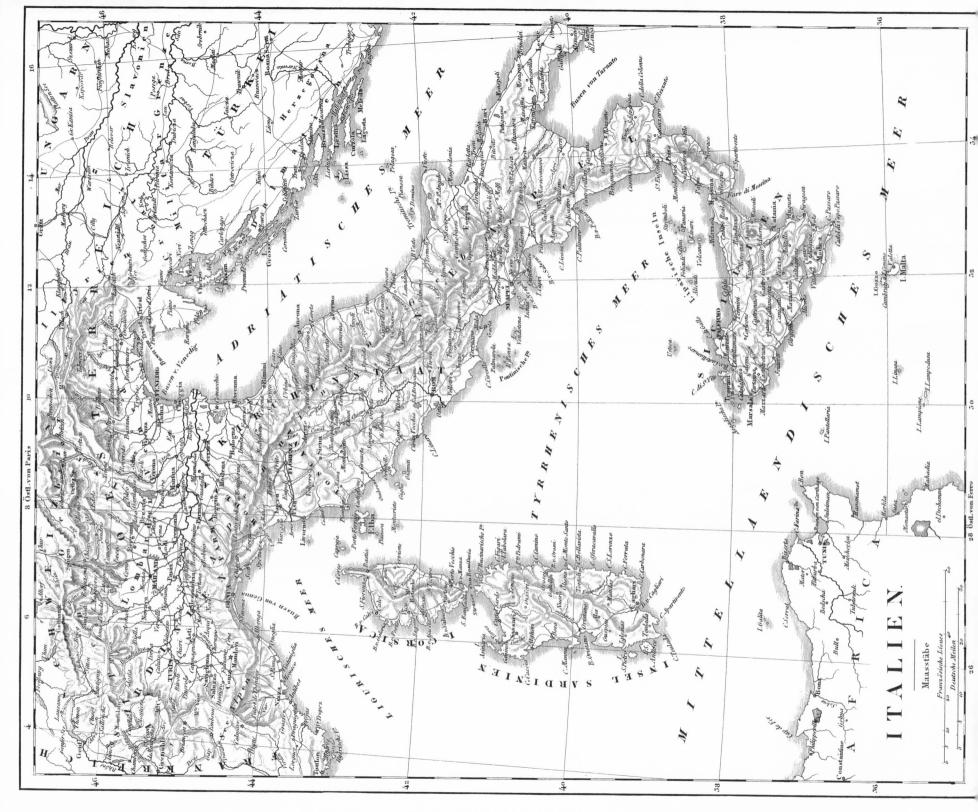

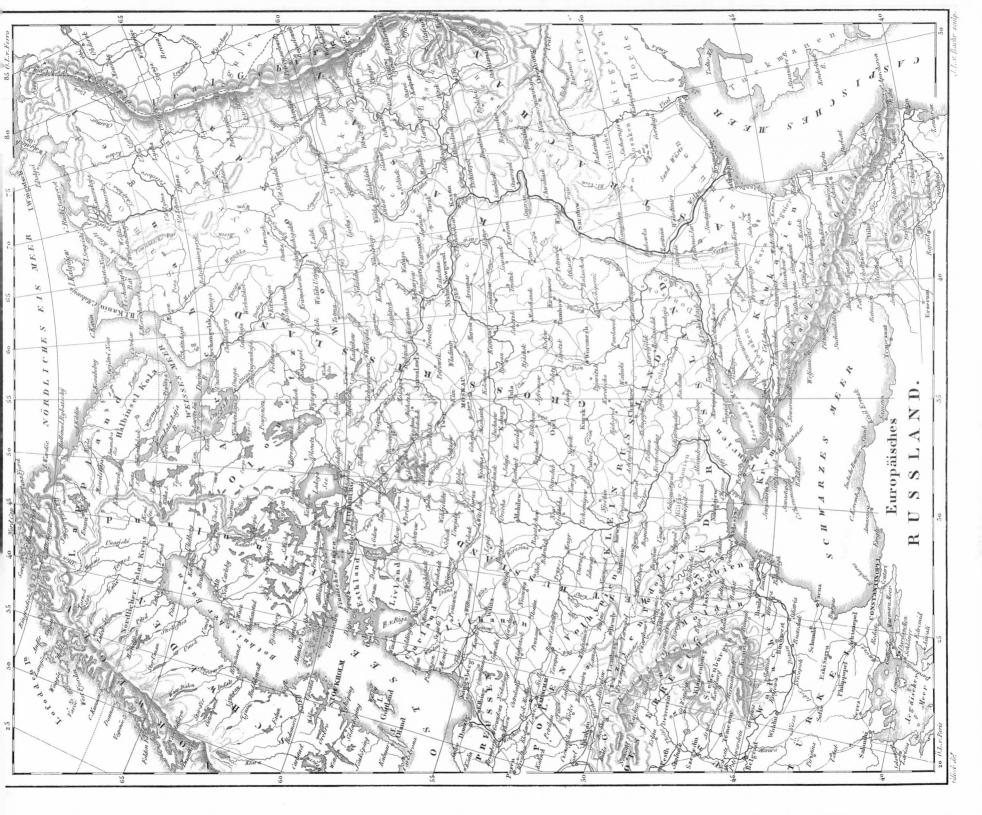

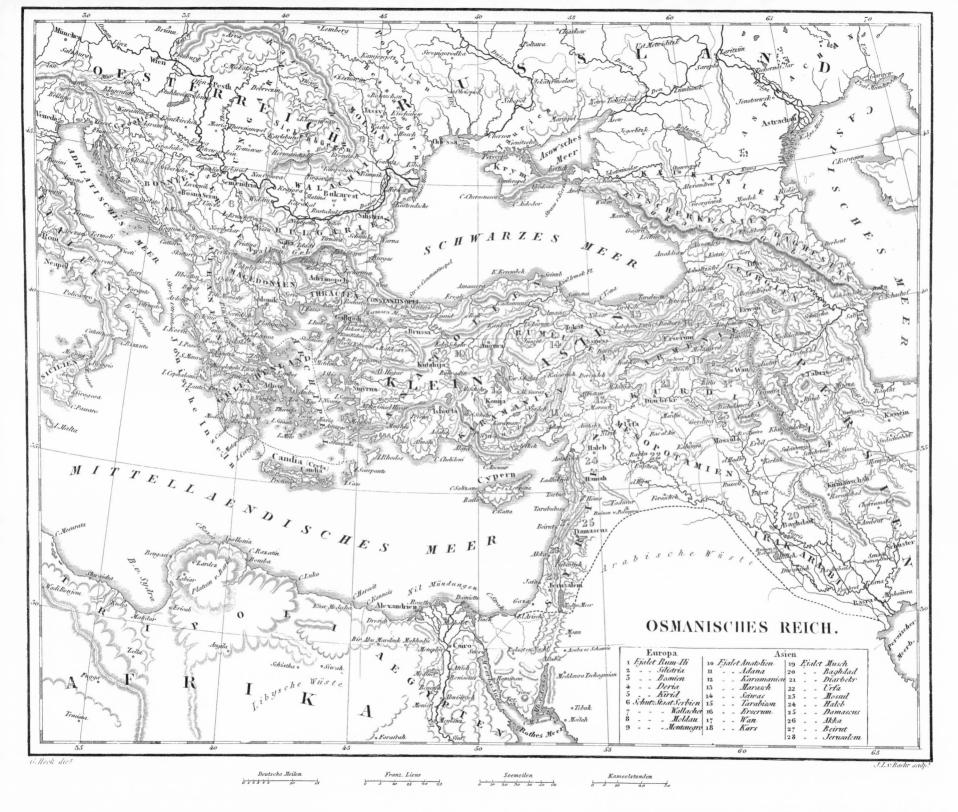

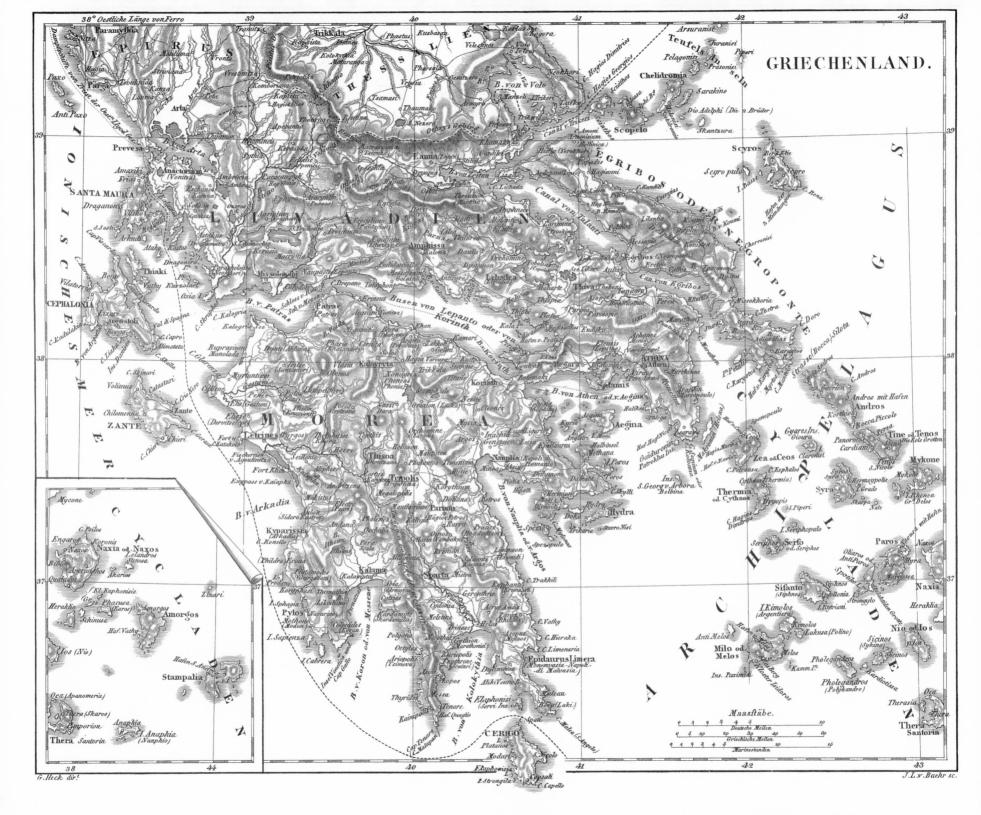

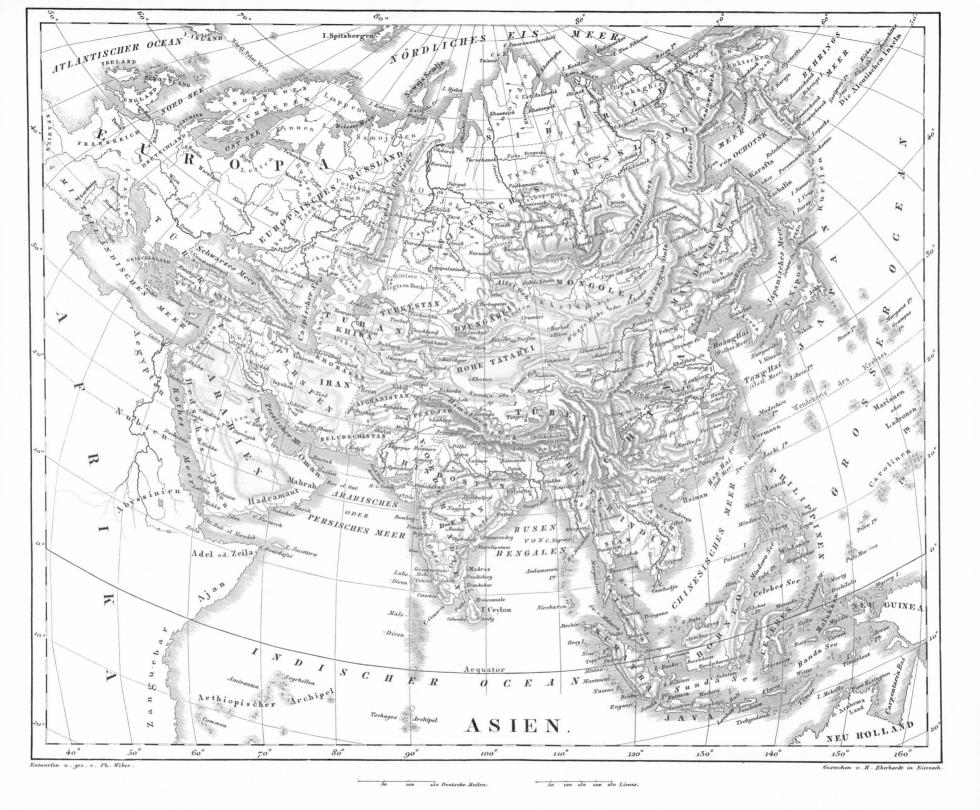

PLATE 169. ASIA

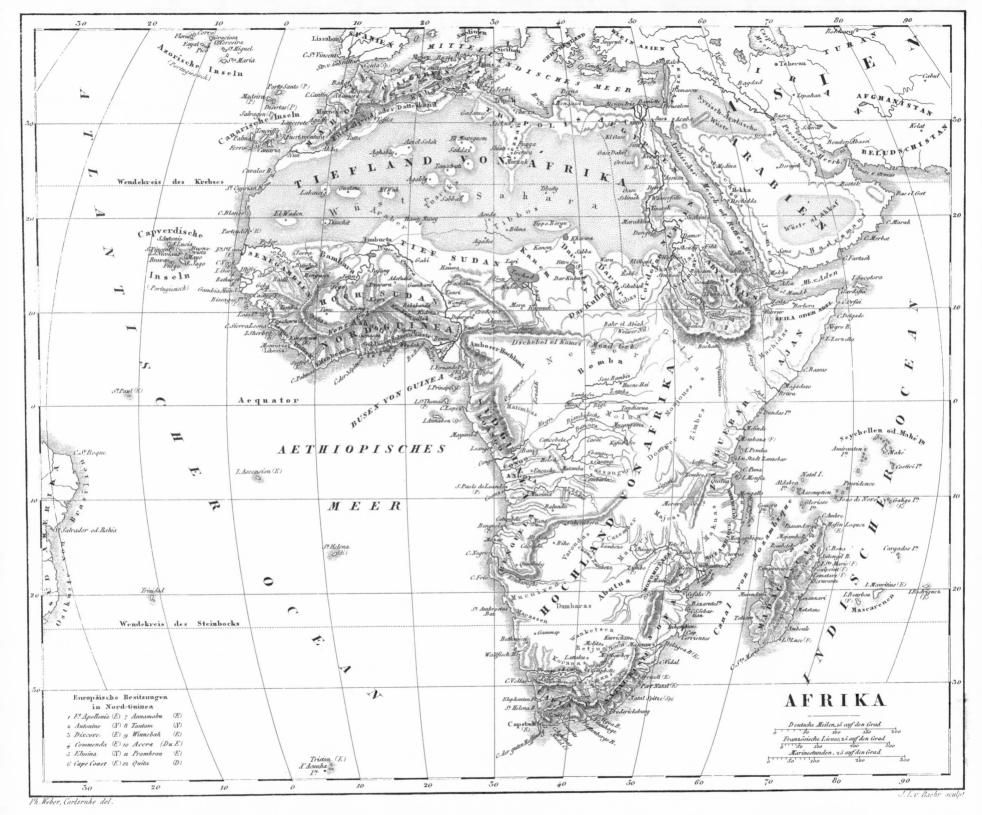

PLATE 170. AFRICA

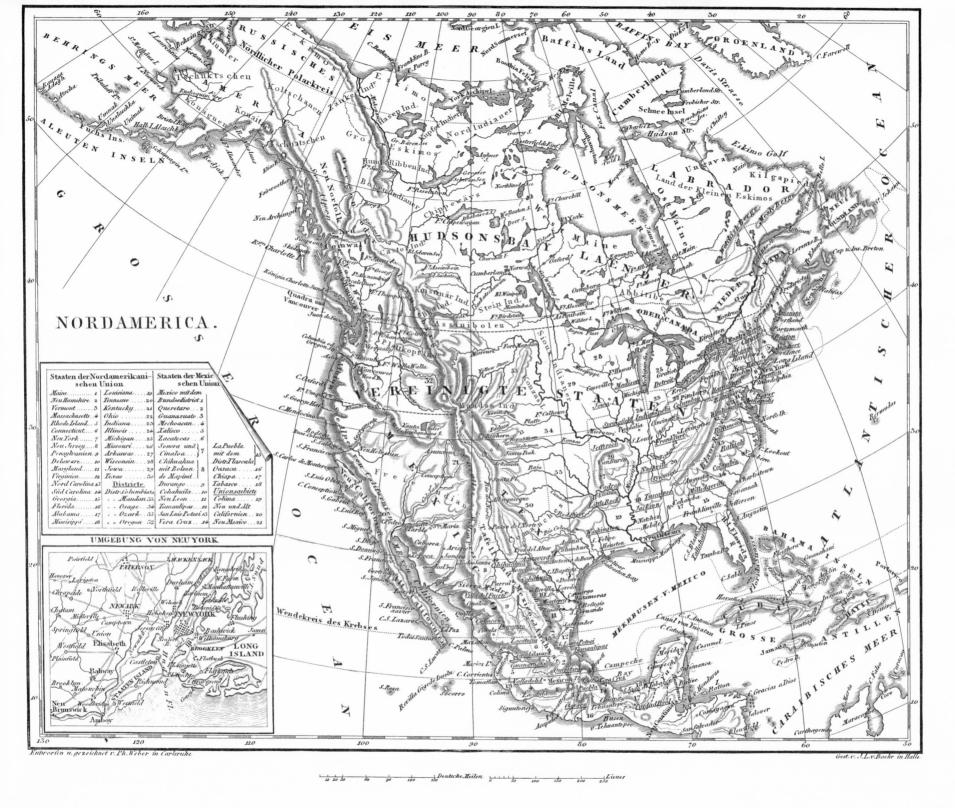

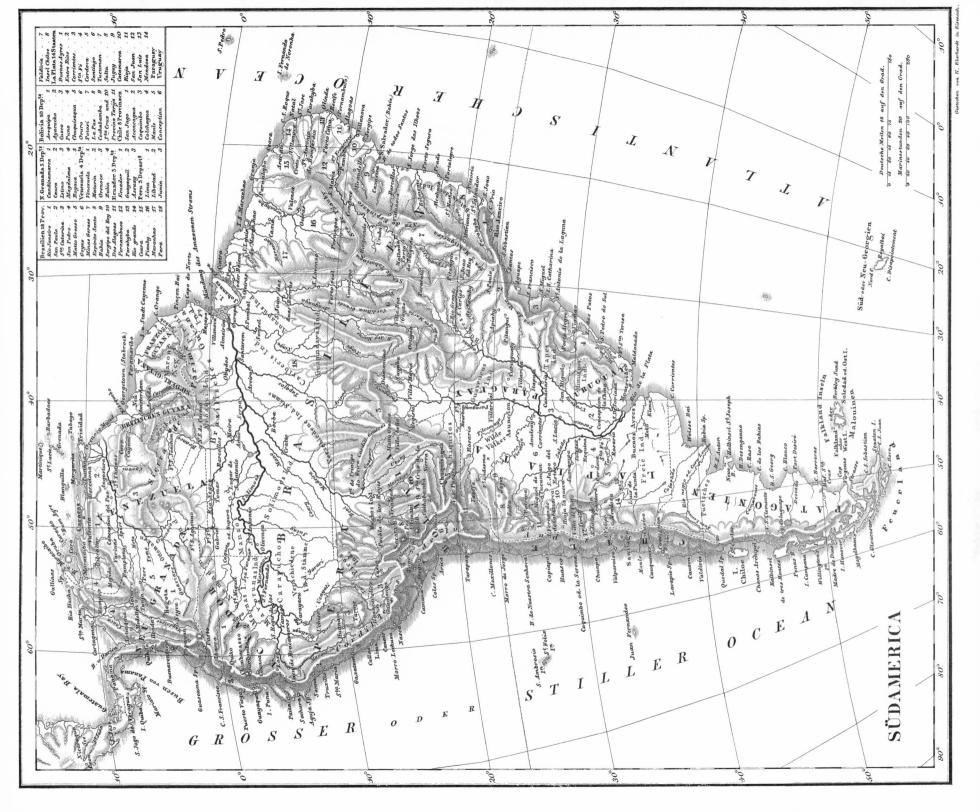

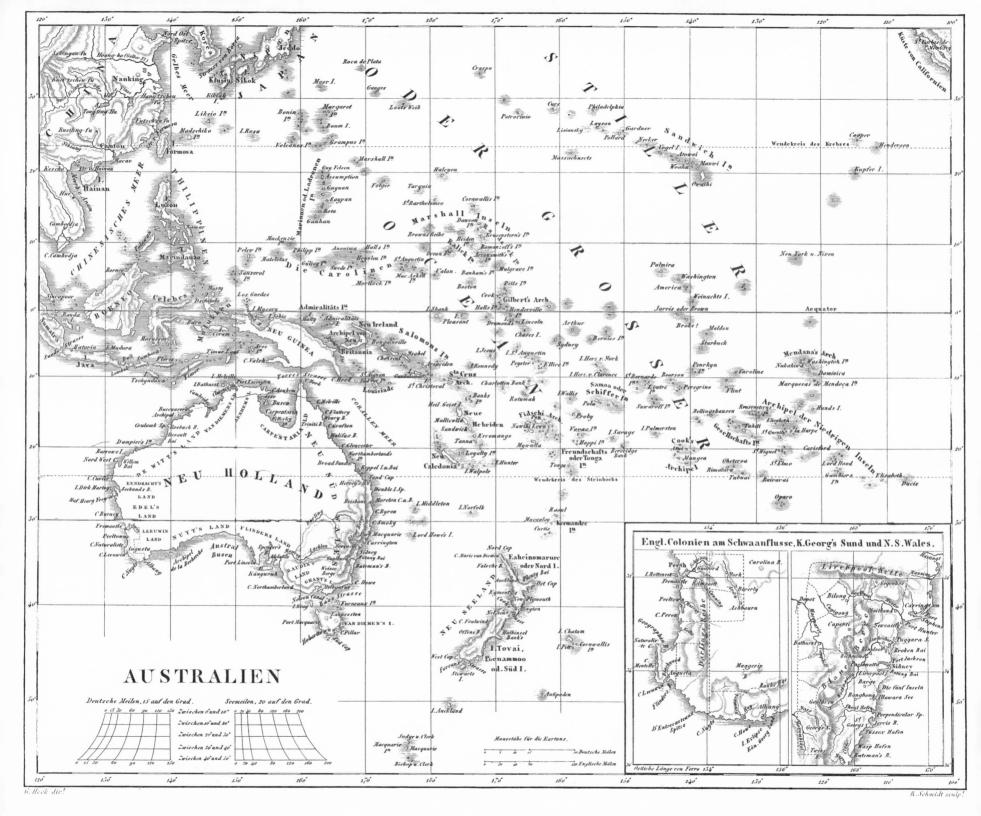

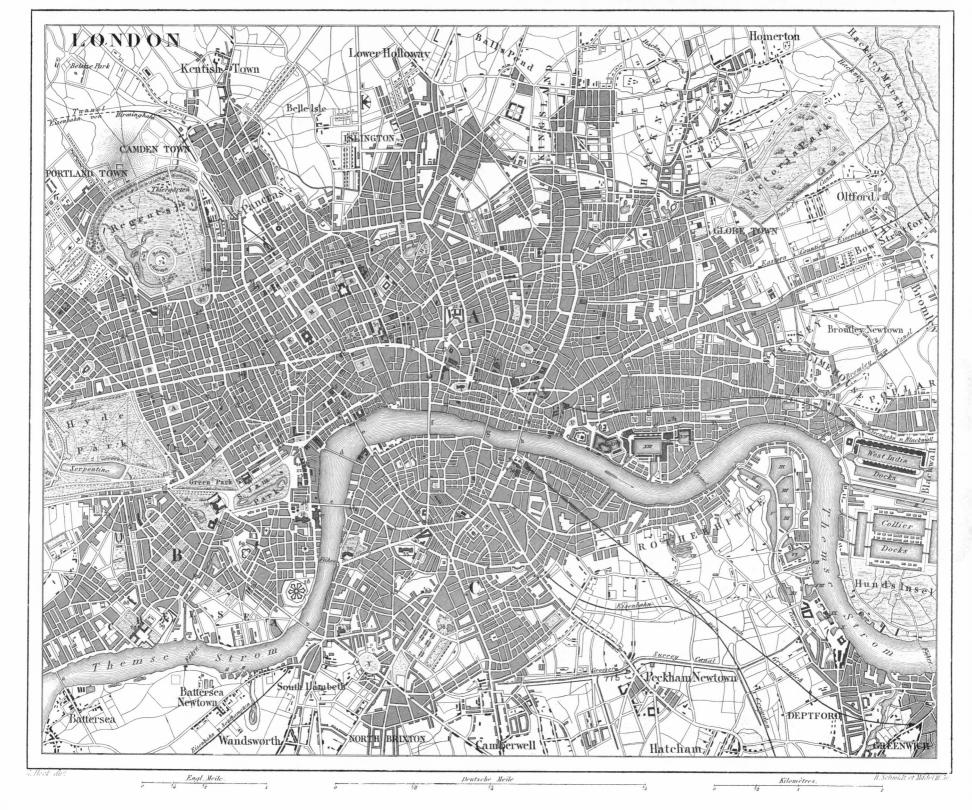

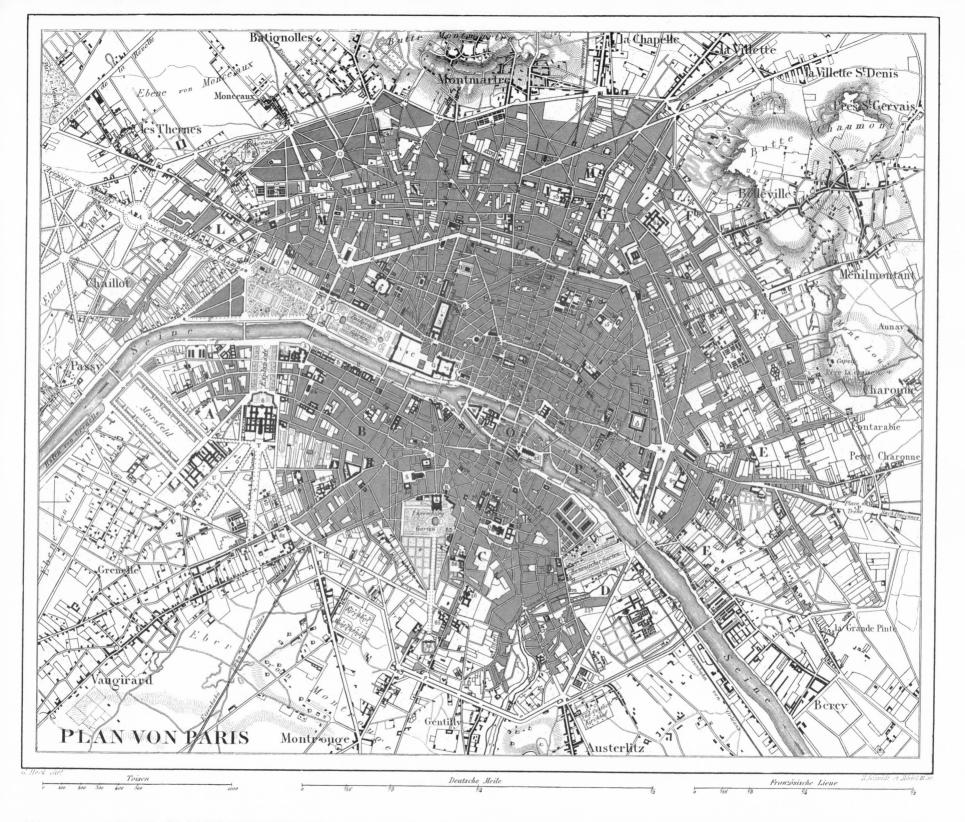

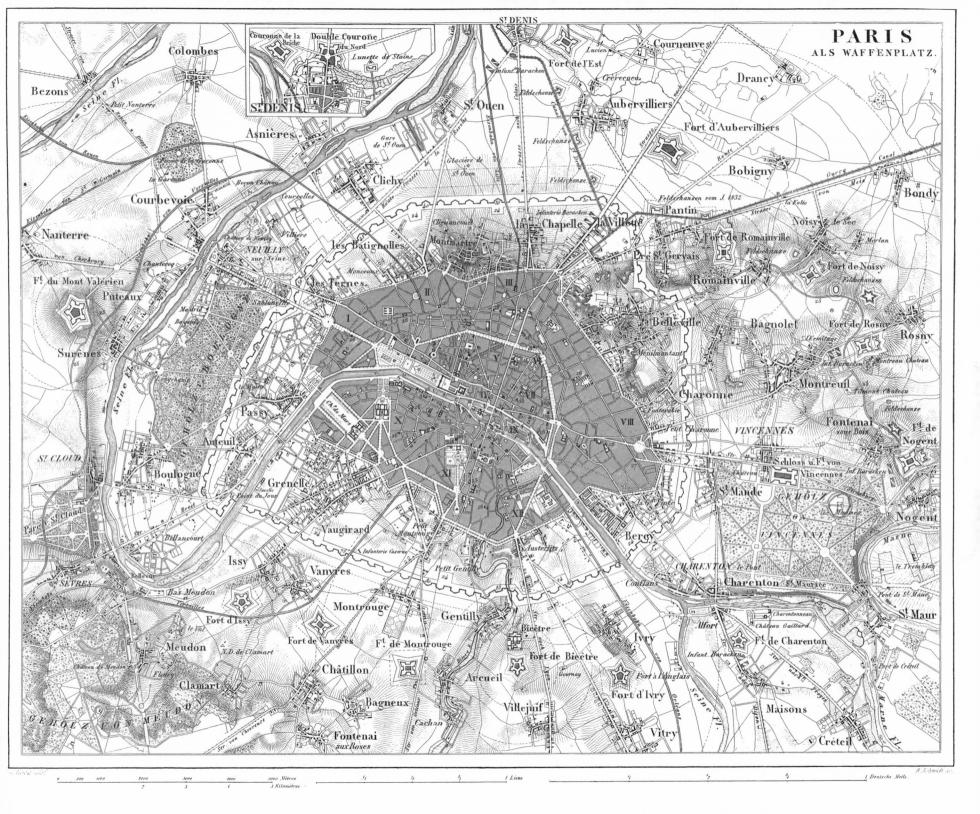

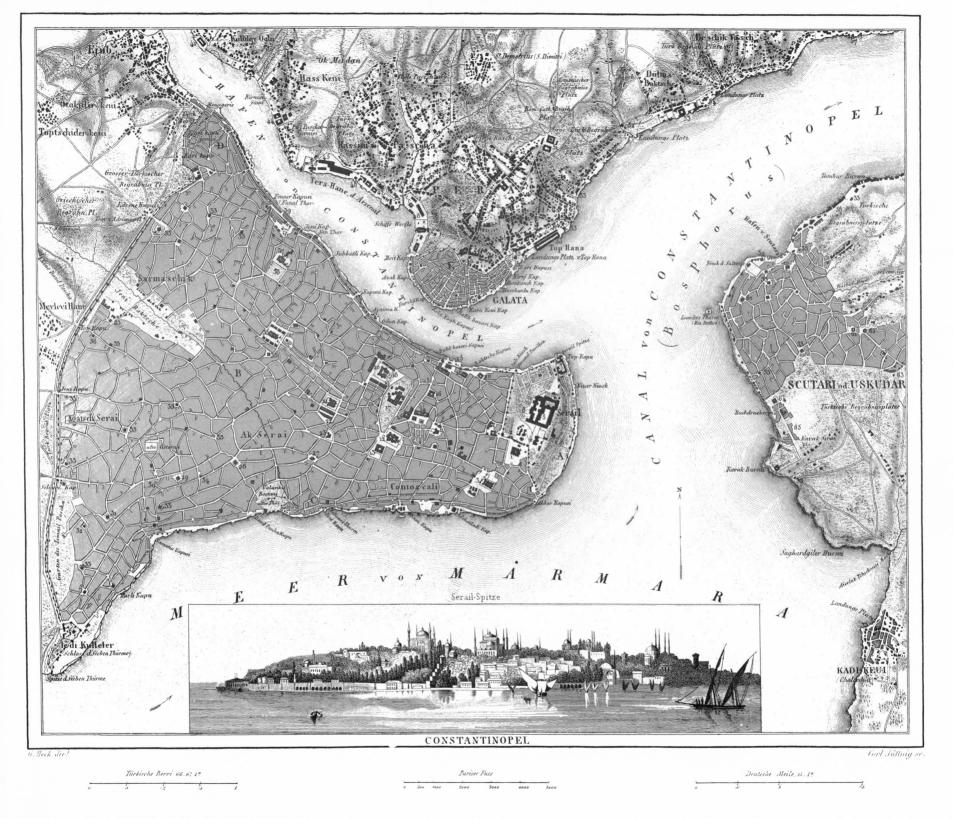

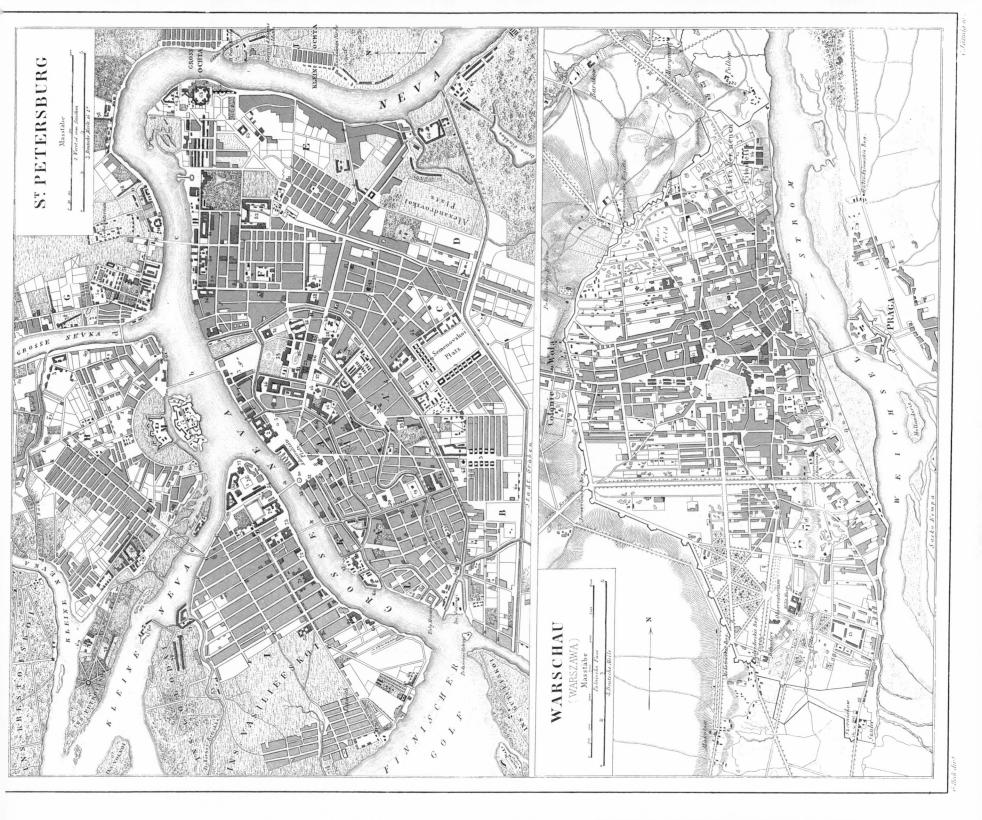

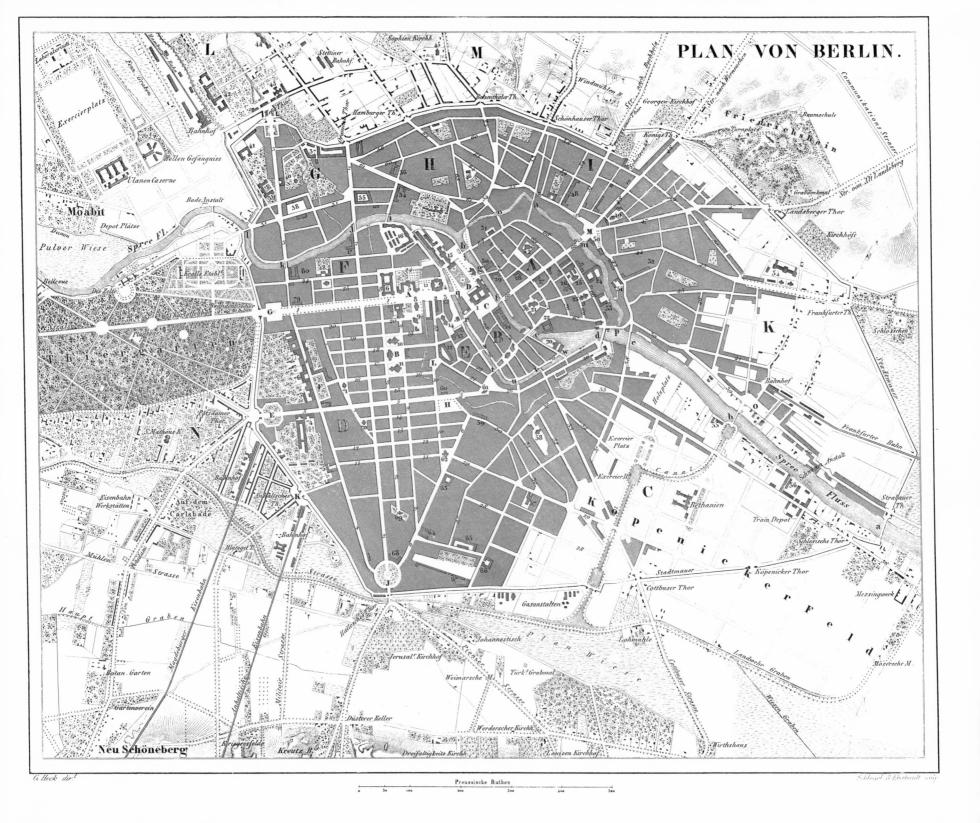

PLATE 179. BERLIN

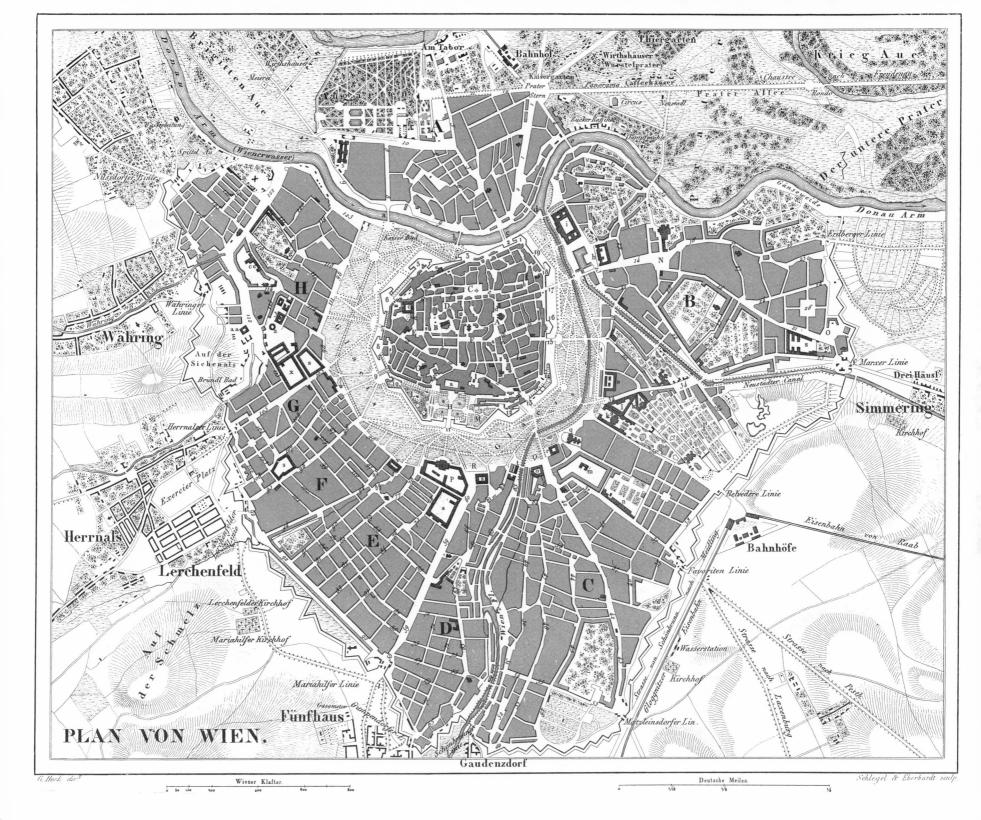

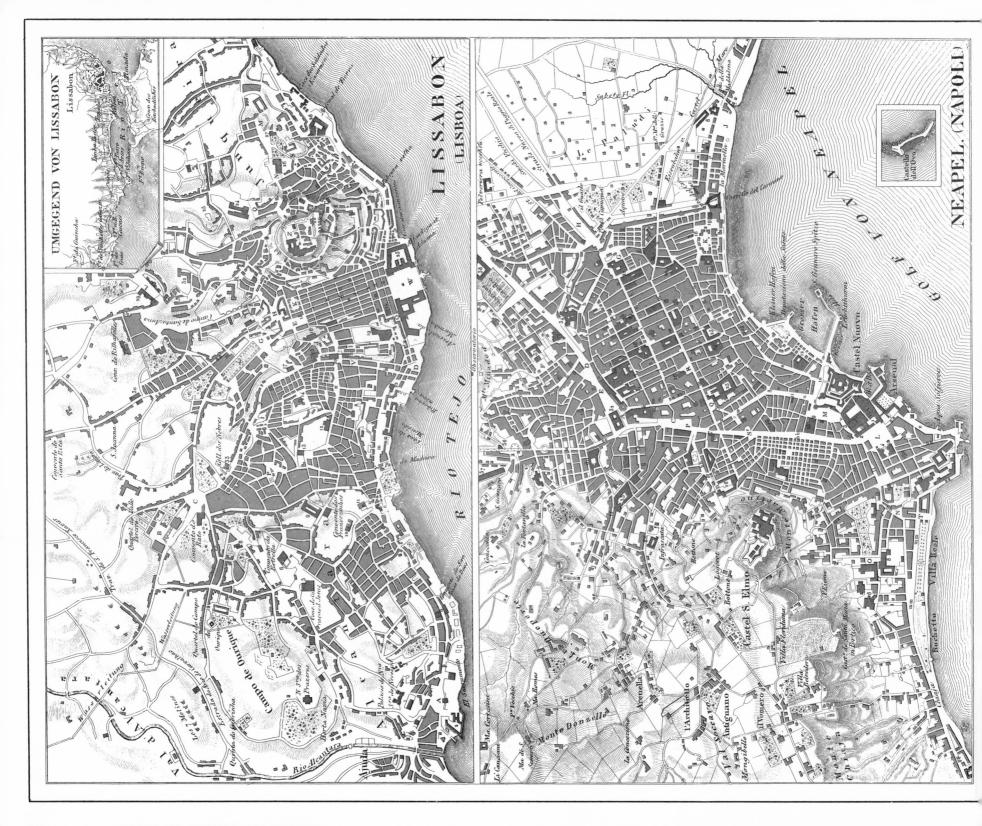

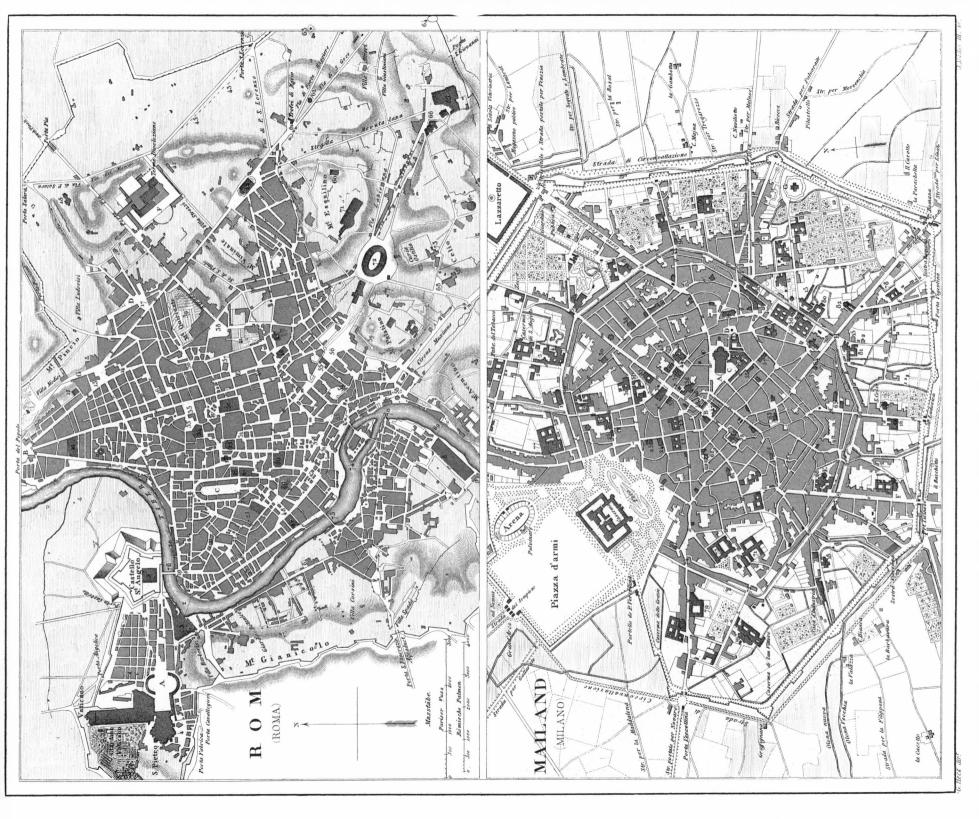

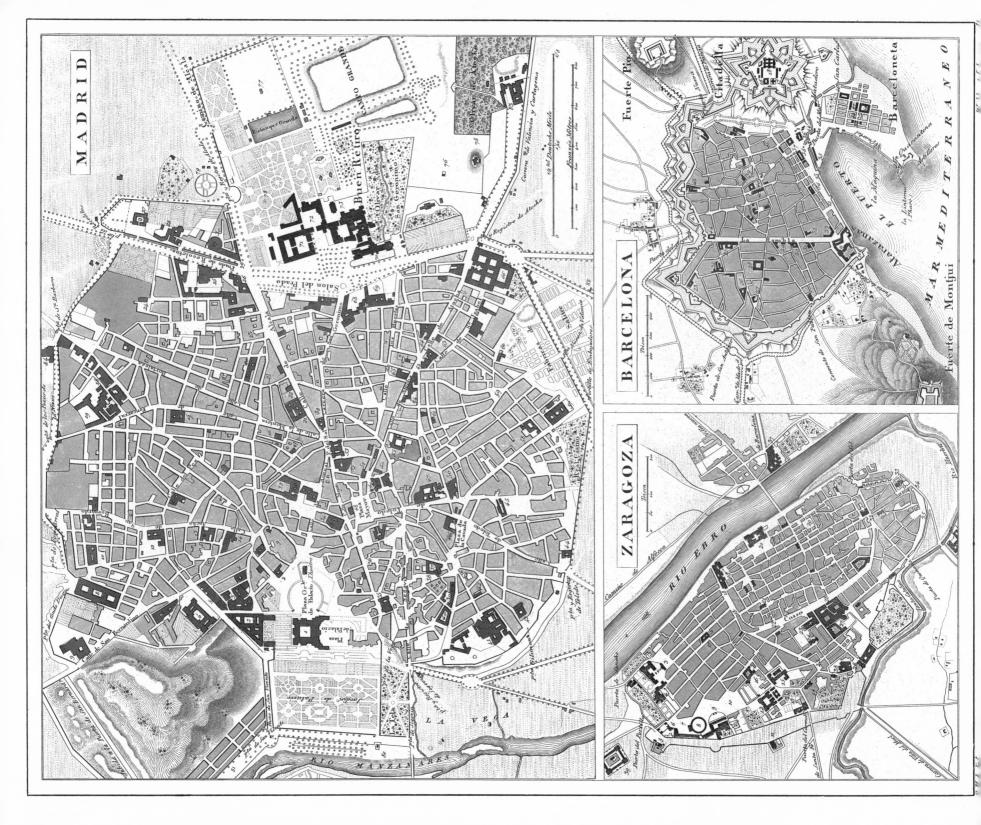

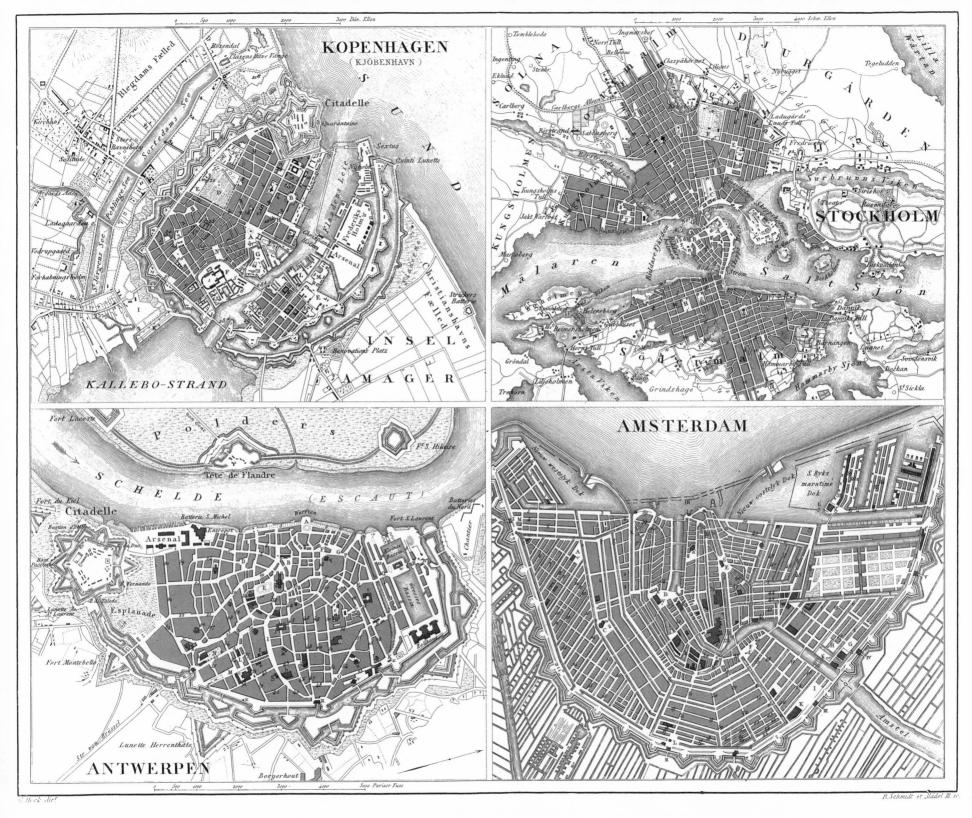

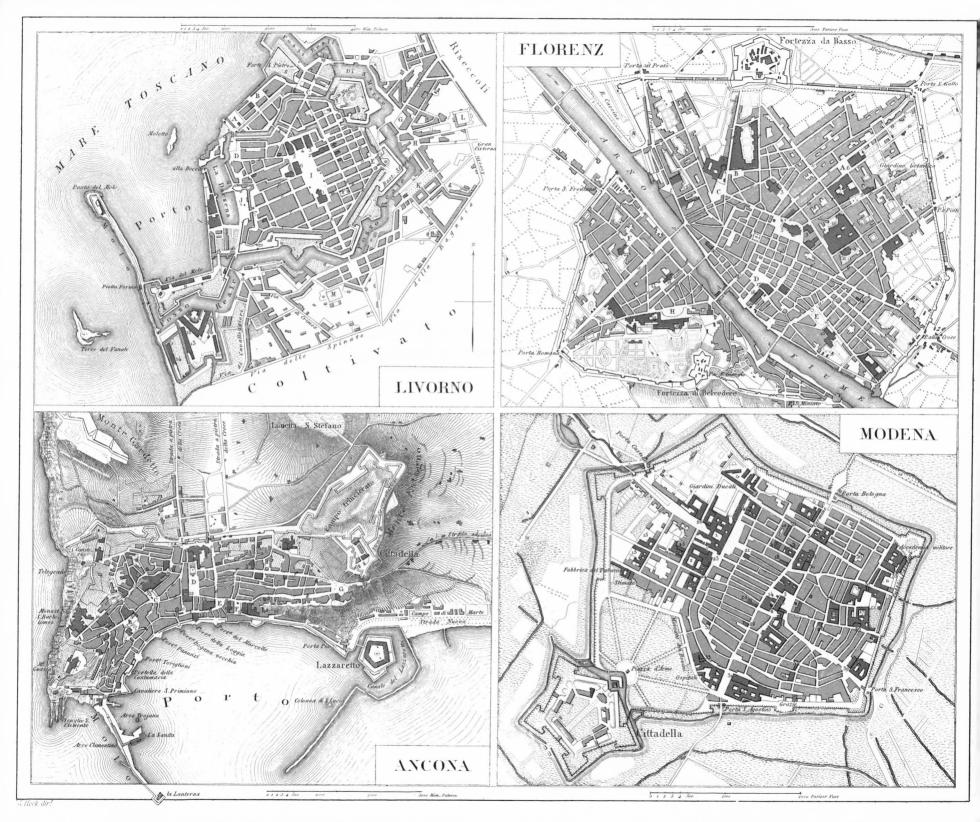

PLATE 185. LEGHORN, FLORENCE, ANCONA, AND MODENA

Captions to the History and Ethnology Plates 186–266

NCIENT TIMES AND MIDDLE **AGES**

PLATE 186. Egypt

- The court of the dead
- -4. Different trades
- Agriculture
- , 7. Hunting and fishing
- Vintage
- . King in his chariot
- 0. King on his throne, receiving presents

PLATE 187. Ancient Middle East and the Orient

- -3. Egyptian costumes
- Lybian costume
- Chinese
- -14. Assyrians
- 15, 16. Medes
- 16-20. Persians

PLATE 188. Tombs and Funerary Objects

- -4. Egyptian features and headdresses, from monuments
- 5ab. Heads of male mummies ab. Heads of female mummies
- Mummy with the inner fillets
- Mummy with the exterior
- 9-11. Mummies with the coffins
- 12. Coffin with its cover
- 13, 14. Embalmed animals
- 15, 16. Vases
- 17-19. Large stone vases
- 20ab. Pitchers 21, 22. Altars
- 23, 24. Chairs
- 25. Folding chair
- 26, 27. Thrones
- 28, 29. Lounge and footstool

- 30. Knife
- 31. Royal sceptre
- 32, 33. Sphinxes
- 34, 35. Obelisks
- 36. Entrance to the Egyptian labyrinth
- 37-39. Indian pyramids, ground plan, elevation, and section
- 40. Rock-tombs near Persepolis

PLATE 189.

Various Peoples of Antiquity

Figure

- 1. Carthaginian king
- Mauritanian
- 3. Persian woman
- 4-6. Armenians
- Arab
- 8. Phrygian
- 9. 10. Dacians
- 11, 12. Dacian women
- 13. Syrian
- 14. Parthian
- 15. Celtiberian
- 16. Iberian woman
- 17. British woman
- 18-23. Germans

PLATE 190.

Scenes of Germans and Gauls

Figure

- 1. German dwelling
- German infant plunged in the river
- 3. German wedding
- 4-8. Gauls

PLATE 191.

Tombs and Funerary Objects

Figure

- 1, 2. Egyptian sphinxes
- 3-6. Altars
- 7. Table
- 8-14ab. Pitchers and vases
- 15-19. Cups and other drinking vessels
- 20. Bowl

- 21. Dipper (Simpulum)
- 22ab. Royal necklace and sceptre
- 23, 24. Ethiopian royal headgear
- 25. Numidian royal headgear
- 26. Armenian royal headgear (Kidaris)
- 27. Dacian headgear
- 28. Sarmatian headgear
- 29. Scythian royal tiara
- 30, 31. Persian royal tiara
- 32. Assyrian tiara
- 33-37. Indian caps
- 38. Assyrian helmet
- 39. Phrygian cap
- 40ab. Assyrian headgear
- 41, 45h. Indian necklace and girdle
- 42. Chinese imperial cap
- 43-45. Fans and fly-brushes
- 46. Persian covering for the feet
- 47. Persian fan
- 48-50. Persian drinking vessels
- 51. The rock-tomb of Midas in Asia Minor
- 52. Rock-tombs at Persepolis
- 53. Monument near Tortosa in Svria
- 54. Absalom's tomb in the valley of Josaphat, near Jerusalem
- 55-75ab. Carthaginian coins and medals

PLATE 192. **Grecian Costumes**

Figure

- 1, 2ab. Maidens
- 3. Youth
- Spinner
- 5. Singer
- 6. Amazon
- 7–13. Women 14. Phrygian
- 15, 16. Greeks from Mount Ida
- 17. Philosopher
- 18. Poet 19. Prefect
- 20. War-leader

PLATE 193.

Greek and Roman Scenes

- 1. Ceremony at a Greek wedding
- Greek dancer
- 3. Roman funeral ceremony
- Interior of a Greek dwelling
- The Areopagus

PLATE 194. **Grecian Games**

Figure

1-6. Games of Greek youth 7-24. Olympian games

PLATE 195.

Grecian Garden and Artifacts

Figure

- The philosophers' garden at Athens
- 2-34. Various Grecian articles of furniture
- 35-39. Various Grecian tools
- 40-54. Various Grecian articles of toilet

PLATE 196. Tombs, Urns, and Coins

Figure

- 1. The rock-tombs of Tarquinii
- Those of Assus
- 3, 4. Those of Ceræa, and their ground plan
- 5, 6. Tombs of Orela; elevation
- 7, 8. The same; the ground plan 9. 10. Tombs in Telmessus;
- elevation and ground plan 11, 12. Tomb in Falerii; ground plan and section
- 13, 14. Tomb in Agrigentum; elevation and section
- 15. Tomb from an antique vase
- 16-20. Urns and vases 21-23. Tripods
- 24-34ab. Greek coins

PLATE 197. Rome

Figure

- 1-3. Emperors
- 4, 5. Empresses 6, 7. Senators
- 8. Philosopher
- 9. Lictor
- 10. Citizen and his wife
- 11. 12. Youths
- 13-16. Women
- 17-29. Female headgear
- 30-32. Male headgear

PLATE 198. Rome

Figure

- 1. Exhibition of captives in the
- Gladiators in the theatre
- Gladiators at funerals Funeral of emperors

PLATE 199. **Details from the Circensian Games**

Figures 1-16.

PLATE 200. Scene in Roman Coliseum and Roman Coins

- **Figure** 1. Combat with wild beasts in the Coliseum at Rome, under
- Domitian 2-19. Roman consular coins 20-25. Roman imperial coins

PLATE 201. **Roman Furniture and Tools**

Figures 1-66.

PLATE 202.

Roman Tombs, Sarcophagi, and **Artifacts**

Figure

1. The street of tombs in Pompeii

- 2-4. Monuments
- 5-7. Sarcophagi
- 8-59. Roman furniture and tools

PLATE 203.

Scenes and Artifacts from Gaul and Various Monuments

Figure

- Gallic women of the Roman time
- 2-6. Bas-reliefs from Gaul
- 7, 8ab. Gallic coins
- 9, 10. Gallic sepulchral urns
- 11-39. Various Gallic trinkets and utensils
- 40-42. German sepulchral urns
- 43-56. Coins, medals, and matrices
- 57, 58. Carthaginian monuments
- 59, 60. Gallic monuments
- 61. The Roman column at Cussy

PLATE 204.

Catacombs, Churches and Chapels

Figure 1. The Apostles' grotto near

- 1. The Apostles' grotto near Jerusalem
- 2. The catacombs of Syracuse
- 3-6. The catacombs of Naples; ground plan; vertical section of a part; horizontal section of another part; the chapel
- 7-10. The catacombs of San Marcellino near Rome; ground plan, perspective view, and details
- Plan of Platonia, near St. Sebastian, before the walls of Rome
- 12, 13. Tombs of Christian martyrs
- 14. Christian sarcophagus from the catacombs
- 15. Chapel of St. Hermes
- 16. Chapel of St. Agnes
- 17. Plan of the subterranean church of St. Hermes
- 18. External elevation of the subterranean church of St. Prisca
- Tabernacle of the church of St. Nereus and St. Achilleus, near the baths of Antoninus

at Rome

PLATE 205.

The Tribes of the Migration

Figure

- 1. Goth
- Sueve
 Gepide
- Gepide
 Vandal
- 5. Marcoman
- 6. Quade
- 7. Herulian
- 8. Briton
- 9. Frank
- 10. Hun
- 11-14. Picts
- 15. Anglo-Saxon chieftain
- 16-18. Anglo-Saxons
- 19. Danish king
- 20. Danish warrior
- 21-23. Danes

PLATE 206.

Costumes of Central Europe

Figure

- 1. Queen Clotilda (6th century)
- 2. Maid of honor
- 3. Frankish leader
- 4ab. Frankish warriors
- 5. King Clovis
- 6. Charlemagne
- 7, 8. Prince and princess of his house
- 9, 10. Noble and his wife
- 11. Leader under Charlemagne
- 12ab. Warriors
- 13. Bishop
- 14. Common people
- 15-18. Frankish king, queen, prince, and princess
- 19, 20. Prebendary and nun
- 21. Citizen
- 22, 23. Norman king and queen
- 24-26. Norman nobles
- 27, 28. Norman citizen and peasant

PLATE 207.

Scenes and Artifacts from the Time of Charlemagne and the Franks

Figure

1, 2. Clovis, king of the Franks, and his queen Clotilda

- 3. Fredegonda, from her tomb
- 4. Childebert, king of the Franks
- 5, 6. Statues of females from the 8th century
- 7. Charlemagne
- 8. Charlemagne receiving the submission of Wittekind
- 9-37. Arms, utensils, and furniture of Charlemagne's time
- 38. Statue of Wittekind
- 39-63. Utensils and furniture of Charlemagne's time

PLATE 208.

Scenes of French Medieval Life

Figure

- 1. Travelling of Frankish kings in the 8th century
- Manner of transporting wounded or sick princes in the 13th century
- 3. St. Louis administering justice in the open field
- 4. Clerical punishment of French princes in the 13th century
- 5. Vassals paying homage to their liege lord

PLATE 209.

German and English Armor and Tournaments

Figure

- 1. Full armor of Emperor Maximilian
- 2. Full armor of King Henry VIII
- 3. English knight
- 4. German knights
- 5. Squires
- 6. English knights in tournament
- 7. German knights before a tournament
- 8. Judge of the tournament

PLATE 210.

Different Modes of Combat

Figure

- 1. Joust with lances in Germany
- 2. Judicial combat
- 3. Combat with maces in France

- 4. Judicial combat with shields
- 5. Combat with swords
- 6. Combat with lance points
- 7. Carrying the ring in the carrousel
- 8. Squire taking the oath of knighthood on the sword

PLATE 211. Becoming a Knight

Figure

- 1. Young knight taking the solemn oath on the altar
- 2. The ceremony of dubbing a knight

PLATE 212. Crowns and Shields

Figure

- 1–13. Forms of shields
- 14–32. Colors and figures of shields
- 33-63. Divisions of shields
- 64-86. Different crowns
- 87-92. Crests of shields

PLATE 213. Coats of Arms

Figures 1–21.

PLATE 214. Coats of Arms

Figures 1–31.

PLATE 215. **The Inquisition**

Figure

- 1 Session of the tribunal
- Session of the tribunal
 The punishment of the
- scourge

 Nailing the hand to the post
- 4. The punishment of strangling
- 5. The fire-torture on the wheel
- 6. Auto-da-fé at Seville

PLATE 216. The Inquisition

Figure

- 1. The torture of the rope and pulley
- 2. The water-torture
- 3. The fire-torture
- 4. Auto-da-fé in Spain

PLATE 217.

Founders and Representatives of Various Monastic Institutions

Figure

- 1. St. Augustin
- 2. St. Antony
- 3, 4. Maronite patriarch and
- 5, 6. Armenian patriarch and monk
- 7. St. Basil
- 8. Greek monk in Poland
- 9. Jacobite monk
- 10, 11. Benedictine monk and nun
- 12. Nun of Fontevrault
- 13, 14. Augustine monk and nun 15. Prebendary of the
- Congregation of the Lateran
- 16. Barefoot Carmelite monk
- 17. Carmelite nun
- 18. Carthusian nun19. Calmalduensian monk
- 20. Valombrose monk
- 21. Bernardine nun
- 22, 23. Capuchin monks
- 24. Nun of St. Clarissa
- 25. Sylvestrine monk26, 27. Dominican monk and nun

PLATE 218.

Representatives of Religious Communities

- Figure
 1. Monk of the Holy Sepulchre
- Monk of the Ho.
 Coelestine monk
- 3. Franciscan monk
- 4. Ursuline nun
- 5. Theatine nun
- 6. Beguine7. Hospitaller of St. Jacques du
- haut pas
 8. Alexian monk
- 9. Ambrosian monk10. Religious of the order of
- Jesus
- 11. Annunciate nun12. Nun of "the Immaculate Conception"
- 13. Nun of "the Visitation of St. Mary"14. Nun of "the Word become
- Flesh"
 15. Franciscan nun
- 16. Hospital nun of Hotel-Dieu in Paris

- 7. Jesuit
- 8. Jesuit missionary in China
- 9. Sister of Charity
- 0. Bethlehemite monk
- 1. Priest of the Oratory in France
- 2. Doctrinary
- 3. Barnabite monk
- 4. Priest of the pious schools of France and Belgium
- 5, 26. Feuillantine monk and
- 7. Monk of St. Maurus

PLATE 219.

Members of Various Religious and **Military Orders**

- Figure
- Visitantine nun in Flanders Nun of "Notre-Dame"
- Nun of "Notre Dame de la Miséricorde"
- Priest of the Congregation of Missions
- Sister of Charity of St.
- Vincent de Paula
- Hospital nun of La Flèche
- a. Trappist monk
- b. Poor volunteer monk of Flanders
- Grand master of the Order of Malta
- Grand cross of the same
- 0. Knight of Malta
- 1. Lady of the Order of St. John of Jerusalem
- 2. Templar in house dress
- 3. Templar in war costume
- 4. Templar in full armor mounted
- 15. Grand master of the German Knights
- 16. Knight of St. James of the Sword
- 7. Knight of the Order of Calatrava 18. Knight of the Order of
- Alcantara
- 19. Knight of St. Avis in Portugal
- 20. Knight of St. Stephen
- 21. Knight of the Holy Ghost
- 22. Hospitaller of the Holy Ghost
- 23. Religious of the Order d'Aubrac

PLATE 220. Freemasonry

Figure

- 1. Initiation of apprentice
- Initiation of master
- Initiation of the 33d degree of the Scottish lodge
- 4. Funeral of a companion

PLATE 221.

Hawking and Crusaders

- 1. Hawking in France
- Departure of crusaders for Palestine

PLATE 222. Crusaders

- **Figure**
- 1. Combat between crusaders and Saracens
- 2. Harangue to crusaders before the walls of Jerusalem

PLATE 223.

Knights Returning from Crusade and at Tournament

Figure

- 1. Return of crusaders from Palestine
- 2. Tournament in Germany

PLATE 224.

Church of the Holy Sepulchre and Church of St. Mary of the Manger

- 1. Ground plan of the church of St. Mary of the Manger at Bethlehem
- 2. Interior of the church of St. Mary of the Manger in Bethlehem, with the entrance to the chapel of the Holy Grotto
- 3. Interior of the chapel with the Holy Grotto
- 4. Ground plan of the church of the Holy Sepulchre in Jerusalem
- 5. Portico and entrance to the
- Interior of the same, with the Holy Chapel

ETHNOLOGY OF THE NINETEENTH CENTURY

PLATE 225. The Five Principal Races

1. Caucasian Race

Figure

- 1. Inhabitants of Central Europe
- Greek
- Turk 3.
- Cossack
- Persian
- Hindoo
- Bedouin
- 8, 9. Cabyles
 - 2. Mongolian Race
- 10. Kalmuck
- 11. Chinese
- 12. Samovede
- 13. Esquimaux

3. Ethiopian Race

- 14. Guinea Negro
- 15. Boussa Negro
- 16. Hottentot
- 23, 24. Papuas (Australia)
 - 4. American Race
- 17-21. Indians
 - 5. Malay Race
- 22. Native of New Zealand

PLATE 226.

Germanic Peoples

Figure

- 1. Peasant girl from Baden
- 2. Peasant from the Baden highlands
- 3. 4. Inhabitants of the Black Forest
- 5-9. Wirtembergers
- 10-15. Bayarians
- 16, 17. Hessians
- 18, 19. Inhabitants of Rhenish Prussia
- 20. Inhabitants of Brunswick
- 21, 22. Inhabitants of the District of Coblentz (Rhine)
- 23, 24. Inhabitants of Altenburg (Saxony)

PLATE 227.

Germanic and Austrian Peoples

Figure

- 1. Inhabitants of the District of Erfurt (Thuringia)
- Inhabitants of Holstein
- Inhabitants of the District of Lüneburg (Hanover)
- 4, 5. Inhabitants of the District of Hamburg
- 6-8. Inhabitants of East Friesland (Hanover)
- 9-11. Inhabitants of Silesia
- 12-15. Inhabitants of Tyrol
- 16-19. Inhabitants of Austria 20-22. Inhabitants of Styria
- 23. Inhabitants of Bohemia
- 24. Inhabitants of Illyria

PLATE 228.

Gymnasium and Acrobatics

Upper Division

Figure

1-12. The German gymnasium

Lower Division

Figure

1-8. Acrobatic feats

PLATE 229. Equestrian Feats

Figures 1-3.

PLATE 230. Races and a Ball

Figure

- 1, 2. Horse races
- 3. Masked ball at Paris

PLATE 231. **Scenes of Public Events**

Figure

- 1. Grand promenade in the Elysian Fields (Paris)
- Festival at St. Petersburg
- 3. Public meeting in England

PLATE 232. Outdoor Celebrations

Figure

1. Naumachy on the Seine in **Paris**

- 2. Rural ball
- Illumination in Rome

PLATE 233.

Spanish and Sardinian Scenes

Figure

- 1. Spanish barn
- 2. Sardinian barn
- Sardinian wedding
- 4. The Bolero (Spanish dance)
- Spanish bull-fight

PLATE 234.

Russian and Caucasian Tribes

Russian Tribes

Figure

- 1. 2. Strielzi
- 3. Russo-Polish guard
- 4-7. Inhabitants of Little Russia
- 8-10. Fishermen from the Volga
- 11. Inhabitants of Novgorod
- 12, 13. Inhabitants of the district
- of Twer
- 14. Inhabitants of the Ukraine 15. Cossack of the Don
- 16. Inhabitants of the district of Moscow

Caucasian Tribes

- 17-22. Circassians
- 23. Turkoman
- 24. Abasian 25. Mingrelian
- 26. Imeritian 27. Georgian

PLATE 235. Scenes of Russian Life

- Figure
- 1, 2. Russian rural games 3. Russian public bath
- 4, 5. Russian large and small knout

PLATE 236.

Scenes of Russian Life

Figure

- 1. Russian sleighing and gliding
- Russian serfs on the Don
- Russian national dance
- Festivity at Pergola (Russia)

5. Lapland winter cabins

PLATE 237.

Eastern Peoples and Costumes

Figure

- 1 a-s. Oriental headgear
- 2. Syrians
- 3, 4. Smyrnese
- 5-8. Maronites
- 9. Girl of Nablous
- 10. Nazarenes
- 11–15. Arabs
- 11-13. Alabs
- 16, 17. Armenians
- 18. Turk of Mardin

PLATE 238.

Scenes from Middle Eastern Life

Figure

- 1. Public baths for women in Turkey
- 2. Interior of a harem
- 3. Supper at the grand vizier's
- 4. Ceremony in the sultan's presence chamber
- 5. Dance of the dervises
- Prayer and ablution of the Mahomedans
- 7. Penitent dervise

PLATE 239.

Persians and Other Eastern Peoples

Figure

- 1-9. Persians
- 10. Beludshis
- 11. Usbek
- 12. Afghan
- 13. Kurd
- 14. Kirghis
- 15. Imeritian
- 16. Georgian
- 17. Mingrelian
- 18. Caucasian mountaineer

PLATE 240. Scenes of Eastern Life

Figure

- 1-3. Bashkirs and Kirghis in camp
- 4-6. Tartars
- 7, 8. Kurds

220

9. Persian nobleman

PLATE 241. Scenes of Persian Life

Figure

- 1. Wedding in Persia
- 2. Persian women travelling
- 3. Persian music
- 4. Persian meal
- 5. Persian game
- 6, 7. Persian punishments

PLATE 242.

Scenes of the English East Indies

Figure

- Rajah of Cutch and his vassals (English East Indies)
- 2. Caravan in Kattiavar (English East Indies)

PLATE 243.

East Indian and Arabian Scenes

Figure

- 1. Arabian nomades
- 2. Bedouin camp
- 3, 4. Arabian music and dance
- 5, 6. Travelling in Lahore

PLATE 244.

Scenes from Indian, Arabian, and Persian Life

Figure

- 1-3. Indian women and girls
- 4. Slave of a harem
- 5. Indian harem
- 6. Car festival in India
- 7. Salutation of the Arabians
- Persian funeral

PLATE 245. Hindoo Scenes

Figure

- 1. Penitent Hindoo fanatic
- Burning of a Hindoo widow with the remains of her husband
- 3. Wedding ceremony of the Tzingaris (Indian gipsies)
- 4. Nuptial procession of wealthy Hindoos

PLATE 246. **Oriental Peoples**

Figure

- 1-6. Chinese
- 7. Corean

8. Loo-Choo islander 9–14. Japanese

PLATE 247.

Scenes from Chinese Life

Figure

- 1. Tea culture in China
- 2. Silk culture in China
- 3. Chinese rice-dealer

PLATE 248.

Chinese Entertainment and Punishment

Figure

- 1. Chinese jugglers
- 2. Chinese theatre
- 3. Chinese punishment

PLATE 249.

Chinese Street Scenes

Figure

- 1. Chinese puppet-show
- 2. Chinese mandarin visiting
- 3. Chinese quack

PLATE 250.

African Scenes and Peoples

Figure

- 1. Moorish baths in Algiers
- 2, 3. Moorish noble and merchant
- 4. Arabian chief in Algiers
- 5. Jewess of Algiers
- 6. Slave
- 7. Lady of Cairo
- 8. Girl of Bornou (Senegal)
- 9. Negro king of Boussa
- 10, 11. Girls of Timbuktoo and Sokna (Fez)
- 12. Idolatry in Central Africa

PLATE 251.

Arabian and Egyptian Scenes

Figure

- 1. Egyptian Fellahs
- 2. Arabian dames and tents
- 3. Bedouins
- 4, 5. Arabian caravan
- 6. Nuptial procession in Cairo

PLATE 252.

Peoples of African Tribes

Figure

1. Abyssinian costumes

- 2. Abyssinian travelling
- 3. Elephant hunting
- 1. Negro chief and suite
- 5. Negro funeral south of the
- Coango River
 6. Christian negro-women of
- Benguela
- 7. Negro soldier (Portuguese Africa)
- Molua negroes guarding their king's dwelling
- 9. Human sacrifices of the Cassange negroes

PLATE 253.

Sports of Indian Tribes

Figures 1–7.

PLATE 254.

Peoples and Costumes of Mexico and South America

Figure

- 1. Mexican
- 2, 3. Inhabitants of La Puebla
- 4. Woman of Jalapa
- 5, 6. Costumes of Guatemala
- 7. Rich mulatto woman
- 8. Brazilian Mestizo
- 9, 10. Costumes of Bolivia
- 11. Girl of Bogota
- 12. Girl of Lima
- 13. Squaw of the district of Quito
- 14. Muleteers of the Cordilleras15, 16. Costumes of La
- Conception
- 17. Costumes of Chili18. Gaucho of Buenos Ayres

PLATE 255. Brazilian Scenes

Figure

- 1. Travelling farmer from the Rio Grande in Brazil
- 2. Traveller from the province of Minas
- 3. Brazilian planter's family driving to mass
- 4. Townsmen from the Brazilian Rio Grande travelling
- 5. Caravan of Brazilian merchants6. Convoy of diamonds

PLATE 256.

Various South American Peoples

Figure

- 1. Brazil Camacans in the forest
 - . Festivity of the Camacans
- 3. Negroes from Bahia
- 4. Free negro bringing up a fugitive slave
- 5. Inhabitants of San Paulo
- 6, 7. Civilized Paraguay Indians

PLATE 257.

Life in Brazil and Patagonia

Figure

- 1. Brazilian plantation
- 2, 3. Diamond washing
- 4, 5. Brazilian sports
- Brazilian planter's family
 walking to mass
- 7. Patagonian camp

PLATE 258. Brazilian Slave Trade

Figures 1–6.

PLATE 259.

Scenes from Greenland, Brazil, and Patagonia

Figure

- gure
- Greenland seal-hunting
 Brazilian Indians
- bird-shooting
 3. Attack by Guaycouros
- horsemen (Brazil)
 4. Cattle-hunting on the Pampas
- (Brazil)
- Negro dances at San Paulo
 South Patagonian huts and graves

PLATE 260. Sports and Duels of Various South American Indians

C:----

- Figure 1-4. Sports of Brazilian Indians 5ab. Duels and combats among
- the Botocudos
 6. Duel among the Purvis

PLATE 261.

Rites and Ceremonies of Mexican and South American Indians

Figure

1. Human sacrifice of the

- ancient Mexicans
- 2. Cannibals of the Paraguay forests
- 3. Cannibals preparing a peculiar beverage
- 4-6. War-dance, execution of captives, and funeral with the Tupinambas

PLATE 262.

Scenes of the Pacific

Figure

- 1, 2. Funeral of a chief (Sandwich Islands)
- 3. Funeral in New Zealand
- 4. Tahitian girl, carrying presents
- 5. Dance of the Tahitians
- 6. Dance of the aborigines of the Caroline Islands

PLATE 263.

Scenes of Australian and Polynesian Natives

Figure

- 1. Chief from the Tonga islands
- 2. Combat of Tonga women
- 3-5. Girlish sports on the Tonga islands
- 6. Dance of Australian aborigines
- 7-9. Wedding ceremony, funeral, and ball of Australian aborigines
- 10. Ceremony of the Gna-Lung

PLATE 264.

Natives of the South Pacific

Figure

- . War dance of the Booro islanders
- Cock-fight on the Philippine islands
- Making brandy on the Marian islands
- 4. Caroline islander
- 5, 6. Aborigines of New Zealand
- 7. Dance of the same

PLATE 265.

Rites and Ceremonies of the Pacific

Figure

1. Ceremonial salutation among

- the aborigines of New Zealand
- 2. Tattooing of the same
- 3. Indian and his squaw from the Caroline islands
- 4. Dance of the Indians of this tribe
- 5-7. Indians of the island of Hawaï
- 8. Dance of Australian savages

PLATE 266.

Scenes from the Lives of Various Indian Tribes

Figure

- 1. Dance in Samoa
- 2. Dwelling of the Chinooks
- 3. Meeting on Drummond's island

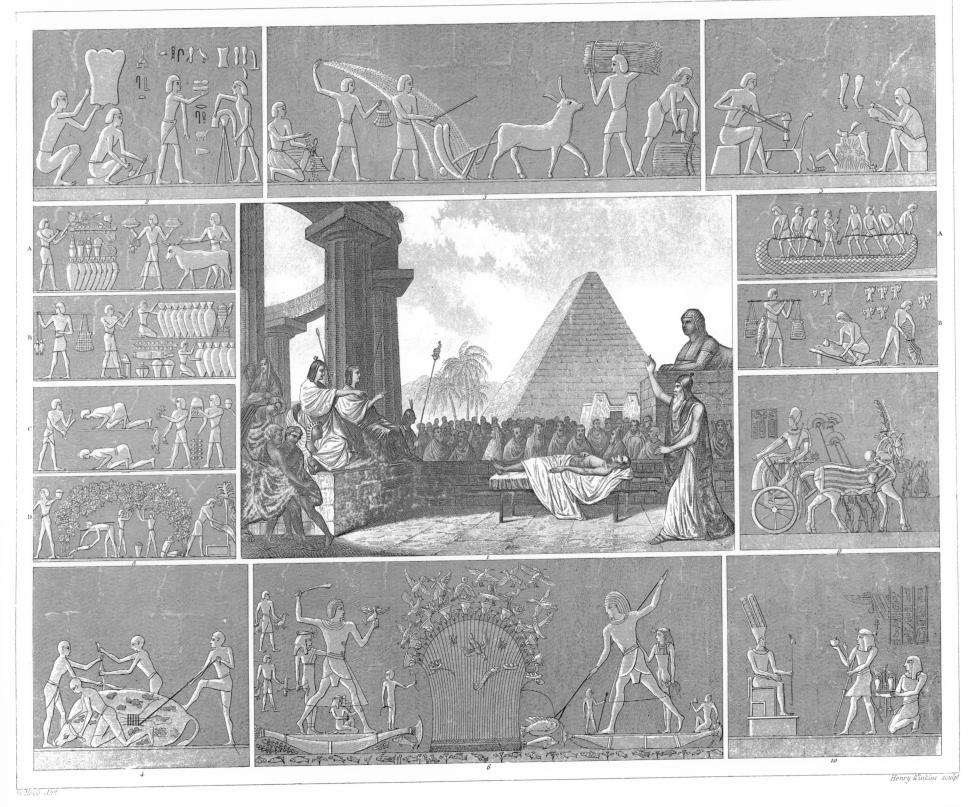

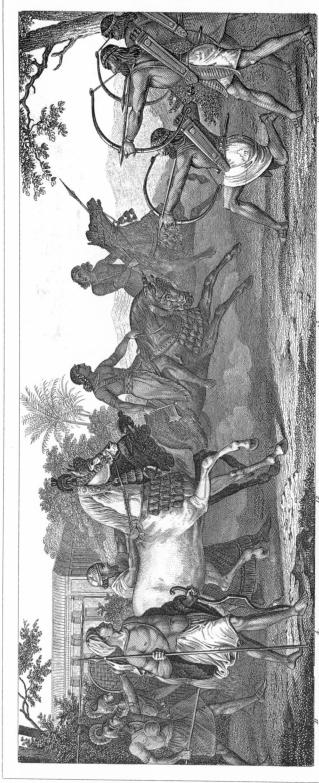

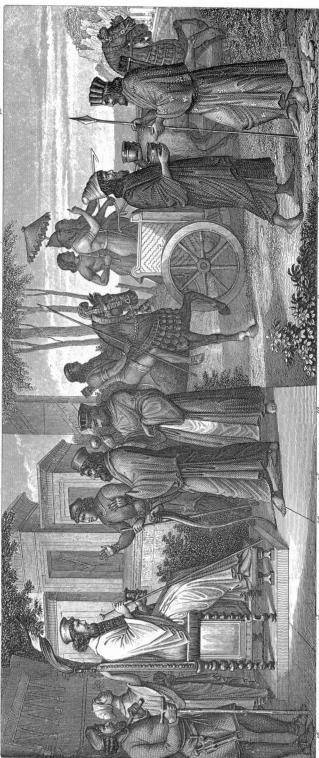

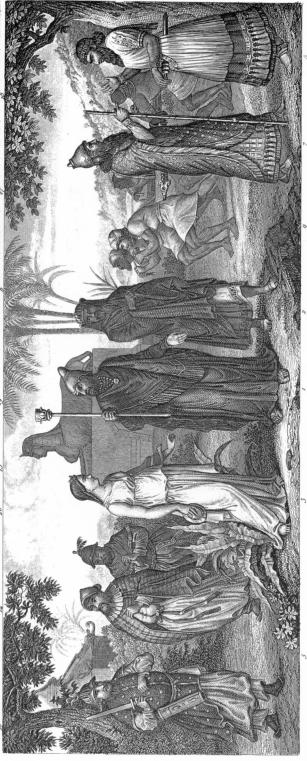

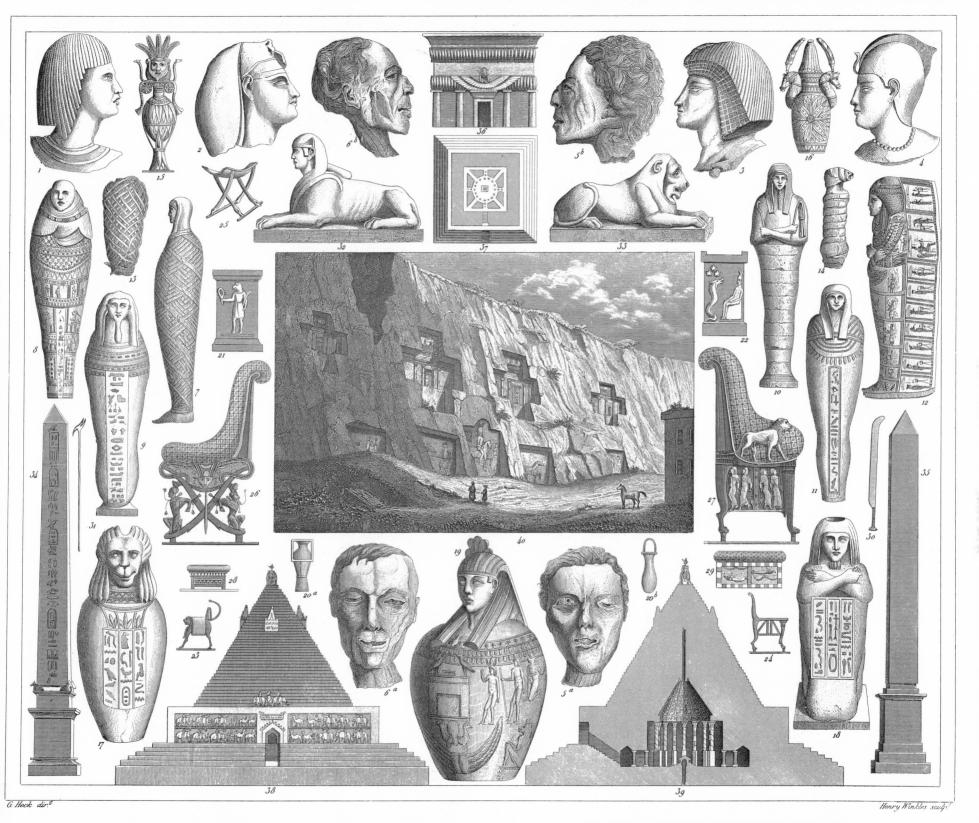

PLATE 188. TOMBS AND FUNERARY OBJECTS

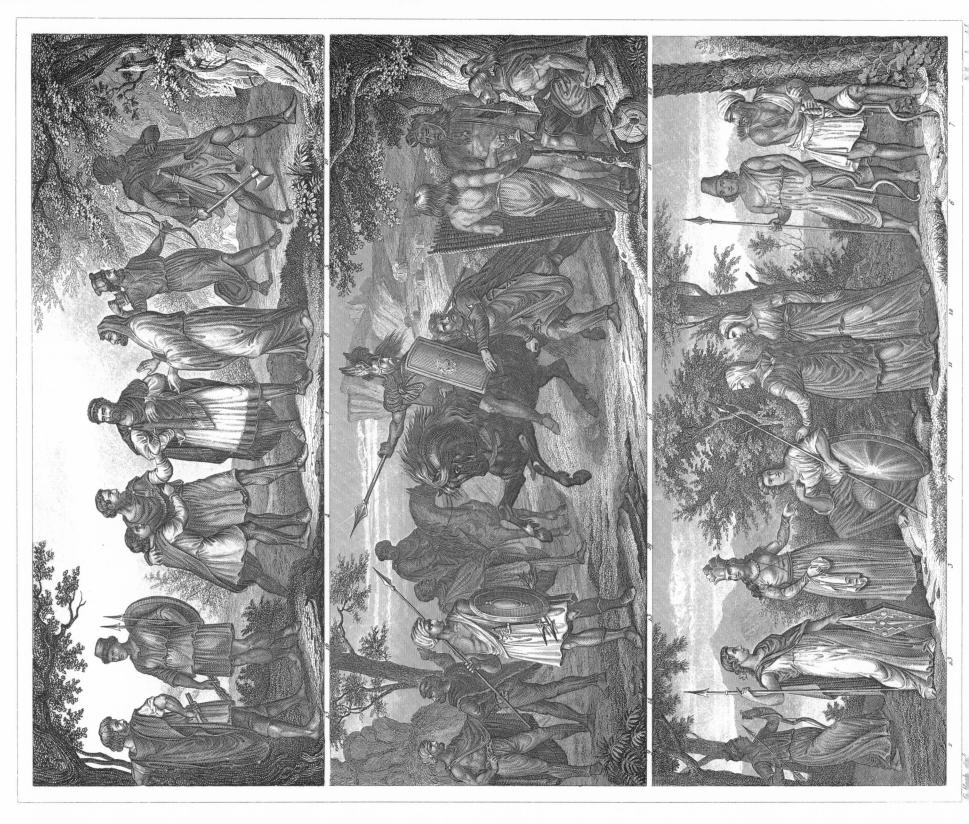

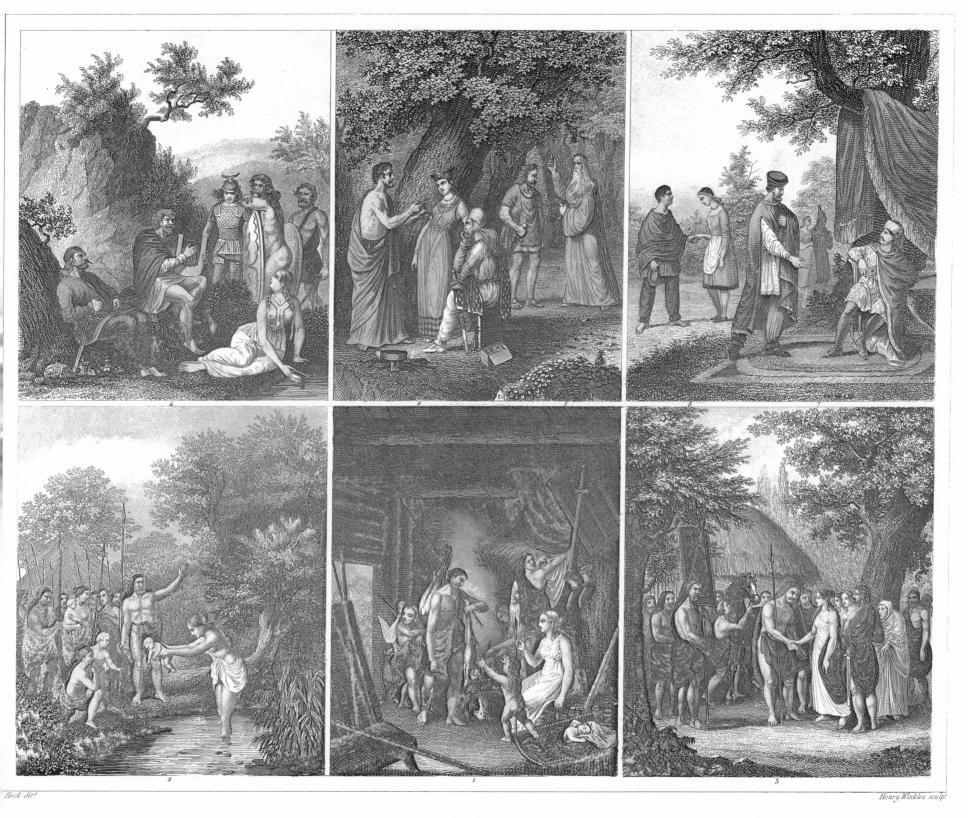

PLATE 190. SCENES OF GERMANS AND GAULS

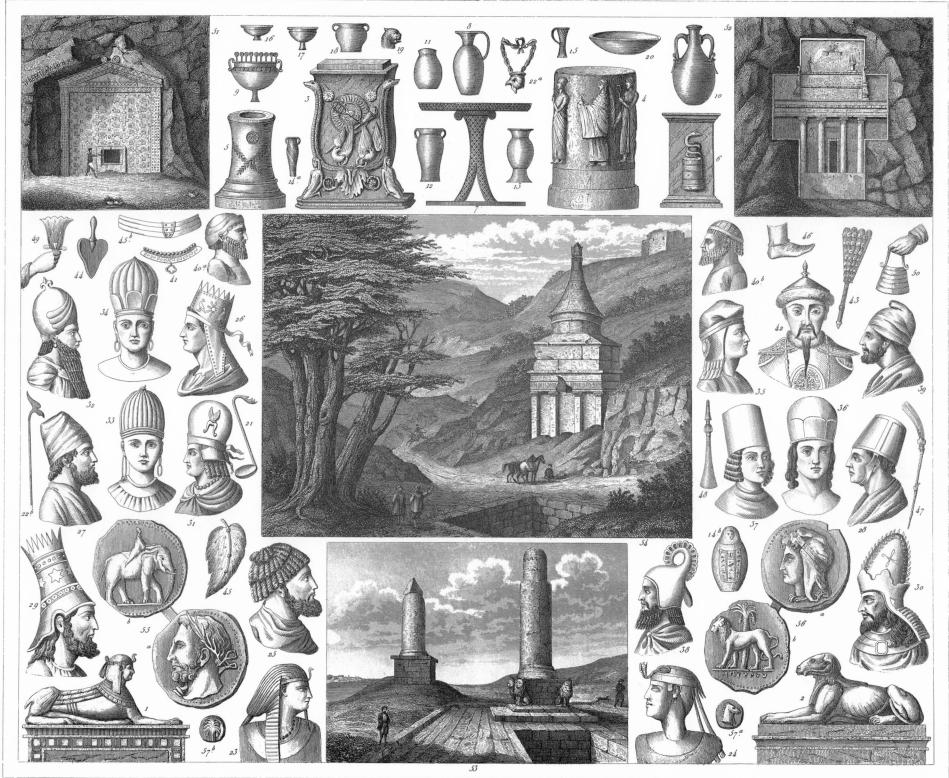

228

A. Krausse sen. sculp.

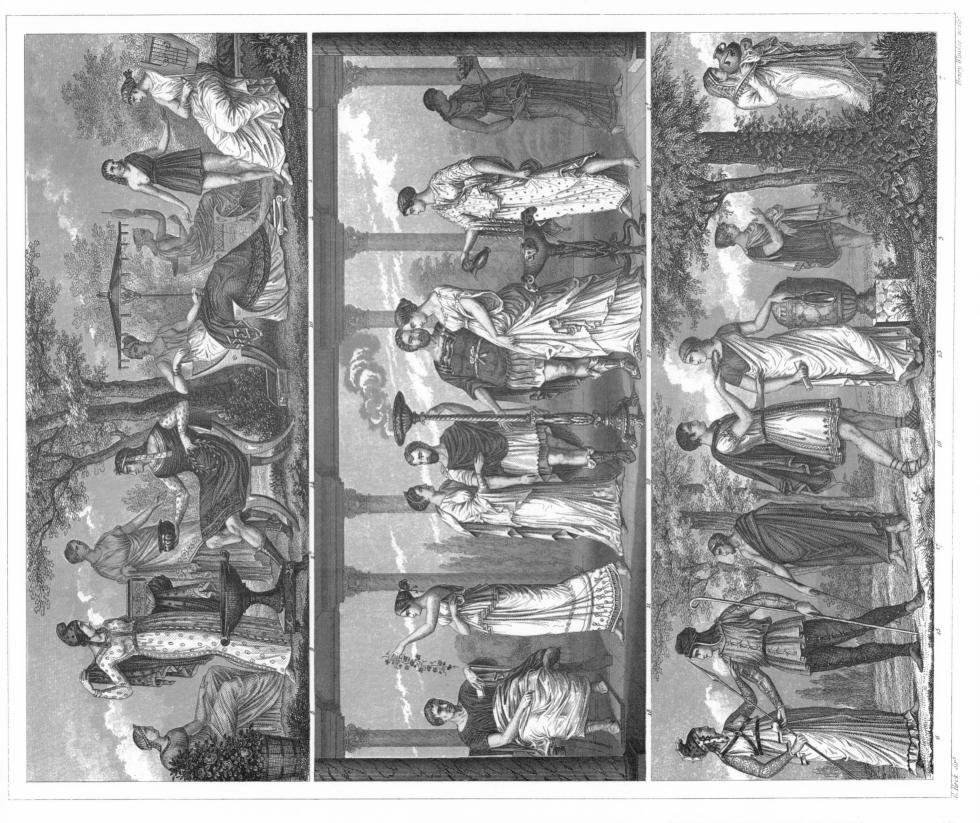

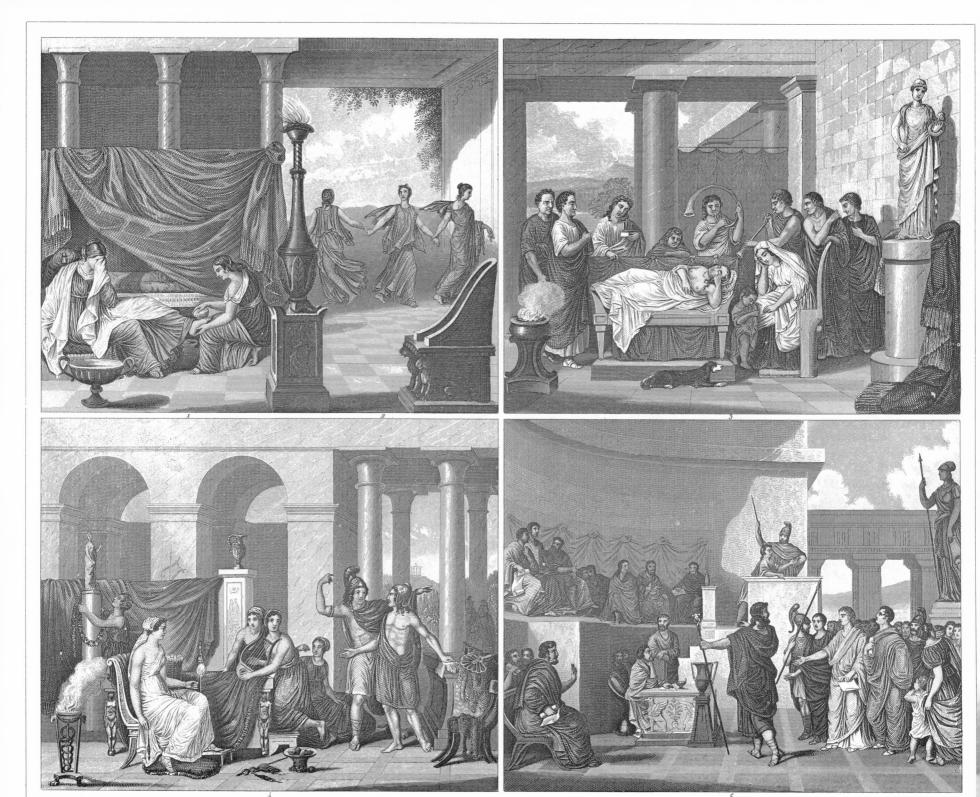

Henry Winkles sculp!

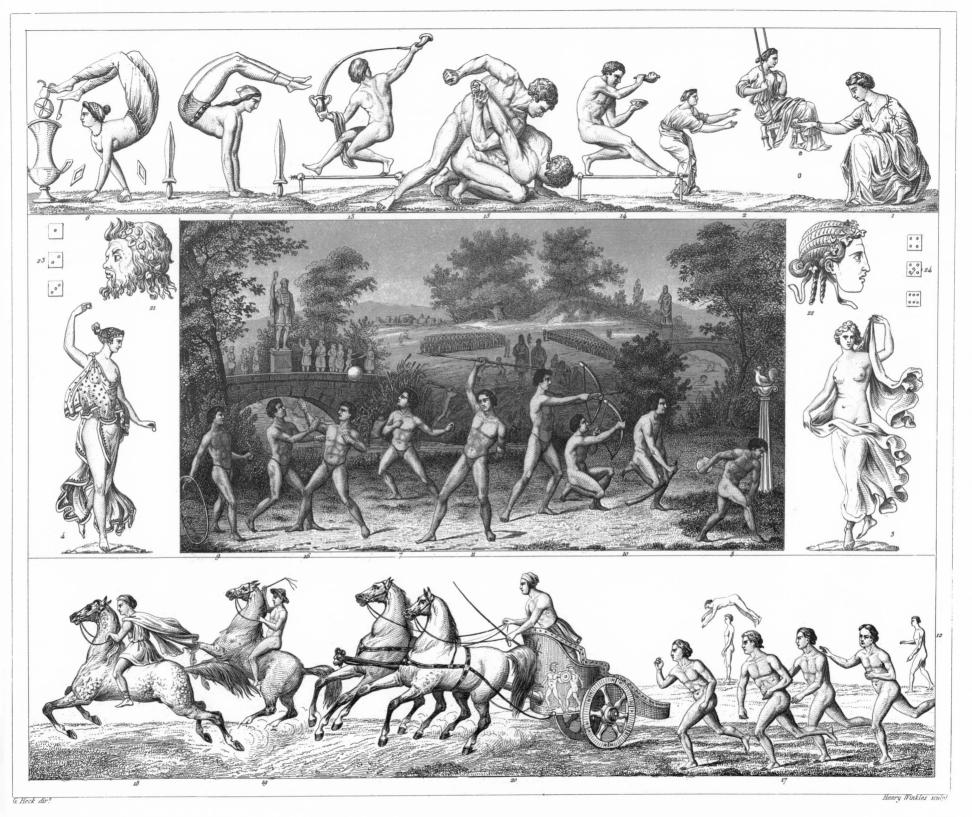

PLATE 194. GRECIAN GAMES

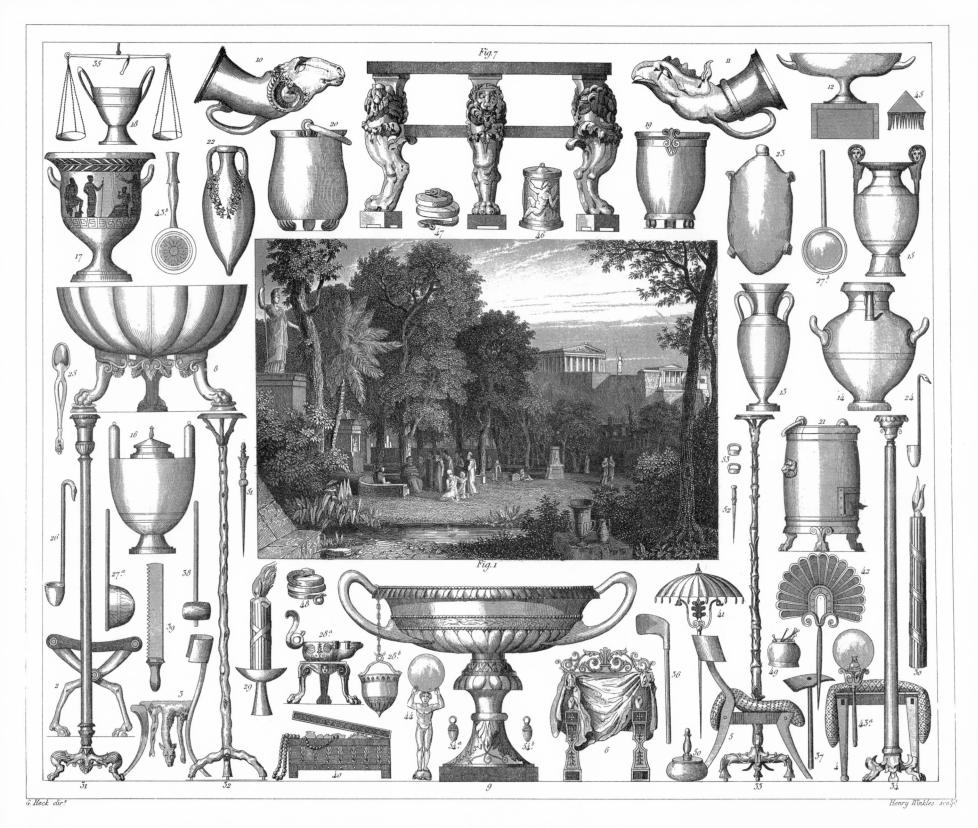

PLATE 195. GRECIAN GARDEN AND ARTIFACTS

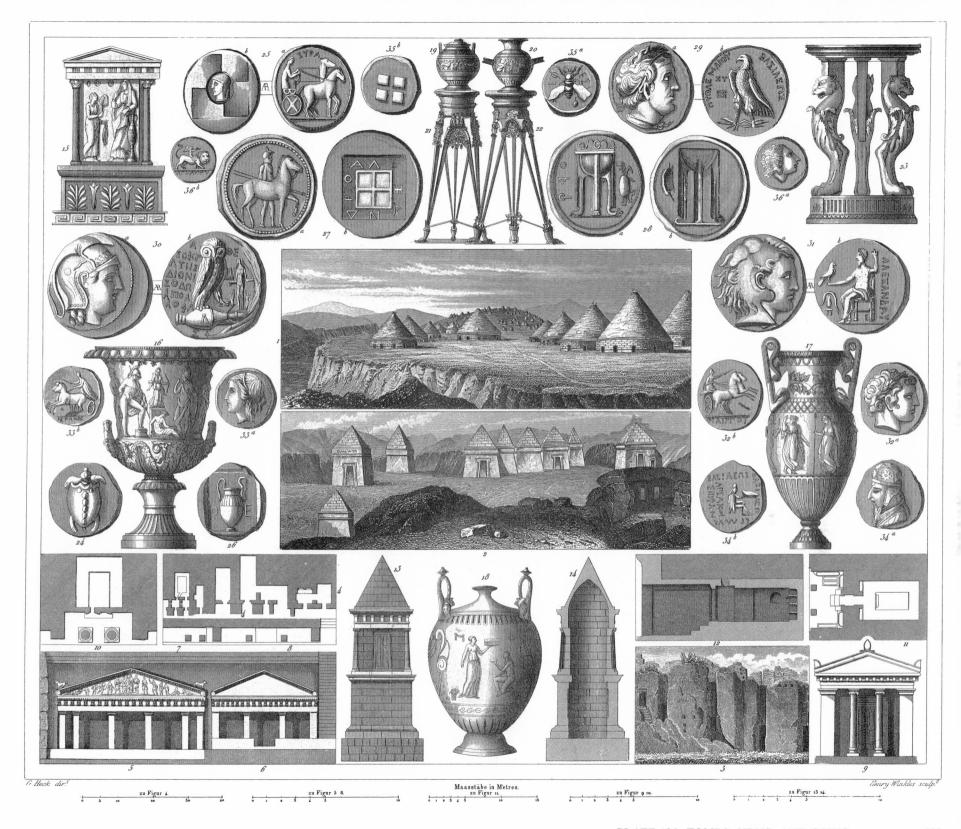

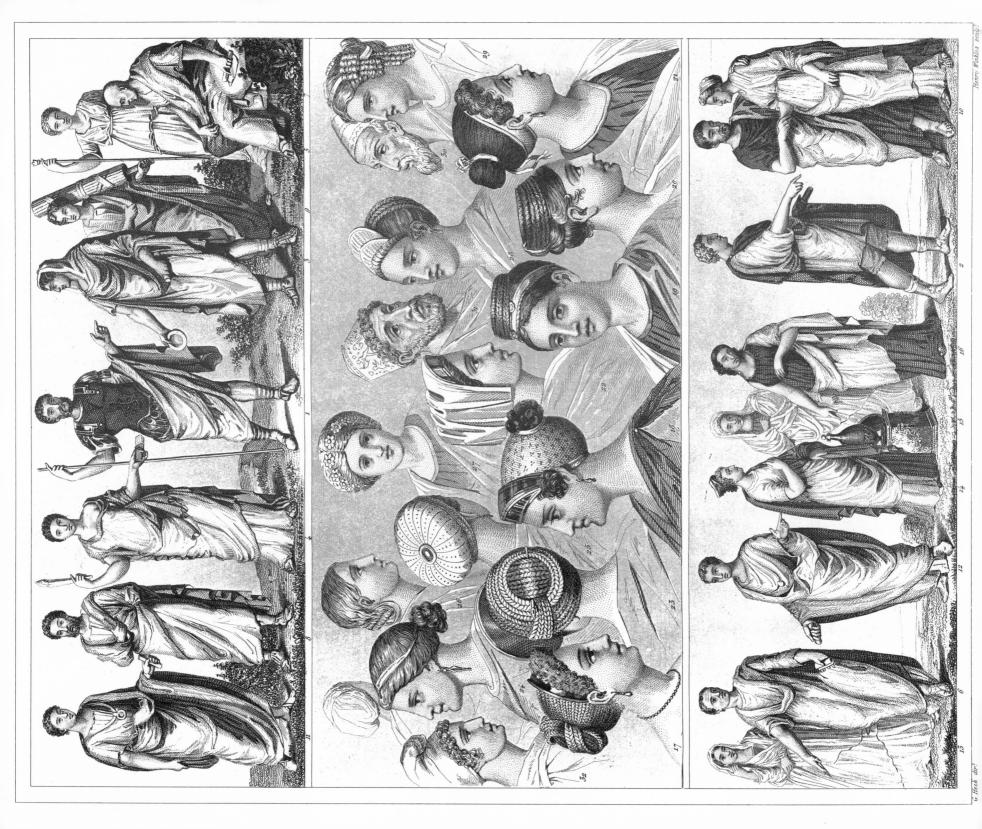

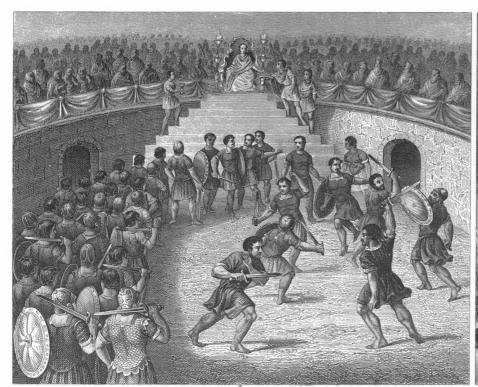

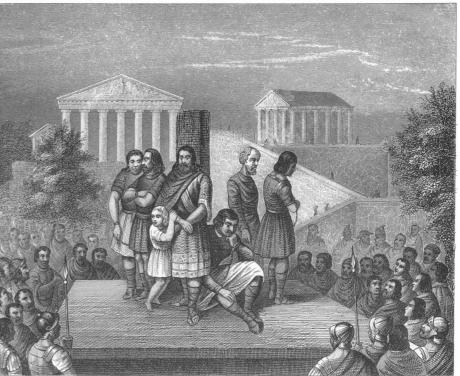

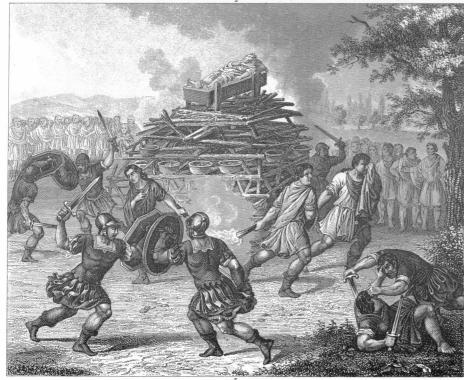

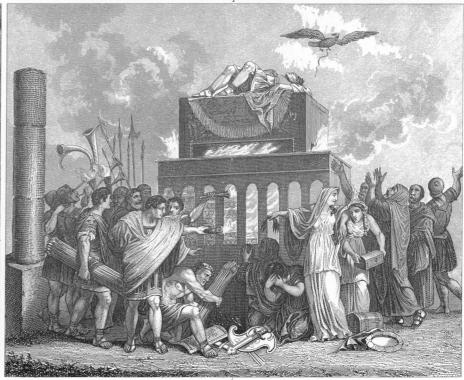

Henry Winkles sculp.

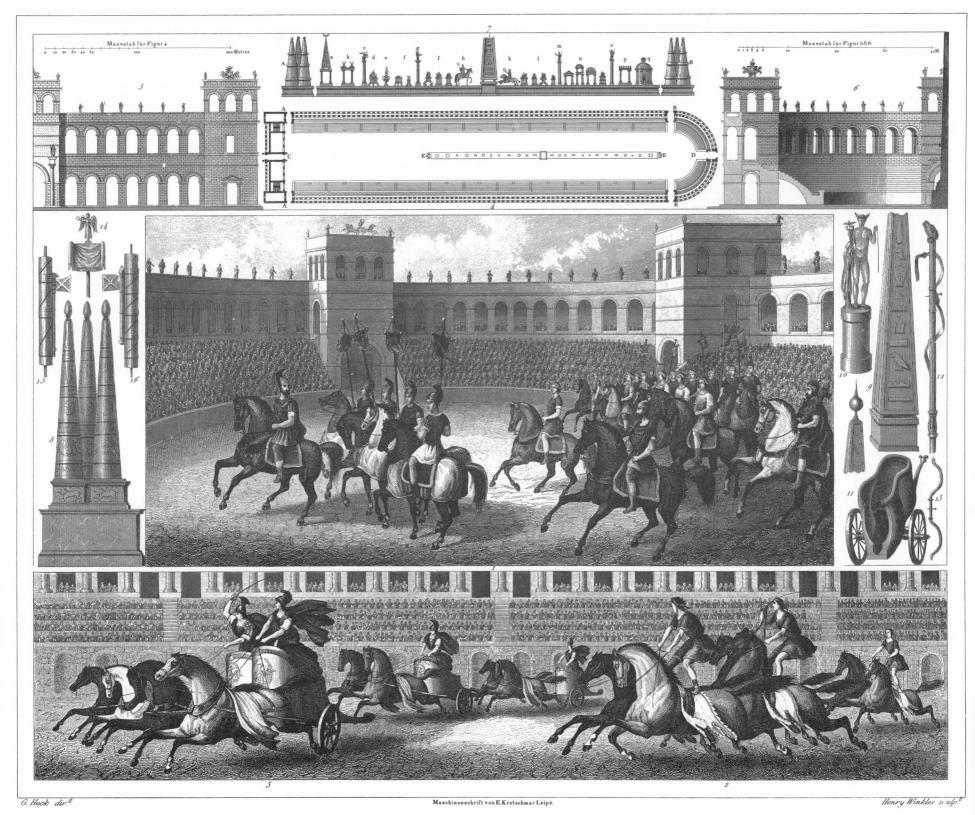

PLATE 199. DETAILS FROM THE CIRCENSIAN GAMES

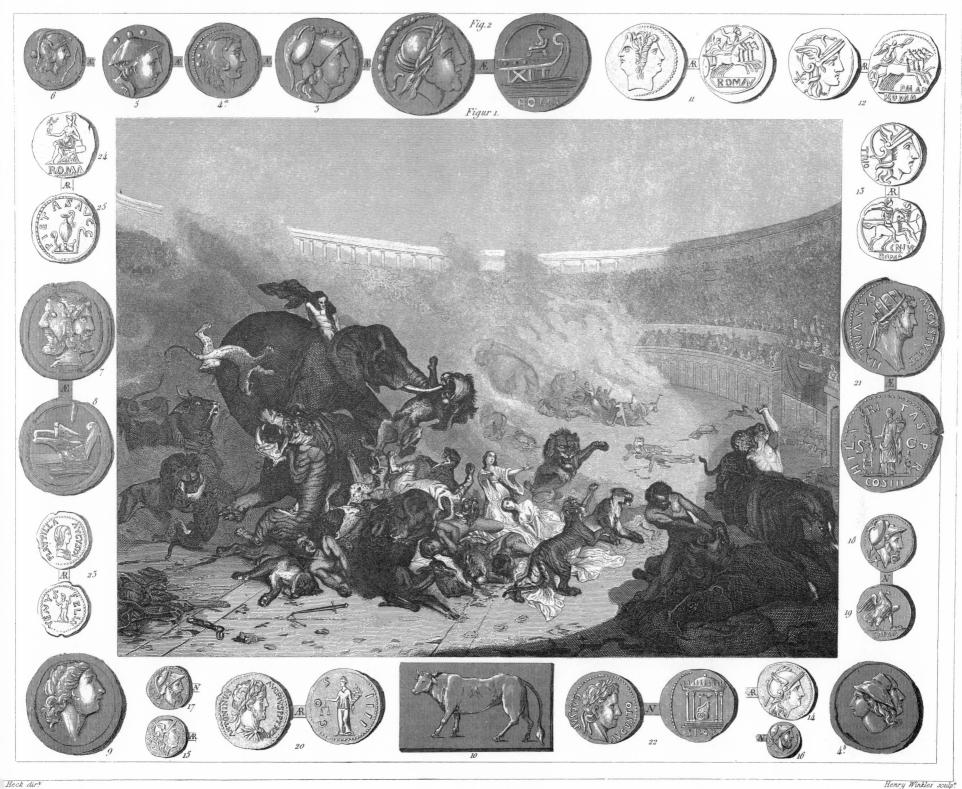

Henry Winkles soulpt

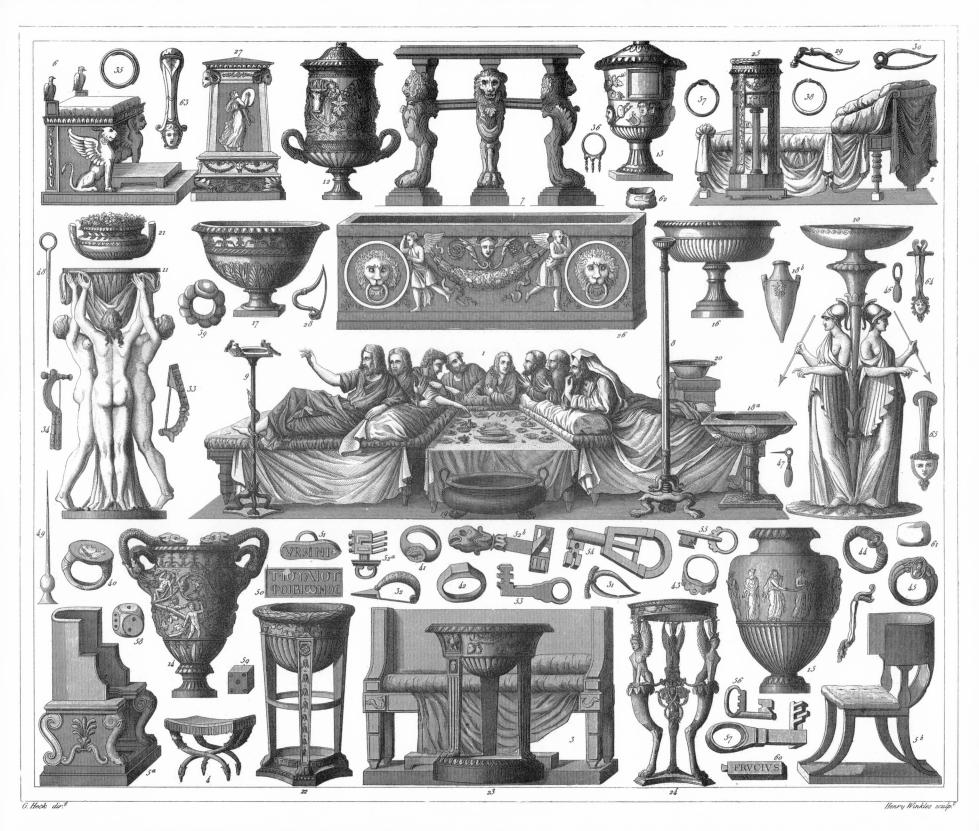

238

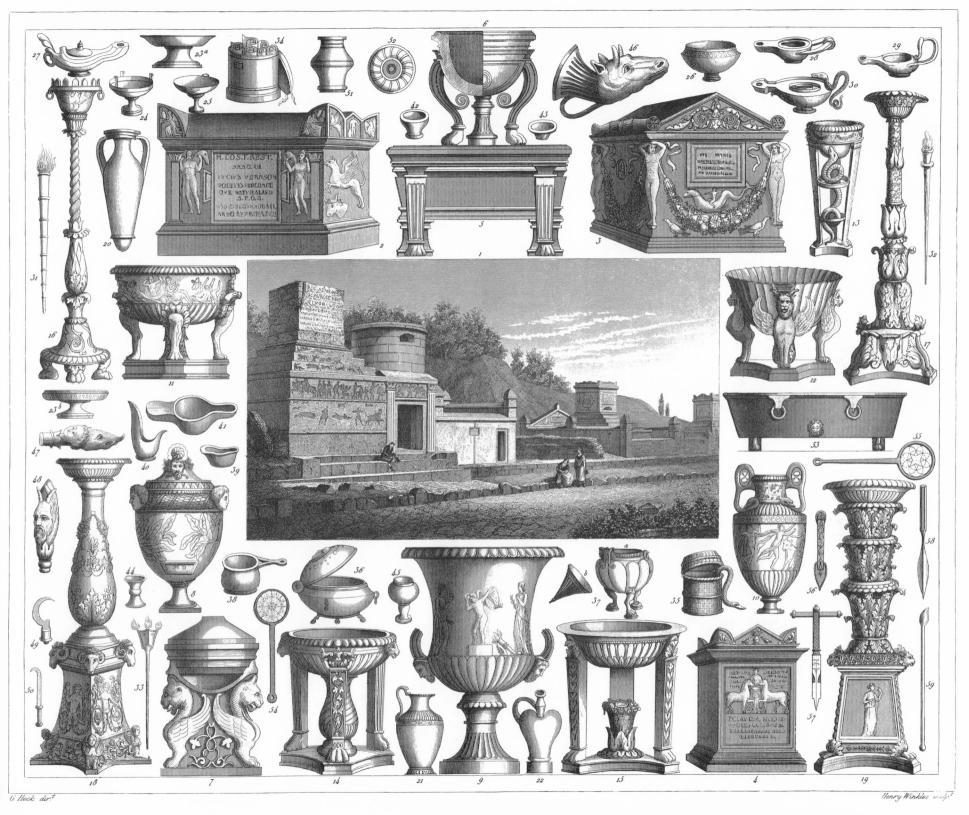

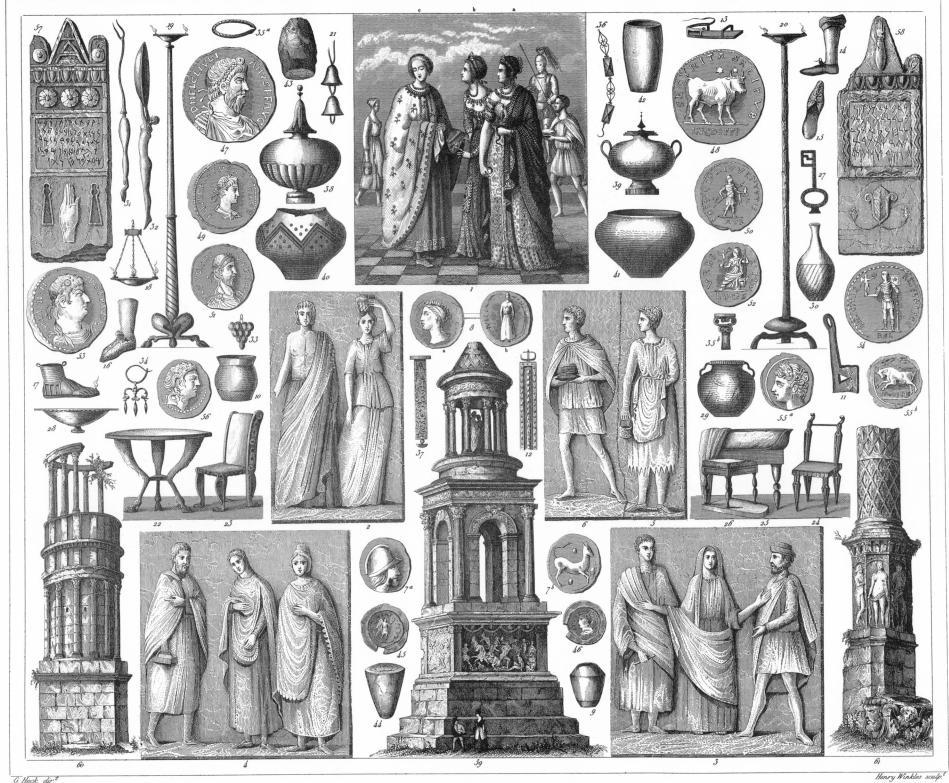

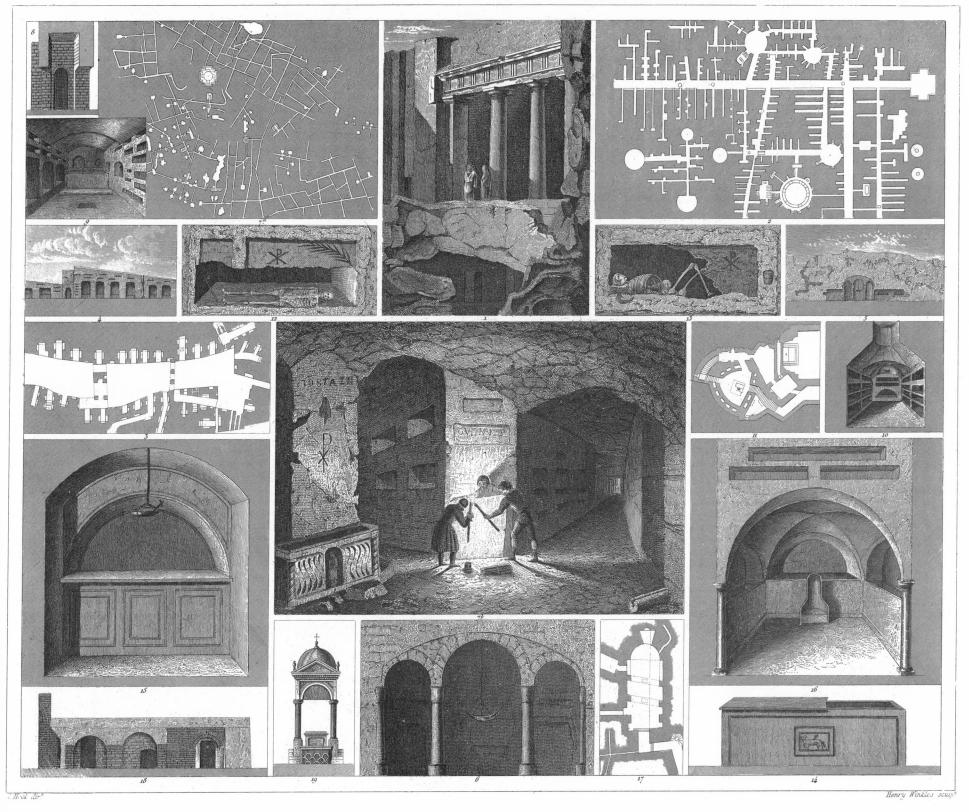

PLATE 204. CATACOMBS, CHURCHES, AND CHAPELS

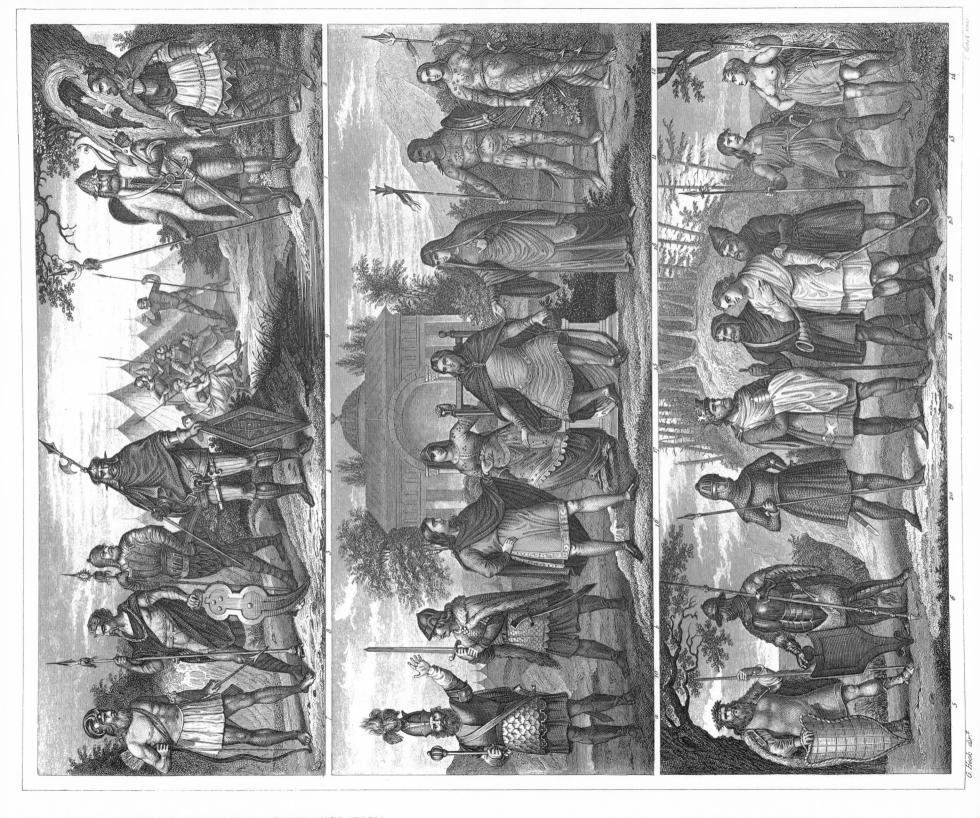

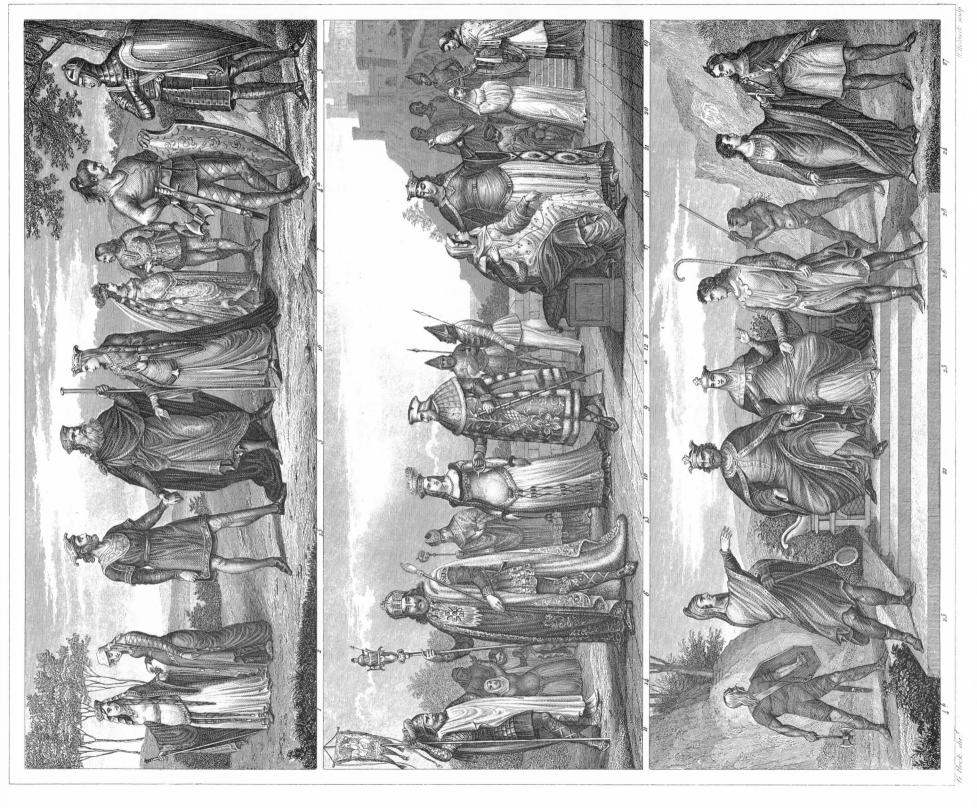

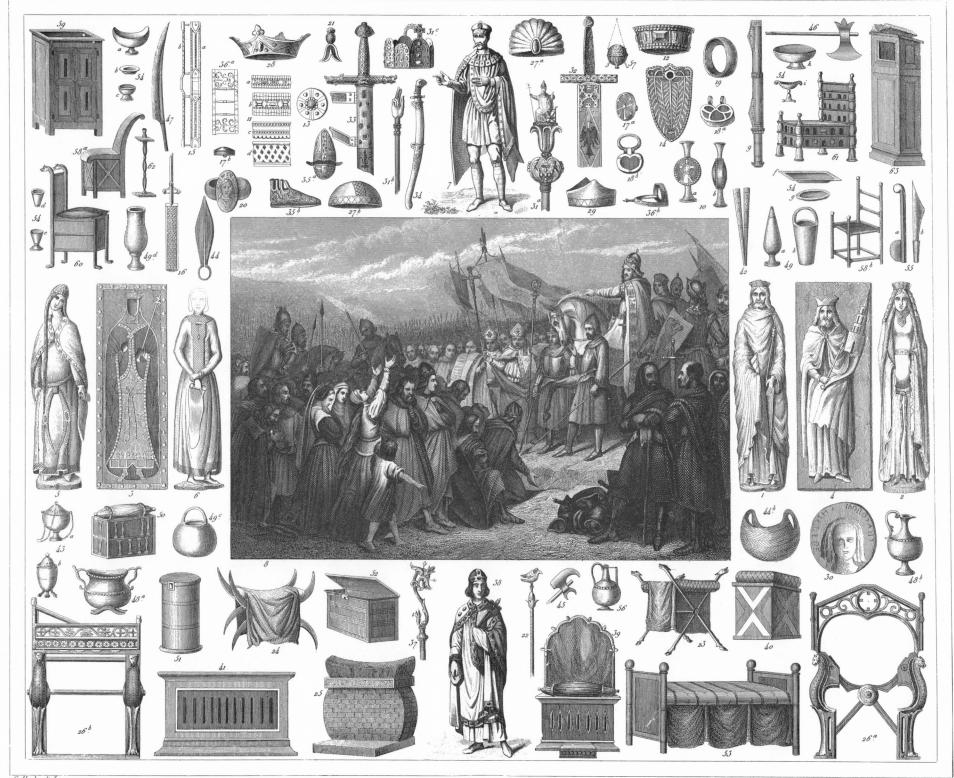

A. Krausse saulp!

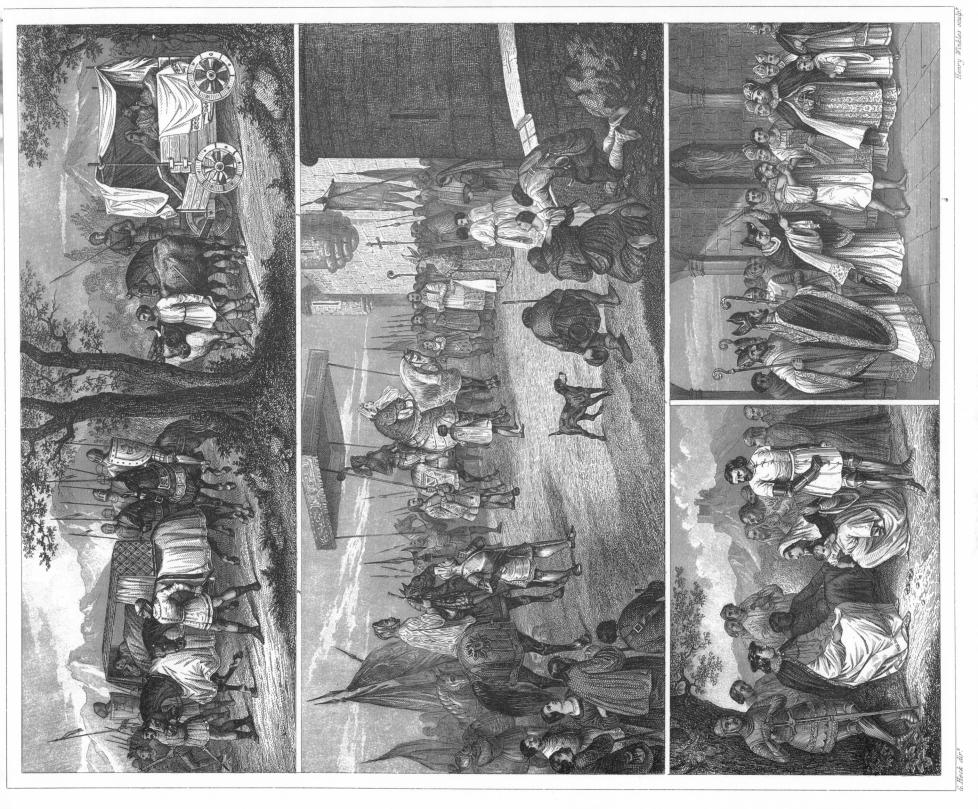

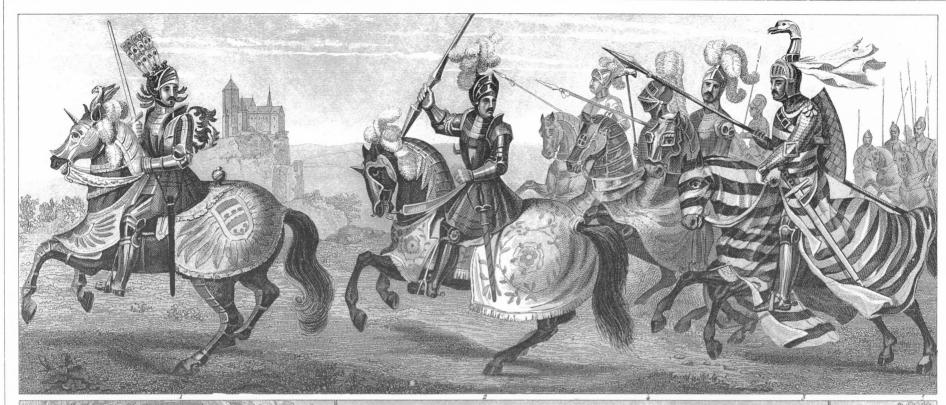

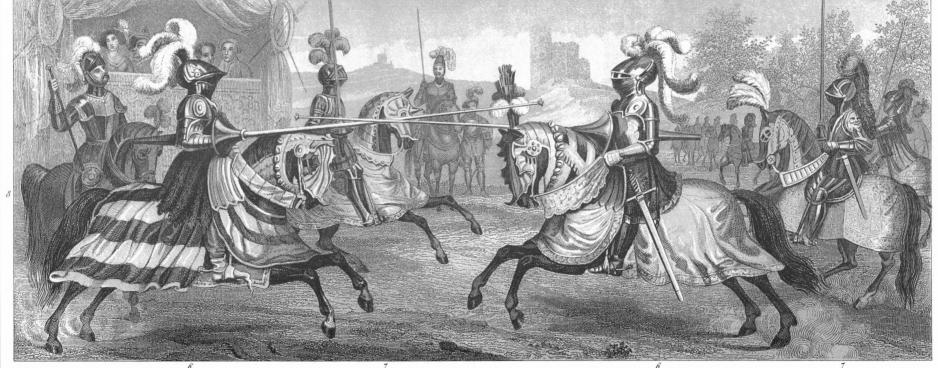

Henry Winkles sculp!

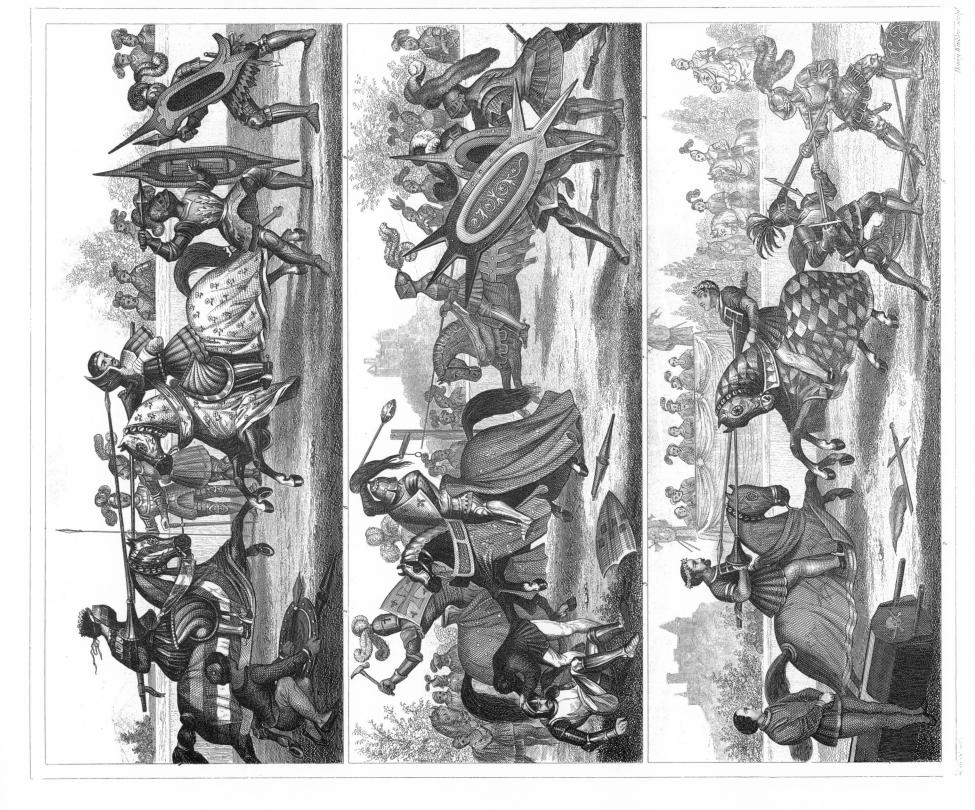

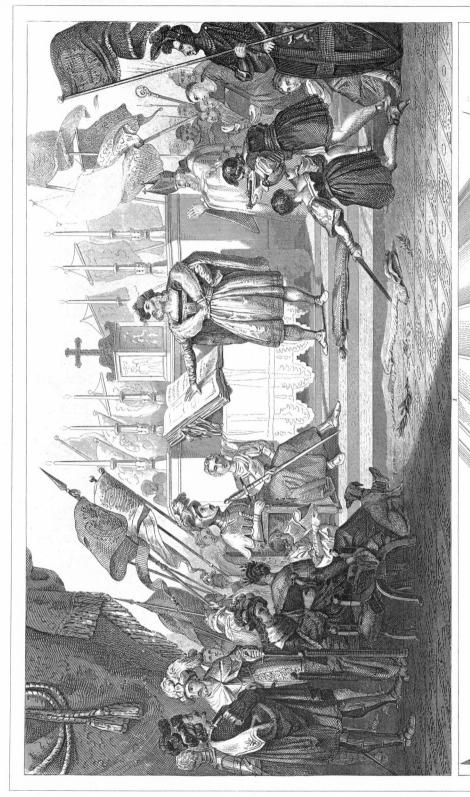

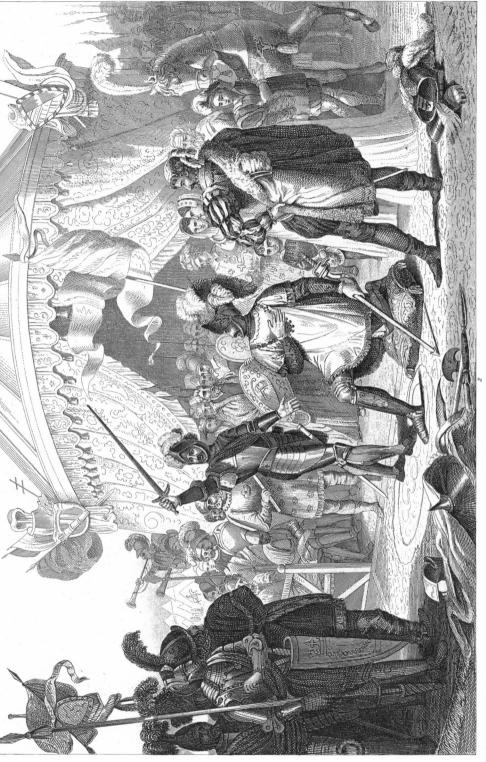

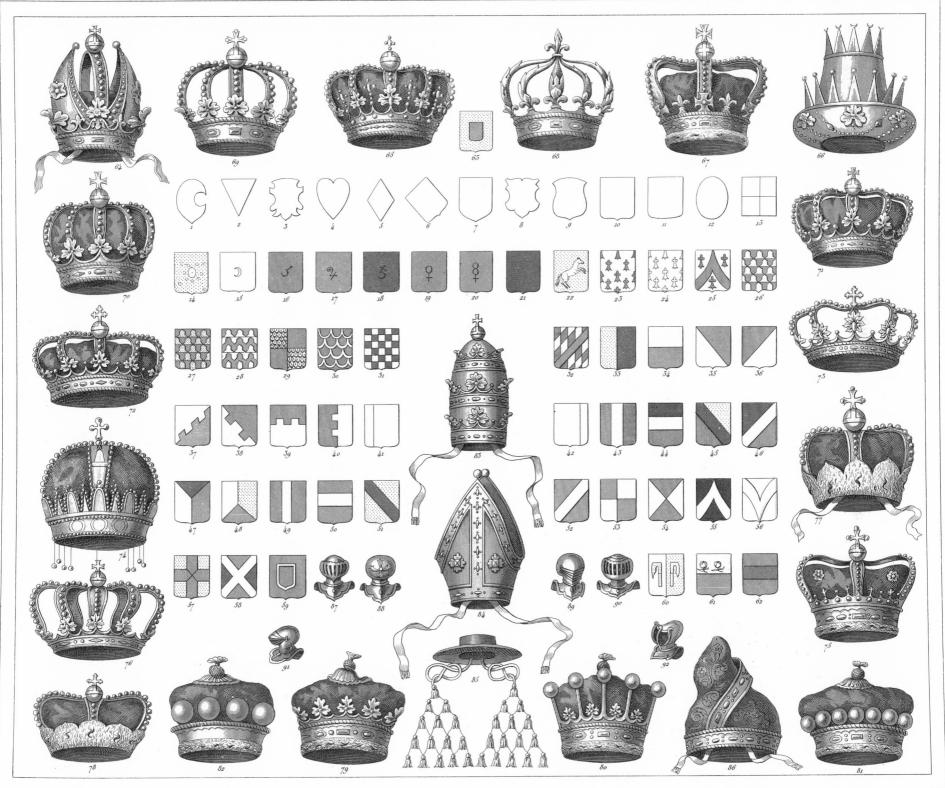

G. Heck dir!

Henry Winkles sculp!

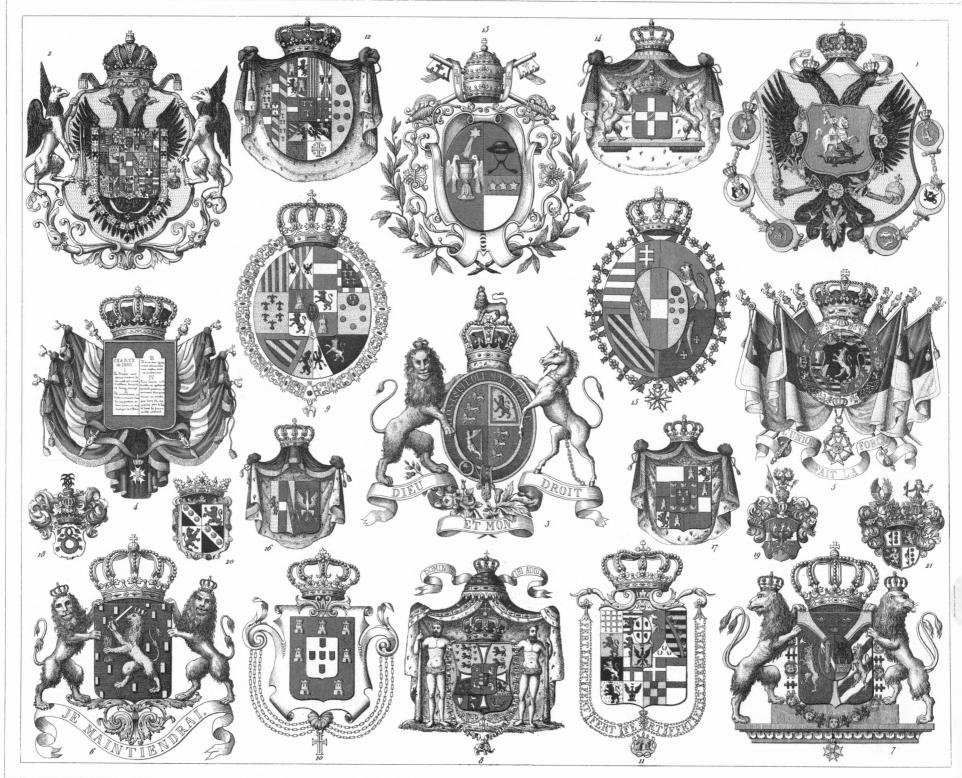

G. Heck dir.t

1. Krausse sen scu

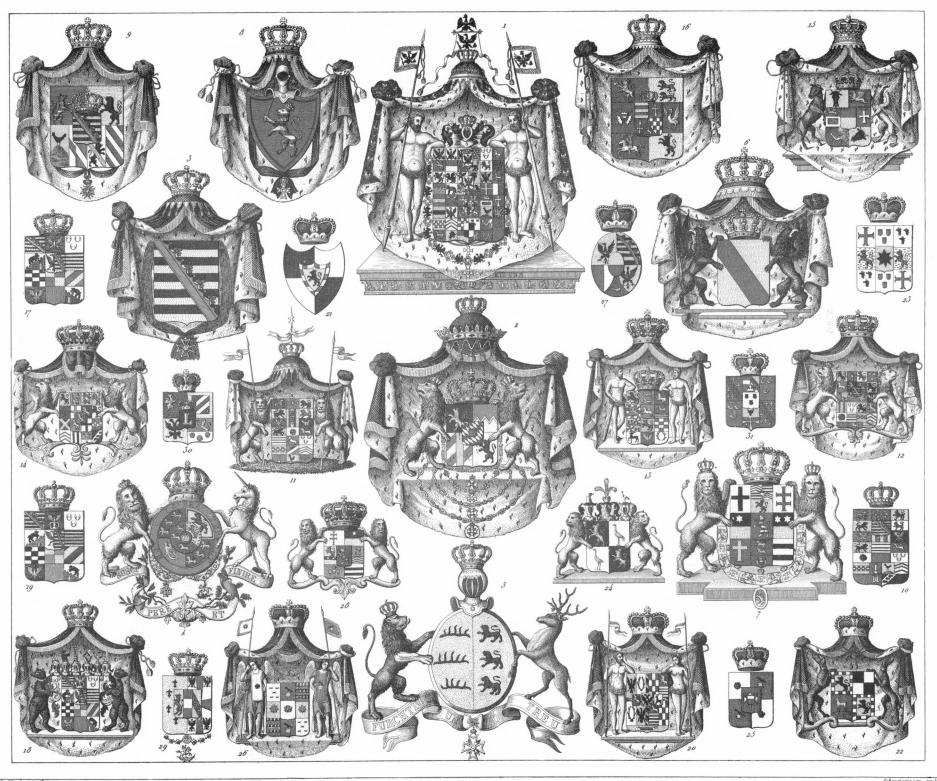

Sawetssinger si

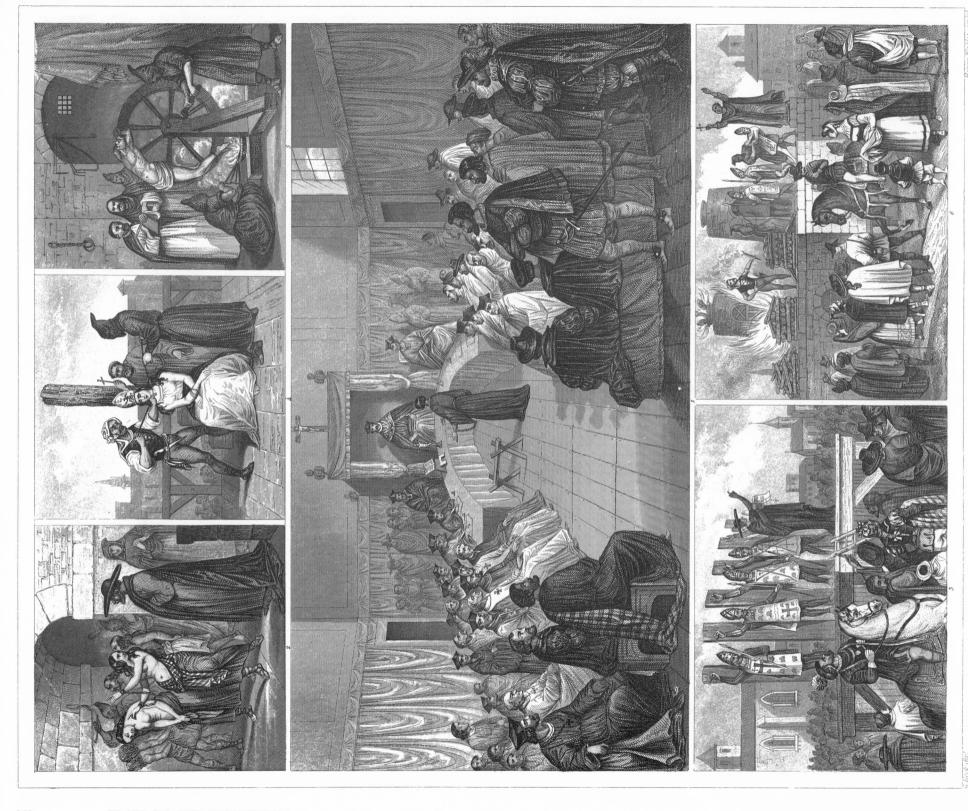

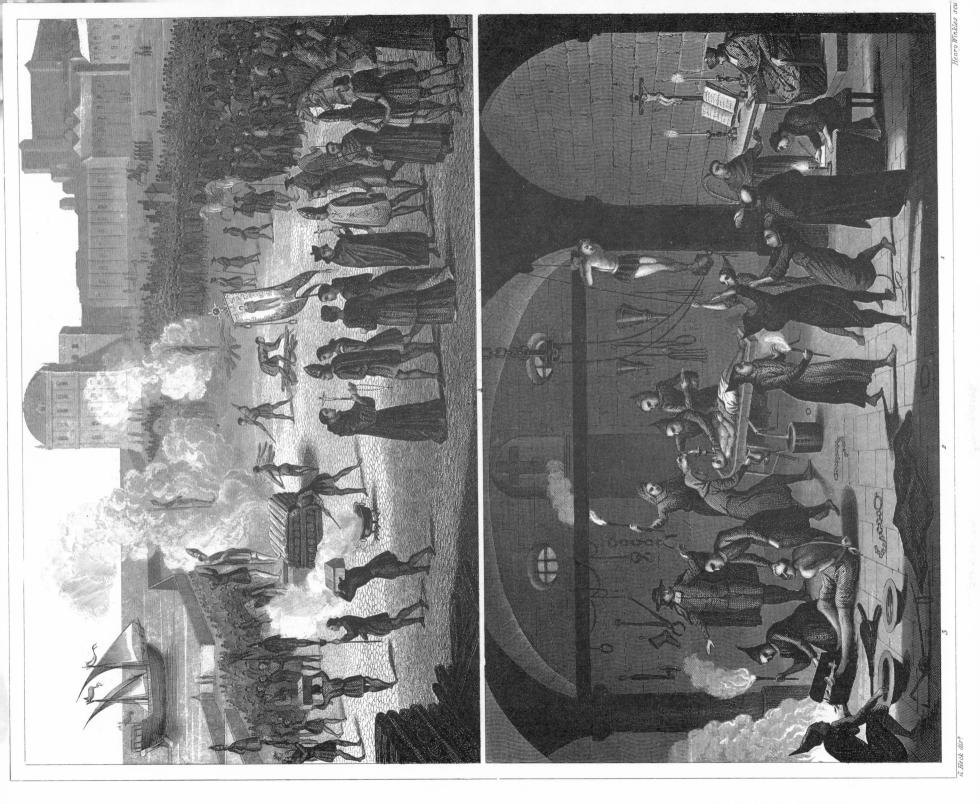

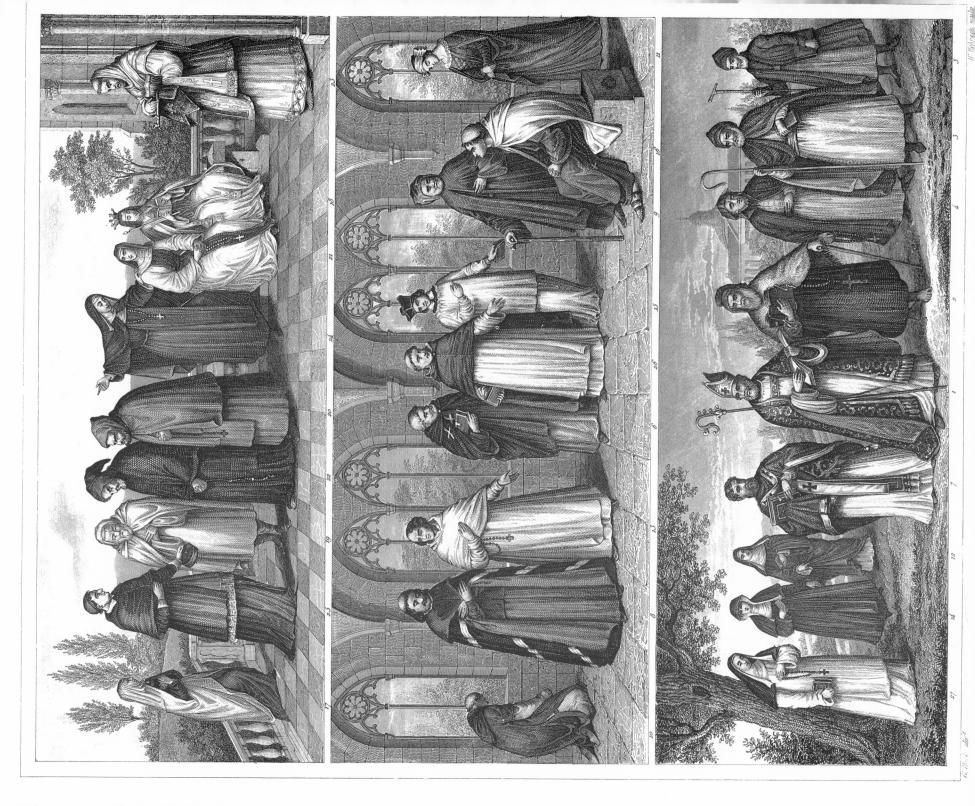

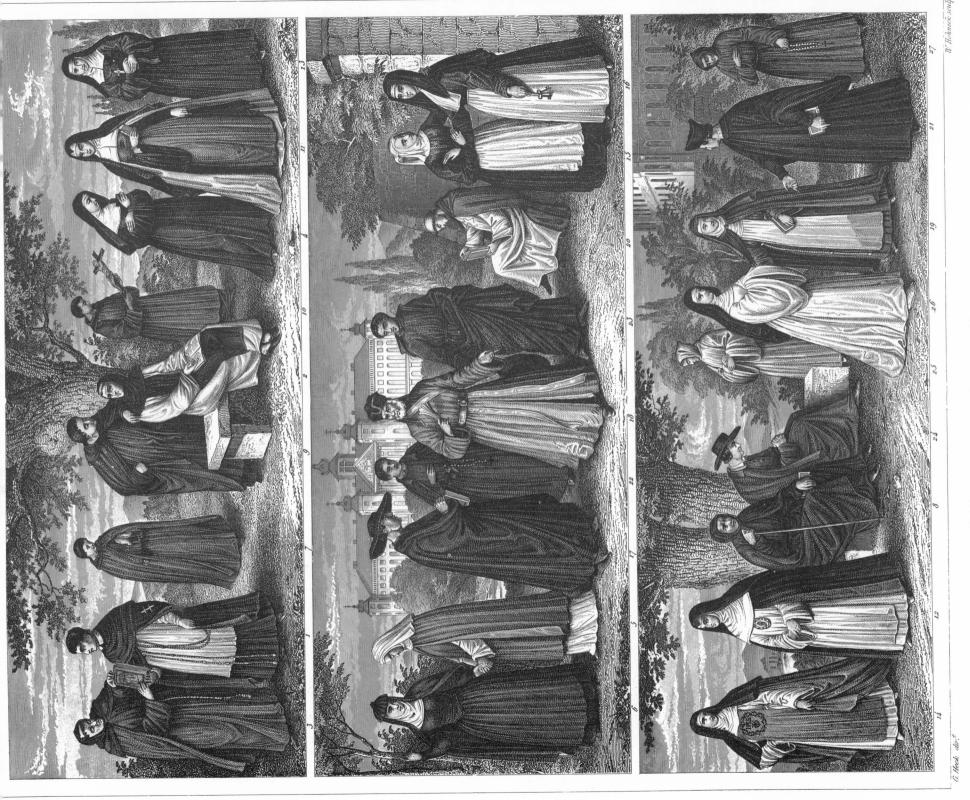

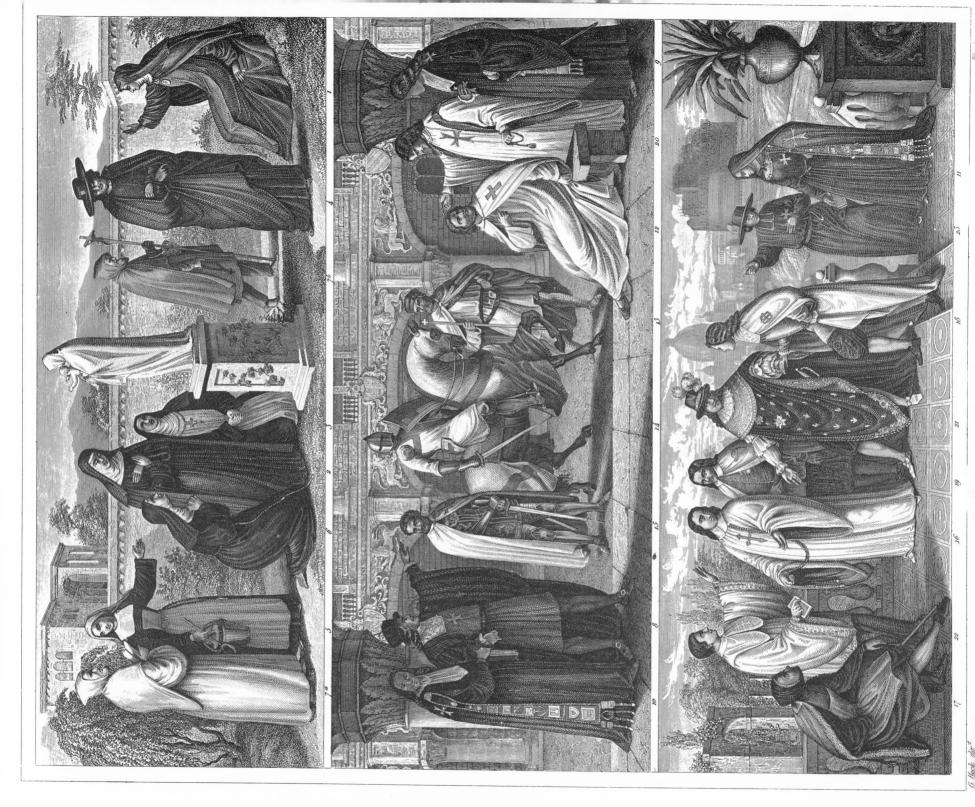

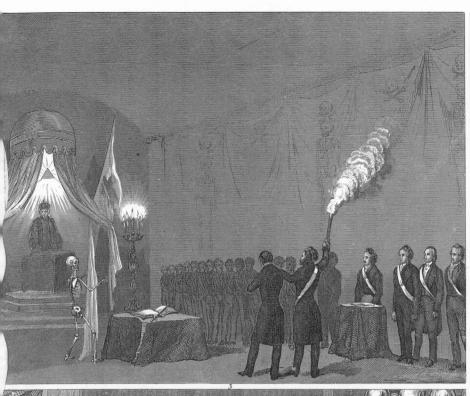

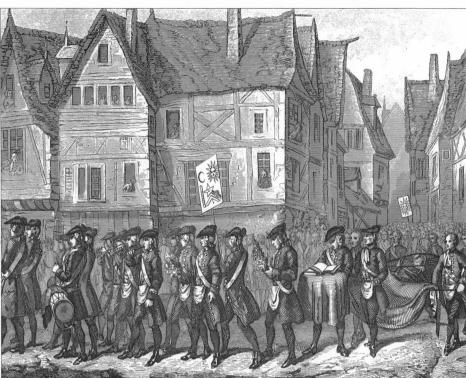

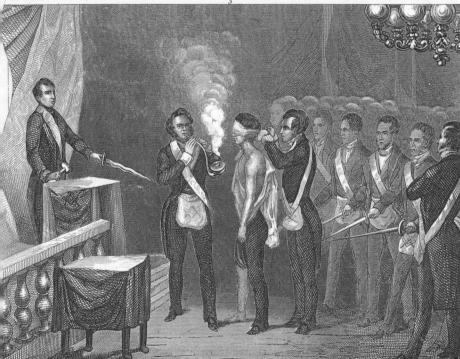

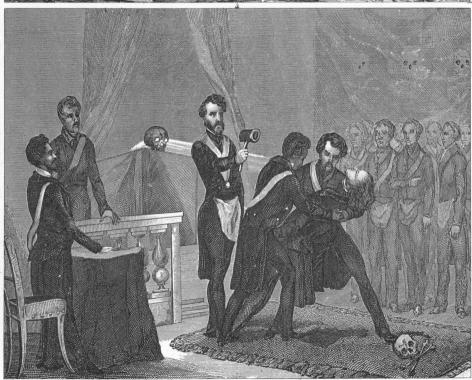

Henry Winkles sculp!

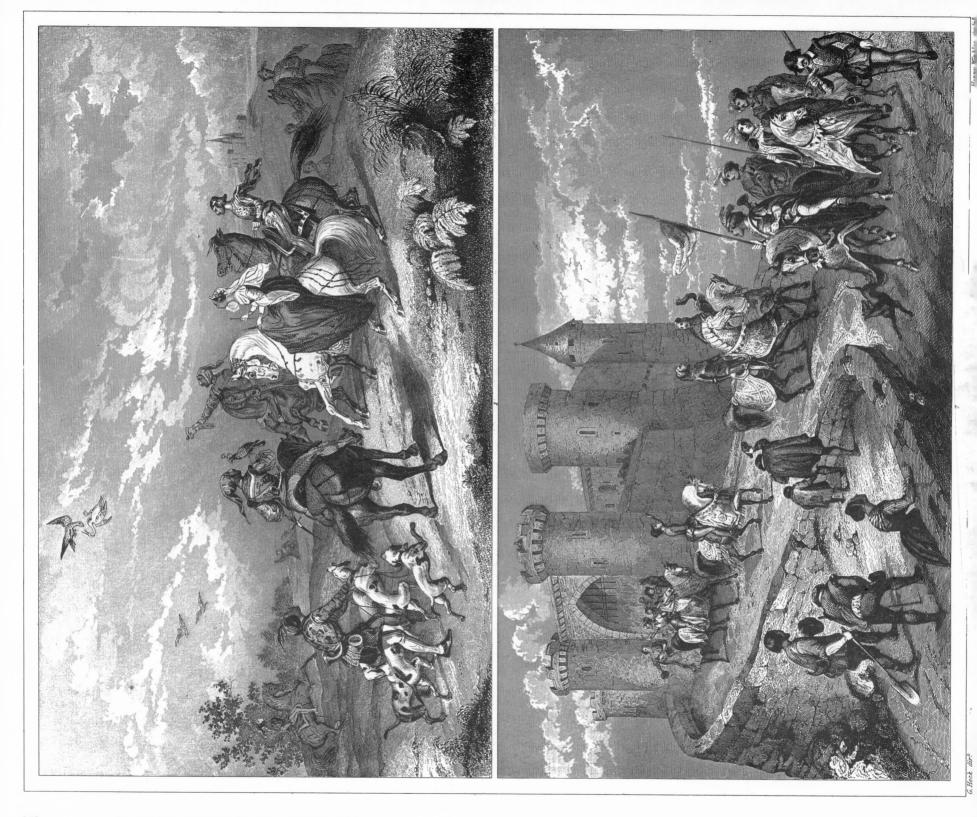

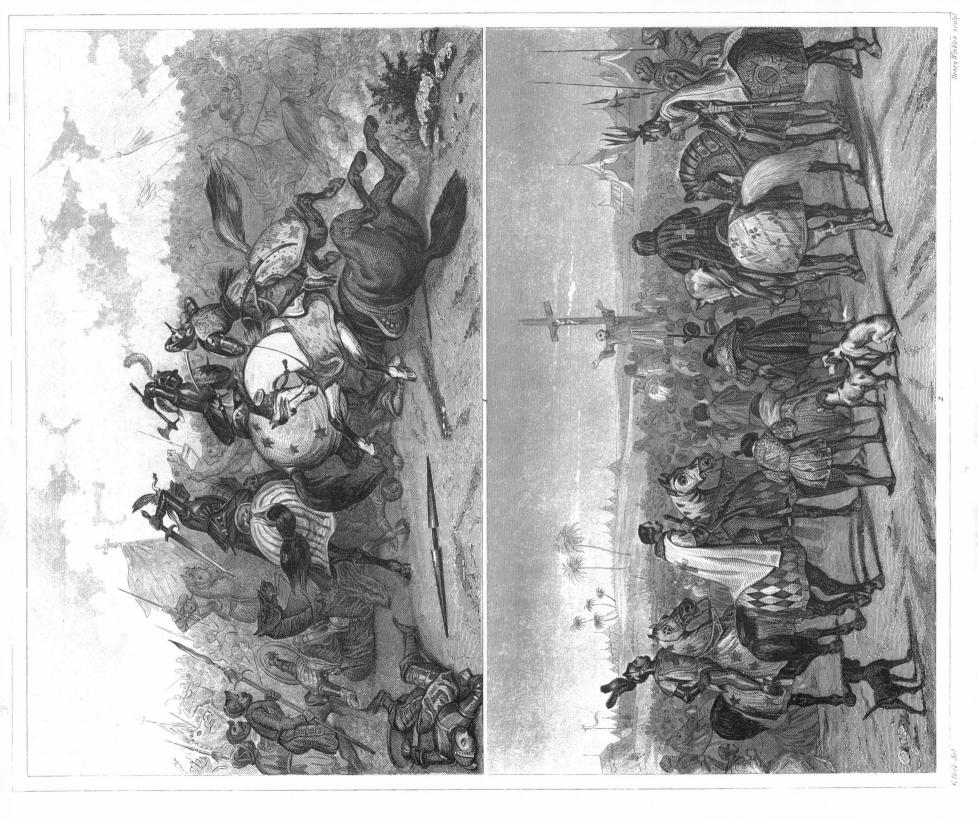

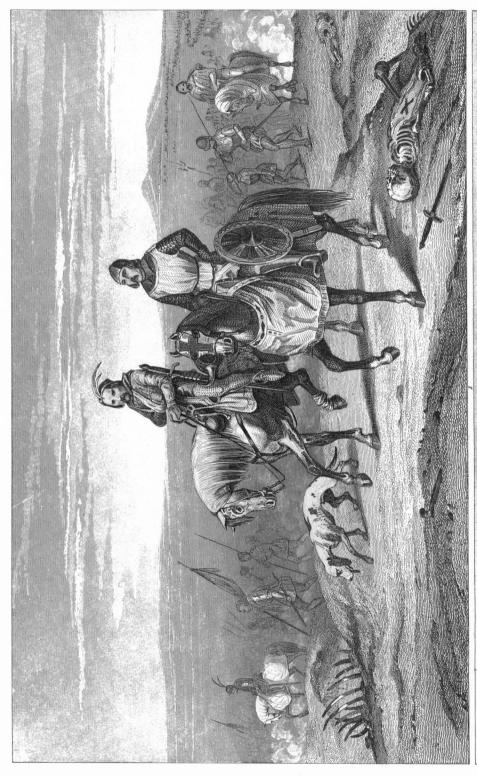

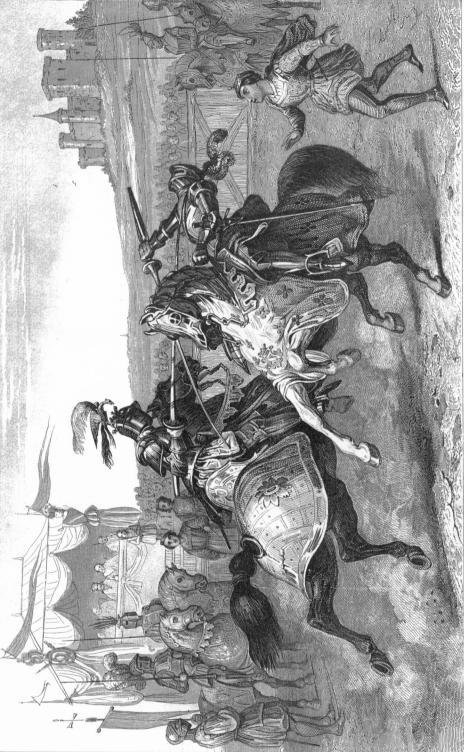

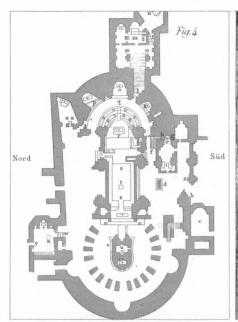

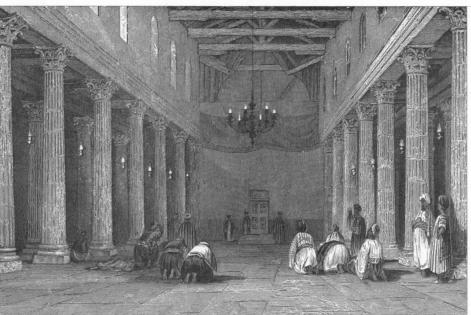

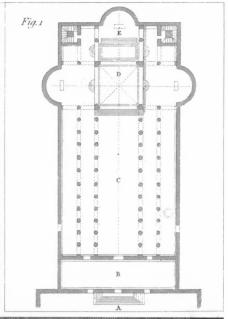

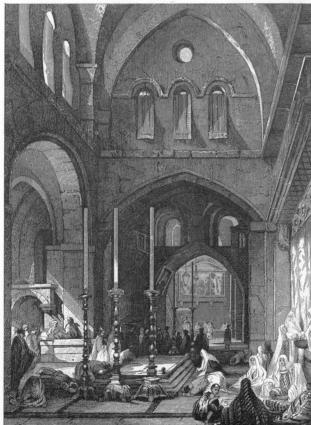

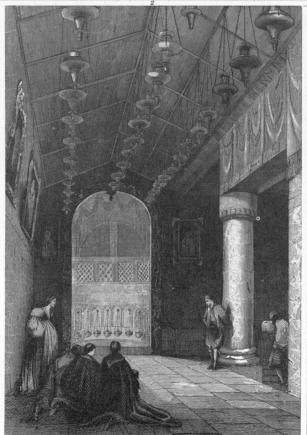

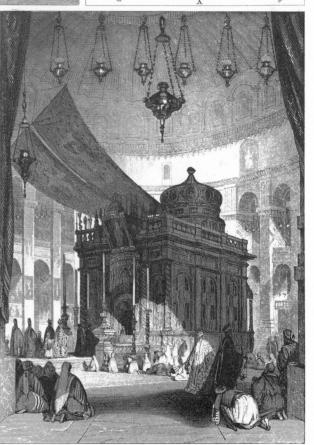

Heck dirt

Henry Winkles sculp!

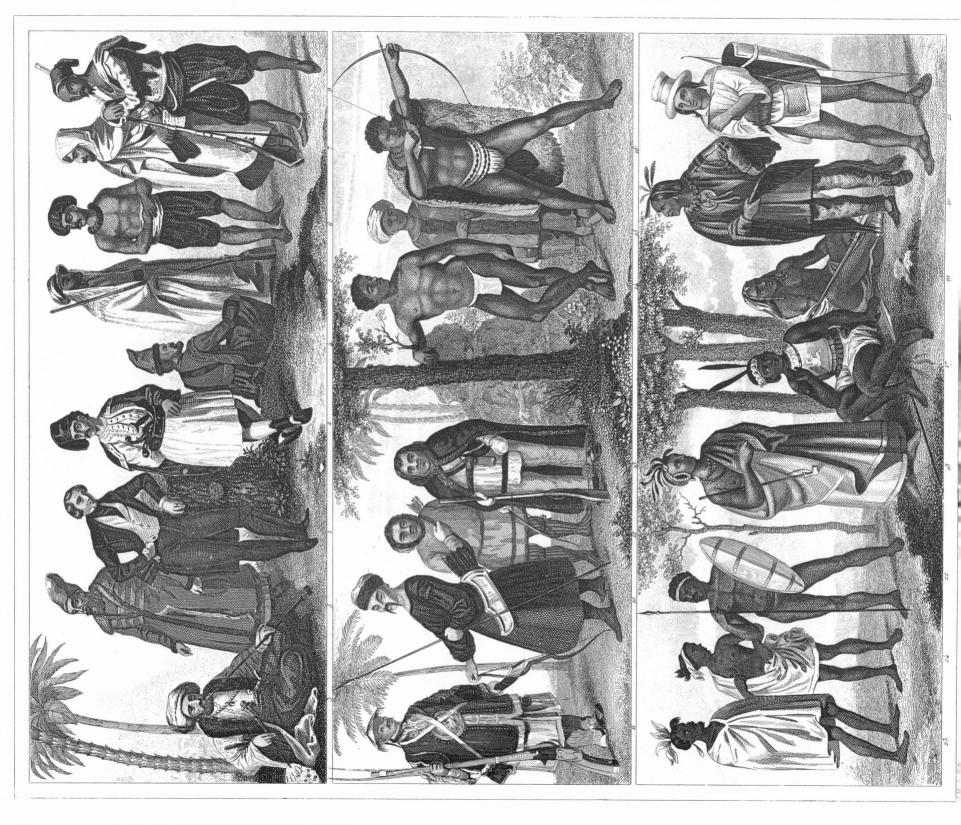

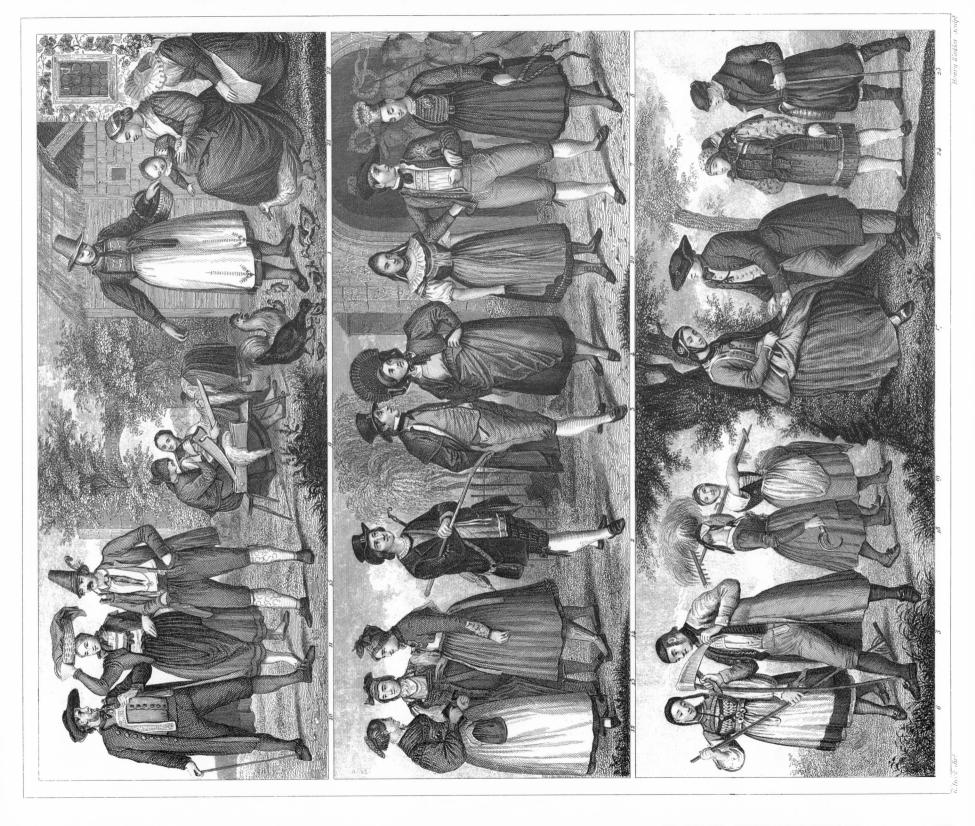

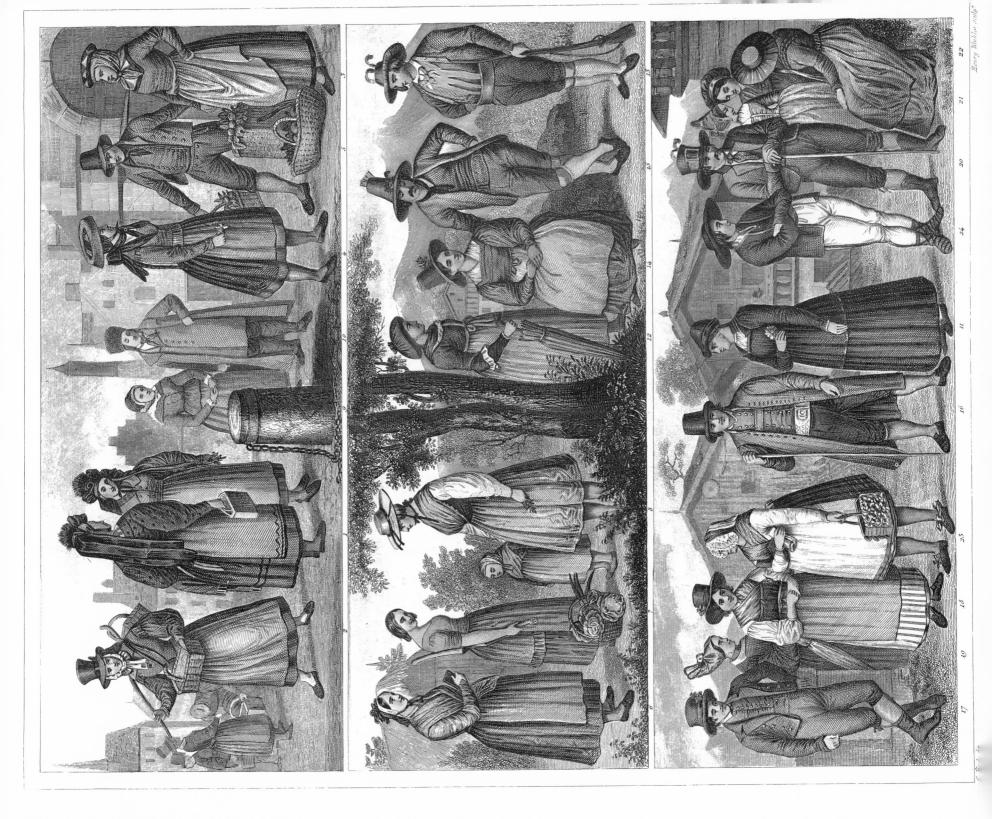

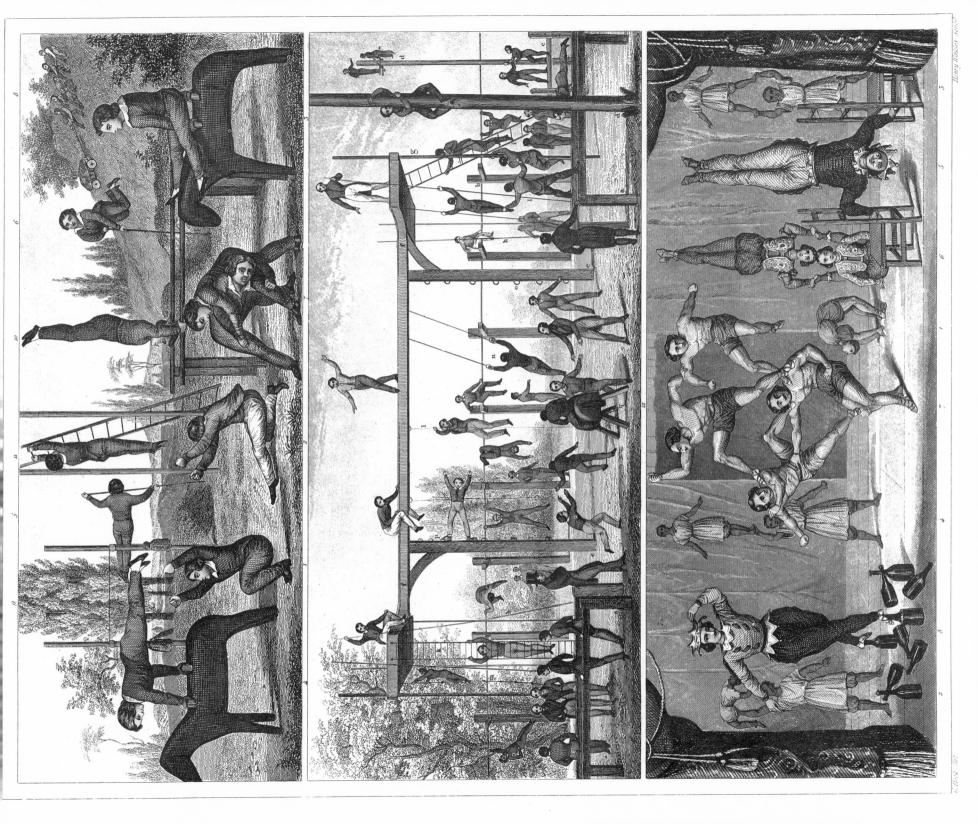

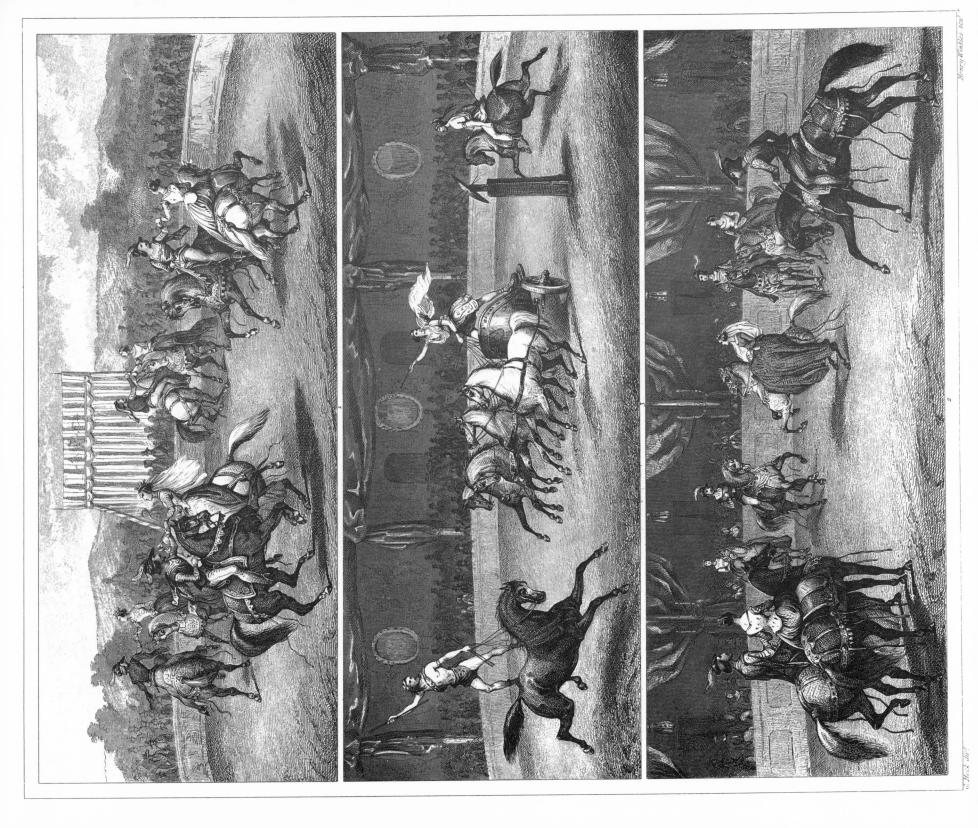

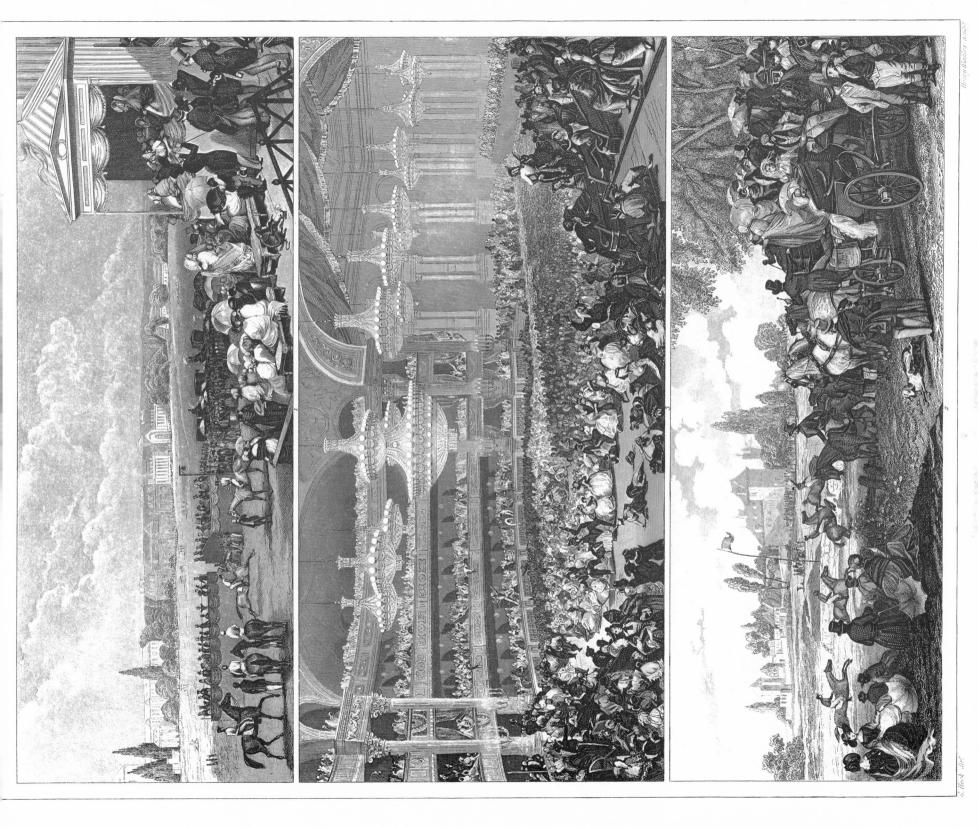

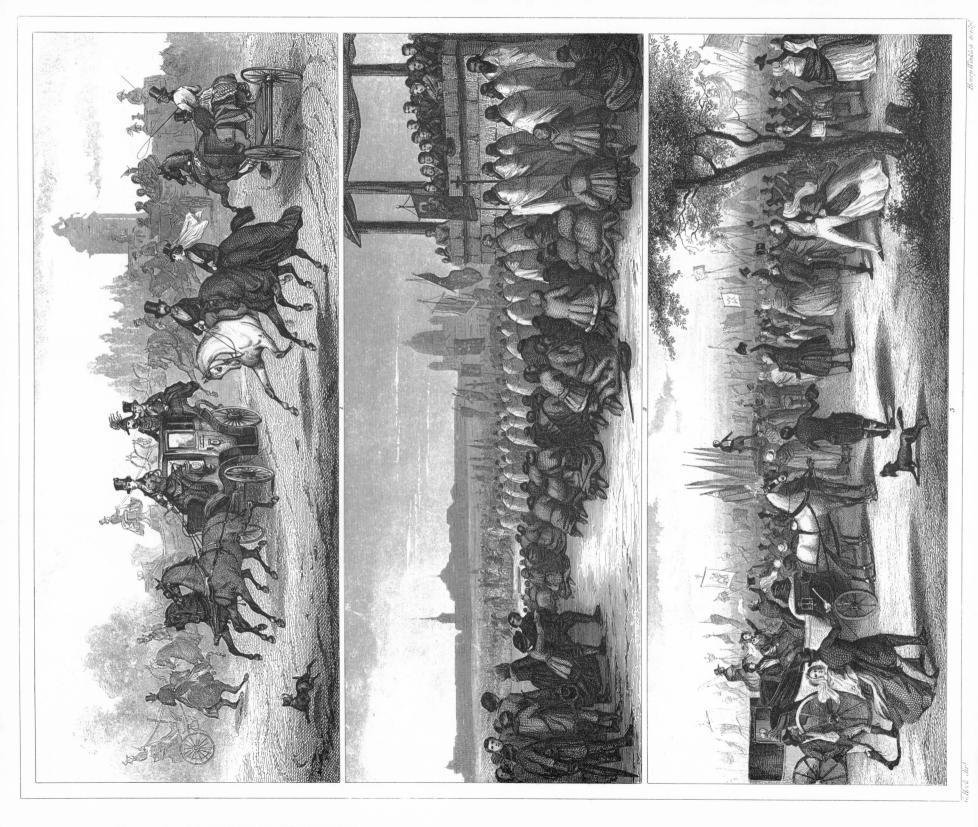

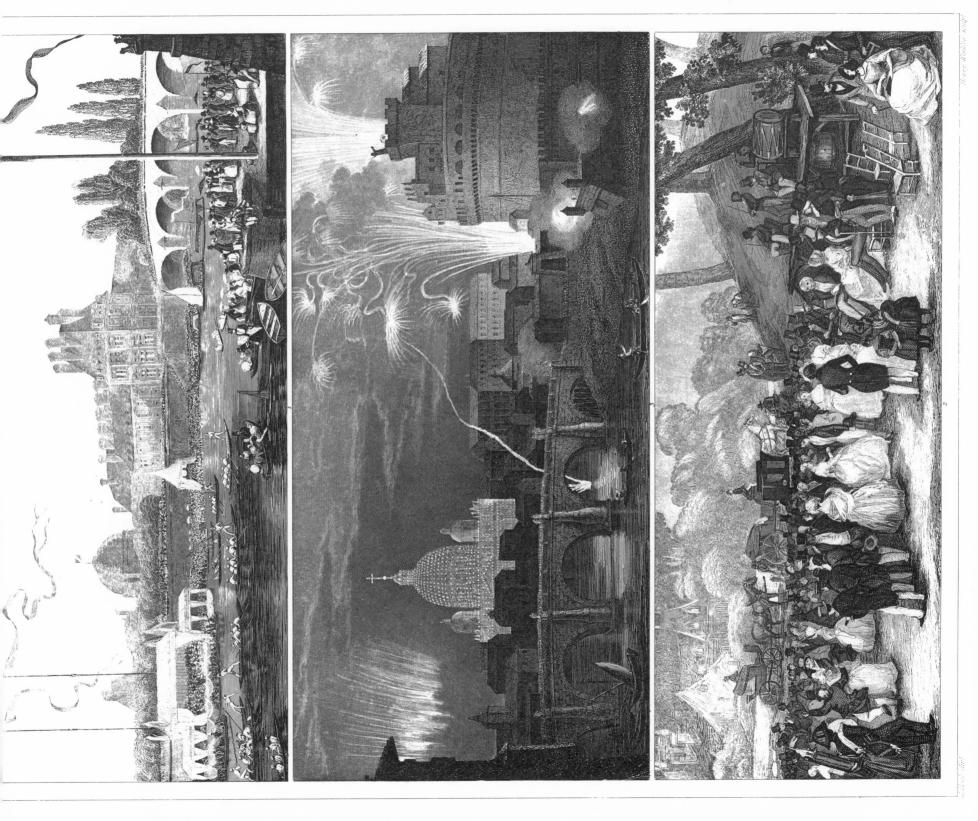

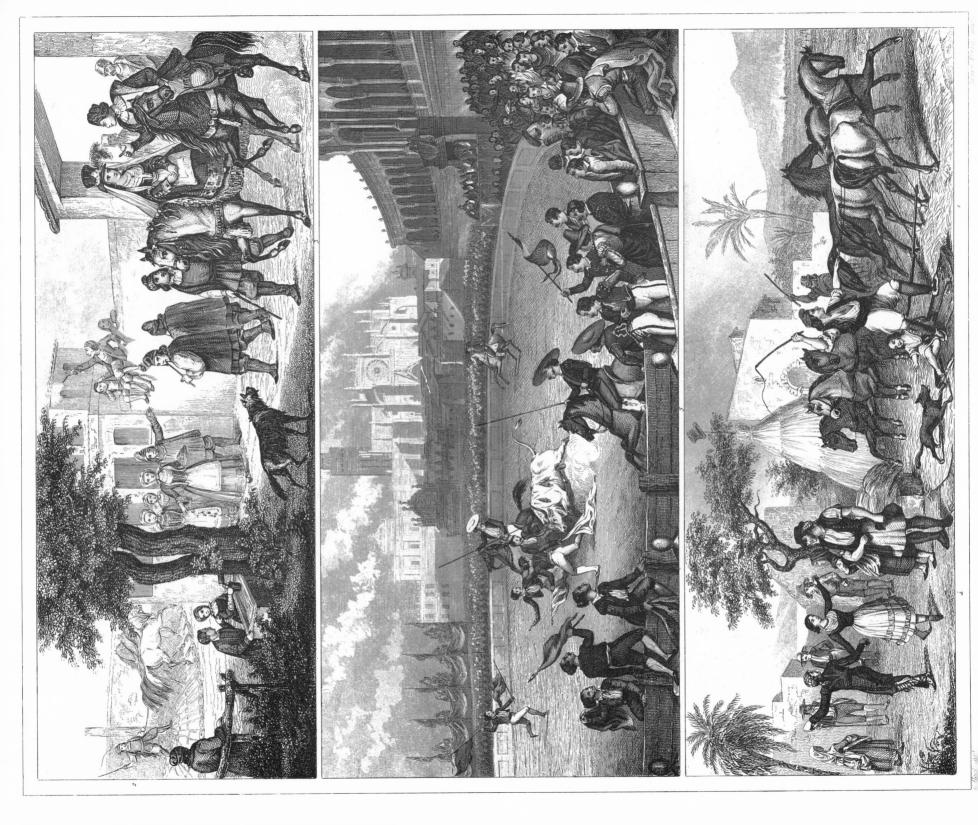

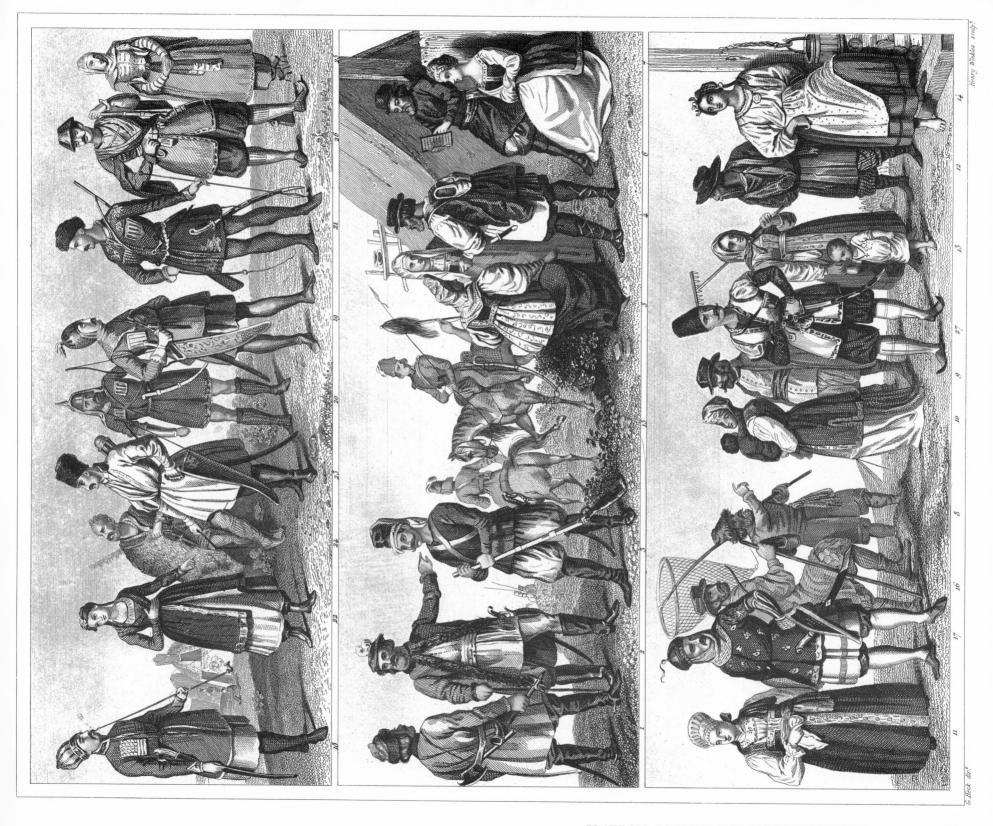

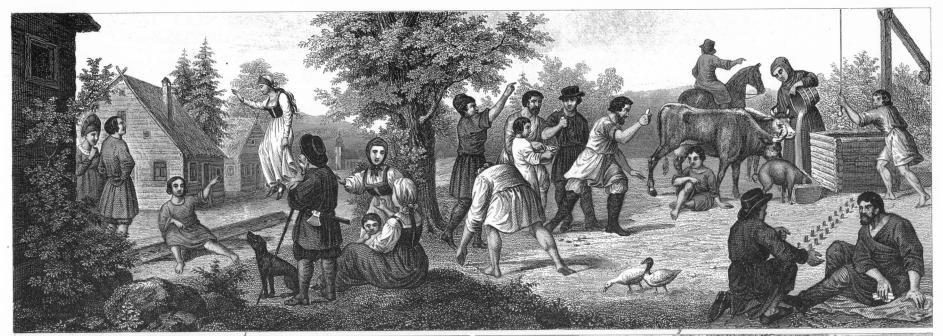

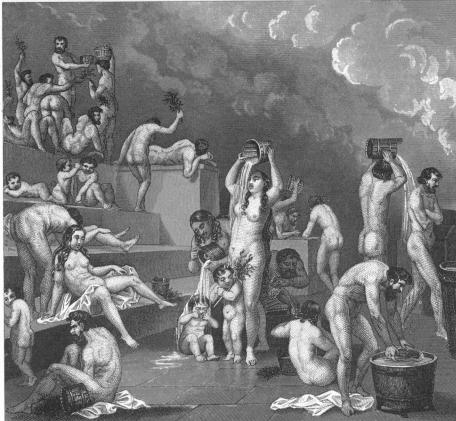

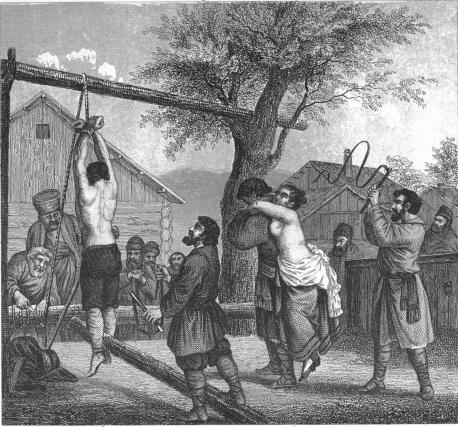

G. Heck dir.t

Henry Winkles sculp:

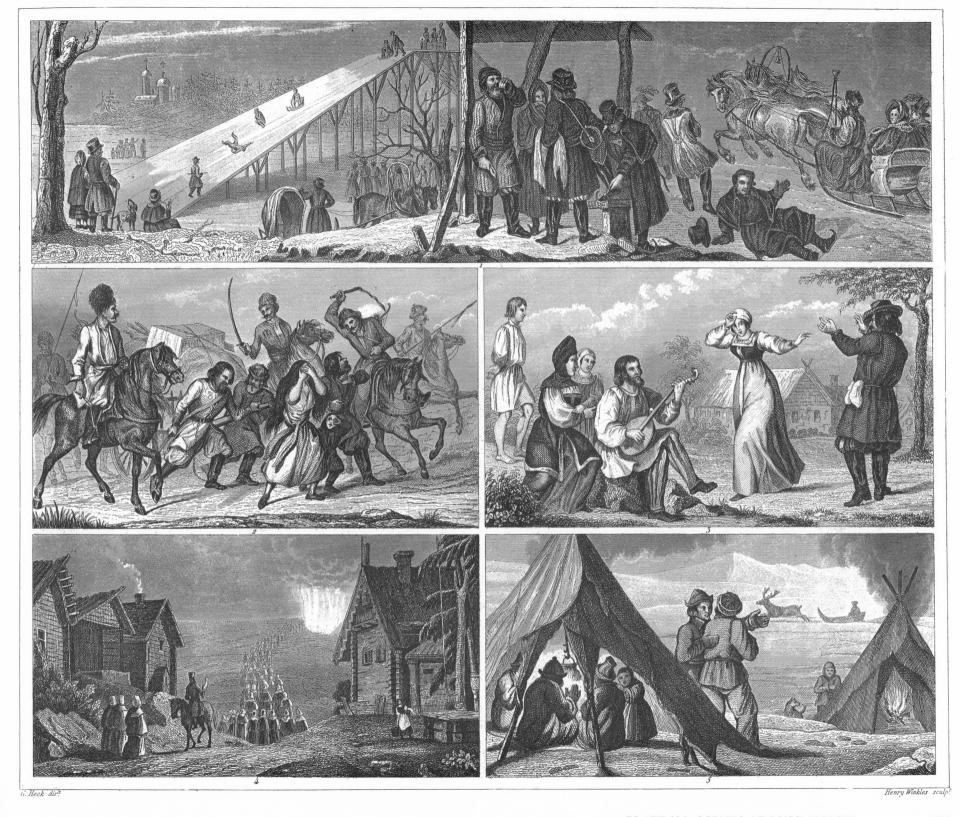

PLATE 236. SCENES OF RUSSIAN LIFE

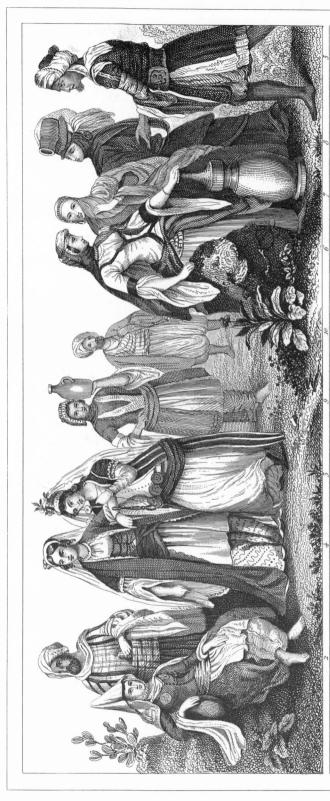

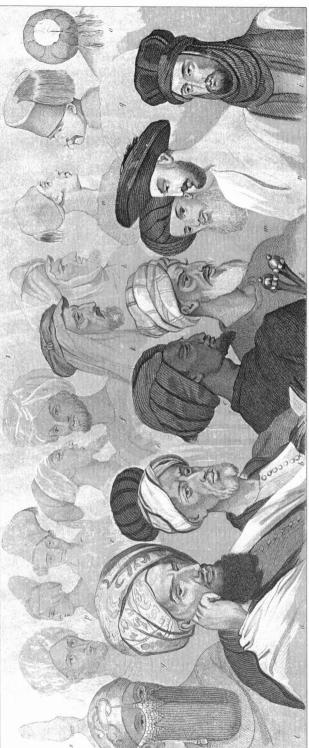

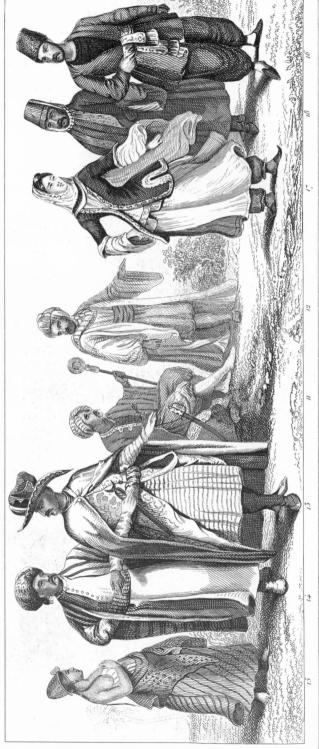

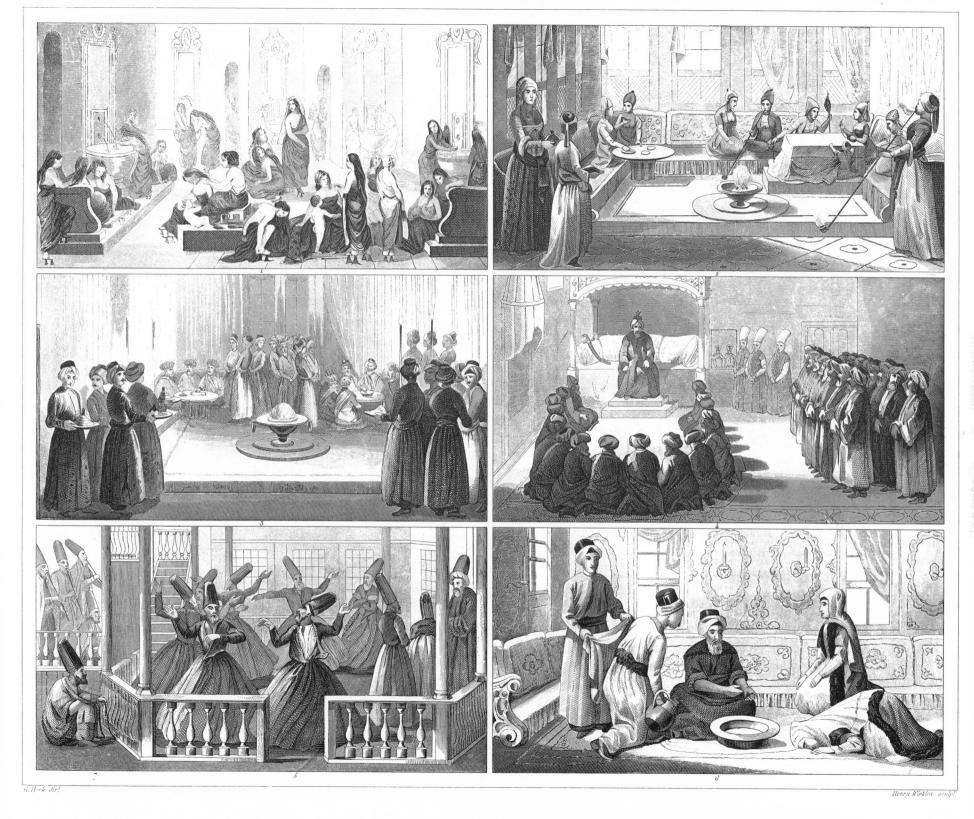

PLATE 238. SCENES FROM MIDDLE EASTERN LIFE

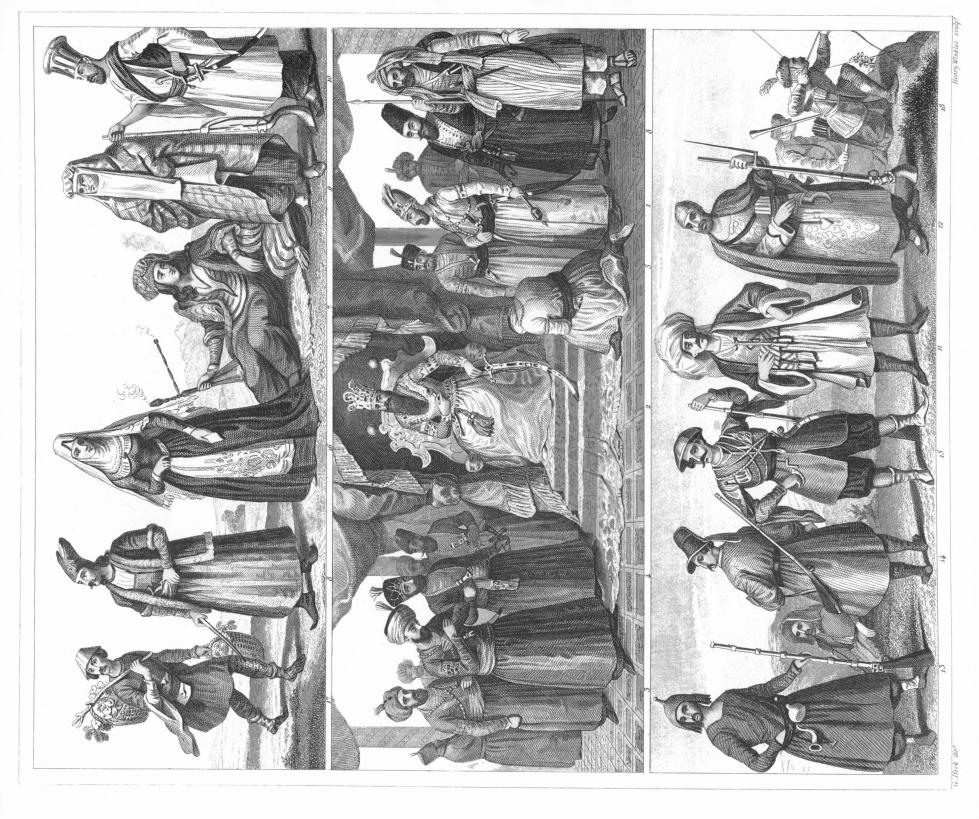

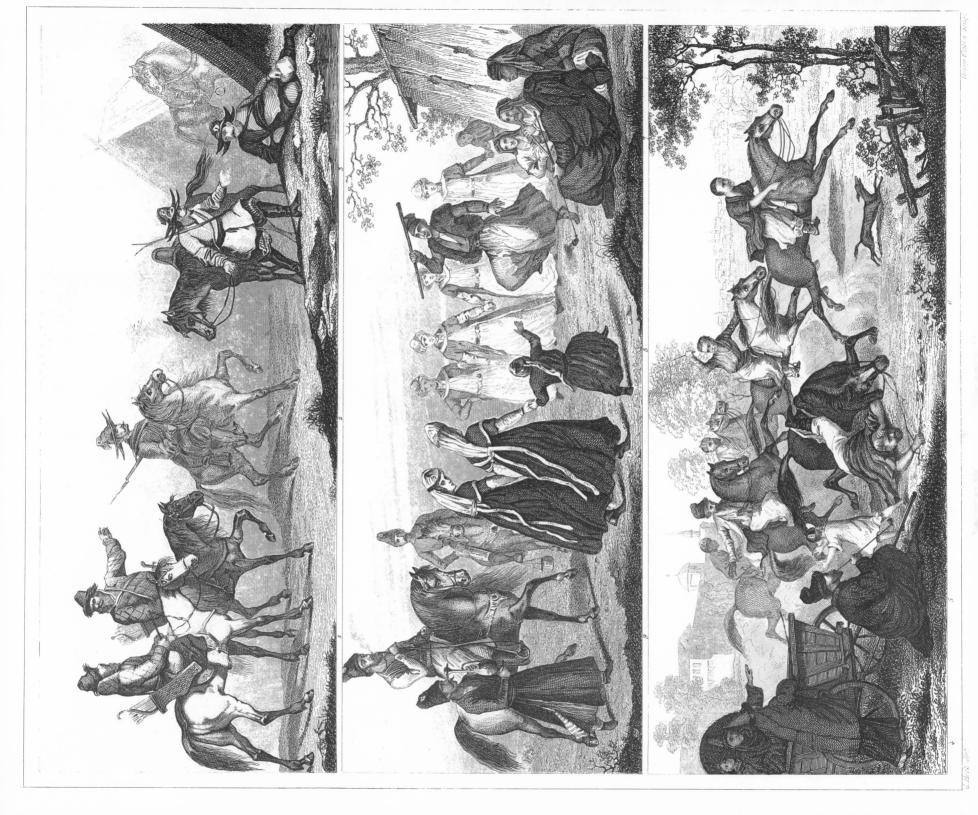

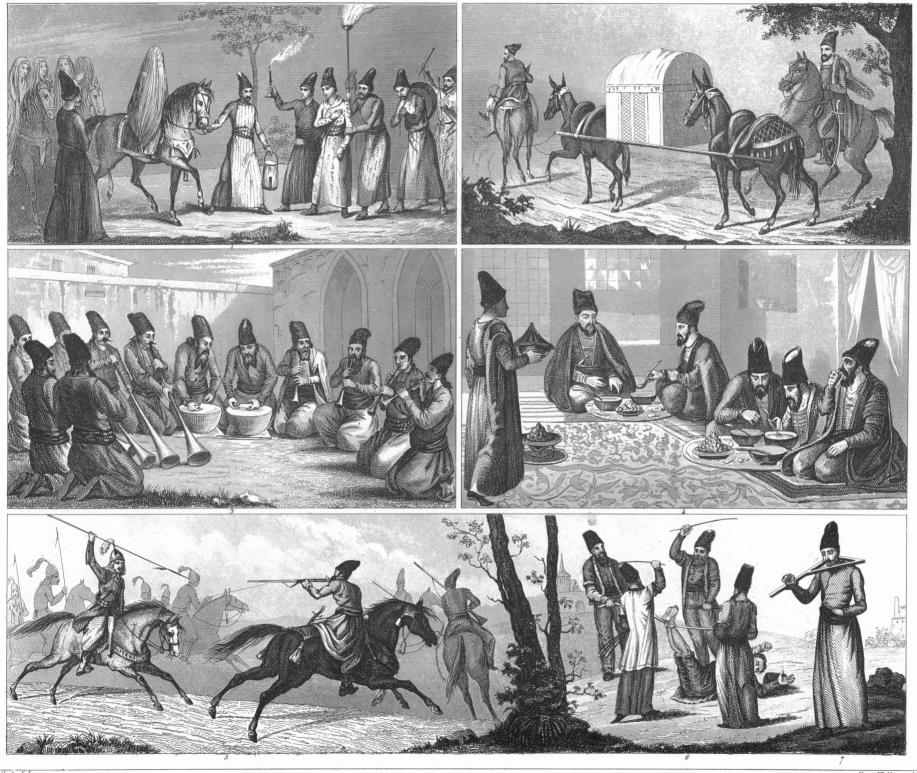

278

Henry Winkles sculp!

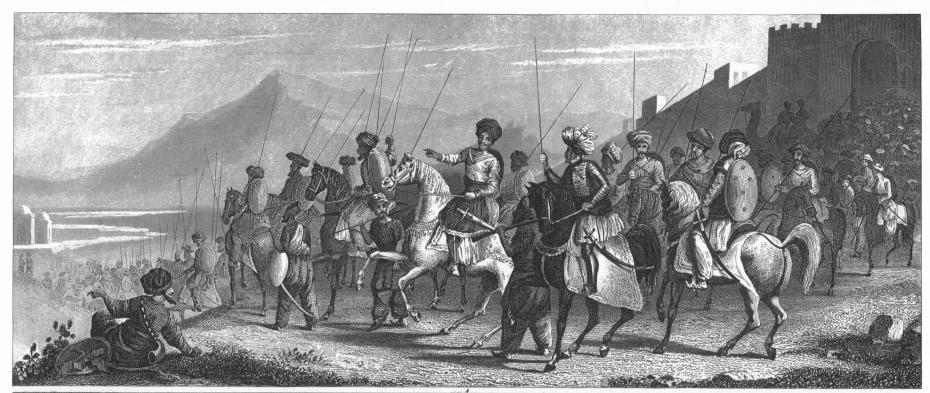

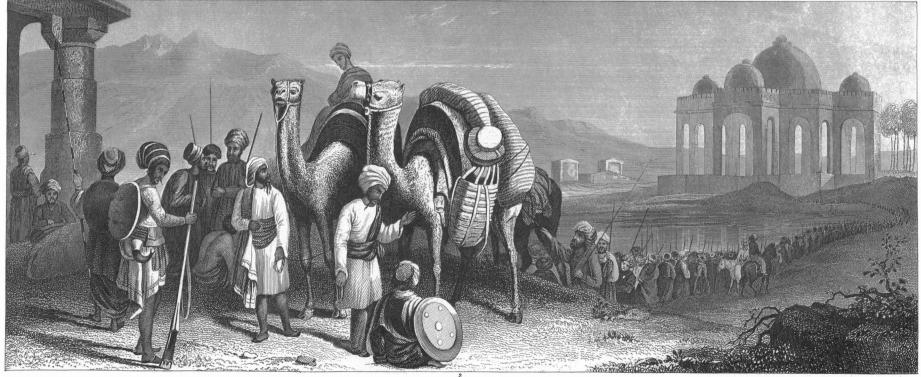

G. Heck dir!

Winkles et Lehmann sculp !

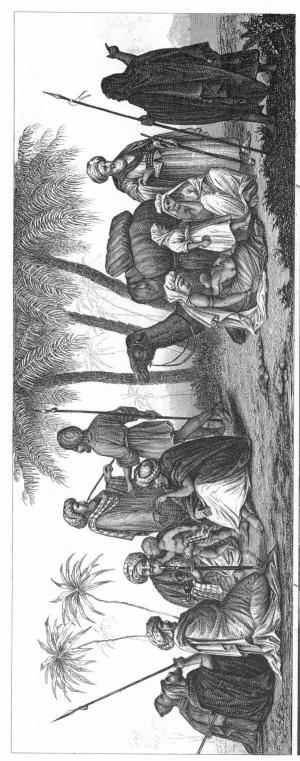

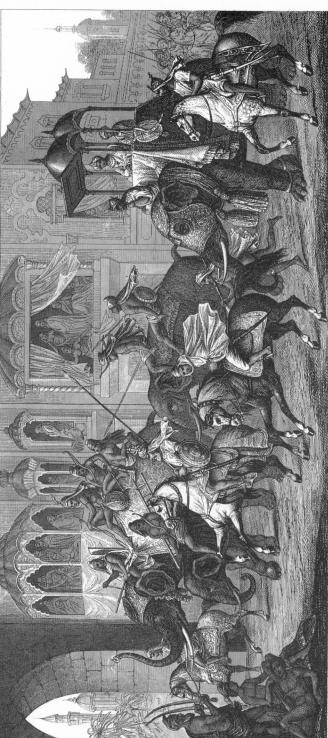

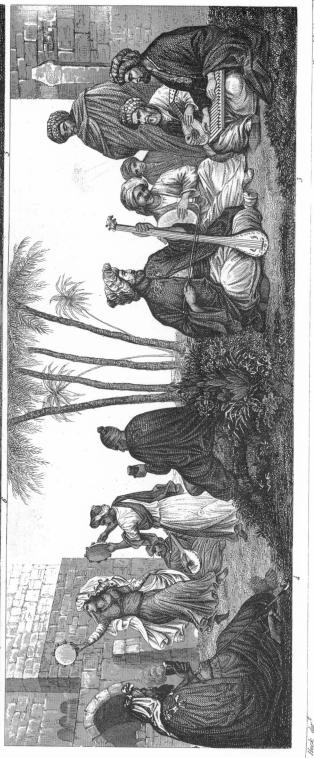

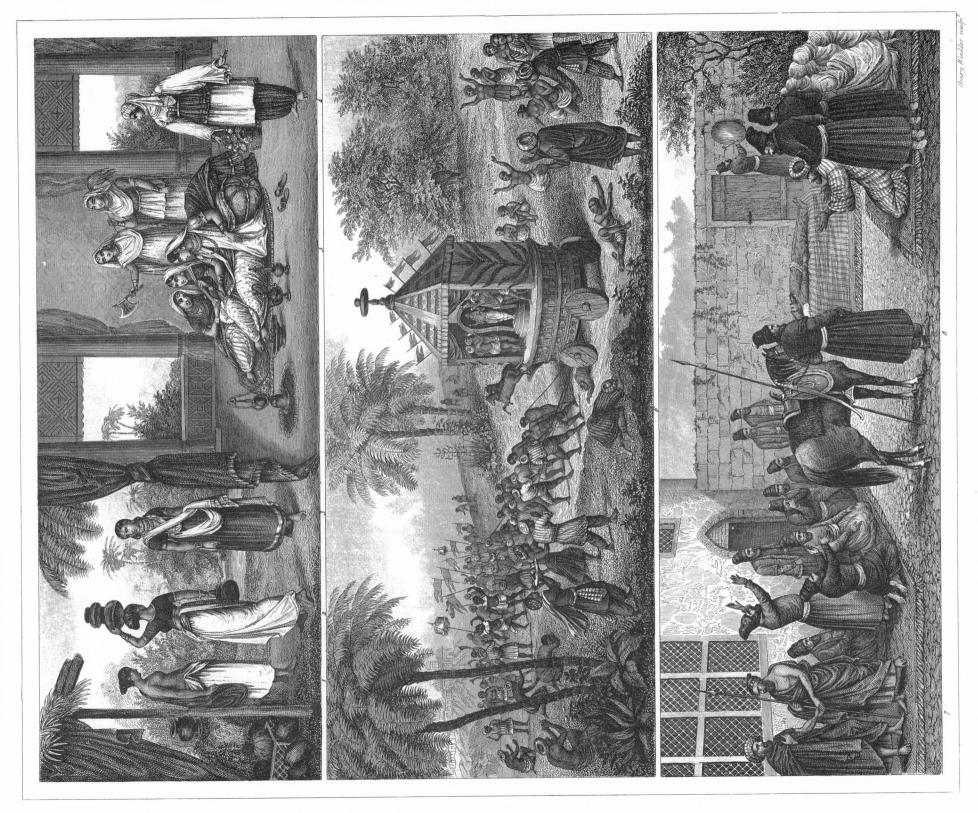

PLATE 244. SCENES FROM INDIAN, ARABIAN, AND PERSIAN LIFE

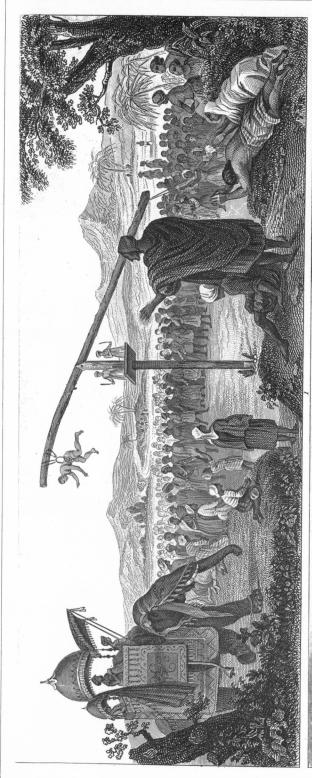

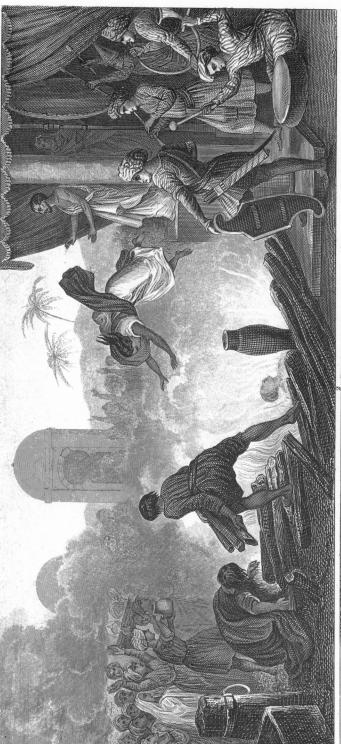

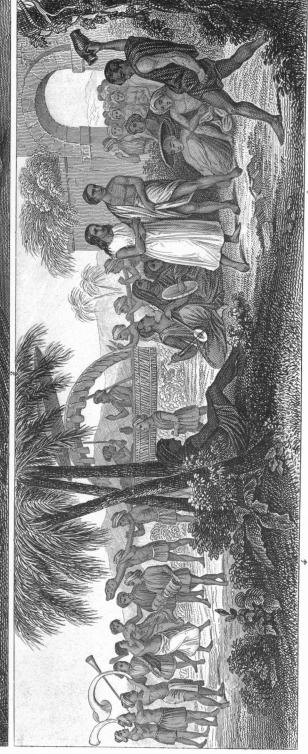

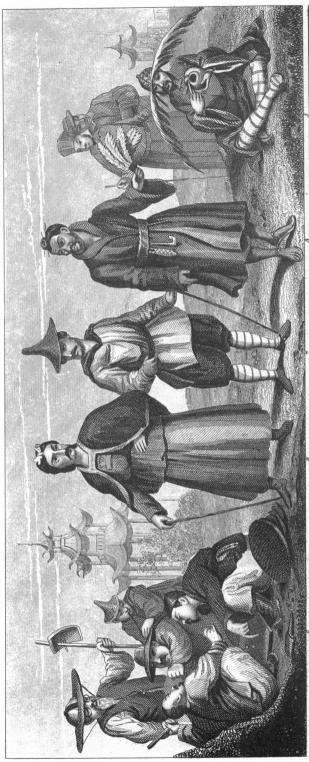

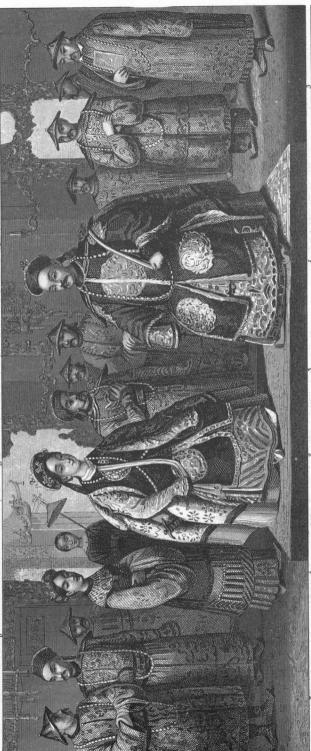

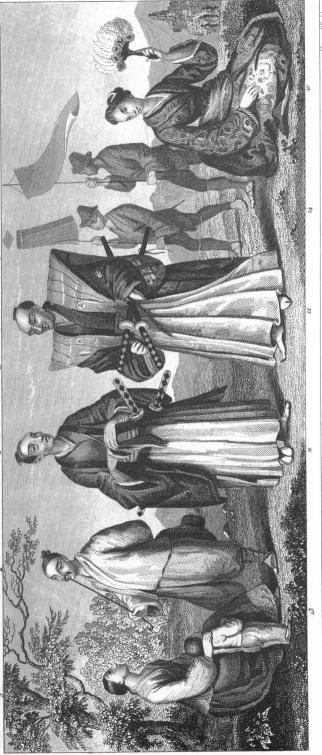

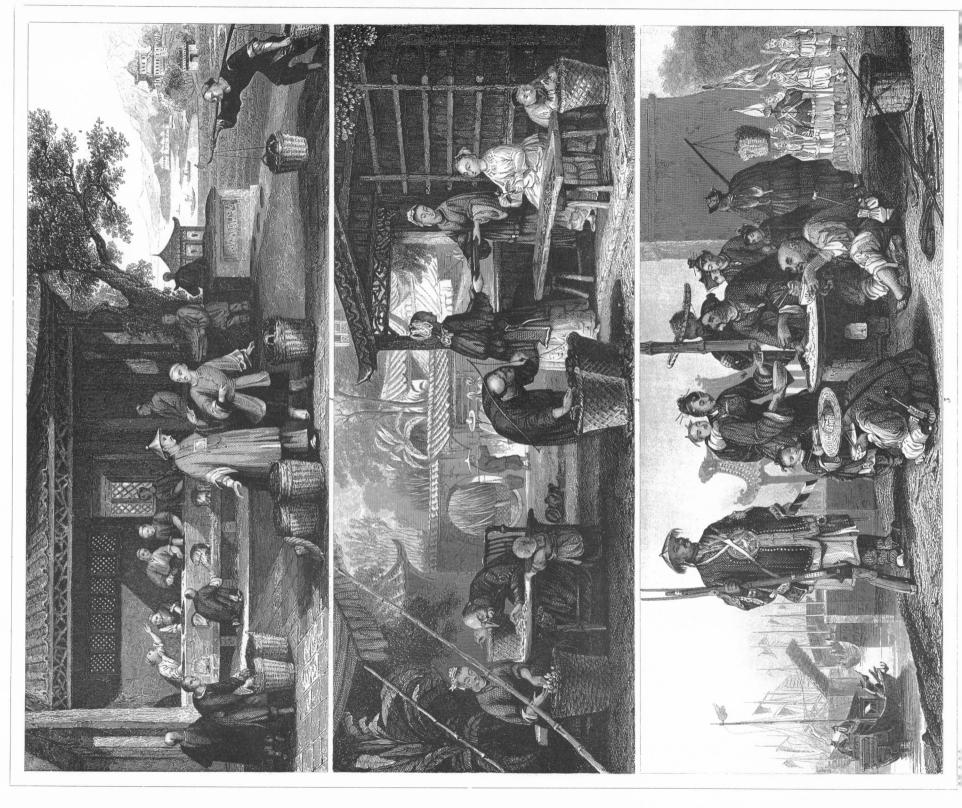

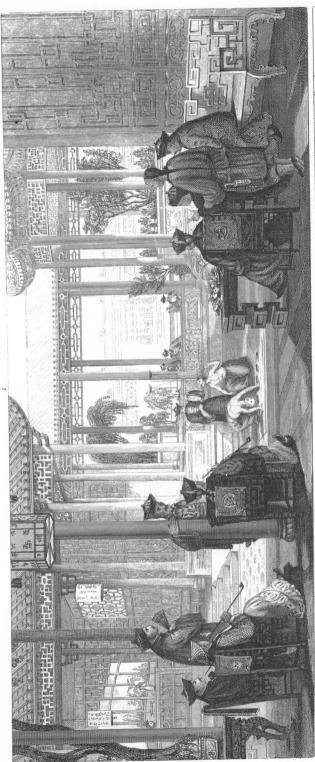

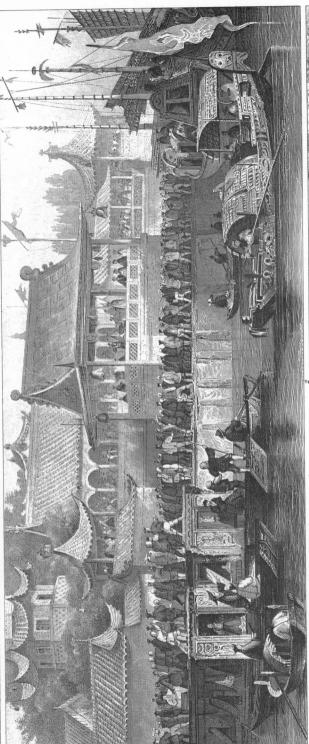

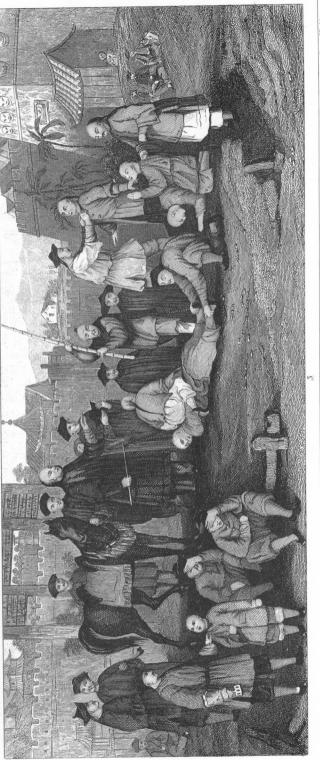

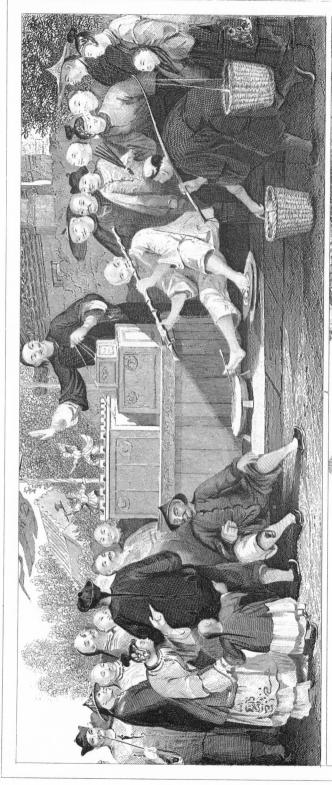

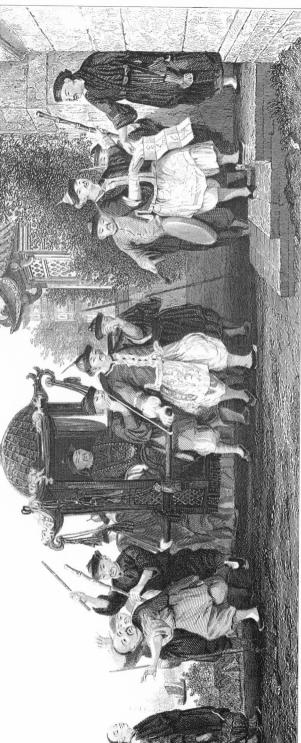

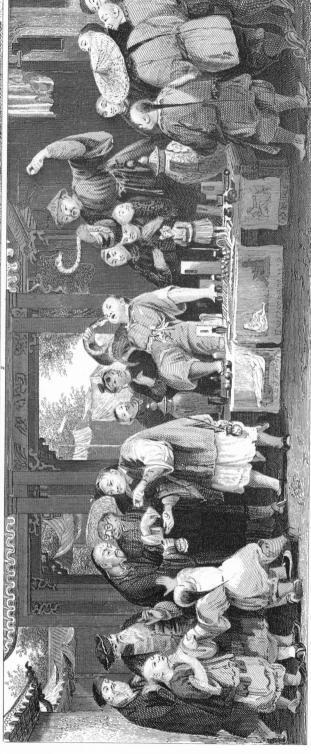

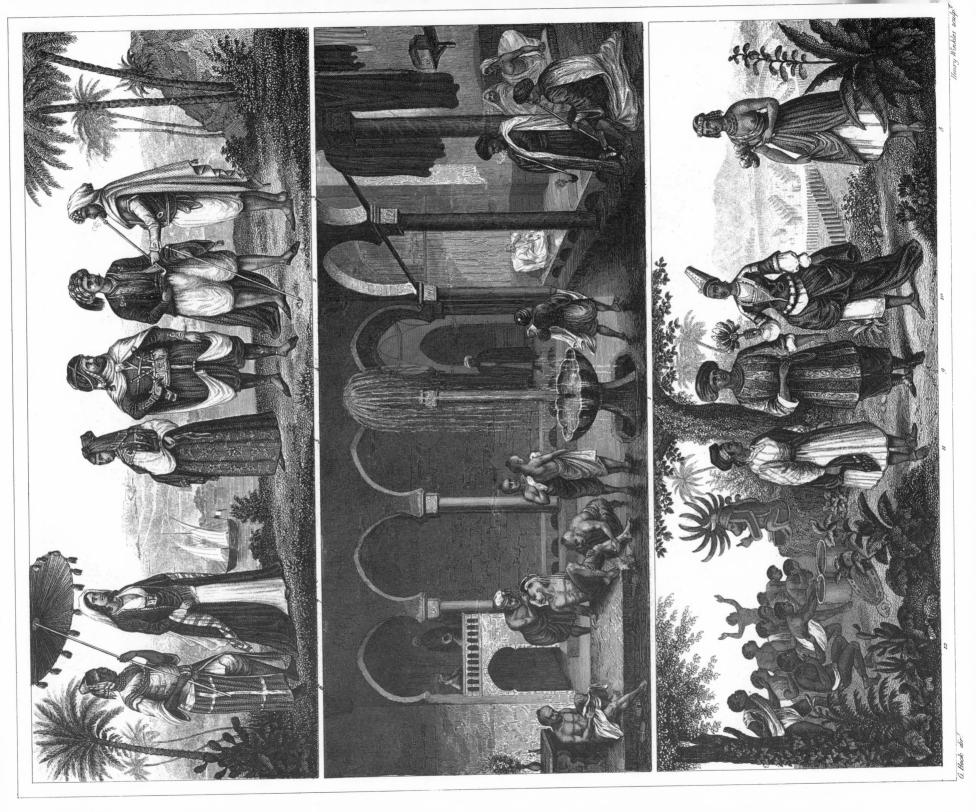

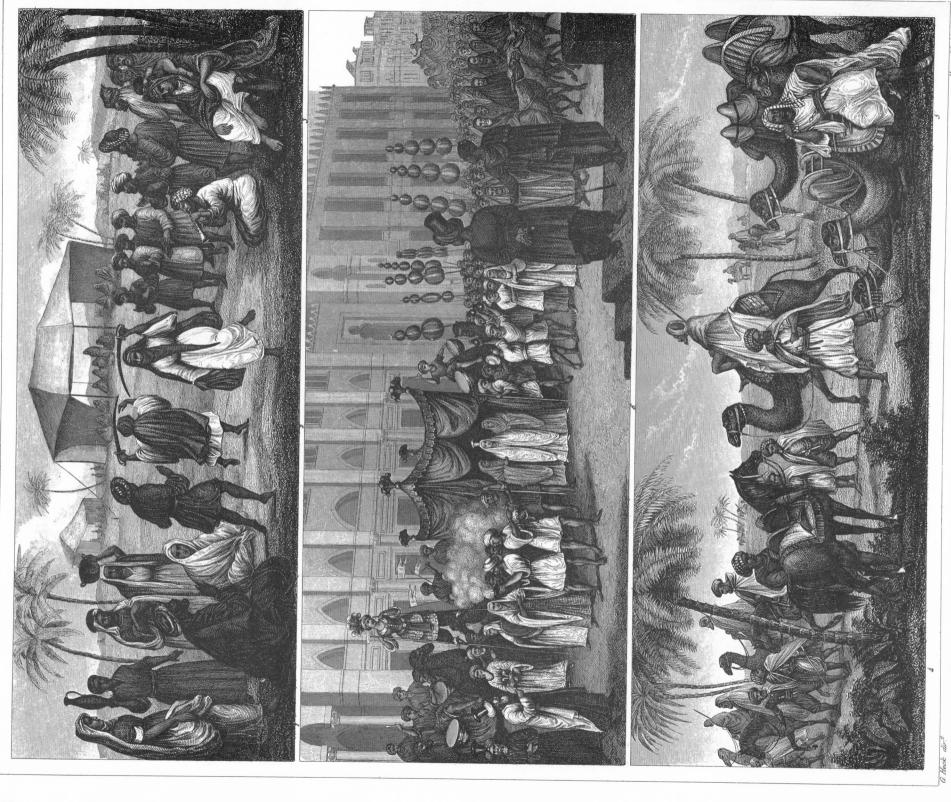

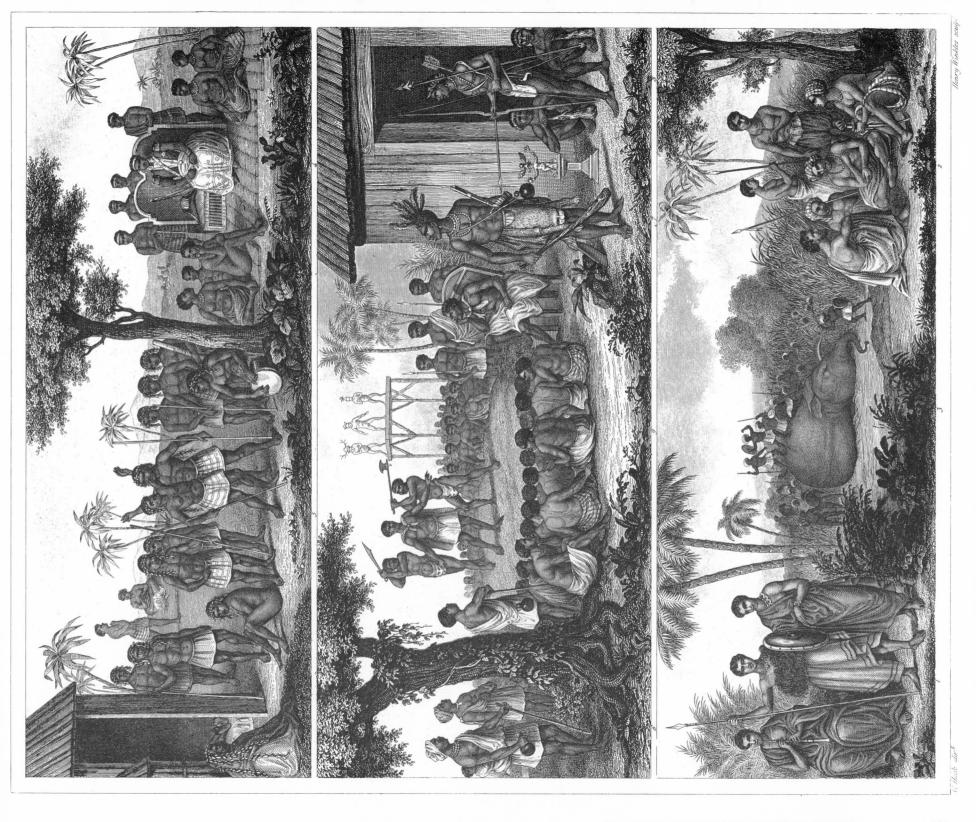

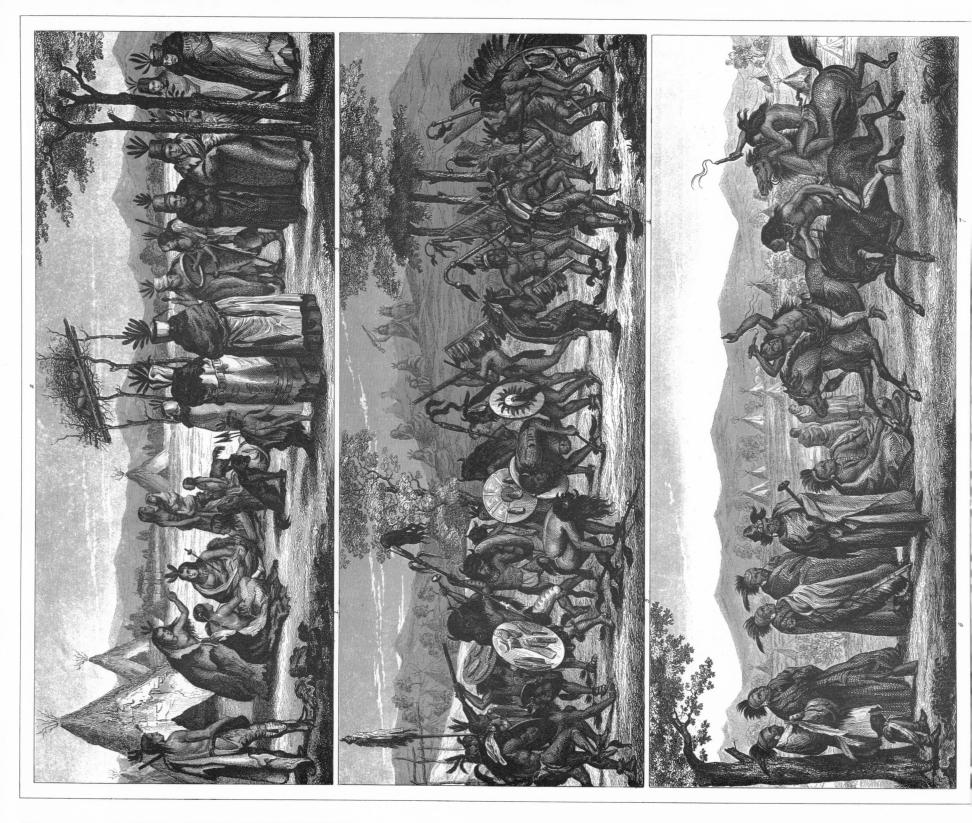

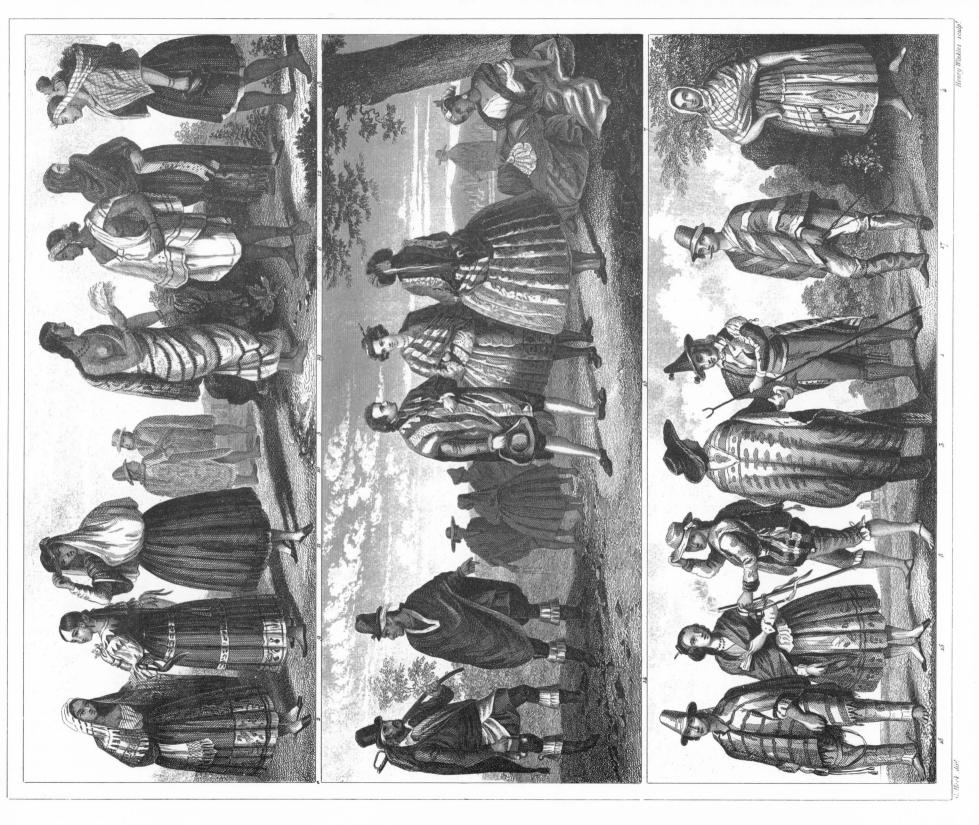

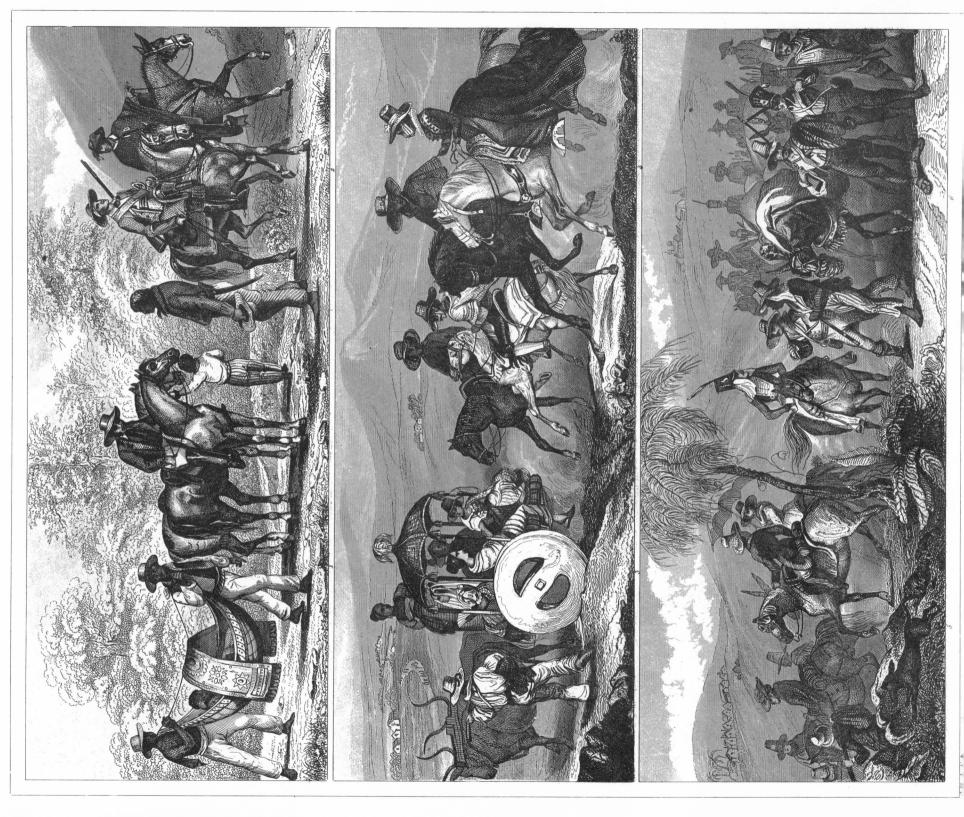

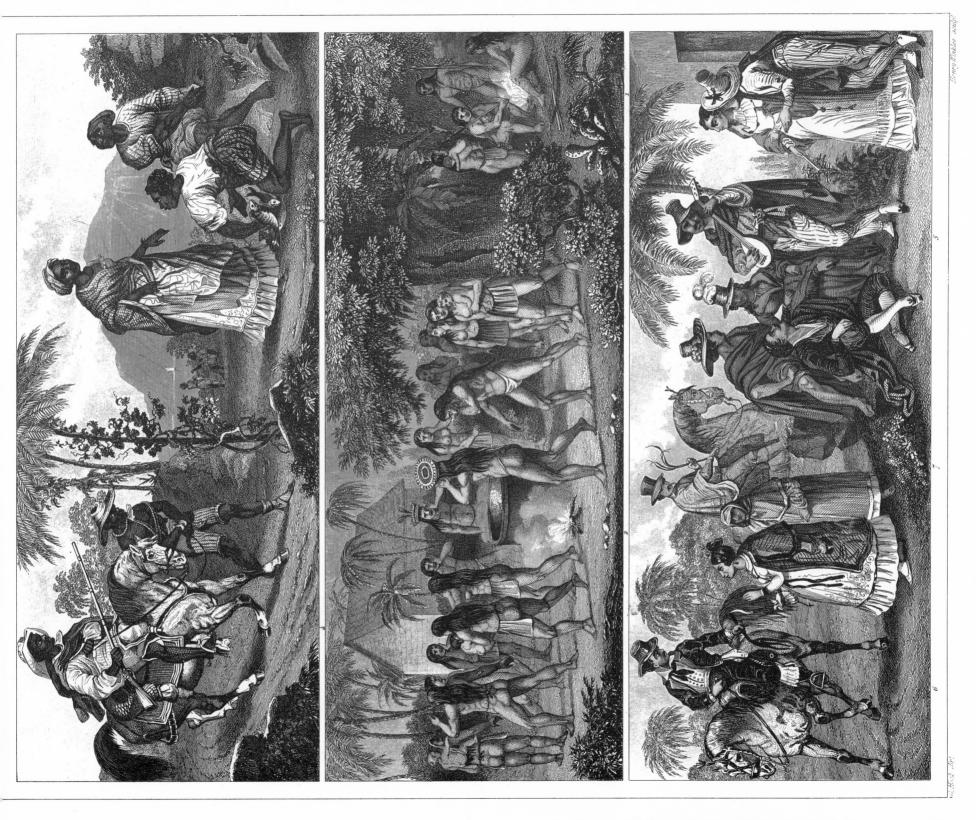

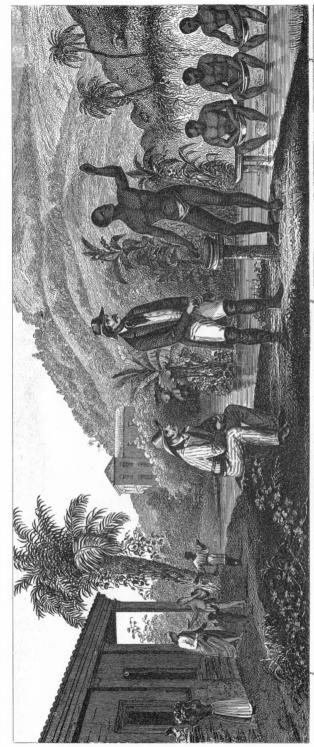

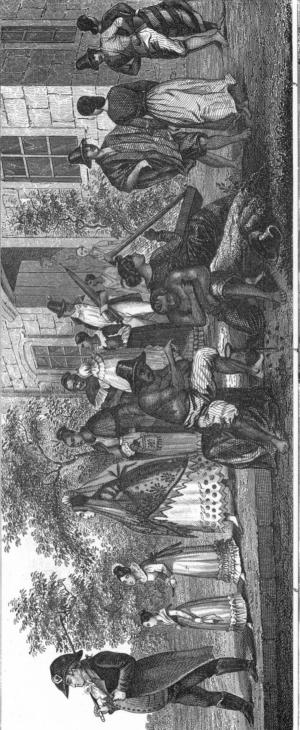

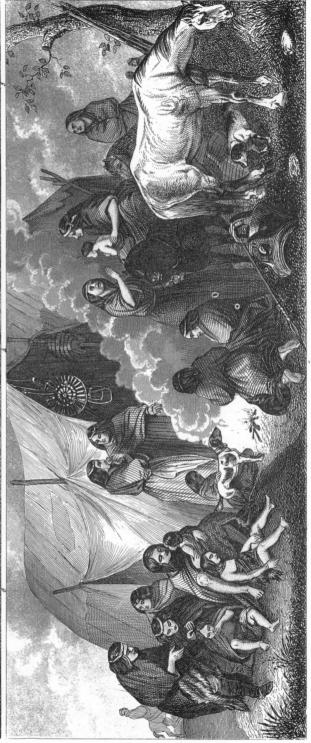

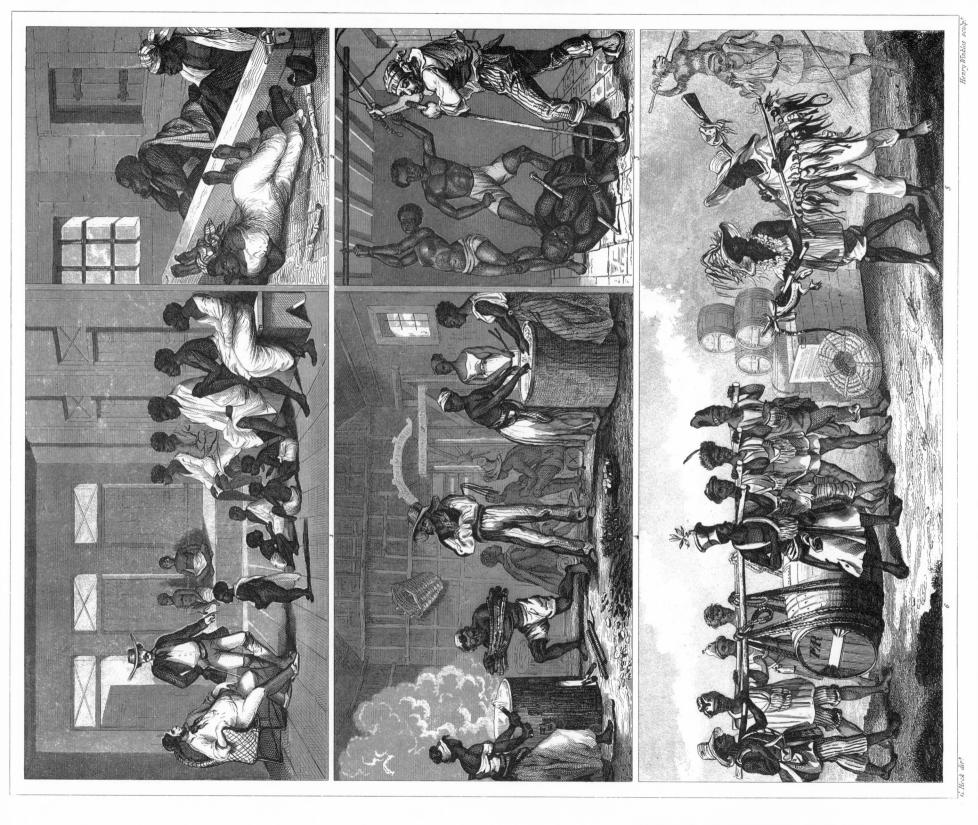

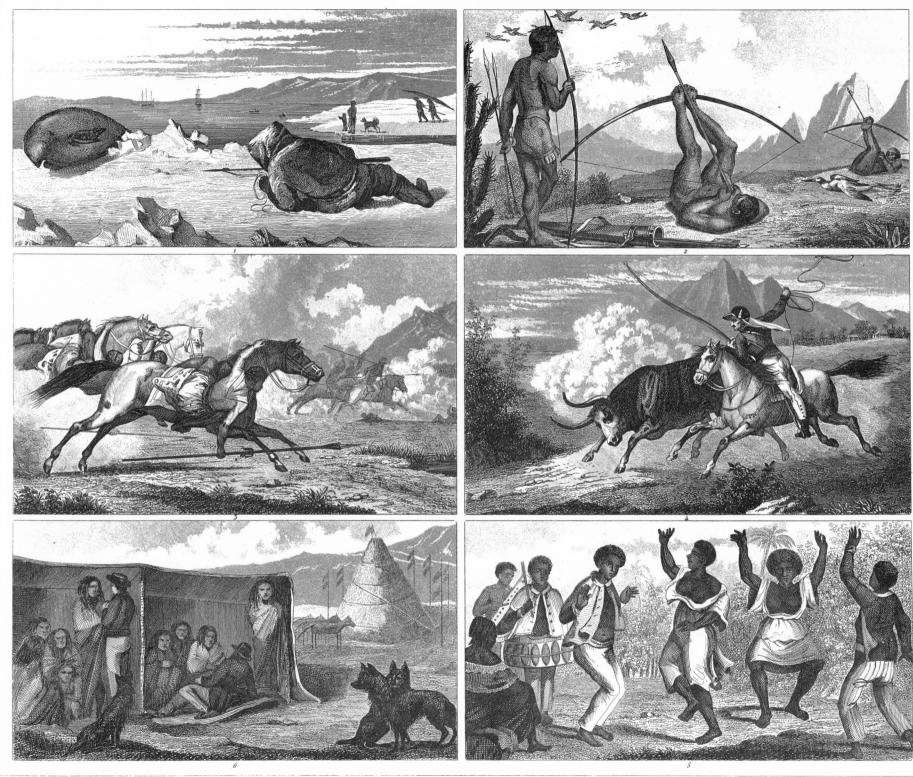

G. Heck dir

Henry Winkles sculp!

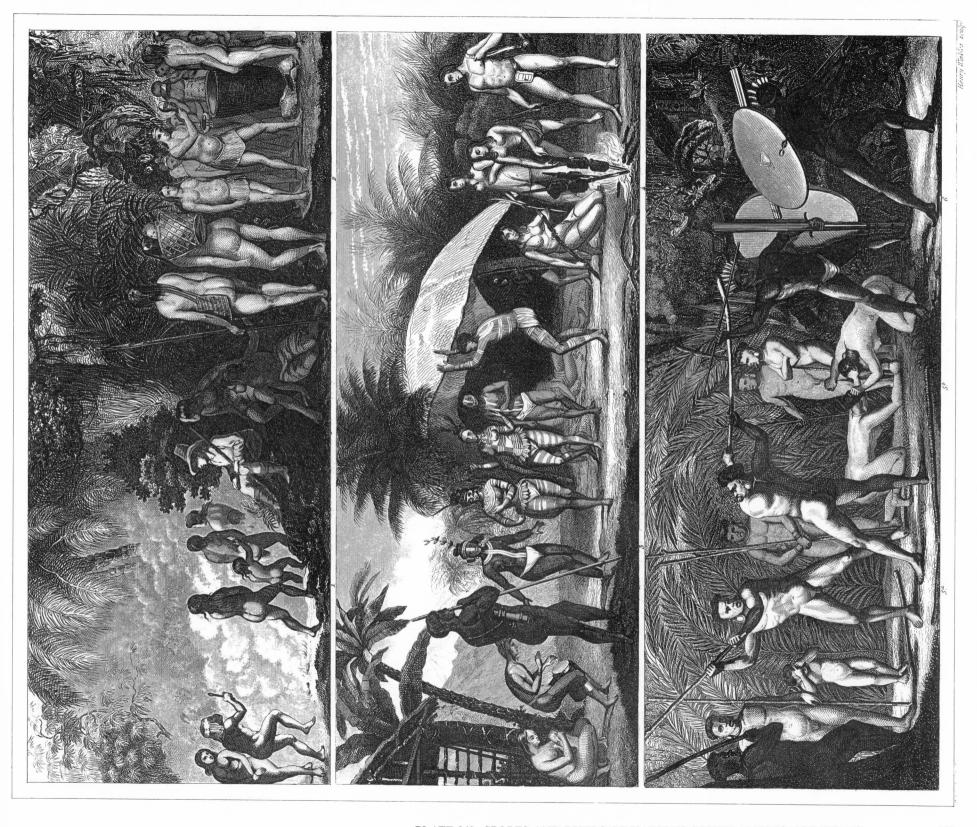

PLATE 260. SPORTS AND DUELS OF VARIOUS SOUTH AMERICAN INDIANS

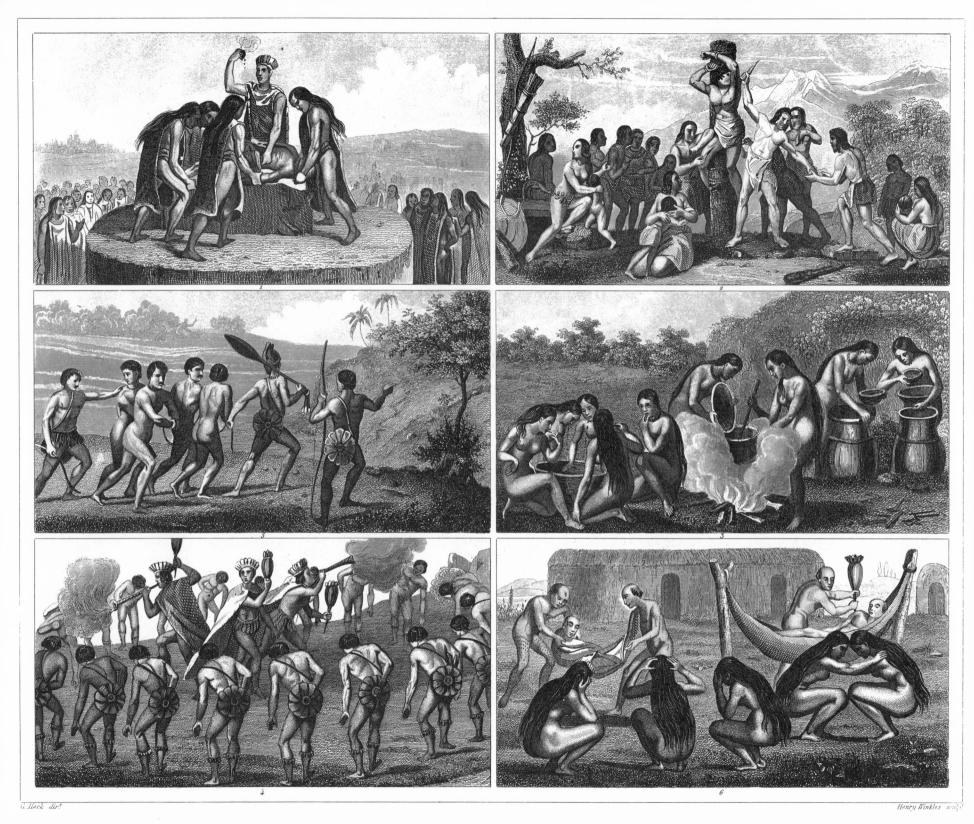

PLATE 261. RITES AND CEREMONIES OF MEXICAN AND SOUTH AMERICAN INDIANS

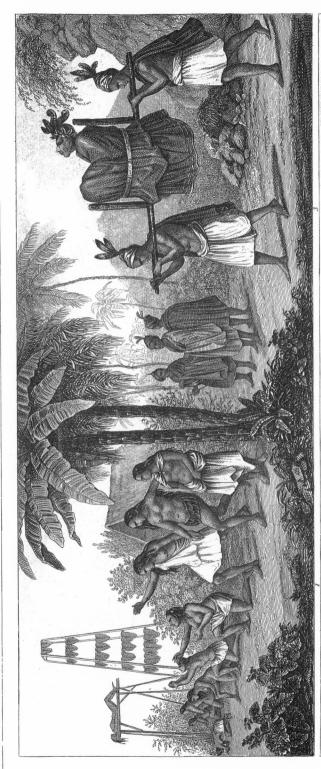

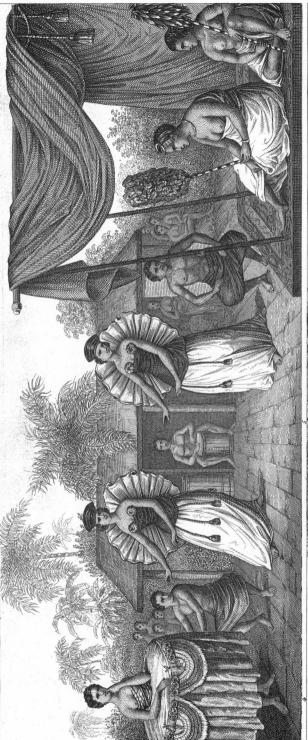

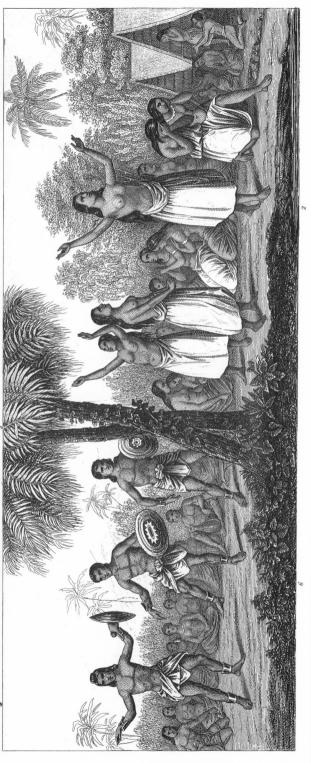

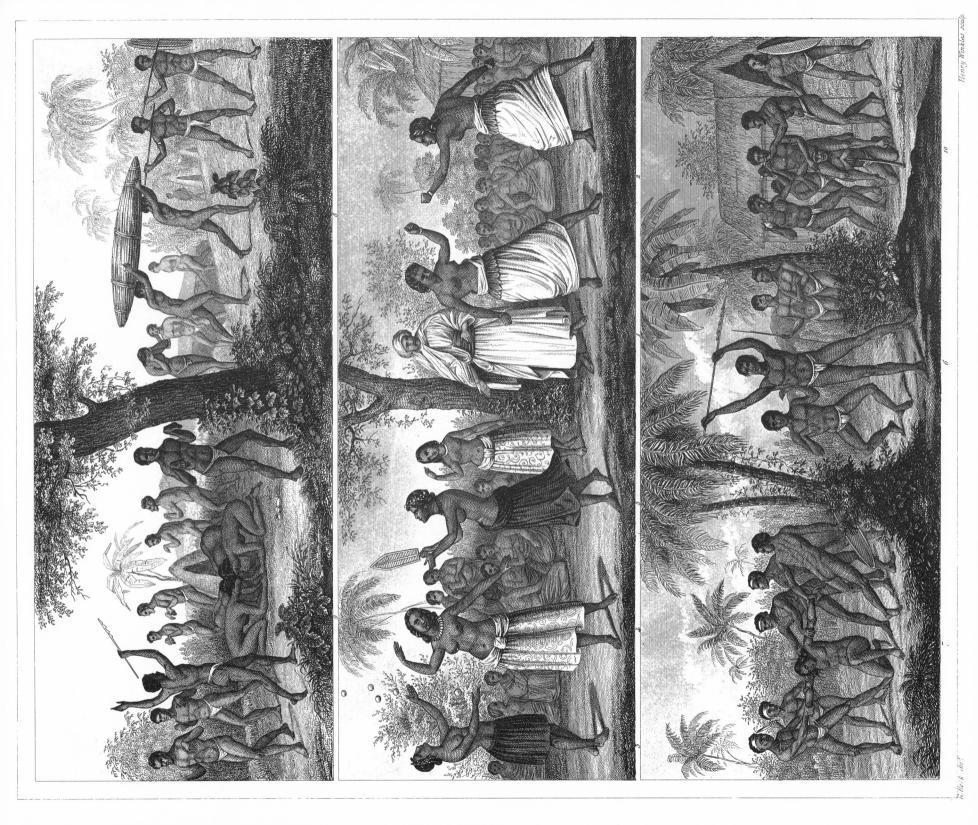

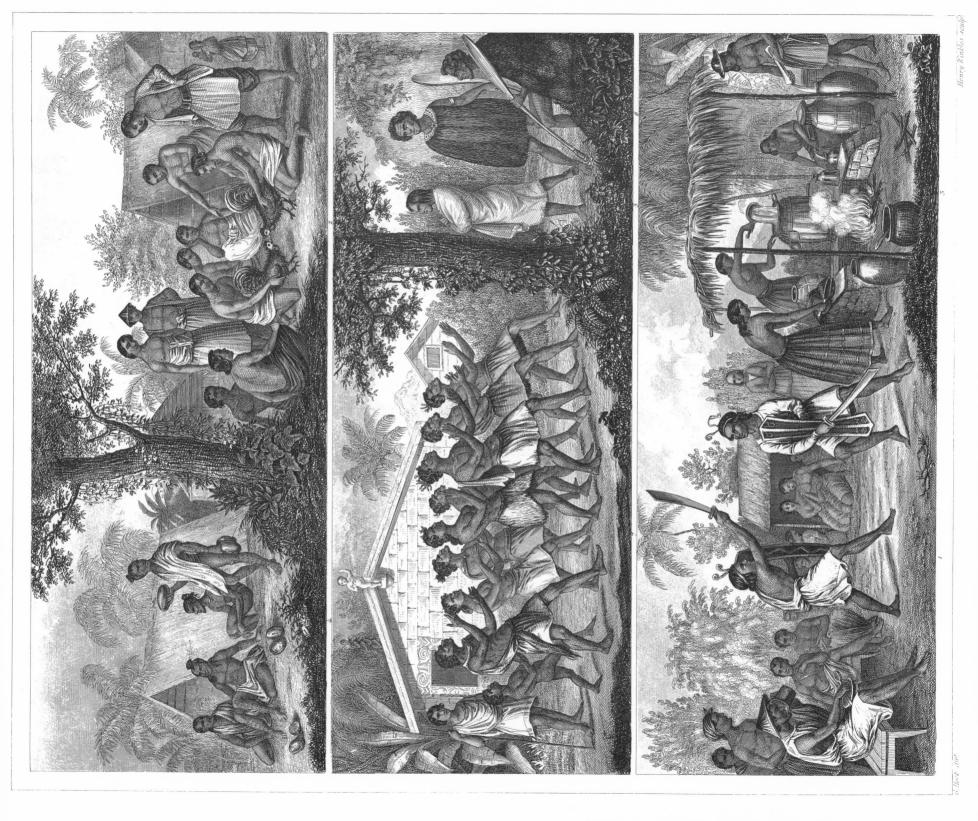

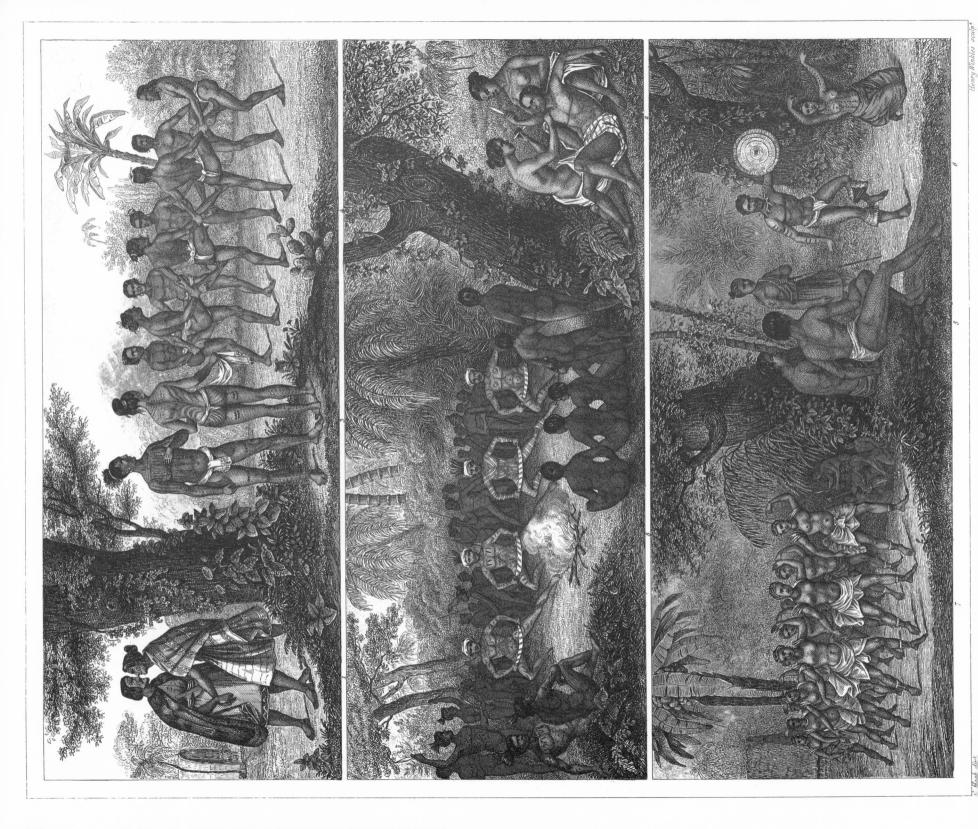

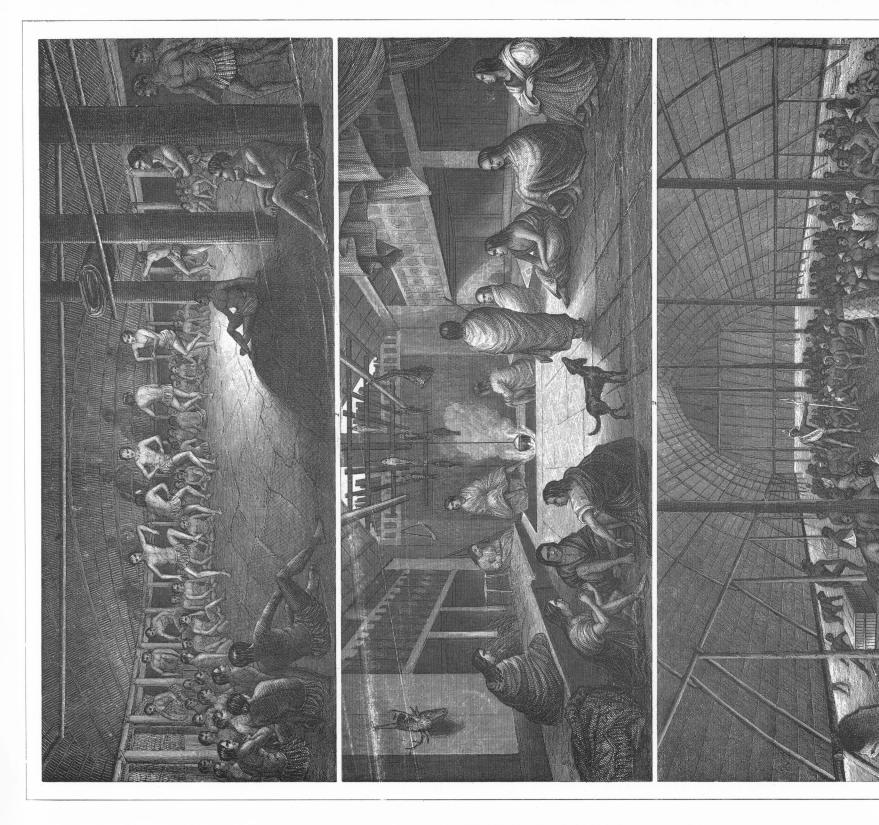

Captions to the Military Sciences Plates, 267-317

PLATE 267.

Weapons of the Egyptians, Medes, and Persians

Figure

1-22. Weapons of the Egyptians 23-56. Weapons of the Medes and Persians

PLATE 268. **Greek and Etruscan Warriors**

- 1. Grecian hero
- 2. Amazon from the Black Sea
- 3-8. Grecian warriors on foot
- 9. Grecian trumpeter
- 10. Grecian combat
- 11. Grecian herald
- 12. 13. Grecian horsemen
- 14. Etruscan archer
- 15. Etruscan hornblower
- 16-18. Etruscan soldiers

PLATE 269.

Weapons of the Greeks, Etruscans, and Romans

- 1-21. Weapons of the Greeks
- 22-35. Weapons of the Etruscans 36-43. Weapons of the Romans

 - **PLATE 270. Greek and Roman Troop**

Movements

Figure

- 1-30. Illustrating the movements of Grecian troops
- 31-51. Illustrating the movements of Roman troops

PLATE 271.

Scenes of Ancient Warriors

Figure

- 1. Grecian funeral and death
- Roman imperator and suite
- The war-elephant in combat Armed chariot

PLATE 272.

Ceremonial Processions

Figure

- 1. Funeral procession of Alexander the Great
- Triumphal procession of a 2. Roman general

PLATE 273.

Ranks and Allies of the Roman Army

Figure

- 1-5. Roman Italian allies
- 6, 7. German allies
- 8. Roman trumpeter
- Roman hornblower
- 10. Roman slinger
- 11. Roman lancers
- 12. Velites
- 13-19. Various ranks in the Roman army

PLATE 274.

Soldiers and Officers of Roman **Times**

Figure

- 1. Roman imperator
- Roman general
- Roman lictor
- The Imperator's body-guard
- Sarmatian mailed horseman
- Roman legate
- Roman standard-bearers 7.
- Roman decurion of cavalry
- Roman cavalry soldier

PLATE 275.

Ancient and Medieval Weapons and Armaments

Figure

- 1-46. Weapons of the Gauls, Franks, Germans, Britons, Anglo-Saxons, and Anglo-Danes
- 47. Roman saddle
- 48. Anglo-Saxon saddle
- 49-62. Various saddles of the

middle ages

63, 64. Spurs of the fourteenth century

PLATE 276.

Military Trappings of Ancient Rome

Figure

- 1. 2. Roman legion eagles
- 3. 4. Standards
- 5-15. Field badges
- 16-23. Honorary crowns
- 24, 25. Honorary medals
- 26, 27. Trophies
- 28. Trajan's column

PLATE 277.

Military Ceremonies and **Processions of Rome**

Figure

- 1. Roman prisoners passing under the voke
- 2. Roman victor thanking the
- 3-5. Triumphal processions

PLATE 278.

Military Life of the Germanic **Tribes**

Figure

- 1. The war dance of German vouths
- 2. Ceremony of bestowing the right to bear arms
- Ceremony of soothsaying before battle
- 4. Germans in combat

PLATE 279.

Roman and Carthaginian Military **Formations**

Figure

- Roman camp
- Roman order of battle
- The solid wedge
- The boar's head
- The tortoise

6. Carthaginian order of battle with elephants

PLATE 280. Medieval War Scenes

Figure

- 1. Decimation of prisoners
- Election of commander
- Combat of infantry against cavalry

PLATE 281.

Weapons of the Germans, Normans, Anglo-Saxons, and Danes

Figures 1-77.

PLATE 282.

Armor of the Middle Ages

Figures 1–23.

PLATE 283.

Medieval Armor and Tournaments

Figure

- 1. Emperor's suit of armor
- Elector's suit of armor
- 3. 4. Knights' armor
- 5, 6. Footsoldiers 7-10. Tourney equipments
- 11. Awarding the prize at a tourney

PLATE 284.

Military Dignitaries and War **Camps**

Figure

- 1-10. Different dignitaries of the war-ban
- 11. The marching forth of an army from its camp

PLATE 285.

Prussian and French Infantry

Upper Division

Figure

1-14. Prussian infantry

Lower Division

Figure

1-12. French infantry

PLATE 286.

Prussian and French Cavalry

Upper Division

Figure

1-10. Prussian cavalry

Lower Division

Figure

11-19. French cavalry

PLATE 287.

Austrian and British Infantry

Upper Division

Figure

1-8. Austrian infantry

Lower Division

Figure 1-11. British infantry

PLATE 288.

British and Belgian Cavalry

Figure 1-9. British cavalry

10-20. Belgian cavalry, artillery, and engineers

PLATE 289. Turkish Troops

Figure

1-10. Troops of the older Turkish military system 11-17. Modern Turkish army

PLATE 290.

Scenes from Turkish Military Life

Figure

- 1. Turkish pasha and suite
- Encampment of a pasha of three tails

- 3. Body-guard
- 4, 5. Turkish warlike games

PLATE 291.

Illustrating the Various Kinds of Arms of the Mid-Nineteenth Century

Figures 1-60.

PLATE 292.

Illustrating Military Gymnastics

Figures 1-41.

PLATE 293.

Illustrating Military Fencing

Figures 1-48.

PLATE 294.

Practical Exercises in Fencing

Figures 1-18.

PLATE 295.

Military Tactics and French Troops in Algiers

Figure

1-47. Illustrating modern tactics 48. Disembarkation of French troops in Algiers

PLATE 296. Austrian and Prussian Orders

Upper Division

Figure

1-13. Austrian orders

Lower Division

Figure

1-11. Prussian orders

PLATE 297.

German and Danish Medals and **Military Orders**

Figure

- 1-4. Bayarian orders
- 5, 6. Saxon orders
- 7-9. Hanoverian orders
- 10–12. Wirtemberg orders
- 13-15. Orders of Baden
- 16, 17. Orders of Electoral Hesse
- 18. 19. Orders of the grand-duchy of Hesse

- 20, 21. The Danish Dannebrog order
- 22. Order of the white falcon
- 23. Order of the Saxe-Ernestine house
- 24, 25. Orders of Saxe-Altenburg
- 26. War medal of Saxe-Meiningen
- 27. War medal of Saxe-Hildburghausen
- 28. War medal of Saxe-Gotha-Altenburg
- 29-31. Orders of Brunswick and Nassau
- 32. Mecklenburg order
- 33. Oldenburg order
- 34. War medal of Anhalt Köthen
- 35. Volunteer's cross of Anhalt Dessau

PLATE 298.

Military Orders of Many Lands

Figure

- 1. 2. French orders
- 3, 4. British orders
- 5. 6. Russian orders
- 7, 8. Turkish orders
- 9. Persian order
- 10, 11. Spanish order
- 12. Portuguese order
- 13. Neapolitan order
- 14, 15. Sardinian orders
- 16. Papal order
- 17. Tuscan order
- 18. Grecian order
- 19. Belgian order
- 20, 21. Swedish orders
- 22, 23. Dutch orders
- 24. The Danish elephant-order
- 25. Brazilian order

PLATE 299.

Ancient Military Engines

Figures 1-18.

PLATE 300.

Military Engines of the Middle Ages

Figures 1-24.

PLATE 301.

Military Structures, Engines, and Formations of Ancient and **Medieval Times**

Figure

1. Watch tower

- 2. Siege tower
- 3-6. Movable towers
- 7. Ancient trenches
- 8. The storming ram
- 9. The lifting forceps
- 10. Drawbasket
- 11. Storming a wall

PLATE 302.

Illustrating Modern Artillery

Figures 1-48.

PLATE 303.

Illustrating Artillery Carriages

Figures 1-34.

PLATE 304.

Illustrating Artillery and Pontoon Carriages

Figures 1-24.

PLATE 305.

Illustrating the Fabrication of Artillery and Projectiles, Balls and **Bombs**

Figures 1-50.

PLATE 306.

Illustrating Military Pyrotechny

Figures 1-57.

PLATE 307.

Roman Military Structures and **Techniques**

Figure

- Roman fortified camp
- Scipio's circumvallation of Numantia
- 3. Cæsar's siege of Massilia

PLATE 308.

Gates and Walls of Ancient Times

Figure

- 1-4. The simplest ancient gates 5. The Gate of the Lions in
 - Mycenæ
- 6-9. The walls of Messene
- 10, 11. The gate of Spello
- 12, 13. The walls of Babylon
- 14, 15. The walls of Assos
- 16. The gates of Falerii
- 17. The Appian gate of Rome
- 18. Gate at Pompeii

19, 20. Sections of the walls of Rome

PLATE 309.

Walls of Greece and Rome

Figure

- 1-5. Walls between Athens and the Piræus
- 6. The Capitoline hill
- 7-9. Details of the walls
- 10-15. The walls of Pompeii

PLATE 310.

Castles of the Middle Ages

Figure

- 1. Ditch of a castle
- 2. Dungeon
- 3. Oubliette
- 4. Turret
- 5, 6. Plan and view of tower stairs
- 7. Lantern
- 8. Tower window
- 9. Magazine under a dungeon
- 10. Machicolis
- 11-13. Drawbridges
- 14, 15. Castle of Vincennes, plan and view
- 16. Castle of Rheinstein

PLATE 311. The Great Wall of China; Various **Towers and Battlements**

- **Figure**
- 1. The Chinese wall
- 2-4. Different towers 5-10. Battlements
- 12-14. Loopholes

PLATE 312.

Various Fortified Structures

Figure

- 1. Fortified bridge
- 2-7. Fortified gates
- 8-10. The Bastille in Paris
- 11. The old Louvre in Paris

12-21. Various forms of loopholes

PLATE 313.

Illustrating Field Fortification

Figures 1-57.

PLATE 314. Illustrating Permanent

Figures 1-42.

PLATE 315.

Fortifications

Illustrating Attack and Defence of **Fortified Places**

Figures 1-37.

PLATE 316.

Illustrating Attack and Defence of **Fortified Places**

Figures 1–51.

PLATE 317.

Illustrating the Pioneer and **Pontoon Service**

Figures 1-54.

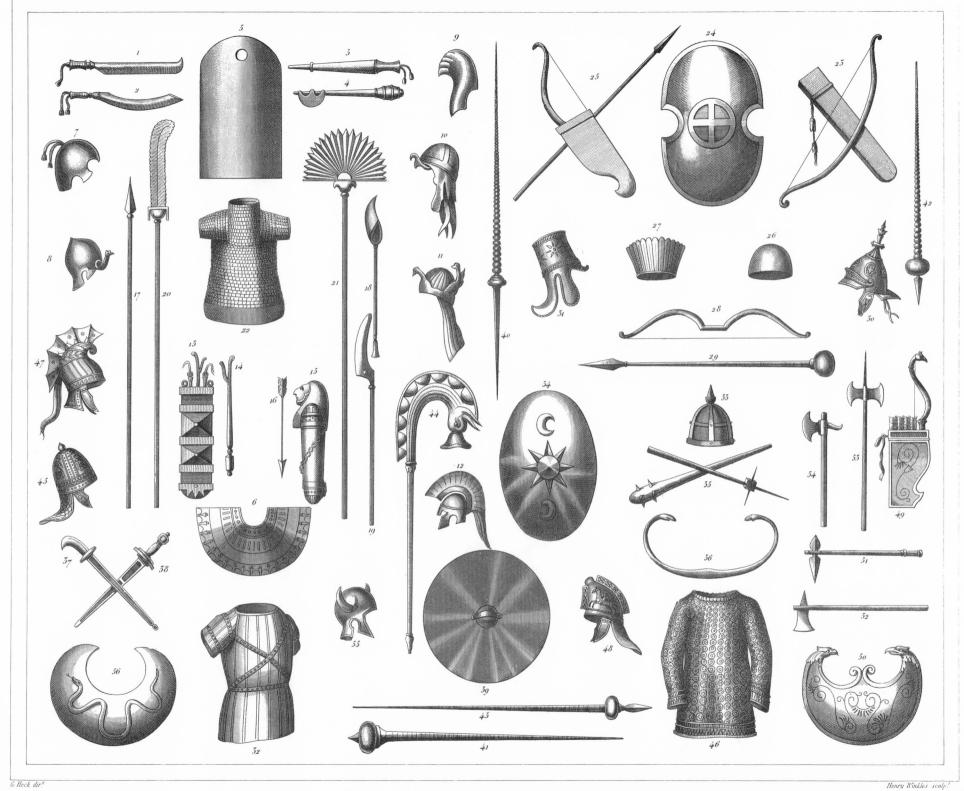

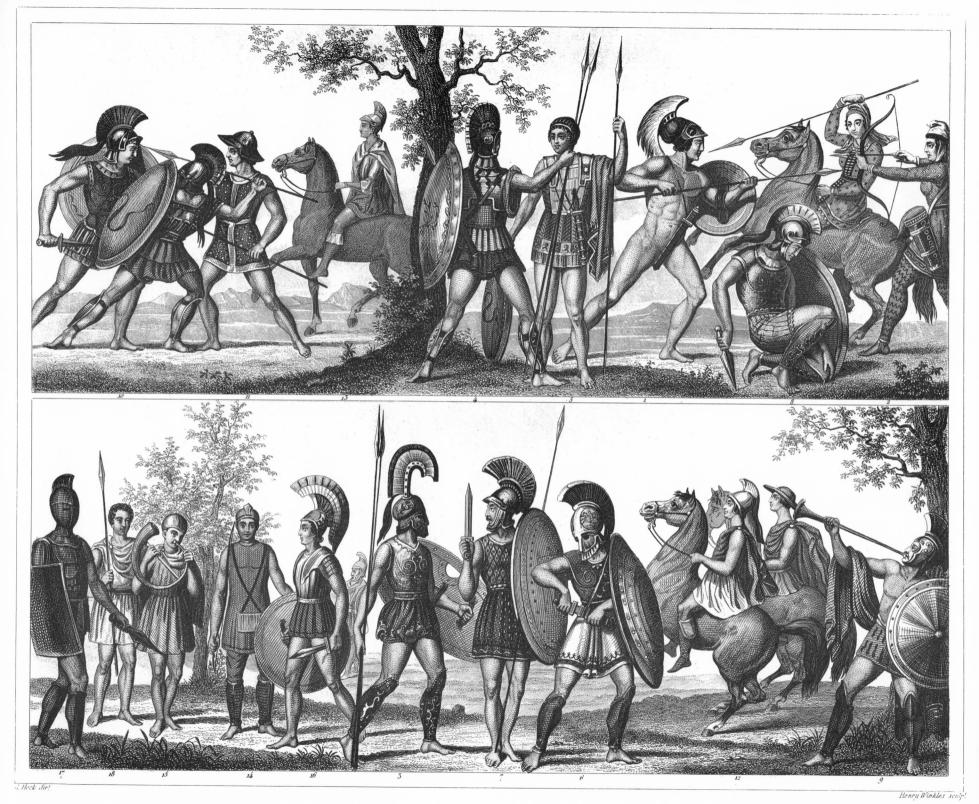

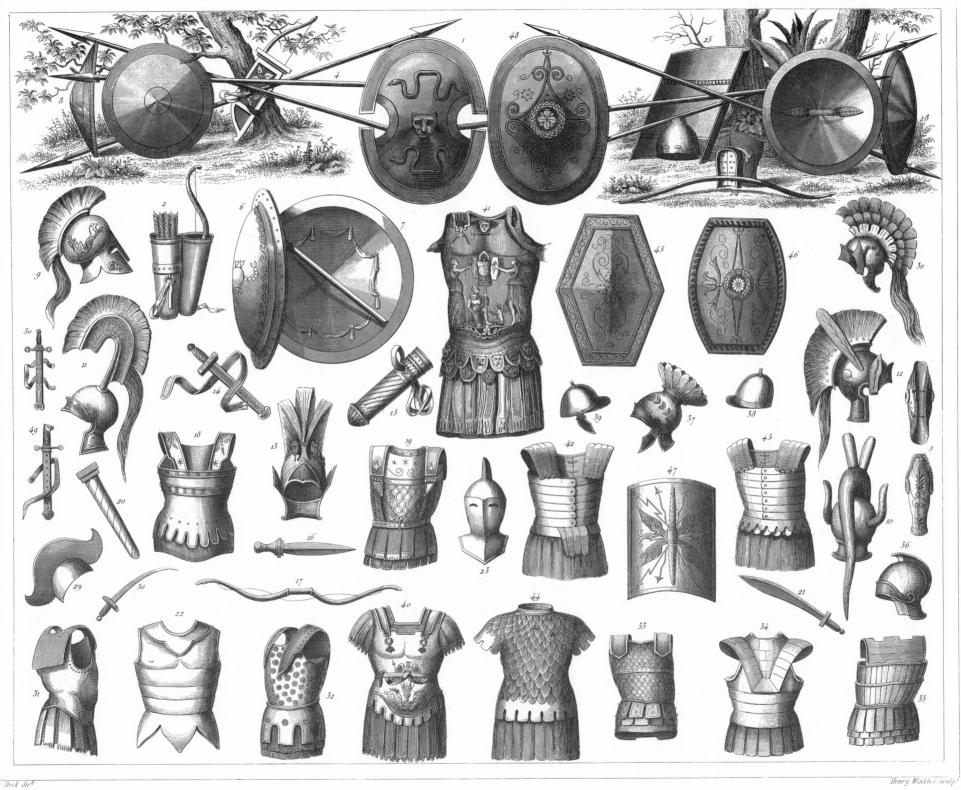

Henry Winkles soulp

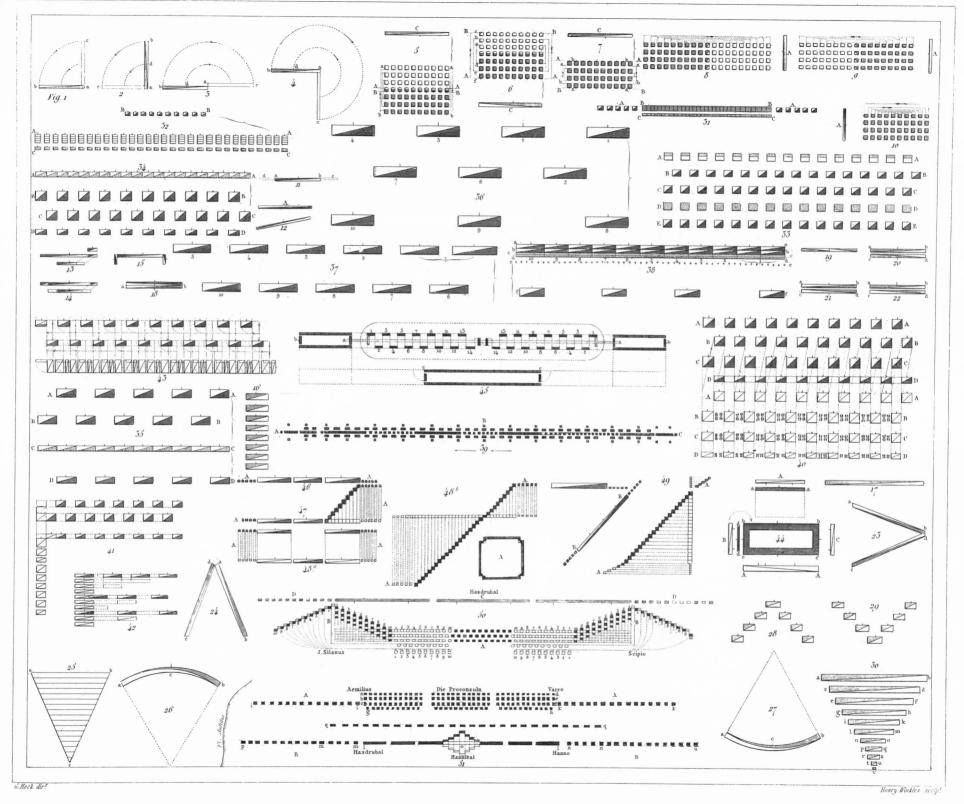

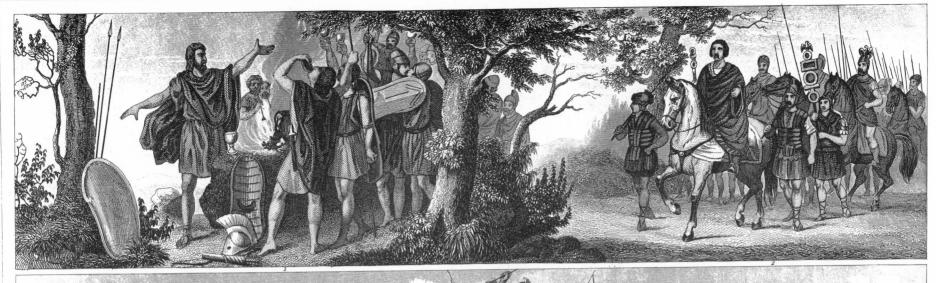

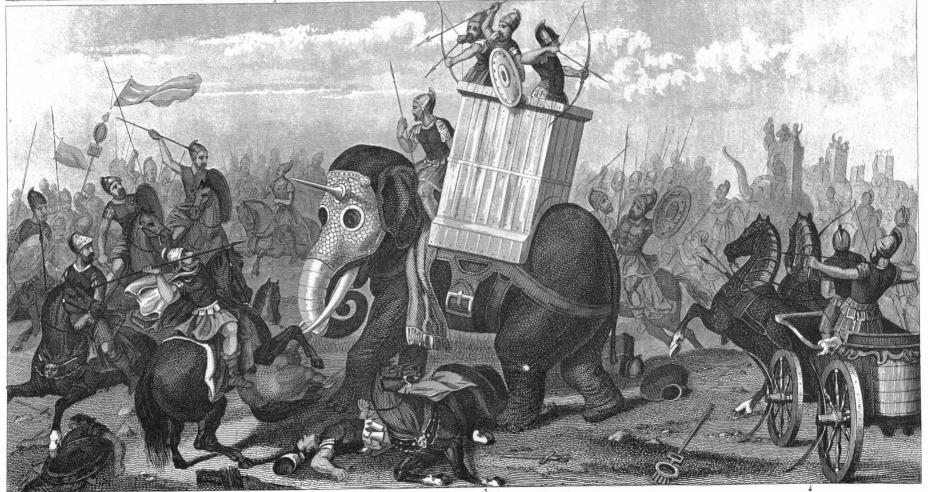

G. Heck dir!

Henry Winkles sculp!

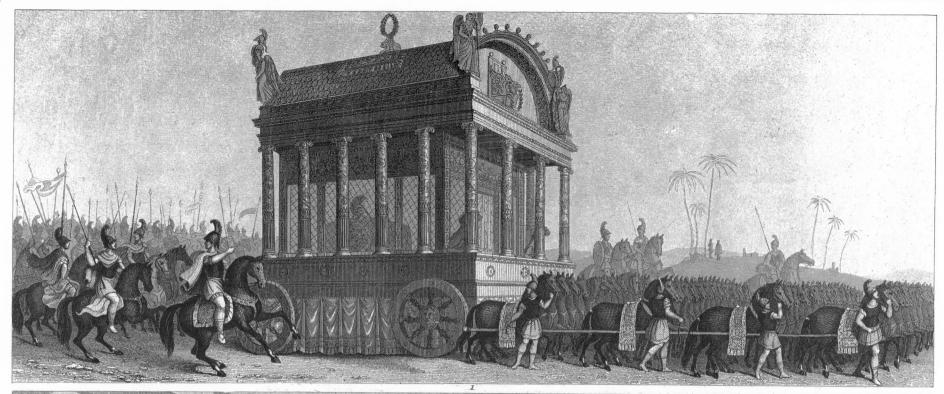

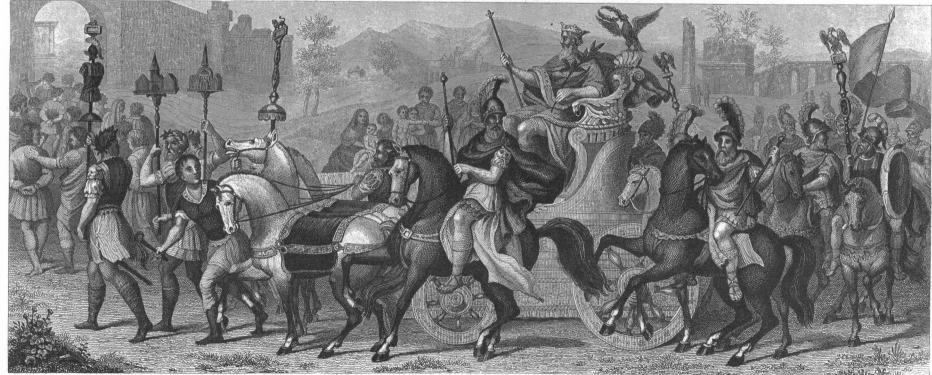

6. Heck dir.

Henry Winkles sculpt

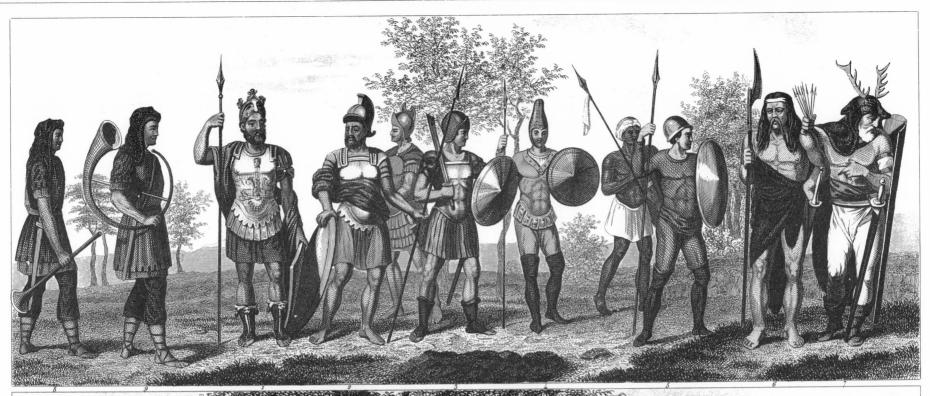

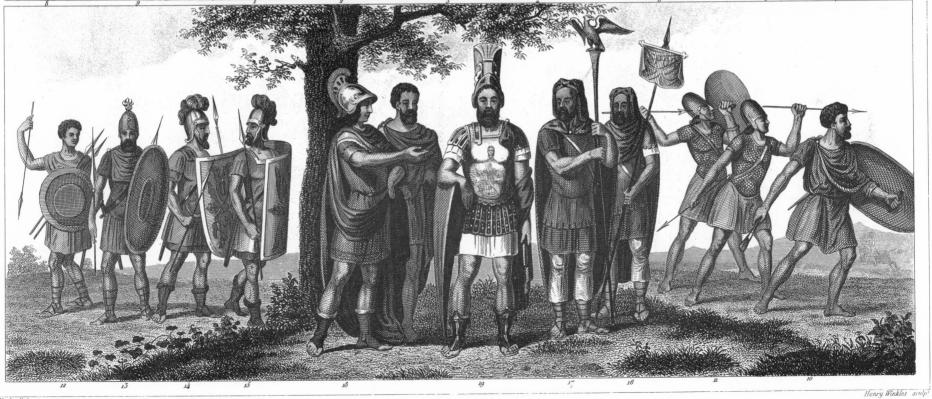

6. Heck dirt

315

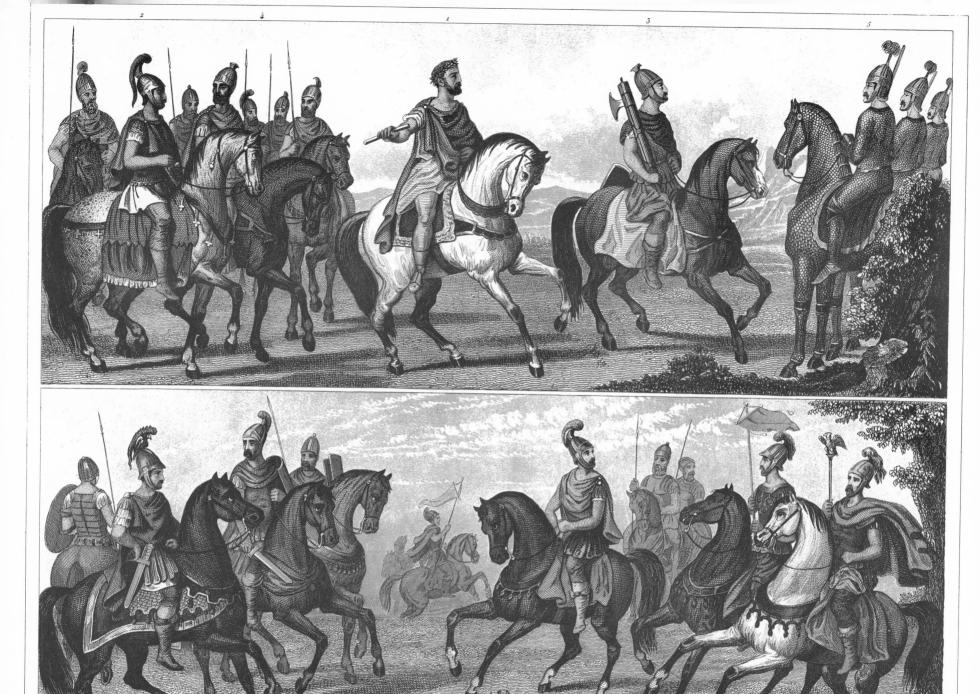

Henry Winkles sculy!

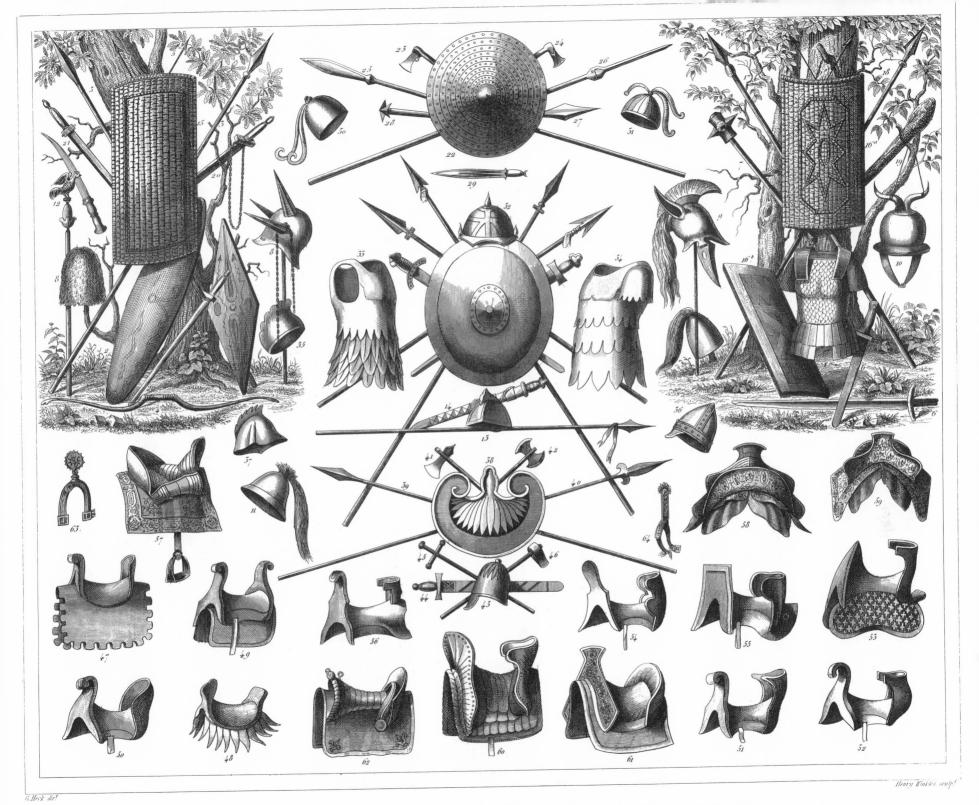

317

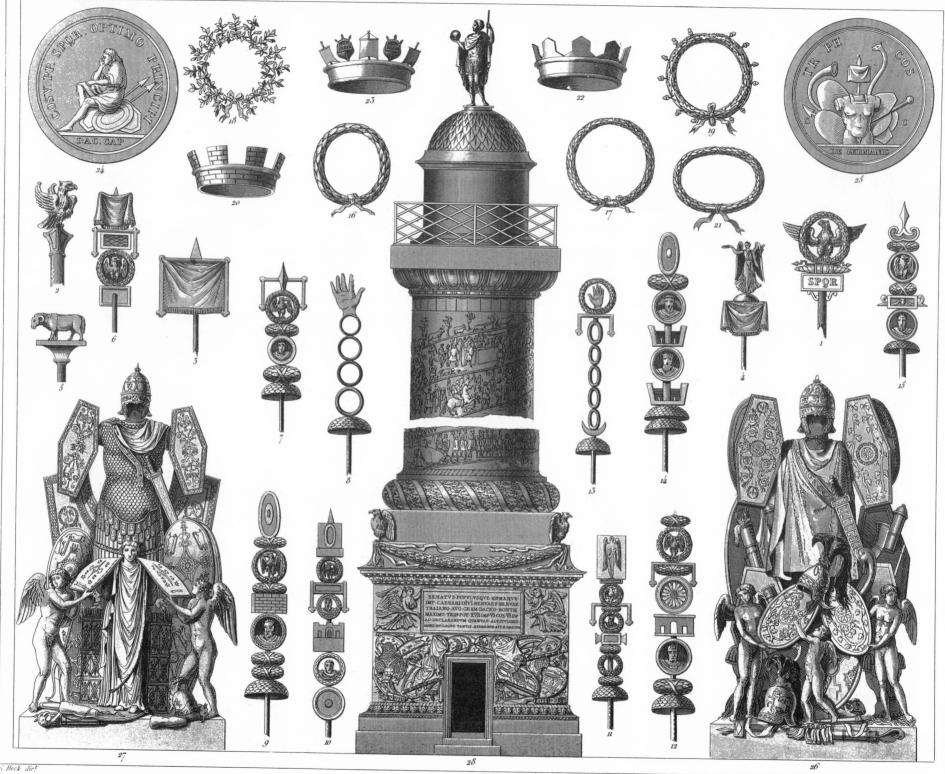

Henry Winkles sculp!

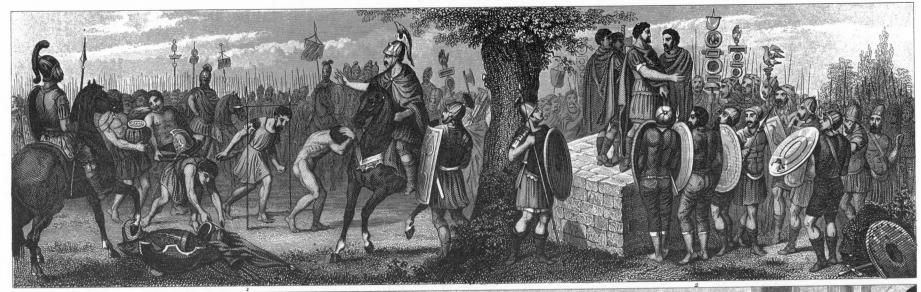

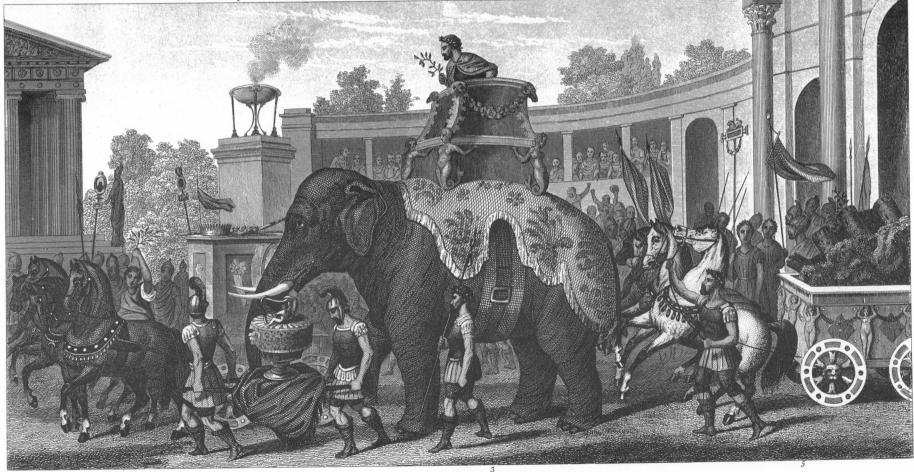

6. Heck dir!

Henry Winkles sculp!

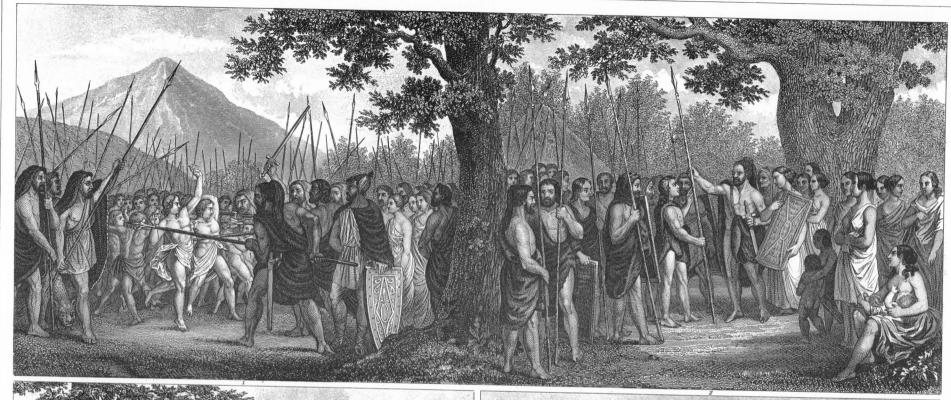

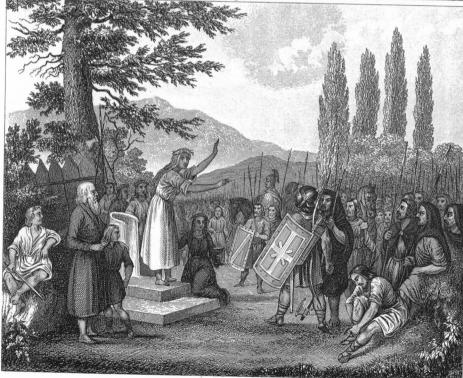

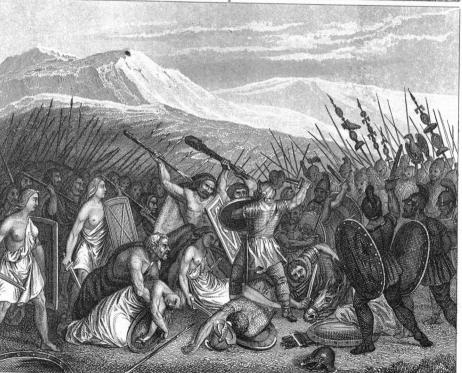

G. Heck dir

Henry Winkles sculpt

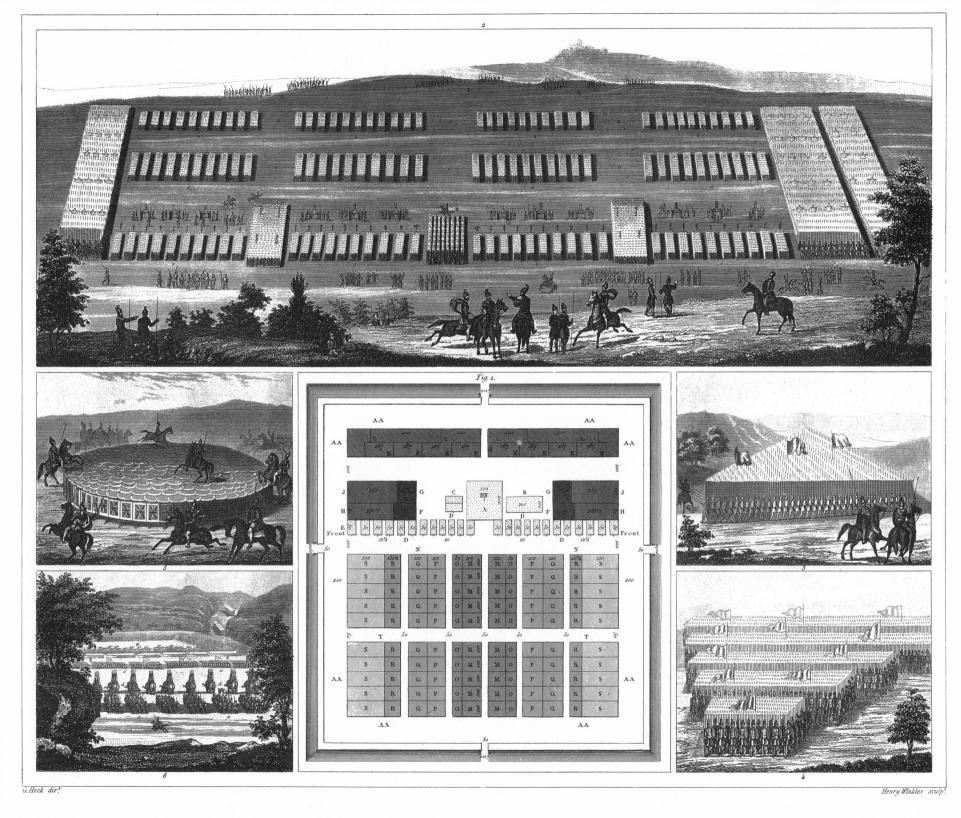

PLATE 279. ROMAN AND CARTHAGINIAN MILITARY FORMATIONS

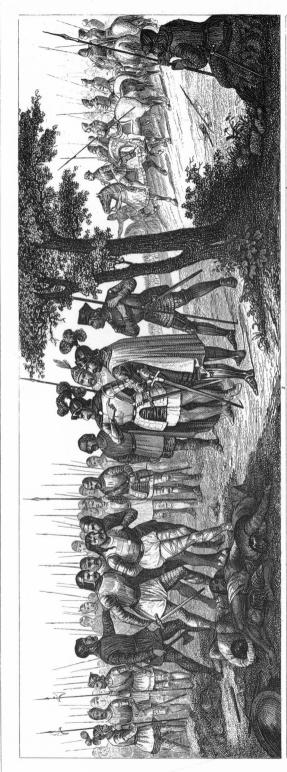

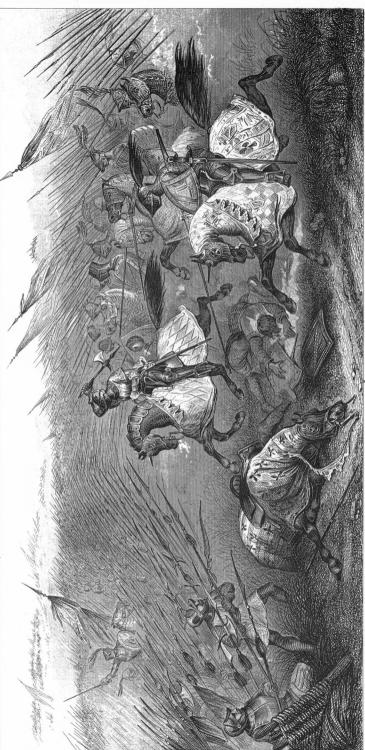

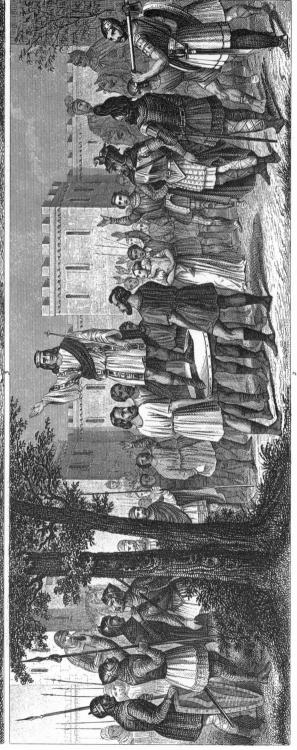

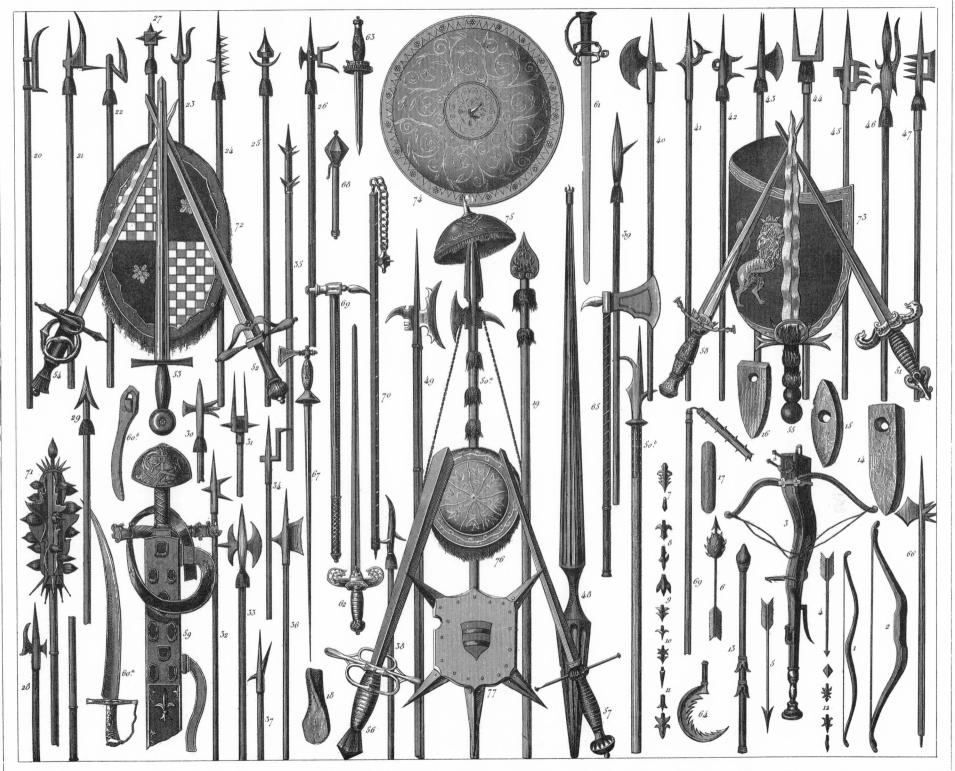

G. Heck dir!

Henry Winkles sculp'

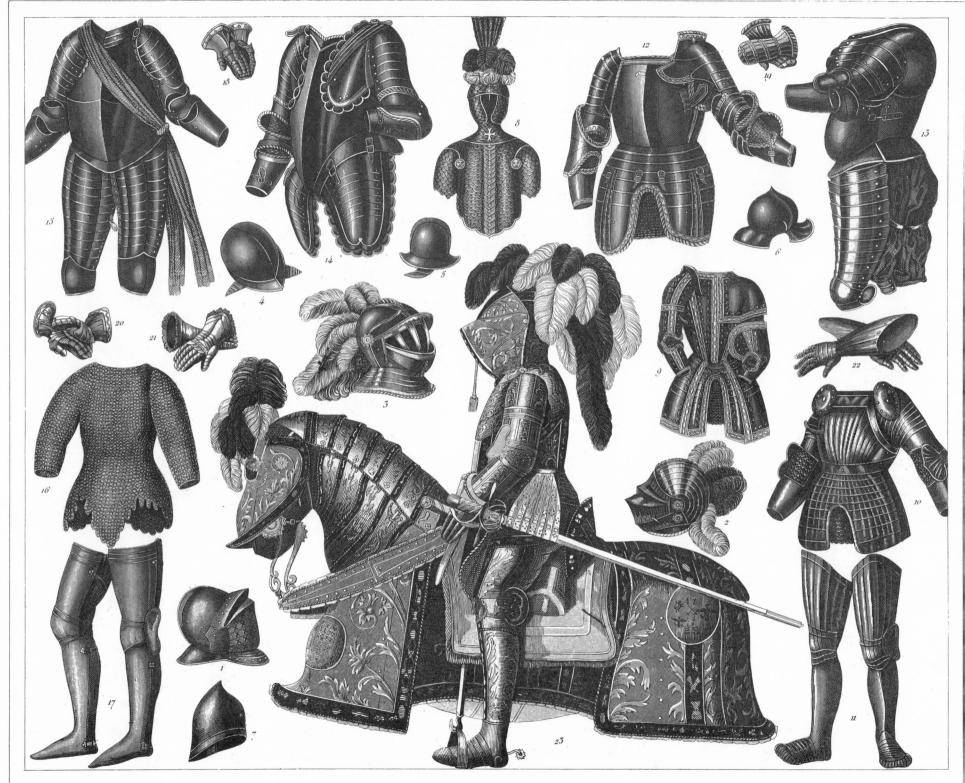

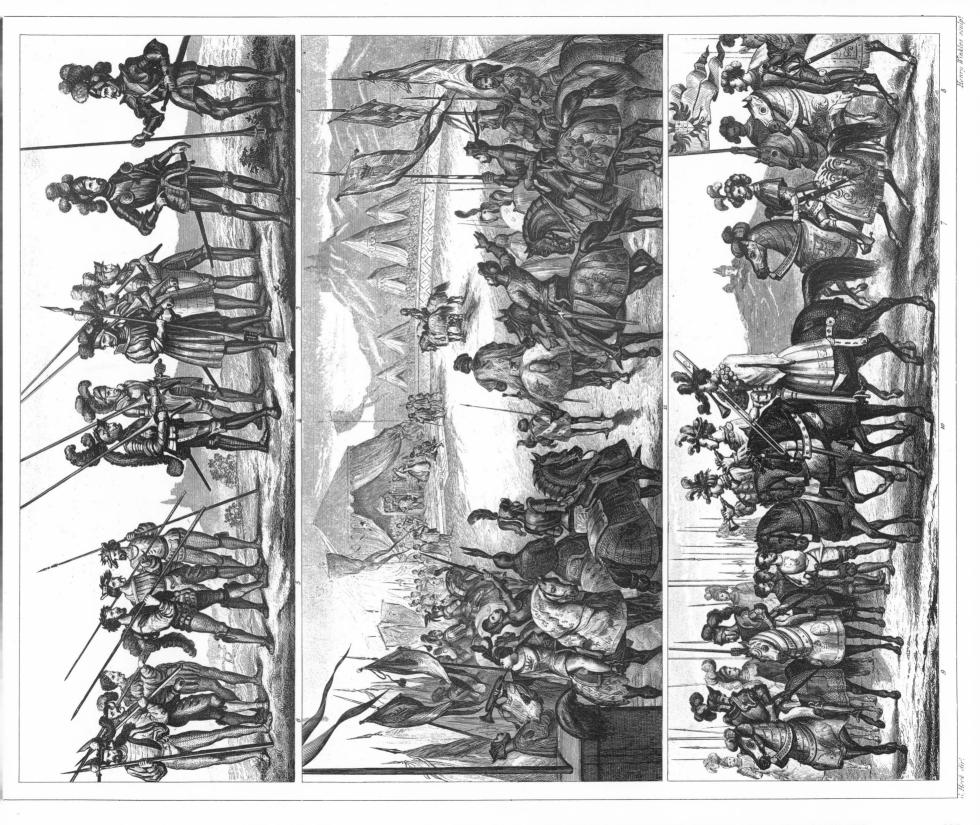

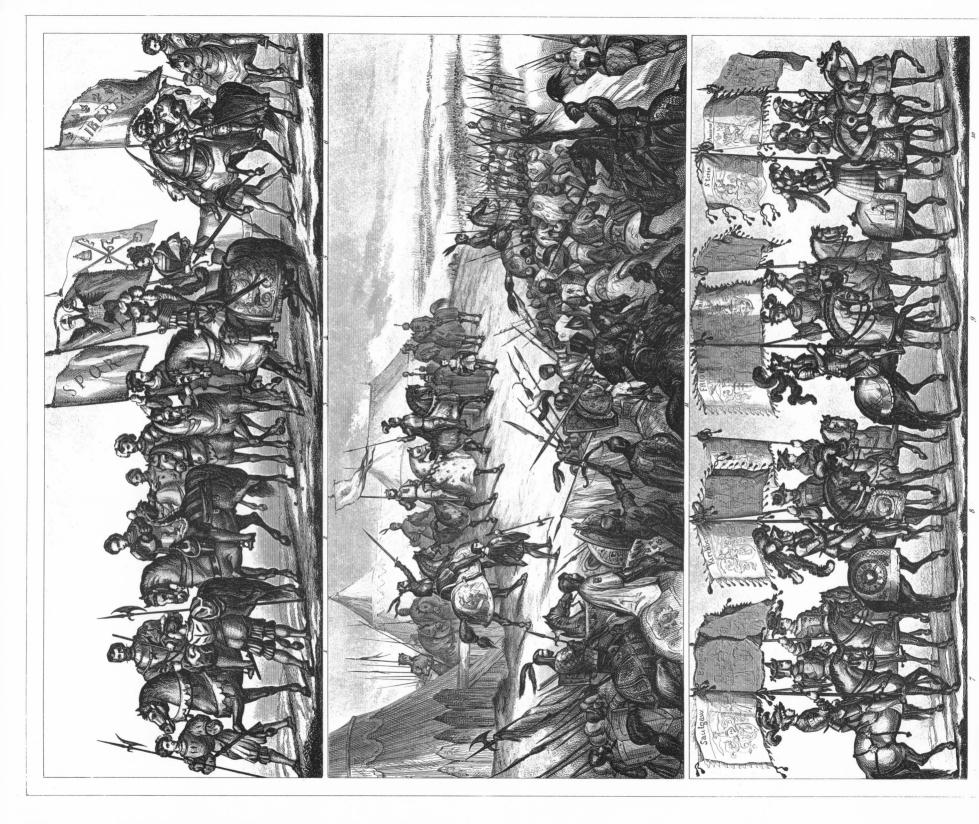

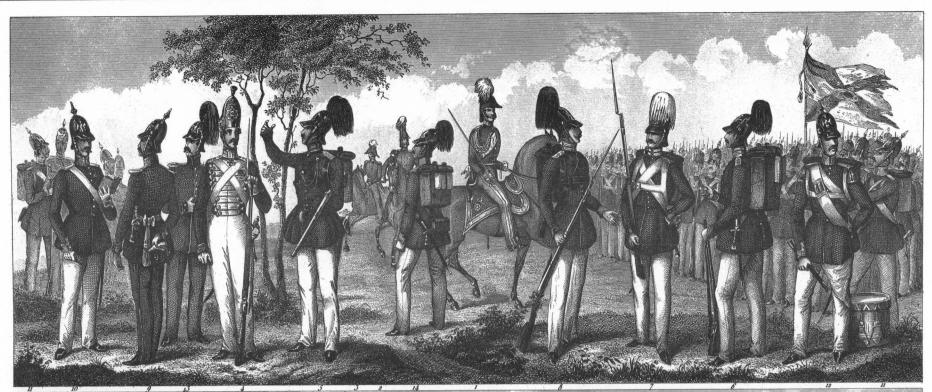

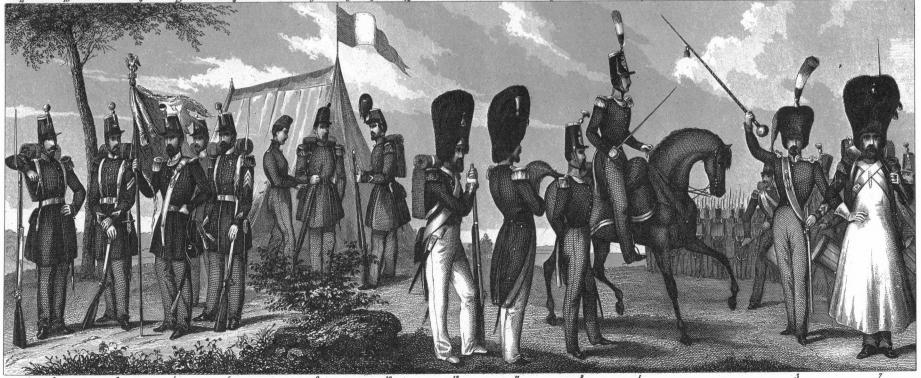

Henry Winkles souls

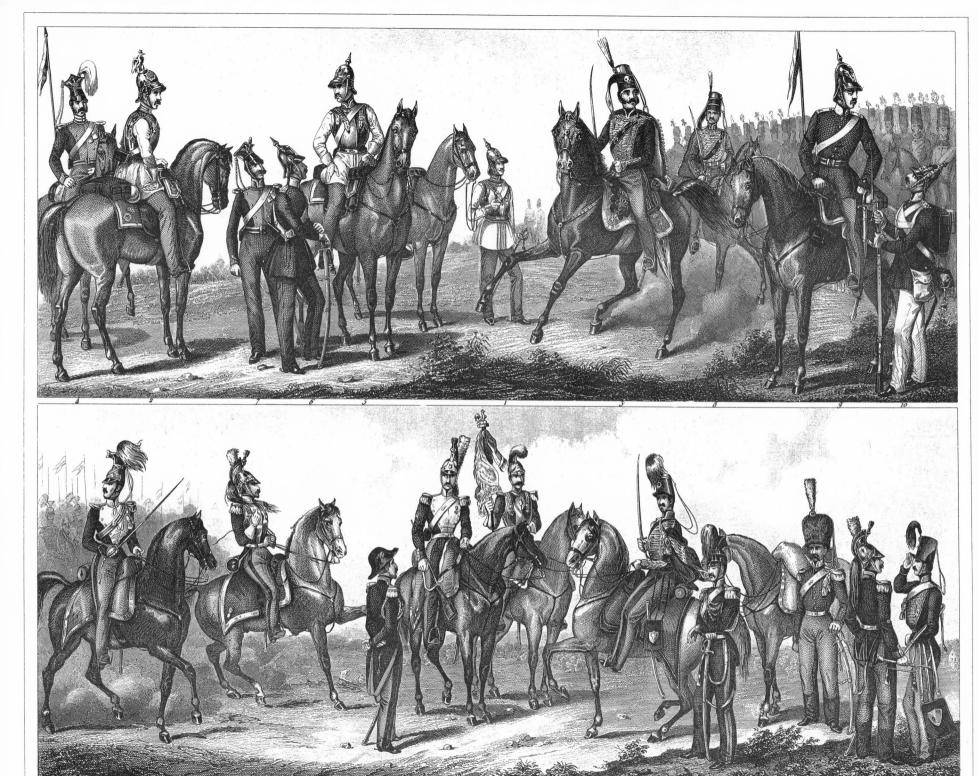

Henry Winkles sculp.t

328

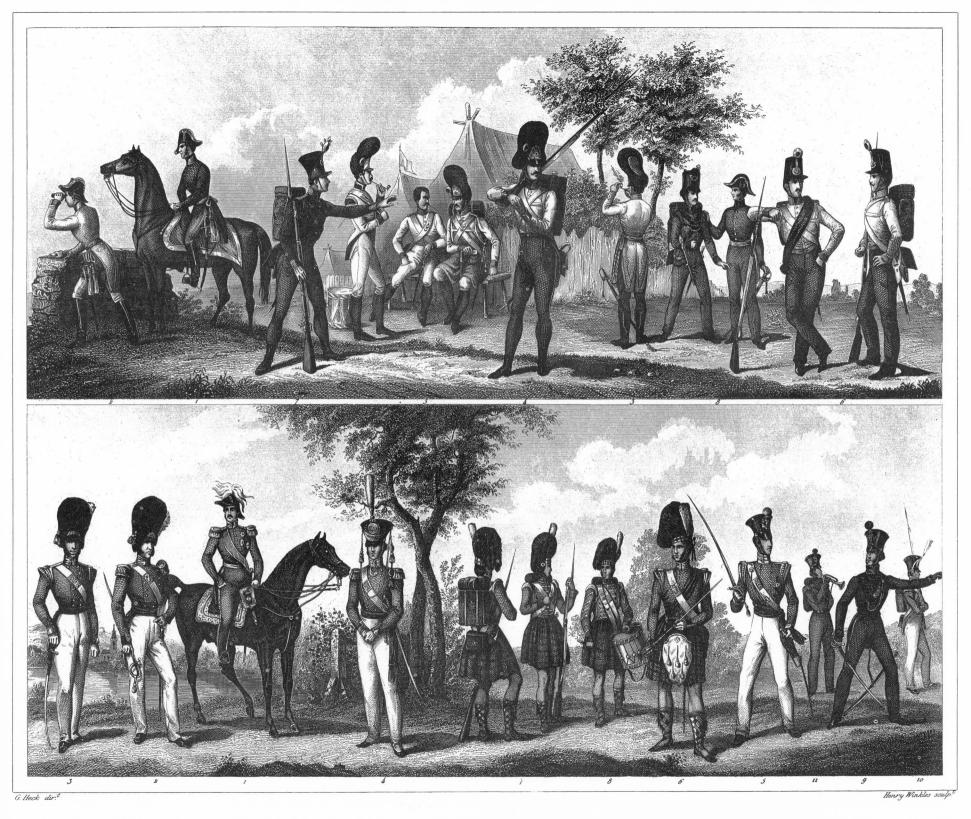

PLATE 287. AUSTRIAN AND BRITISH INFANTRY

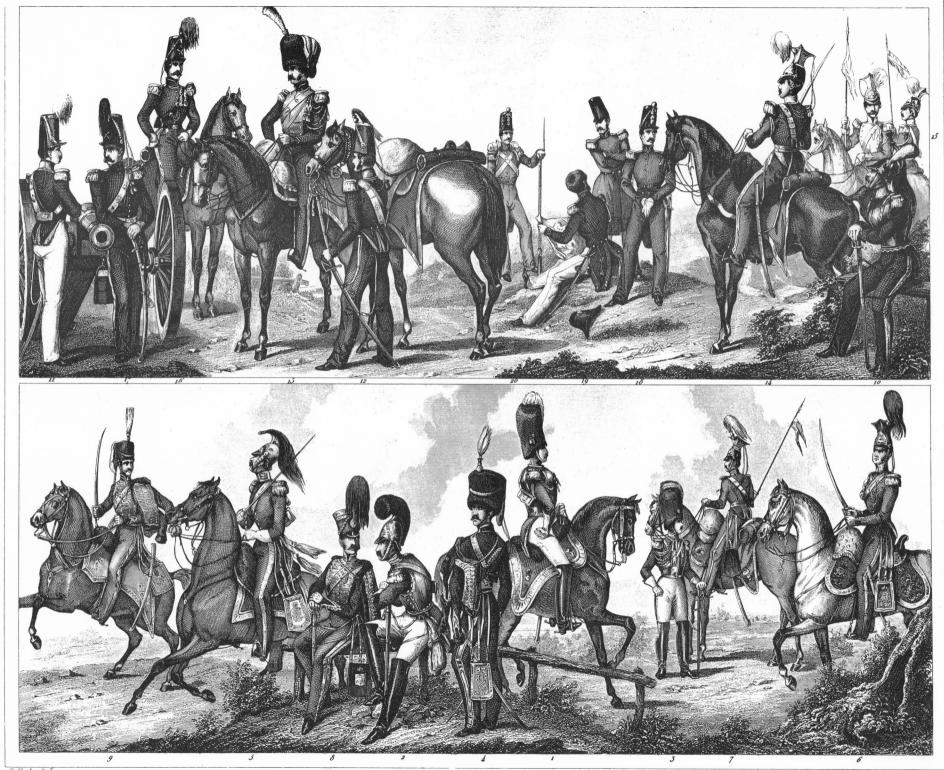

Henry Winkles sculp

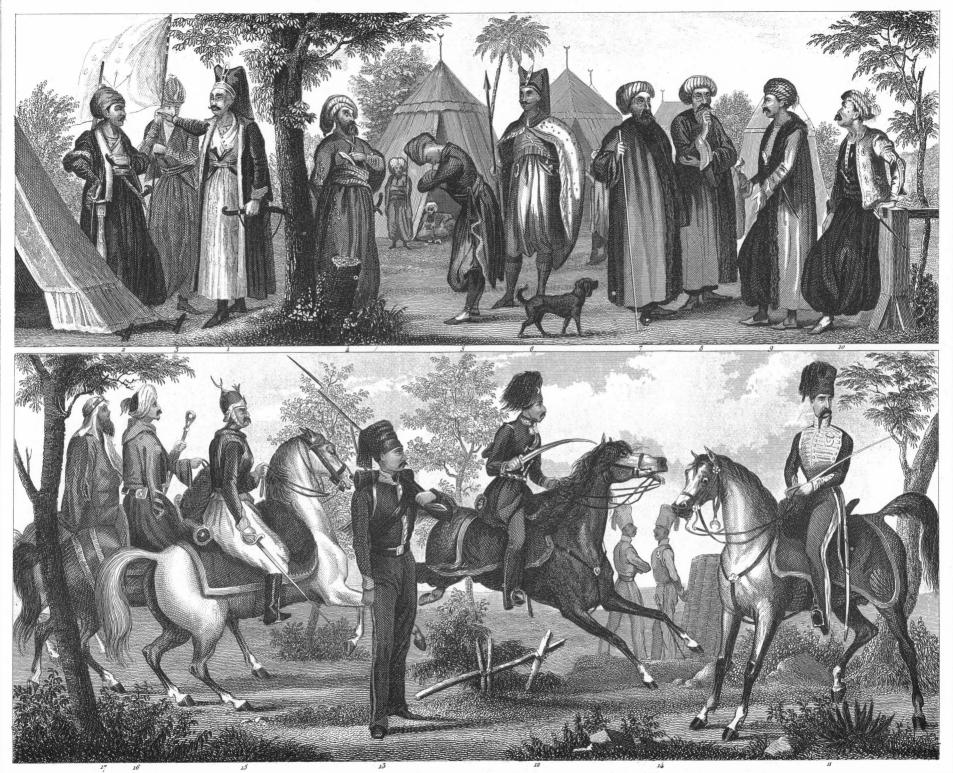

Henry Winkles sculp!

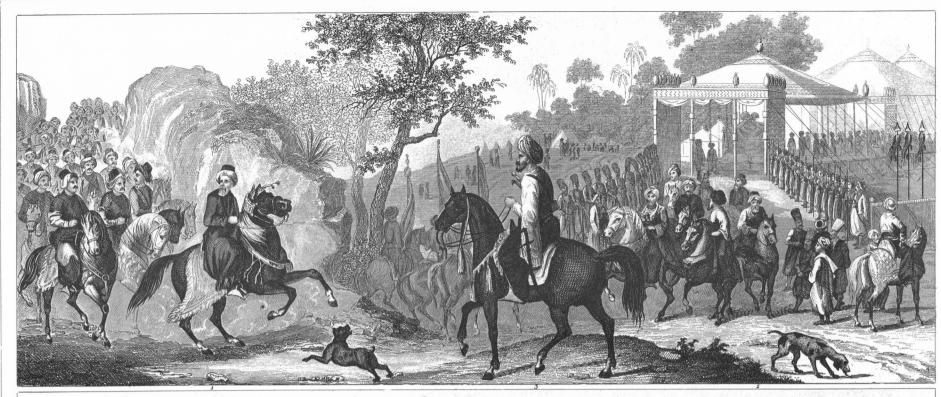

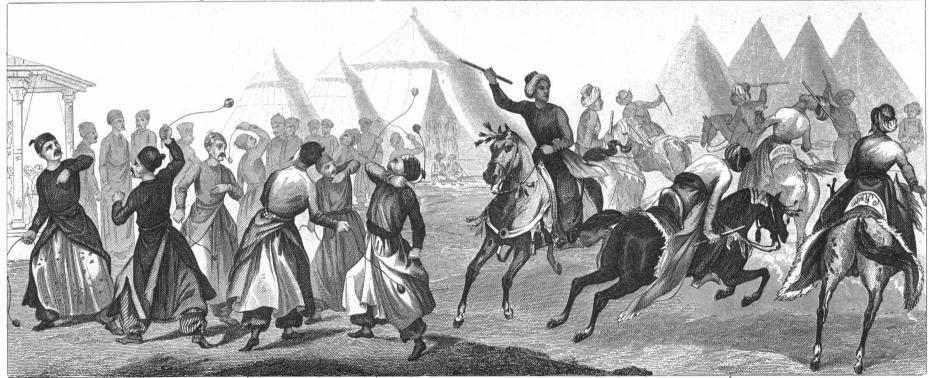

G. Heck dir.

Henry Winkles sculpt

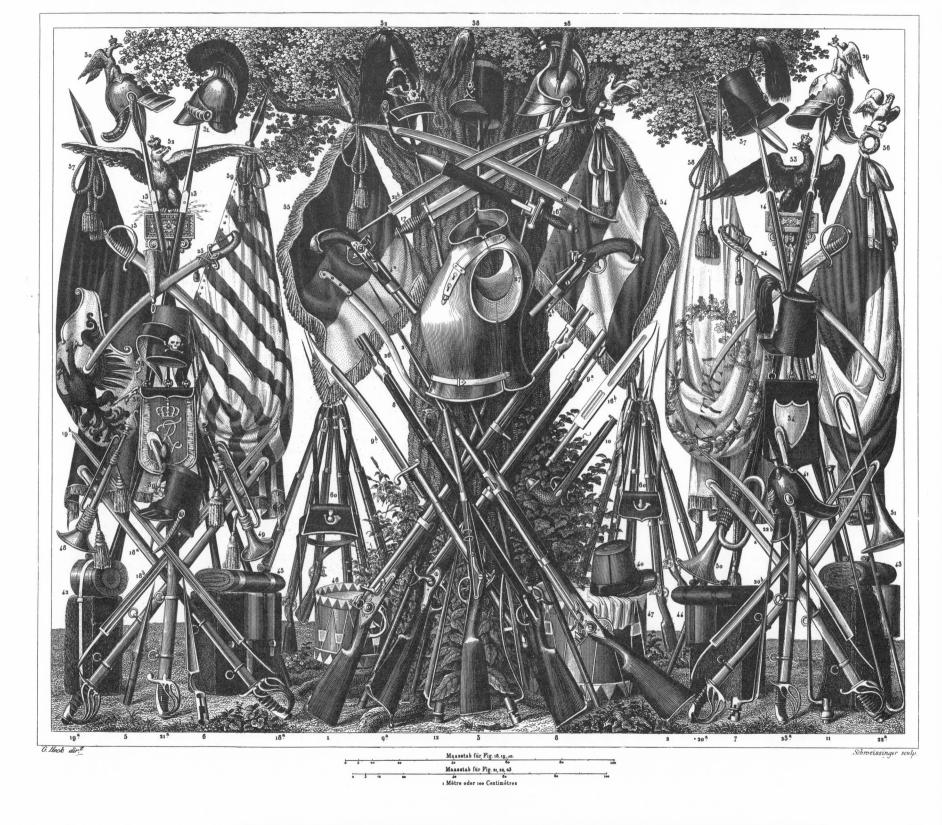

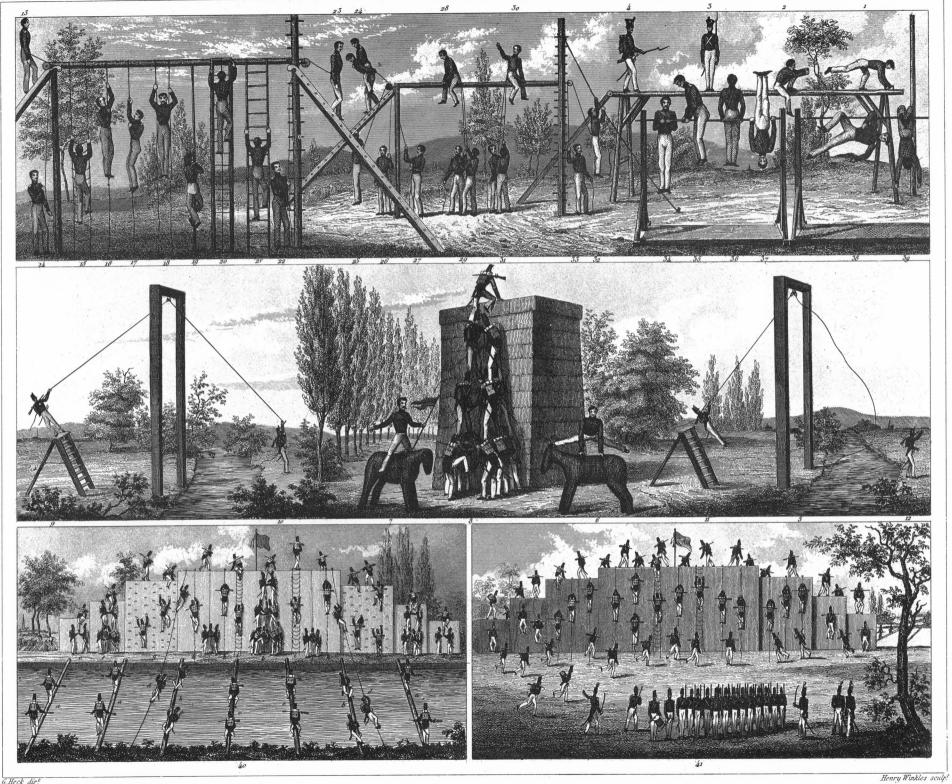

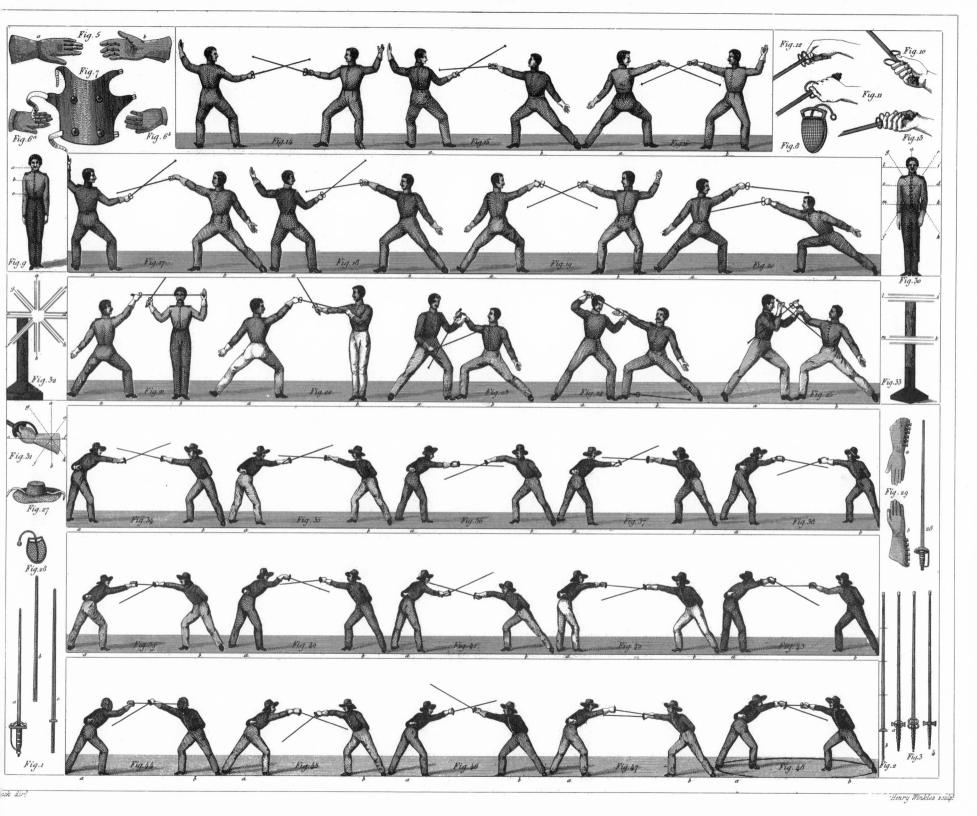

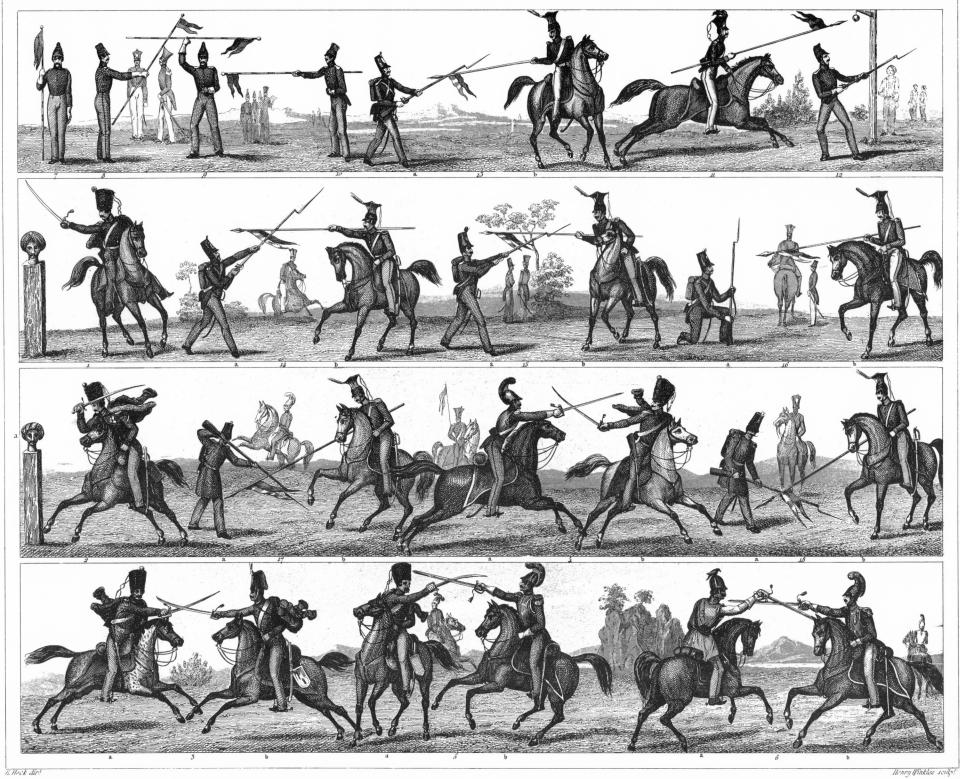

.

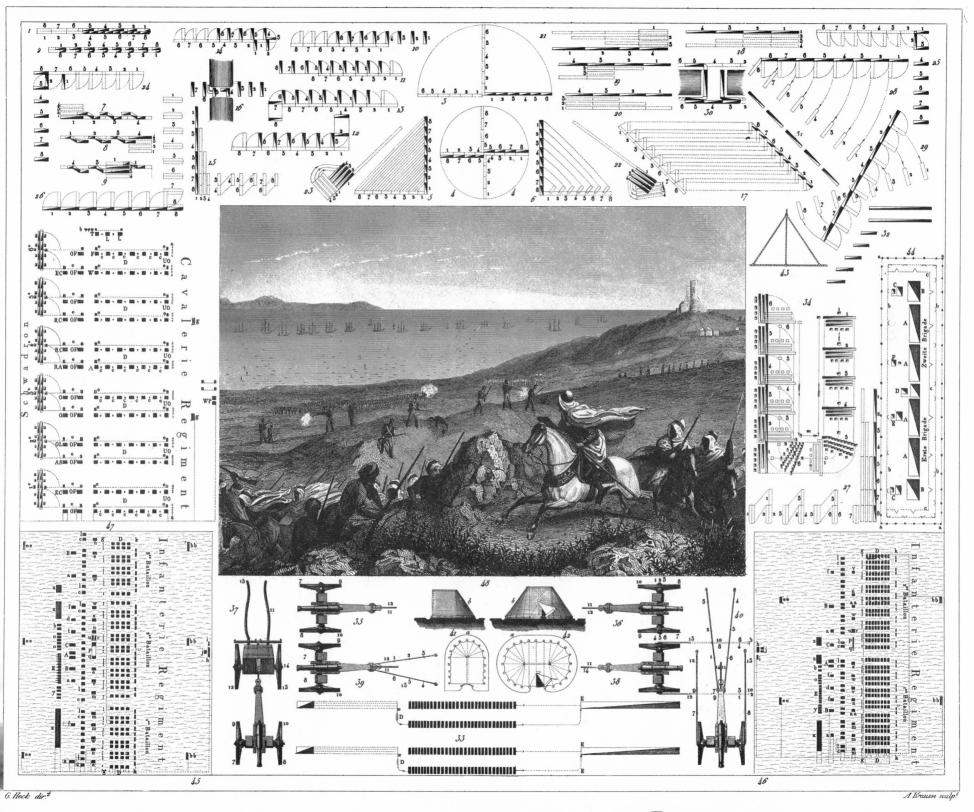

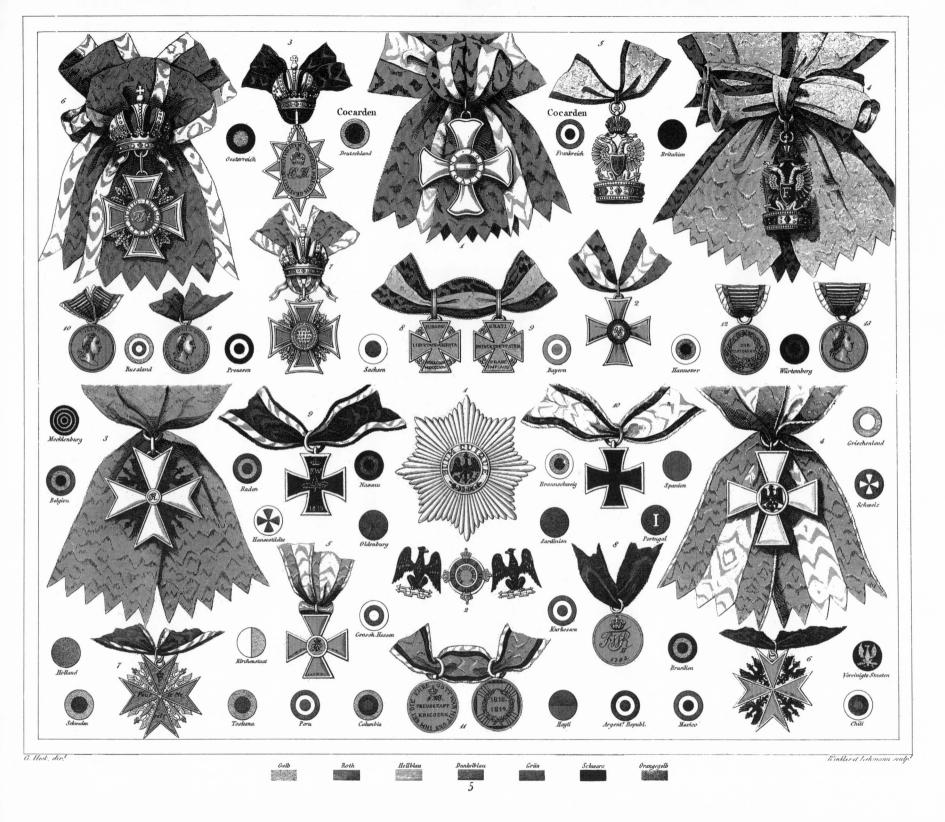

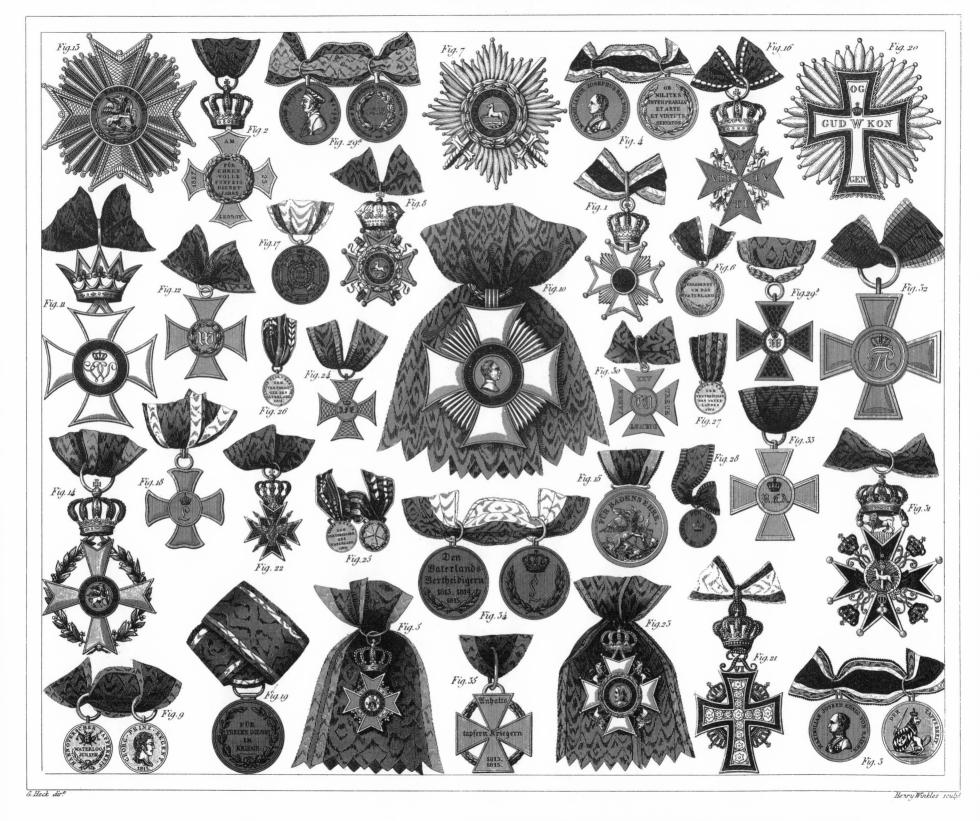

PLATE 297. GERMAN AND DANISH MEDALS AND MILITARY ORDERS

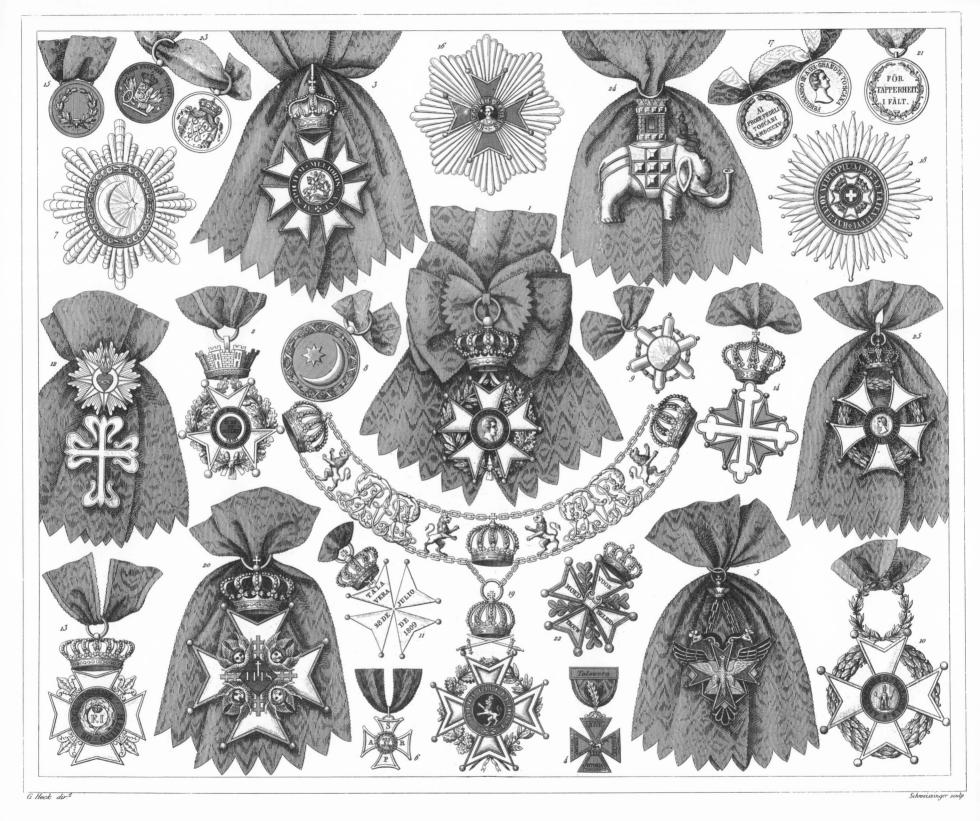

340

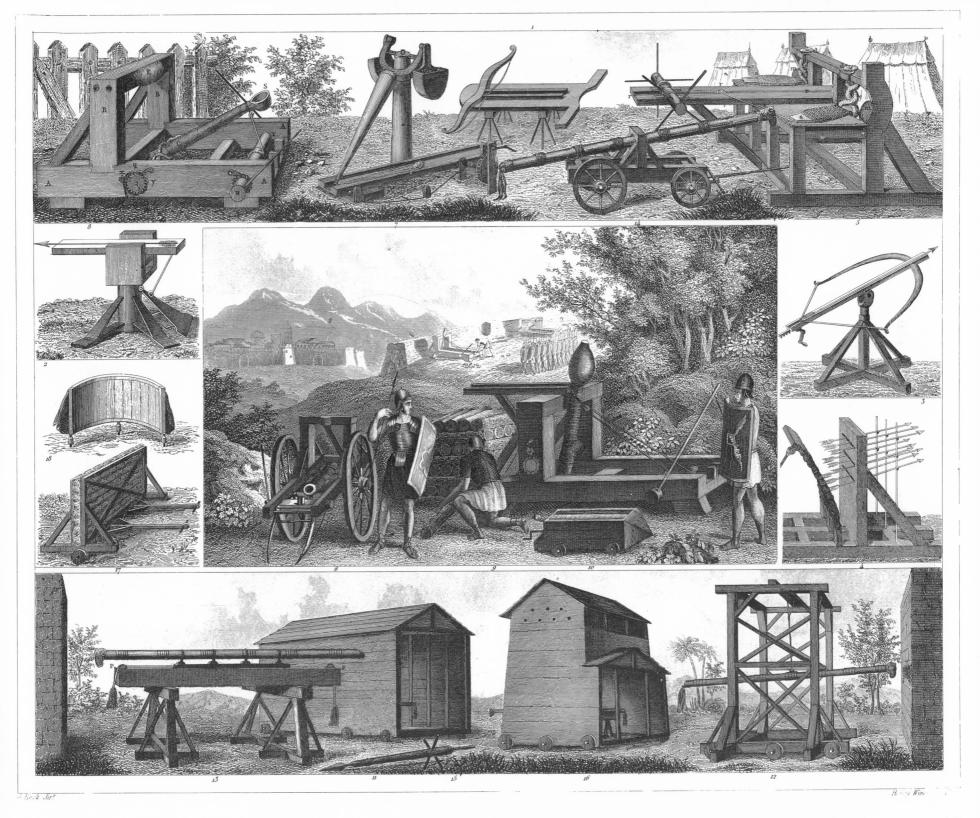

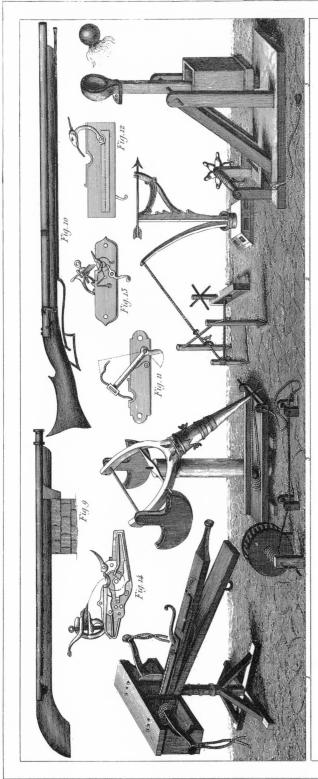

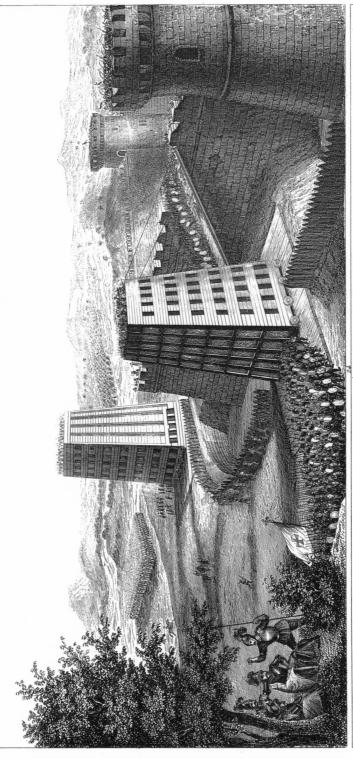

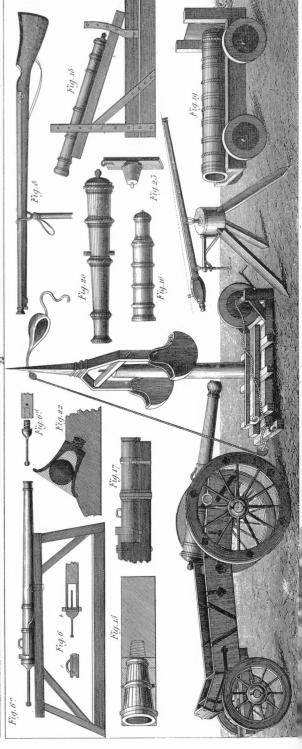

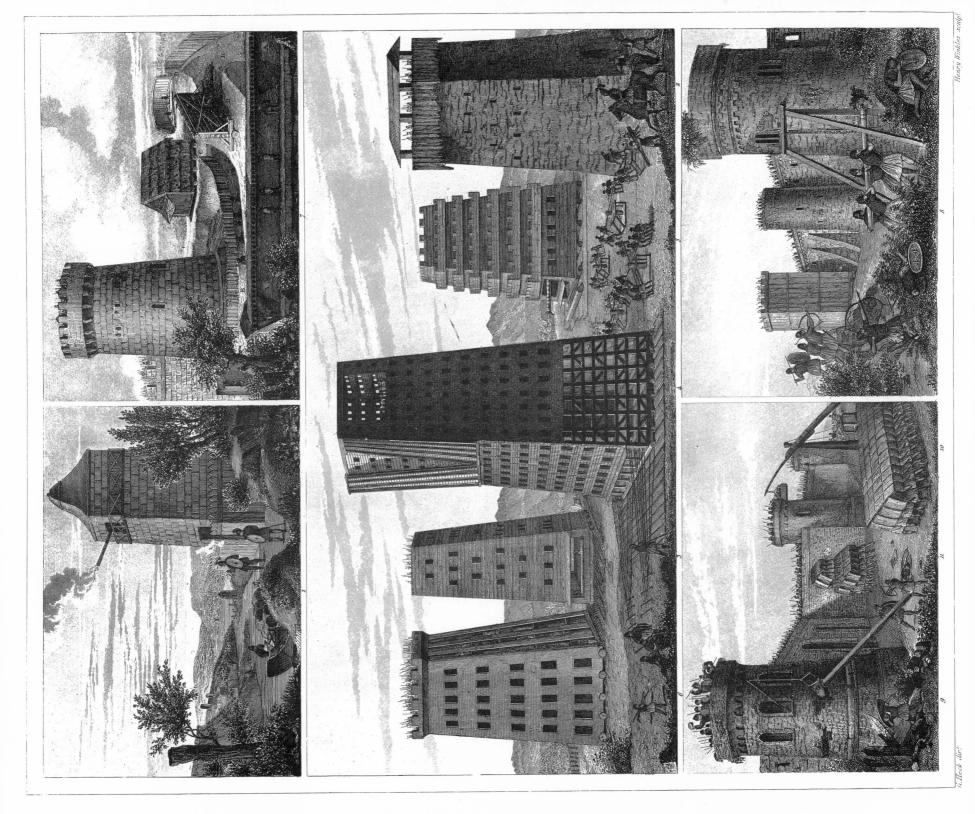

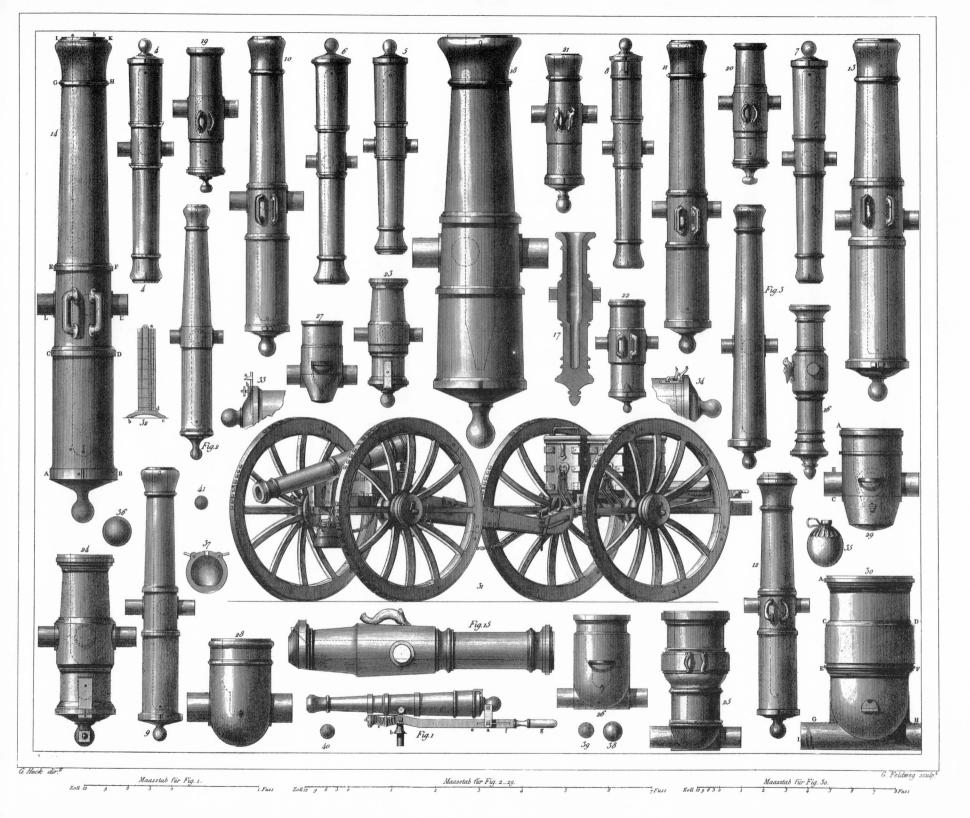

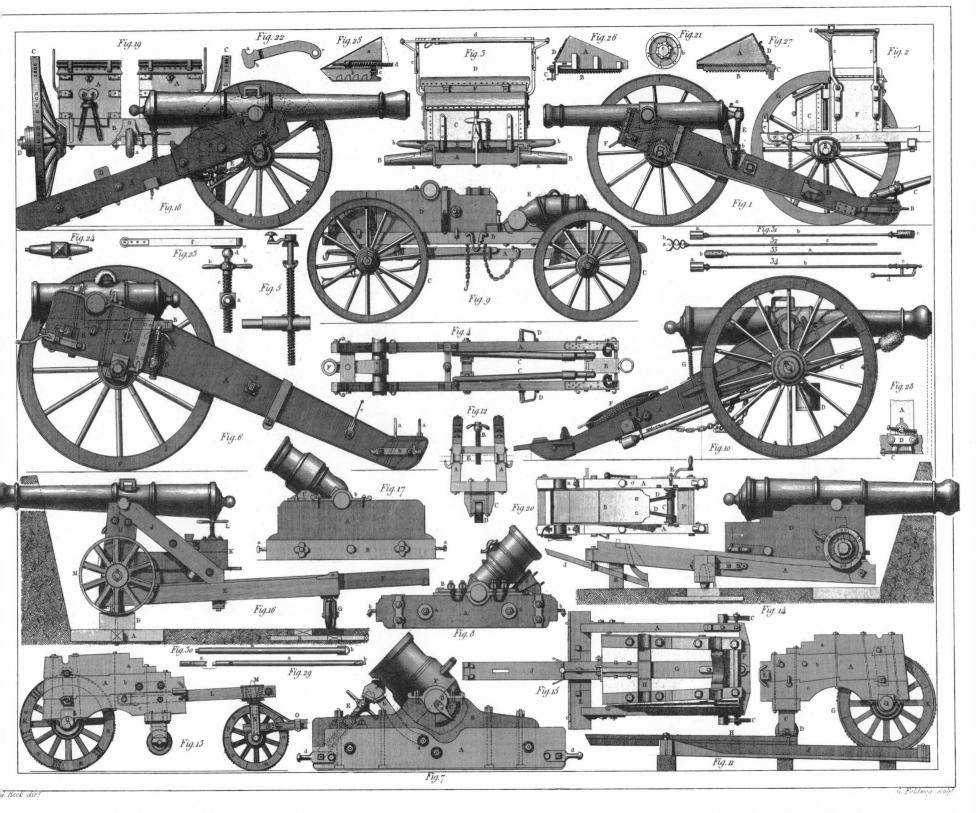

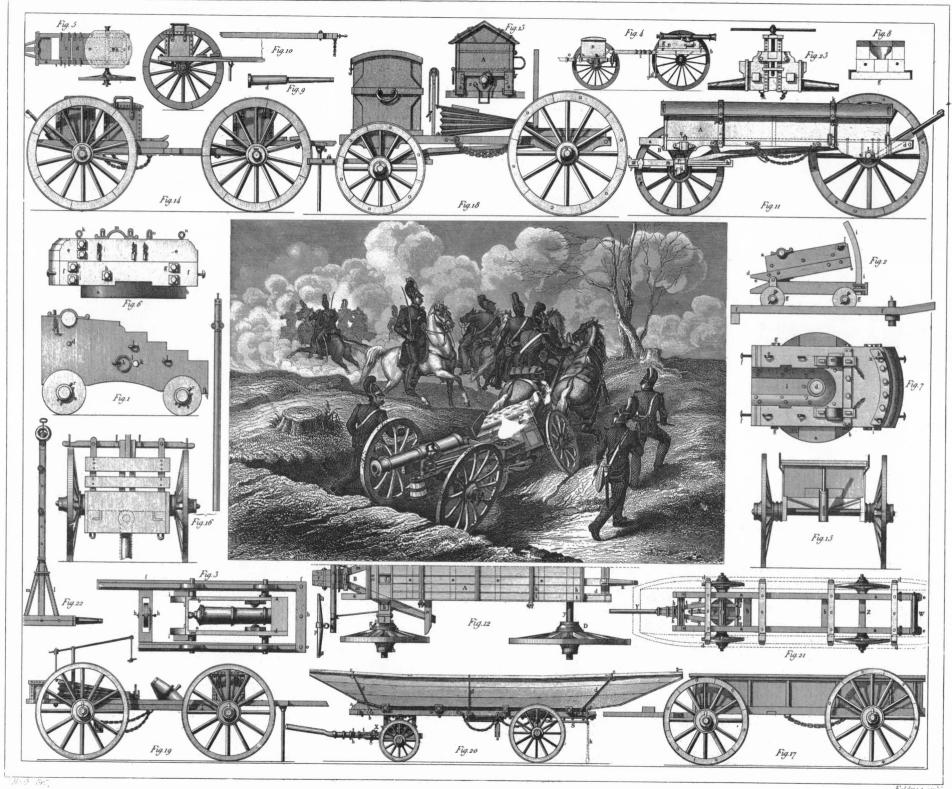

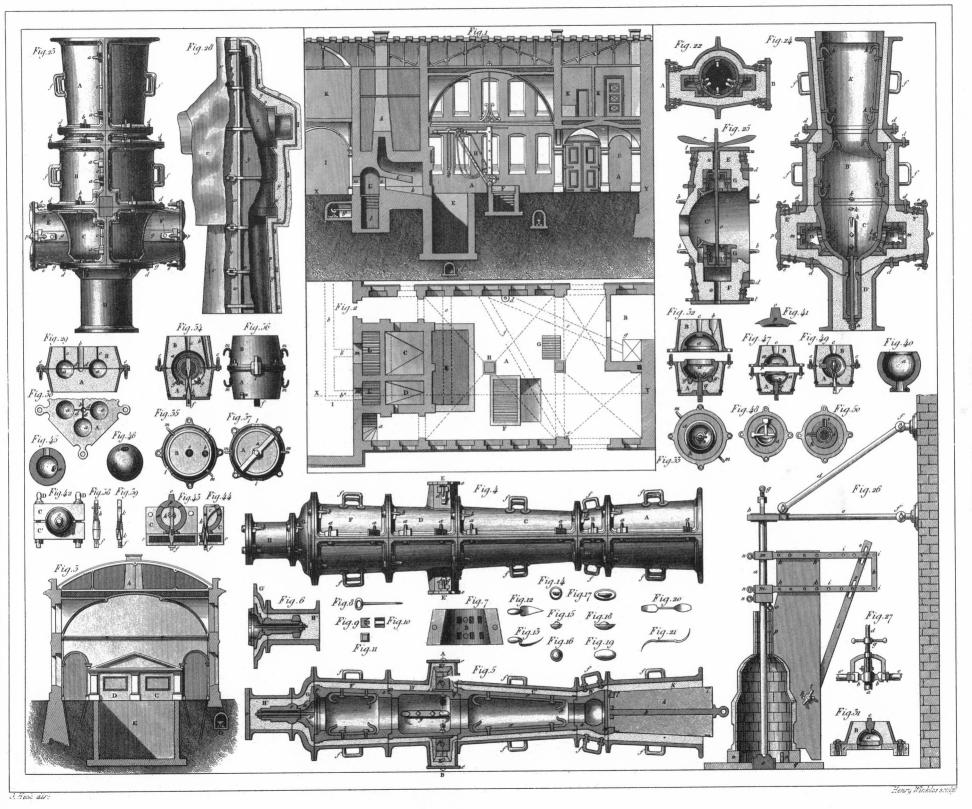

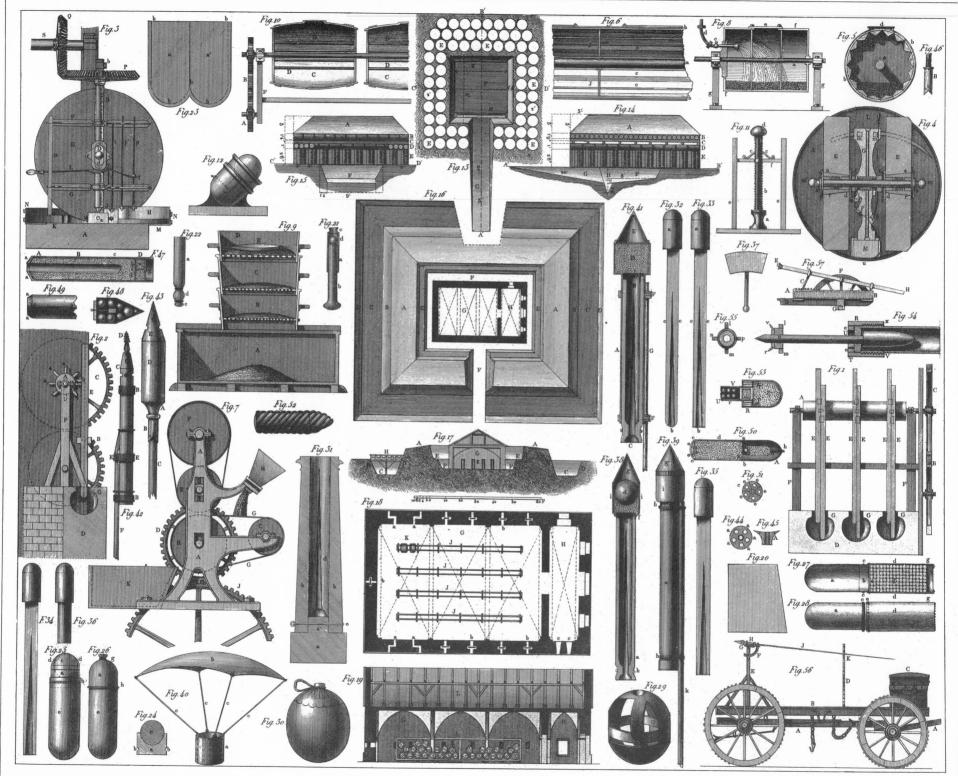

G. Heck dir.

Feldweg sculp

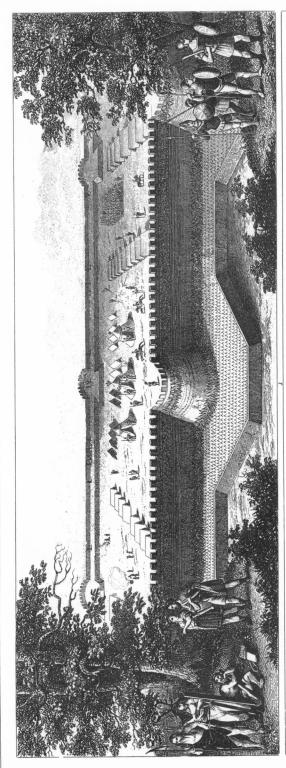

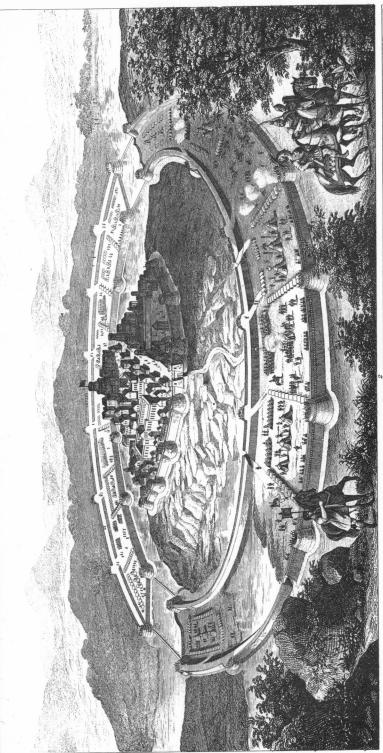

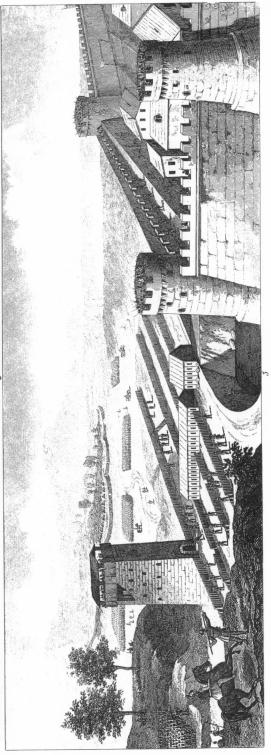

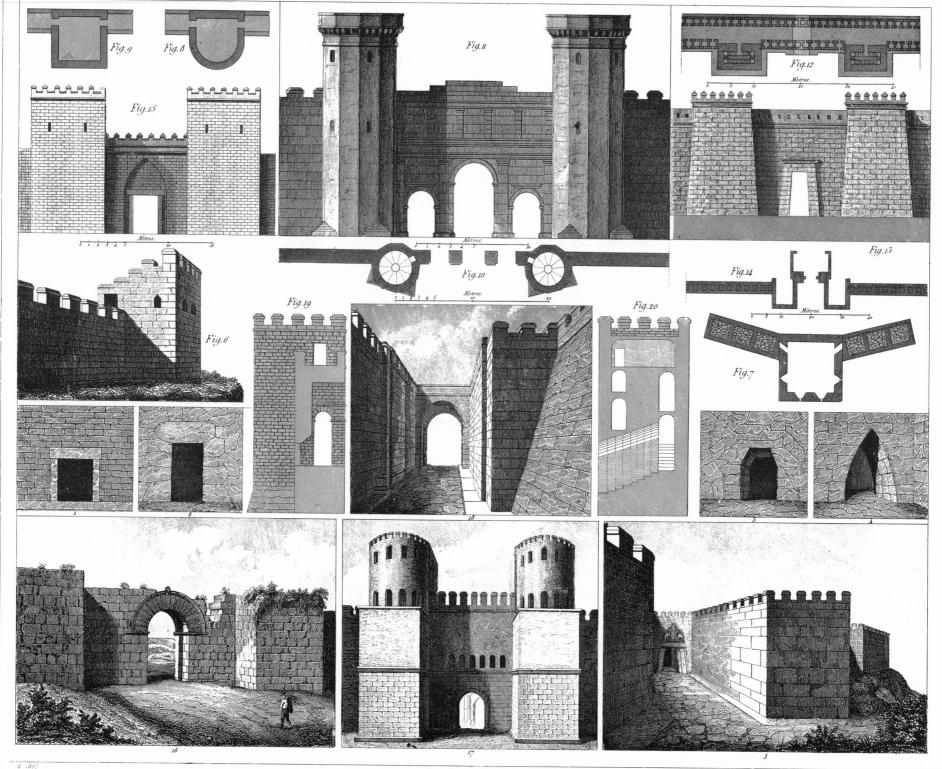

Henry Winkles sculpt

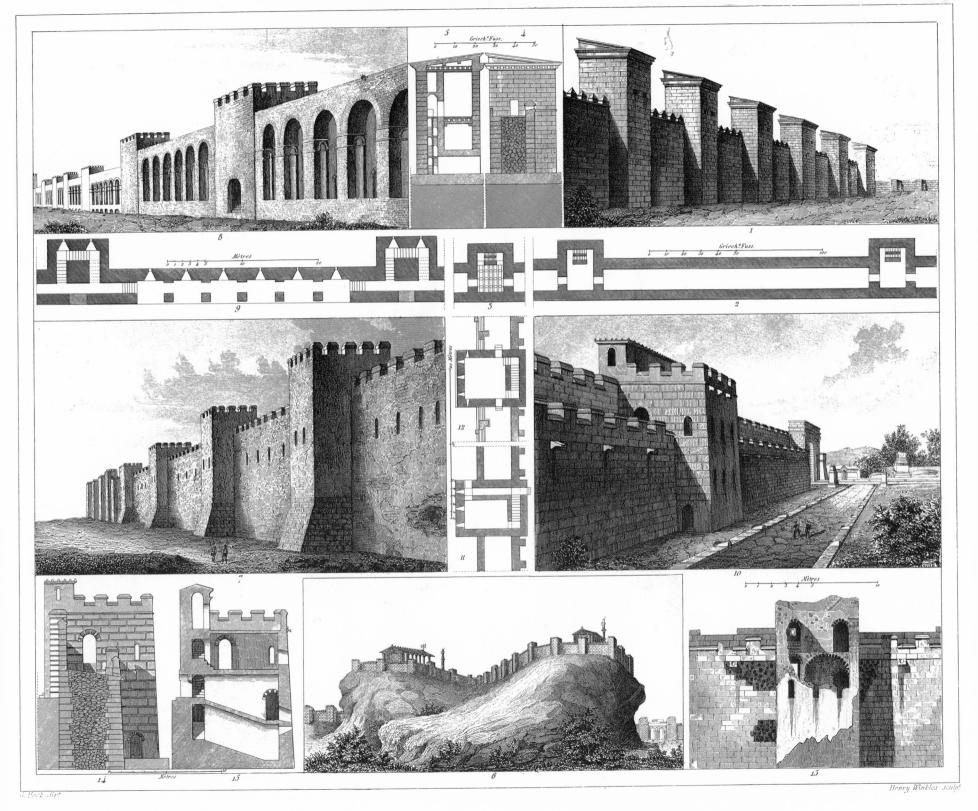

PLATE 309. WALLS OF GREECE AND ROME

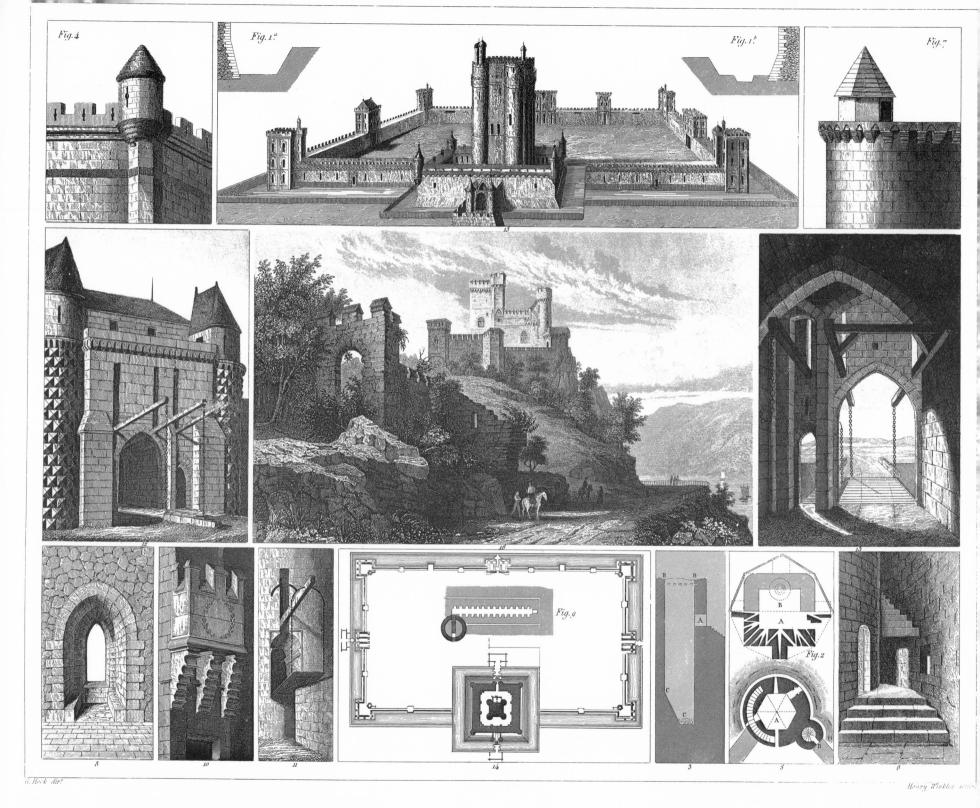

352

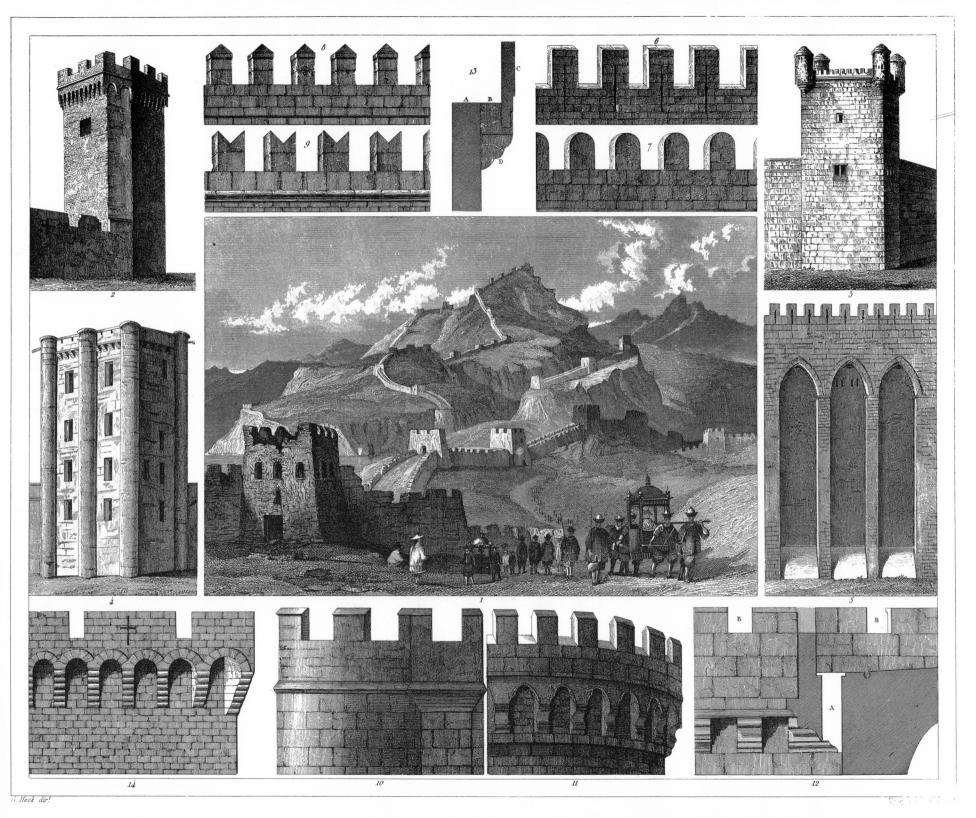

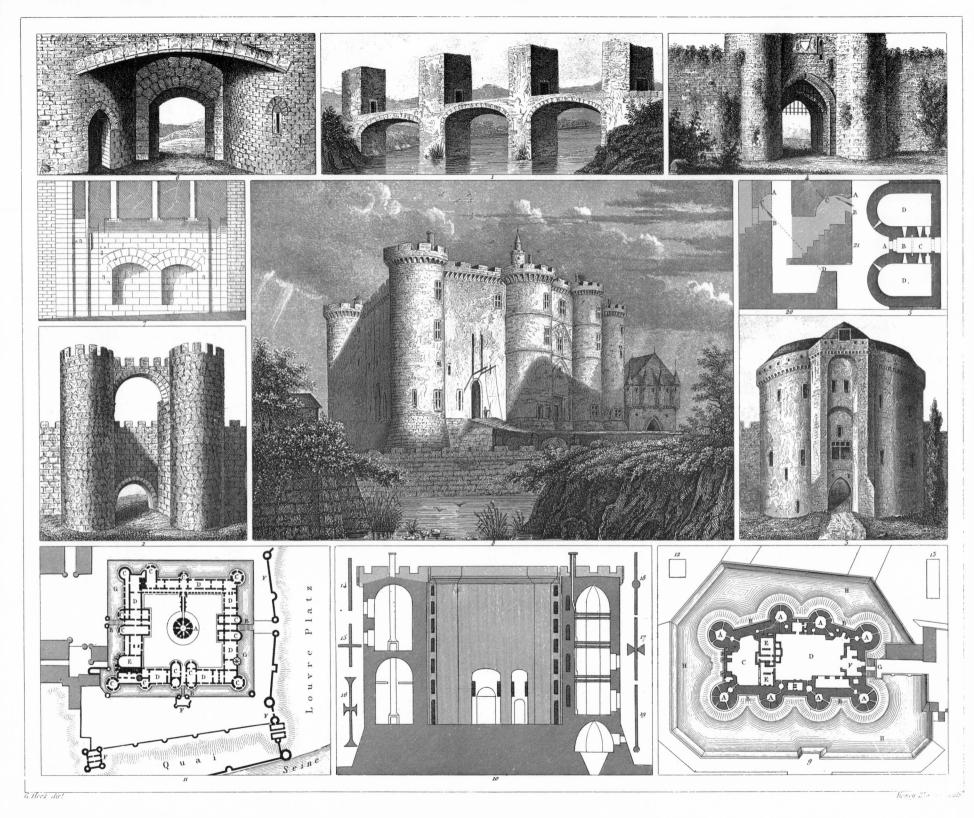

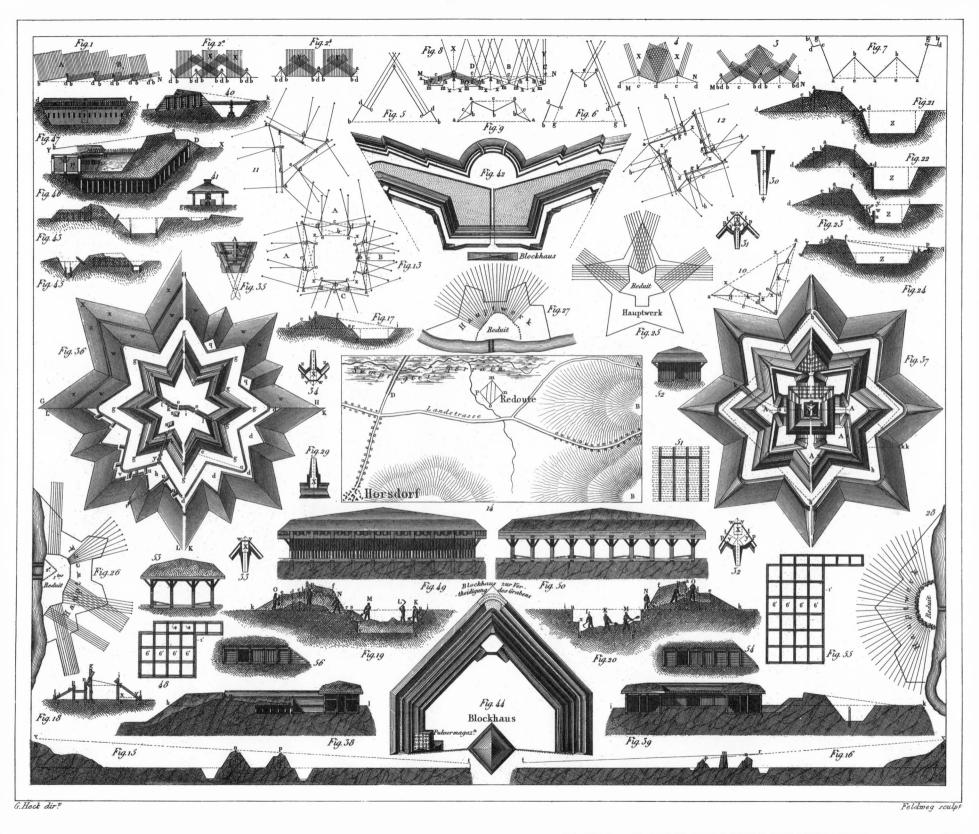

PLATE 313. ILLUSTRATING FIELD FORTIFICATION

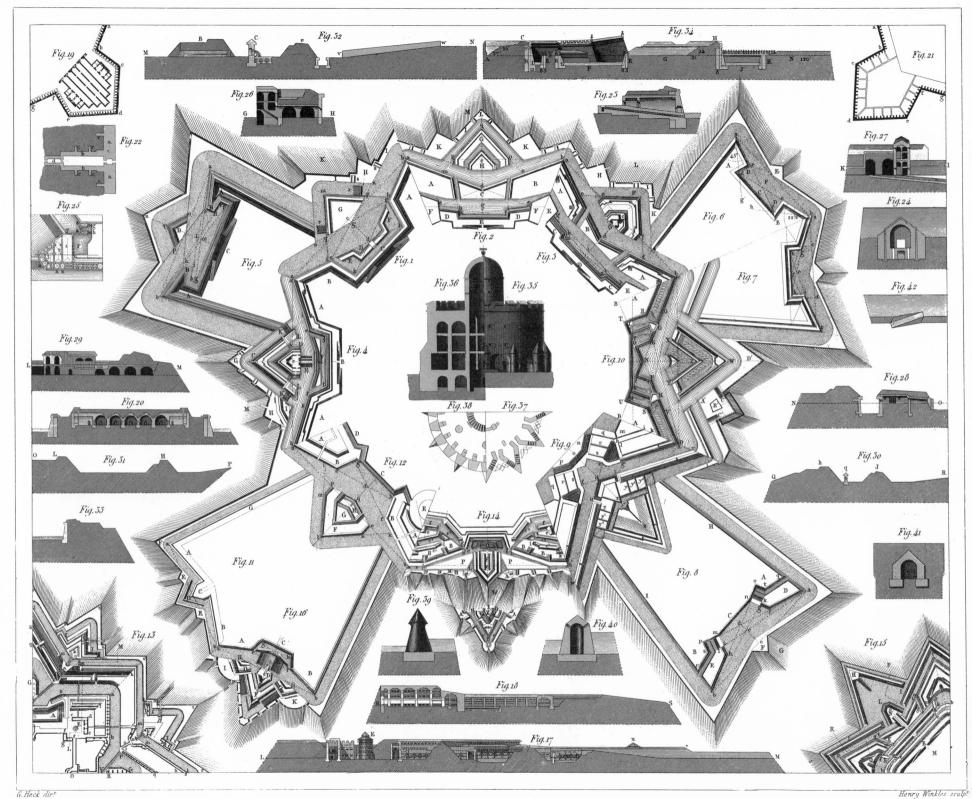

Henry Winkles sculp!

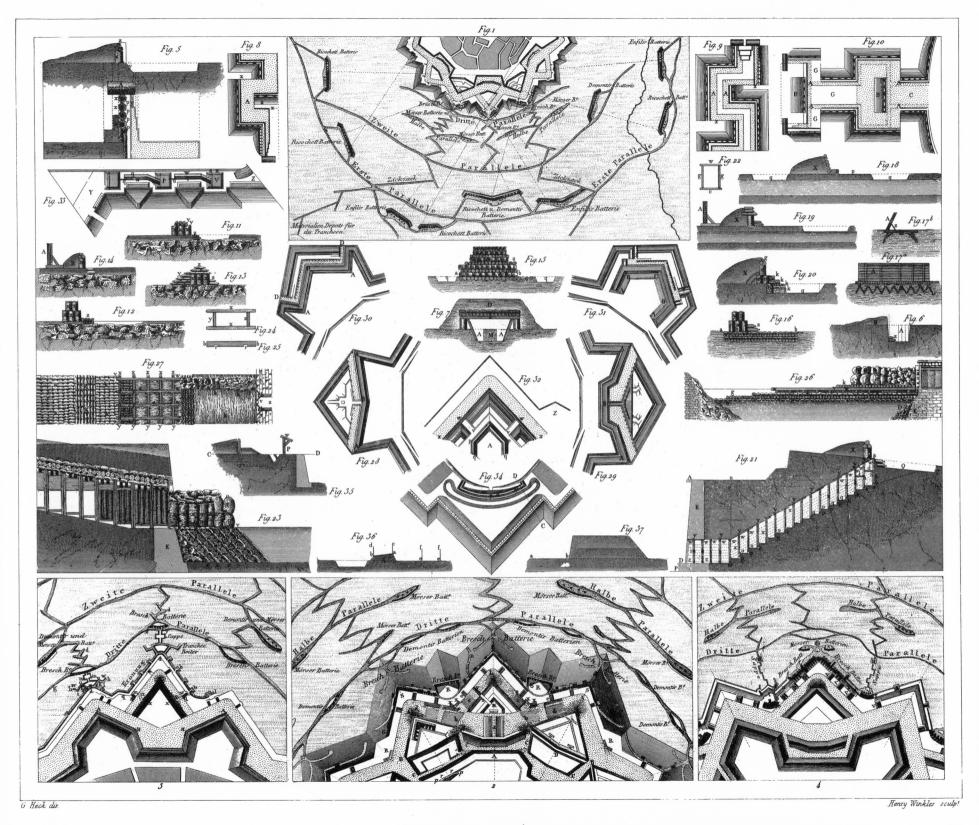

PLATE 315. ILLUSTRATING ATTACK AND DEFENCE OF FORTIFIED PLACES

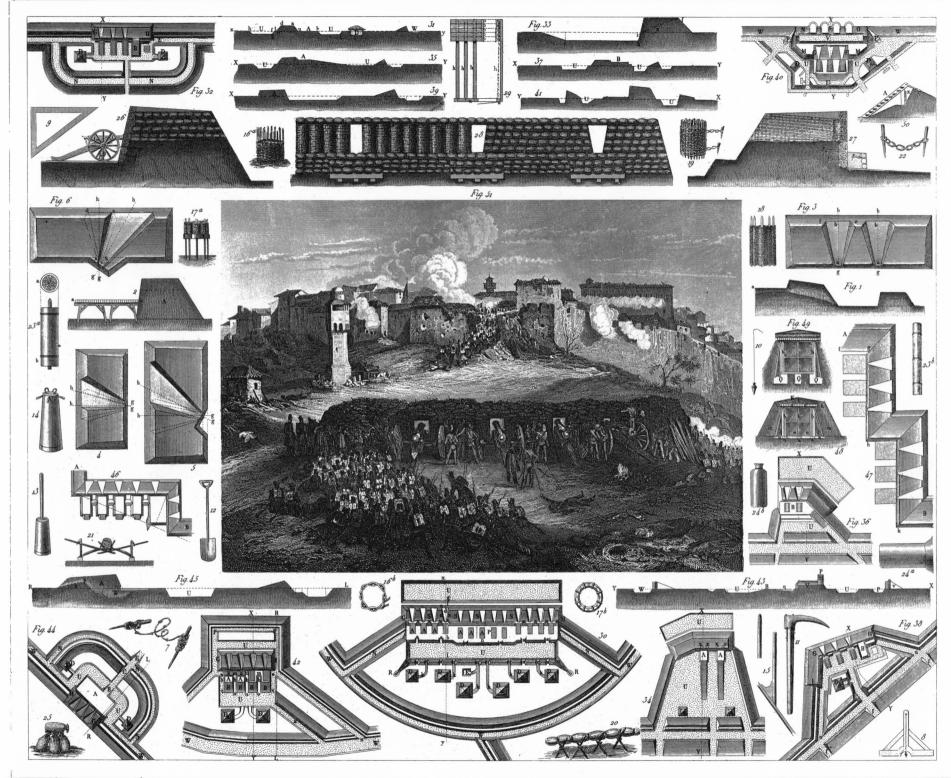

Henry Winkles sculp.t

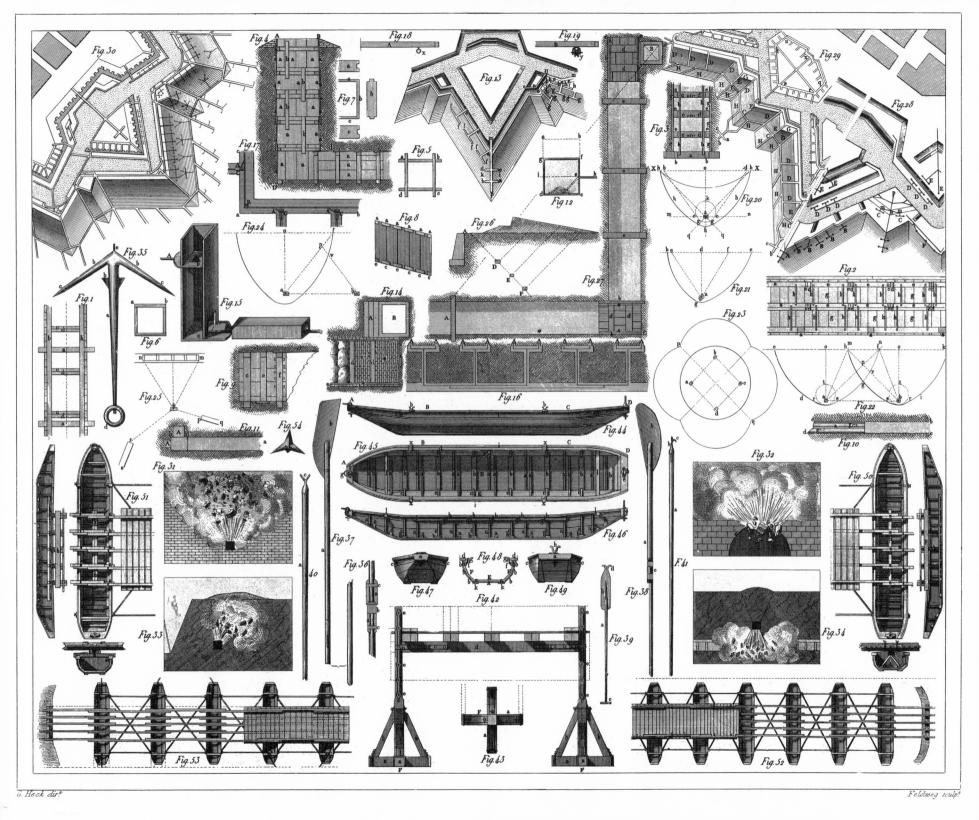

PLATE 317. ILLUSTRATING THE PIONEER AND PONTOON SERVICE

Captions to the Naval Sciences Plates, 318–349

PLATE 318.

Sea Vessels of Ancient Times and the Dark Ages

Figure

1. 2. Phœnician vessels

3. 4. Prows

5. Stern-figure (aplustre)

6, 7. Prow-figures

8. Hiero's show-ship

Vessel used in the Roman

Naumachia

10. Ship with a tower

11-14. Roman vessels of war

15. Norman vessel of war

16. Roman sea-fight

PLATE 319.

Ancient Vessels and Naval Trappings; A Roman Naval Spectacle

1. Egyptian boat

2. Phœnician vessel

3. 4. Greek vessels

5, 6. Greek vessels

7. Roman vessel

Greek prow

9. Egyptian vessel

10. Cleopatra's show-ship

11. Ptolemy's show-ship

12. Roman Naumachia

13, 14, Anchors

15. Rudder

16. Oar

17. Oar-holes

18. Prow

19. Lighthouse

19 a-d. Ground-plans of the lighthouse

20-24. Coins showing

lighthouses

25. Naval column

PLATE 320.

Ships of Several Nations

1. French vessel of the 16th century

Genoese prow

3. Spanish ship of war

The Sovereign of the Seas

5. Soleil royal

6. Venetian galley

The ship Ocean

PLATE 321. Ships of Europe

Figure

Portuguese carac

The Great Harry

Stern of a ship

French galley

Observatory

Lighthouse 7, 8. French cutters

9. English cutter

10. Bomb ketch

11. Felucca

PLATE 322.

Ships of the Orient

Figure

European factory at Canton

Chinese war penish

The same under sail

4. 5. Chinese coasters

6, 7. Chinese gondolas

Chinese junk

Coaster of the Maldives

10. Malay coaster

11. Malay anchor

12, 13. Malacca vessels

14. Java vessel

PLATE 323.

Ships of the Far East and the **Pacific**

Figure

1. Macao vessel

Chinese coaster

Malacca vessel

4, 5. Vessels of the Moluccas

6. Java coaster

7, 8. Vessels of the Coromandel coast

9, 10. Manilla coasters

11, 12. Coasters of the Philippine islands

13. 14. Coasters of Celebes

PLATE 324.

Illustrating the Theory of Shipbuilding

Figures 1-33.

PLATE 325.

Construction and Maintenance of a Ship

Figure

1. Ship of the line on the stocks

2. Launch of a ship of the line

Caulking of a vessel

Graving of a vessel

Rope-walk

Sail bench

PLATE 326. Basic Structure of a Ship

Figure

1. Longitudinal section of a ship of the line

2. Transverse section of the same

3. Iron knee

Construction of a ship's stern

5. Construction of deck

6-25. Illustrating Seppings's system of ship-building

26. A capstan

27. Longitudinal section of a ship of the line, showing its interior arrangement

PLATE 327.

Various Views and Equipment of a Ship

Figure

1. View from above of the lower gun deck

View from above of the upper deck

French frigate

Topsail-yard and topgallant sail

5, 6. Fore-and-aft sails

7. A vane

8, 9. Pennants

10. A ship's pump

11. A windlass

12. 13. Details of the same

14-29. Anchors

30. Splicing cables

31, 32. Anchor-buovs

33. Mushroom anchor

PLATE 328.

French Ship of the Line and **Equipment**

Figure

1. French ship of the line, showing the outfit of a ship

Normandy fishing-smack

Mainyard with its jeers

Upper part of a mainmast 5, 6. Caps

Dead-eyes

Tackle with runner Winding tackle in threefold blocks

10-16. Various blocks and dead-eves

17. 18. Pitch ladles

19. Axe

20. Pole-axe

21. Scraper

22. Double scraper

23. Horse-bait

24. Adze

25. Hatchet 26, 27. Caulking tools

28, 29. Trucks

30. Knobbed rope 31, 32ab. Caulking mallets

33. Tar brush

34. Callipers

35-40. Implements for serving

41-49. Various kinds of shot

PLATE 329.

Various Views of French Ships

Figure

1. Main forward deck of a

French ship of the line

2. The after-deck

3. Lengthwise view of a French two-decker, with a portion of the planking removed

PLATE 330. Flags of Various Nations

(The colors of the flags are indicated by the different lines and dots marked at the foot of the plate: Gelb meaning yellow; Roth, red; Hellblau, light blue; Dunkelblau, dark blue; Schwarz, black; Hellgrün, light green; Dunkelgrün, dark green: Purpur. purple: Braun. brown.)

Figure

1. Kingdom of Great Britain

2. Kingdom of France under L. Philippe

3. Empire of Russia

Empire of Austria

Kingdom of Spain Kingdom of Portugal

Kingdom of Holland Kingdom of Sweden and

Norway Kingdom of Prussia

10. Kingdom of Denmark

11. Kingdom of Naples 12. Kingdom of Hanover

13. British red flag 14. British white flag

15. British blue flag 16. British admiralty's flag

17. British admiral's flag 18. East India Company's flag

19. Republic of the Ionian islands

20. Maltese flag 21. French commercial flag

22. Franco-Algerine flag

23. Russian naval flag 24. Russo-American flag

25. Russian commercial flag 26. Austrian naval and commercial flag

- 27. Austro-Venetian flag
- 28. Spanish naval flag
- 29. Spanish commercial flag
- 30. Spanish-Philippine commercial flag
- 31. Portuguese naval and commercial flag
- 32. Dutch commercial flag
- 33. Dutch Batavian flag
- 34. Norwegian national flag
- 35. Swedish naval flag
- 36. Swedish commercial flag
- 37. Prussian naval flag
- 38. Prussian commercial flag
- 39. Danish naval flag
- 40. Danish commercial flag
- 41. Schleswig-Holstein flag
- 42. Hamburg admiralty flag
- 43. Hamburg commercial flag
- 44. Old Lubec naval flag
- 45. Lubec commercial flag
- 46. Bremen commercial flag
- 47. Hanoverian commercial flag
- 48. Oldenburg commercial flag
- 49. Mecklenburg commercial flag
- 50. Belgian naval and commercial
- 51. Flag of the Saxon river cities
- 52. Flag of the Bayarian river cities
- 53. Flag of the Wirtemberg river cities
- 54. Flag of the Baden river cities
- 55. Swiss flag
- 56. Flag of Frankfort on the Main
- 57. Hungarian flag
- 58. Servian flag
- 59. Moldavian flag
- 60. Wallachian flag
- 61. Neapolitan naval and
- commercial flag 62. Papal flag
- 63. Tuscan naval and commercial flag
- 64. Leghorn flag
- 65. Flag of Lucca
- 66. Flag of Massa-Carrara
- 67. Flag of Modena
- 68. Flag of Monaco
- 69. Royal Sardinian flag
- 70. Sardinian naval and commercial flag
- 71. Old Genoese flag
- 72. Old Savoy flag

- 73. Flag of the island of Sardinia
- 74. Greek naval flag
- 75. Greek commercial flag
- 76. Greek pirate's flag
- 77. Turkish imperial flag
- 78. Turkish naval flag
- 79. Turkish commercial flag
- 80. Flag of the grand vizier
- 81. Flag of Capudan Pasha
- 82. Comm. flag of Tunis, Tripoli, Morocco
- 83. Flag of Tunis
- 84. Flag of Morocco
- 85. Flag of the vicerov of Egypt
- 86. Egyptian commercial flag
- 87. Flag of Tripoli
- 88. Old Algerine flag
- 89. Algerine pirate's flag
- 90. Arabian flag
- 91. Abyssinian flag
- 92. The flag of the Shah of Persia
- 93. Persian commercial flag
- 94. Flag of Afghanistan
- 95. Flag of Beloochistan
- 96. Flag of the Great Mogul
- 97. Flag of Bengal
- 98. Flag of Scind
- 99. Flag of the Birmans
- 100. Flag of Pegu
- 101. Flag of Siam
- 102. Flag of Sumatra
- 103. Chinese imperial flag
- 104, 105. Chinese commercial flags
- 106. Flag of Cochin-China
- 107. Japanese imperial flag
- 108. Commercial flag of Japan
- 109. Flag of the United States, N.A.
- 110. Flag of Texas
- 111. Flag of Mexico
- 112. Flag of Guatemala
- 113. Flag of Hayti
- 114. Flag of Columbia
- 115. Flag of Venezuela
- 116. Flag of Bolivia
- 117. Flag of Peru
- 118. Flag of Chili 119. Flag of Brazil
- 120. Flag of La Plata
- 121. Flag of Equador
- 122. Flag of Otaheite
- 123. Flag of the Sandwich Islands
- 124. Flag of New Zealand

PLATE 331.

European Ships of Various Functions

Figure

- 1. A galliot
- An English lugger
- A sloop of war
- 4. French frigate
- 5. French ship of the line
- Prison ship

PLATE 332.

Trading and Fishing Ships

Figure

- 1. Newfoundland fisherman
- Havre de Grace fishing-smack
- Coaster of the Mediterranean
- French coaster
- Mediterranean xebec
- Mediterranean pink
- 7. Danish coaster
- A galliot
- Dutch brig galliot
- 10. A barque
- 11. Slave ship
- 12. After part of a French merchantman

PLATE 333.

Steamships and Sailing Ships of Various Rigs

Figure

- 1. A cutter
- Hermaphrodite brig 2.
- Barque taking in freight 3.
- Whale ship 4.
- Emigrant ship
- The Bremen steamboat Gutenburg
- The American steamship Washington

PLATE 334.

French Steam-Propelled Sailing Ships; European Sailing Ships of War

Figure

- 1. Spanish gun-boat
- French iron steam propeller
- English war cutter
- 4. Swedish brig of war English brig of war

6. French steam frigate

PLATE 335.

Illustrating the Construction of Steamships

Figures 1-22.

PLATE 336.

Illustrating the Construction of Steamships

Figures 1-31.

PLATE 337.

Naval Officers and Sailors

Figure

- 1-5. French naval officers
- 6-10. Russian naval officers 11-13. English naval officers
- 14. Naval cadet (midshipman)
- 15-19. Sailors, boatswains, etc.

PLATE 338.

Scenes from Shipboard Life

Figure

- Officer on watch
- The wheel
- 3. Middle deck
- Starboard battery at night
- Starboard battery in daytime Midshipmen's cabin

PLATE 339. Scene on a French Frigate

- Figure 1. Forward part of a French
- frigate After part of a French frigate
- Carronade with its carriage
- Gun with its carriage
- Port-guard Davits with lifting tackle

PLATE 340. Sailors on Deck Duty

Figure

- 1. Caulking shot holes
- 2. Look-out from the topsail yard

Throwing the lead

- Taking in sail and reefing
- Hoisting out a boat Heaving the log

7. Cleaning the deck

PLATE 341.

Incidents Aboard Ship

Figure

- 1. Court-martial
- Keel-hauling
- Hoisting the flag
- 4. Ship on fire

PLATE 342.

Ships on Parade and Shipboard Life

Figure

- 1. English ship of the line firing
 - French ship of the line in flag parade Hoisting flag in running into
- Striking flag in surrendering
- 5. Night signals
- Top-men 6.
- Sailors playing cards Confinement in irons

PLATE 343. Ship Manoeuvers

- **Figure**
- Ship signalizing with flags
- Ship drying sail
- Ship inclosed with ice Ship with all sails set
- Ship setting sail
- Ship getting under weigh Ship bracing round
- 8ab. Ships sailing on a half wind 9ab. Ships going about
- 10. Ships bearing to windward
- 11. Ships shortening sail 12. Ship of the line under short sail

PLATE 344. Ships at Sea

- **Figure** Ships getting under weigh
- Ships pitching Barque rolling
- Barque under close-reefed topsails
- Barque thrown on one side Shipwreck

PLATE 345.

Illustrating Manœuvers of Fleets

Figures 1-35.

PLATE 346.

Ships at War

Figure

- 1. Manœuvers by schooners
- 2. Steamer of war carrying despatches
- 3. Line of battle
- 4. Naval battle

PLATE 347.

Ships in Drydock and in Port

Figure

- 1. Drydock in Toulon
- 2. Towing a vessel into port
- 3. Ship-ways dry at ebb tide
- 4. Graving-dock
- 5-7. Diving-bells
- 8, 9. Steam dredgers

PLATE 348.

Roadsteads and Harbor Equipment

- Figure 1, 2. Roadsteads
- 3. Crane for setting masts
- 4. Pile-driving machine
- 5. Naval arsenal
- 6. Common dredging machine

PLATE 349.

Lighthouses and Docks

Figure

- 1. Ground plan of the West India docks in London
- 2. Ground plan of the harbor of Toulon
- 3-6. Prince's docks at Liverpool
- 7. Profile of the wall of the London docks
- 8. Profile of the Mersey quay at Liverpool
- 9-12. Dundee dry dock
- 13-17. The lighthouse of Trieste
- 18. Lighthouse of Bell rock (vertical section)
- 19-23. Iron lighthouse at Bermuda

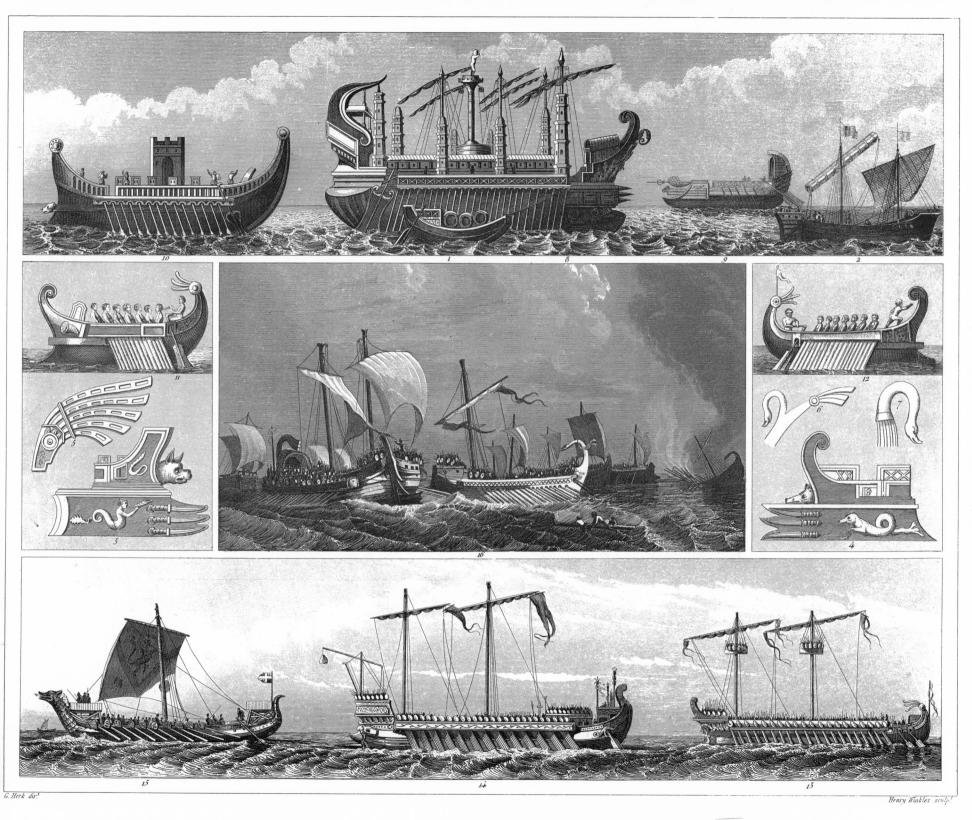

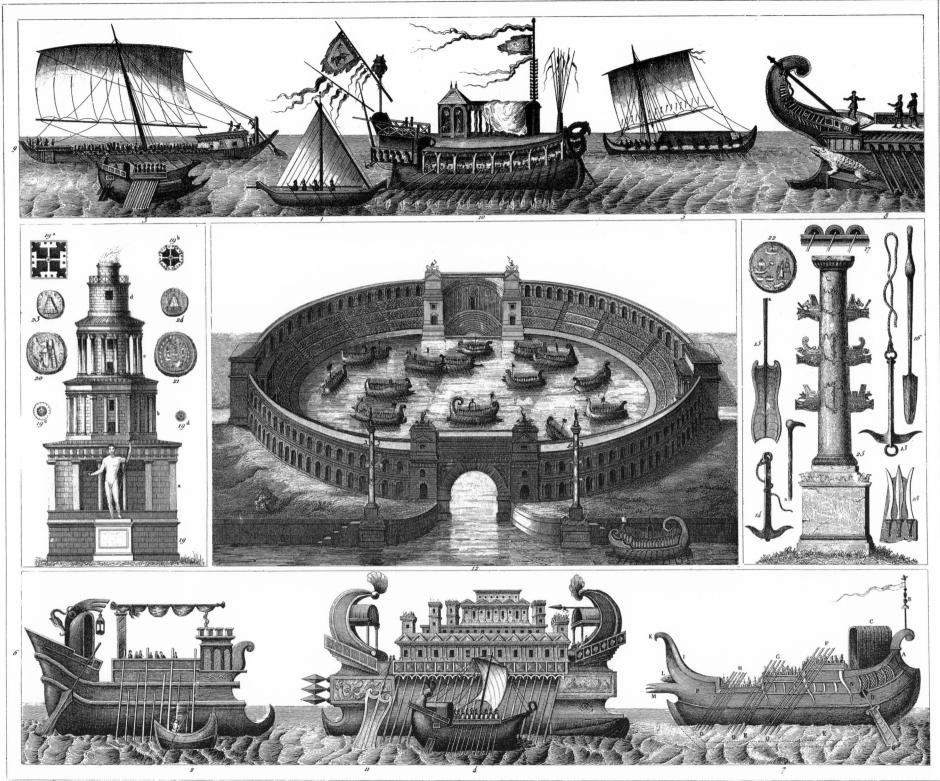

Henry Winkles sculp!

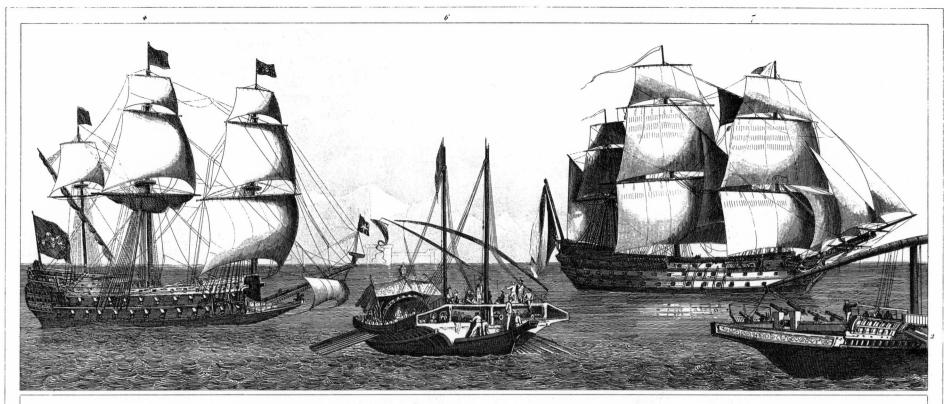

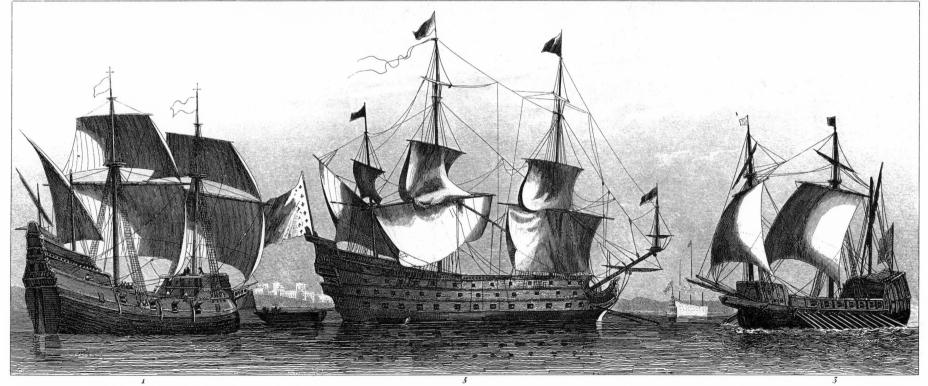

Henry Winkles sculp.

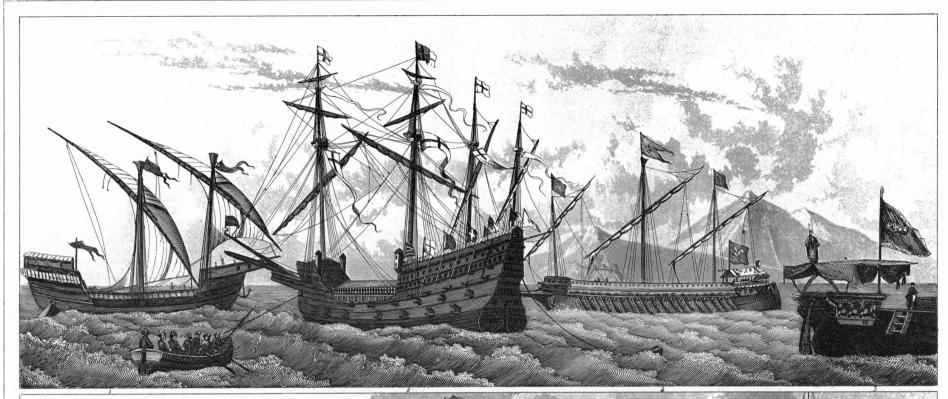

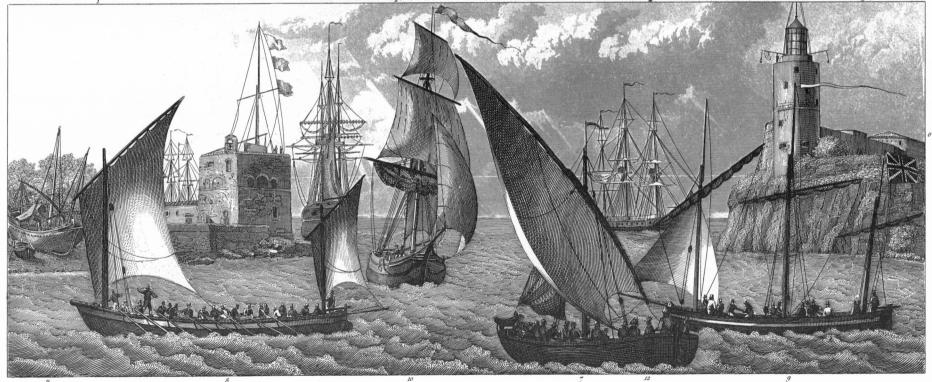

ir. Heck dir!

Henry Winkles sculp!

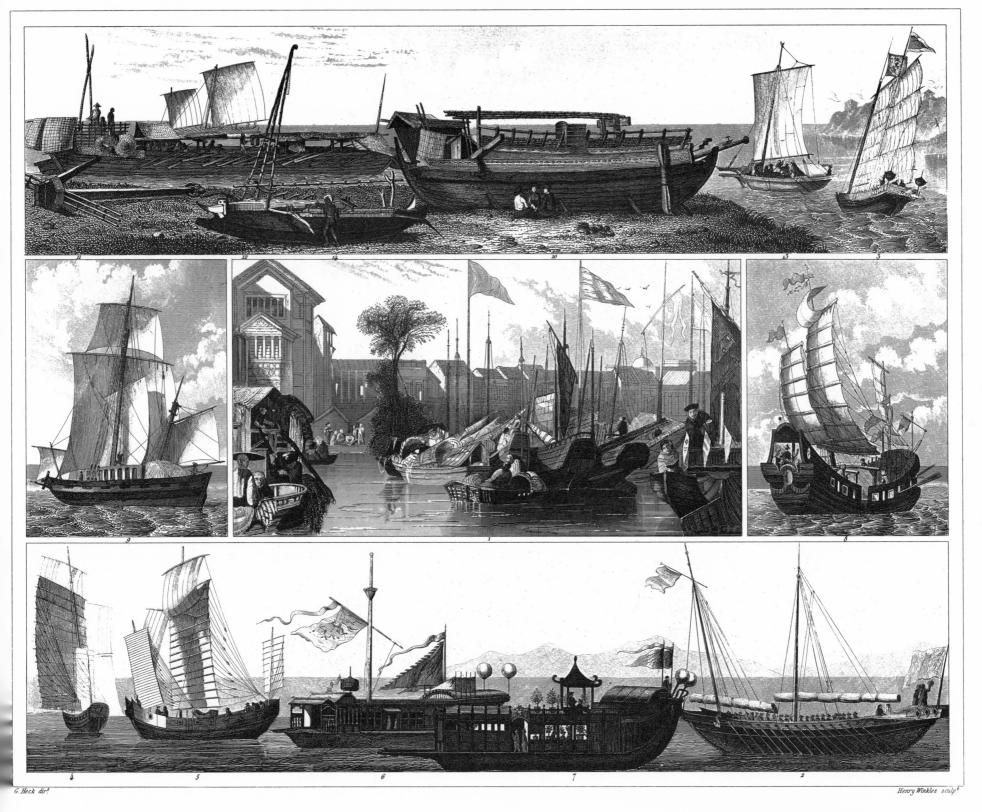

PLATE 322. SHIPS OF THE ORIENT

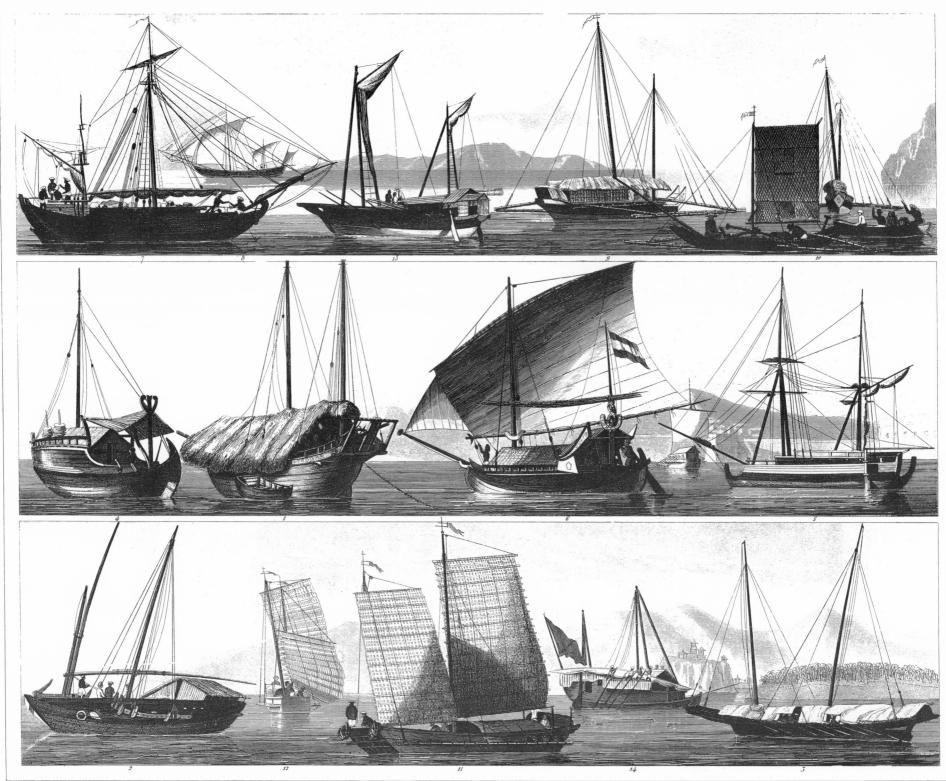

G. Heck dir.t

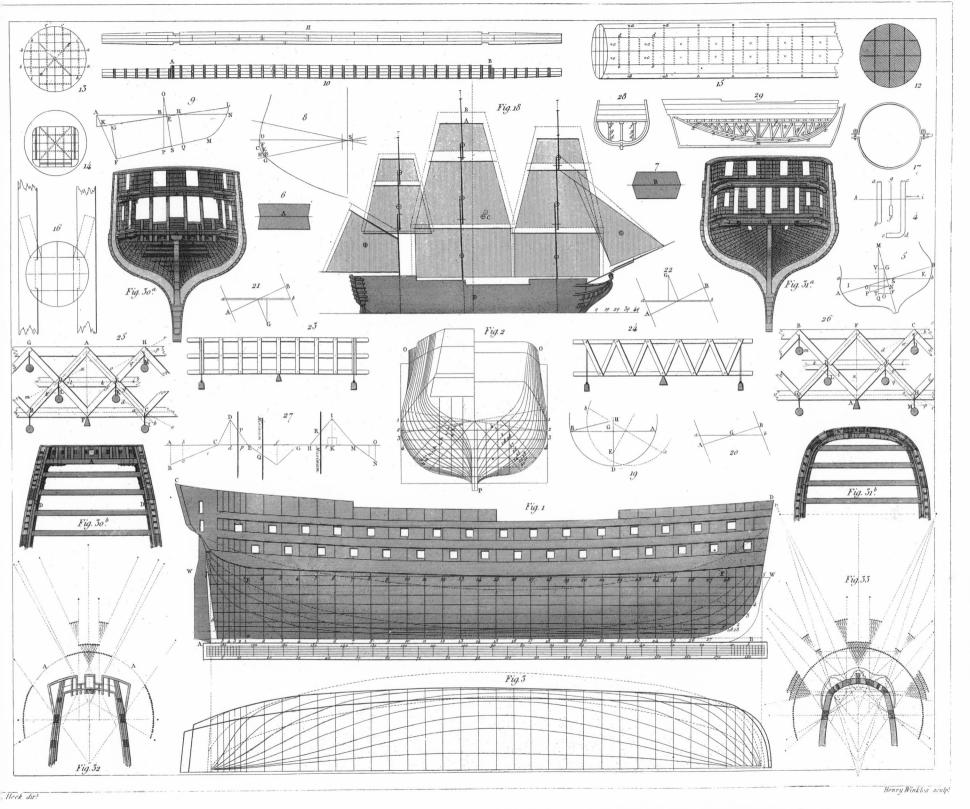

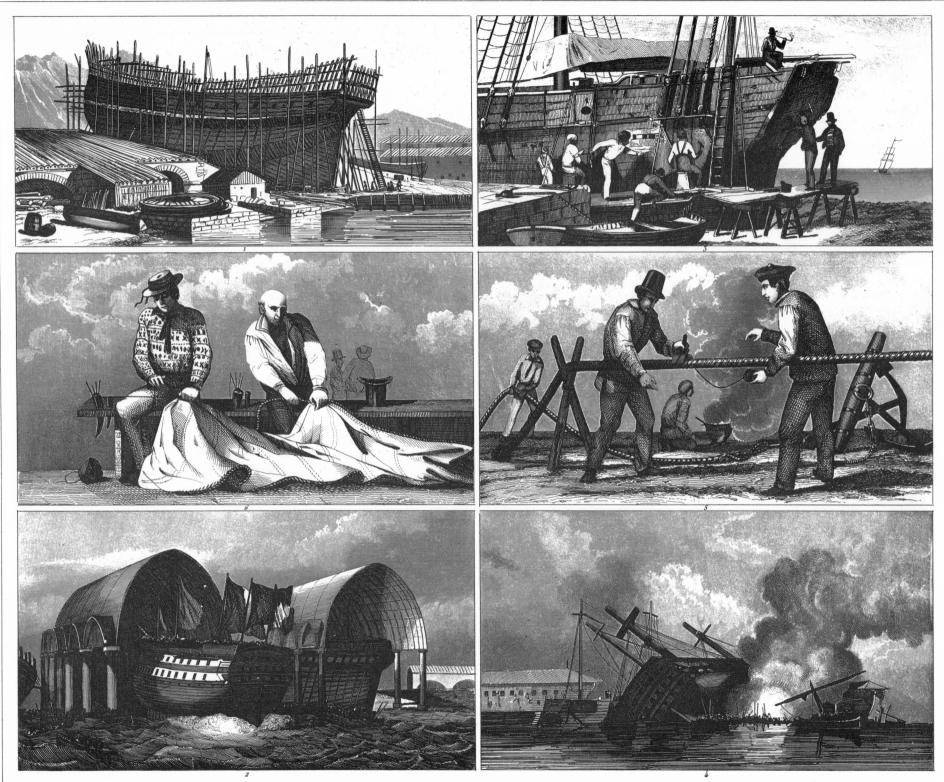

i. Heck dir!

Henry Winkles sculp!

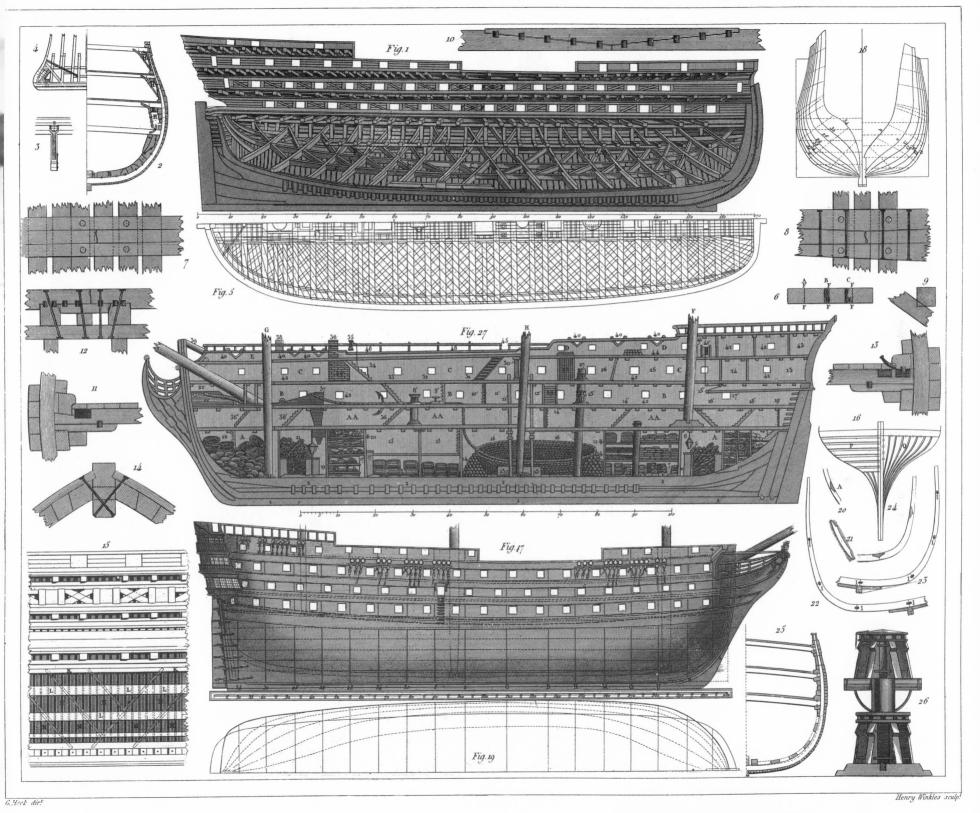

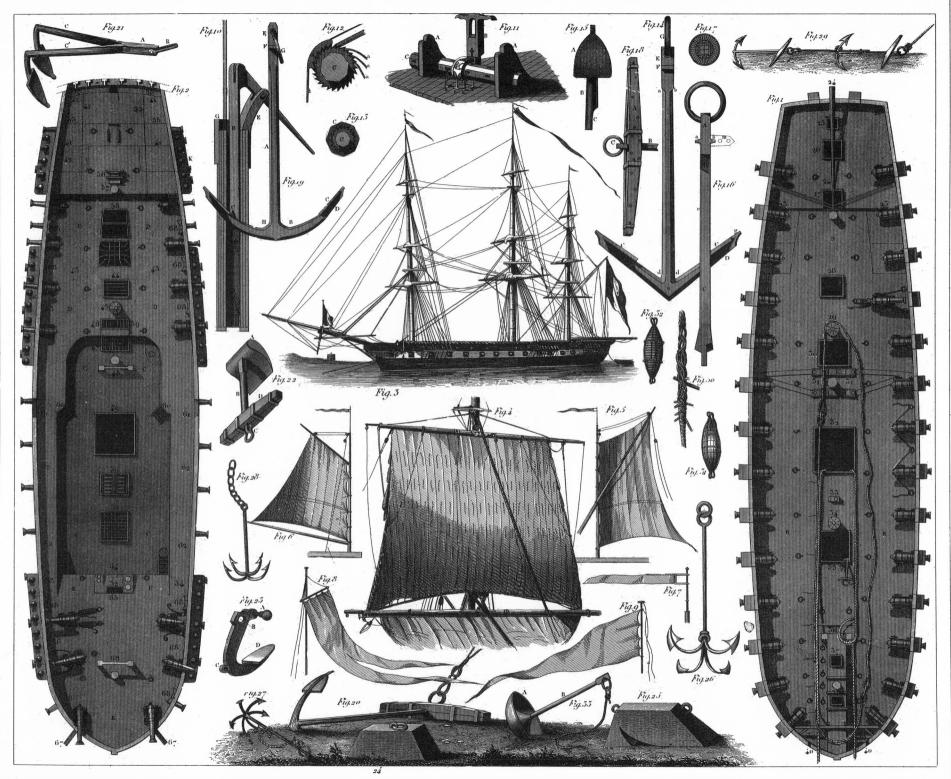

Willord die!

Henry Winkles soulp!

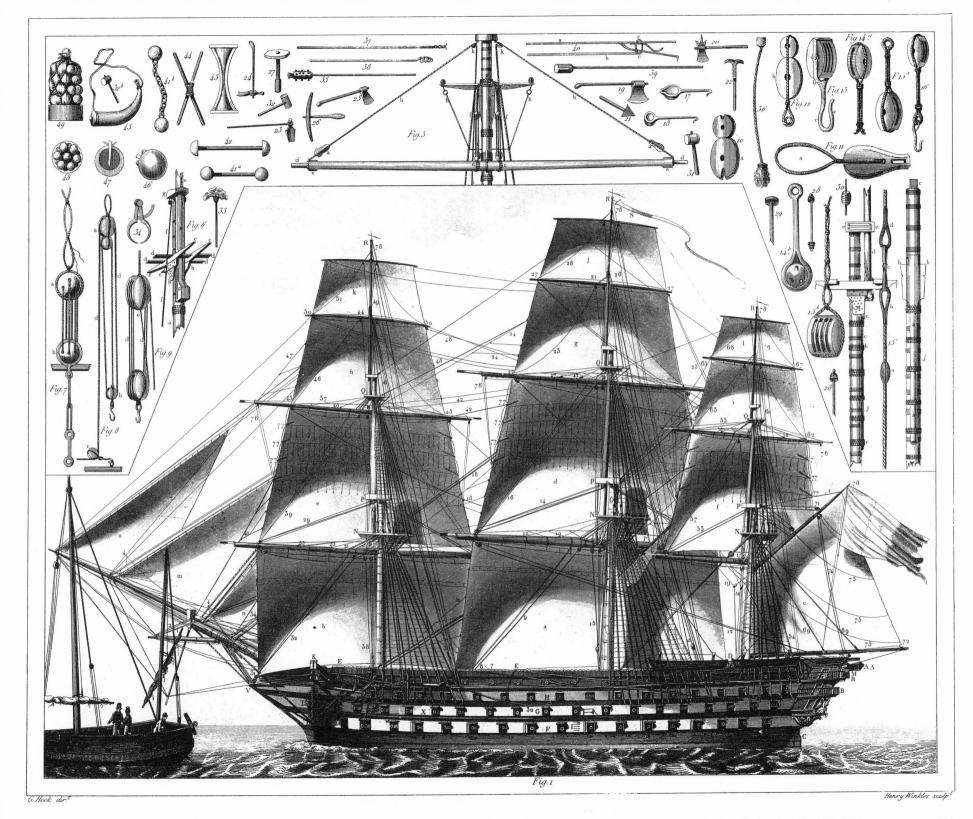

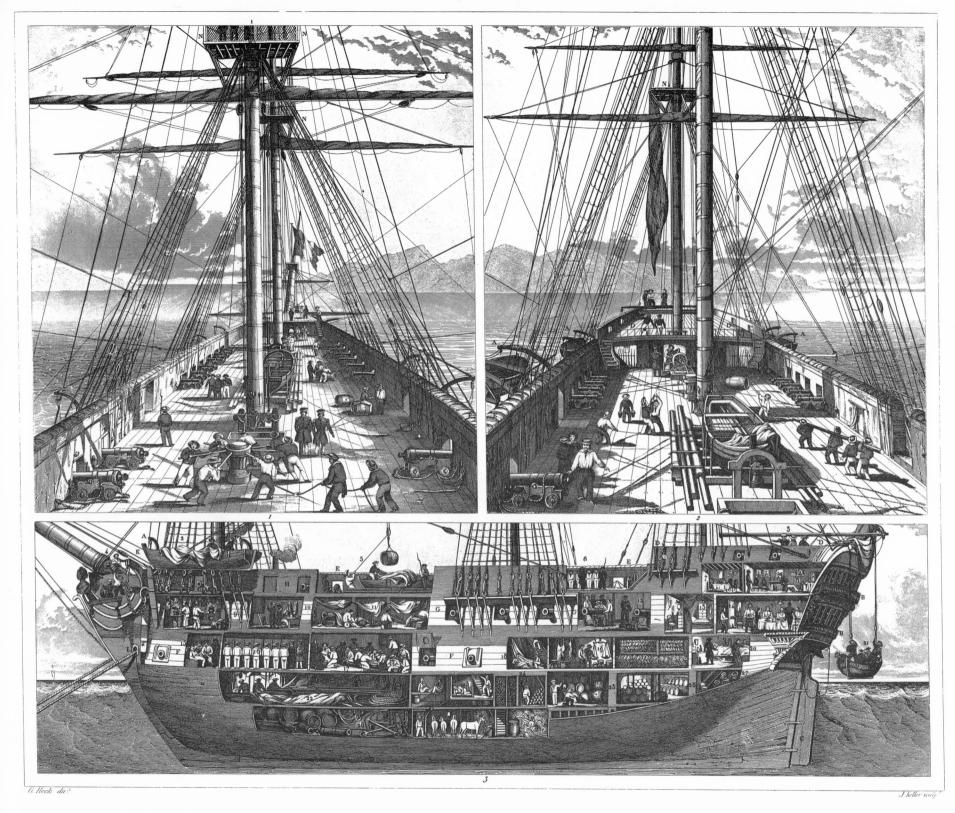

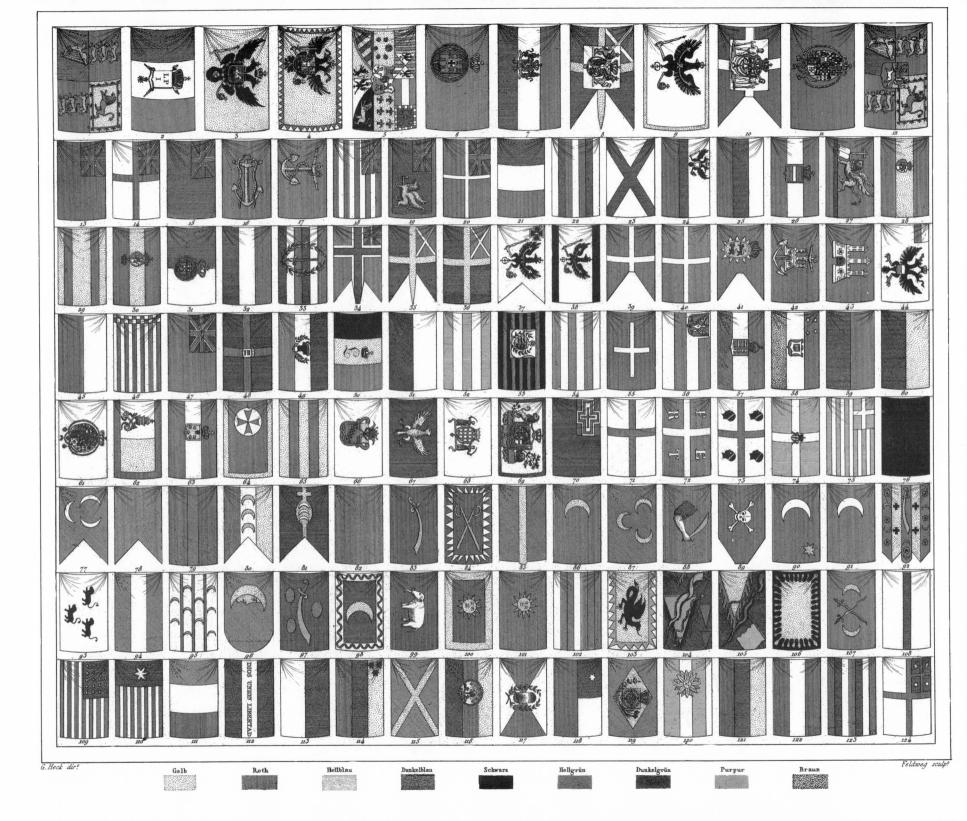

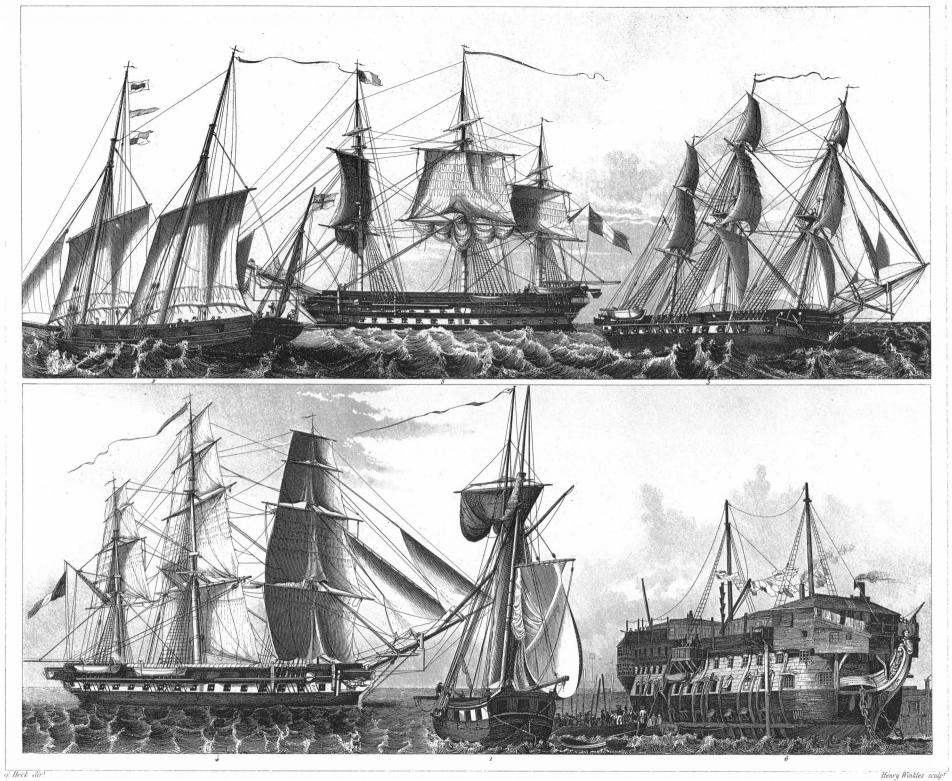

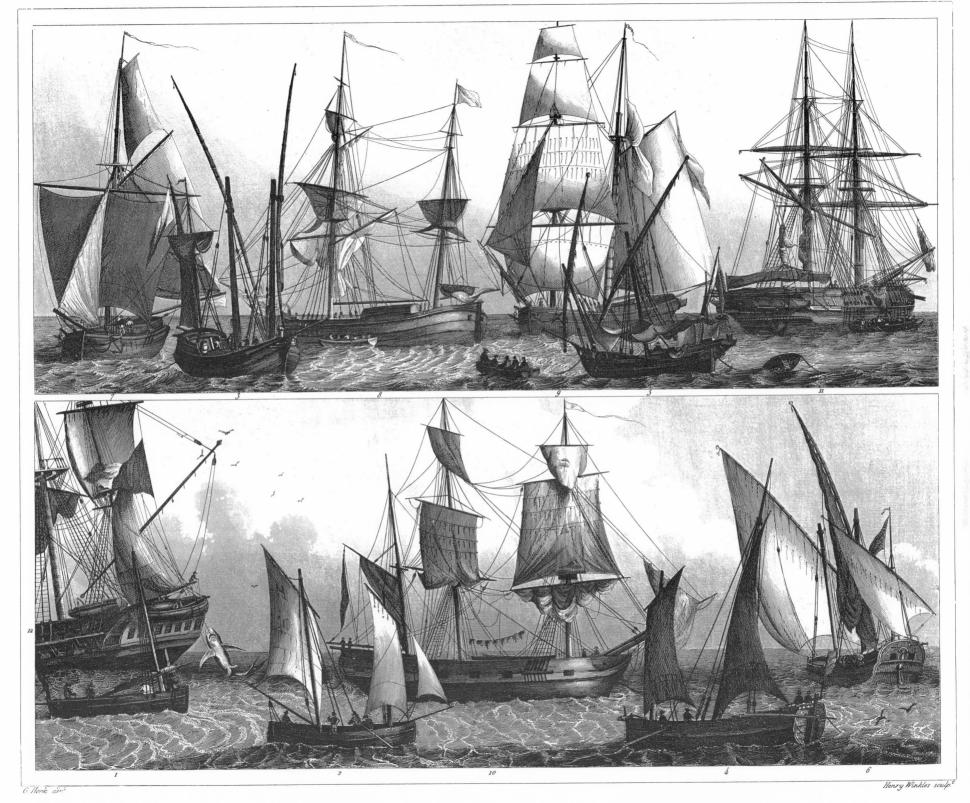

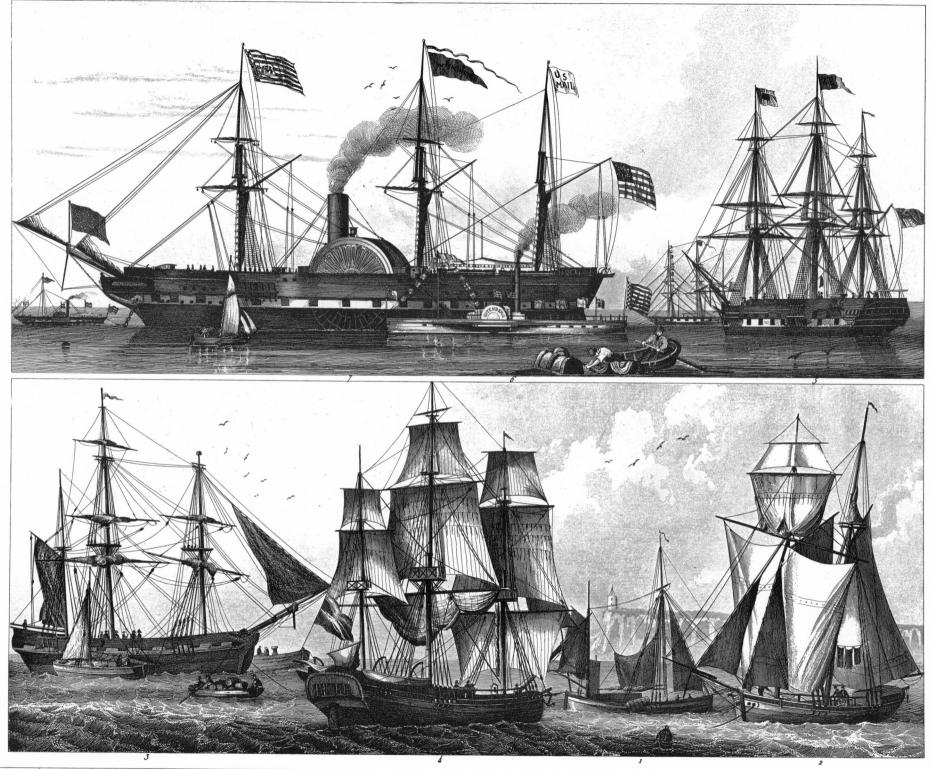

G. Heck dir.t

Henry Winkles sculp.t

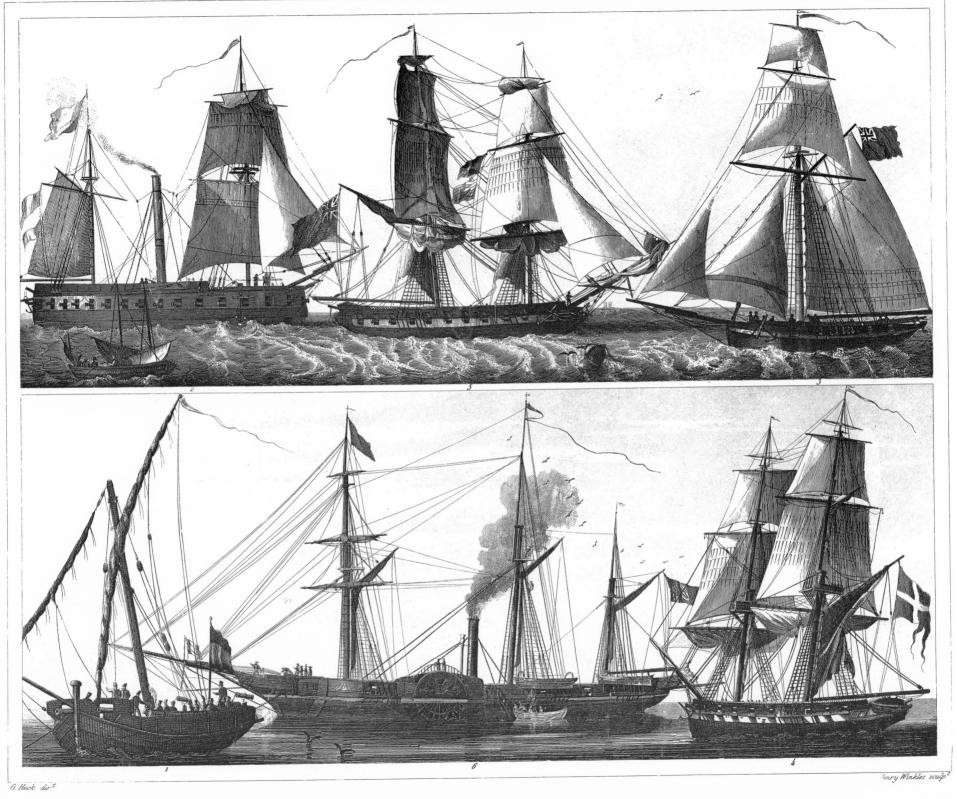

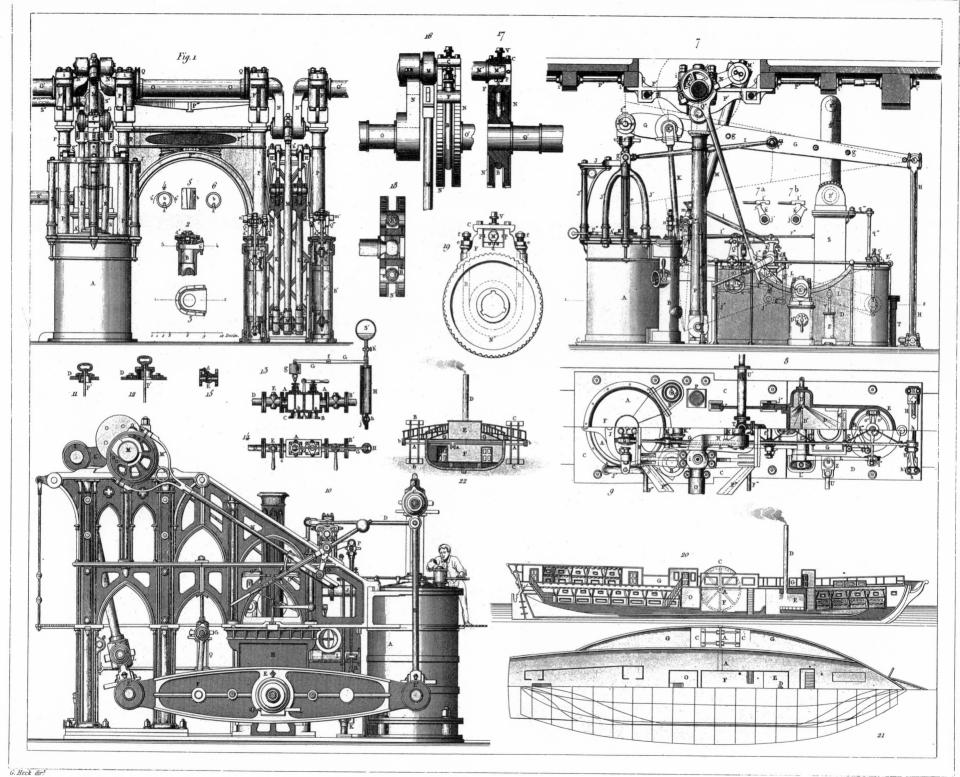

Henry Winkles sculp!

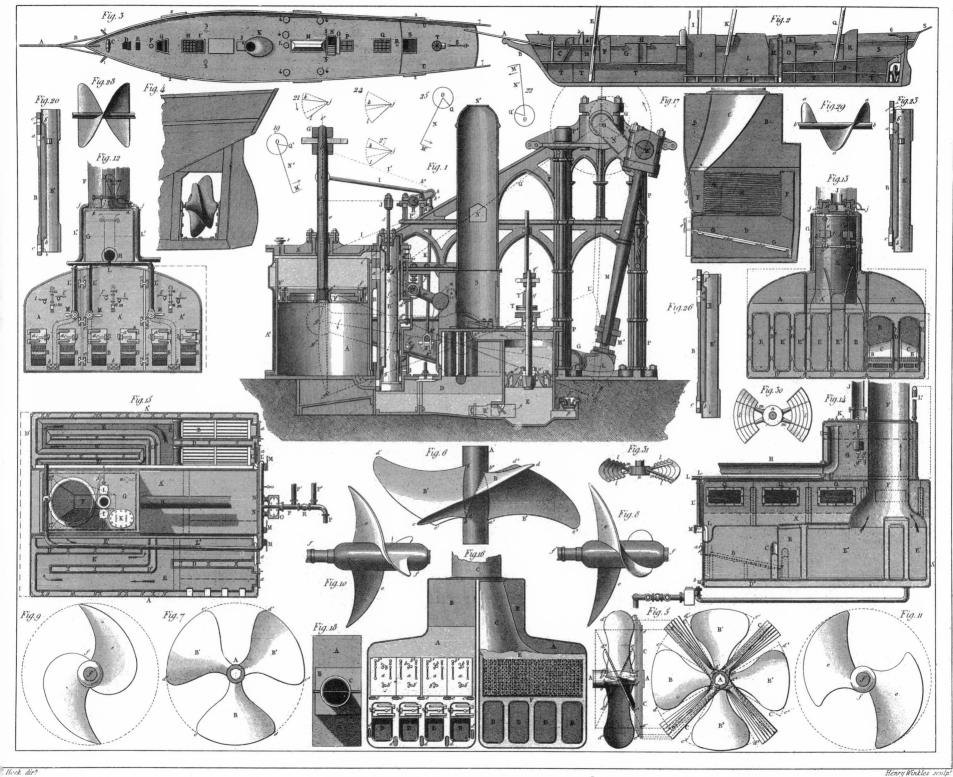

Henry Winkles sculp!

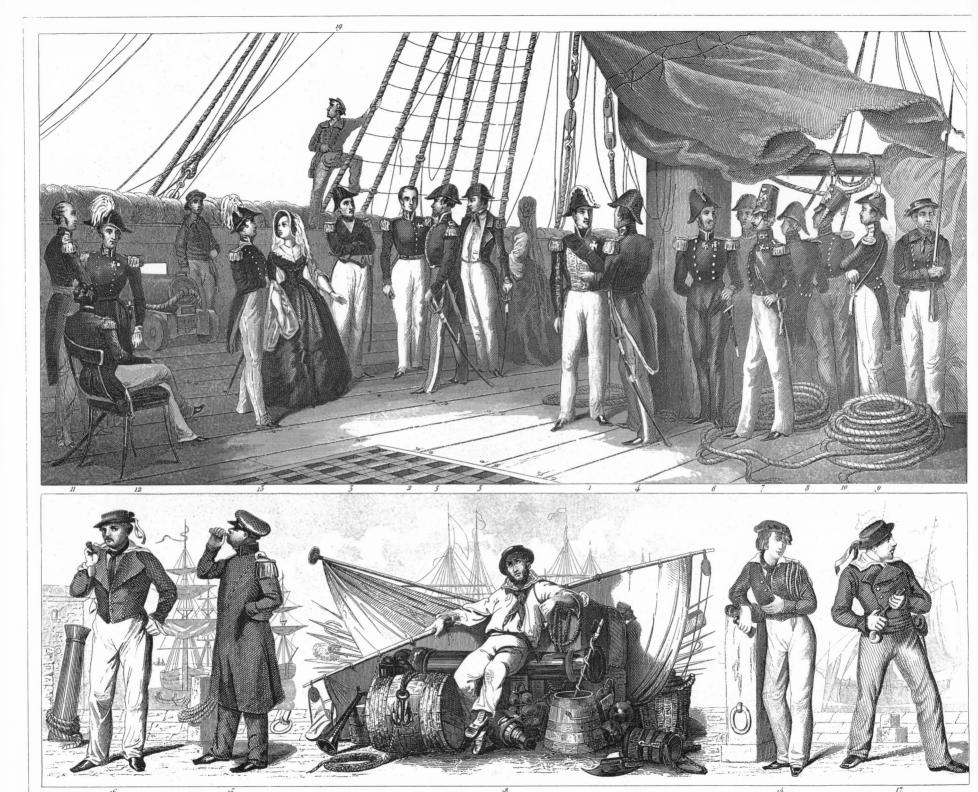

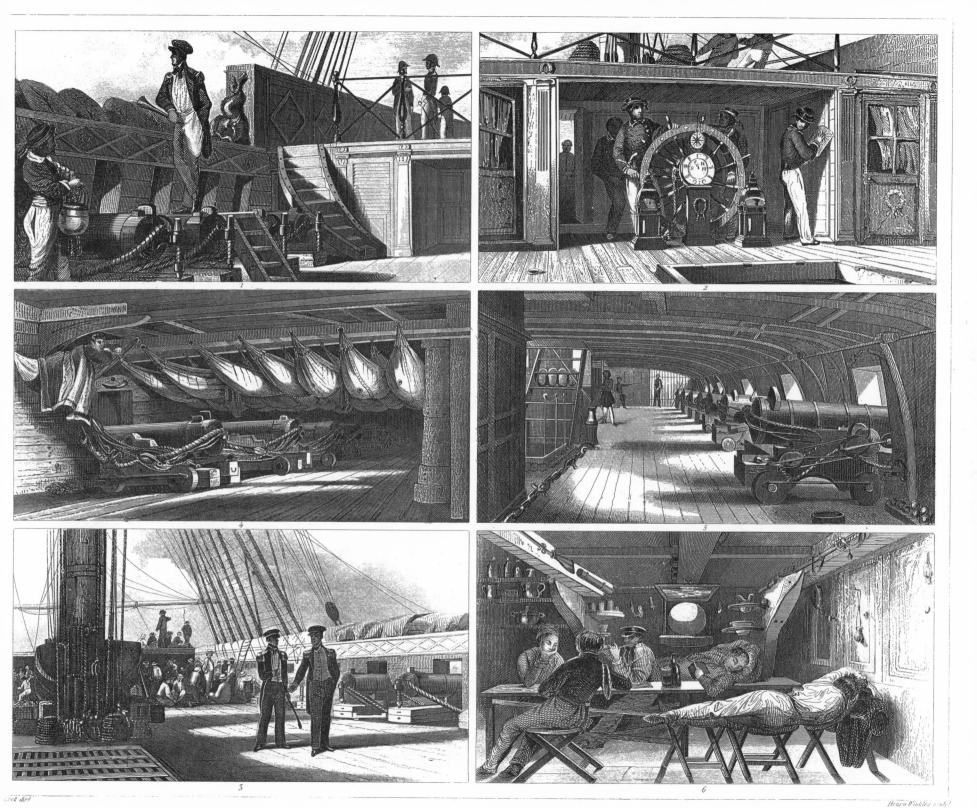

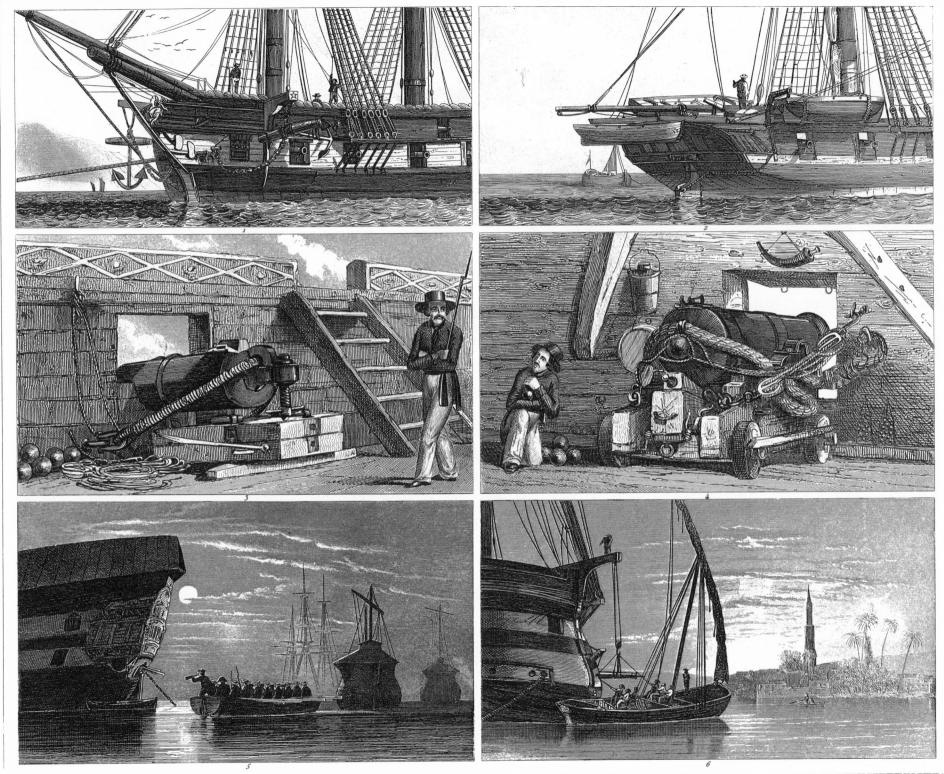

Henry Winkles soulp

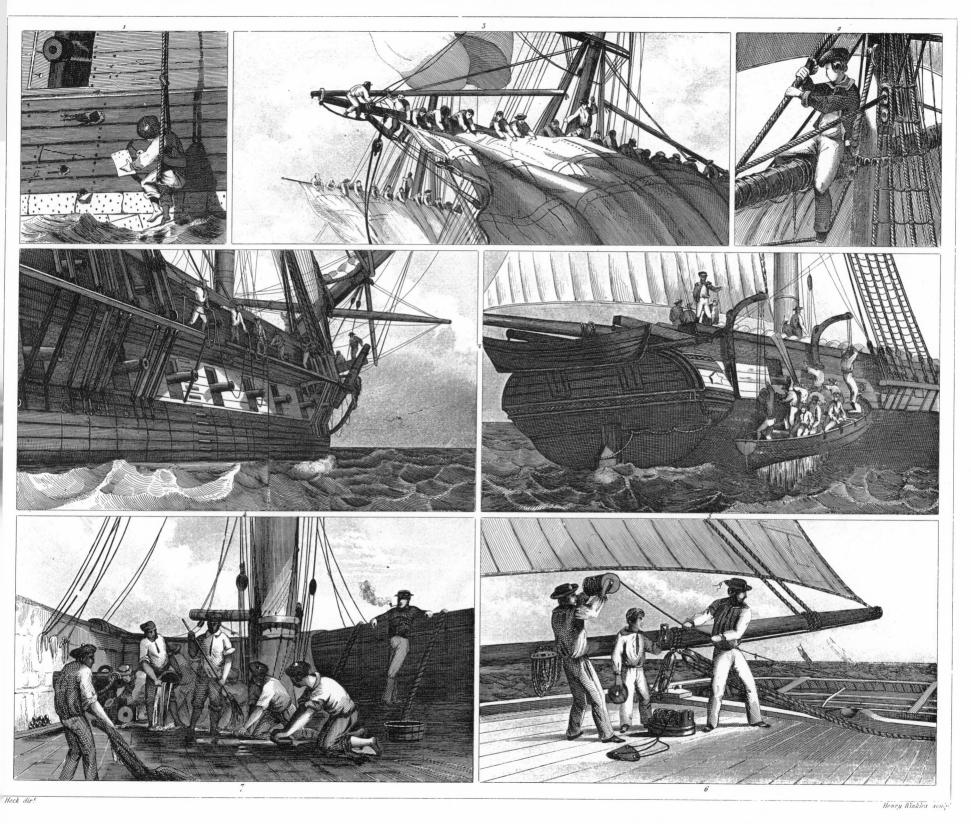

PLATE 340. SAILORS ON DECK DUTY

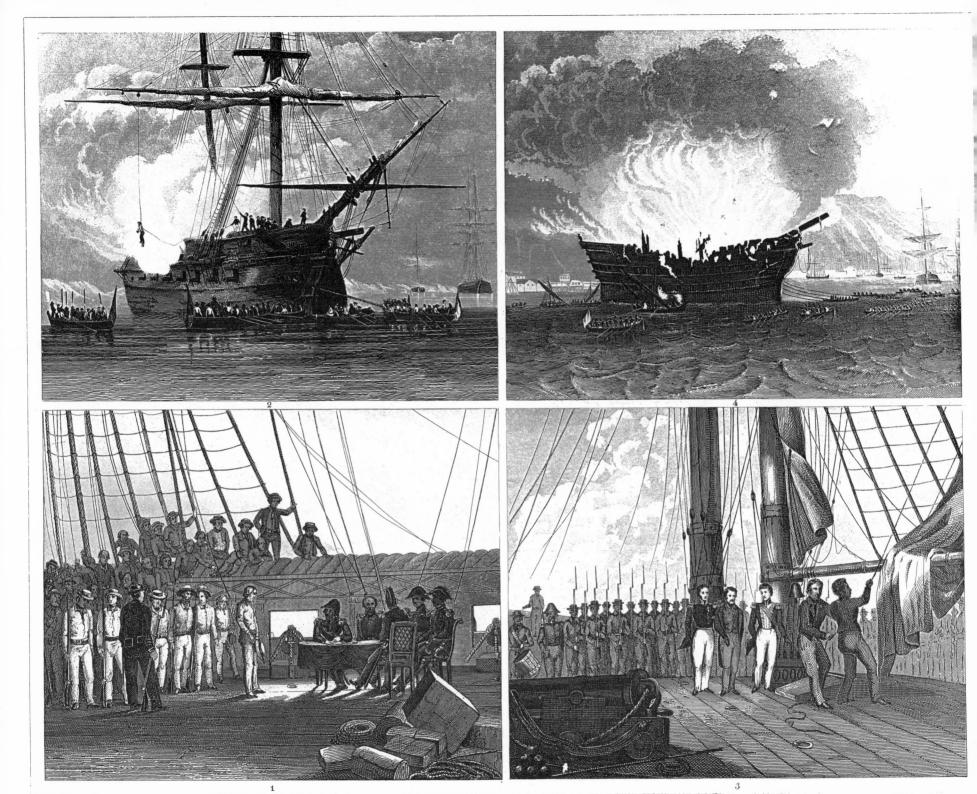

G. Heck, dir.t

Winkleset Lehmann set

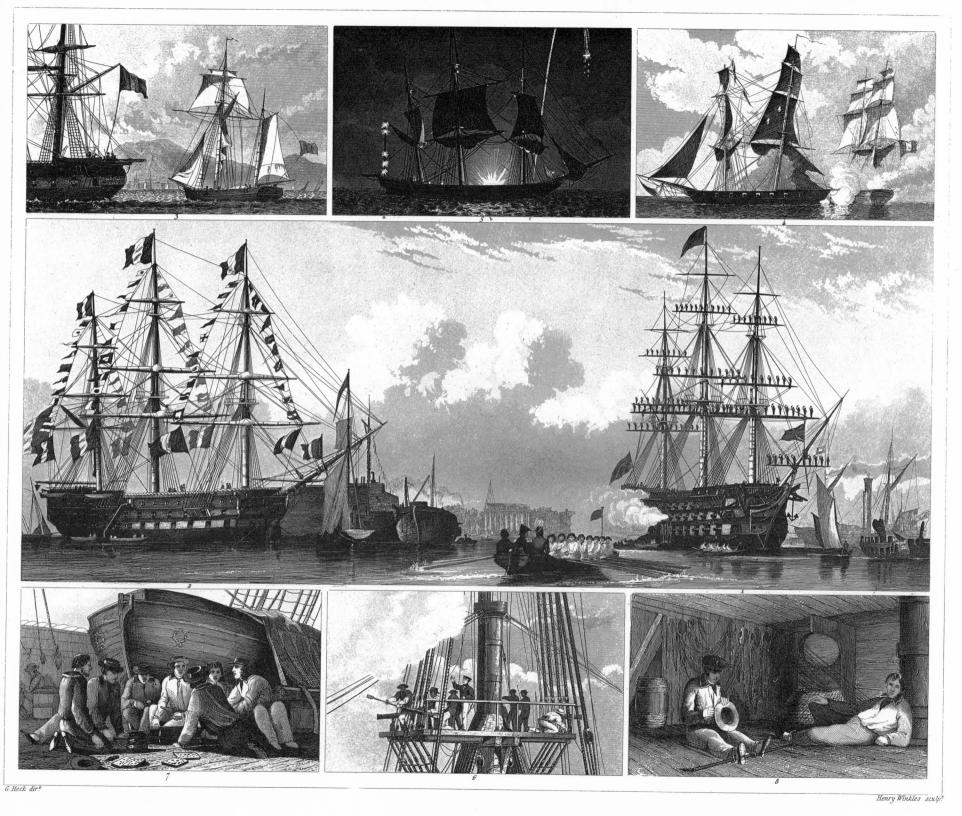

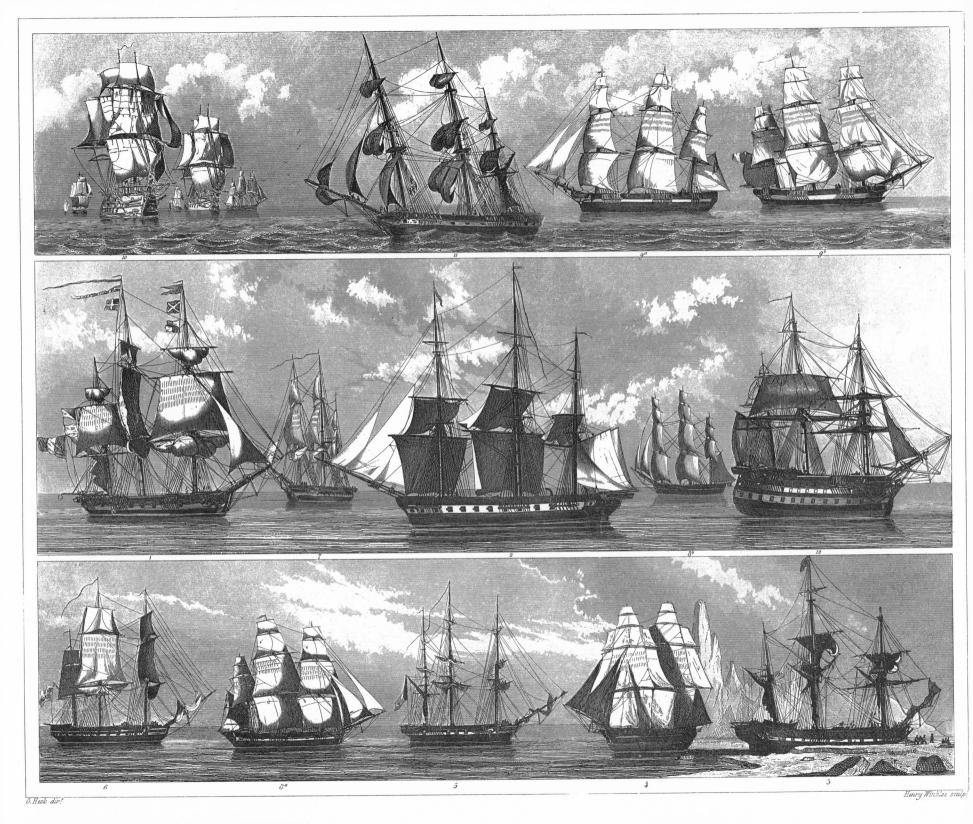

PLATE 343. SHIP MANOEUVERS

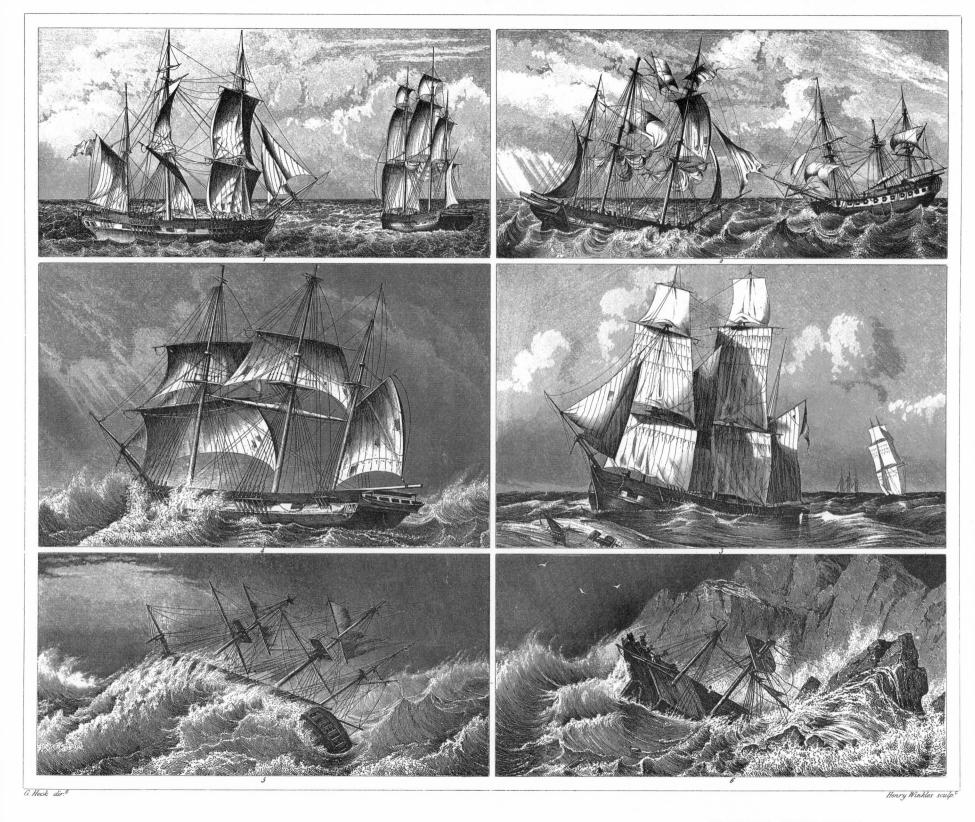

PLATE 344. SHIPS AT SEA

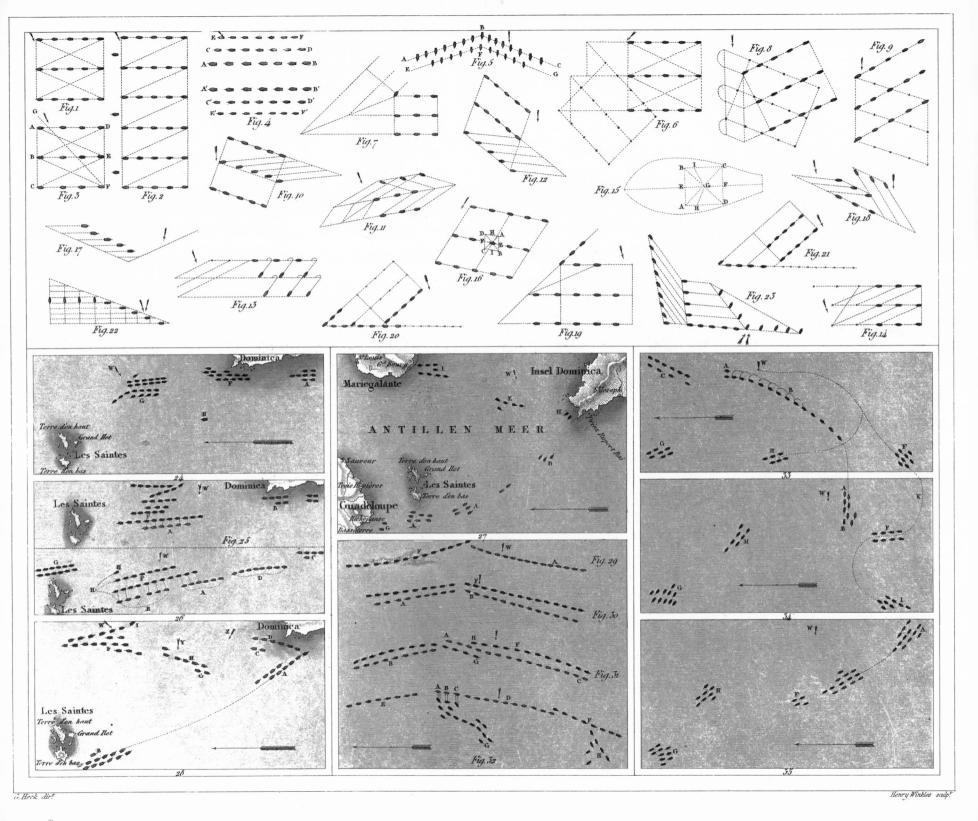

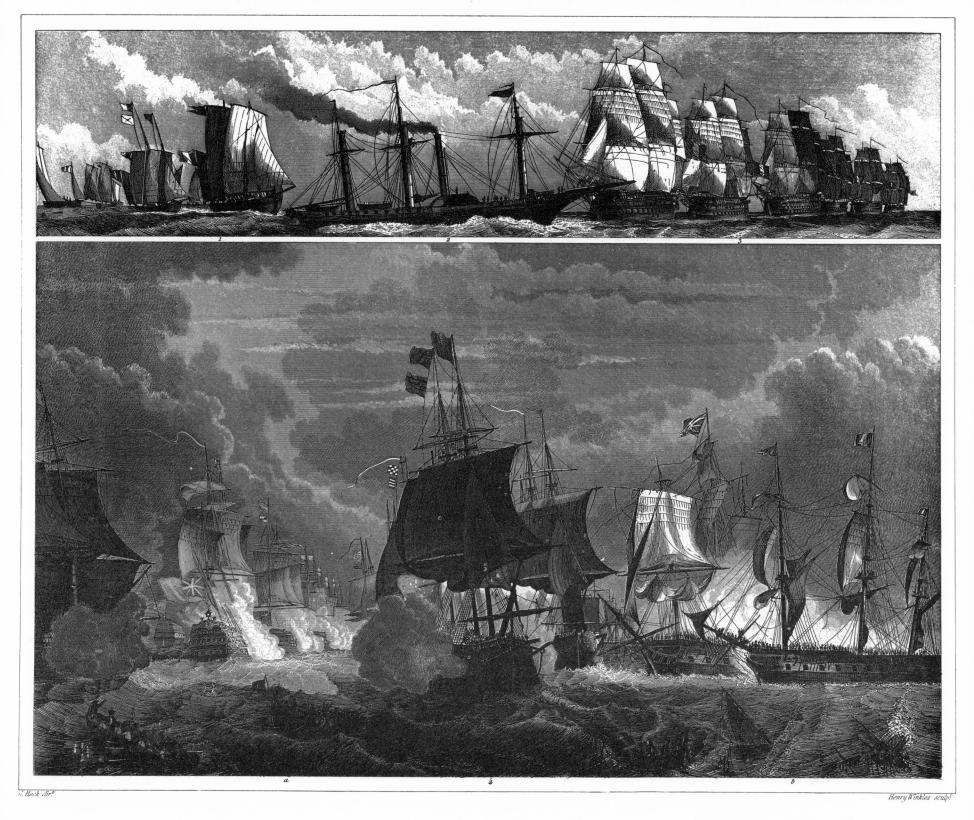

PLATE 346. SHIPS AT WAR

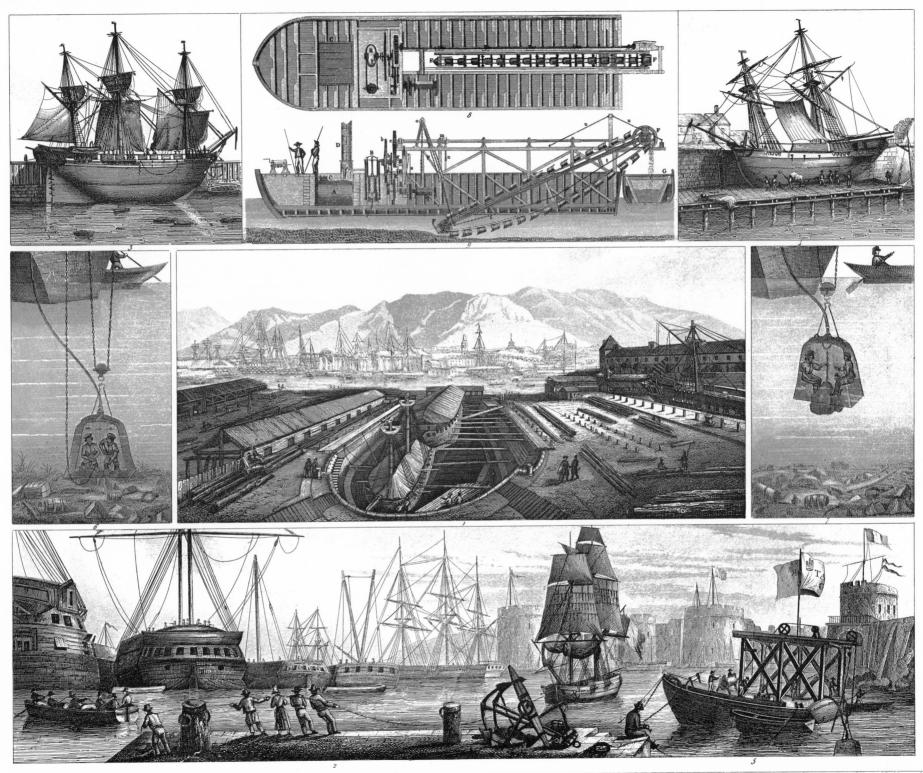

Henry Winkles sculp.t

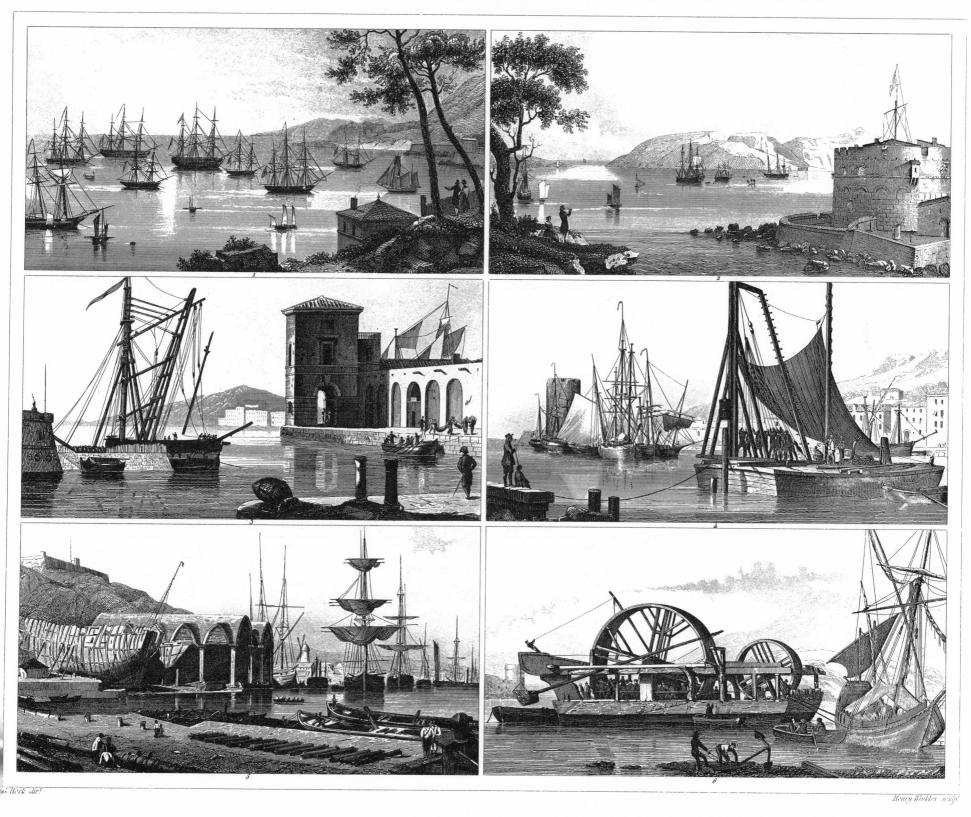

PLATE 348. ROADSTEADS AND HARBOR EQUIPMENT

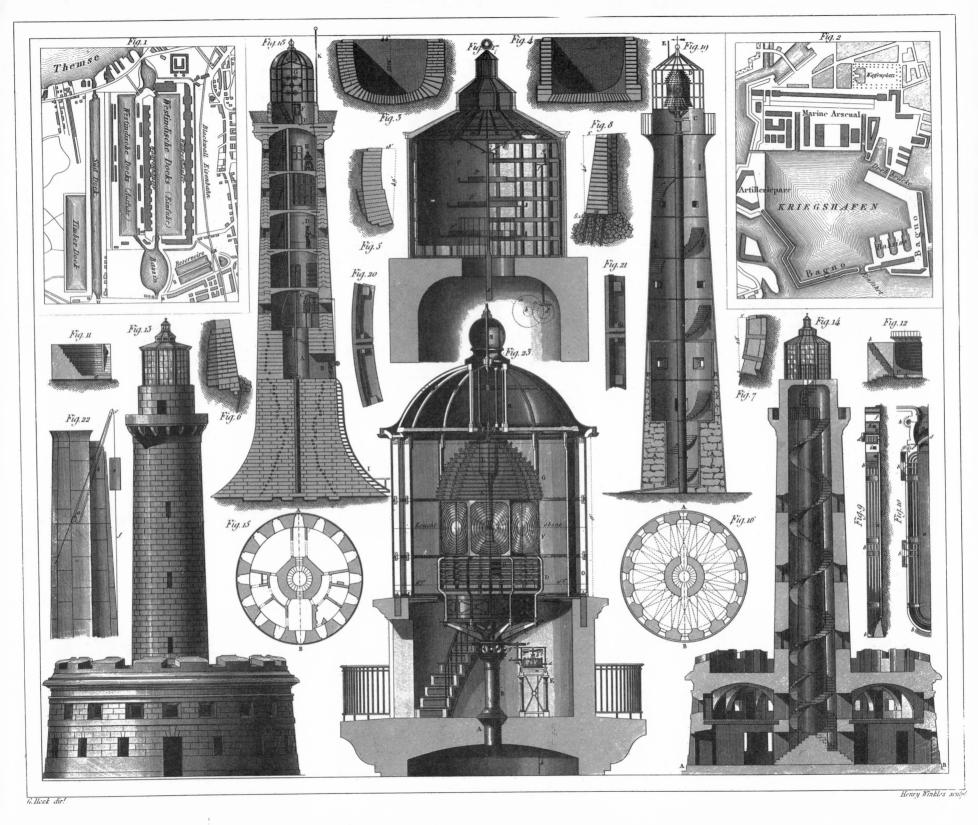

PLATE 349. LIGHTHOUSES AND DOCKS

	4

Captions to the Architecture Plates, 350-409

PLATE 350.

Ancient Indian Temples and Pagodas

Figure

- 1. Rock temple of Mavalipuram
- 2. Pagoda at Chalembaram
- 3. Pagoda at Tretshengur
- 4. Pagoda near Benares
- 5. Interior of the temple of Indra
- 6, 7. Grotto temples

PLATE 351.

Indian Temples at Ellora and Elephanta

Figure

- 1. Temple of Kailasa near Ellora
- 2. Temple of Indra Sabah at Ellora
- 3. Interior of the grotto temple on the island of Elephanta
- Interior of the temple of Wisua Karmah at Ellora

PLATE 352.

Ancient Architecture and Sculpture

Figure

- 1, 2. Sculptures from Nineveh3-11. Fragments from Persepolis
- 12. Tomb of Nakshirustam
- 13-15. Hindoo pillars

PLATE 353.

Egyptian Temples and Tombs

Figure

- 1. Temple of Antæopolis
- 2. Theatre in Antinoe
- Ruins of Apollinopolis Magna
- Temple of Carnak
- 5a. Temple of Tentyra
- 5b. Temple at Latopolis
- 6. Temple on the island of Philæ
- 7. Rock-cut tombs of Silsilis
- 8. Entrance to the temple of Typhon at Denderah

PLATE 354.

Temple, Palace, and Catacombs

Figure

- 1-6. Temple of Apollinopolis Magna
- 7. Plan of the Palace of Carnak
- 8–11. Details from the same
- 12. Catacombs at Thebes
- 13, 14. Catacombs of Alexandria

PLATE 355.

Pyramids and Monuments

Figure

- 1. Pyramid in Lake Mœris
- 2. Pyramids of Gizeh
- 3. Section of a pyramid at Memphis
- 4. Pyramid at Assur in Nubia
- 5. Colossi at Thebes
- 6. The Sphinx of Gizeh
- 7. Hall of the palace at Carnak
- 8. Entrance into the palace of Luxor
- Propylæa on the island of Philæ

PLATE 356.

Illustrating General Considerations on Architecture

Figures 1–24.

PLATE 357.

Ancient Architecture

Figure

- 1. The Acropolis of Tiryns
- 2. Section of the same
- 3, 4. The Grottoes of Corneto
- The Gate of the Lions at Mycenæ
- 6. Section through the same
- 7. Entrance of the Treasury of Atreus at Mycenæ
- 8. Section of the same
- 9-11. Plan and sections of the Giganteja on the Island of Gozzo

PLATE 358.

Architecture of Classical Greece

Figure

- 1. View of ancient Athens
- 2. Western front of the Parthenon
- 3. The temple of Theseus
- 4. The Tower of the Winds
- 5. The Choragian monument of Lysicrates
- 6. Temple of Segesta in Sicily

PLATE 359. Classical Greek Temples

Figure

- 1, 2. Temple of Jupiter at Olympia
- 3-5. Temple of Theseus
- 6. Eastern front of the Parthenon
- 7. Plan of the Parthenon
- 8, 9. Temple of Minerva Polias, etc.
- 10-12. The Odeon in Athens
- 13, 14. Doric portico
- 15. Temple on the Ilissus
- 16. The temple of Diana in Eleusis
- 17. Temple of Cybele in Sardis
- 18, 19. Temple of Concordia in Agrigentum
- 20, 21. Temple at Pæstum
- 22, 23. Temple at Euxomus in Ionia
- 24-27. Temples at Pæstum

PLATE 360.

Greek and Roman Temples

Figure

- 1. The Acropolis of Athens
- 2. Temple of Jupiter Olympius in Athens, elevation
- 3. Temple of Jupiter Olympius in Athens, plan
- 4. Temple of Jupiter Olympius in Athens, section
- Temple of Minerva Polias, Erechtheus, and the Hall of

- the Nymph Pandrosos in Athens (restored view)
- 6. Longitudinal section of the Parthenon in Athens
- 7, 8. Temple of Castor and Pollux in Rome
- 9–12. Temple of Faustina in Rome
- 13. Plan of the temple of Cybele in Sardis
- 14. Plan of the temple of Concordia in Agrigentum
- 15. Plan of the temple of Juno in Agrigentum
- 16, 17. Plans of Doric temples in Selinuntiæ
- 18. Plan of the temple of Ceres in Pæstum
- 19. Plan of the temple of Minerva in Sunium
- 20. Plan of the temple of Apollo at Bassæ

PLATE 361.

Greek Temples in Several European Countries

Figure

- 1, 2. Temple of Diana at Ephesus
- 3, 4. Temple of Apollo at Miletus
- 5, 6. Temple of Bacchus at Teos
- 7, 8. Temple of Diana in Magnesia
- Ruins of the temple of Neptune at Pæstum
- 10, 11. Temple of Jupiter at Selinuntiæ
- 12. Temple of the Sun in Palmyra
- 13, 14. Temple of Nemesis at Rhamnus
- 15, 16. Temple of Portumnus at Ostia
- 17. Temple of Jupiter in Rome

PLATE 362.

Roman and Middle Eastern Architecture

Figure

1. Ruins of Baalbec

- 2. Plan of the temple of the Sun at Baalbec
- 3. Plan of the temple of Jupiter at Baalbec
- 4, 5. Temple of Concordia in Rome
- 6. Plan of the temple of the Sun in Palmyra
- 7. Plan of the temple of Mars in Rome
- 8. Plan of the temple of Portumnus in Ostia
- 9. Plan of the temple of Serapis in Pozzuoli
- 10. Plan of the temple of Augustus in Pompeii
- 11. Plan of the Rotunda on the Via Prænestina in Rome
- 12. Plan of the temple of Theseus in Athens
- 13. Plan of the temple of Jupiter in Ægina
- 14, 15. Portico of Metellus
- 16, 17. Forum of Nerva
- 18–22*ab*. Mausoleum at Halicarnassus

PLATE 363.

Roman Forum and Various Amphitheatres

т.

- Figure
 1. The Forum Romanum
- Amphitheatre of Flavius
 Half ground plan of the
- Coliseum
 4. Section of the Amphitheatre
- at Verona5. Section of the Amphitheatre

at Nismes

PLATE 364.

Greek and Roman Temples

Figure

- 1, 2. Temple of Neptune in Pæstum
- 3-5. Temple of Jupiter at Olympia

- 6, 7. Temple of Jupiter Capitolinus in Rome
- 8. Temple of the Sun in Rome
- 9. Plan of the Temple of Quirinus in Rome
- 10, 11. Maison Quarrée in Nismes
- 12, 13. Temple of Honor and Virtue in Rome
- 14. Plan of the temple of Ceres at Pæstum
- 15. Plan of the temple of Jupiter in Forli
- 16. Plan of the temple of Pictas in Rome
- 17. Plan of the temple of Janus in Rome
- 18. Plan of the temple of Spes in Rome
- 19. Plan of the temple of Minerva in Syracuse

PLATE 365.

Temple at Baalbec and Other Greek and Roman Architecture

Figure

- 1-6. Temple of Venus and Rome in Rome
- 7, 8. Temple of Fortuna Virilis in Rome
- 9-12. Temple of Vesta in Tivoli
- 13. Ruins of the temple of Jupiter at Baalbec
- 14. Plan of the temple of Jupiter Olympius in Athens
- 15. Plan of the temple of the Sun in Rome
- 16. Plan of the temple of the Sun in Baalbec
- 17. Plan of the temple of Jupiter Nemæus near Corinth
- 18. Plan of the temple of Minerva at Priene
- 19. Plan of the temple of Diana at Eleusis
- 20. Plan of the temple of Jupiter at Ostia
- 21. Plan of the temple of Minerva in Assisi
- 22. Plan of a temple at Palmyra
- 23. Plan of the temple of Nemesis at Rhamnus
- 24. Plan of the temple of Hercules at Cori

- 25. Plan of the temple of Augustus at Pola
- 26. Plan of a temple at Selinuntiæ
- 27. Plan of a temple at Palmyra
 28. Plan of the temple of Fortune
- in Pompeii

 29. Plan of the chapel of Mercury
- in Pompeii
 30. Plan of the chapel of Isis in Pompeii
- 31. Plan of the temple of Æsculapius in Pompeii
- 32. Plan of the temple of Nike Apteros in Athens
- 33. Plan of the temple of Themis at Rhamnus
- 34. Plan of a temple at Selinuntiæ
- 35. Plan of the temple of Diana in Eleusis
- 36. Plan of an Ionic temple at Athens
- 37. Plan of the temple of Jupiter at Pompeii
- 38. Plan of a temple of the Sybil in Tivoli

PLATE 366.

Monumental and Triumphal Architecture in Greece and Rome

Figure

- 1-3. The Odeon of Pericles at Athens
- 4–7. The Pantheon in Rome
- 8-13. The island of the Tiber, with its temple and bridges
- 14. The bridge of Æmilius in Rome
- 15. The bridge of Senators in Rome
- 16ab. Triumphal arch at Xaintes 17ab. The arch of Gabius in
- Verona 18ab. Trajan's triumphal arch at Ancona
- 19ab. Trajan's triumphal arch at Beneventum
- 20. Triumphal arch of Septimius Severus in Rome
- 21. Constantine's triumphal arch in Rome
- 22ab. Pedestals at Palmyra
- 23*ab*. The tomb of the Horatii near Albano

PLATE 367.

Roman Memorial and Ceremonial Architecture

Figure

- 1-7. Hadrian's mausoleum in Rome
- 8, 9. The Trophæon of Augustus near Torbia
- 10. Sepulchre of Septimius Severus in Rome
- 11, 12. Trajan's triumphal arch in Beneventum
- 13, 14. Constantine's triumphal arch in Rome
- 15, 16. Triumphal arch of Marius in Orange
- 17, 18. Triumphal arch of Titus in Rome
- 19ab. Gate of Verona
- 20, 21. Triumphal arch of Augustus at Pola
- 22, 23. Gate of Mylasa
- 24-30. Trajan's column in Rome
- 31-36. Column of Marcus Aurelius in Rome

PLATE 368.

Greek and Roman Capitals and Bases

Figure

- 1. Doric capital from Pæstum
- 2. Doric capital from Delos
- 3. Doric capital from Pæstum
- 4. Doric capital from Albano5. Doric capital from Rome
- 6ab. Ionic capitals from Athens
- 7, 8. Ionic capitals from Rome
- Corinthian capital from Athens
- 10. Corinthian capital from Athens
- 11. Corinthian capital from Rome
- 12. Corinthian capital from Rome
- 13. Corinthian capital from Rome
- 14. Composite capital from Albano
- 15. Composite capital from Rome
- 16, 17. Attic base from Athens
- 18. Corinthian base from Athens19. Corinthian base from Tivoli
- 20. Corinthian base from Rome
- 20. Corinthian base from Rome 21. Corinthian base from Rome
- 22. Ornamented base from Nismes

- 23. Ornamented base from Rome
- 24. Crowning flower from Athens
- 25, 26. Ornamented shafts from Rome
- 27. Architrave soffit from Rome
- 28. Architrave soffit from Rome
- 29. Frieze from Palmyra
- 30. A Persian
- 31. A Caryatide
- 32, 33. Terminal statues (Hermæ)
- 34-38. Antefixæ

PLATE 369.

Classical Columns, Doors, and Balusters

Figure

- 1. Tuscan order
- . Doric order
- 3. Ionic order
- 4. Corinthian order
- 5. Composite order
- 6. Tuscan column arrangement with arches
- 7. Tuscan pedestal
- 3. Doric entablature
- 9. Details of the Doric order
- 10-13. Illustrating the reduction and torsion of columns
- 14. Scotia of the Attic base
- 14a. A Corinthian door
- 15. Doric door
- 16-19. Balusters

PLATE 370.

Classical Column Arrangement and Ornamentation

Figure

- 1. Tuscan column arragement
- 2. Doric entablature
- 3. Doric column arrangement
- 4. Ionic capital
- 5. Ionic column arrangement
- 6. Corinthian capital
- 7. Corinthian column arrangement
- 8. Composite capital
- 9. Arrangement of Composite columns

PLATE 371.

Classical Capitals and Bases

Figure

Tuscan capital and entablature

- 2. Doric base and pedestal
- 3. Doric capital and entablature
- 4. Ionic base and pedestal
- 5. Ionic capital and entablature
- 6. Corinthian base and pedestal7. Corinthian capital and
- 7. Corinthian capital and entablature
- 8. Composite base and pedestal
- Composite capital and entablature

PLATE 372. Classical Arcades

Figure

- 1. Tuscan arcade
- 2. 3. Doric arcades
- 4. 5. Ionic arcades
- 6, 7. Corinthian arcades
- 8. 9. Composite arcades

PLATE 373.

Primitive Standing Stone Architecture of Western Europe

Figure

- 1. Men-hir in Bretagne
- 2. Half Dolmen of Kerland
- 3. Dolmen of Trie
- 4. Double Dolmen of the Island
- of Anglesea
- 5. Trilith at St. Nazaire
- 6. Druid altar near Cleder7. Rocking stone near West
- Hoadley
 Rocking stone of
- Perros-Guyrech
- 9. Covered way in Morbihan
- 10. Dolmen of Locmariaquer
- 11. Grotto near Esse
- 12. Grotto des Fées near Tours13, 14. The witches' grotto near
- Saumur
- 15. Mound at Salisbury16. Galleries in a mound near
- Pornic
 17. Section of a mound in the Orkneys
- 18. Pierced stone near Duneau
- and Gallic Tomb

 19. Cromlech from the Orkneys

PLATE 374.

Traditional Chinese Architecture

Figure

1–11. Details of Chinese houses

- 12. Chinese ceiling
- 13. Chinese window
- 14, 15. Chinese roofs
- 16. Dwelling of a mandarin
- 17. Porcelain tower near Pekin
- 18, 19. Pagoda at Ho-nang
- 20. Entrance to the temple of Confucius in Tsing-hai

PLATE 375.

Pre-Columbian Architecture of Central America

Figure

- Bridge in the district of Tlascala
- . Temple at Xochicalco
- 3. Pyramid of Teotihuacan
- 4. The house of the ruler in Yucatan
- 5ab. Details from the same
- Pyramid of Tuzapan
- 7. Pyramid of Papantla
- 8. Fragment from the front of the Temple of the Two Serpents in Uxmal

PLATE 376.

Early Christian Architecture

Figure

- 1. Plan of St. Marcelline's church in Rome
- Plan of St. Martin's church in Tours
- 3. Plan of the church of Parenzo
- 4. Plan of St. Paul's before the walls of Rome
- Plan of St. Peter's basilica in Rome
- 6. Plan of the basilica Santa Maria Maggiore in Rome
- 7. Plan of the church of the Holy Cross, Jerusalem
- 8-13. The basilica St. Lorenzo in Rome
- 14. Church of St. Agnes near Rome
- 15. Basilica of St. Stephen in Rome
- 16. Romanesque basilica
- St. Clement's basilica in Rome
- 18. Rear view of a basilica
- 19, 20. Ciborium and choir of St. Clement's in Rome
- 21-24. Baptisteries

- 25-27. Baptismal fonts
- 28. Baptistery in Cividale
- 29. Baptistery in the basilica of St. Agnes in Rome
- 30. Cloister in St. Paul's basilica before Rome

PLATE 377. **Byzantine Architecture**

Figure

- 1. Panhagia Nicodimo in Athens
- 2. Church of Samara in Greece
 - 3, 4. St. Sophia's in Constantinople
 - 5-12. The church of Theotokus in Constantinople
 - 13, 14. Details of the Panhagia Nicodimo
 - 15. St. John's Church in Pavia
- 16. Church in Trani
- 17. St. Castor's church in Coblentz
- 18. Mausoleum of Theodoric in Ravenna
- 19. Capital from the Turkish baths in Constantinople

PLATE 378. Byzantine Architecture

Figure

- 1-8. St. Vital's church in Ravenna
- 9-17. The Catholicon in Athens
- 18. Plan of St. Sophia's in Constantinople
- 19. Plan of the mosque Achmed in Constantinople

PLATE 379.

Byzantine and Early Romanesque Architecture

Figure

- 1, 2. St. Peter's basilica in Rome
- 3-5. Cathedral of Pisa
- 6, 7. St. Mark's church in Venice
- 8. Court of the mosque of Osman in Constantinople
- 9ab. Cathedral of Bonn
- 10, 11. Ruins of a Latin basilica near Athens
- 12. Plan of the church of Navarino
- 13. Side portal of St. Nicodemus's church in

- Athens
- 14. Choir of St. Theotokus's church in Constantinople
- 15-23. Details from Byzantine edifices
- 24. Plan of the church of St. Agnes in Rome
- 25. Plan of the basilica in Tyre

PLATE 380. Islamic Architecture

Figure

- Interior of the mosque of Cordova
- Interior of the hall
 Maksourah in the mosque of
 Cordova
- 3. Interior of the chapel Zancaron in Seville
- 4. Entrance of the villa El Generalife in Granada
- 5. Court of the mosque El Moyed in Cairo

PLATE 381. Islamic Architecture

Figure

- 1. The Court of the Lions in Alhambra
- 2-12. Details from Alhambra
- 13. The Golden Hall in Alhambra
- 14. The Hall of the Two Sisters
- 15. The mosque at Cordova, longitudinal section
- 16-25. Details from the same
- Mosque of Ebn Touloun in Cairo, longitudinal section
 Details from the same
- 27–33. Details from the same

PLATE 382. Islamic, Indian, and Early Romanesque Architecture

Figure

- 1. Plan of the mosque at Cordova
- 2-4. Details from the same
- 5. Plan of the mosque of Ebn Touloun at Cairo
- 6. Court in the same
- 7. Plan of the mosque of El-Moyed in Cairo
- Mausoleum at Bedjapur
 Kutub Minar near Delhi
- 10. The Antler Tower in Ispahan

- 11-20. The abbey of Lorsch
- 21-26. Basilica St. Saba at Rome

PLATE 383.

Cologne Cathedral; Medieval Architecture

Figure

- 1-39. Details illustrating the architecture of the Middle Ages
- 40. The cathedral of Cologne as it is to be

PLATE 384.

Various Architectural Styles of the Middle Ages

Figure

- Plan of the church St. Germain de Prés
- 2. Cross-arms of a transept
- 3. Portal of Notre Dame la Grand in Poitiers
- 4-15. Details illustrating the architecture of the Middle Ages
- 16, 17. The minster of Freyburg

PLATE 385.

Various Architectural Styles of the Middle Ages

Figure

- 1-41. Details illustrating the architecture of the Middle Ages
- 42. The minister of Strasburg

PLATE 386.

Medieval Cathedrals and Architectural Details

Figure

- 1-22. Details illustrating the architecture of the Middle Ages
- 23. The church of St. Michael and St. Gudula in Brussels
- 24. The cathedral of Antwerp
- 25. Interior of St. Stephen's church in Vienna

PLATE 387.

Medieval Cathedrals and Architectural Details

- **Figure**
- 1-19. Details illustrating the

- architecture of the Middle Ages
- 20. The minster at York
- 21. Interior of the cathedral of Milan
- 22. The cathedral of Burgos

PLATE 388.

Cathedral of Rouen; Architectural Details of the Middle Ages

Figure

- 1-44. Details illustrating the architecture of the Middle Ages
- 45. The cathedral of Rouen

PLATE 389.

Romanesque and Gothic Architecture

Figure

- 1. Plan of Notre Dame in Paris
- 2. Plan of the cathedral at Milan
- 3-39. Details illustrating the architecture of the Middle Ages
- 40. Interior of Notre Dame in Paris

PLATE 390.

Scenes and Details of Gothic Cathedrals and Abbeys

٠.

- Figure 1–12. Details from the cathedral of Cologne
- 13, 14. Cathedral of Magdeburg
- 15. Interior of the Collegiate church in Manchester
- 16. Interior of the church of St. Simon at Palermo
- 17. Interior of Melrose abbey
- 18. Crypt under the abbey of St.
 Denis

PLATE 391.

Ecclesiastical and Secular Architecture of the Renaissance

Figure

- The church of St. Zacharias in Venice
- 2-5. The church of Notre Dame in Vetheuil
- 6-14. Church near the charter-house near Pavia
- 15-18. The royal palace in Venice

- 19. Portal of the Ecole des Beaux Arts in Paris
- 20. Triumphal arch of Alphonso I. in Naples

PLATE 392.

Renaissance Churches and **Architectural Details**

Figure

- 1-3. Church of the Redeemer in Venice
- 4-16. Church of St. Francis in Perugia
- 17. Plan of the church of St. Zacharias in Venice
- 18, 19. Monument of the Doge Vendramini in Venice
- 20-22. Monument of Louis XII. in St. Denis
- 23. Capital from the triumphal arch of Alfonso I. in Naples

PLATE 393. Saint Peter's in Rome

Figures 1-4.

PLATE 394.

Italian Churches of the Middle Ages and Renaissance

Figure

- 1, 2. The church Della Superga in Turin
- 3, 4. The church of the Assumption in Genoa
- The basilica in Vicenza
- The church of Santa Maria del Fiore in Florence
- 7-9. The church San Pietro in Montorio in Rome
- 10. The church delle Figlie in Venice
- 11. The church of Trevignano

PLATE 395.

European Churches of Various Architectural Styles

Figure

- 1. Interior of St. Magdalene's church in Paris
- The church of Notre Dame de Lorette in Paris
- 3, 4. The church of St. Gervais and St. Protais in Paris

- 5. The church of St. Paul and St. Louis in Paris
- 6, 7. The church of Mary Magdalene at Bridgenorth
- All Saints church in Munich
- The basilica St. Boniface in Munich
- 10. The church of San Giorgio Maggiore in Venice
- 11. The church of St. Francesco de la Vigna in Venice
- 12. The church of San Pietro in Montorio in Rome
- 13, 14. Chapel at Fresnes
- 15. Plan of the basilica Bibiana in Rome
- 16. Plan of the church of St. Agnes in Rome
- 17. Plan of the basilica Julia in Rome
- 18. Plan of the church St. Cosmo e Damiano
- 19, 20. Church Madonna degli Angeli in Rome
- 21, 22. The church of St. Cyriacus in Ancona

PLATE 396.

European Churches of the Sixteenth and Seventeenth Centuries

Figure

- 1-6. The Hotel des Invalides in **Paris**
- 7. 8. St. Isaac's church in St. Petersburg
- 9-11. The church of the Sorbonne in Paris
- 12-14. The church of the Assumption in Paris

PLATE 397.

European Churches of the Seventeenth and Eighteenth **Centuries**

Figure

- 1, 2. St. Magdalene's church in **Paris**
- 3-5. The Pantheon in Paris
- 6. Plan of Notre Dame de Lorette in Paris
- 7, 8. The Garrison church at Potsdam

- 9. The church of St. Ignatius in Rome
- 10, 11. The church of San Carlo alle Ouattro Fontane in Rome
- 12. The bell tower of Palermo

PLATE 398.

Major European Cathedrals

Figure

- 1-3. St. Paul's church in London 4. 5. Church of St. Sulpice in
- **Paris**
- 6. Plan of Santa Maria del Fiore in Florence
- 7. Interior of the church of All Saints in Munich
- 8. Interior of the church in Faubourg Au in Munich

PLATE 399.

European Churches of Various Architectural Periods

Figure

- 1. Interior of the Invalides' church in Paris
- Church of St. Louis in 2. Munich
- Werder church in Berlin
- The chapel of St. Ferdinand at Sablonville
- The church Santa Maria della Vittoria in Rome
- 6. 7. The church della Consolazione in Todi
- Ground plan of a church in the form of a Latin cross
- Plan of the church San Andrea in Mantua
- 10-12. The chapel of the Knights of Malta in St. Petersburg
- 13. The clock tower in Venice

PLATE 400.

Secular Architecture of the Renaissance and Baroque Eras

Figure

- 1-4. The palace of Caserta near Naples
- Court of the Palazzo Saoli in Genoa
- Plan of the palace of Laeken
- Plan of the country seat of the duke of Argyle in Scotland

8-13. Markets

PLATE 401.

Palatial Architecture of Various Periods

Figure

- 1. 2. The Louvre in Paris
- 3. The papal Cancelleria in Rome
- The papal palace in Rome
- The Palazzo Paolo in Rome
- The Palazzo Sora in Rome
- The Palazzo Sacchetti in Rome
- 8. The Villa Medici in Rome
- 9. The Palazzo Giraud in Rome
- 10a-c. The Casa Silvestri in Rome
- 11. Ground plan of an antique Roman building

PLATE 402.

Palatial and Monumental Architecture of France and Germany

Figure

- 1. The palace of the Tuileries in Paris
- 2, 3. The navy department in
- 4. The Luxembourg palace in **Paris**
- 5. The palace of Laeken
- Plan of the Glyptothek in Munich
- 7-9. The column of the Place Vendôme in Paris
- 10ab, 11. The column of July in Paris
- 12, 13. The bell tower in Rome

PLATE 403.

Neo-Classical Architecture in France and Rome

Figure

- 1. The palace of Versailles
- The battle gallery in the same
- The Palazzo Doria Tursi in Genoa
- The Fontana Paolina in Rome
- The fountain of Marius
- 6-9. Doors from Roman palaces

PLATE 404.

Neo-Classical Architecture in Germany and Holland

Figure

- 1. 2. The Walhalla at Ratisbon
- 3ab. Candelabra from the same
- 4-6. The royal residence in Amsterdam
- The city hall at Maestricht
- 8. 9. The town hall in Neuenburg

PLATE 405.

Public Buildings in the **Neo-Classical Style**

Figure

- 1. The Capitol at Washington
- The Glyptothek in Munich
- 3. The edifice for exhibitions in Munich
- 4. The Exchange in New York
- 5-7. The Exchange in Paris 8. 9. Plans of the Exchange in
- Ghent
- 10. The University of Ghent 11. The Exchange in London

PLATE 406.

Monumental and Public **Architecture of Various Periods**

- **Figure** 1. The triumphal arch in Paris
- 2, 3. The Paris observatory
- 4. The theatre at Dresden
- 5, 6. The theatre in St. Petersburg
- 7. St. Charles theatre in New Orleans
 - The Custom-house in New York
- 9. Plan of the Palazzo del Te in
- Mantua 10-12. Casino in Liège
- 13. The museum in Cassel
- 14. Old Exchange in Amsterdam
- 15ab. Plans of caravansaries 16ab, 17. Watchhouses

18. Plan of the prison in Aix

PLATE 407.

Commercial Architecture

- **Figure** 1-4. Grain hall in Paris
- 5-7. Market of St. Germain in **Paris**

- 8. The market at Pavia
- 9, 10. The Magdalene market in Paris
- 11. Plan of the market in Pavia
- 12, 13. The Almeidan at Ispahan

PLATE 408.

Various European Prisons

Figure

- 1-14. The prison at Halle
- 15. Plan of the prison of Newgate in London
- 16-18. Plans of Prisons in Ghent, Milan, and Amsterdam

PLATE 409.

The Architecture of Bridges

Figure

- 1, 2. Bridge over the Rialto in Venice
- 3-6. Bridge at Ispahan
- 7. Bridge of Gignac
- 8–10. Bridges at Paris
- 11. Waterloo Bridge in London
- 12. Bridge of St. Maizence
- 13. Bridge of Kösen
- 14. Bridge of Zwetau
- 15. Bridge over the Taff
- 16. Bridge over the Melfa
- 17. Bridge of the Ticino
- 18. Bridge near Lyons
- 19, 20. Chinese bridges
- 21. Bridge of Toledo
- 22. The bridge of Colebrookdale

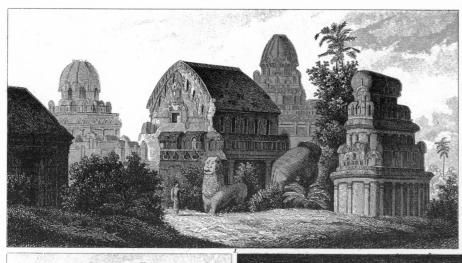

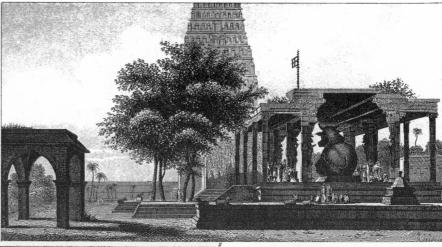

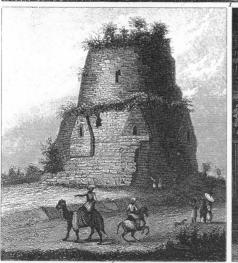

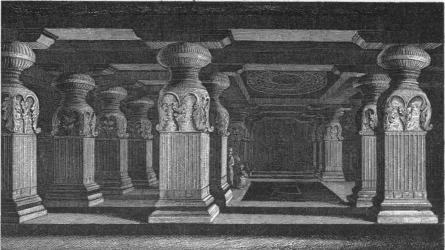

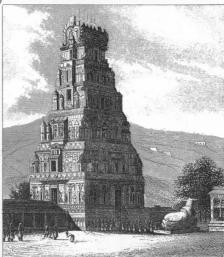

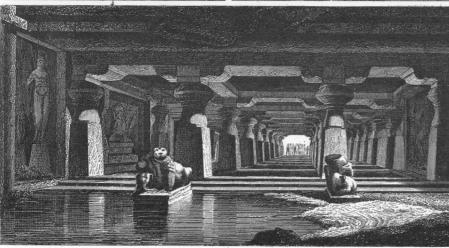

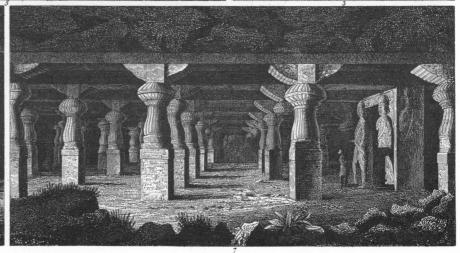

Henry Winkles scu

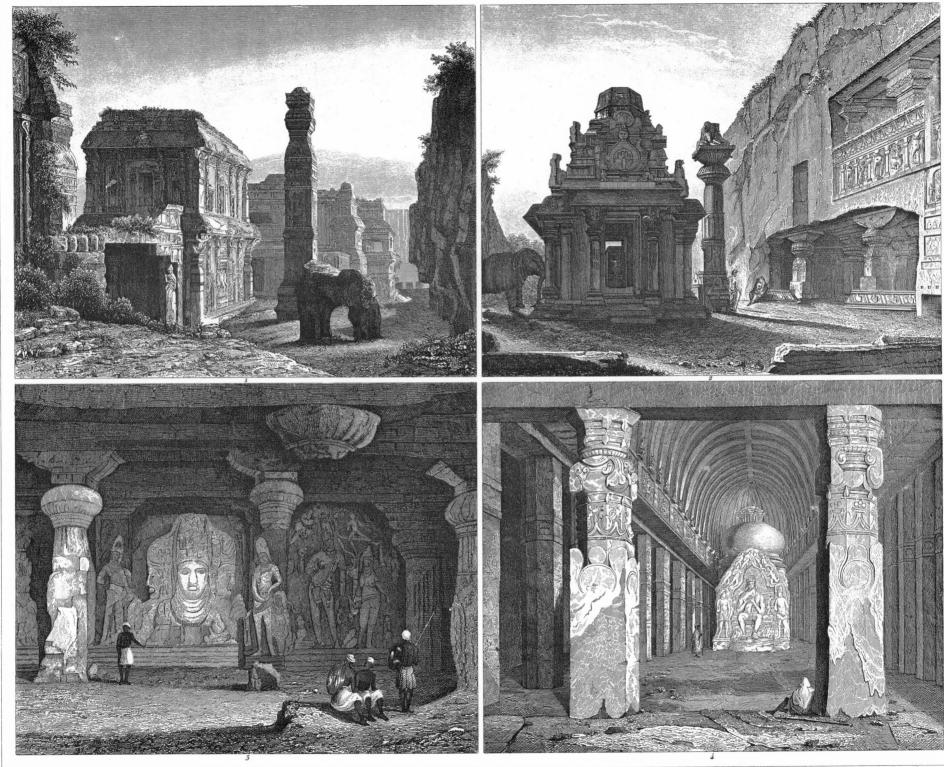

Henry Winkles sculp!

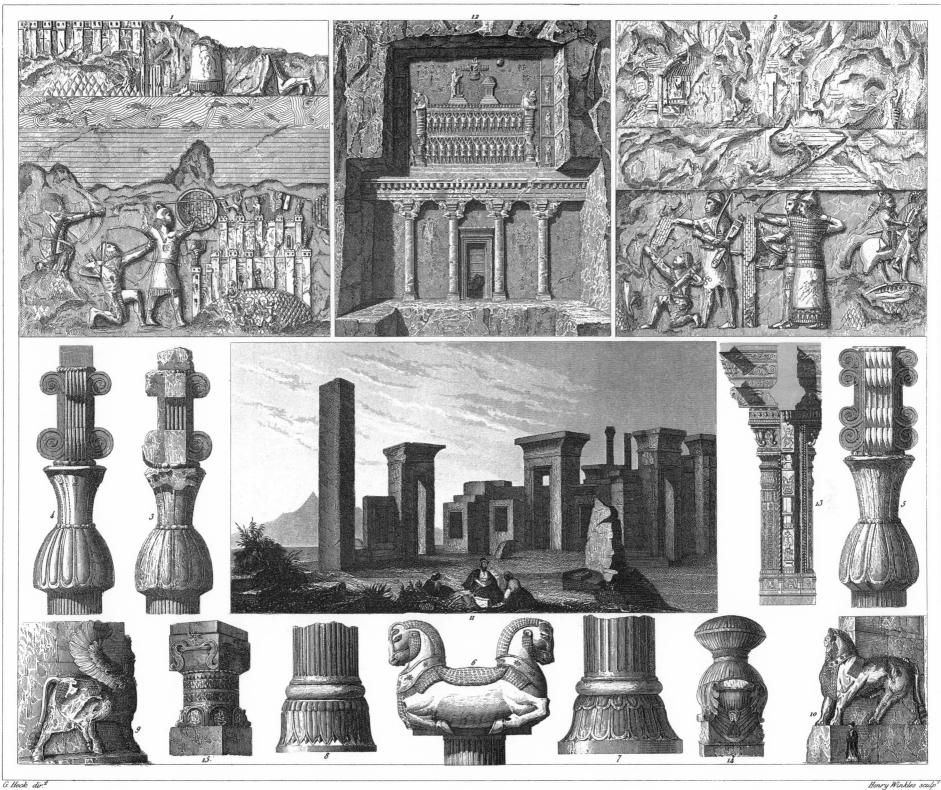

Honry Winkles soulp!

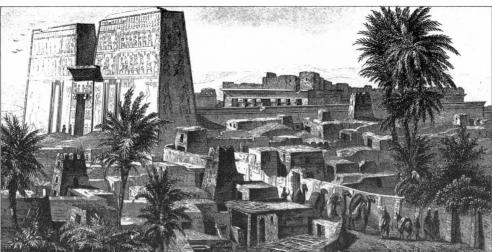

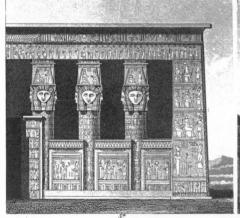

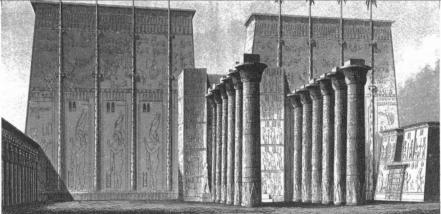

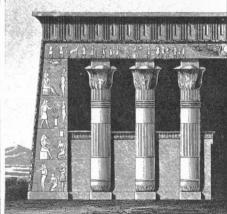

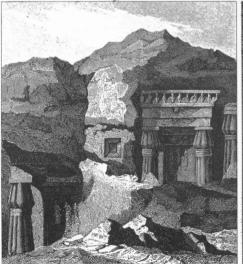

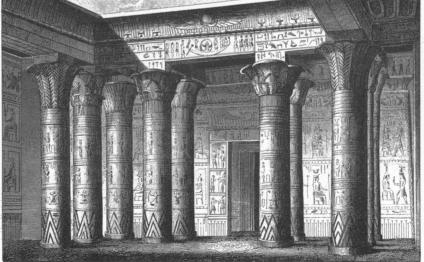

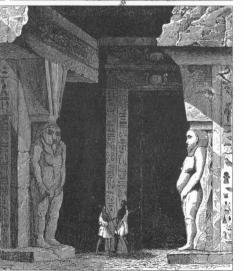

G Heck dir

Henry Winkles sculpt

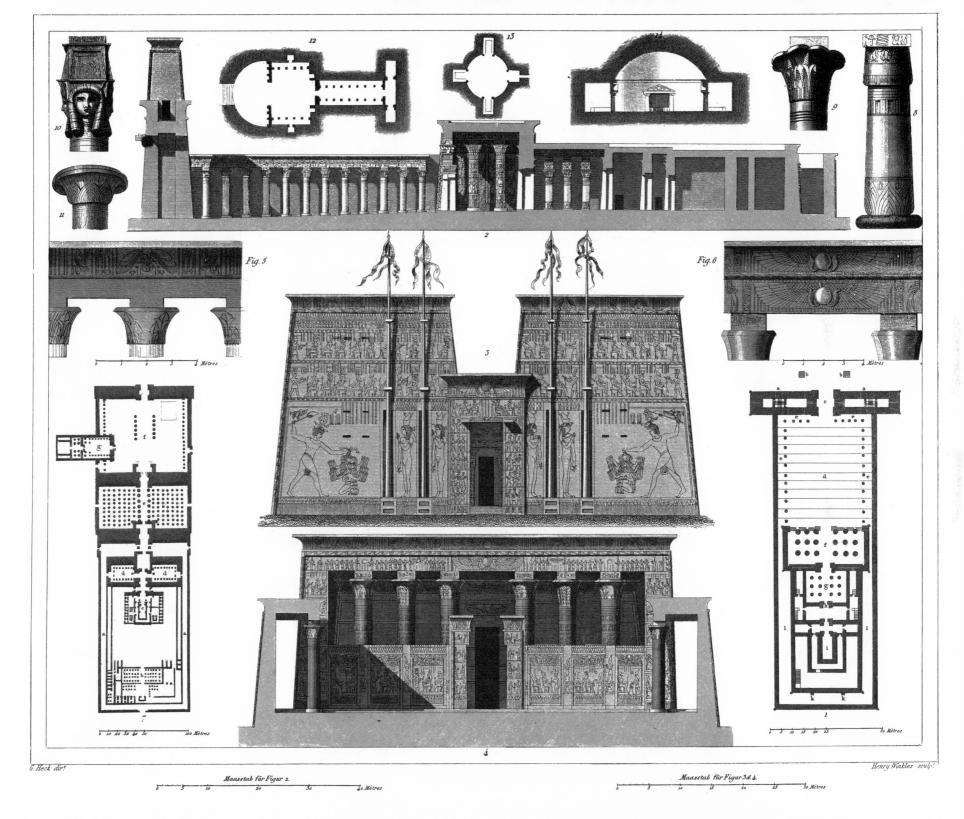

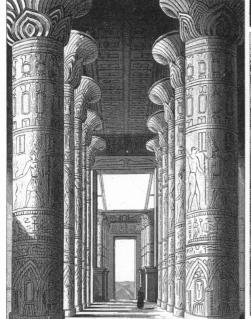

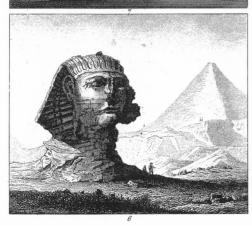

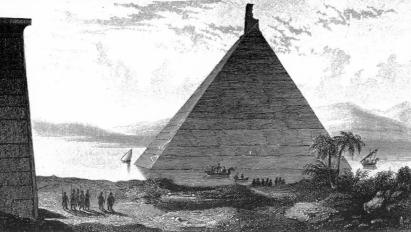

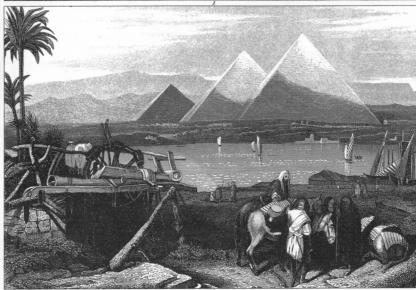

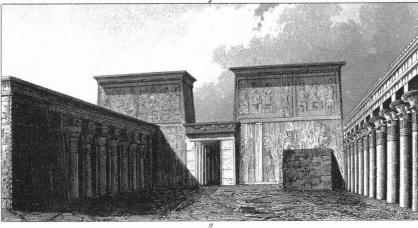

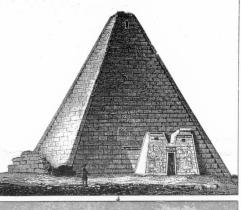

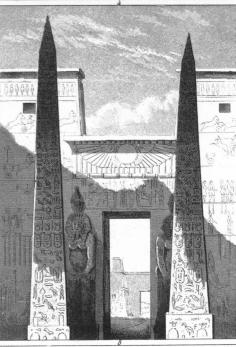

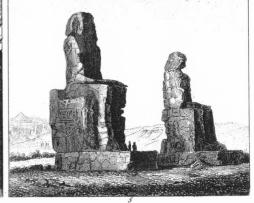

Henry Winkles scuin!

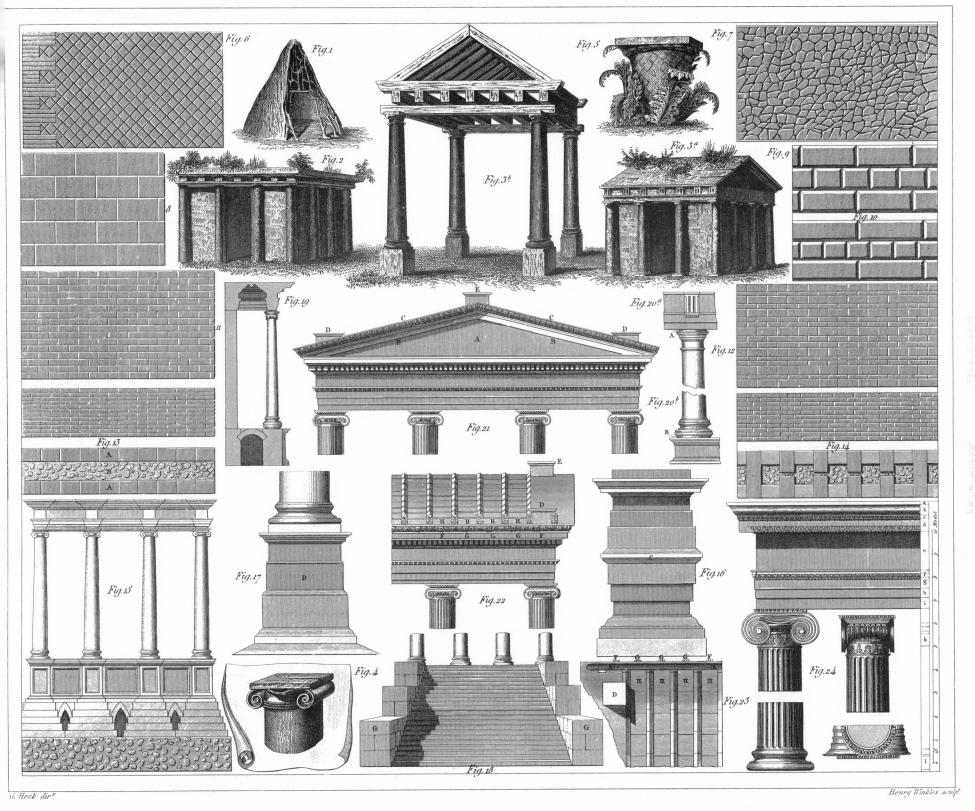

PLATE 356. ILLUSTRATING GENERAL CONSIDERATIONS ON ARCHITECTURE

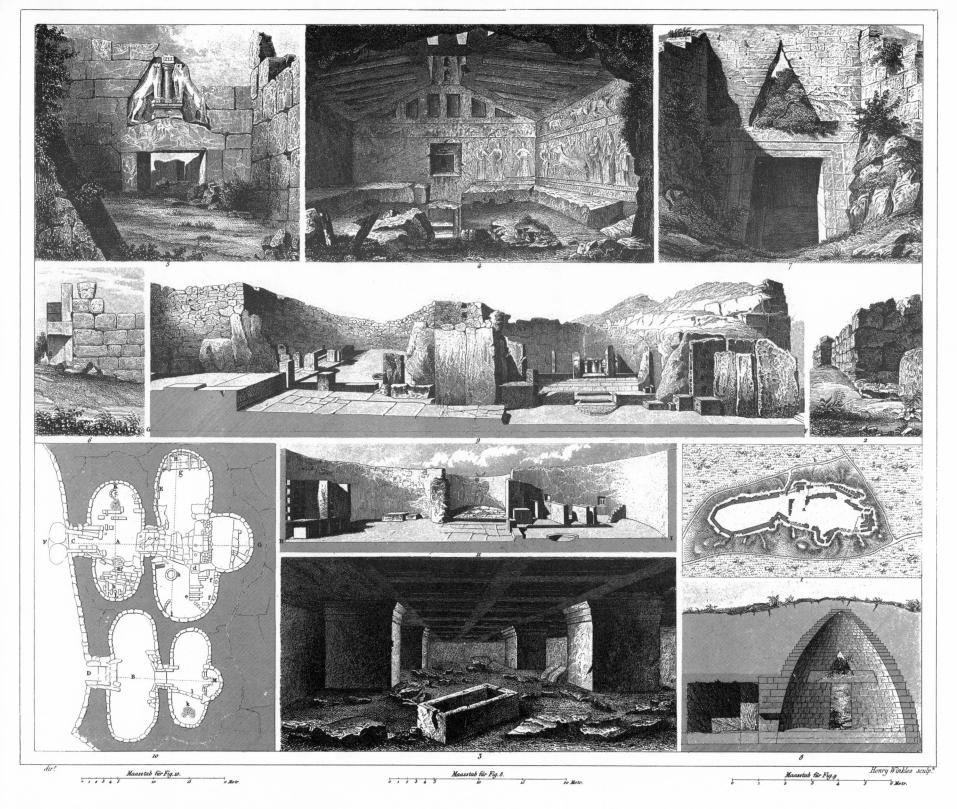

PLATE 357. ANCIENT ARCHITECTURE

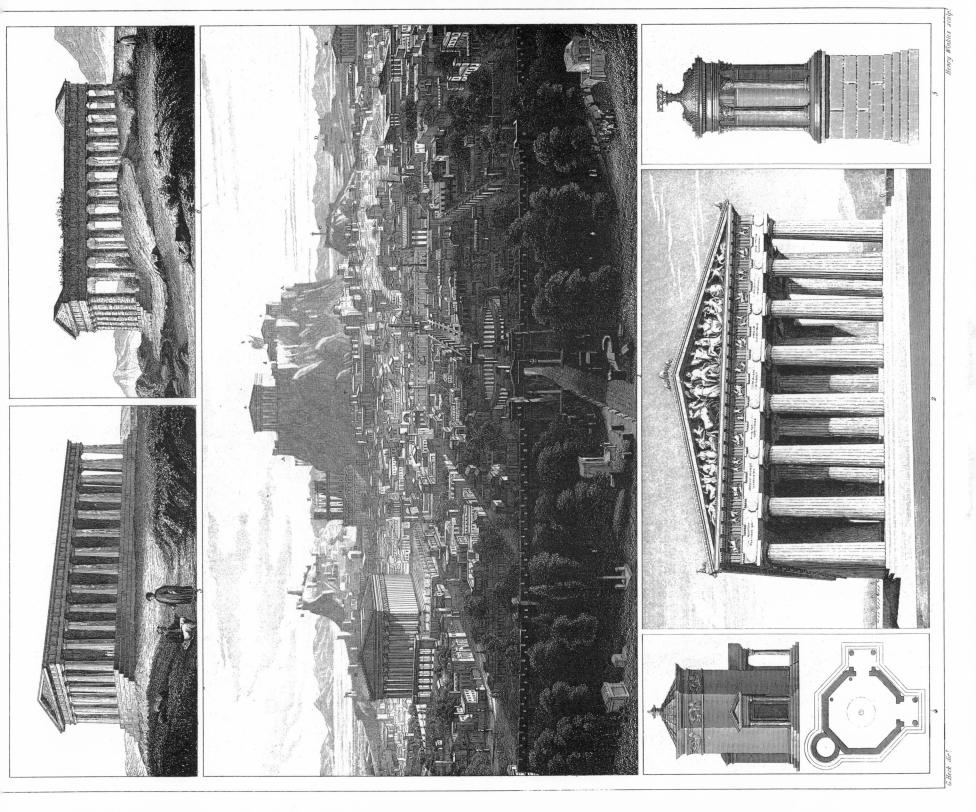

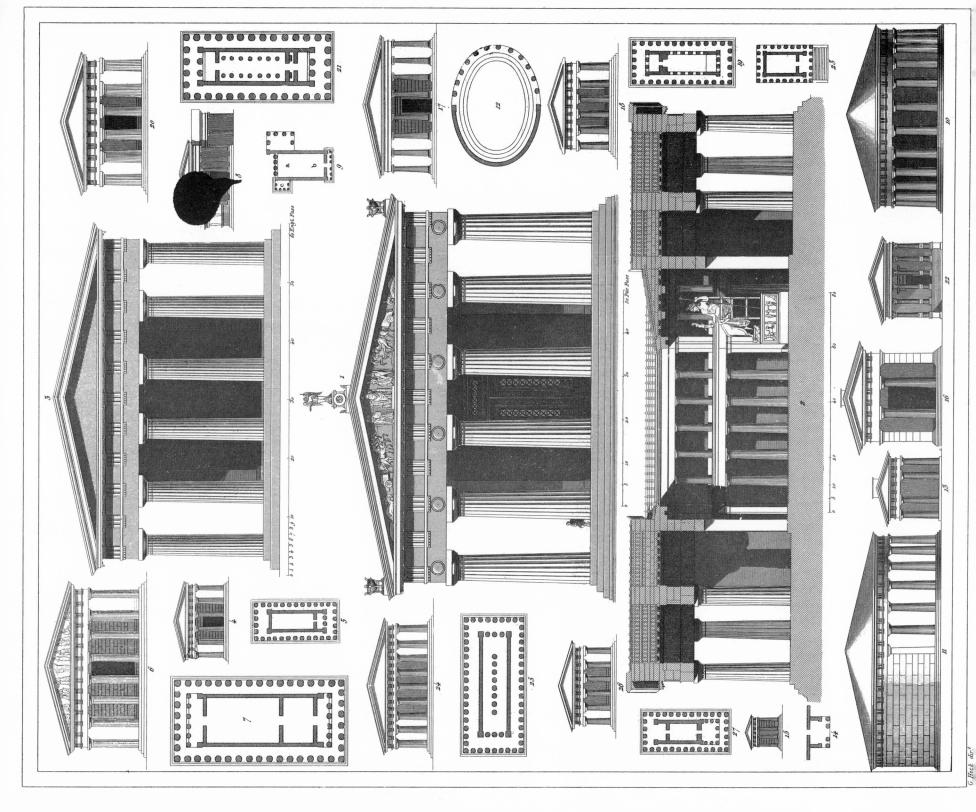

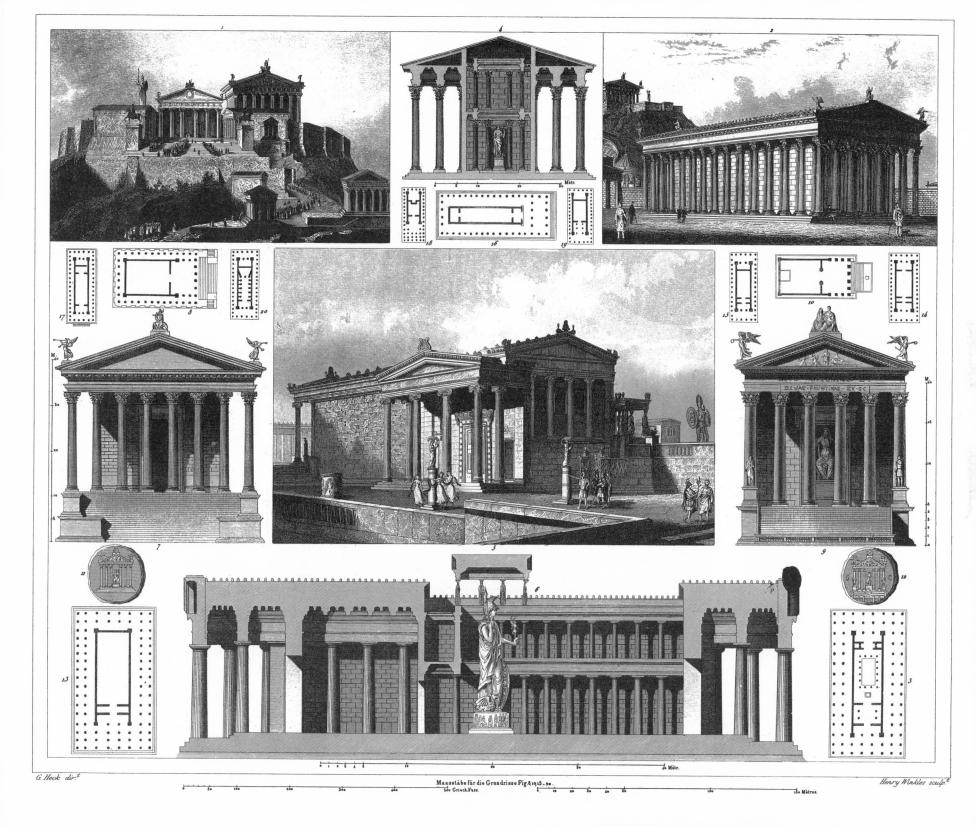

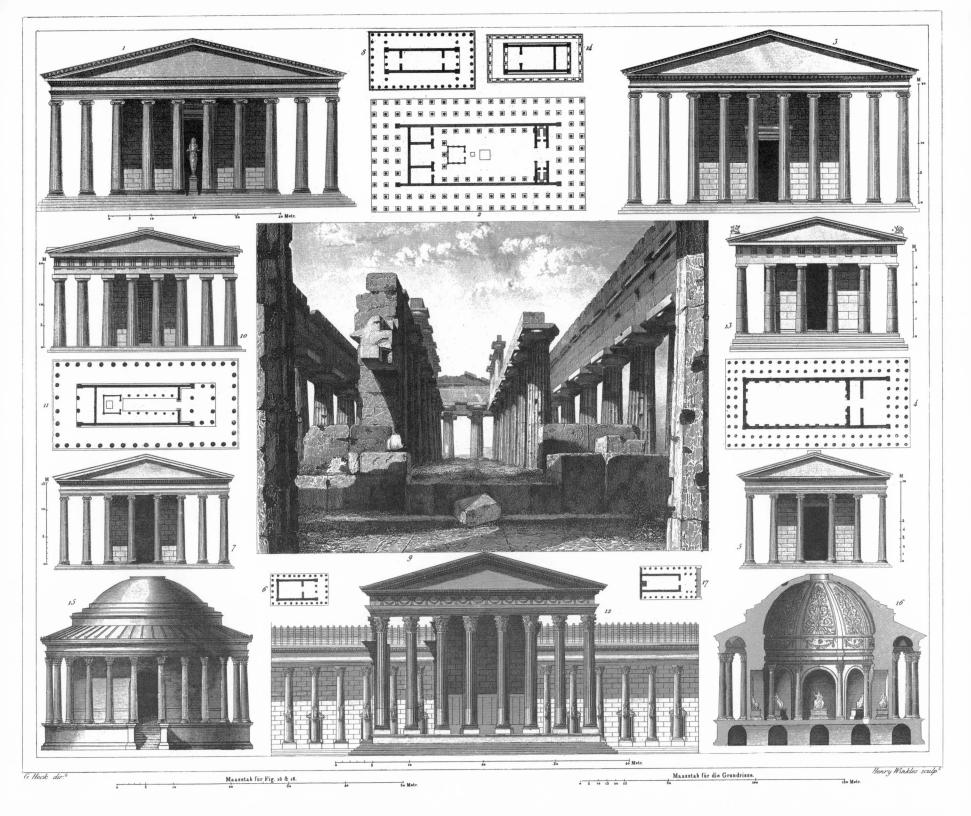

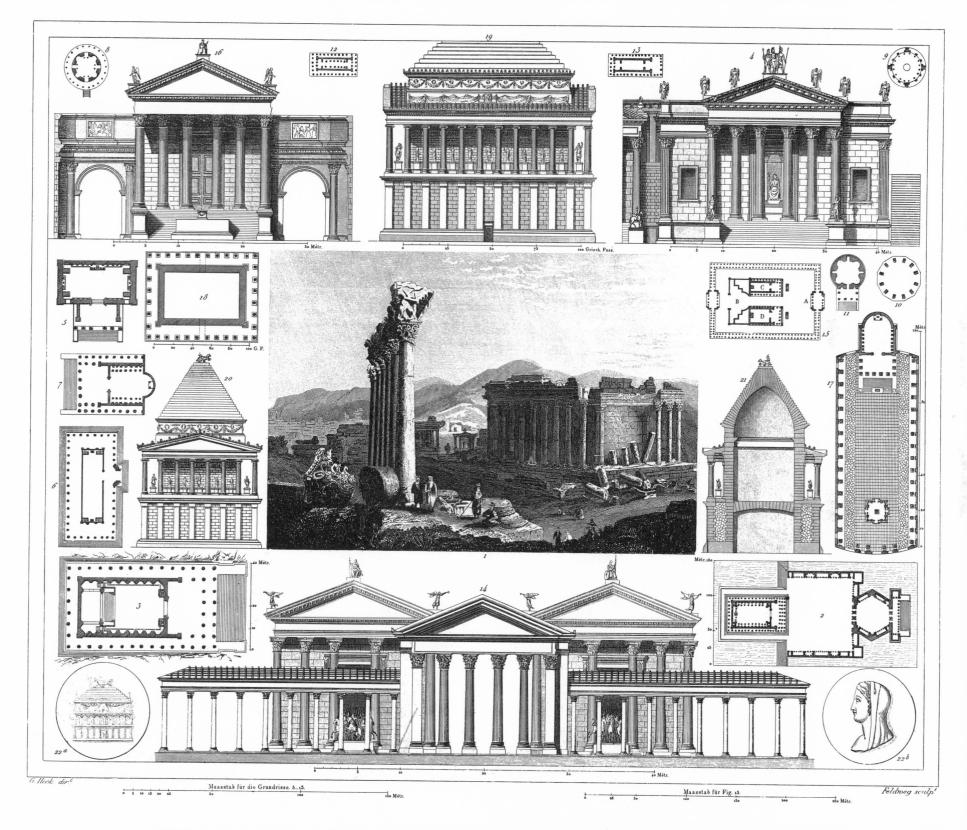

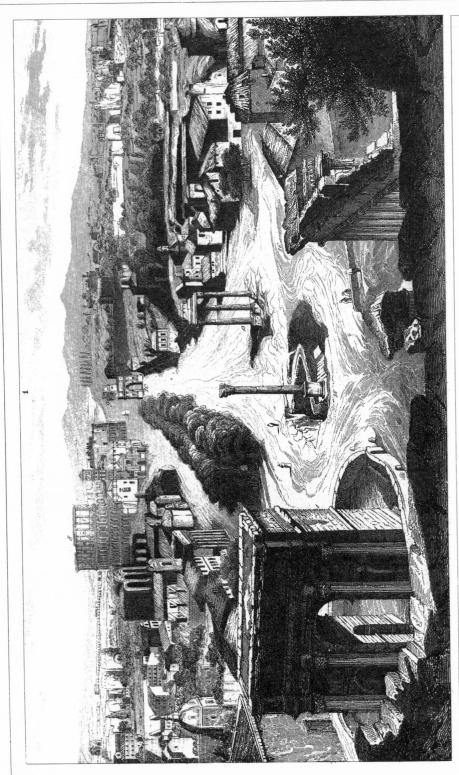

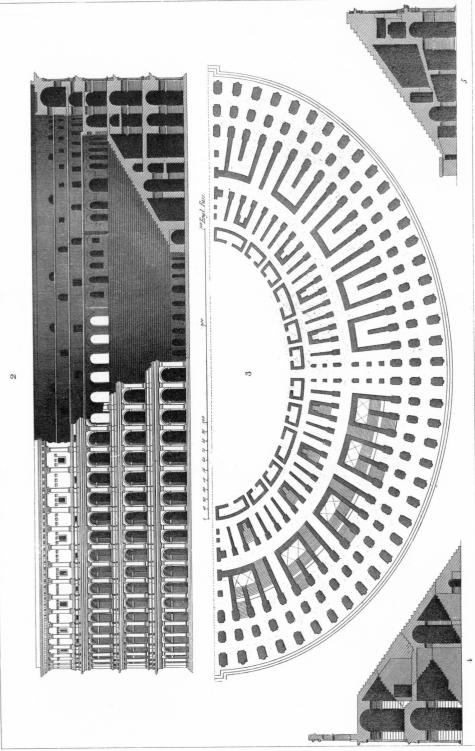

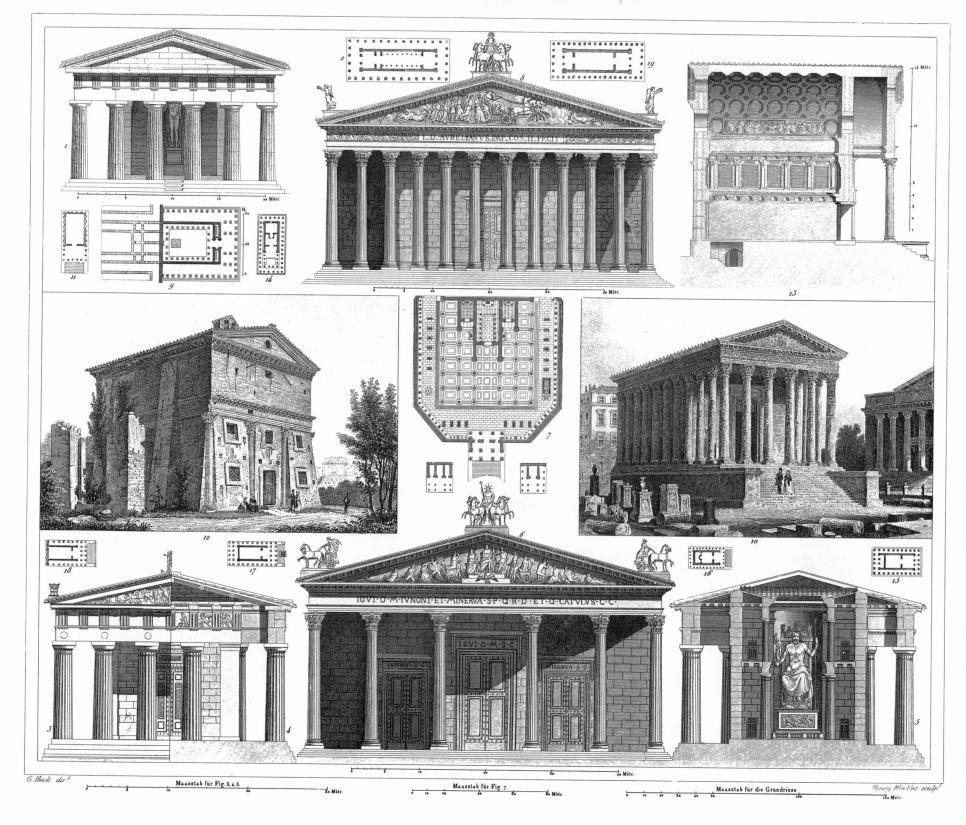

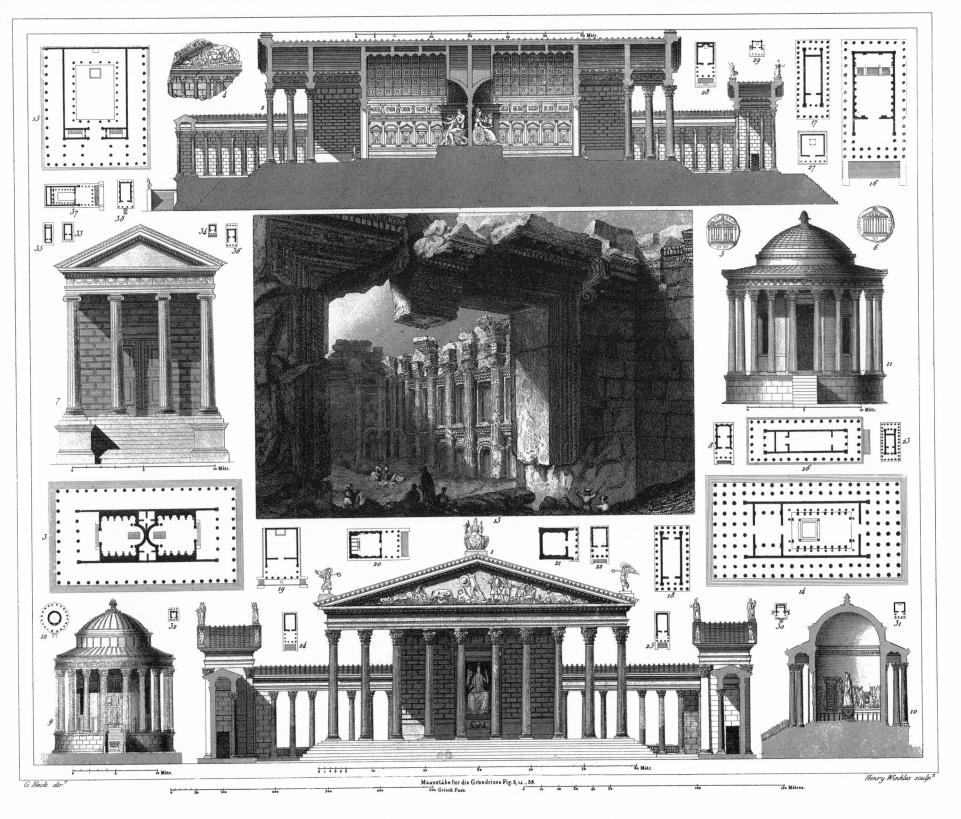

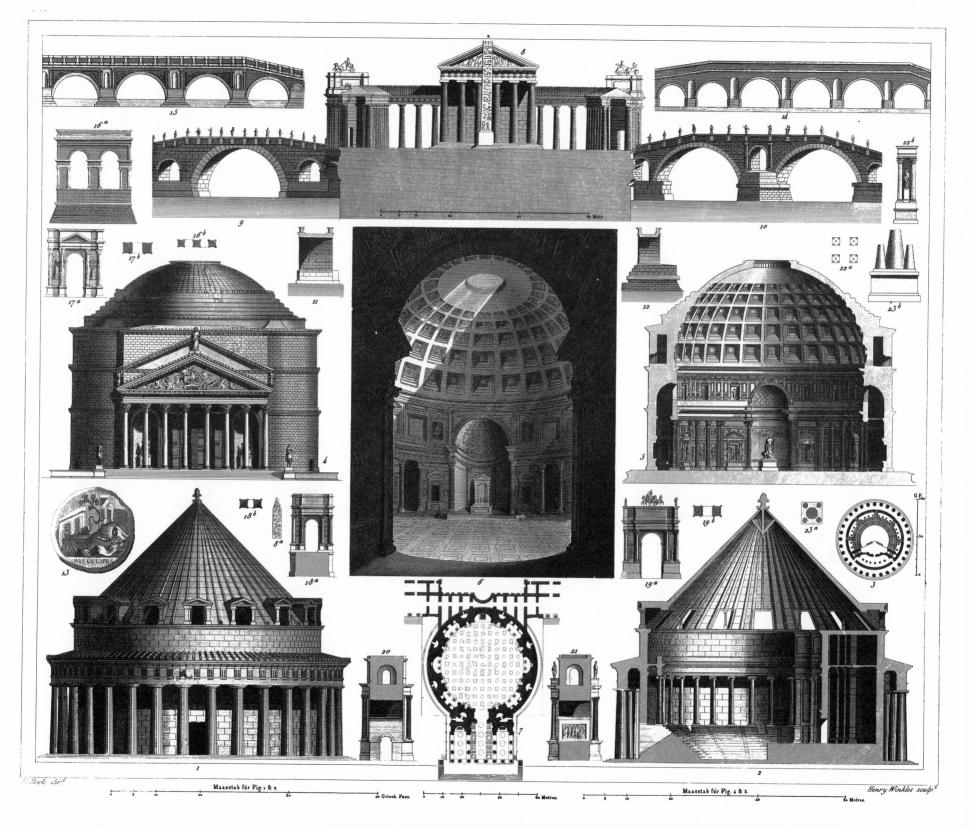

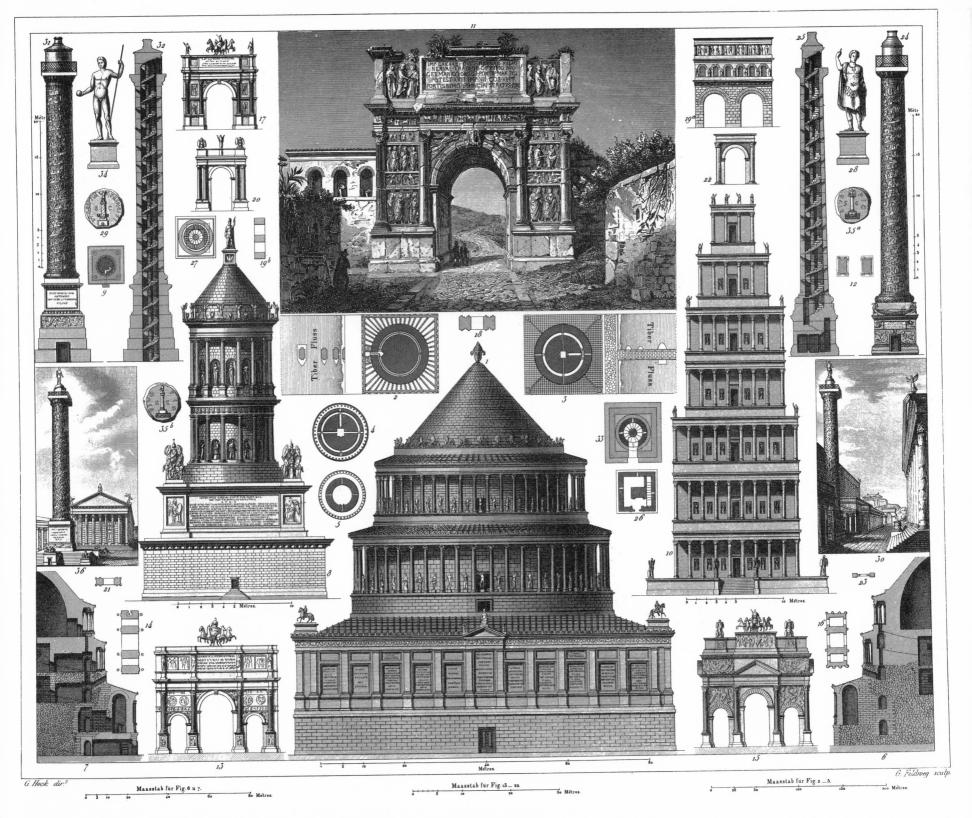

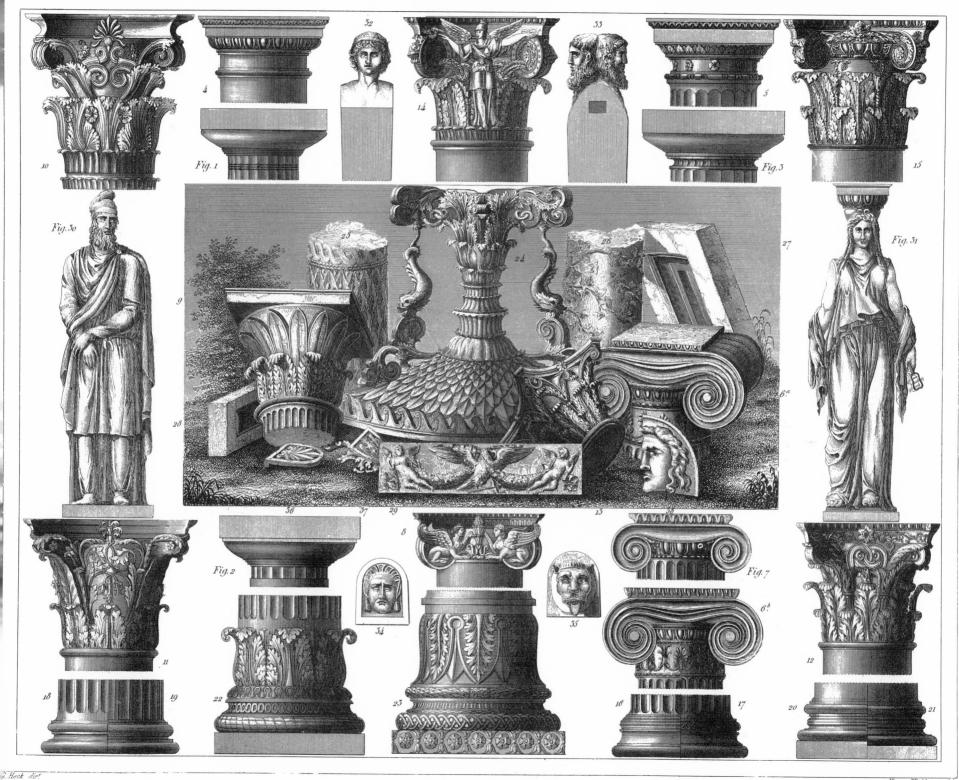

Henry Winkles sculp!

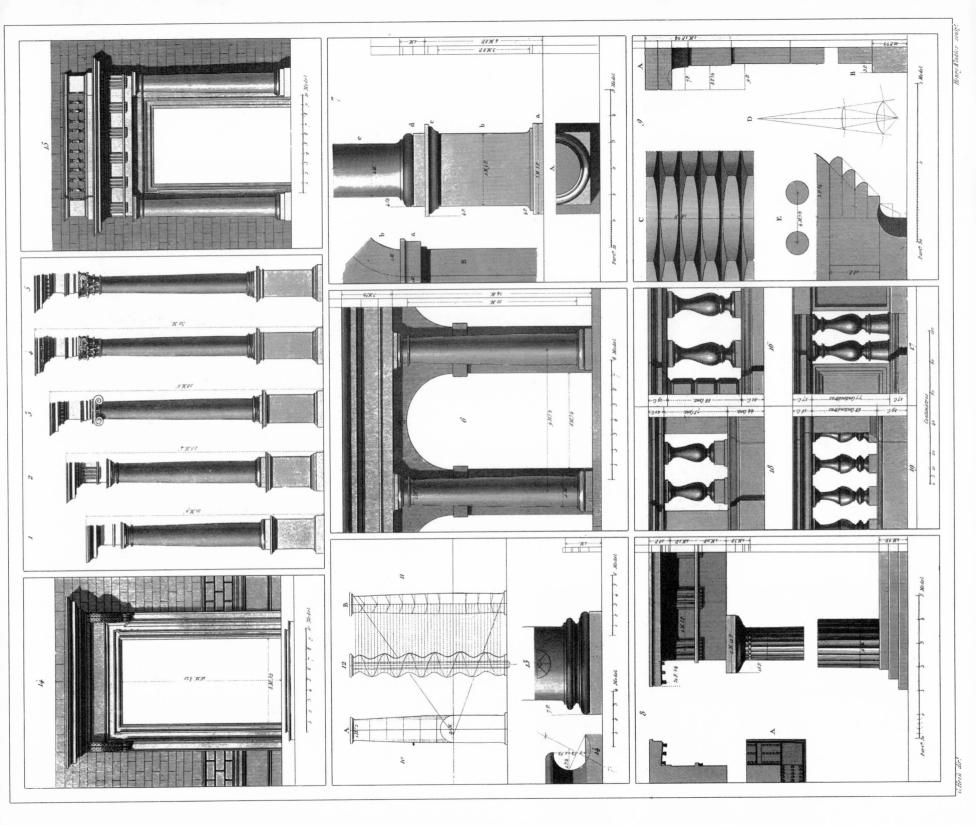

PLATE 369. CLASSICAL COLUMNS, DOORS, AND BALUSTERS

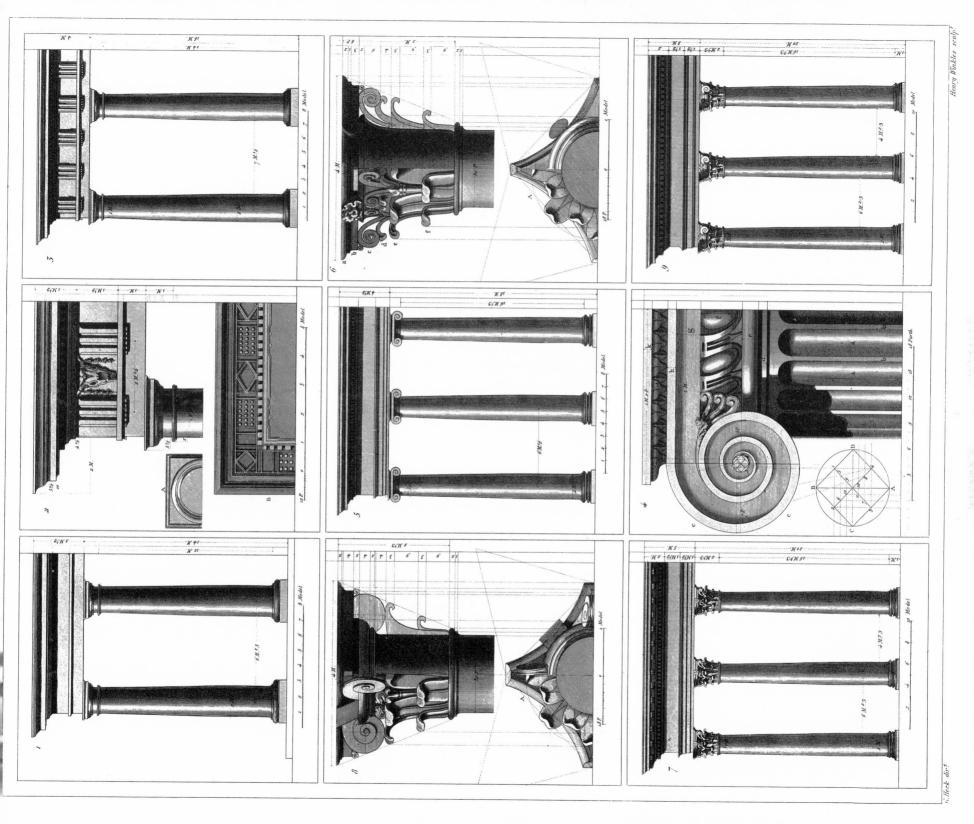

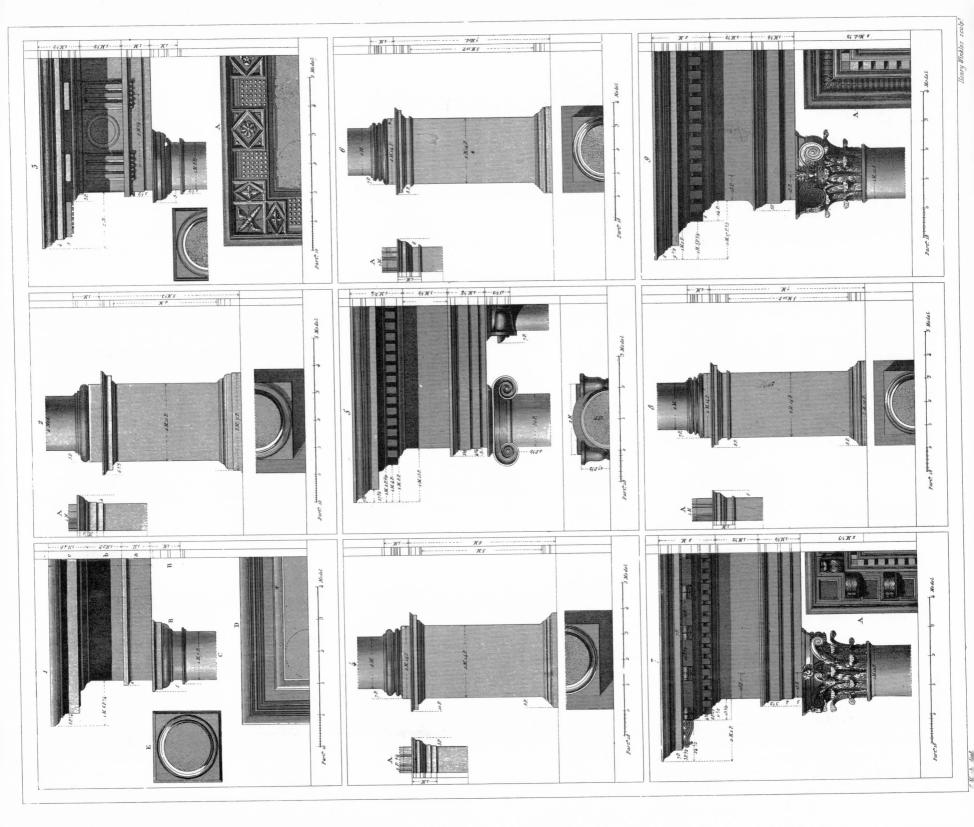

PLATE 371. CLASSICAL CAPITALS AND BASES

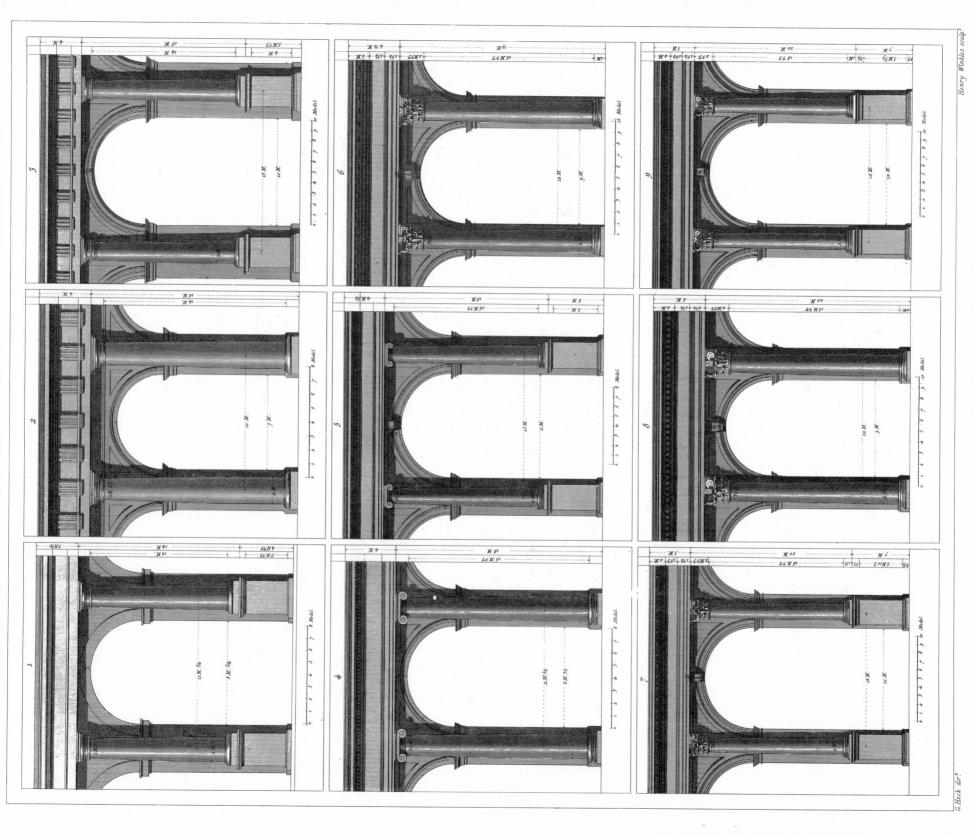

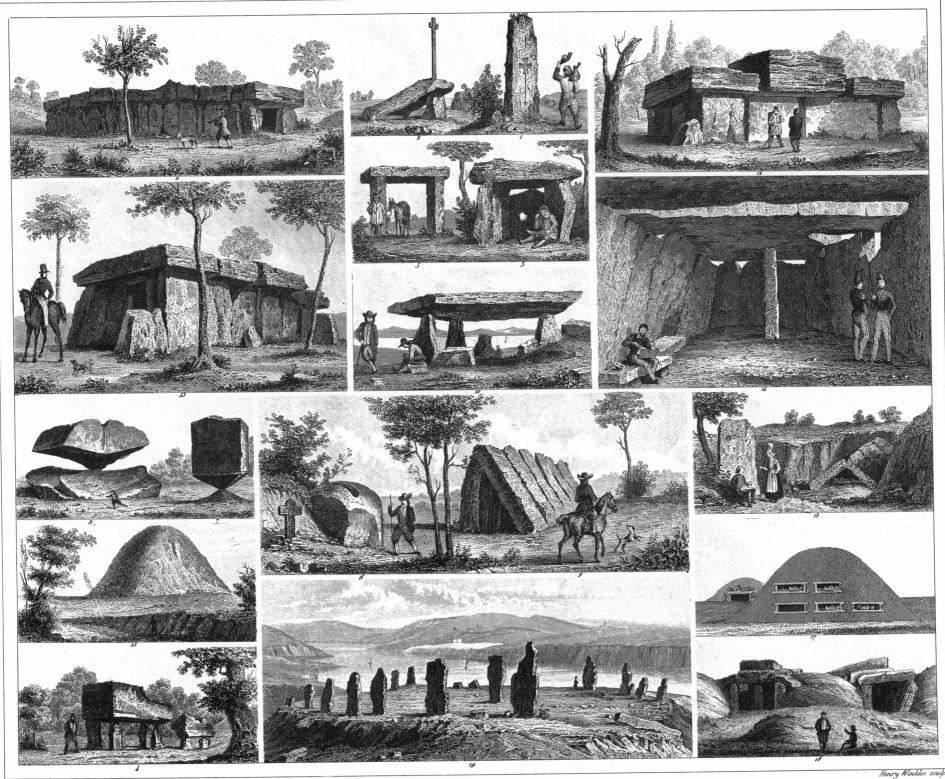

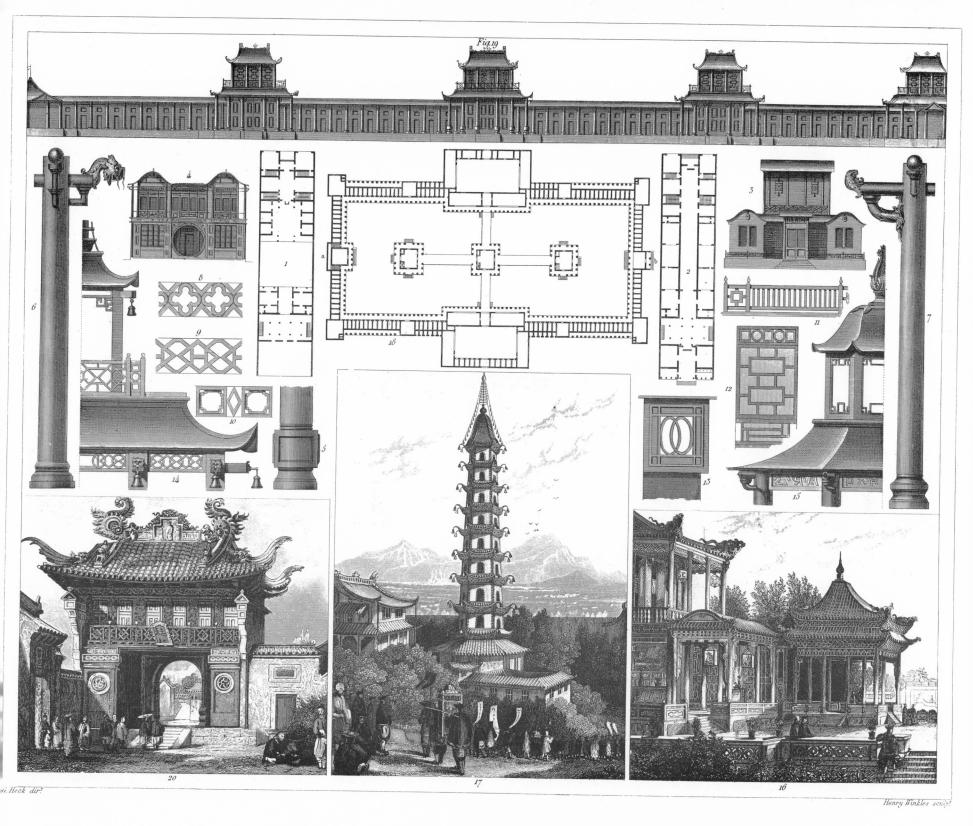

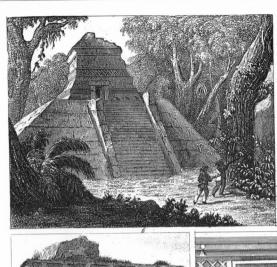

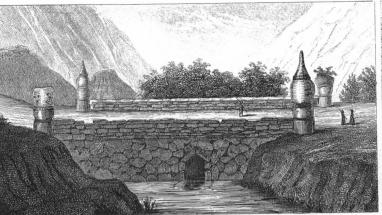

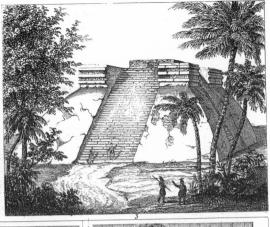

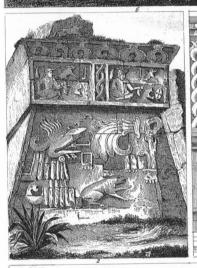

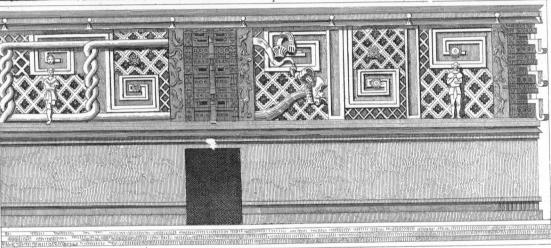

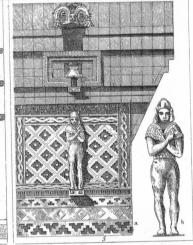

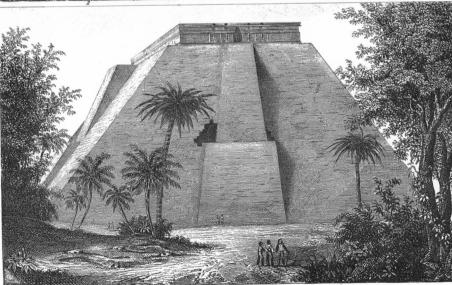

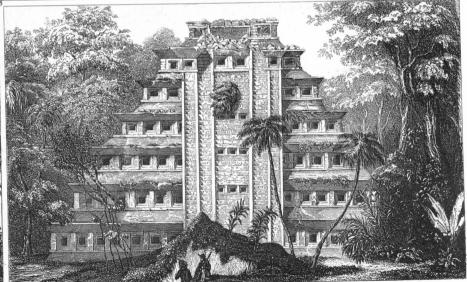

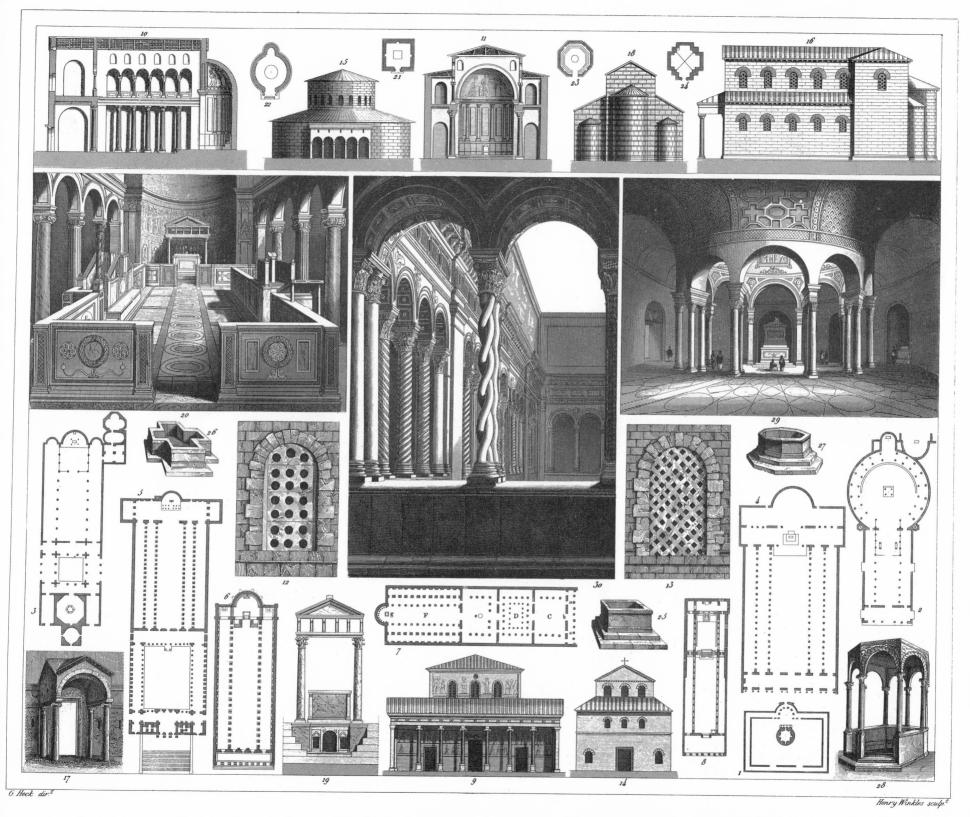

PLATE 376. EARLY CHRISTIAN ARCHITECTURE

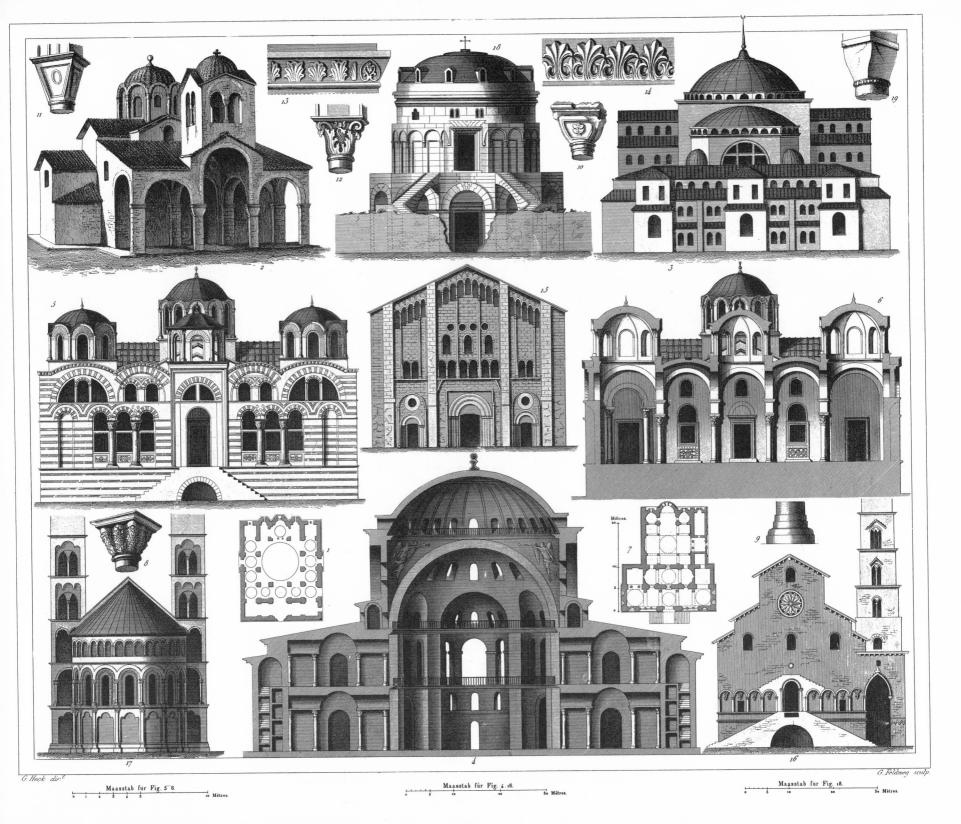

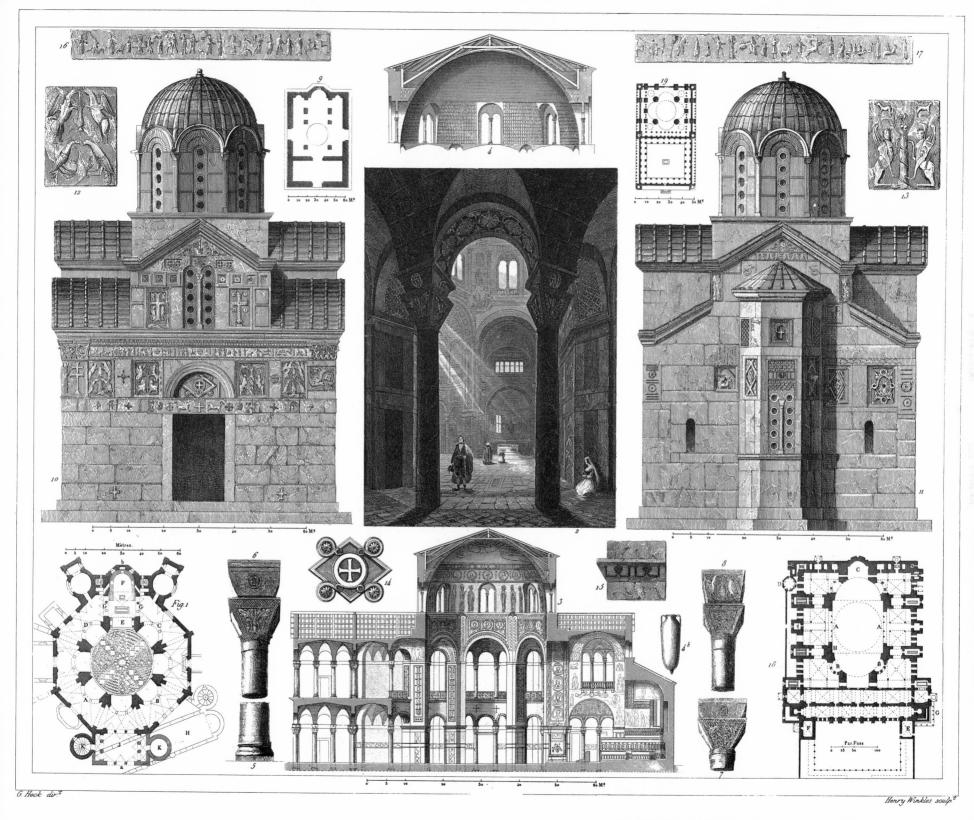

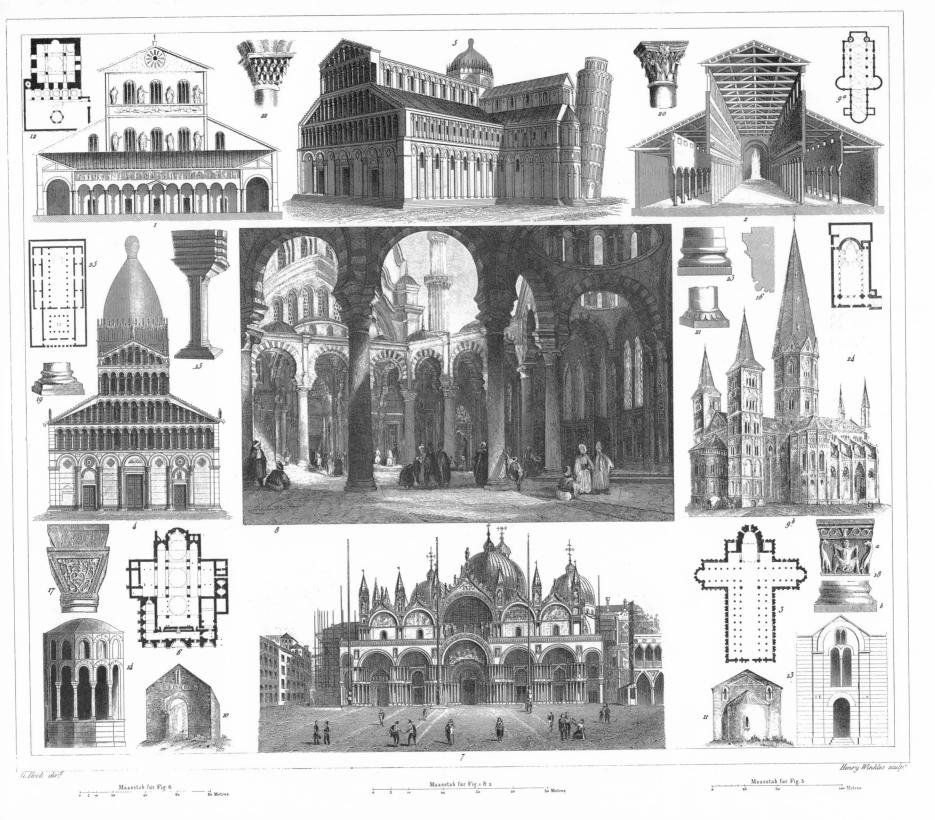

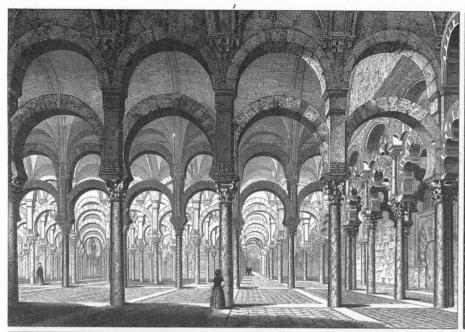

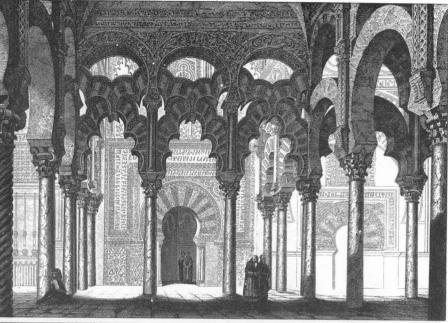

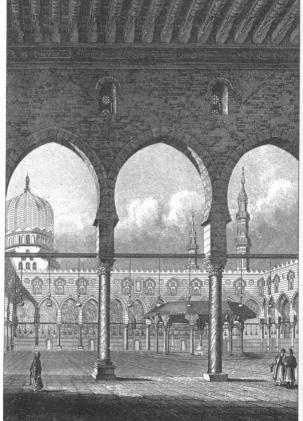

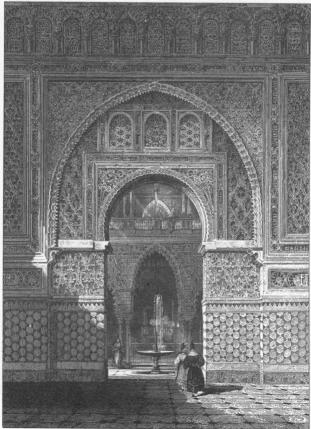

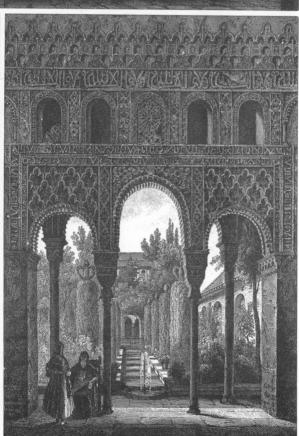

G. Heck dir.t

Henry Winkles scul

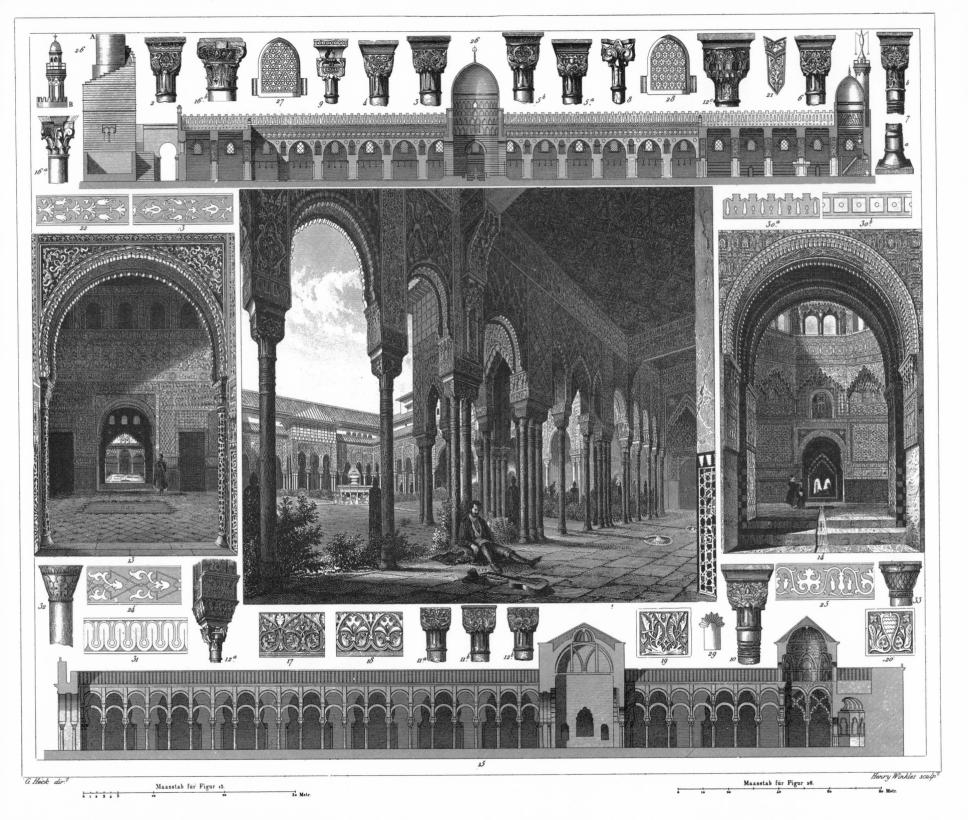

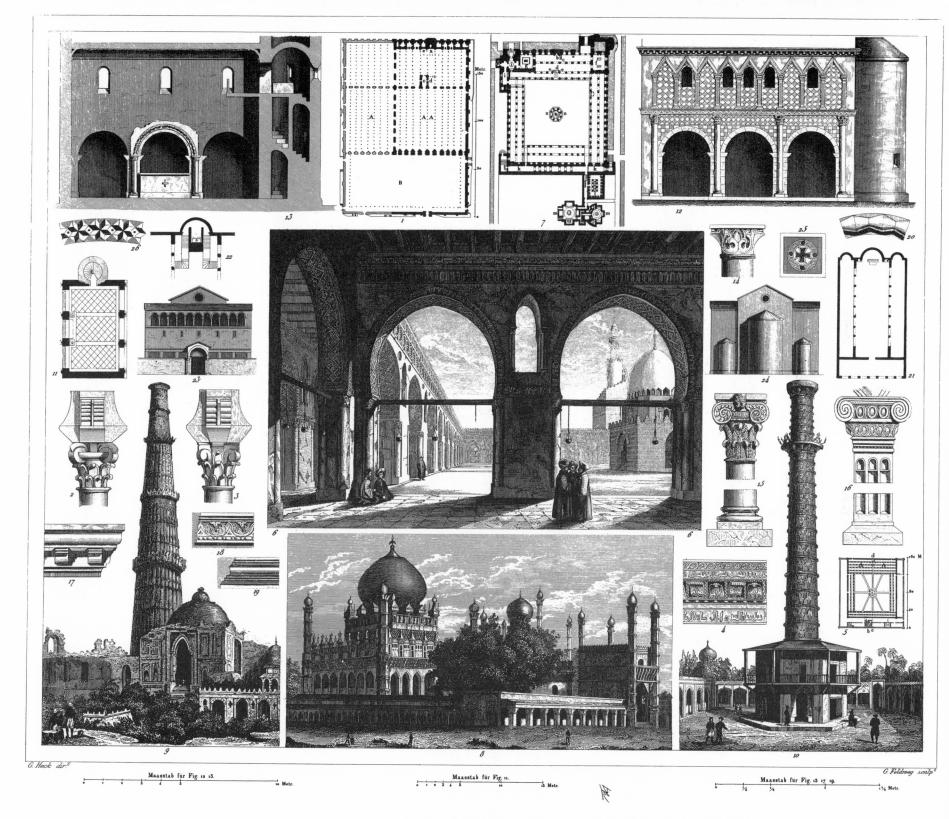

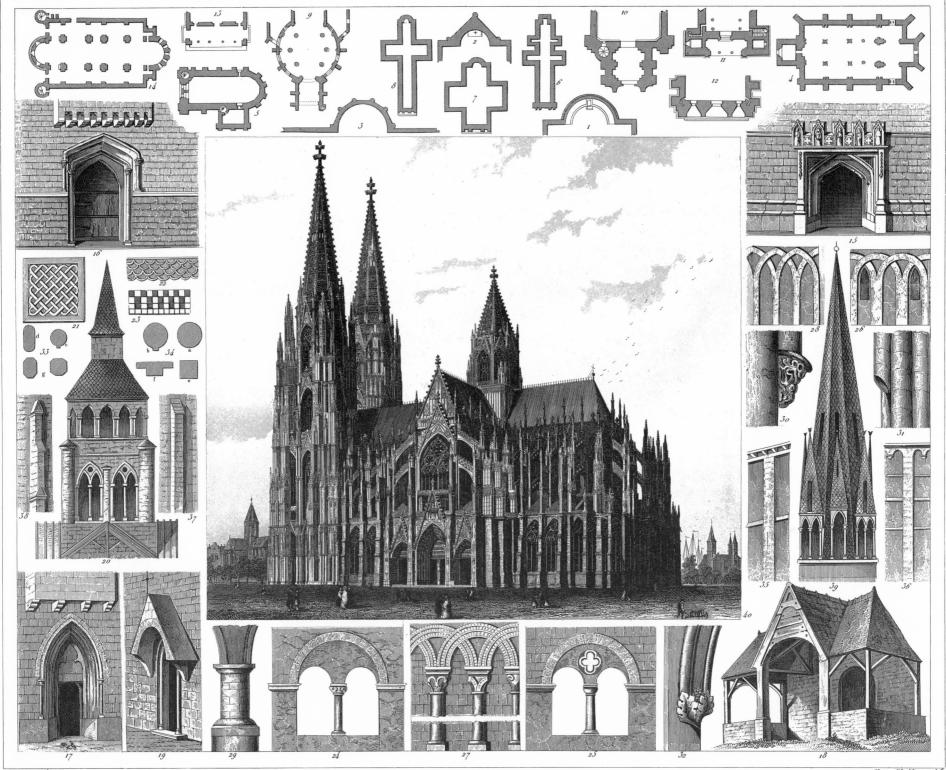

Henry Winkles sculp.t

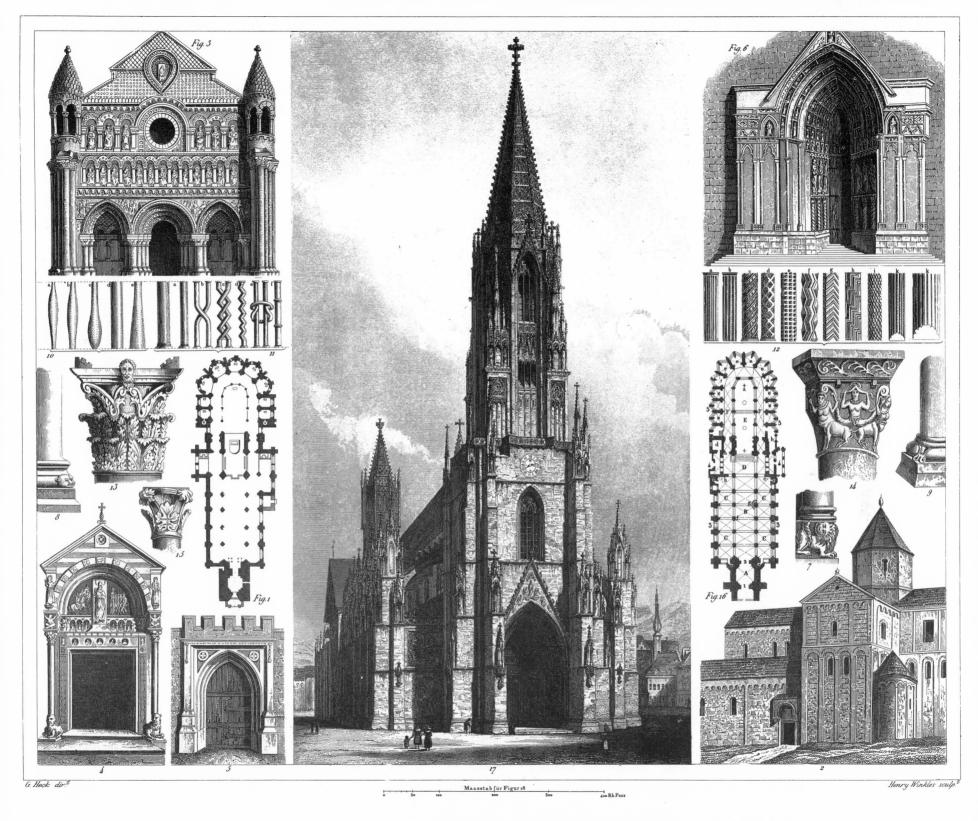

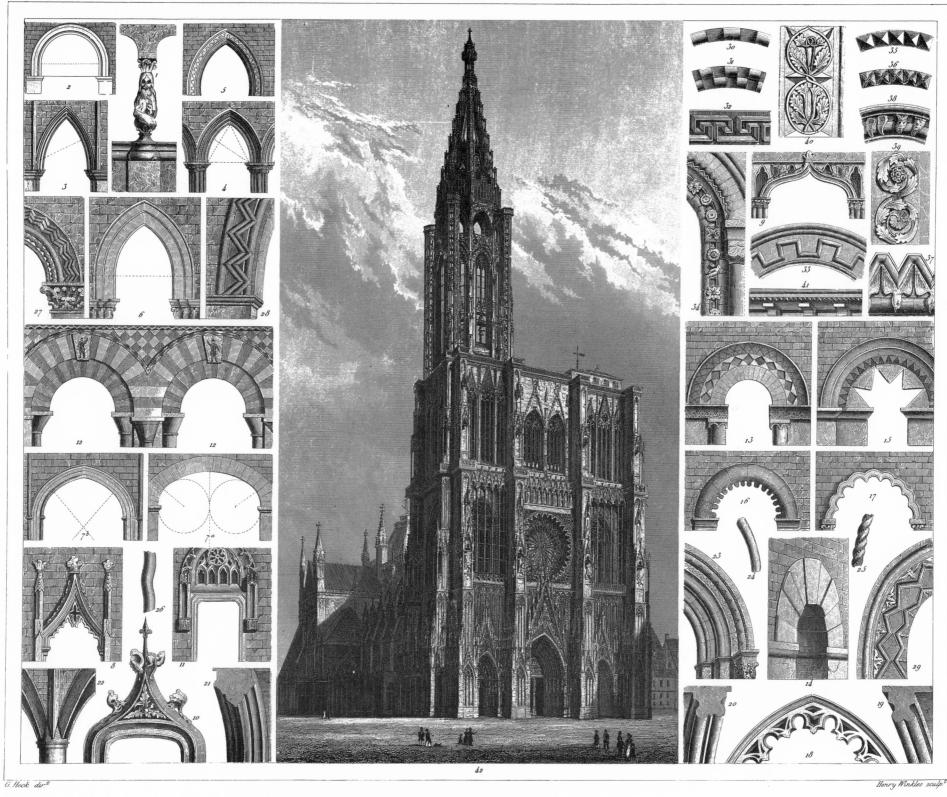

442

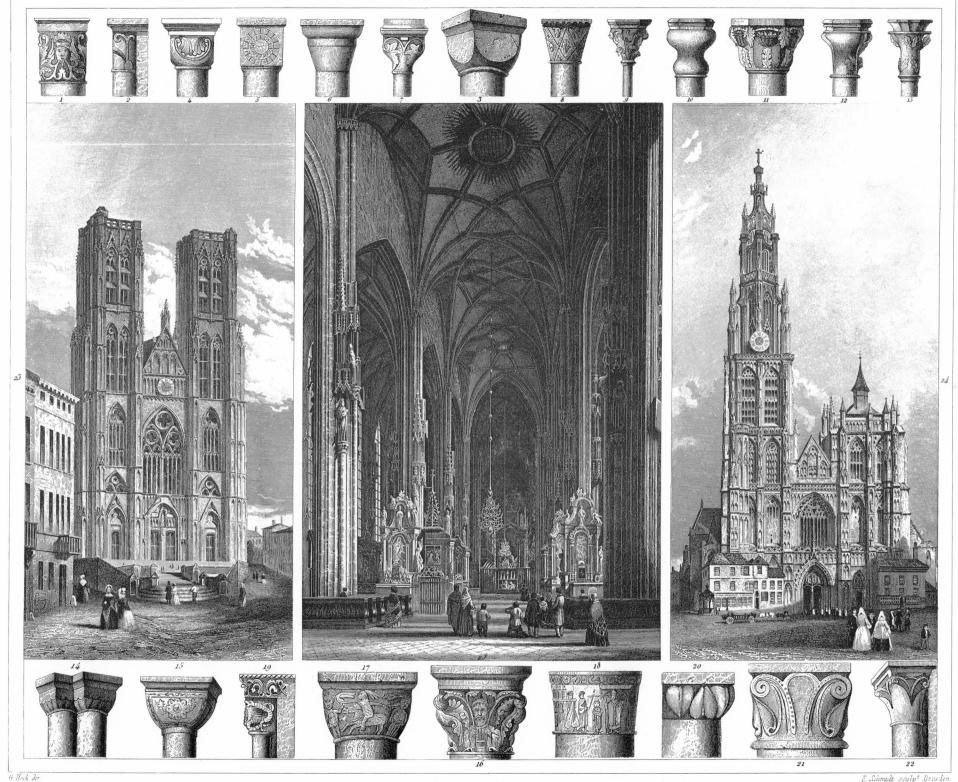

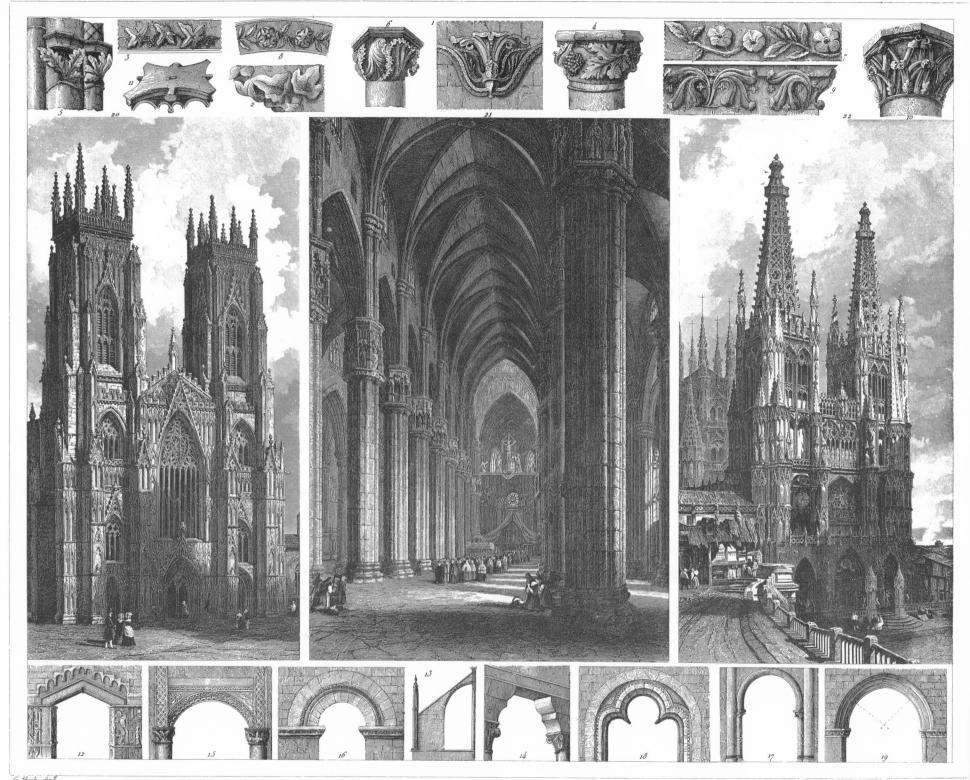

F. Schmidt sculp. Dresder

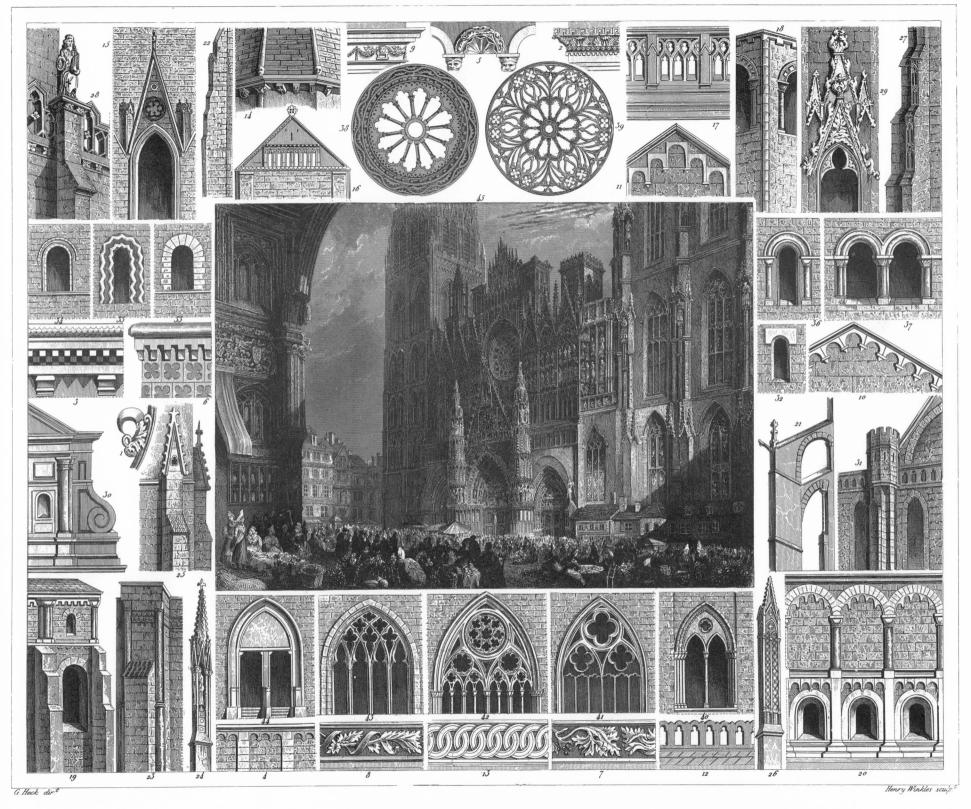

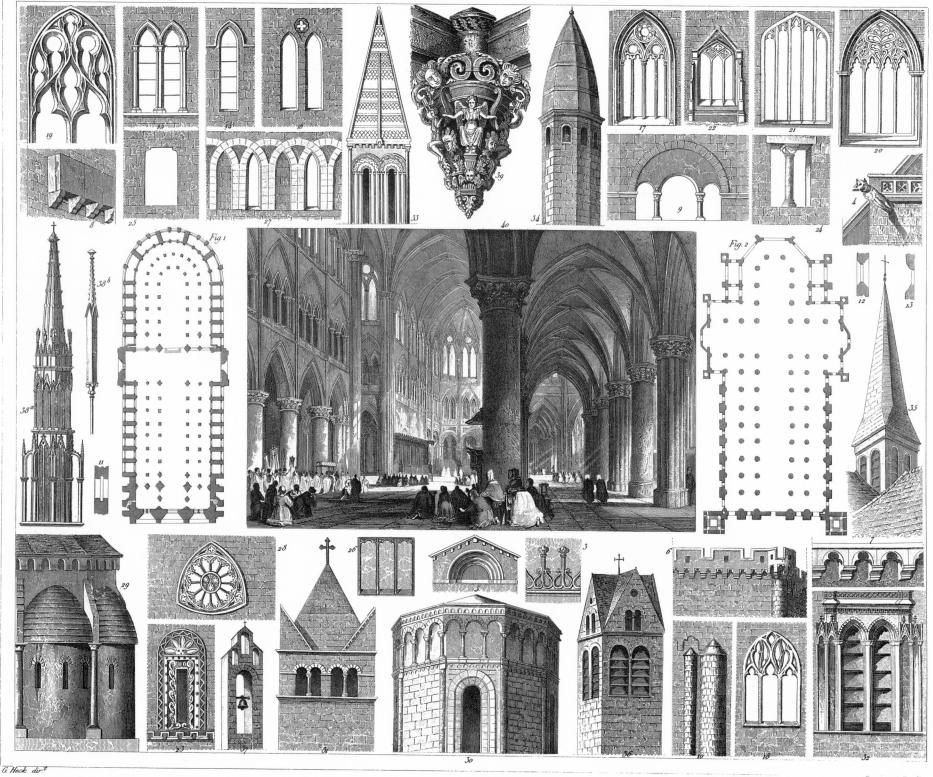

Henry Winkles sculp.

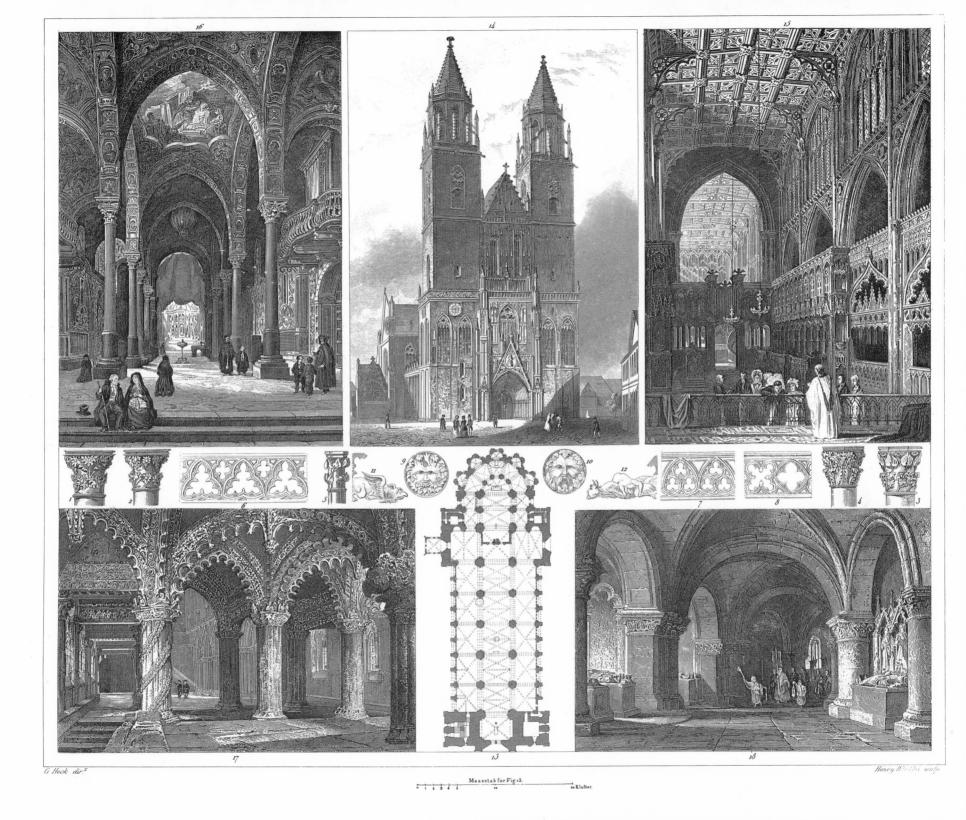

PLATE 390. SCENES AND DETAILS OF GOTHIC CATHEDRALS AND ABBEYS

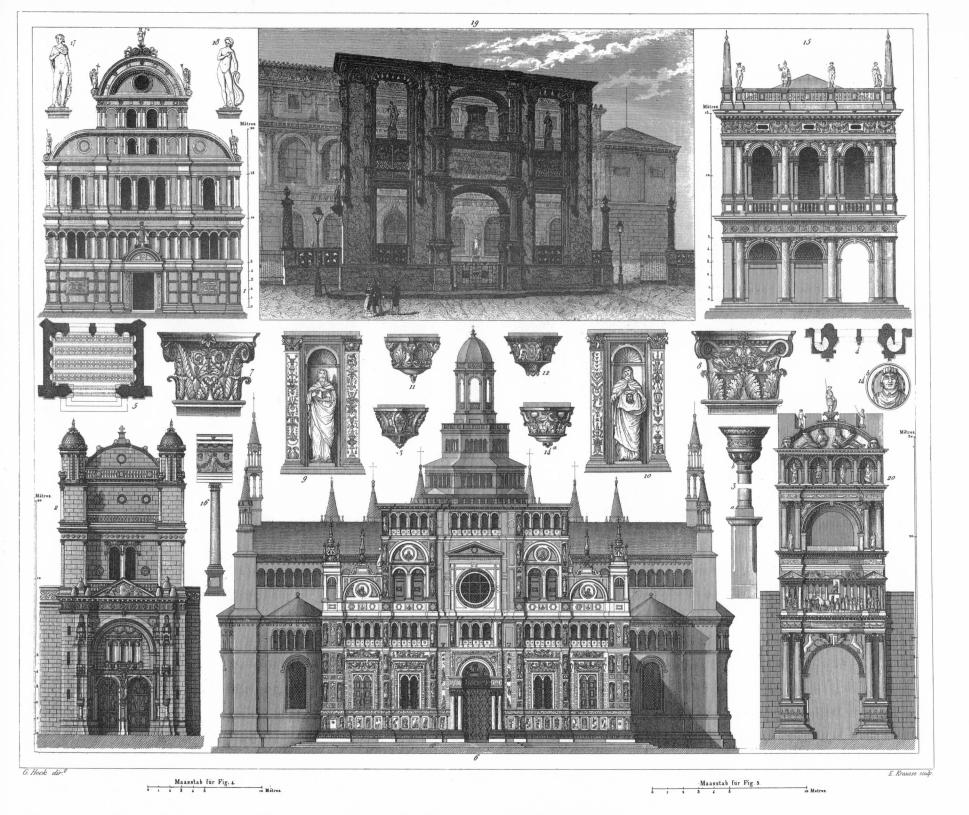

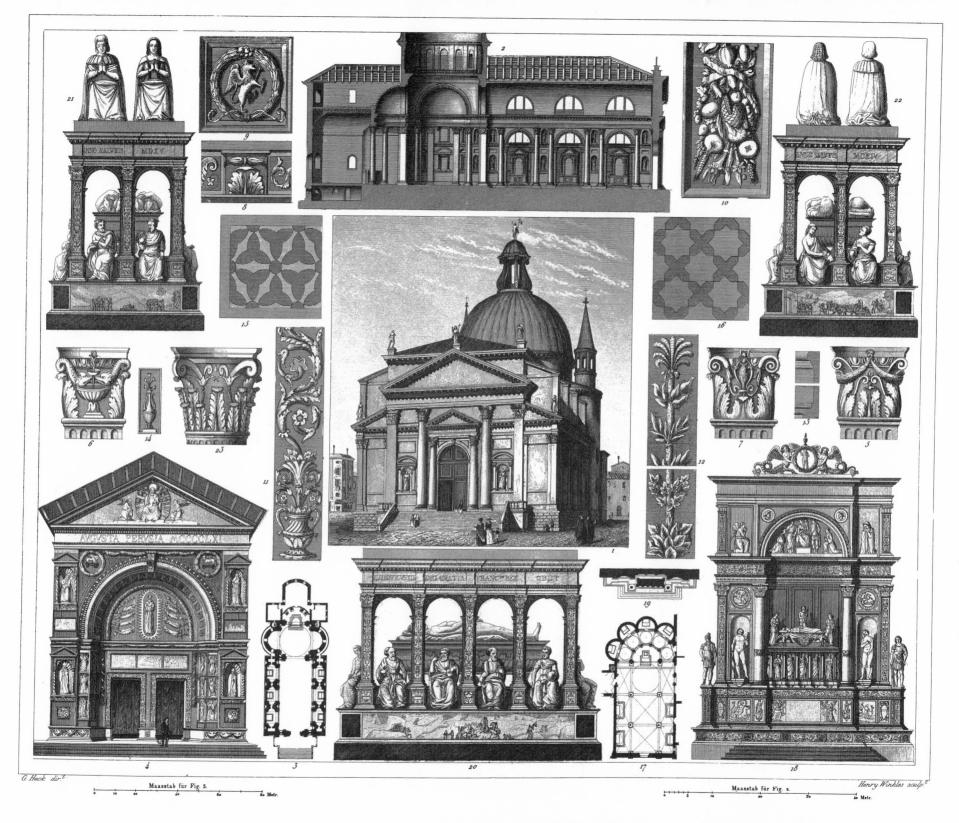

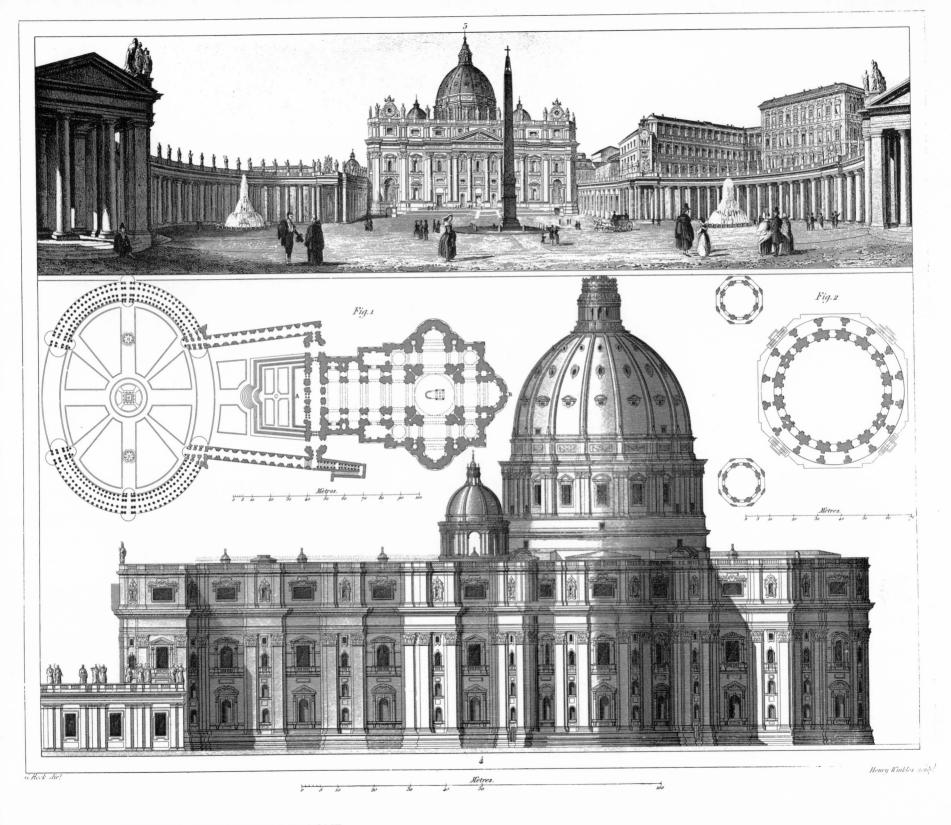

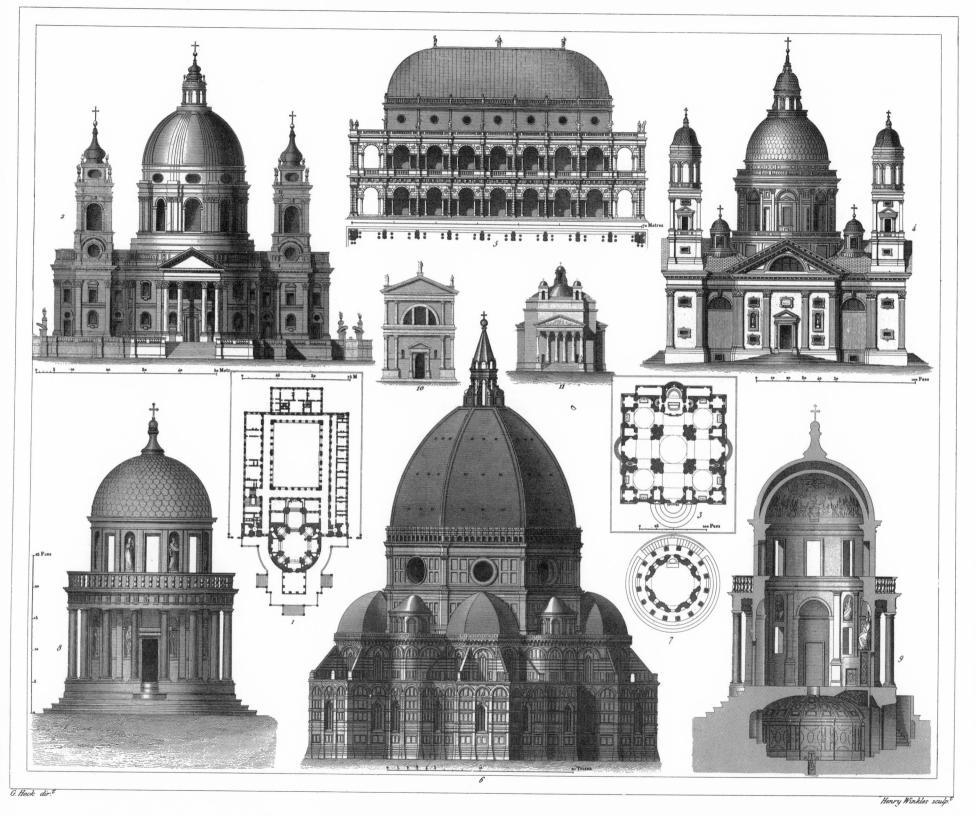

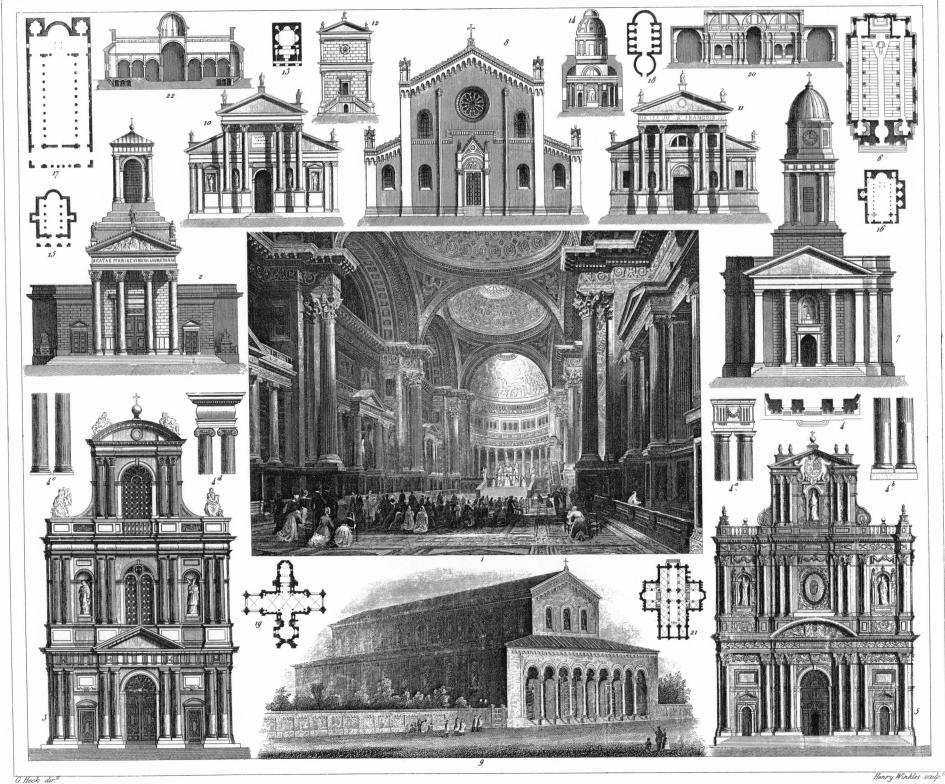

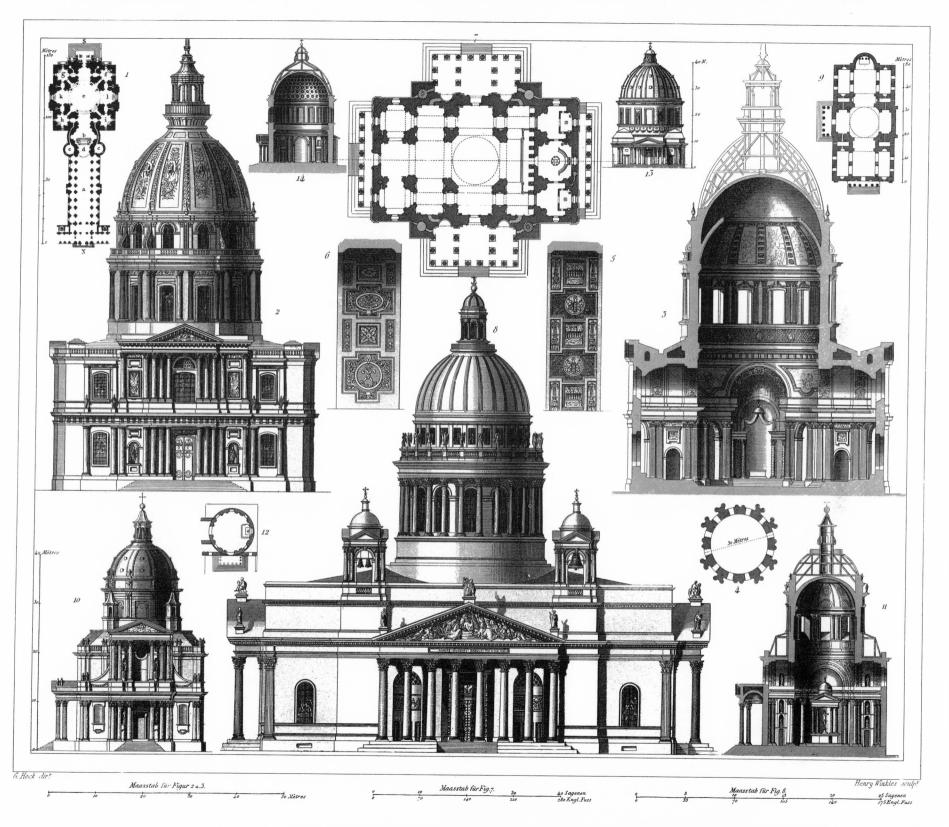

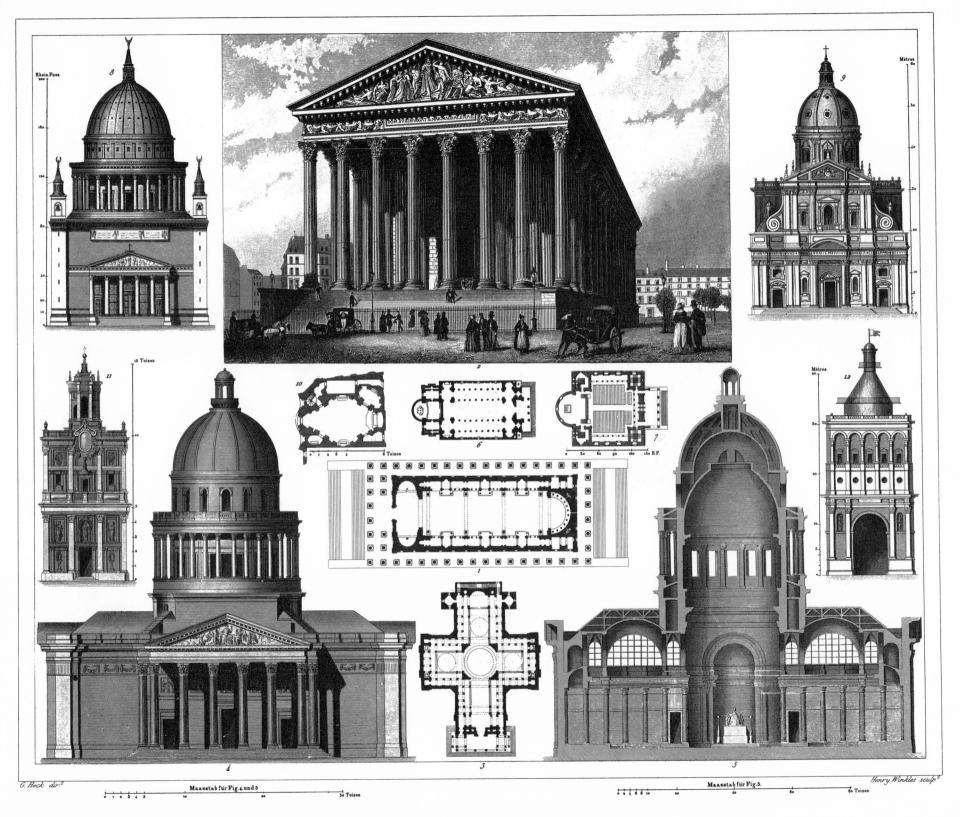

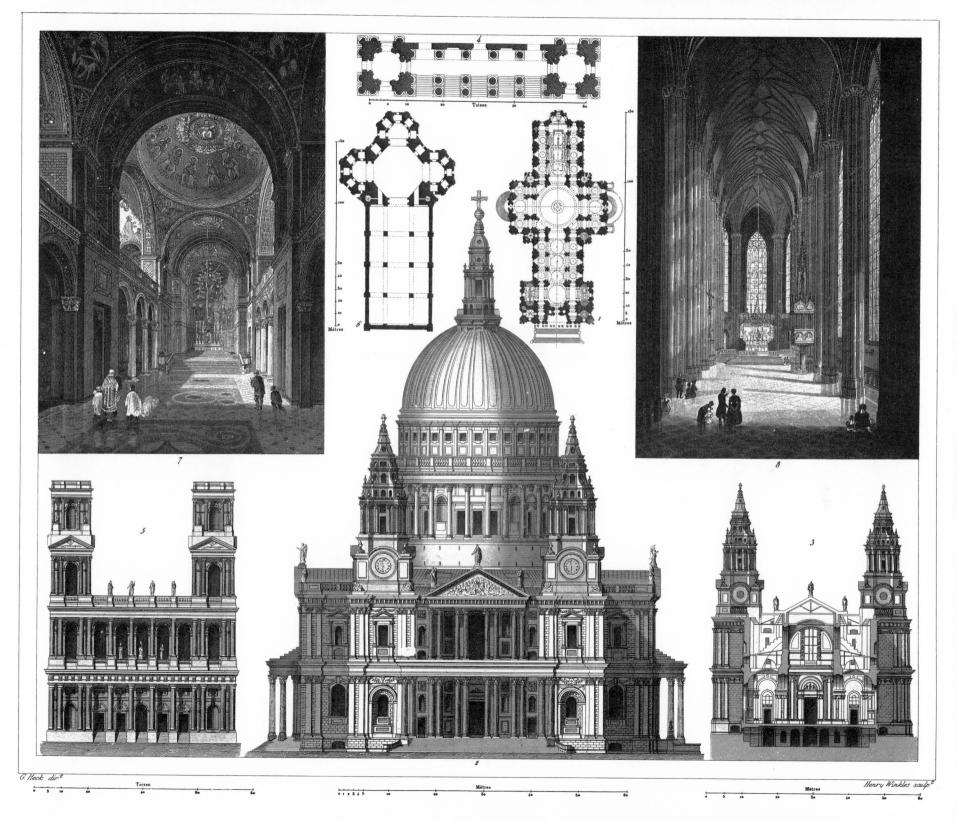

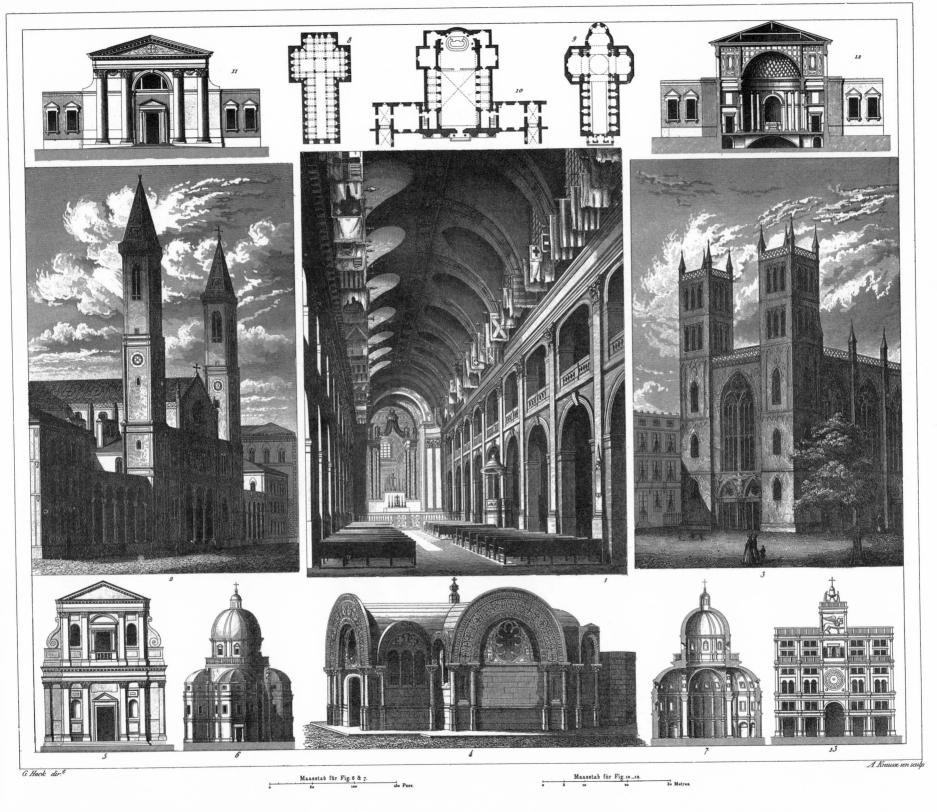

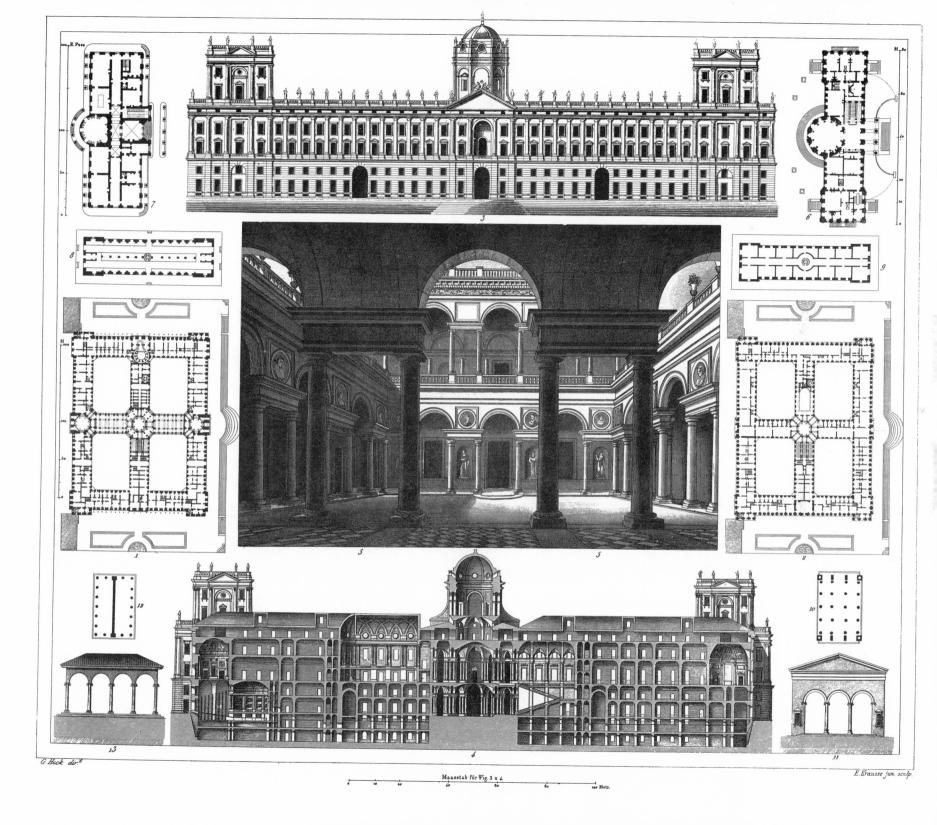

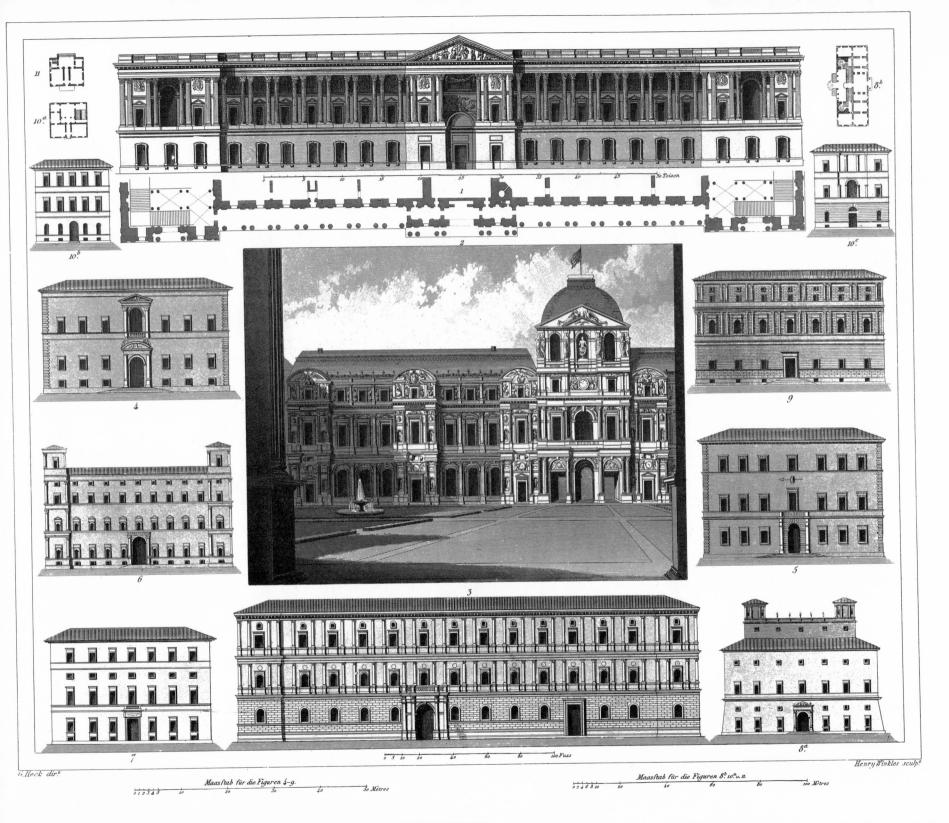

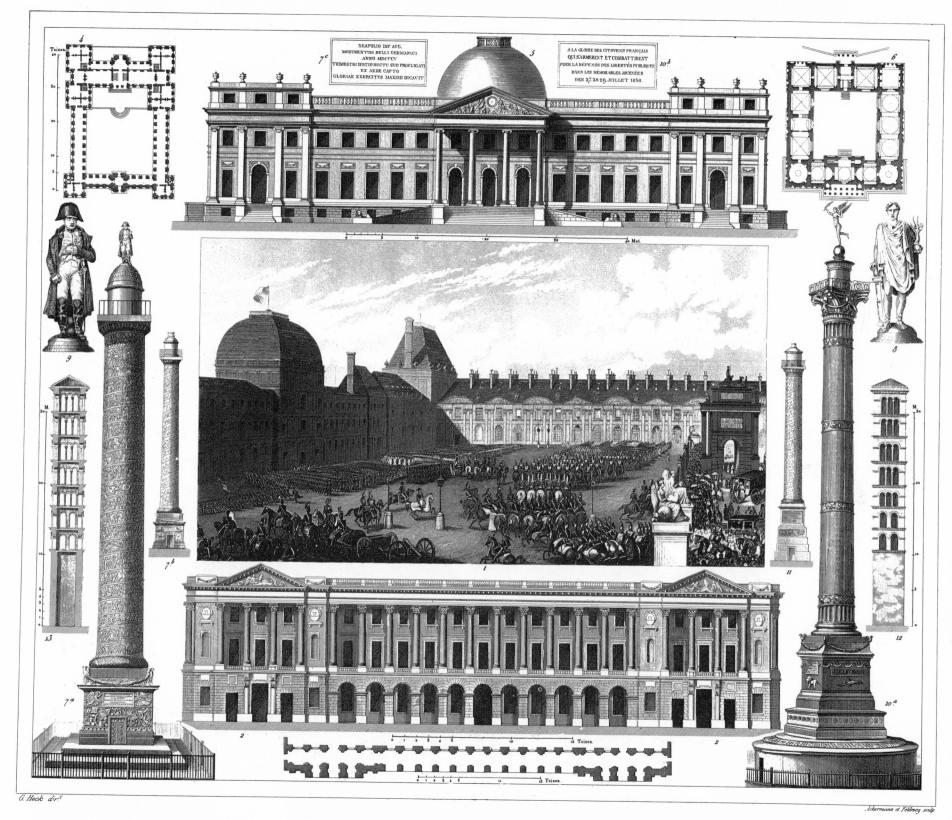

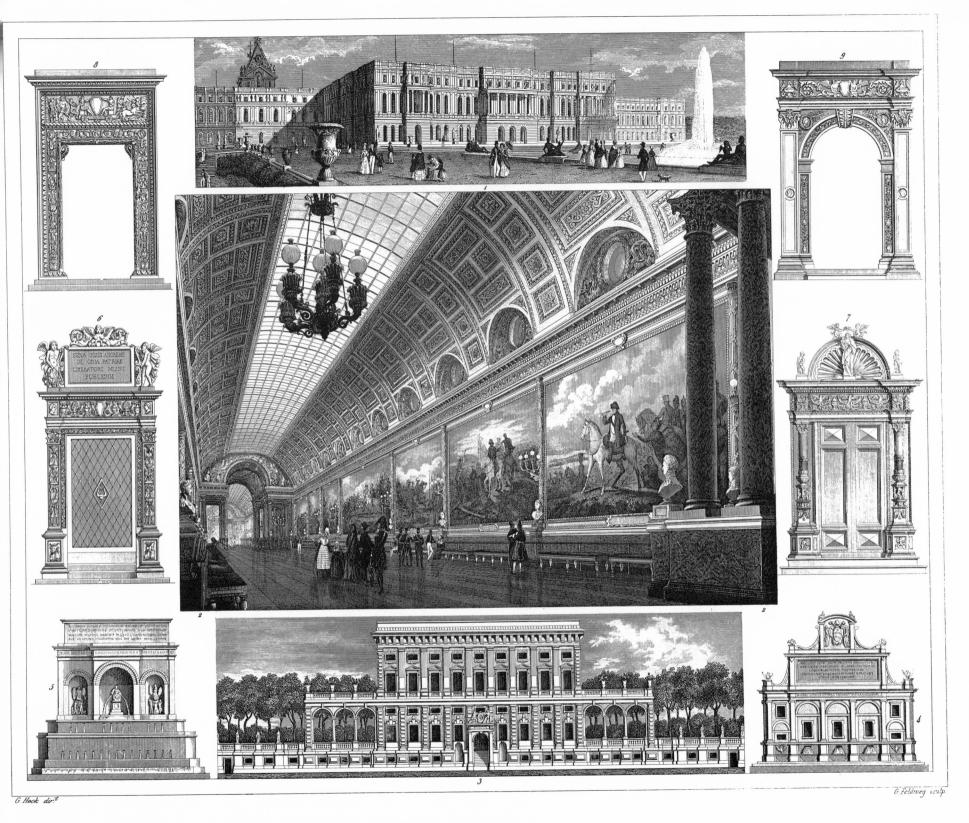

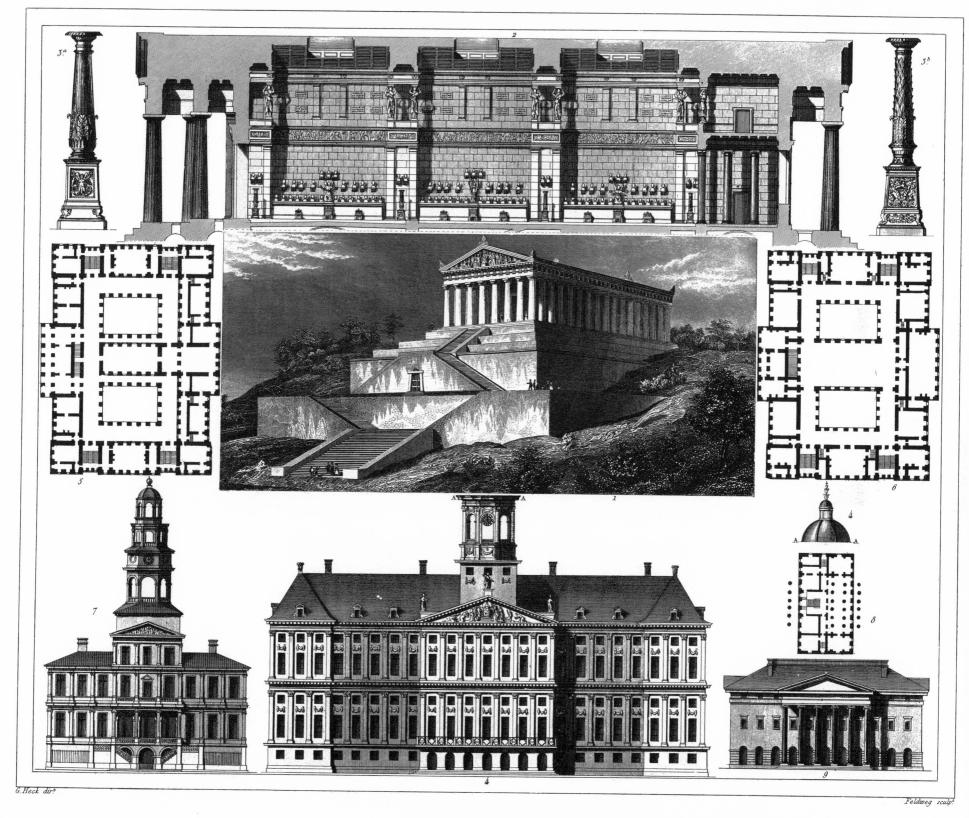

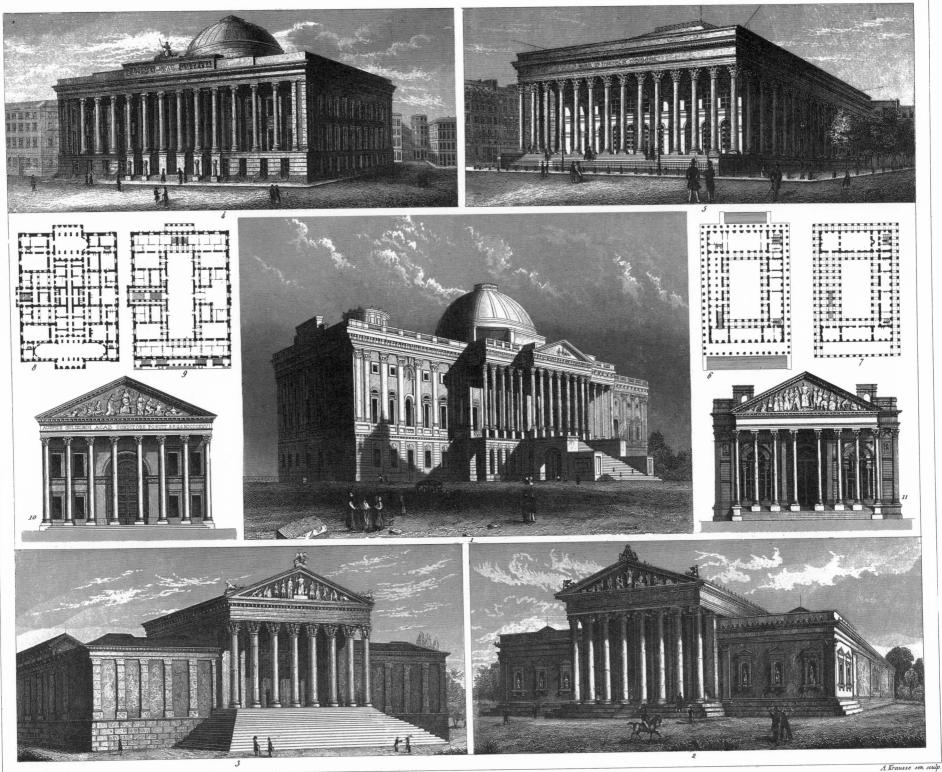

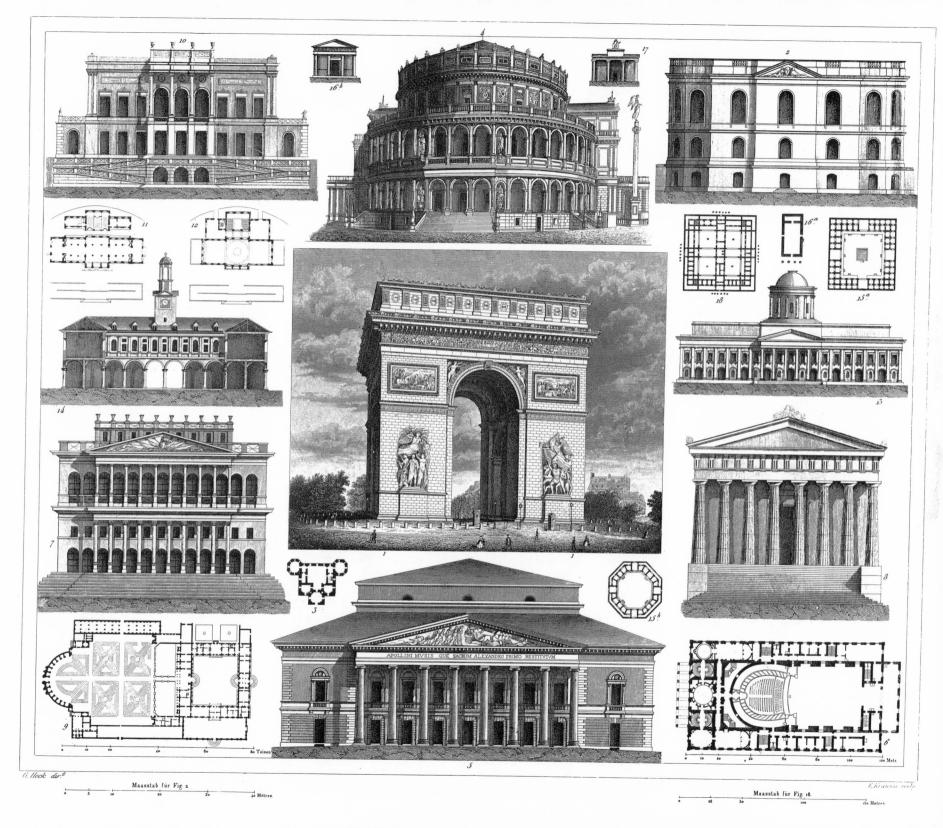

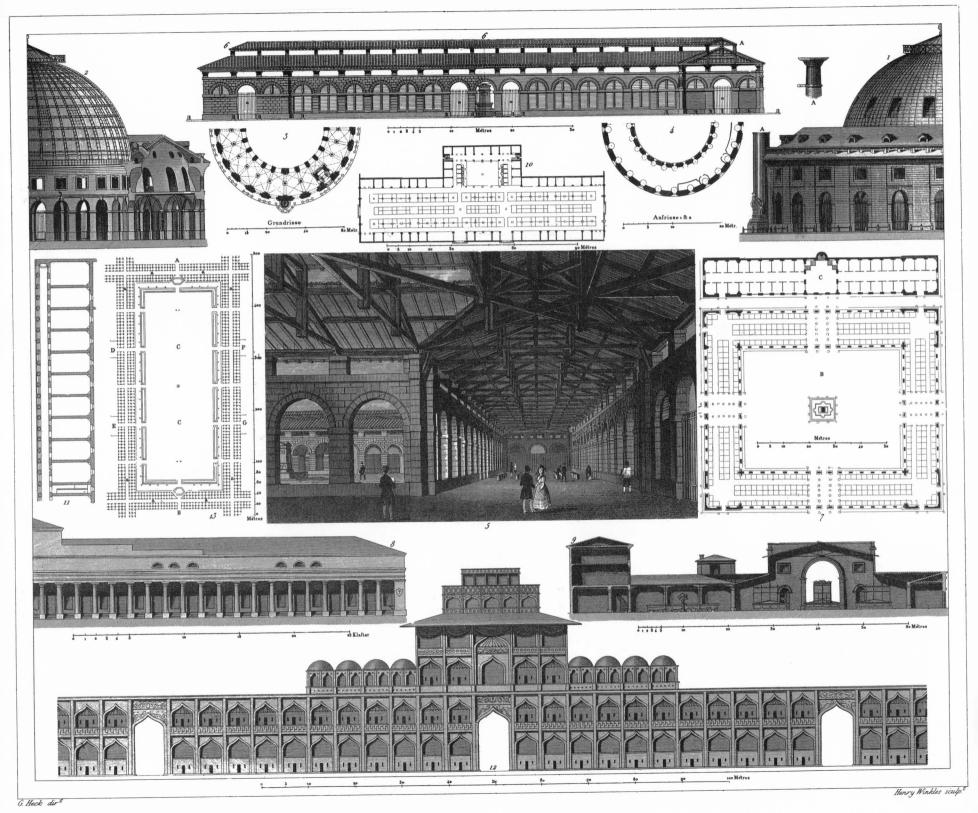

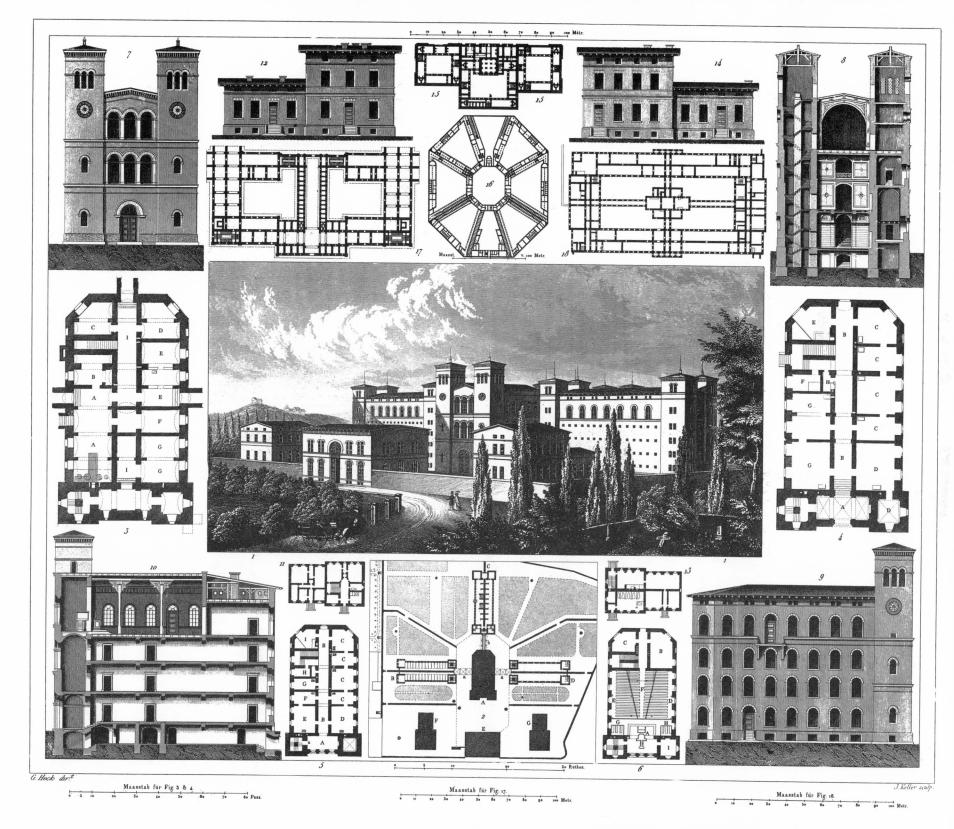

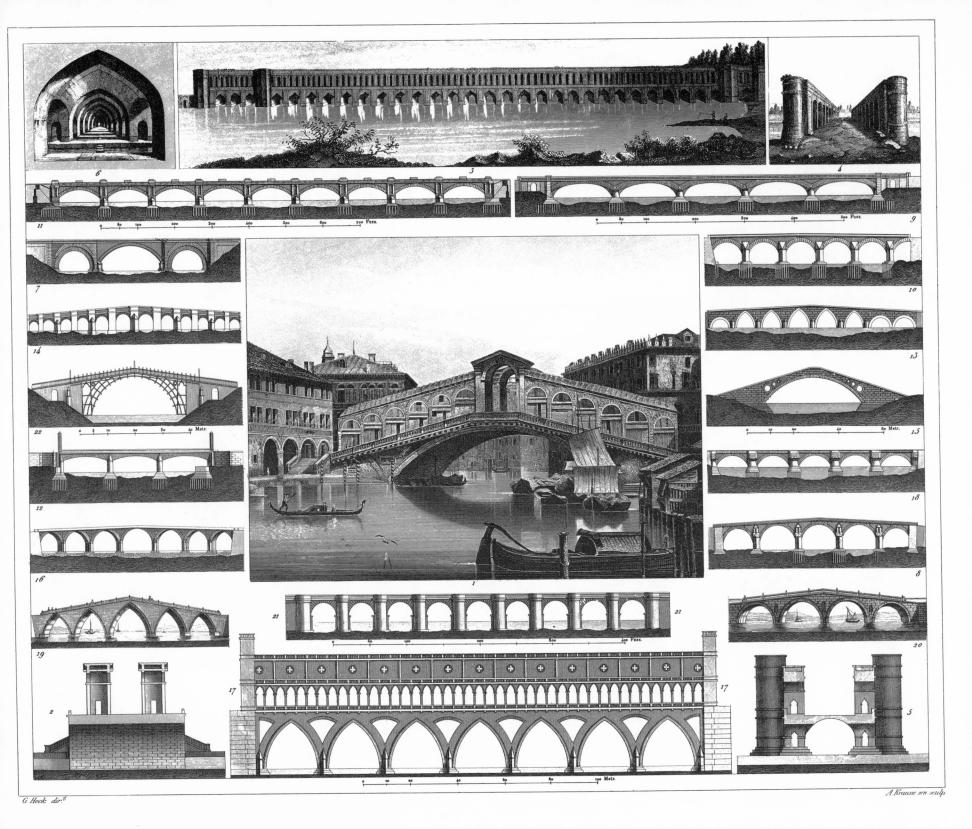

Captions to the Mythology and Religious Rites Plates, 410-439

PLATE 410.

Hindoo and Buddhist Symbols and Religious Implements

Figure

- 1a. Vishnu the Creator
- 1b. Brahm wrapped in the Maya
- 2. The Maya as Bhavani
- 3. Brahma, the creative power
- 4. Birth of Brahma
- 5. Siva, the destroying power
- 6. The Trimurti
- 7. The Lingam
- 8. The Hindoo symbol of wisdom
- 9. The figure Om or Aum
- 10. The Hindoo symbol of creation
- 11. Pracriti
- 12. The tortoise supporting the world
- 13. The seven celestial spheres
- 14. Siva Mahadeva
- 15. Parvati
- 16. Lakshmi or Sri
- 17. Siva as Rudra
- 18. Vishnu as man-lion
- 19. Surva, the god of the sun
- 20. Camadeva or Camos
- 21. Ganges, Jamuna, and
- Saraswadi
- 22. The giant Garuda
- 23. The giant Ravana
- 24. Buddhistic altar-piece
- 25-28. Buddhistic temple implements

PLATE 411.

Hindoo Penitents, Religious Figures and Paraphernalia; Mongolian Idols; Figures of Buddha

Figure

- 1. The Trimurti
- 2. Vishnu and Siva
- 3. Vishnu as a fish
- 4. Vishnu as a tortoise
- 5. Vishnu as a bear
- 6. Vishnu as a dwarf
- 7. Vishnu as Parasu Rama

- 8. Siva
- 9. Vishnu
- 10. Vishnu as Krishna
- 11. The nymphs of the Milk Sea
- 12. Vishnu as Kaninki or Katki
- 13. Siva as Hermaphrodite
- 14. Siva on the giant Muyelagin
- 15. Brahma and Saravadi
- 16. Buddha
- 17. Buddha-Surya
- 18. The Hindoo solar system
- 19. Mythic camel
- 20. Hindoo penitents
- 21-24. Hindoo sacrificial utensils
- 25-30. Mongolian idols

PLATE 412.

Religious Scenes and Figures of India and Central Asia

Figure

- 1-5. Hindoo idols
- 6. Vishnu on the giant Garuda
- 7. Indian idol of Astrachan
- 8. Buddha
- 9. A Brahmin
- 10-12. Hindoo ascetics
- 13-20. Idols of Lamaism
- 21. Mongolian Lama
- 22. Tartar Lama
- 23. Funeral of the Dalai Lama

PLATE 413.

Religious Scenes and Figures of the Far East

Figure

- 1. Allegorical pillar from Barolli
- 2. Chinese god of immortality
- 3, 4. Chinese idols
- 5. Worship at Honan
- 6. Chinese bonzes
- 7–13. Japanese idols
- 14, 15. Japanese house gods
- 16. Temple of Nitsirin at Honrensi
- 17. Temple at Foocoosaizi
- 18-32. Buddhistic temple implements
- 33-36. Buddhistic votive tablets

PLATE 414.

Rites and Religious Figures and Paraphernalia of the Far East

Figure

- 1. Worship of Fo in Canton
- 2, 3. Japanese idols
- 4. Temple of Miroc in Japan
- 5-10. Japanese idols
- 11. Chapel of the Cami at Givon
- 12, 13. The two Inari
- 14-17. The four Camini
- 18-36. Japanese temple utensils
- 37, 38. Japanese monks
- 39, 40. Buddhistic priests
- 41. Blind monk of Japan
- 42. Japanese nun and lay sister

PLATE 415.

Religious Scenes, Symbols, and Figures of China, Japan, and Indonesia

Figure

- 1–3. Japanese idols
- 4. Chief priest of the Tensjû
- 5. Priest of the same
- 6. High priest of Japan
- 7. 8. Buddhistic priests
- 9. Chinese procession
- 10. Chinese fanatic
- 11. Japanese procession
- 12-15. Japanese temple utensils
- 16, 17. Necklaces of the chief priest of the Tensjû
- 18-23. Javanese idols

PLATE 416.

Religious Scenes and Symbols of the Ancient Near East

Figure

- 1, 2. Persian processions
- 3. Persian Magi
- 4. Median high priest and Feruer
- 5. Persian fire worship and Feruer
- 6. Worship of the sun 7, 8. The priest kings
- 9. Sacrifice by Mithras

- 10, 11. Mythic animals
- 12ab. Persian coin
- 13. The celebration of the Darun
- 14. Idols of Afghanistan
- 15-17. Abraxas Gems

PLATE 417.

Egyptian Gods and Religious Symbols

Figure

- 1. Egyptian symbol of the sun
- 2. The All-seeing Eye
- 3-5. Sacred ships
- 6. Egyptian Amun
- 7. Nubian Amun
- 8. Kneph Mendes or Pan
- 9. Athor with the dove
- 10. Isis upon a lotus
- 11. Statue of Isis
- 12. Isis as a cow
- 13. Isis as a star
- 14. Isis nursing Osiris
- 15. Osiris upon a cow
- 16. Osiris with the serpent 17. Amun, Isis, and Osiris
- 17. Amun, Isis, and 18. Hermes as Ibis
- 18. Herme
- 19. Horus
- 20. The bull Apis
- 21. Typhon
- 22. Ailures
- 23. Serapis as the sun24. Serapis and the seven planets
- 25. Harpocrates
- 26ab. Sacred jugs
- 27a-c. Egyptian family idols
- 28. The Sistrum
- 29. The sacred camel
- 30. The Egyptian zodiac31. Priests and priestesses of Isis

PLATE 418.

Egyptian Religious Symbols and Tableaux

Figure

- 1. Kneph
- 2. Isis nursing Osiris
- 3. Isis nursing Horus4. Osiris as a lion
- 5. Osiris as a bull

- 6. Anubis, Hermes, or Thot
- 7. Anubis and Isis
- 3. Anubis, Canop, and Horus
- 9. The wolf
- 10. The tribunal of the dead
- 11-14. Head-dresses of Egyptian idols
- 15, 16. Sacred jugs
- 17–19. Egyptian family idols
- 20, 21. Egyptian mythic animals
- 22. A sphinx
- 23. The Sistrum
- 24–28. Sacred vessels
- 29. Mystic procession
- 30, 31. Abraxas Gems

PLATE 419.

Sacrifice to Isis; Religious and Mythological Figures of Egypt

Figure

- Figure
- Head of Isis
 Isis Pharia
- 3. 4. Statues of Isis
- 5, 6. Serapis and Isis
- 7. Statue of Serapis
- 8. Serapis on his throne
- 9. Isis nursing Horus
- 10, 11. Statues of Osiris
- 12, 13. Statues of Anubis 14. Statue of Harpocrates
- 15. Harpocrates on a ram
- 16. The Nile
- 17. The Nile key18. Kneph as Agathodemon
- 19-22. Votive hands 23, 24. Sphinxes
- 25. The flower of the lotus 26–31. Egyptian priests
- 32-34. Egyptian priestesses 35. Sacrifice to Isis

PLATE 420.

Scene of Chinese Worship; Ancient Middle Eastern Deities and Idols; Norse Gods

Figure

- 1. Assyrian sacrifice
- . Syrian idol
- 3. The goddess Astarte

- 4. Phœnician Deities
- Phœnician procession of the gods
- Odin, Thor, Freyr, Tyr, and Loke
- 7-10. Odin
- 11ab. Norwegian idol
- 12. Ziselbog
- 13. Ipabog
- 14, 15. Slavonic idols
- 16. Nehalennia
- 17. 18. Runic stones
- 19. Runic calendar
- 20. Chinese worship

PLATE 421.

Figures and Scenes of Norse and Germanic Mythology

Figure

- 1. Frigga
- Braga
 Idunna
- 3. Idunna
- 4. Freya
- 5. Heimdall
- The tree Yggdrasill and the Norns
- 7. The Valkyræ
- 8. Triglay
- 9. Svantevit
- 10. Radegast
- 10. Rauega
- 11. Prove
- 12. Siebog
- 13. Shvaixtix
- 14. Nirthus or Hertha
- 15. Flyntz
- 16. Magusanus
- 17. Alemanic idol
- 18. Germanic religious ceremony
- 19. Venus Anadyomene
- 20. The Gallic Isis

PLATE 422.

Deities and Religious Rites of the Norse, Gauls, and Celts

Figure

- 1. Odin the supreme
- 2. Thor the thunderer
- 3. Freyr, god of the sun
- 4. Freya with her maids
- 5. Niord, god of winds
- 6. Tyr, god of battle fields
- 7. Hermode the messenger
- 8. Aske and Emla, the first human beings
- 9. Radegast

- 10. Sieba, goddess of love
- 11. Podaga
- 12ab. Perkunust
- 13. Nemisa
- 14a. Sarmatian idol
- 14b. Silesian idol
- 15, 16. Northern idols
- 17, 18. Gallic Jupiter
- 19. Gallic Vulcan
- 20. Gallic Mercury
- 21. Hercules Saxanus
- 22. Gallic Diana
- 23. Mercury, Abelio, Vulcan, Ceres, and Minerva
- 24, 25. Druid and Druidess
- 26. Annual search for the mistletoe

PLATE 423.

Aztec and Mayan Religious Rites, Figures, and Artifacts

Figure

- 1-7. Mexican idols
- 8. Fragment of Aztek writing
- 9ab. Mexican priestess
- 10. The Mexican year
- 11. The Mexican almanac
- 12. Mexican altar top
- 13. Mexican sacrifice
- 14-19. Idols of Guatemala
- 20. Altar with idols
- 21-24. Sacrificial vessels of Guatemala
- 25-28. Idols of Yucatan
- 29. Sacrificial vase from Yucatan
- 30, 31. Abraxas Gems

PLATE 424.

Religious Rites and Figures of Ancient Greece and Rome

Figure

- 1, 2. Statues of Janus
- 2ab. Heads of Janus
- 3. Saturnus
- 4. Opis or Ops
- 5. Jupiter as Deus pater
- 6, 7. Hera
- 8. Hestia
- 9. Vesta
- 10. Diana
- 10. Dialia
- 11. Apollo
- 12. Tages
- 13. Mars the advancing
- 14. Bellona
- 15. Hermes

- 16. Ancharia
- 17. Aphrodite (Venus)
- 18. Vertumnus
- 19. Pomona
- 20. Voltumna
- 21ab. Fortuna
- 22ab. Vejovis
- 23. Asclepios (Æsculapius)
- 24. Tyrrhenian Heracles
- 24ab. Sacred coin
- 25. The shield dance of the Salii 26ab. Demeter (Ceres)
- 27ab. Demeter and Zeus

PLATE 425.

Sacred Rites, Religious and Mythological Figures, and Religious Paraphernalia of Greece and Rome

Figure

- 1. Faunus
- 2. Nemesis
- 3. Proserpine
- 4. The genius of death
- 5, 6. Two heroes
- 7–9. Lares
- 10. Æon
- 11. 12. Cronos
- 13. Cronos and Rhea
- 14. Rhea
- 15. Atvs
- 16ab. Attributes of Atys
- 17. The goat Amalthea
- 18. Jupiter Axur
- 19. Zeus Ammon
- 20. The Olympian Zeus21. Zeus the Supreme
- 22. Zeus with the eagle
- 23. Hera suckling Ares
- 24. Bonus Eventus
- 25. Ceres Catagusa26. Diana Lucifera
- 27–33*ab*. Grecian sacrificial vessels
- 34. The Augures

PLATE 426.

Legendary Scenes and Figures from Greek and Roman Mythology

Figure

- 1. Nux or Night
- Cœlus
 Rhea
- 4. Jupiter Axur

- 5. Zeus Hellenios
- 6. Jupiter receiving the homage of the gods
- 7. 8. Zeus as warrior
- 9. Pegasgian Zeus
- 10. Zeus carrying off Europa
- 11. Birth of Athene (Minerva)
- 12. Jupiter Conservator
- 13. Pelasgian Hera
- 14-17. Juno
- 18-21. Ares (Mars)
- 22. Mars Pacificus
- 23. Victoria (Nike)
- 24. Ganymede
- 25. Hebe
- 26. Apollo and Daphne
- 27. Sibylla
- 28. Apollo's raven
- 29. A sacrificial knife
- 30. The Delphian oracle

PLATE 427.

Classical Deities and Mythological Characters

Figure

- 1. Zeus
- Zeus conquering the Titans
- 3. Europa on the bull
- 4. Zeus on the centaur
- 5. Ares and Aphrodite
- 6-8. Genii of Mars
 9. Nymph of Artemis
- 10. The Dioscuri11. Poseidon, Amphitrite, and
- Eros
- 12. Bacchanalian genii13. Dionysos (Bacchus)
- 13. Dionys
- 14. Apollo
- 15. Ariadne16. Demeter (Ceres)
- 17–24. Roman sacrificial
- implements
 25. The assembly of the gods

PLATE 428. Greek and Roman Gods and

Religious Paraphernalia Figure

1. The twelve planet gods

Ceres (Demeter)

- Zeus, Hermes, and Aphrodite
 Pallas Athene
- 5. The muse Erato6, 7. Flora

- 8. Fortuna
- . A naiad
- 10. Genii
- 11. The Seasons
- 12. Tritons
- 13. Bacchanalia
- 14. Priestess of Bacchus
- 15, 16. Priestesses of Ceres 17, 18. Grecian priest and
 - priestess
- 19. 20. Altars
- 21-47. Sacrificial utensils

PLATE 429.

Greek Festival and Mythological Figures and Scenes

Figure

- 1. Argos guarding Io
- Argos guarding 10
 Leda and the swan
- 3. 4. The Dioscuri
- 5. Leto (Latona)
- 6. Lunus7. Apollo and Marsyas
- 7. Apollo
- 8. Aurora9 Artemis Locheia
- 10. Diana Lucifera
- 11. Artemis Soleia12. Juno Sospita
- 13. Helios
- 14. Artemis (Diana)
- 15. Artemis and her nymphs
- 16. Mountain nymphs
- 17. Niobe

Athens

- 18. Amphion
- 19. Hermes the messenger
- 20. Hermes Agonios21. Zeus with the eagle
- 22. Europa and the bull23. The Panathanæan festival at

PLATE 430. Classical Legends and

Mythological Figures

Figure

Death of the children of

- Artemis of Ephesus
 Artemis Tauropolos
- Artemis Selene
 Hebe
- 5. Iris
- Niobe . Nereus
- 8. Palæmon
- 9. Nereid

470

10. Taras

11. Poseidon

12. Poseidon and Pallas Athene

13. Hippocamp

14. River god and naiad

15ab. Nilus (the Nile) 16ab. Tibris (the Tiber)

17-19. Sirens

20. Artemis and Orion

21. Mænade

22. Hermes (Mercury)

PLATE 431.

Gods and Mythological Creatures

1. Hylas carried off by nymphs

2. Nereids

3. A Triton

4. Pelasgian Poseidon

5, 6. Statues of Poseidon

7, 7a. Neptune

8. Hippocamp

Melicertes (Palæmon)

10. Thetis

11. Hebe 12-15. The winds

16. Boreas bearing off Oreithyia

17. Hades (Pluto)

18ab. Proserpine (Persephone)

19. Sacrifice to Neptune

PLATE 432.

Gods and Mythological Characters

Figure

1. Hades (Pluto)

Zeus Ammon

Hades (Pluto)

4. Poseidon and Amymone

5ab. Nemesis

6. Hypnos (Sleep)

7. Thanatos (Death)

8, 9. Hypnos (Sleep)

10. The genius of sleep

11, 12. Persephone (Proserpine)

13. Hecate

14. Erinnyes or Eumenides

15. Prometheus

16. Pandora

17. The Dreams

18. Demeter and Triptolemus

19. Dionysos nursed by nymphs

20. Triumph of Poseidon and **Amphitrite**

21, 22. Tritons

PLATE 433.

Gods and Mythological Creatures and Figures

Figure

1. Pelasgian Demeter

Bust of Demeter

3. Ceres

4. Persephone

Procession of Dionysos and Ariadne

Triptolemus

Birth of Dionysos

8. Leucothea

9. The sacred lion

10ab. The sacred serpent

11. Dionysus and Faunus

12, 13. Dionysos

14. Ariadne

15. Indian Dionysos

16. Pan and Olympos

17ab. Pan and the Panic

18. Silenos

19. Hygeia

20. Hephæstos (Vulcan)

21. Telesphorus

22, 23. Hermes (Mercury)

24. Charon

25. Sisyphos, Lapithæ, and **Tantalos**

PLATE 434.

Gods and Mythical Characters

Figure

1. Faunus and a Bacchante

2, 3. Pan

4, 5. Dionysos

6. Dionysos of Naxos

The Dionysian mysteries

Apollo and Marsyas

9. Marsyas and Olympos

10-12. Silenos

13. Priapos

14-18. Heracles

19a. Persephone

19b. Dionysos Zagreus

20. Hephæstos (Vulcan)

21. Mount Parnassos

PLATE 435.

The Muses and Other Legendary Female Figures; Apollo and **Dionysus**

Figure

1. The nine Muses

The muse Calliope

3. The muse Clio

The muse Polyhymnia

The muse Euterpe

6ab. The muse Urania

7. The muse Thalia

Mnemosvne

9a. Flora

9b. Vestal virgin

10a. Aurora

10b. Medusa

11. Apollo and the Hours

12. Dionysos as god of the sun

PLATE 436.

Aphrodite and Other Goddesses and Gods

Figure

1. Artemis (Diana)

Hermes (Mercury)

A herma

4. Hermes the Eloquent

5. Hermes with the tortoise

Vesta

7-14. Pallas Athene (Minerva)

15. The Delphian Apollo

16. Antinous

17-25a. Aphrodite (Venus)

25b. Mars and Ilia

26. Aphrodite as goddess of matrimony

27. Mars the Avenger

28. Athene, Asclepios, and Hygeia

29. Asclepios and Hygeia

30. Venus Victrix

31. Birth of Aphrodite

PLATE 437.

Apollo; Sacrifice to Mars; Other **Mythological Figures**

Figure

1-4. Apollo

5. Dionysos and Apollo

6. Bust of Athene (Minerva)

7–12. Hermes (Mercury)

13. Silenos 14-18. Aphrodite (Venus)

19-21. The Graces

22. Hermaphrodites 23. Hymen 24. Asclepios

25. Melicertes (Palæmon)

26. The sacred bull of Dionysos 27. Sacrifice to Mars

PLATE 438.

A Sacrifice in Rome: Gods and **Mythological Characters**

Figure

1. Ariadne

2. Dionysian orgies

3-6. Eros (Amor)

7-10. Amor and Psyche

11. Statue of Psyche

12. The Graces

13. The Hours

14. Fides

15. Pax

16. Pietas

17. Pudor or Pudicitia

18. Concordia

19. Bonus Eventus

20. Spes

21. Astræa

22. A centaur

23. Sacrifice in Rome

PLATE 439.

Legendary and Mythological Scenes and Figures of Greece and Rome

Figure Roman pontifex maximus

Roman augur Guardian of the Sibylline books

Priest of Jupiter

5. Vestal virgin Victimarius

The Suovetaurilia

Sacrificial tripod 9. Sacrificial horn

10. Gorgons 11, 12. Perseus

13ab. Medusa 14. Charybdis

15. Scylla

16. The nymph Circe 17. Minotaur 18ab. Sphinxes

19. A centaur 20. Œdipous slaying the sphinx

21-23. Giants

24. Allegorical representation of Atlas

25, 26. Bellerophon

27, 28. Amazons 29. Pygmies

30, 31. Pallor, Pavor

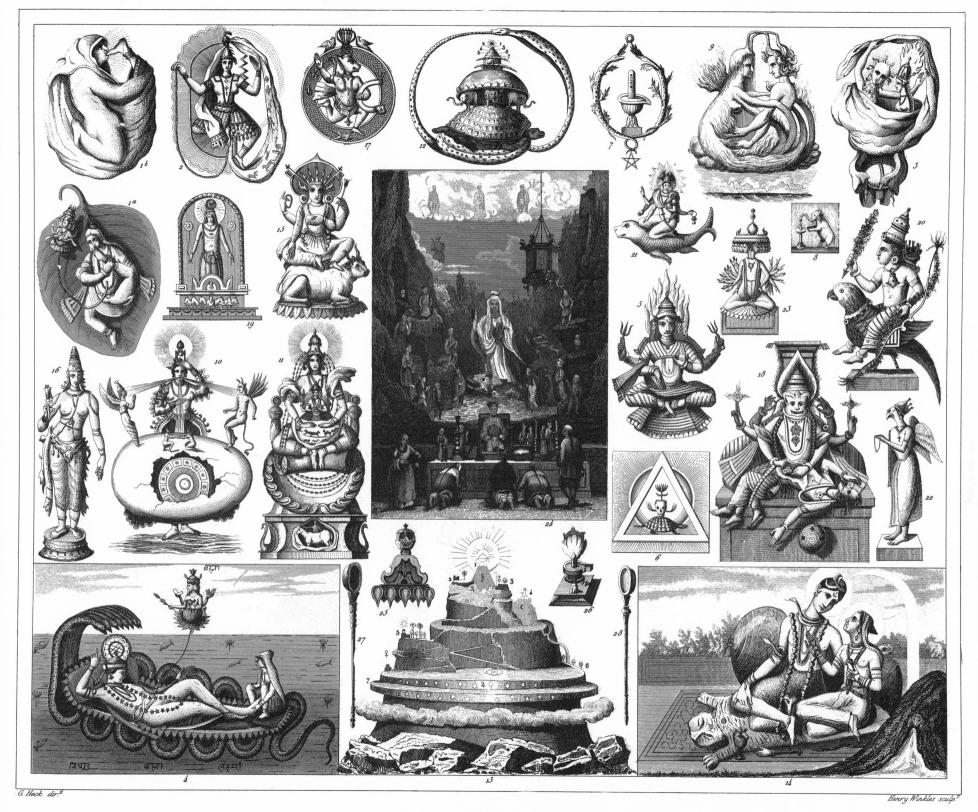

PLATE 410. HINDOO AND BUDDHIST SYMBOLS AND RELIGIOUS IMPLEMENTS

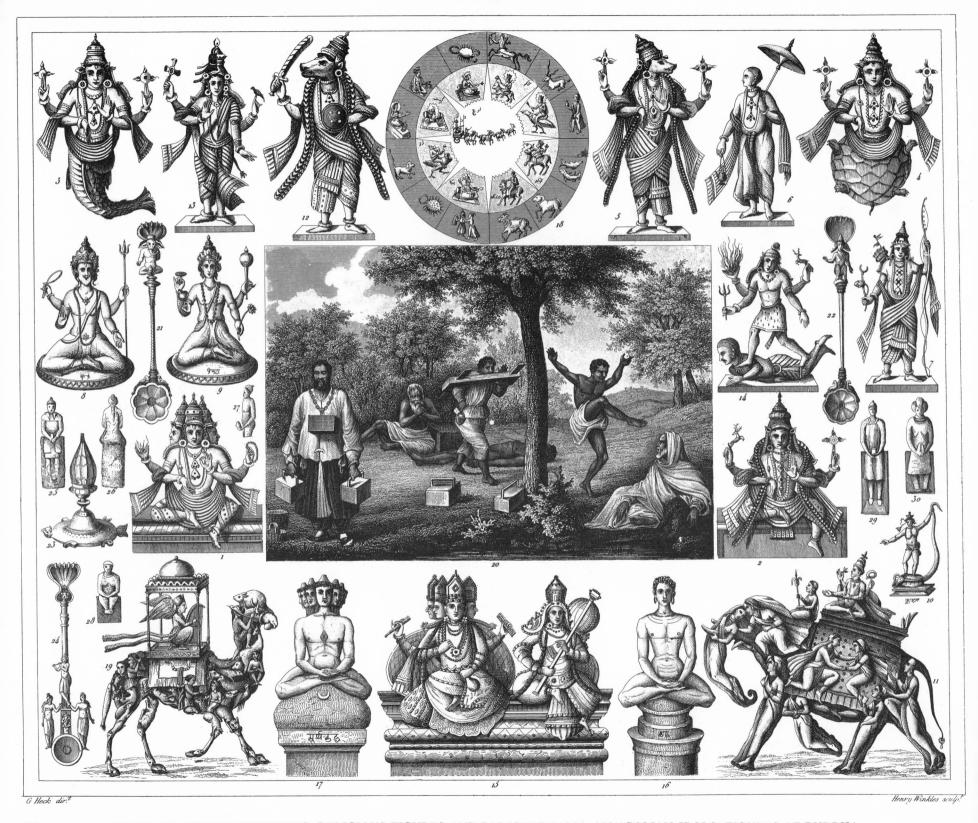

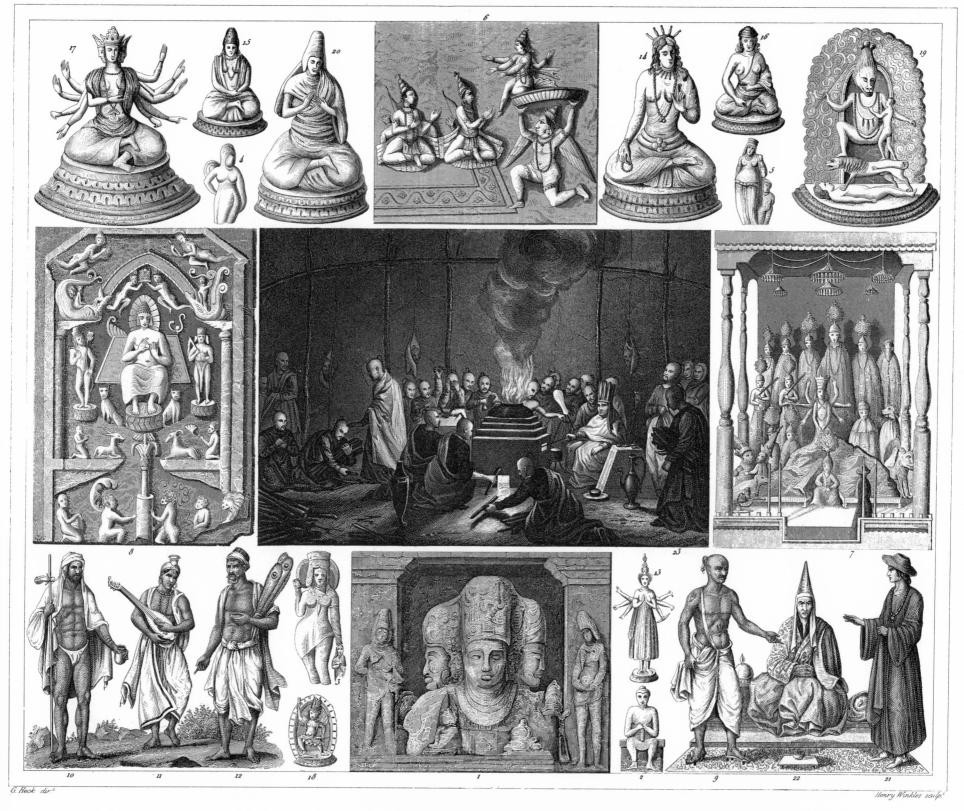

PLATE 412. RELIGIOUS SCENES AND FIGURES OF INDIA AND CENTRAL ASIA

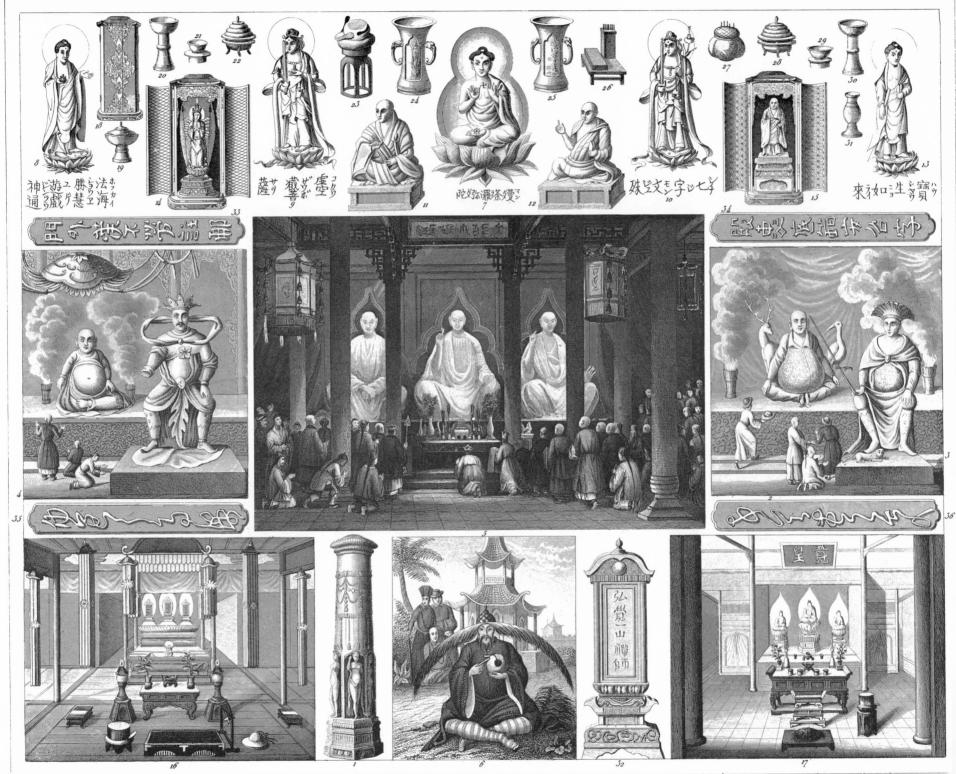

G. Heck dir.t

Henry Winkles sculp.

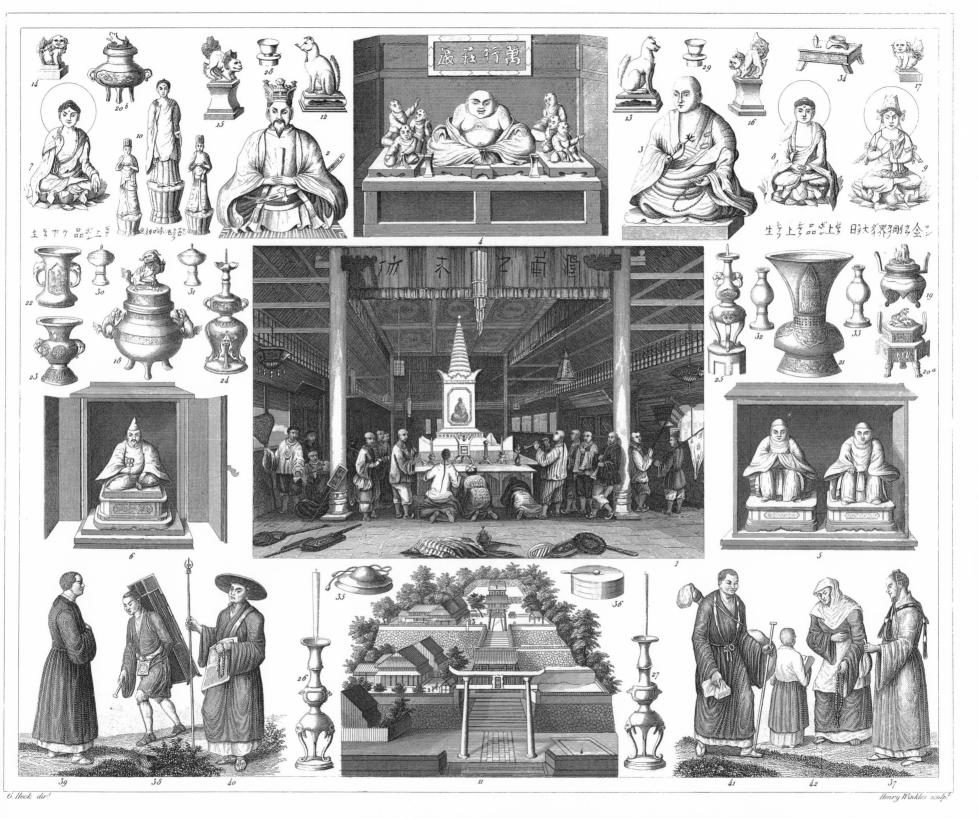

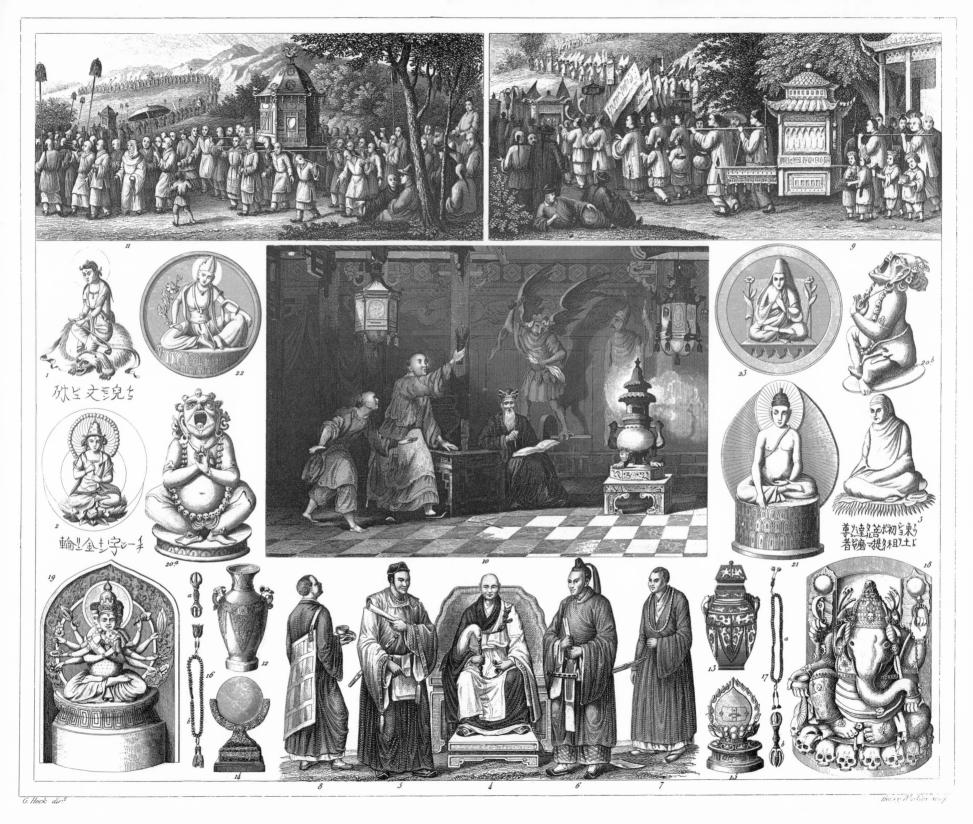

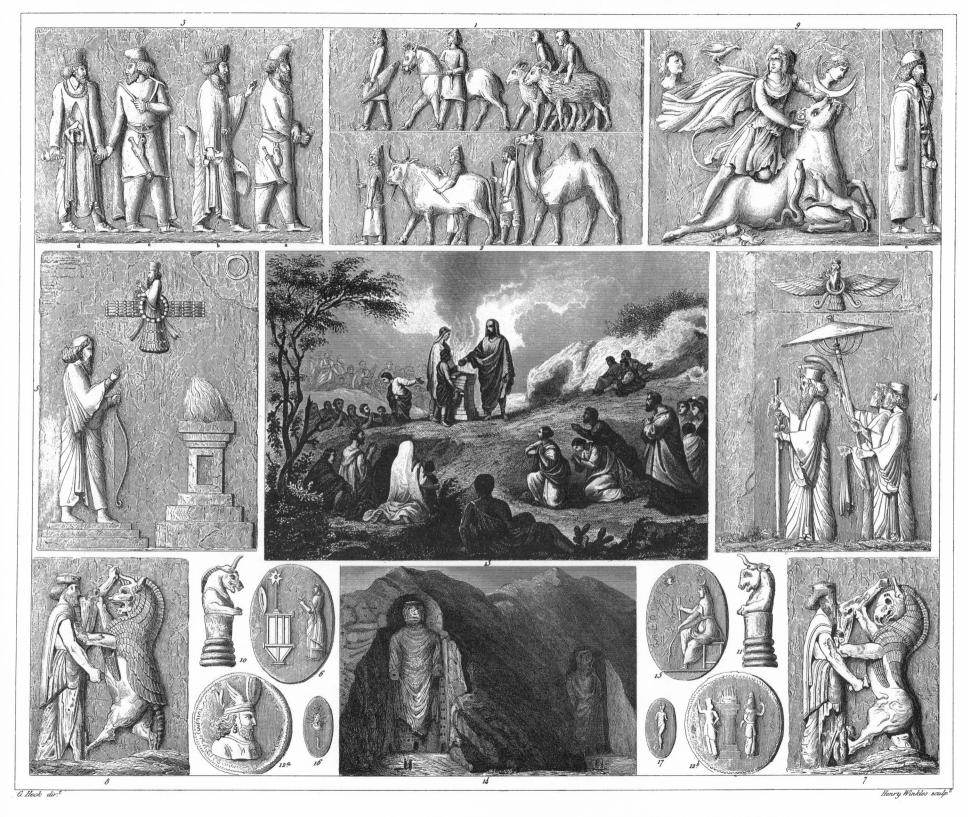

PLATE 416. RELIGIOUS SCENES AND SYMBOLS OF THE ANCIENT NEAR EAST

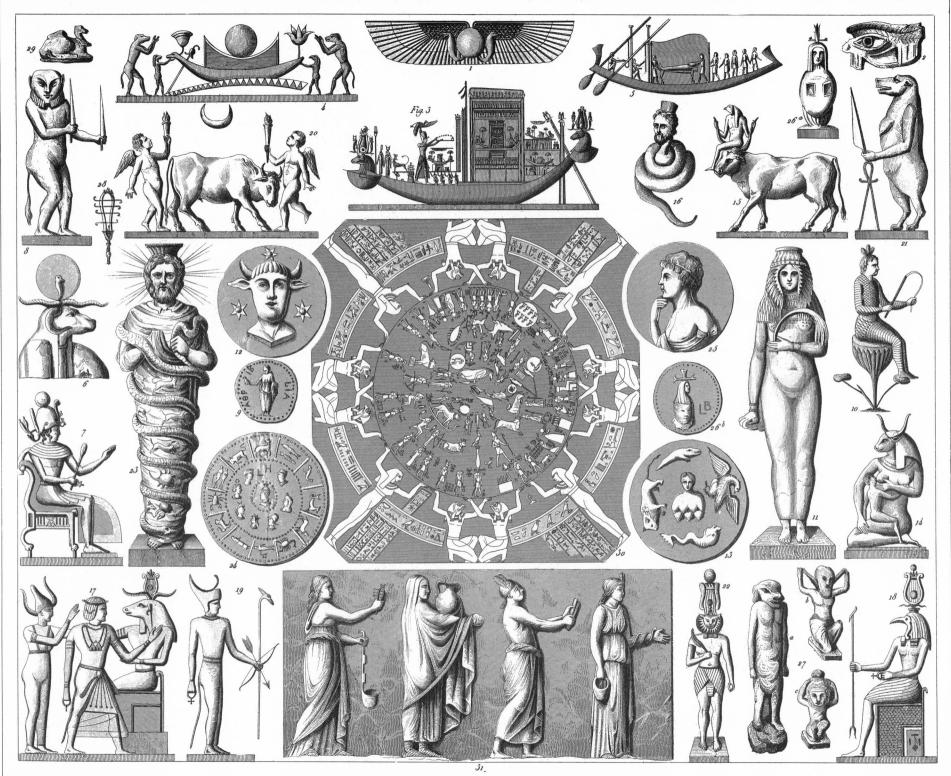

G Heck dir.t

Henry Winkles scul

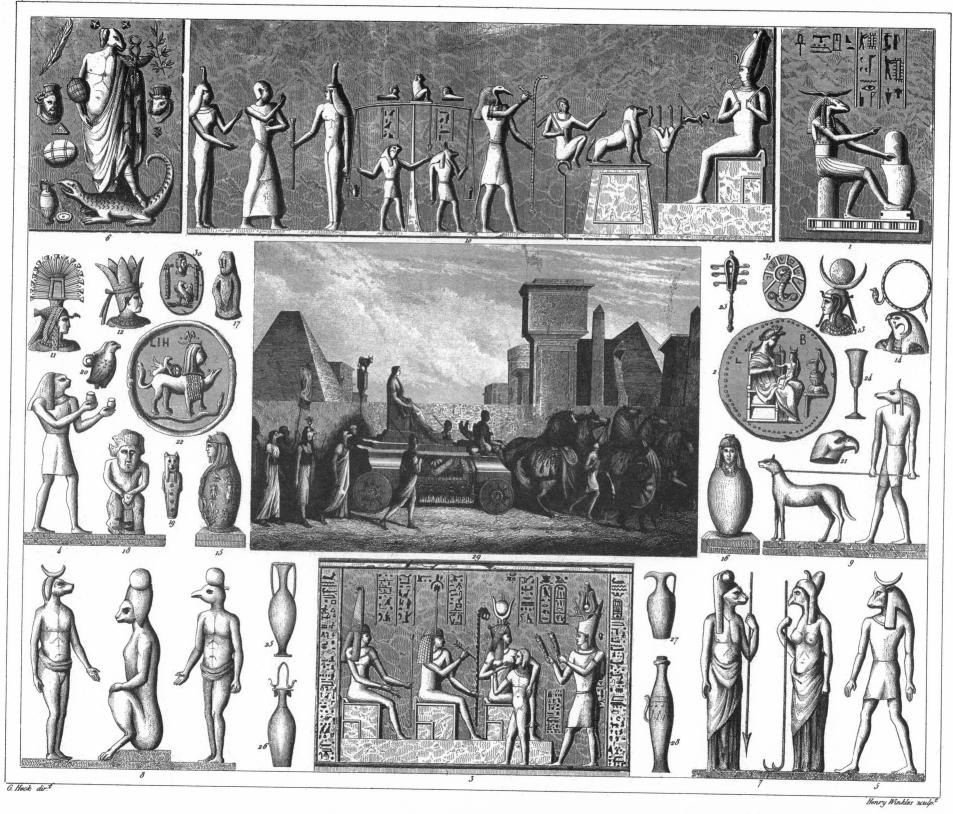

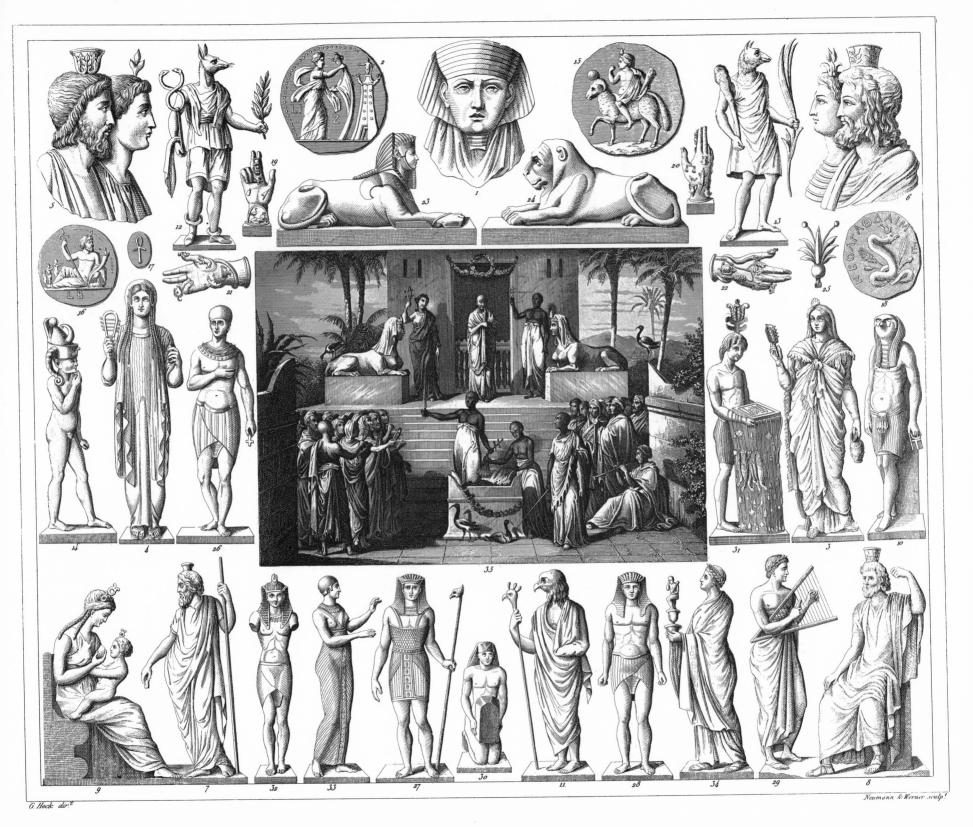

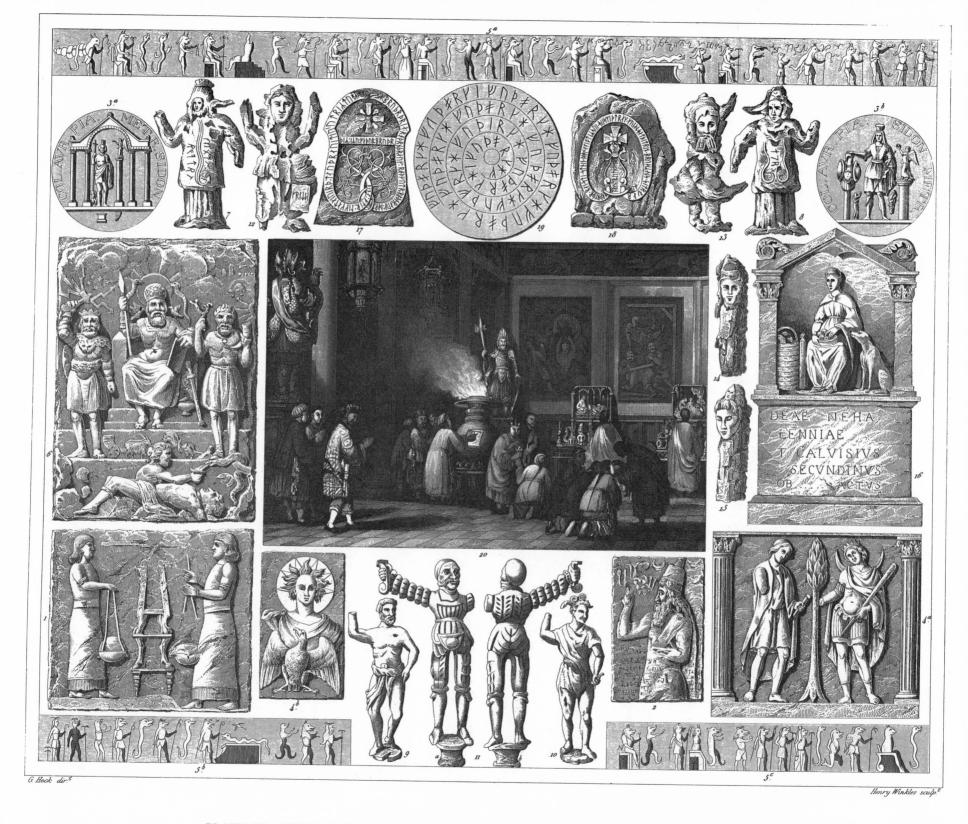

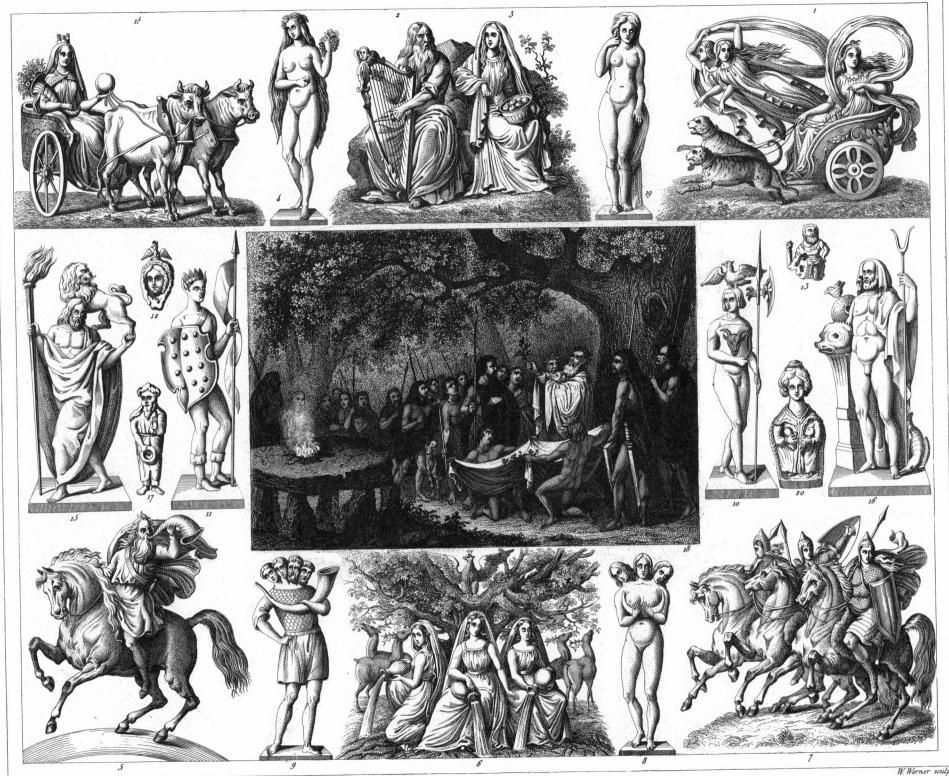

G. Heck dir.t

W. Werner soug

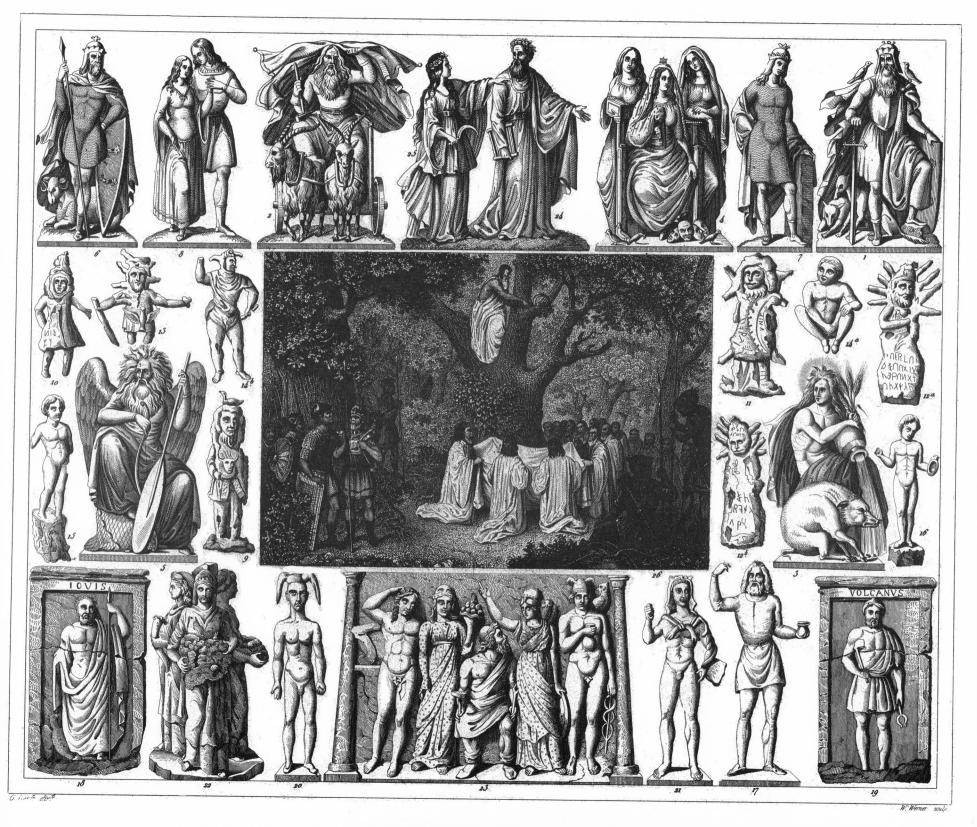

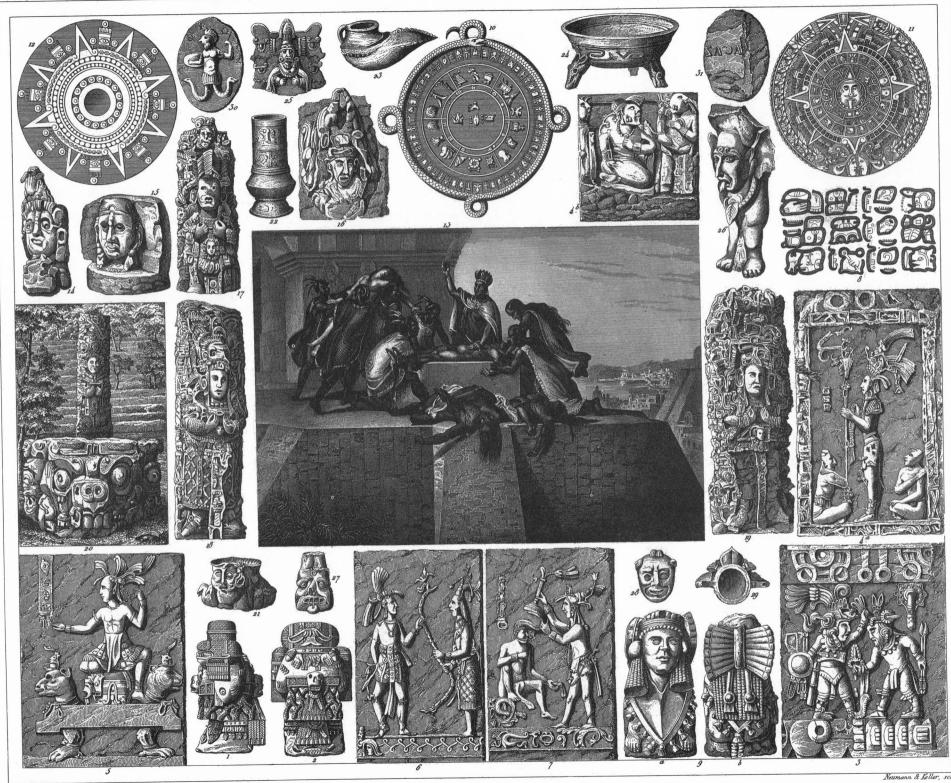

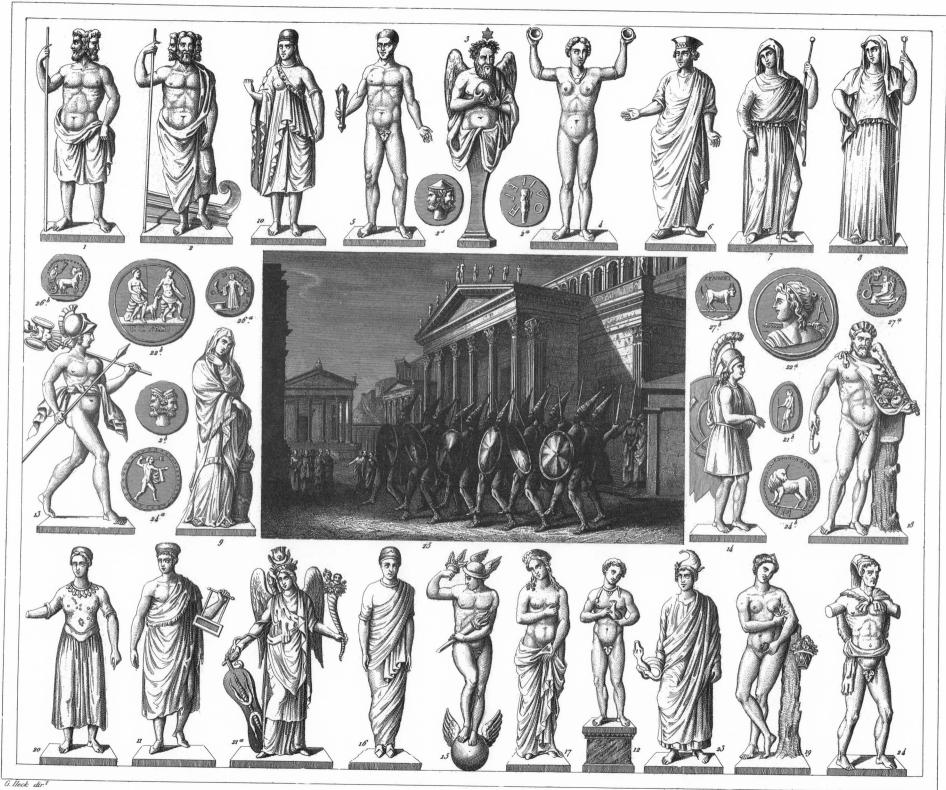

W. Hohneck sculp.

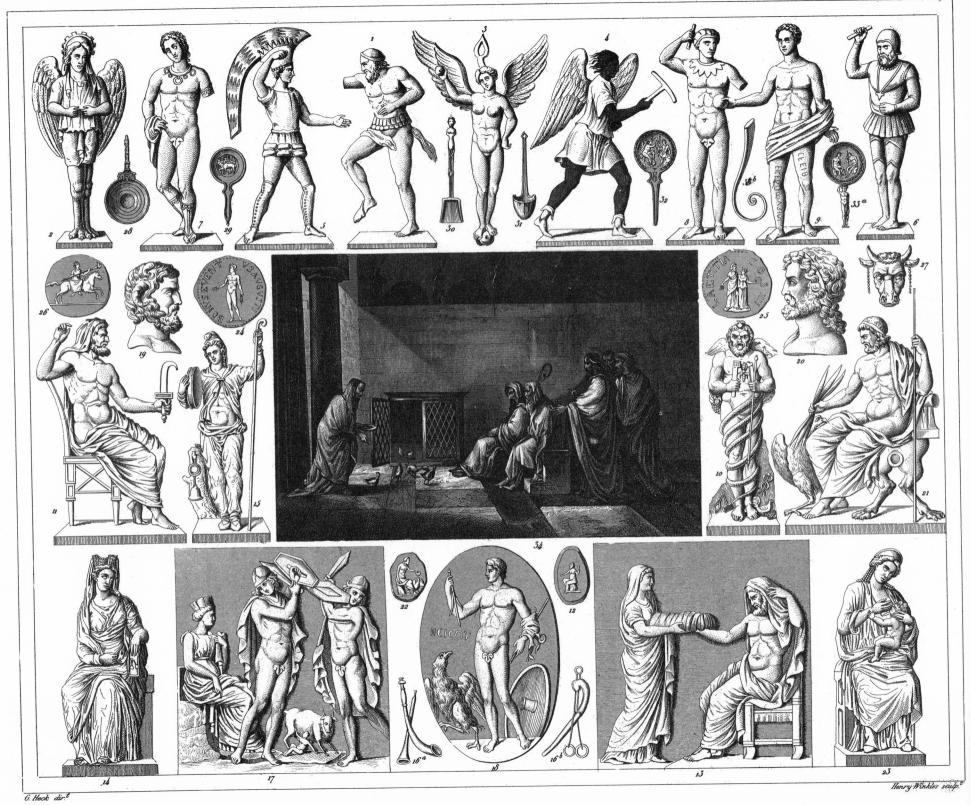

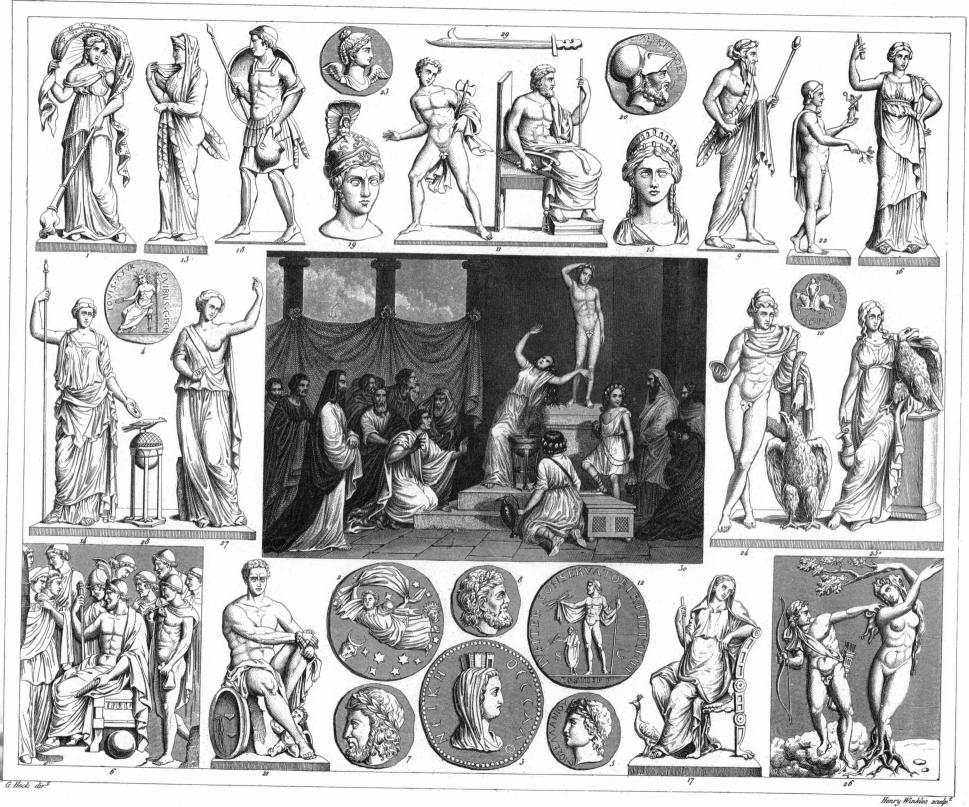

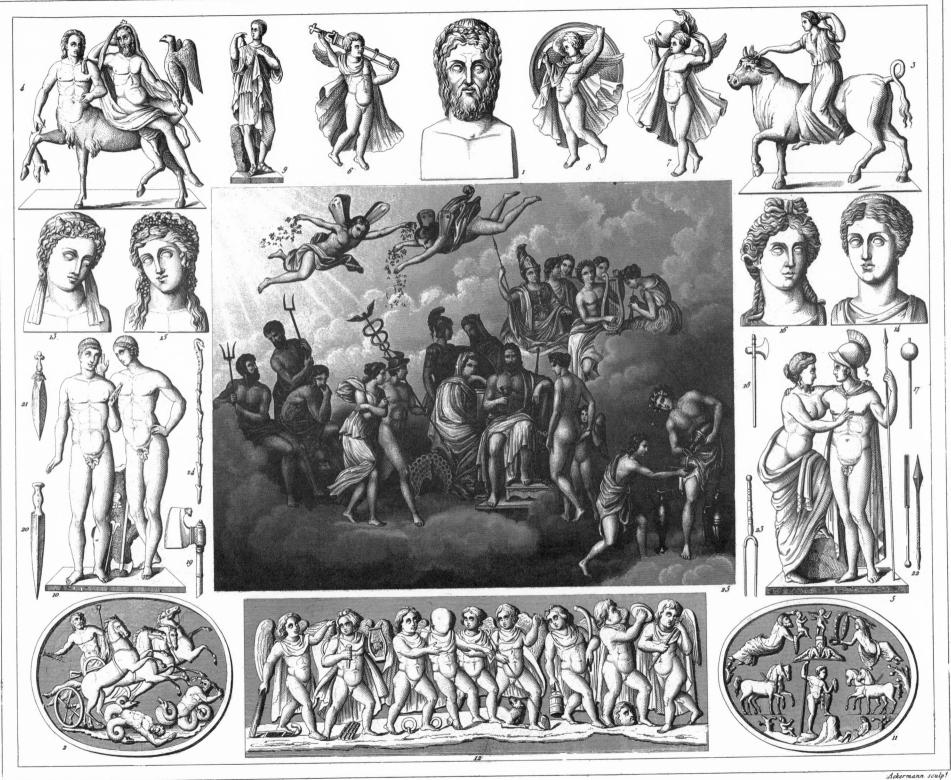

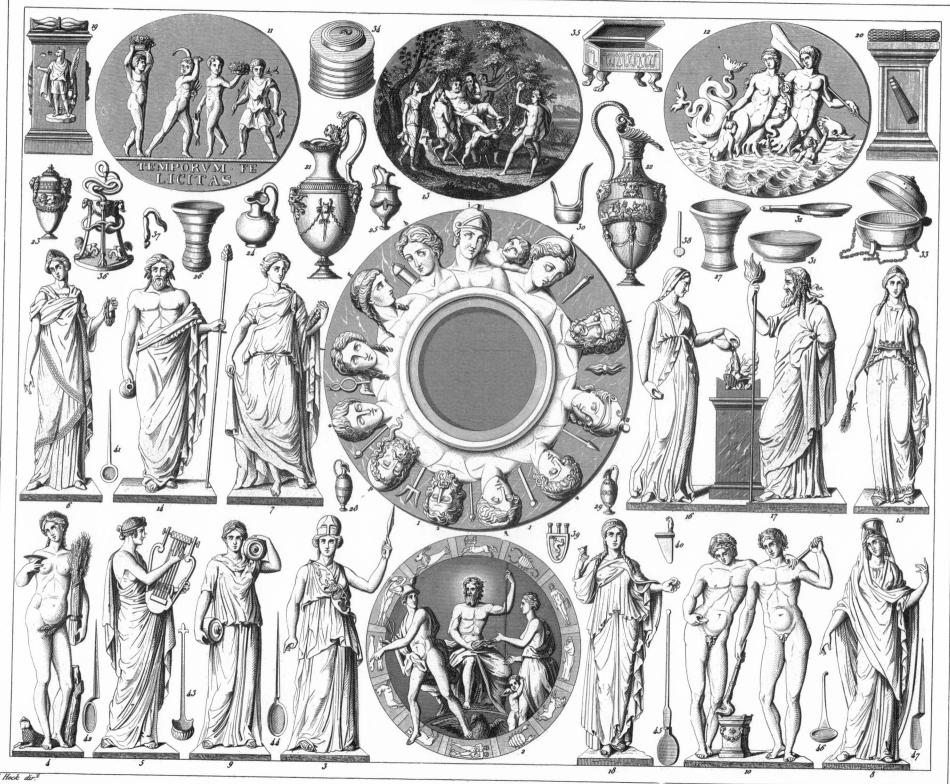

Henry Winkles sculp.t

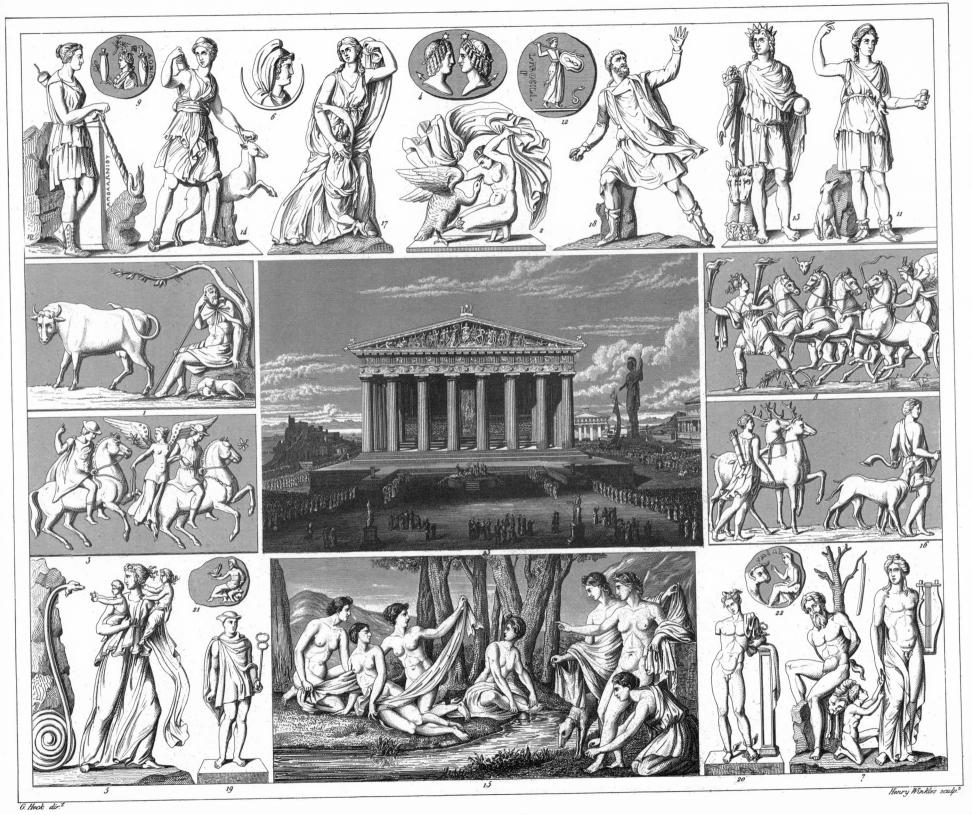

PLATE 429. GREEK FESTIVAL AND MYTHOLOGICAL FIGURES AND SCENES

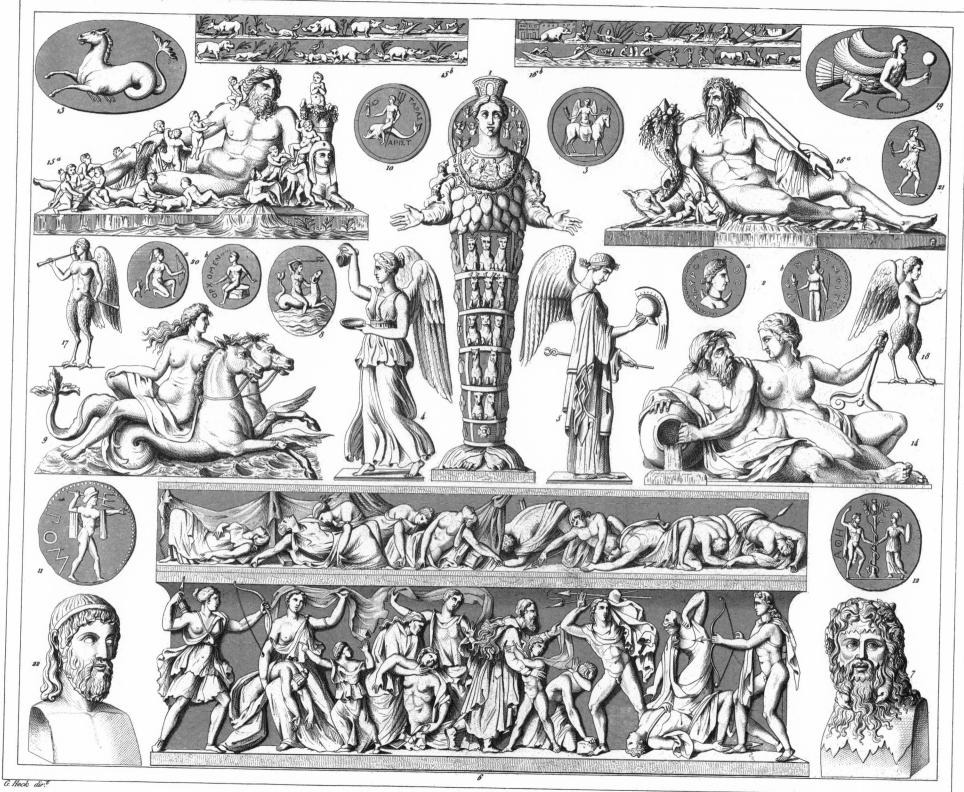

Henry Winkles sculp.

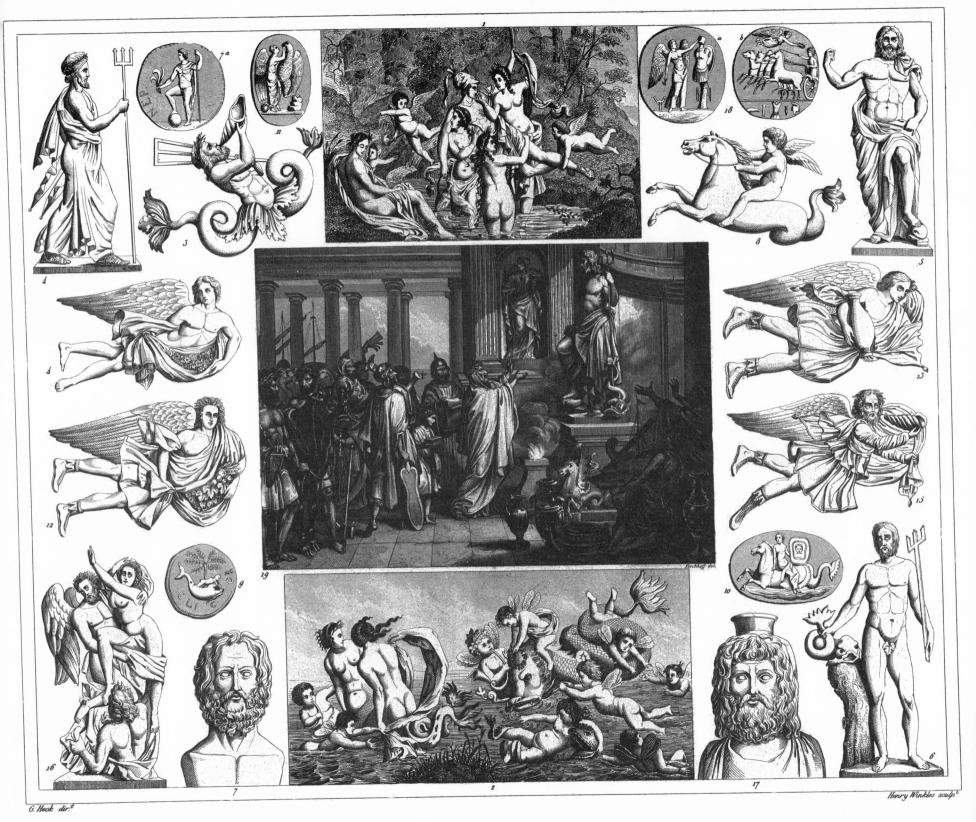

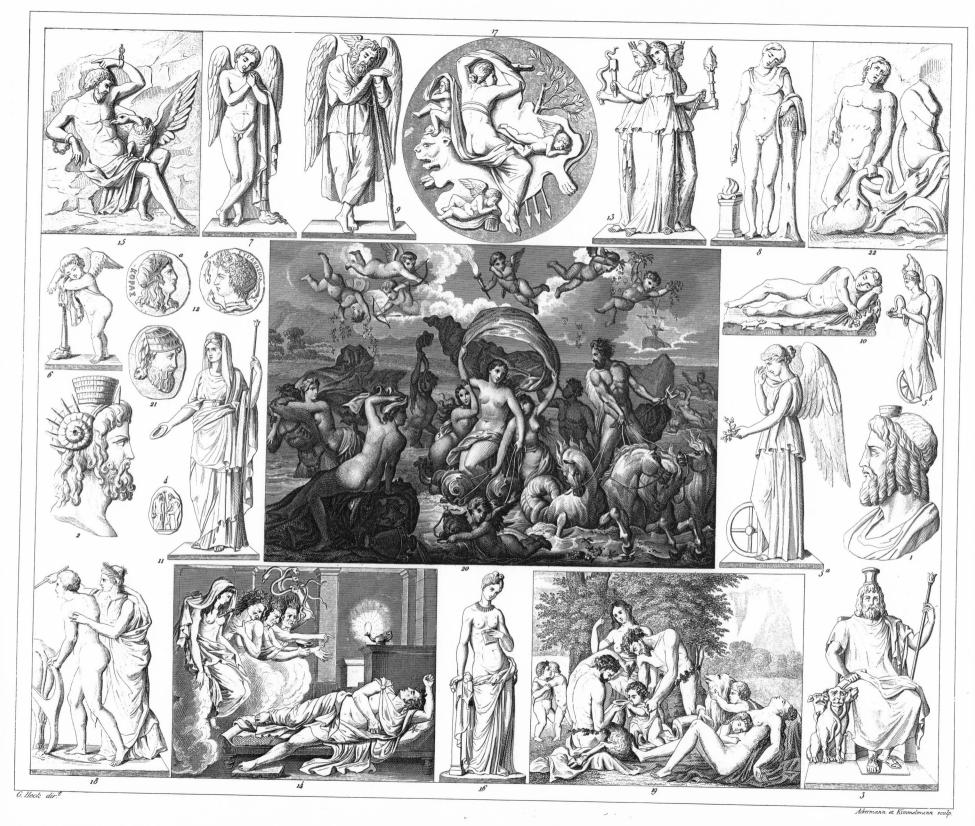

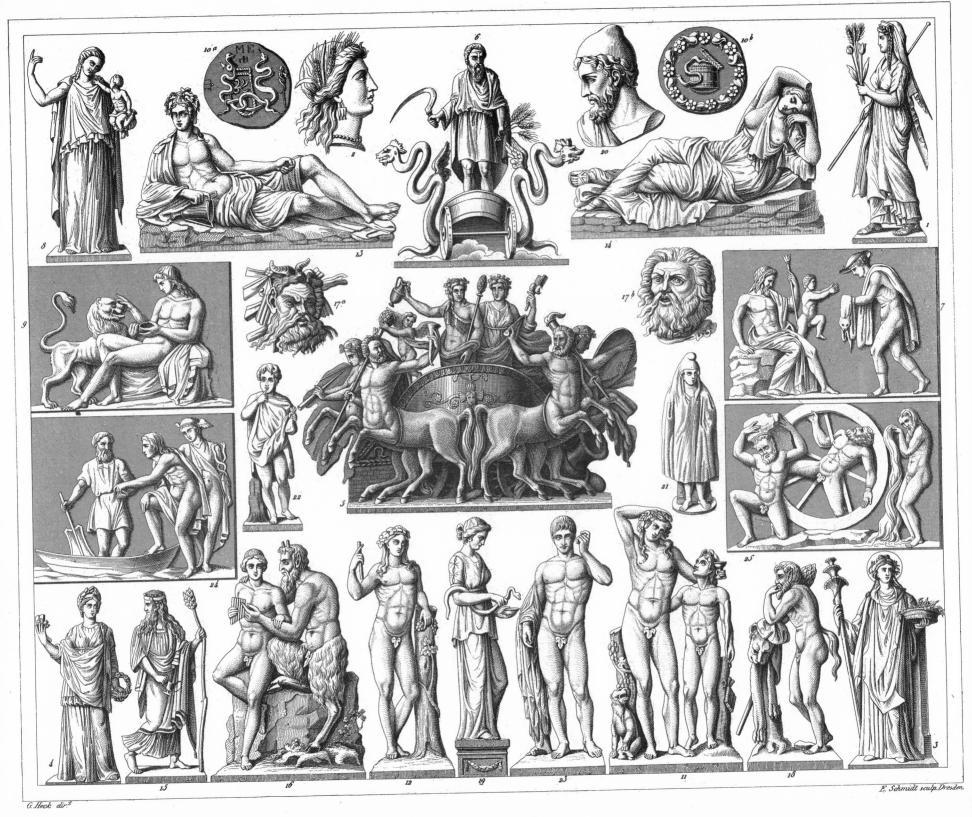

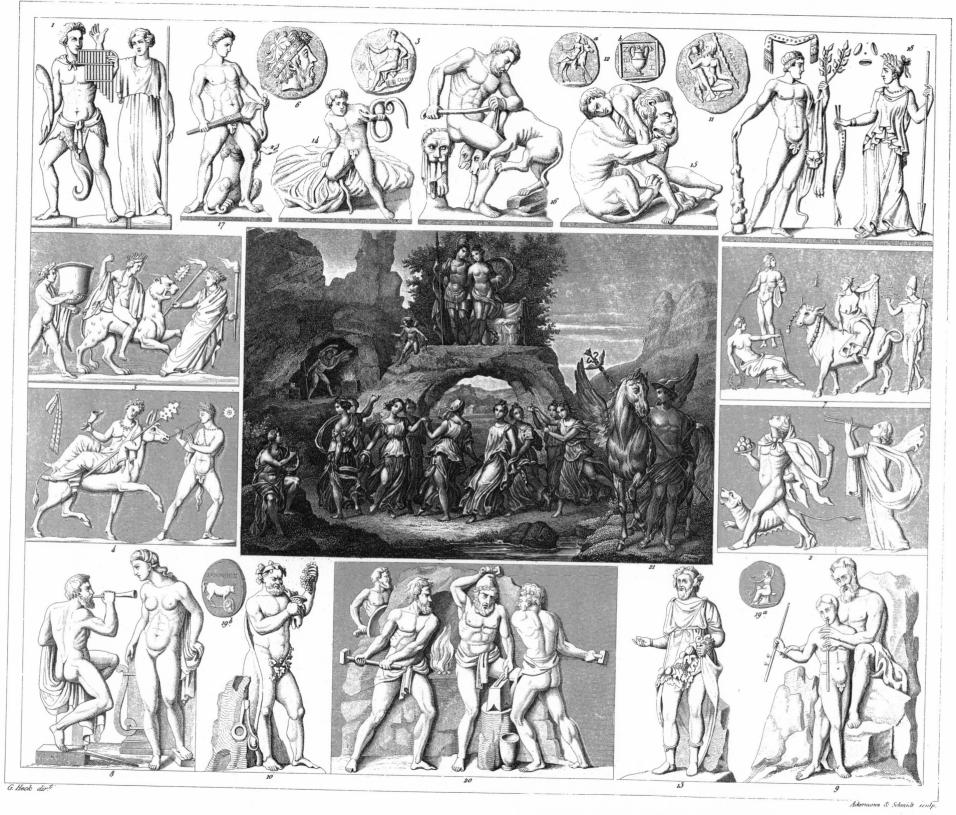

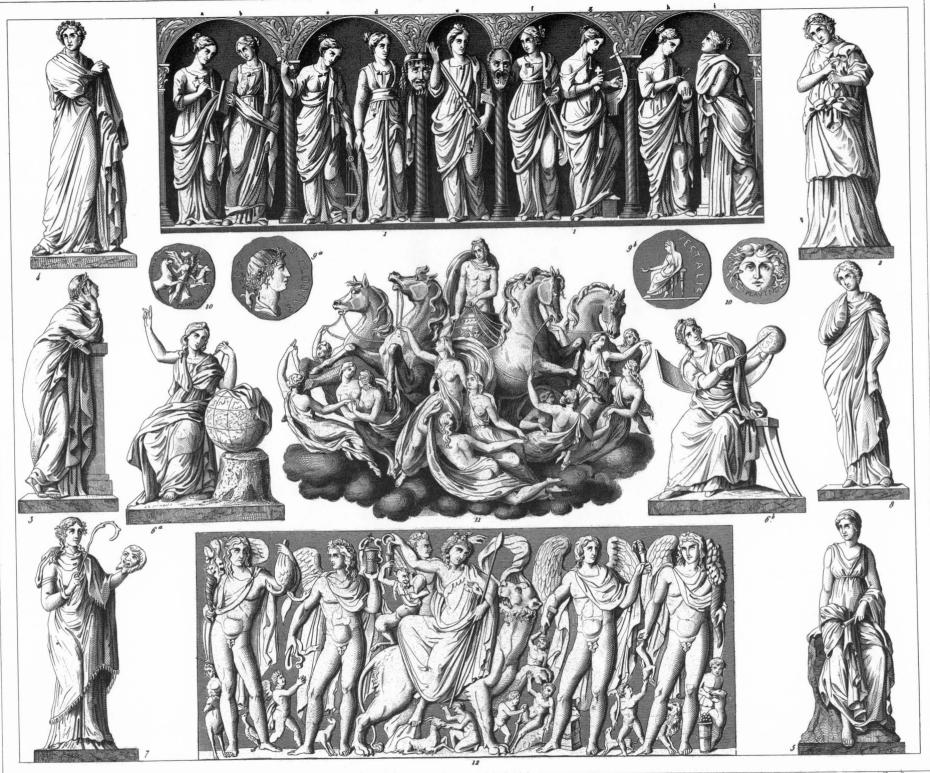

Kimmelmann sculp.

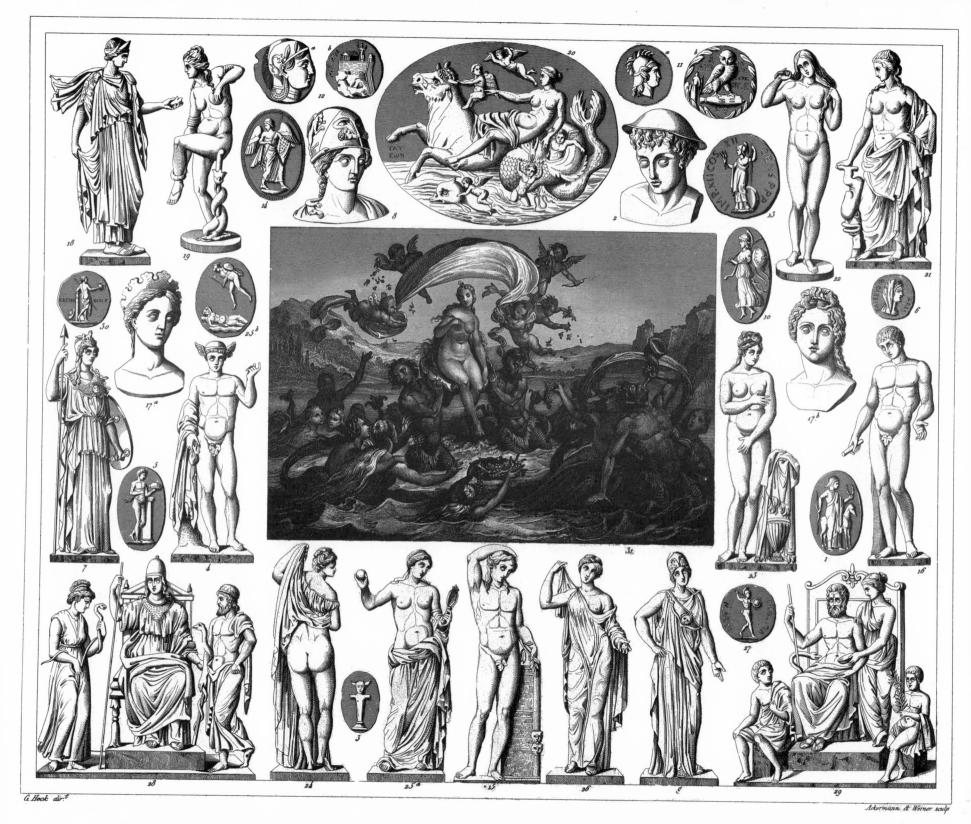

PLATE 436. APHRODITE AND OTHER GODDESSES AND GODS

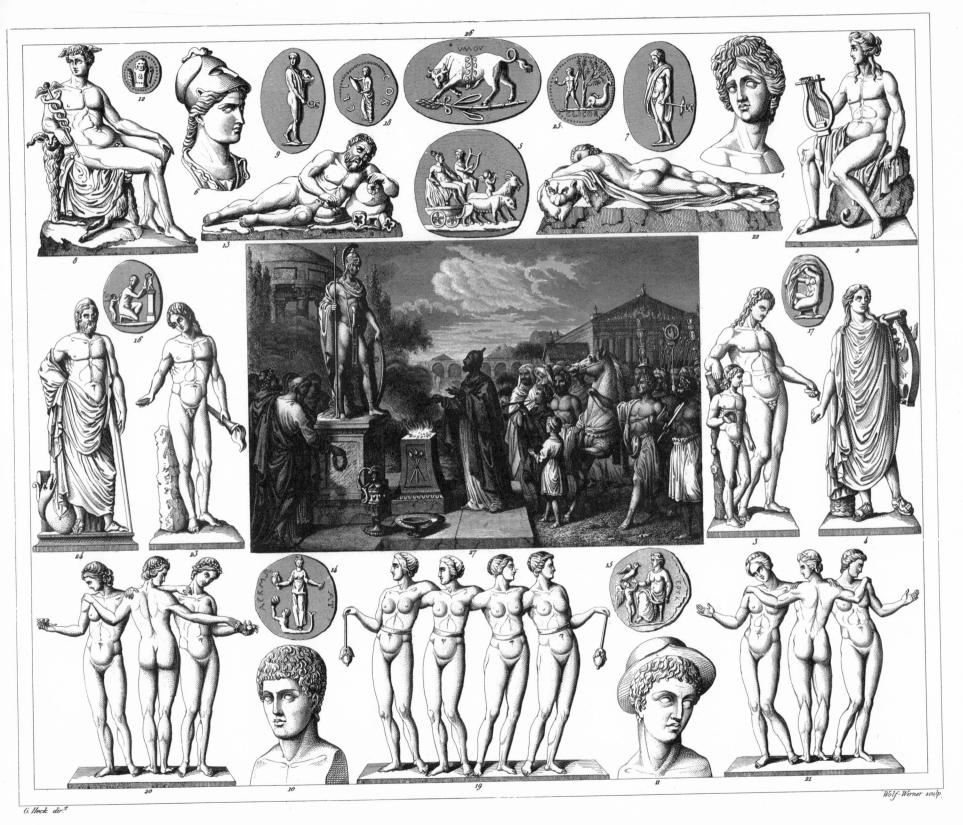

PLATE 437. APOLLO; SACRIFICE TO MARS; OTHER MYTHOLOGICAL FIGURES

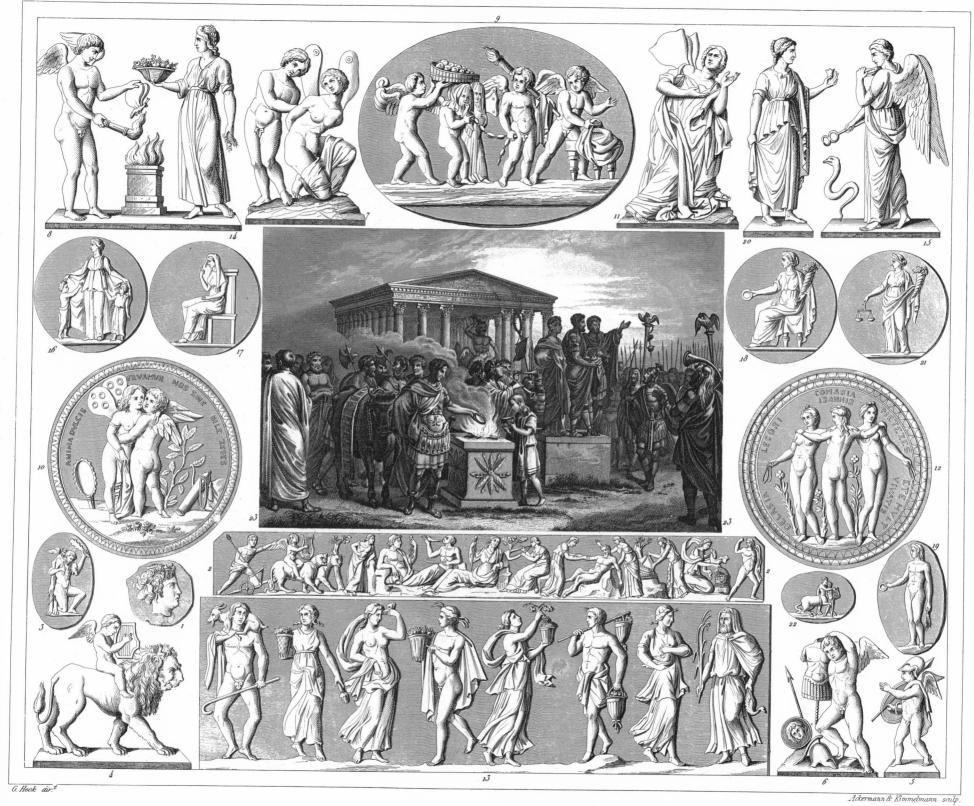

PLATE 438. A SACRIFICE IN ROME; GODS AND MYTHOLOGICAL CHARACTERS

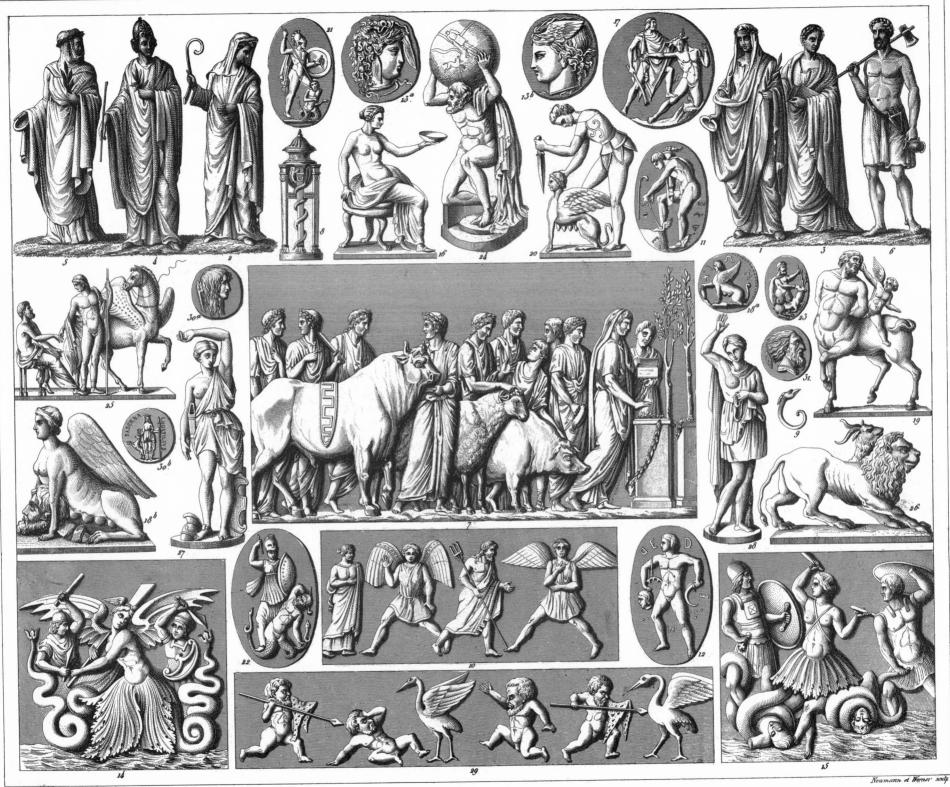

G. Hock dir.t

Captions to the Fine Arts Plates, 440-465

PLATE 440. **Ancient Sculpture**

Figure

- 1. Bas-relief from the ruins of Persepolis
- 2. Trimurti from the temple of Elephanta
- 3. Bas-relief from Ellora
- 4. Bas-relief from Kenneri
- 5. Bust from Ægina
- 6. Mask from Selinuntiæ
- 7, 8. Etruscan bas-reliefs
- 9-11. Grecian sculptures of the second period
- 12. Bas-relief from Selinuntiæ
- 13, 14. Bas-reliefs from Xanthus

PLATE 441. Ancient Sculpture

Figure

- 1-9. Egyptian statues
- Façade of the temple of Hathor at Ipsambul
- 11, 12. Phœnician grave-stones
- 13. Numidian half-bust
- 14. Statue of Lakshmi from Bengalore
- 15. Statue from Isura
- 16-19. Persian sculptures

PLATE 442.

Greek and Roman Sculpture and Coins

Figure

- 1. Hercules's combat with Antæus
- 2. Aphrodite and Ares (Venus and Mars)
- . The reclining Hermaphrodite
- 4. Pallas, in the Villa Albani
- 5. Pallas with the serpent
- 6. The Farnese Flora
- 7. The wounded Amazon of Ctesilaus
- 8. The dancing Hours
- 9. Fragment of the frieze of the Parthenon
- 10. Fragment from the Capitoline Museum

- 11. Bas-relief from a tripod-stand in Dresden
- 12-17. Grecian portrait-busts
- 18-20. Grecian animal heads
- 21. The Gonzaga cameo
- 22-26. Grecian coins

PLATE 443. Greek and Roman Sculpture

Figure

- 1. Phidias's statue of Pallas in the Parthenon in Athens
- 2. The Medicean Venus
- 3. The Venus of Melos
- 4. The Venus of the Dresden Museum
- 5. The Venus Victrix from Capua
- 6. The Capitoline Venus
- 7. Diana the Huntress in Paris
- 8. Statue of Sallustia Barbara Urbana with Eros, in Rome
- 9. Statue of Julia Soæmis in Rome
- 10. Sleep as a boy, in Dresden

PLATE 444. Classical Sculpture

Figure

- 1, 2. The Farnese Hercules
- 3. The Torso Belvedere
- 4. The Borghese Gladiator
- The Dying Gladiator
- 6. The Pallas from Velletri
- 7. Cupid and Psyche
- 8. Venus crouching in the bath
- 9. Statue of Adonis
- 10. Statue of Dionysus, in Paris
- 11. Statue of Bacchus, in Dresden
- 12. Statue of Cincinnatus in Paris
- 13. Boy extracting a thorn from his foot, in Rome

PLATE 445.

Classical and Classical Revival Sculpture

Figure

1. Statue of Antinous of

Belvedere

- . The Apollo of Belvedere
- 3. Statue of a Faun
- 4. Statue of Germanicus, from the 15th century; it belongs to the period of the revival of art, but the sculptor is not known. It is preserved in the Louvre in Paris
- 5. Hercules with the boy Telephus on his arm, in Rome
- 6. Boy wrestling with a goose
- 7. Laocoön, in the Vatican
- 8. Statue of Meleager, in Rome

PLATE 446. Renaissance Sculpture

Figure

- 1. Pietas Militaris, bas-relief in Rome
- 2. The restoration of the dead to life, bas-relief in the Vatican
- Statue of a bishop, by Agostino and Angelo de Senis
- 4. Shrine of St. Peter the Martyr, by Giovanni Balducci
- 5-8. Four Caryatides from this shrine
- Bust from a fountain at Siena, by Jacopo della Ouercia
- 10. Bust of an apostle, by Andrea Verocchio
- 11. St. John the Baptist, by Donatello
- 12. St. George, by Donatello
- 13. Holy Virgin, by Giovanni da Pisa
- 14. Apollo and Daphne, by Lorenzo Bernini
- 15. The Angel of the Annunciation, by Francesco Mocchi
- 16. Perseus, by Benvenuto Cellini
- Mercury, by Giovanni da Bologna

- 18. Bacchus and a Satyr, by Michael Angelo
- 19. Moses, by Michael Angelo
- 20. Morning and Evening, by Michael Angelo

PLATE 447.

Renaissance, Mannerist, and Neoclassic Sculpture

Figure

- 1. The Three Graces with the Urn, by Germain Pilon
- 2. The Fettered Slave, by Michael Angelo
- 3. The Penitent Magdalene, by Canova
- 4. The Dancing Girl, by Canova
- 5. Statue of Jason, by Thorwaldsen
- 6. Statue of Apollo, by Thorwaldsen
- 7. Statue of Cincinnatus, by Chaudet
- 8. Dancing Neapolitan, by Duret
- 9. Statue of Spartacus, by Fogatier
- 10. The Maid of Orleans, by the Duchess Marie of Orleans

PLATE 448. Neoclassic Sculpture

Figure

- 1. Statue of Hebe, by Canova
- 2. Cupid and Psyche, by Canova
- 3. The Three Graces, by Canova
- 4. Statue of Venus, by Thorwaldsen
- 5. The Three Graces, by Thorwaldsen
- 6. Achilles and Briseis, bas-relief by Thorwaldsen
- 7-11. Fragments from the Procession of Alexander, bas-relief by Thorwaldsen

PLATE 449. Heroic and Memorial Sculpture and Monuments

Figure

- Statue of Admiral Duquesne, by Roguier
- 2. Statue of Bayard, by Montour
- 3. Statue of Du Guesclin, by Bridan
- 4. Statue of the great Condé, by Jean David
- 5. Statue of Mozart, by Schwanthaler
- 5ab. Bas-reliefs from the pedestal of the last-named monument, by Schwanthaler
- 6. Statue of Margrave
- Frederick, by Schwanthaler
 7. Ino with the boy Bacchus, by Dumont
- 8. Leda and the Swan, by Seurre jeune
- 9. Statue of Bavaria, by Rauch
- 10. Statue of Felicitas publica, by Rauch
- 11. Monument to Marshal Saxe, by Pigalle
- 12. Monument to Robert Burns in Edinburgh

PLATE 450. Nineteenth-Century Memorial and Ceremonial Sculpture

г.

- Figure
 1. Statue of Otto the Illustrious, by Schwanthaler
- 2. Statue of Ludwig the
- Bavarian, by Schwanthaler
 3. Statue of Gutenberg, by Jean
 David
- 4. Statue of Gutenberg, by Thorwaldsen
- 5, 6. Bas-reliefs from the pedestal of the last-named monument, by Thorwaldsen
- 7. Statue of Schiller, by Thorwaldsen

- 9. Bas-reliefs from the pedestal of the last-named monument, by Thorwaldsen
- Statue of General Kleber, by Ph. Gross
- 11. Monument to the Duchess of Saxe-Teschen, by Canova
- 12. The Death of Epaminondas, bas-relief by Jean David
- 13. Bellona, bas-relief by Chinard
- 14. Monument to Dugald Stewart in Edinburgh

PLATE 451. Ancient Wall and Vase Painting

Figure

- 1, 2. Egyptian paintings
- 3-7. Etruscan vase-paintings
- 8, 9. Wall-paintings from Pompeii
- 10. Monochrome from Herculaneum
- 11. Achilles and Briseis, from Pompeii
- 12. Achilles at Scyros, from Pompeii
- 13, 14. Wall-paintings from the baths of Titus

PLATE 452. Ancient Decorative Arts

Figure

- 1-4. Etruscan vase-paintings
- 5. Theseus, wall-painting from Herculaneum
- 6. Narcissus, wall-painting from Herculaneum
- 7. The Aldobrandini wedding
- 8. Fresco painting from the villa Pamfili
- 9. The Pythian Apollo
- 10. The Delphian Apollo
- 11, 12. Nymphs, from the Baths of Constantine
- 13, 14. Amorettes, from the same
- 15. Ceiling from the sepulchre of the Naso family
- 16. Masks, mosaic in the Vatican
- 17. Doves, mosaic in the Capitoline Museum
- 18. Relief-mosaic in Rome
- 19-22. Mosaic pavement

PLATE 453.

Ancient and Early Medieval Painting and Mosaics

Figure

- 1-3. Grecian vase-paintings
- 4. Wall-painting from the sepulchre of the Naso family
- 5ab. Miniature paintings of the 8th century
- 6. Mosaic from the Villa Albani
- 7. Mosaic from St. John's in the Lateran
- 8. Fragment from Trajan's column
- 9. Mosaic from Cosmedino
- 10. Mosaic from St. John's in the Lateran
- 11. Mosaic from Florence
- 12. Mosaic from St. Peter's in Rome

PLATE 454.

Italian Painting of the Renaissance

Figure

- 1. School of Athens, by Raphael
- 2. Madonna and Child, by Leonardo da Vinci
- 3. Ecce Homo, by Ludovico Cardi
 - 4. St. Mark, by Fra Bartolomeo
- 5. St. Francis, by Guido Reni
- 6. The Entombment of Christ,
- by Caravaggio
 Mary Magdaler
- Mary Magdalen and St. Francis of Assisi by the body of Christ, by Annibale Caracci
- 8. Joseph and Potiphar's wife, by Carlo Cignani
- 9. Praying Madonna, by Sassoferrato
- 10. Madonna, by Guido Reni
- 11. St. John the Baptist, by
 Guido Reni
- 12. Galathea, by Ludovico Caracci
- 13. Pluto, by Agostino Caracci

PLATE 455.

Italian Renaissance and Baroque Painting

Figure

- 1. St. Cecilia, by Raphael
- Madonna and Child, by Raphael

- 3, 4. Fresco paintings by Raphael
- 5. The Distribution of the Holy Rosaries, by Carlo Maratti
- 6. Venus and Vulcan, by Giulio Romano
- 7. Madonna, by Annibale Caracci
- 8. Descent from the Cross, by Andrea del Sarto
- 9. Polyhymnia and Erato, by Pietro da Cortona
- 10. Euterpe and Urania, by Pietro da Cortona

PLATE 456.

Painting of the Sixteenth and Seventeenth Centuries

Figure

- 1ab, 2ab. Fresco paintings, by Raphael
- 3. Raphael's portrait, by himself
- 4. The Adulteress before Christ, by Tintoretto
- 5. The Dying Magdalen, by Rustichino
- 6. Holy Family, by Francesco
 Albano
- 7. Charity, by Andrea del Sarto
- 8. Madonna, by Murillo
- Vandyk's portrait, by himself
- 10. Passage of the Granicus, by Lebrun

PLATE 457.

Baroque and Mannerist Painting

Figure

- 1. Madonna and the Fathers of the Church, by Raphael
- 2. The Virgin Mary, by Fra Bartolomeo
- 3. Christ crowned with thorns, by Titian
- 4. Andromeda, by Francesco Furini
- Offering brought to Æsculapius, by Guérin
- 6. Guido Reni's portrait, by himself
- 7. Assumption of St. Mary, by Rubens
- 8. Portrait of Rubens, by himself
- . The Adoration of the Shepherds, by Van der Werff

- 10. Youth with the Drinking-cup
- 11. Guitar-player, by Netscher
- 12. The Adoration of the Magi
- 13. Endymion, by Girodet-Trioson
- Belisarius, by François Pascal Gérard

PLATE 458.

Illustrations of the Theory of the Art of Drawing

Figure

- 1-12. The eye
- 13-15. The nose
- 16-19. The mouth
- 20-27. The ear
- 28-31. The feet
- 32-39. The hands
- 40-45. Pictorial perspective

PLATE 459.

Illustrations of the Theory of the Art of Drawing

Figure

- 1-10. The head
- 11-14. The entire body
- 15, 16. Artistical Anatomy
- 17-21. The hands

PLATE 460.

Illustrations of the Theory of the Art of Drawing

Figure

- 1–11. Auxiliary lines
- 12–15. Proportions of the human body
- 16, 17. Proportions of the human face
- 18. Antique torso
- 19-21. Antique heads

PLATE 461.

Illustrations of the Graphic Arts

Figure

- 1. Etching on soft ground
- 2. Etching
- 3. Etching finished with the graver
- 4. Mezzotinto
- 5. Aquatint engraving
- 6. Stippling combined with line engraving
- 7, 8. Manner of holding the graver

- 7a. Engraver's easel
- 8a. Engraver's hand-vise
- Manipulation of cutting stones
- 9a. Engraver's oil-rubber
- 10, 11. Tampons, or dabbers
- 12. Common ruler
- 13. Parallel ruler
- 14, 15. Scrapers
- 16. Burnisher
- 17. Rocking-tool or cradle
- 18. Roulette
- 19. Scratcher
- 20-22. Etching needles
- 23-26. Gravers
- 27. Callipers
- 28ab. Improved callipers
- 29, 30. Punches
- 31, 32. Engraver's anvil and hammer
- 33. Lines made by the cradle
- 34. Reducing frame
- 35. Frame for correctly observing curves on busts, etc.
- 36-38. Hands for engraving stamps

PLATE 462.

Alphabets of Various Languages for the Use of Engravers

* * The values of the letters in English characters are placed opposite them. It will suffice here to give the list of the languages whose superscriptions are in German. The only words that may require explanation are: Kehlhauch, guttural aspiration; Kurz, short; Lang, long; Werth, value; Zahlwerth, numerical value; and Benennung, name

The alphabets are: 1. Japanese; 2. Tamul; 3. Bugic (Malay); 4. Persian arrow-headed characters; 5. Hebrew; 6. Samaritan; 7. Pehlvi (Parthian); 8. Armenian; 9. Ancient Greek; 10. Modern Greek; 11. Coptic; 12, Gothic; 13. Etruscan; 14. Anglo-Saxon; 15. Runic.

PLATE 463. **Alphabets for Engravers**

1. Magadha (older Sanscrit); 2.

Sanscrit; 3. Tibetan; 4. Arabic; 5. Ethiopian; 6. Syriac; 7. Zend; 8. Mongolian; 9. Russian; 10. Wallachian; 11. Serbian.

GLOSSARY

Bemerkungen, Observations; these are: *Jerr adds to the force of the preceding consonant; ** Jehr softens the preceding consonant; ***The Serbian language is printed with Russian type, with the addition of Jerr and Jehr.

Interpuctionszeichen der Zendschrift, Punctuation marks of the Zend language.

PLATE 464.

Details Illustrating the
Construction of Theatrical
Buildings

Figures 1–33.

PLATE 465.

Details Illustrating the
Construction of Theatrical
Buildings

Figures 1-45.

•				

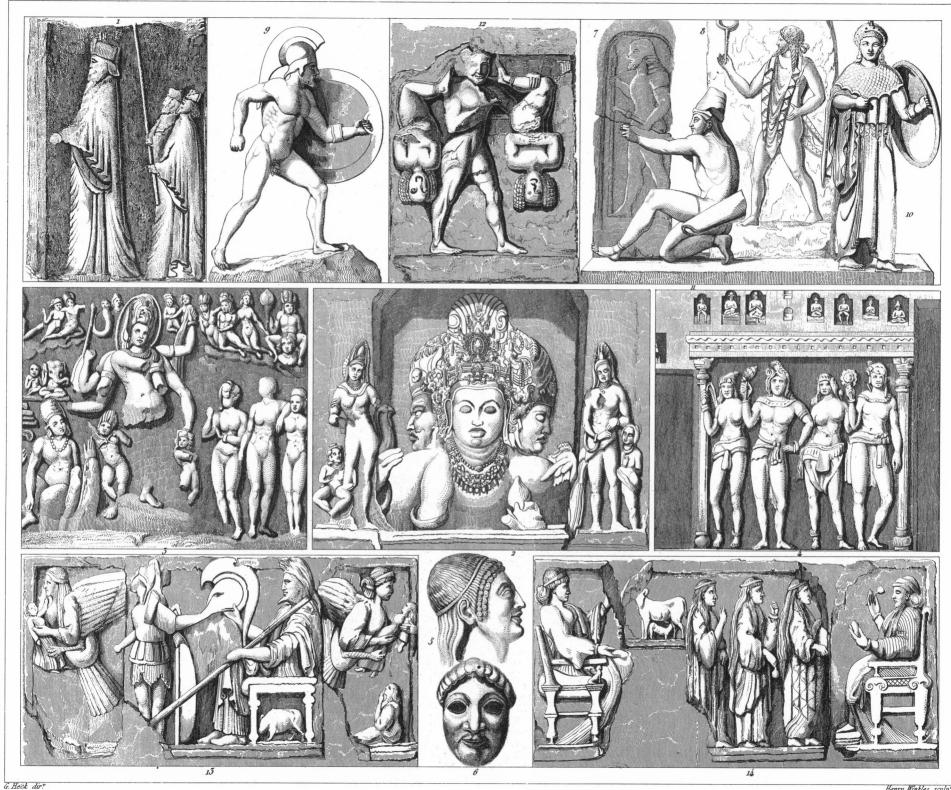

Henry Winkles sculp!

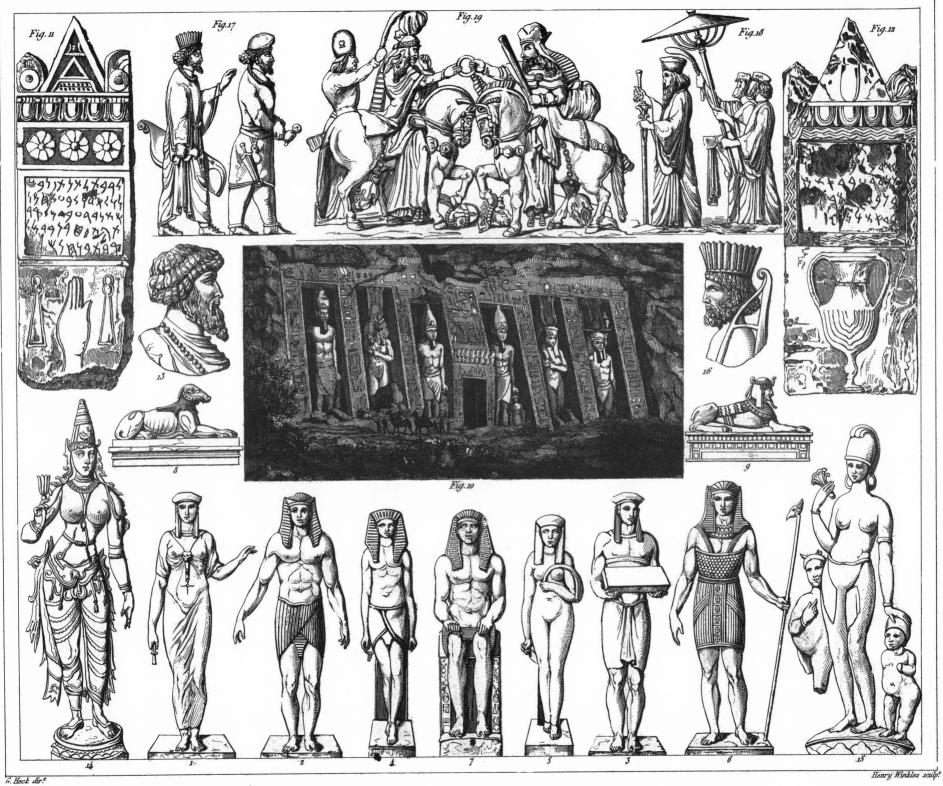

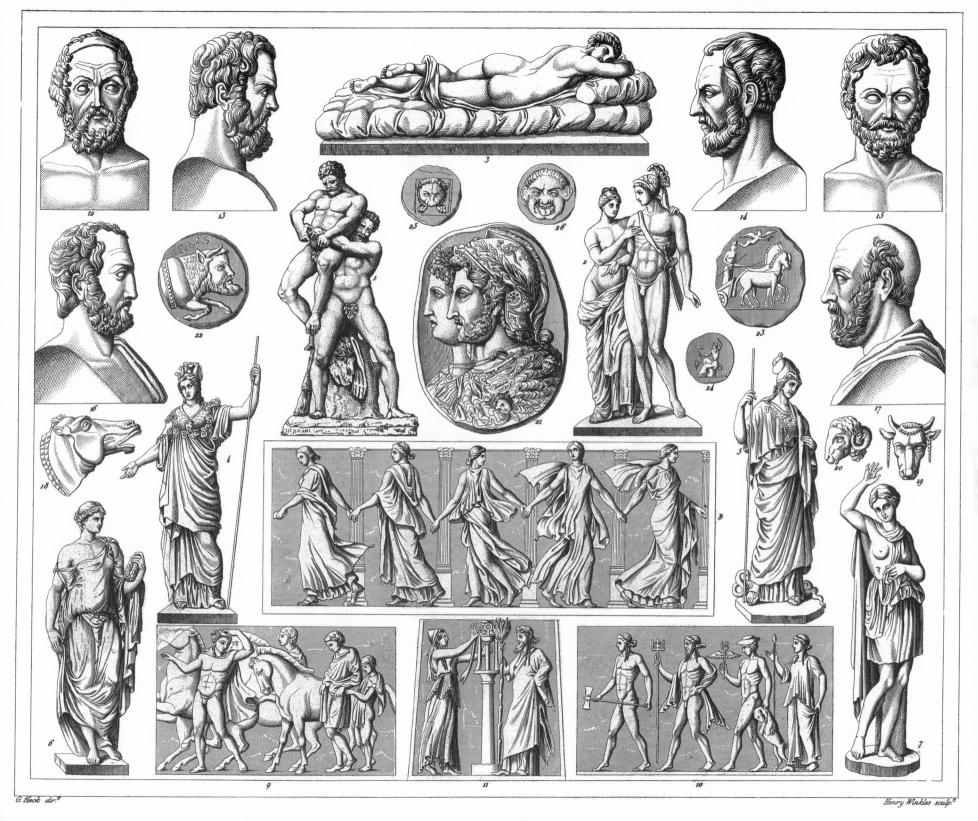

PLATE 442. GREEK AND ROMAN SCULPTURE AND COINS

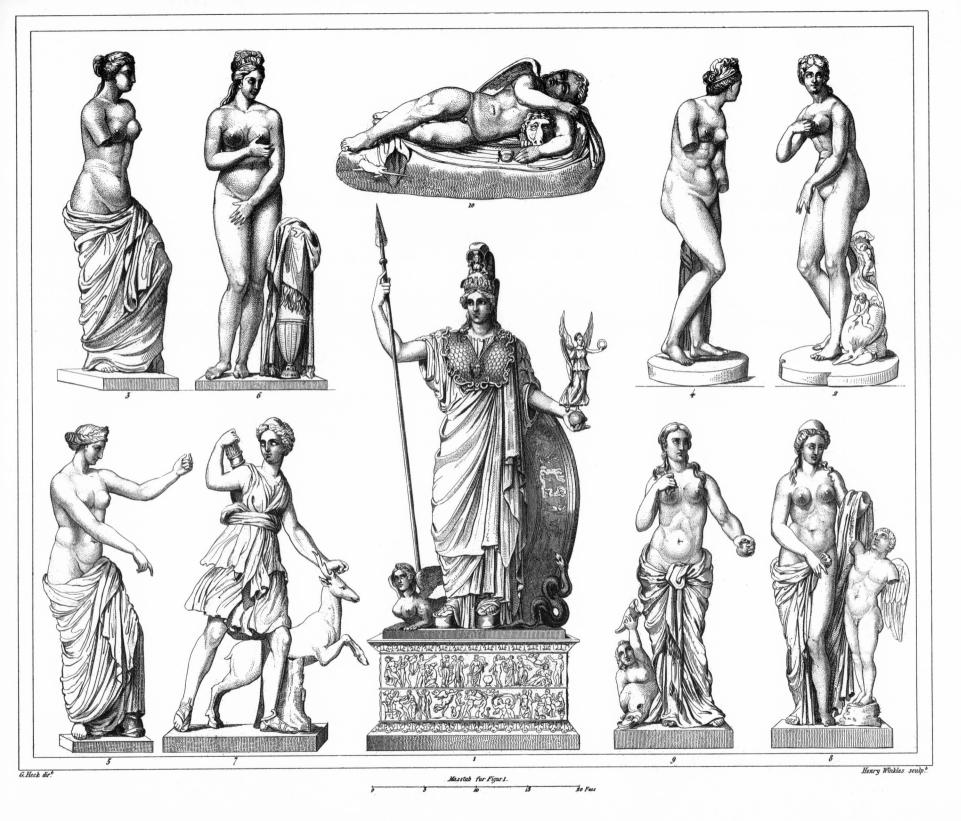

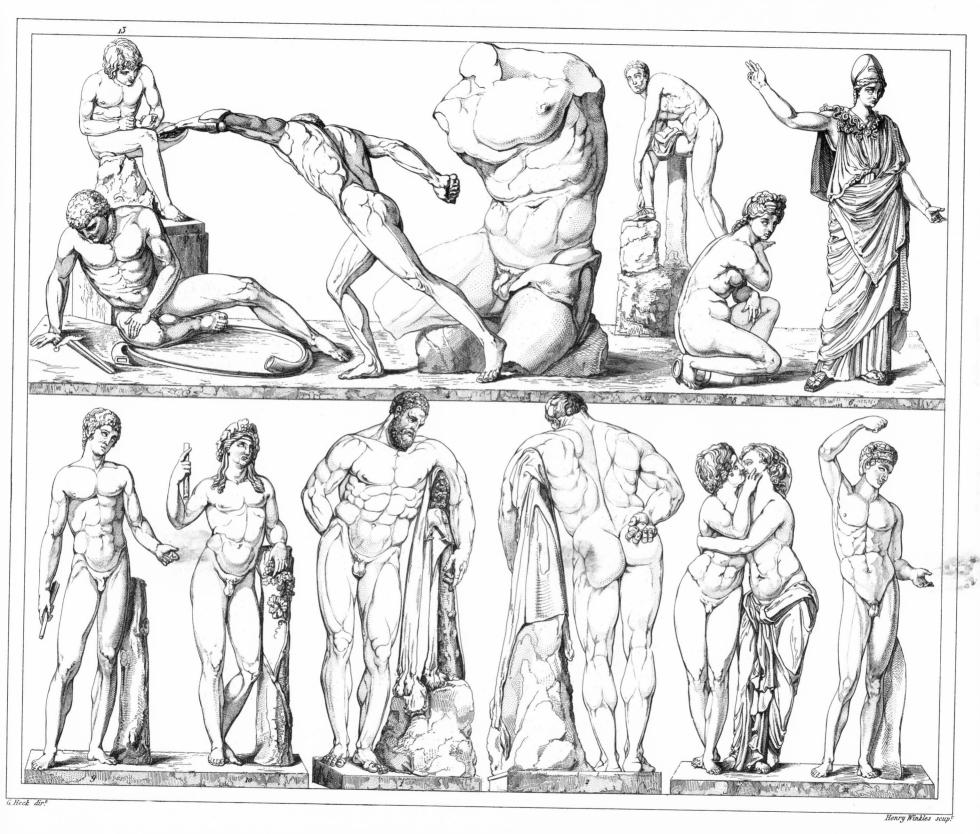

PLATE 444. CLASSICAL SCUI PTURF

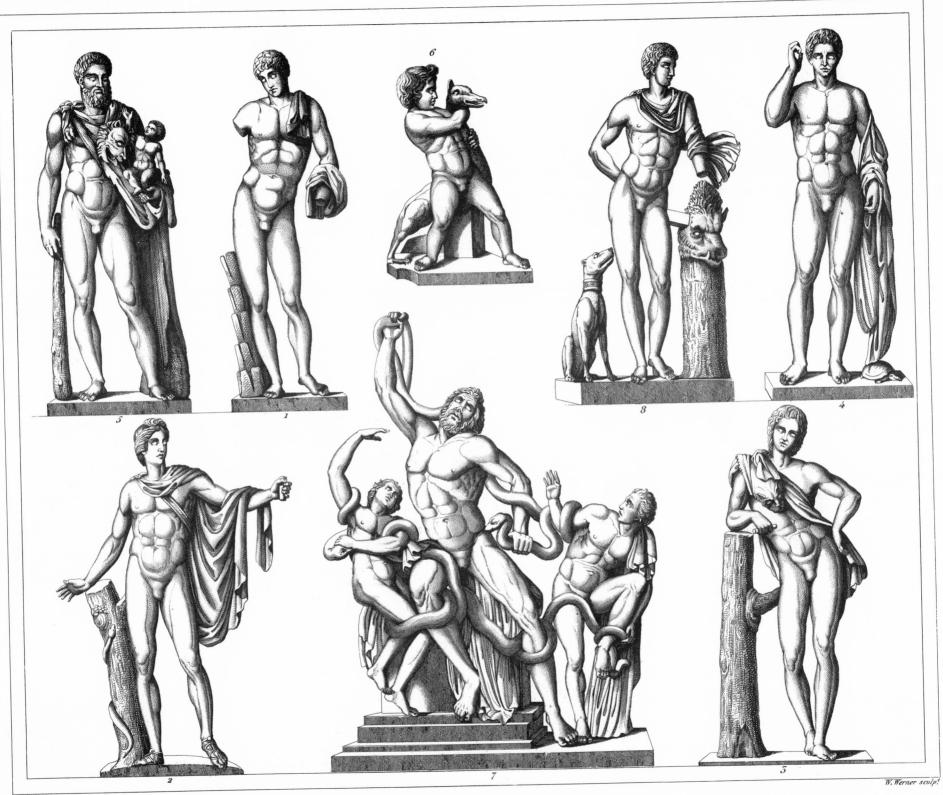

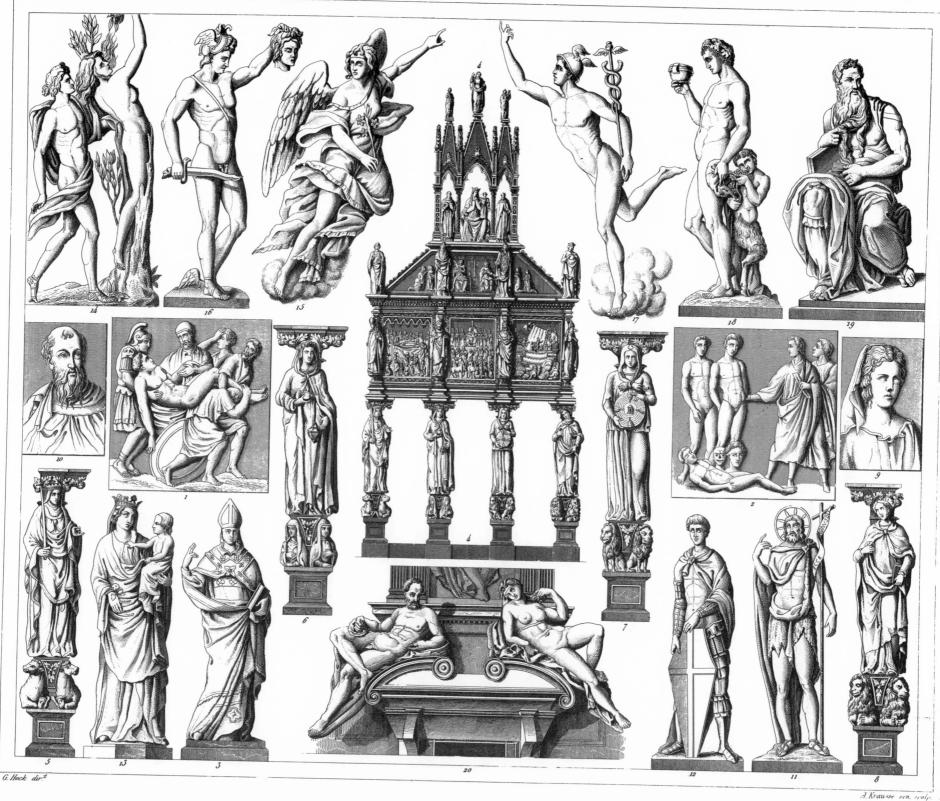

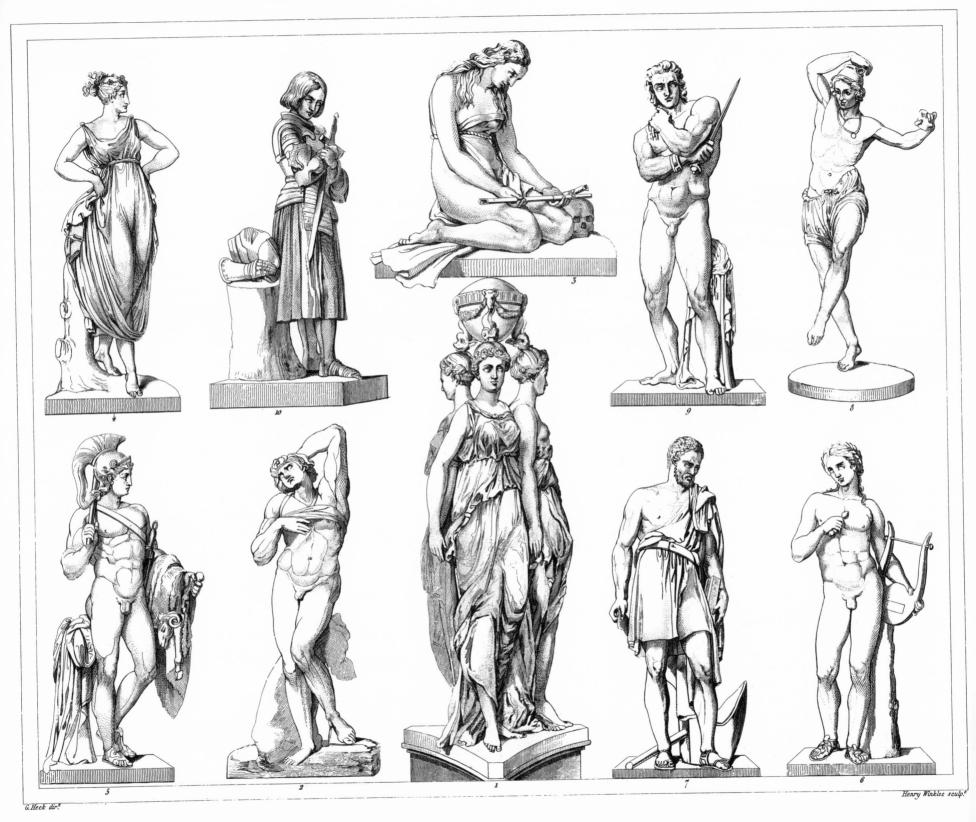

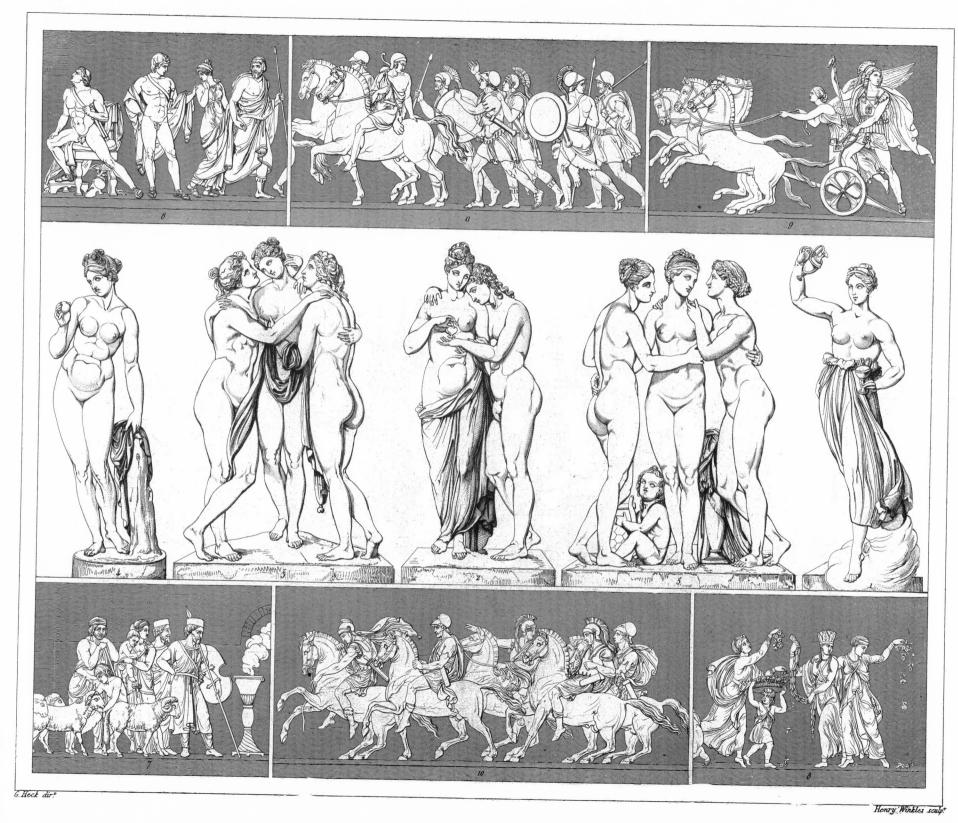

PLATE 448 NEOCI ASSIC SCILI DELIDE

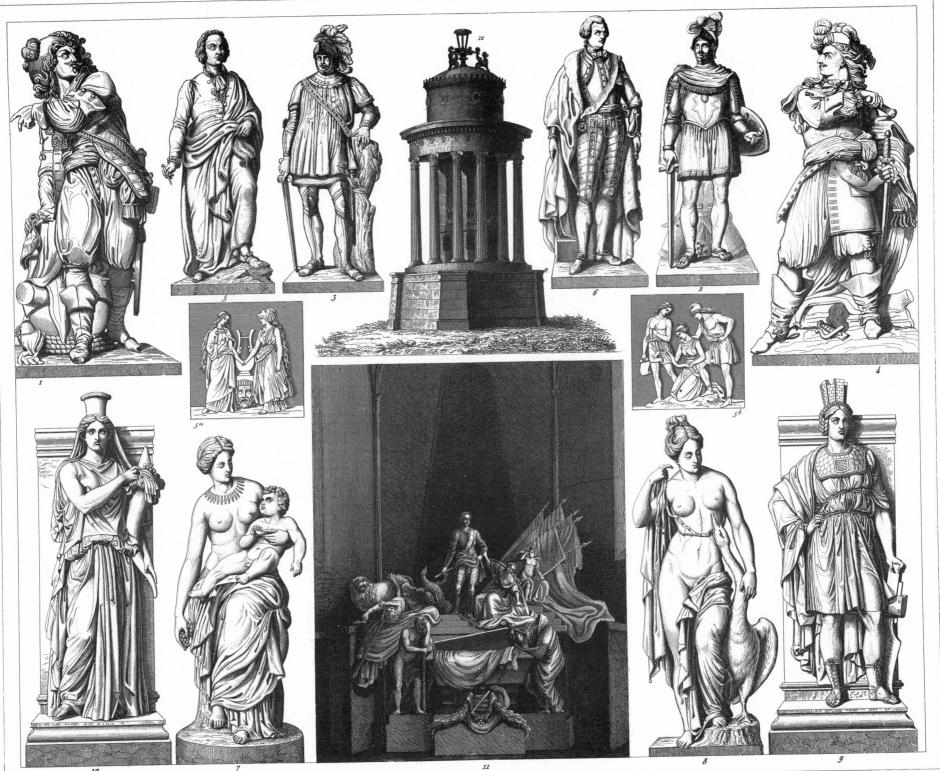

G. Hook dir.

A. Krausse sen. saulp.

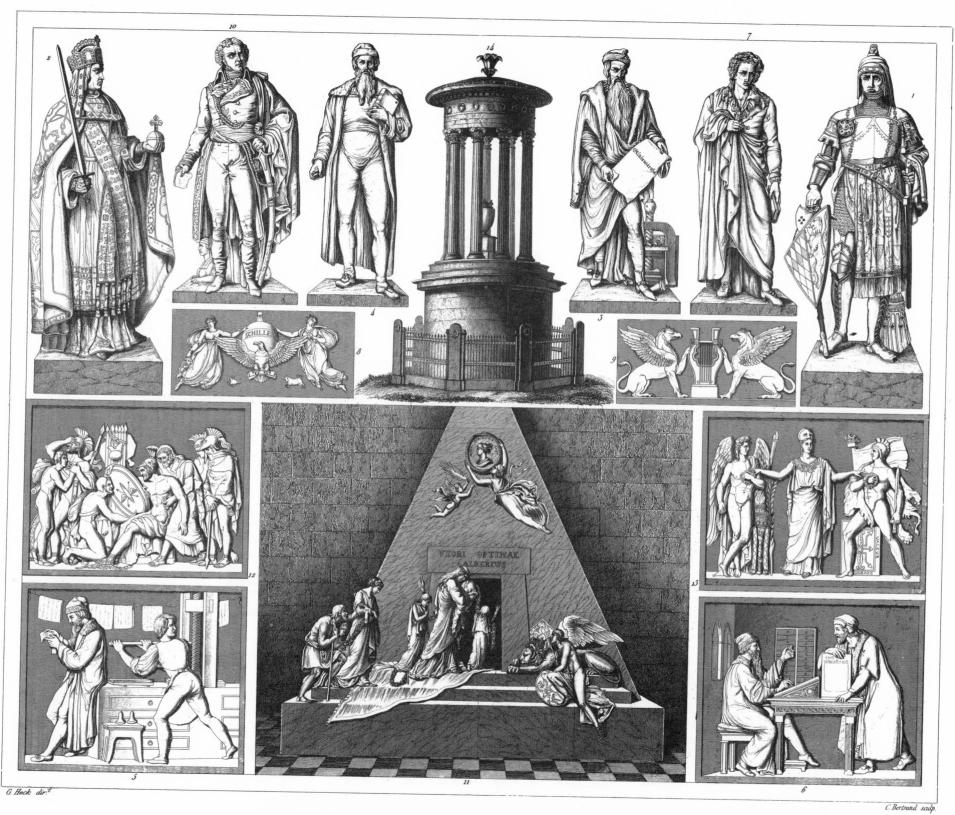

PLATE 450. NINETEENTH-CENTURY MEMORIAL AND CEREMONIAL SCULPTURE

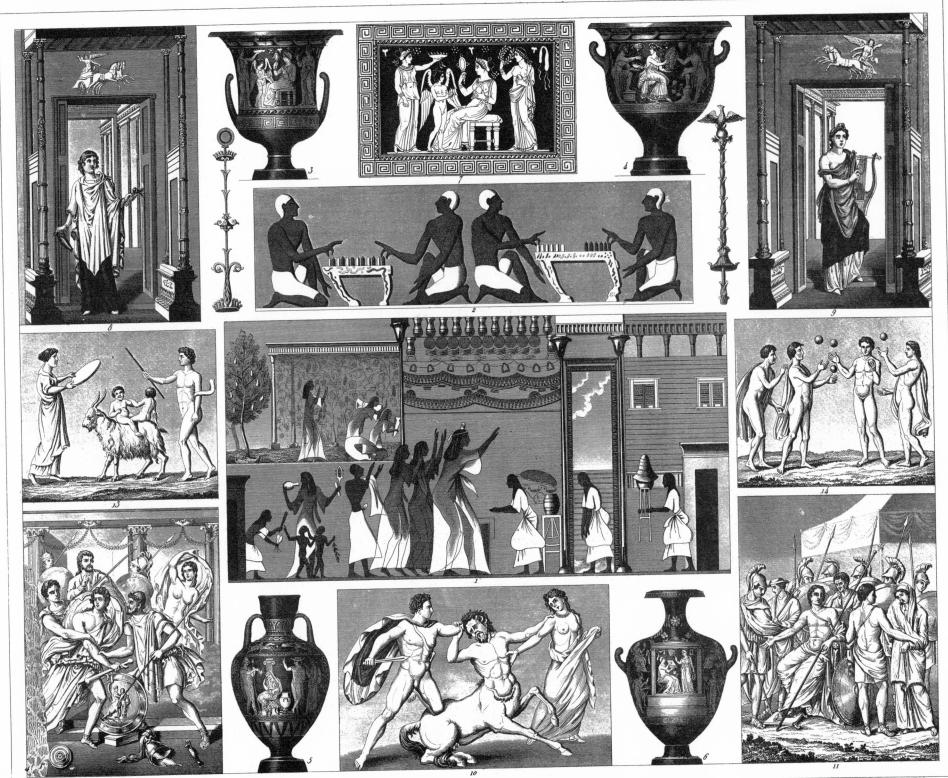

G. Heck dir

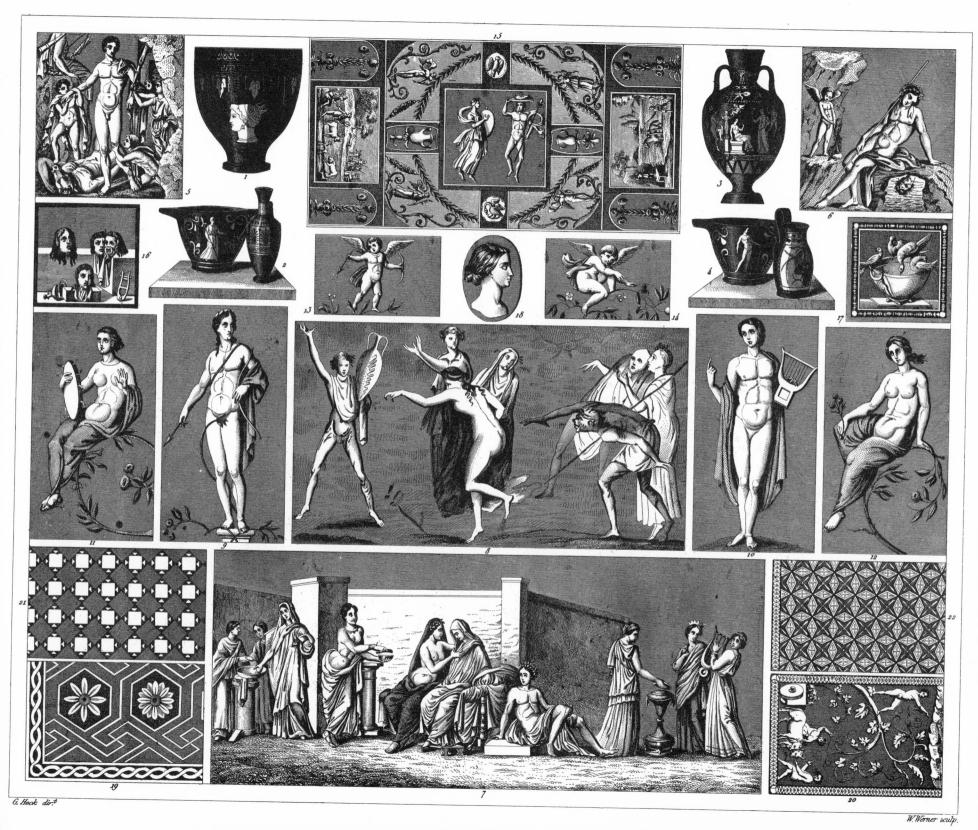

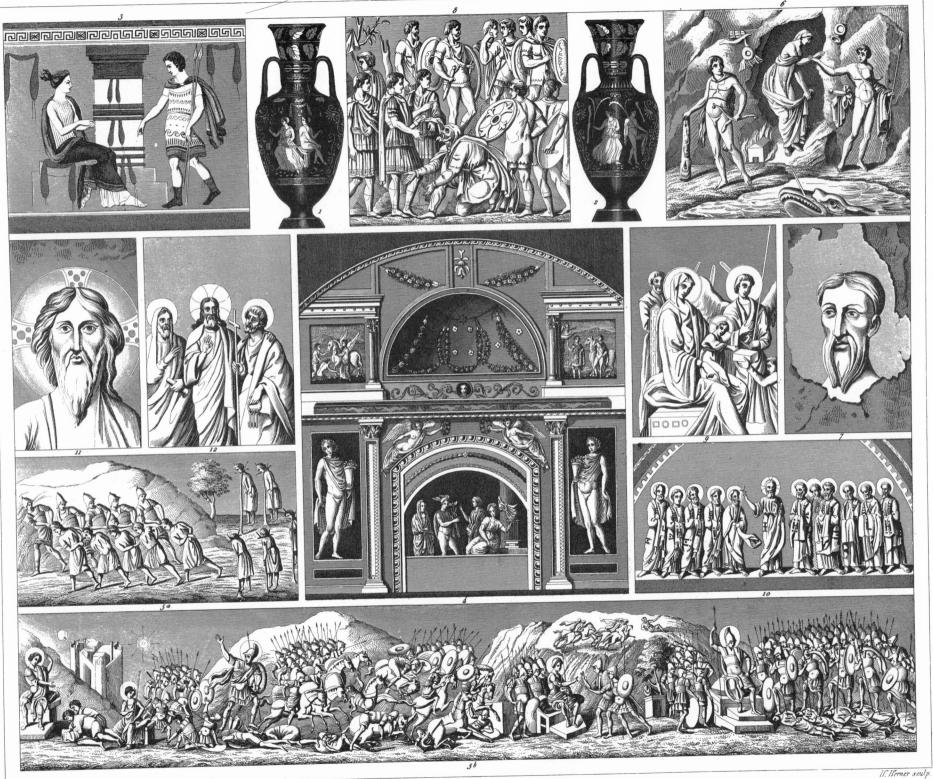

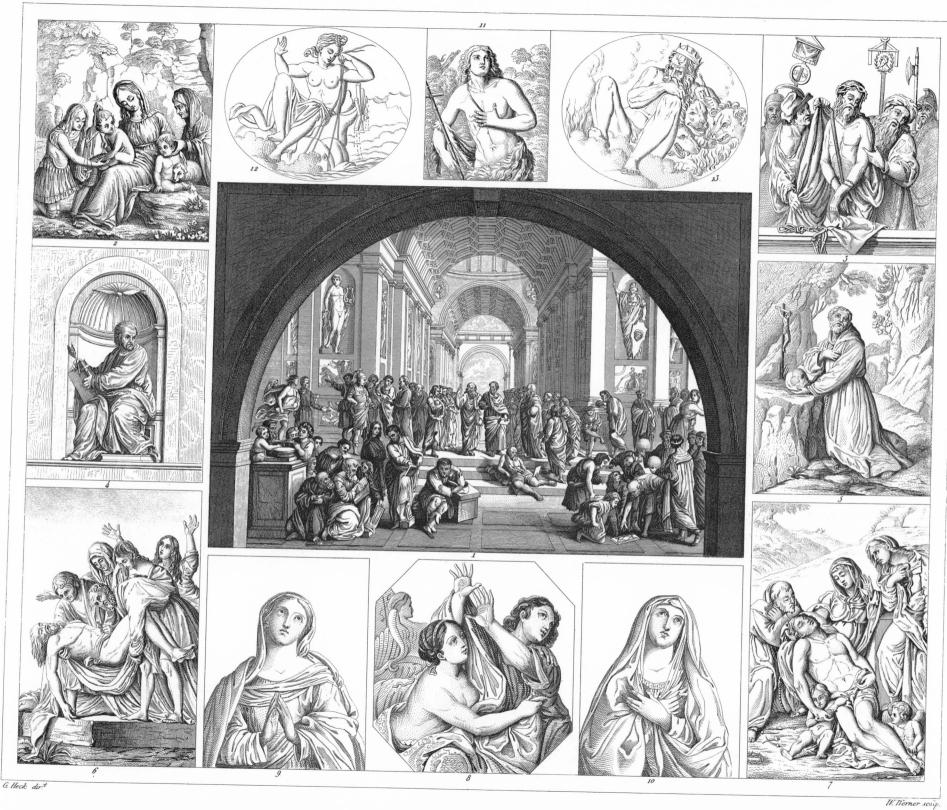

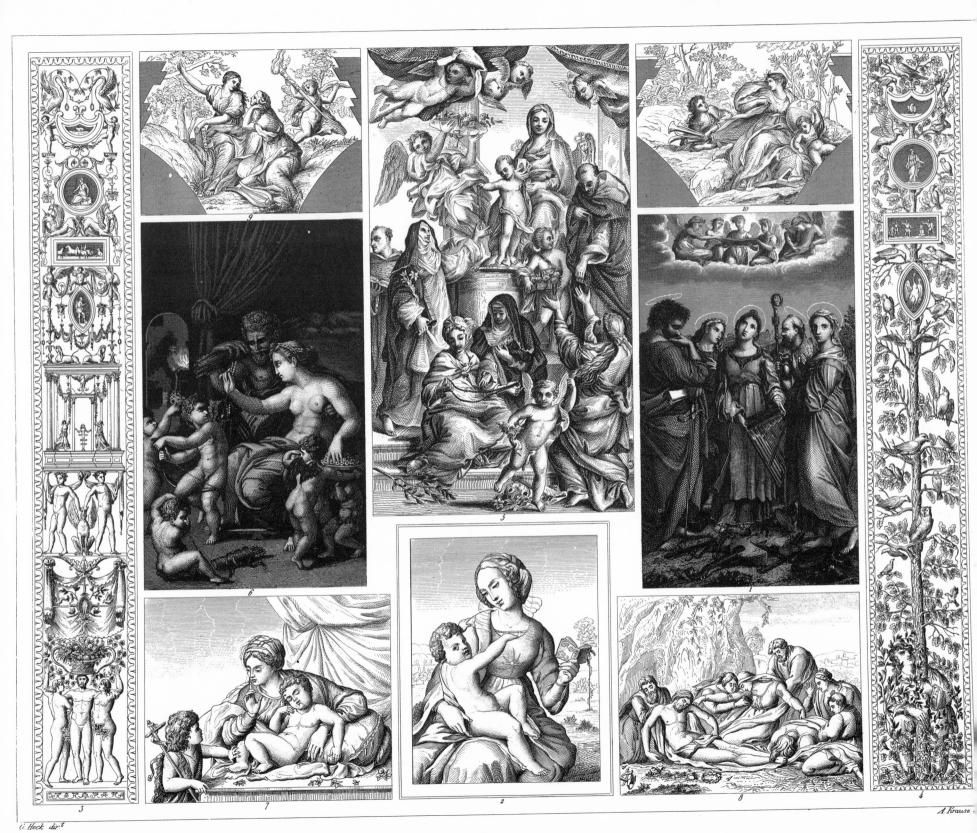

BAROQUE PAINTING

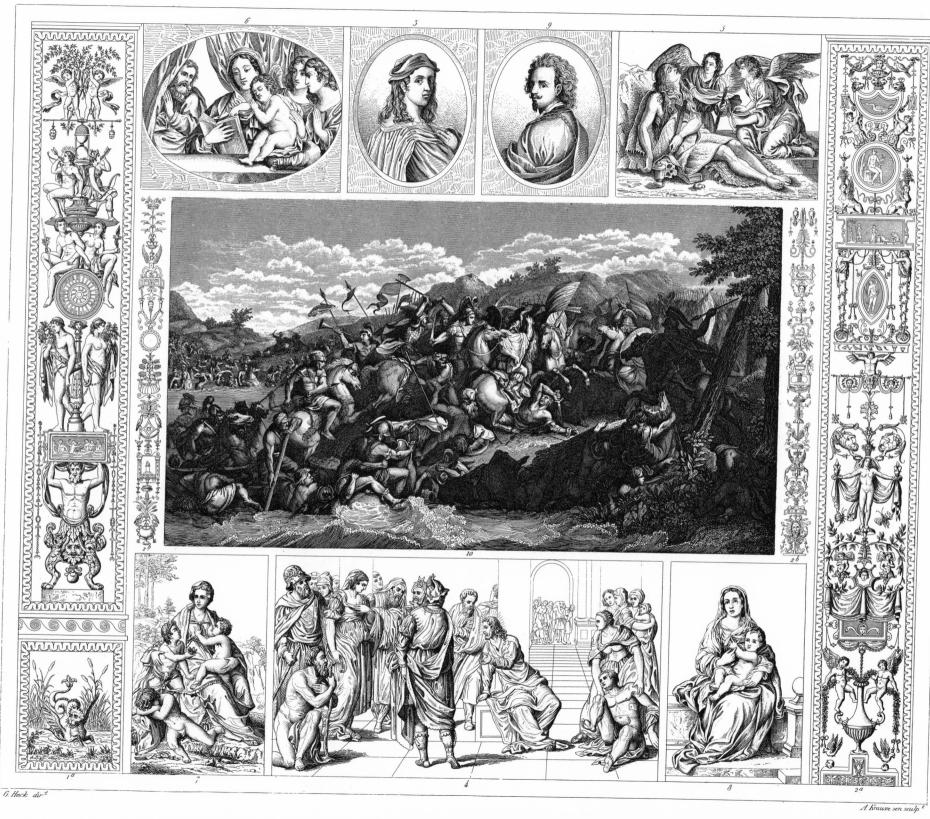

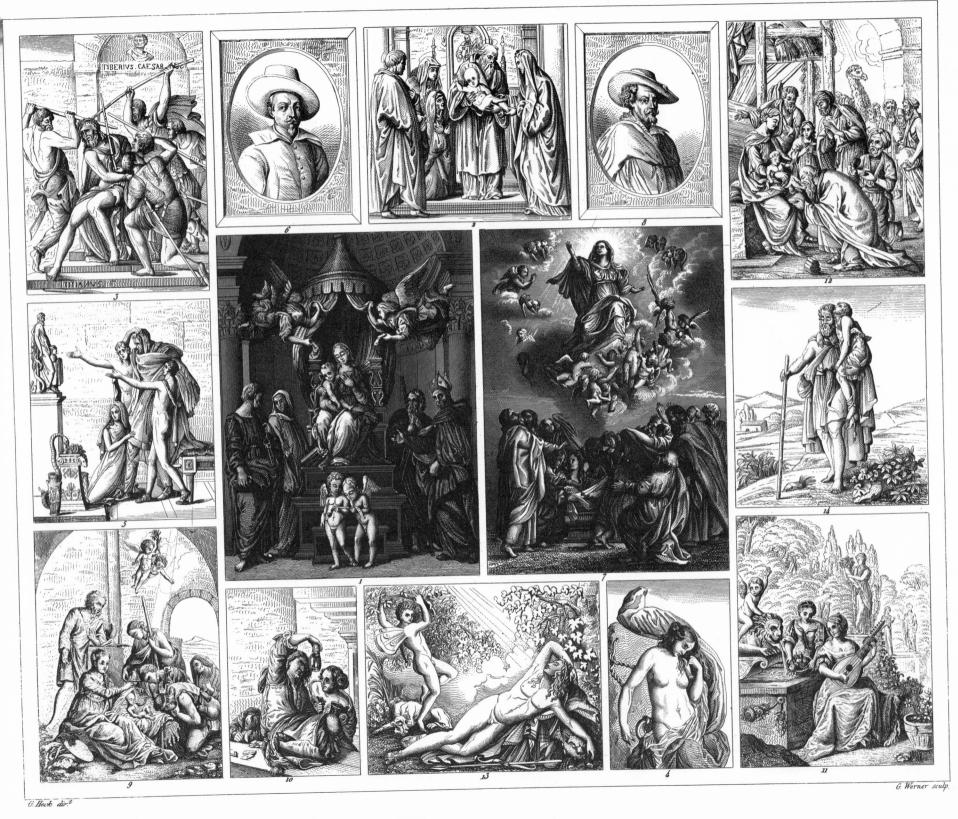

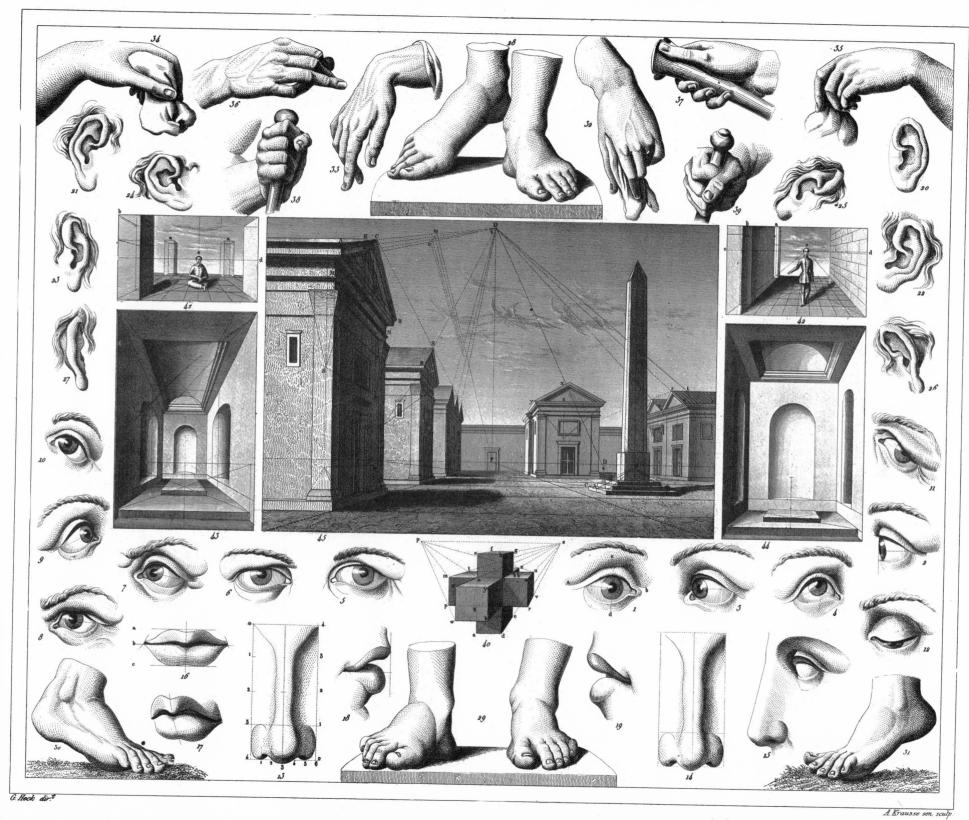

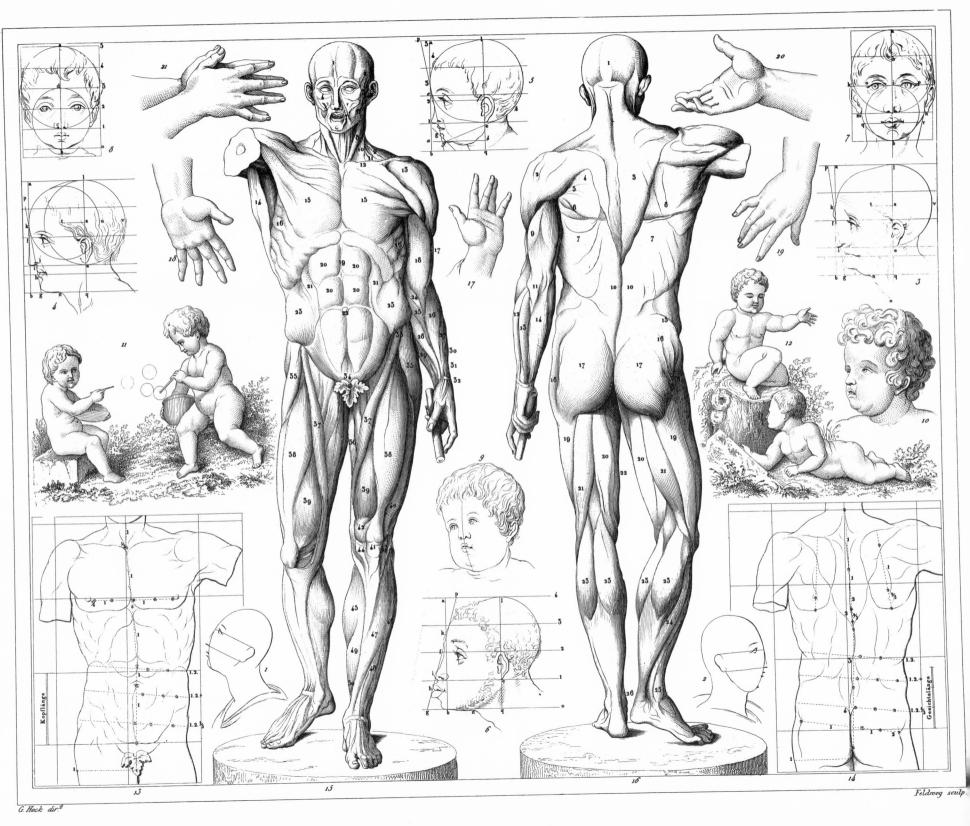

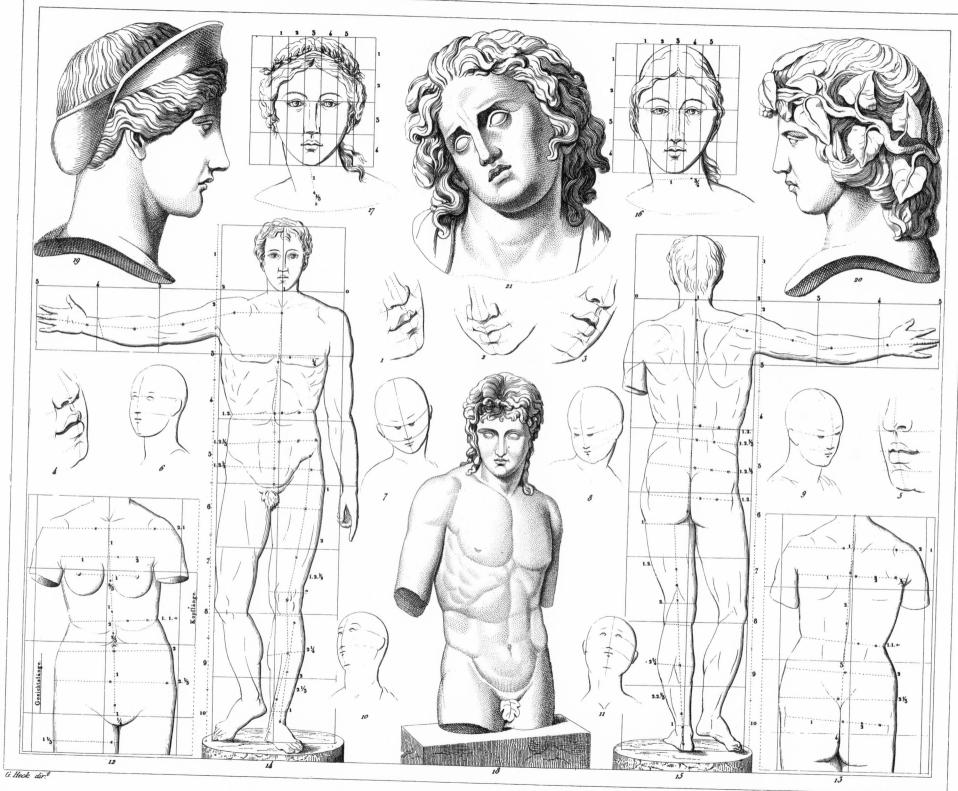

E. Schmidt sculp. Dresden

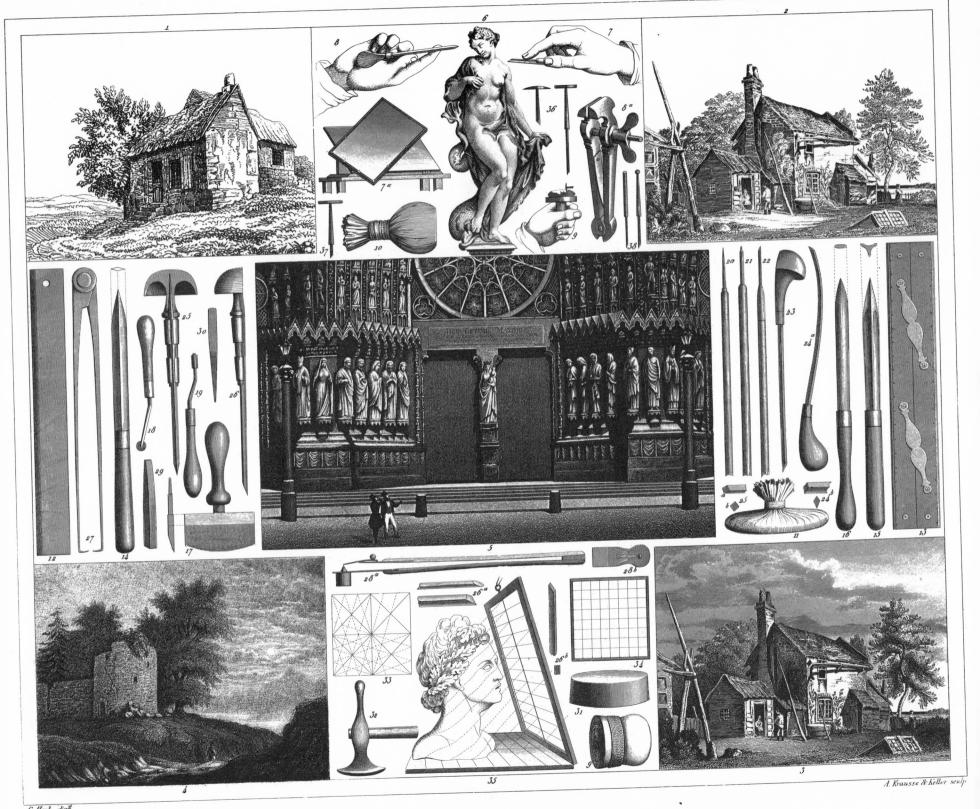

_I. C.	lasse.	I. Classe.	III. Classe	IV. Cla	sse F	igur Benenn	unen. ung Bedeut.	Zahl Fi	ur Renenus	P. Jenton	8 Arr	nenisch	T							1 Ja	apanisch				
-K	a 1 K		₹¥Y g(ds):	1		Fé	1			1	-	Figur	Benennung	-	Zahlwerth	Figur	Werth	Figur	Werth	Figur	Werth	Figur	Werth	Figur	We
v	۷ ب ا	. 1	41.	1	.		f	1 E	w Aip	a	1	ու և	Mjen	m	200	1	I	n	Rou	+	Na	-	Ma	ュ	Y
			A L	111		Ur	u	2 6	p Pjen	P	2	B J	Hi	h	300	13	Ro	7	0	ラ	Ra	17	Ke	x	M
EVV	° E	(' ,	EN E P	₹ 'z	ااف	Thur	s th	3 4	4 Kim	k	3	6 6	No	n	400	<i>></i> >	Fa	ウ	Wa	A	Mou	フ	Fou	Ξ	М
«	1 J 1	اص ع	ت p 🐴	W i	ş	Os	0	4	7 Ta	t	4	1.2	Sha	sh	500	一上	Ni Fo	力	Ka Yo	ッ	Ou	3	Ko	1	S
₩ ,	n ~ K	- 0 E	∢ gh É	1	6	Reid	r	5 0	Jetsch	3	5	n "	Wo	w engl.o	600	1~	Fe	ヨタ	Ta	井	I	エ	Ye	P	1
< ,	MA	1 1	1000 2	1		Kaui			Z Za	z gelind	6	2 ₹	Tsha	tsh	700	F	To	V	Re	1	No	テ	Te	E	F
V			1011	₩ a	11'	.		6 t	5 E	e	7	9 "	Be	b	800	14	Tsi	ク	So	才	Wo	P	A	E	M
	· > Ms	t 🖒 .	₩ ū -	B 3	; پ	k Hagl	h	- -	/ Jeth	e kurz	8	.P. 2	Dahe	dsh	900	1)	Rí Nou	7	Tsou	ク	Kou	+	Sa	乜	S
٠,	. Jul	ds 3	(E) 0, @		1 1	Naud	n	8 6	IJ Tho	th	9	fr "	Rra	rr	1000	才	Nou	子	Ne	ヤ	Ya	#	Ki	ス	S
£ 5	: m	h ż		""		Is	i	9 4	J She	sh franz.j	10	U "	Sa	s	2000	Fig	ur	Werth	1	4 Angel	sächsis		Figu		
W t	<u>س</u>				11 '	Ar	a	10 h	h Ini	i	20	4, 4	Wjev	w	3000	Majuscules	Minuscules	Werth	Majusci	ules Minu	scules	Verth M	ajuscules M		W
E u	,				111	1 Sol			Liun	1	30	8	Diun	d.	4000	Ā	a	A	k	1	5	K	Ð	8	1
)	12 Gothi	sch			'		lu	h Che	ch	40	P /	Re	r	5000	В	ь	В	L		1	L	u	11.	ı
		rth Figur W	sch. Verth Figur We		- 1 '		t	2 0	5 Dsa	ds	50	8 9	Tzo	tz	6000	C	c	C	œ	1	n	M	P	р	,
a	u q	L	i G j	T t	B	Biörk	b 1	3 4	Gjen	g	60	þ	Hiun	u v	7000	e D	8 e	D	N	1	n	N	X	N	2
Ь	Z z		k n u	Y	у	Laug	1 1	4 -	Hho	hh	70	Φ 4	Ppiur	pp ph	8000	F	r	E F	O P		1	O P	У	у	,
g	h h	λ	I Пи р	F f	11	Madr	m I	5 2	Tsa	ts	80	R P	Khe	kh	9000	G	5	G	R	,		R	Z	N	2
d	ψ tl	h M I	,	0 w	h	v	y 1	9	Z Ghad	gh	90	0 .	Aipun	0	10000	ь	h	Н	S	S		S	Æ.	33	4
e Tam	l i		n S s	Q o		Yr		א		dsh engl.g	100	\$ \$	Fe	f	20000	I	1	I	T	7		Т	Þ	P	7
ur	Werth	Figur	Werth	Figur	wskisch. Wertl	Fig	7 Pehlvi ur Wer	th D	9 Alt (Figur	Werth	11 K	optisch		10 Neu G				5 Hebra				6 Samar	itanisch	L-
	A	=	K		1				, , , , , ,	- Igui	Werth	Figur	Benenn. Bed	\dashv	-	nenn. Bed	eut.	Figur	Beneni	n. Bedeu	t. Zahl werth	Figur	Benenn.	Bedeu	\neg
	Â	~	G	AN	A		A	E	A	♦		B B	Alpha a Vida b	11	Al _I	oha a		X	Alepl	Spirit len	is 1	A.	Aleph	Spirit le	enis
-	Î	٦	Gn			-	S B		В В		0	Pr	Gamma g	B	Bet Bet	a b			Beth	bh b	2	2	Beth	b bh	
	U	T	K	3	E	1 1	Т			Г		Ax	Dalda d		' y' Ga	mma g		3	Gime	l gh g	3	Υ	Gimel		
T	U	2 2	P B	1	I	1 6	Dj				P	<u>θ</u> ε ζ	Ei e	1	() Del	lta d	11.	7	Dalet		4			g gh	
	E Ê	, C	M	1 1 7	17			11 *	D	П		HH	Zida z Hida i	1 1	, ,	ilon e ku	rz z	T	He	h	5	J	Daleth	d dh	
	Âi	ما	P	> C K	K	ه ند	Kh	11	E	P	R	0 0	Thida th	1 %	Z Zet	a ds		,	Waw	w	6	J.	He	h Spir as	sper
1	0	_	Т	1	L	3	D	E		R		11	Jauda i	$\mid \mid H$	7 Eta	e la	ng .		Sajin			X	Vau	w v	
	ô	٠	D	ME		133	R		z	Σ		4 . 6	Kabba k	0	9 The	ta th	1				7	4	Sain	s ds	
τ	Au K	•	N	MM	M	5		2		ξ		II ii	Laula l Mi m	1	, lota	i	1 7	7	Cheth	ch Keh		11	Cheth	ch hh	1
	Ng	2	R Tch	И	N				Ê	ς	S	**	Ni n	K	z Kap	pa k	7	פ	Teth	t	9	۴	Teth	t	
	Ch	9		1	P	30	S		TL	С			Exi x	1	2		7		Jod	j	10		Jod	j	
	Ñ	0	J Nĭ		ı	1	Ch	(Th			() o	O o p b	11		m	=	am Ende	Caph	ch k	20	III	Caf	k ch	
	D	26	Ch	19	R	2	Gh	0	CITY.	Т	T	Pp	Pi pb	N	ν Ny	n	3	,	Lamed	1	30	4	_	k ch	
	N	अ	A,I	5	s	1 9	K	8	Th	Y	v	G e	Sima s	E	ξ Xi	x	1 2	am Ende	Mem	m	40	2	Lamed	1	
	T	*	R		5	ق	G		1	Φ	1		Dau t d	10	-	cron o kur	2 5	am Ende 7	Nun	n	50	类	Mem	m	
	N P	8	L	+4	T	11 .					Phi		He i y	1:1	π Pi		1 5	,	Samech	s	60	3	Nun	n	
	M	~		VAJ	v	7	L	K	K	0		$X \propto$	Pui ph Chi chs	1 1	- 1	P	2		Ajin	Kehlhauch	1 11	11	Samech	s	
	Y	~	v			F	M	1 ^	L		Chi	JA A	Ebsi ps	11.	Q Rho							∇	Ain	y der. Heb	br.
	R	0	S	⊙ ♦	Th	1	U,V	1 1 -	1 11		Psi	M a	O o lan		o's Sign			am Ende	1 1	рь р	80	_	Phe		"
	L	8	н	В	F	701	Н	l N	N	Ω			Fei f		Tau Tau	t	7	am Ende	1 1	z	90	7		p ph	1
	V	Figur	Werth			11 .	1	E		∩		Or !	Giangia g Scima sks	Y		lon u	P		Koph	k	100		Tsade	ts	9
	J	Figur		ŧ	Z	.ن		Ξ.	Xi	♦	O long	M a	Scei sch	P	9 Phi	f			Resch	r	200	P	Kuph	k	10
	L P.	50.	Ch	B	Н	0	Tch	2		W		SS	Hori h	X	χ Chi	ch	To		Sin	s		1	Resch	r	20
	Rr N	552	S Kch) છ	P	0	0	区			Chei hh Dei Lig ti	T	ψ Psi	ps	U		Schin	sch	300	.222	Schin	sch	30
		-	K.C.I									E a,	o Ziffer6	0	(1) Omě	ga o lang	1 1		Taw	th t	400	A	Thaw	t th	40

Schlegel & Keller sculp.

	wa mit ui al	8 Mongolisch.			9 Russis			10 Walachis Alphab	
	Alphabet	Consensation	Vocale Mitted am Ende Bedeut Antic		Benennung Bedeut.	Antiqua Cursiv	Benennung Bedeut.	Figur Benenn. Bedt F	igur Benenn. Bedt.
The states of the second of th	Figur Bedeut Figur Bedeut The state of the	Consonanten ZEN Anfang i d Mitte am Ende Bedeut T T T N N G G S T N T Ch T R G B T N T Ch T T T T T T T T T T T T T T T T T T T	Mitte am Ende Bedeut A a a G G G B B G G G G G G G G G G G G G	А а Б б В в Г г Д д Е е Ж ж З з Н Й ий І і ї К К Л Л М М Н Н О о П п Р р С о	Benennung Bedeut. Ass a Buki b Wjedi w Glagol g Dobro d Jehst je e Schiwete sch Semlja s Ische i I i Kako k Ljudi l Müsslete m Nasch n On o Pokoy p Rzü r Slowo	Figur Antiqua Cursiv	/	Figur Benenn Bedt F R a Ahs a O B B Buke b R B Vide v X C C Glagol g A A Bobro B C Jest sch II S 5 Selo 3 Zeffe II S 3 Semlia s veir II I I I I I I I I I I I I I I I I I I	igur Benenn Bedt V OY U u O Fite fo.ph C Chier ch O olang J Zi C Tscherf t
ত্র in	b W a	7 Zend. Bedt. Figur Werth Figur Werth		T III T T		The kje Hoff 4 Arabisch. Figur er B. v. 2 Seiten d.folgend anschliessend anschliess		8 8 Uk u 1 Mag	radha. Figur Werth
Benenn mit ă mit u mit 1 mit Hoi II ba II- hu U hi U	ha γ he γ he Γ	no h			Elif † L		1	HAR	I N
Lawi A la A lu A li A	la A le A le A			1 1 1	Be y -		b 2		д
Mai ma mu a mi	ma OR me OP me OP	mo m s i co t	Beth Somal Ty Ty Ty 8	v 2 3	Te \odot \odot		t 400		O Th
Saut W sa W su W si W Res Z ra Z ru Z ri Zn	ra Z 18 C 18 C	10 r 2 î 10 t	Dolath ?	4	Gjim T	1 -	gj 3		þ D
	sa scha sche sche	scho sch) u 6 th	He on on	5	Hha C C	- X A	hh 8 kh 600	+ K	D Dh
Kaf	ka	ko k 3 û 9 d	Vau o a	oder v 6	Kha さ さ		d 4	1 0 7	⊥ N
Thawi T tha T thu T thi I	tha the the	the th & e (e) & dh	Zain 7 7	er Griech 7	Dsal 3 3		ds 700	/ A G	U P
Tjawi 干. tja 干 tju 干 tji 干 Harm 子 cha 子 chu 子 chi 子	tja T tje T tje T cha Z che Z		1 1 1 1 1 1	oder hh 8	Re) 7	5	r 200	U On	U− Ph
Nahas & na & nu & ni &	na La ne Za ne Z	gno ng b o b f	Teth 2 2 2 3	9	Ze)		s 60	l Ng	п В
Alph A a A u A i A	a h e h e h	0 a 3 ô 3 b	Jud u u u	10		س س س ش ش ش		- 7.1	п ⁱ Вh
Kaf Chaf The chu The chi The	cha h che h che		Coph + + 2 2	c ch 20	Sad o	صصص م		1 O	8 M
Wawe D wa P wi P	wa B we D we O	wo w y an z y zAnf.	Lomad & & 2 2	30		ف <u> </u>		C Di	₩ Y
7 -: TT 99 LL 21 H Z1 H	7.2	zo z g k ss y id Mitte	Mim ∞ ∞ ∞ ∞	m 40		8 8 8	tz 900	Djh	R
Jai H ja H ju H ji H Jaman P ja P ju R ji P	ja H je H je H ja P je E je P	- jo j 03 XII /	Nun	n 50	Ain E	ء ۽ ع	ע זי	П п п	JL
Dent. P da P du P di P	ja H je H je P P de B de B dja dja S 7 ge 7 ge 7 te M	dio di 15	Semcath _m m m	8 60		غافاغ		Р С Т	6 v
Djent p dja p dju p dji p dji p dji p dji p	ga ge ge ge ge	go g e e		d Hebraer 70	1 1	ف ف ف ق ق ق	f 8	1 O Th	du s
Tait in ta in tu in ti in Tschait in tschain tschain tschain	tschall tschell tschell	n to t g gh ev w	Phe a a a	Poder f 80		ع کے ک ک کے ک			F H
D : 1 0 no 0 no 1 X D1 X		- Po P 1	Tsode 3 3	ts z 90		7 7 1	1 3	o B Dh	8. Mh
Zappa H za H zu Z zi Y Af fu A fi A T pu T pi T	Ta Ao fu To pu To pe	20 Z 1 fo f U j , 10 s 1 po p	A G G G	m d Kehle 100 r 200 scł 300	Mim P Nun O C	م ب م د د د ه ه ه	n. 5	Beme Berr giebt dem vorh einen sti Jehr nimmt dem vor	rkungen . ergehenden Consonant irkeren Ton . hergehenden Consonant
Doppenauter. hua hua	kui	Y hue der Zendschrift Y gue	Thau 2 2 2	th 400	1 1 1 .	د پ ی	у	O less Die serbische Sprache	ne Harte. e wird mit russischen Typen ufügung obiger Buchstaben.

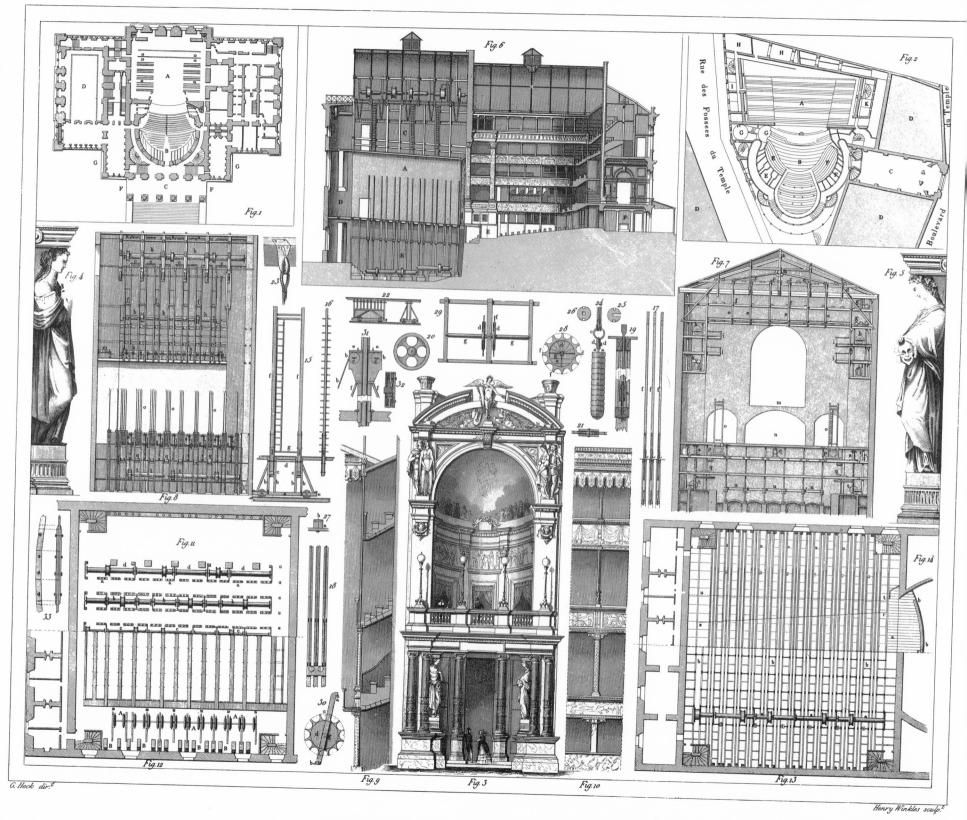

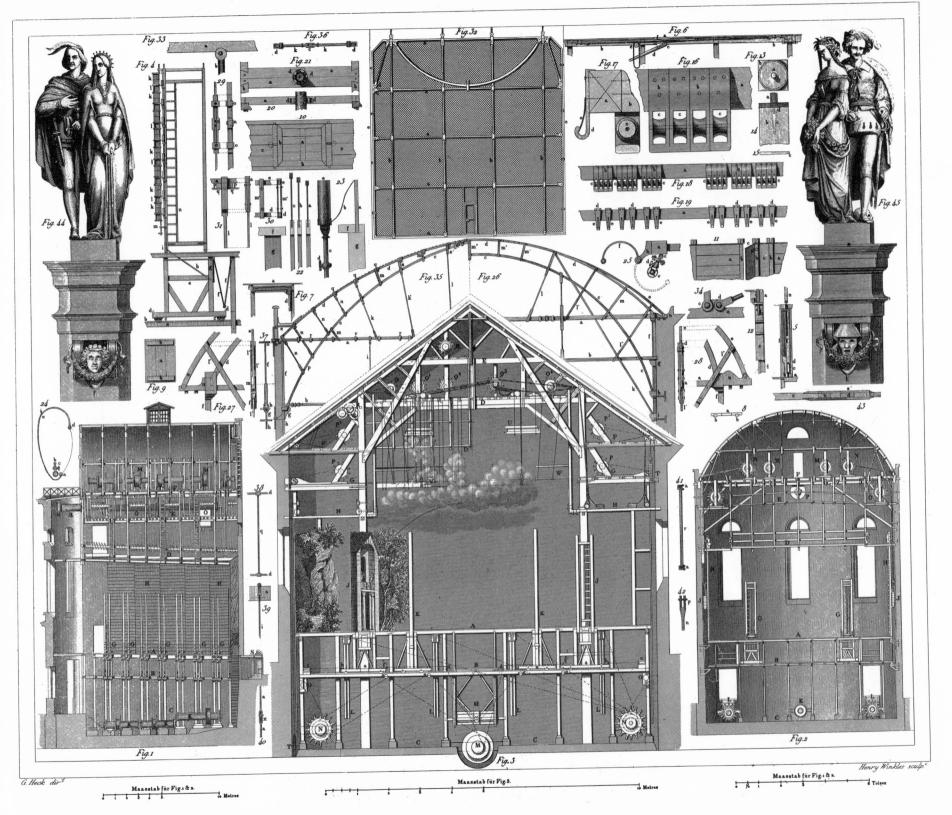

PLATE 465. DETAILS ILLUSTRATING THE CONSTRUCTION OF THEATRICAL BUILDINGS

	11 sè			

Captions to the Technology Plates, 466-500

PLATE 466.
Construction of Streets and Roads;
the Thames Tunnel

Figure

1-27. Illustrating the construction of streets and roads

28-34. Illustrating the Thames tunnel in London

PLATE 467.

Illustrating the Construction of Railroads

Figures 1-54.

PLATE 468.

Railroad Construction; Leipsic Station

Figure

1-29. Illustrating the construction of railroads30. The Leipsic station of the Saxon and Bayarian railroad

PLATE 469.

Motive Power; Construction of Inclined Planes

Figure

1-6. Illustrating the motive power on railroads7-15. Illustrating the

construction of inclined planes

PLATE 470.

Construction of Locomotives and Railway Cars

Figure

1-8. Illustrating Stephenson's locomotive with variable expansion

9-28. Illustrating the construction of tenders and railroad cars

29. Interior of the Duke of Brunswick's car on the Brunswick railroad30. Interior of Queen Victoria's car on the London and Dover railroad

PLATE 471.

Illustrating the Construction of Atmospheric Railroads

Figures 1–10.

PLATE 472.

Illustrating the Construction of Stone Bridges

Figures 1–23.

PLATE 473.

Illustrating the Construction of Wooden Bridges

Figures 1-45.

PLATE 474.

Illustrating the Construction of Iron Bridges

Figures 1–33.

PLATE 475.

Construction of Canals and Dams

Figure

1-28. Illustrating the construction of canals and dams

29. View of a chain of locks on the Rideau canal near Bytown in Canada

PLATE 476.

Canals and Aqueducts

Figure

1-5. Details from the Languedoc canal in France

6-8. The Cesse Aqueduct

9-11. The Croton Aqueduct of New York

12-18. Locks and weirs

PLATE 477.

Illustrating the Construction of Windlasses and Cranes

Figures 1-12.

PLATE 478.

Pumping Devices

Figure

1. A lift pump

2. A forcing pump

3-6. Stephenson's double action pump

7-9. Pump used in the mine Huelgoet in Normandy

10-12. Letestu's pump

13, 14. Jordan's hydraulic ram in Clausthal

15-21. Reichenbach's hydraulic ram in the saltworks at Illfang in Bavaria

PLATE 479.

Fire-Fighting Equipment

Figure

1, 2. The simplest construction of a fire-engine

3, 4. Portable fire-engine

5, 6. Pontifex's fire-engine

7–10. Repsold's fire-engine

11-15. Letestu's fire-engine

16–21. Common double-action fire-engine

22, 23. Bramah's fire-engine

24. Steam fire-engine

25-29. Apparatus to save persons and property at fires

PLATE 480.

Construction of Water-Wheels

Figure

1-18. Illustrating the construction of vertical water-wheels

19-29. Illustrating the construction of horizontal water-wheels

PLATE 481.

Illustrating the Construction of an American Grinding-mill

Figures 1–15.

PLATE 482.

Cotton Processing Equipment

Figure

1, 2. Cotton gin

3-5a. Wolf or willow

6. Spreading machine

7. Lap-machine

8–16. Carders and carding machines

17-20. Drawing frame

21-24. Roving frame

PLATE 483.
Wool Processing Equipment

Figure

1–7. Danforth's tube roving-frame

8-16. Self-acting mule

17-19. Washing-kettle

20, 21. Wringing-machine

22–24. Scales for weighing yarn

25, 26. Starching and steam drying apparatus

27-29. Press for packing yarn

30–33. Woollen willow

PLATE 484.
Weaving Equipment

Figure

1. Beaming for handweaving

2, 3. Warping-mill

4. Simplest loom 5–7. Power-loom

8, 9. Shuttle

10, 11. Jaw-temples

12, 13. Singing-oven

14, 15. Wash-wheel 16–19. Gassing-machine

20. Arrangement of spools

21. Lever of a power-loom22. Batten of a power-loom

PLATE 485.

Minting Equipment

Figure

1, 2. Casting-machine of mints

3, 4. Rolling mill of mints

5, 6. Circular shears

7-9. Flattening-mill

10-14. Drawing machine of mints

15, 16. Coin-punch

17-20. Milling machine

21–37. Stamping machines

PLATE 486. **Minting**

Figure

1. Stamping machine of the mint in Rio Janeiro

VALUE*

Persian gold piece of Imam Riza
 East India Rupee 6 20

East India Rupee 6 20 Zodiac Gold piece of the 4 20

4. Gold piece of the East India Company
5. Gold piece of the Dutch East India

Company

6. Double gold 13 00 sovereign of Brabant

of 1800 Gold Sovereign of 6 50

Brabant of 1796 8. Belgian gold lion of 9 00 1790

Danish Species
 Ducat

 Danish double

10. Danish double 7 90Frederic d'or of 182811. Austrian ducat of 1826 2 25

11. Austrian ducat of 1826 2 25 12. Bavarian ducat of 1821 2 25 13. Hamburg ducat of 2 40

1818

14. Ducat of Electoral 2 25
Saxony of 1797

15. Ducat of Canton of Berne

16. Carl d'or of the duchy of Brunswick,

1799
17. Hanoverian double

pistole, 1829

* Values as of mid-nineteenth century

2 35

2 15

4 00

7 90

18. Wilhelm d'or of the Electorate of Hesse,	4 00		Netherland five guilder piece, 1827		Exterior view of the mines of Persberg in Sweden	lamps 13–15. Anemometer	8-23. Agricultural tools24. Thermometer used to indicate the temperature of heaps in
1829		13.	Netherland ten	4 00	 Coal strata of Ronchamps Coal strata of 	16-28. Means of transport of ores 29-34. Hydraulic ram at Huelgoet	which root crops are stored
19. Royal Prussian	7 90		guilder piece, 1825 Milan zechino,	2 25	Newcastle-upon-Tyne		25, 26. Grain stacks
double Frederick		14.	Joseph II, 1784	2 23	5-7. Slate quarries near Angers	PLATE 492.	27, 28. Clover frames29, 30. Illustrating underground
d'or, 1800 0. Royal Prussian	3 90	15.	Maltese single Louis	3 75	8-11. Apparatus for blasting	Metal Milling	drainage
Frederick d'or, 1822			d'or, 1782		12, 13. Boring apparatus	Figure	31. Stack of roots or fruits
21. Royal Wirtemberg	3 90	16.	Neapolitan twenty	3 75	14-35. Miners' tools36. Interior view of a coal mine	1–7. Open furnaces 8–14. Stack furnaces	32-34. Barns and
Frederic d'or, 1810			lire piece, Joachim		at Newcastle-upon-Tyne	15. Puddling furnace	threshing-floors
22. Sixteen franc piece	4 25	17	Napoleon, 1813 United States	5 00	at Newcastie upon 17110	16. Gold amalgam mill	35-39. Apparatus for drying fruit
or pistole of the		17.	half-eagle of 1798	5 00	PLATE 489.	17, 18. Tongs for handling	40, 41. Grain kilns
Helvetic Republic, 1800		18.	Roman zechin of	2 25	Mining	crucibles	42, 43. Dairy 44, 45. Flax brake
23. Five guilder piece or	2 35	10.	Pius VI, 1783		Figure	19. Interior of a blast furnace	46. English churn
imperial ducat of the		19.	Double Romana of	7 70	1–32. Illustrating the	house	47–49. Apparatus for making
grand duchy of			Pius VII	10.05	construction of levels and	20. Tuyere chambers	cider
Baden, 1827		20.	Scudo d'oro of the	10 25	shafts	21. Stamping mill	
24. Ten guilder piece or	4 50		Roman republic, 1798	7.90	33, 34. Illustrating the ventilation	PLATE 493.	PLATE 496.
Caroline of the		21.	Piedmontese Doppia	7 80	of mines	Metal Milling	Husbandry
grand duchy of			nuova of Charles Emanuel, 1797		35. Exhausting engine		Figure
Hesse, 1826	5 00	22	Polish ducat, 1791	3 75	36–39. Modes of descent and ascent in mines	Figure 1, 2. Stack furnaces	1–8. Neat cattle
25. Royal guinea of Great Britain, 1801	5 00		Portuguese dobrao,	27 50	40–43. Miners at work	3. Reverberatory furnace	9–13. Sheep
Gleat Biltain, 1001		23.	1725		40-43. Willers at Work	4–8. Crucible furnaces	14–17. Hogs
497		24.	Portugalese, 1800	5 40	PLATE 490.	9, 10. Tongs for handling	18–47. The horse
PLATE 487. Coins of Various Nati	one	25.	. Crusado nuovo of	2 60	Mining	crucibles	PLATE 497.
Coins of various Nau	UIIS		Maria I, 1790	4.00		11. Heating chamber for hot-blast	Agriculture
Figure	VALUE*	26	. Russian ducat of	4 00	Figure 1. Interior view of the mines of	12-22. Rollers for the final	
1. English guinea of	\$5 00	27	Paul I, 1801	7 50	Persberg in Sweden	preparation of iron	Figure 1–10. The economy of neat cattle
George III, 1793		21	. Russian imperial of Catharine II, 1766	7 50	2. Interior view of the mines of	404	11–13. Sheep-folds
2. English third of a	1 75	28	. Sardinian gold piece	3 30	Falun in Sweden	PLATE 494.	14-37. The management of
guinea of George III,		20	of 20 lire nuove, 1827		3, 4. Sections of mines	Agriculture	silkworms
1797	4 85	29	. Swedish ducat of	2 00	5. Two coal seams	Figure	38-57. The management of
3. English sovereign of Oueen Victoria, 1845			Charles XIII, 1810		6–9. Apparatus for boring	1–17. Various ploughs 18–23. Various harrows	honeybees
4. French Louis d'or of	3 75	30	. Sicilian double	8 00		24–26. Drags and rollers	DI ATE 409
Louis XVI, 1797	2 70		oncia, 1752	16.00	11–26. Illustrating the construction of levels and	27–36. Sowing and planting	PLATE 498. Hunting
5. Napoleon d'or, 1813	3 85	31	. Spanish quadruple,	16 00	shafts	machines	
6. Italian double	6 50	22	1801 2. Tuscan ruspone of	6 40	1 C1-40	37, 38. Winnowing machine	Figure
Napoleon d'or, 1814		32	Ferdinand III, 1798	0 10	mines	39. Grain shock	1-56. Illustrating the art of hunting
7. French Louis d'or of	3 80	33	3. Turkish zerma-	1 45		40. Grain crusher	nunting
Louis XVIII, 1818	3 85		hubzechino of		PLATE 491.	41. Straw cutter	PLATE 499.
8. French twenty franc	3 63		Selim III		Mining	42. Machine for cleaning flax43. Machine for washing potatoes	Fishing
piece, Louis Philippe, 1831		34	4. Sequin or zechino of	1 45	Figure	44. Plan and elevation of a	Figure
9. French forty franc	7 70		Selim III	2.20	 Interior view of the salt 	farmhouse with barn and	1–8. Illustrating fresh water
piece, 1848		3:	5. Venetian zechino	2 20 3 30	mines of Wieliczka	stables attached	fishing
10. Half guinea of	6 40	30	6. Venetian gold ducat	3 30	2. Interior of the ministone		9-14. Illustrating marine fishing
Ligurian republic,			PLATE 488.		quarry at Niedermendig	PLATE 495.	500
1798	2.00		Mining		3-5. Interior plans of mines6-10. Illustrating the ventilation	Agriculture	PLATE 500.
11. Holland ducat, 1827	2 00		_		of mines	Figure	Fishing
	anth as-		figure . Exterior view of the r	nines of		1-7. Illustrating the management	Figure
* Values as of mid-ninete	eentn cen-	1		innes of	12. Davy's and Dumesnil's safety	of double crops	1-3. Illustrating marine fishing
tury			Falun in Sweden		12. Davy's and Dumesnil's safety	of double crops	

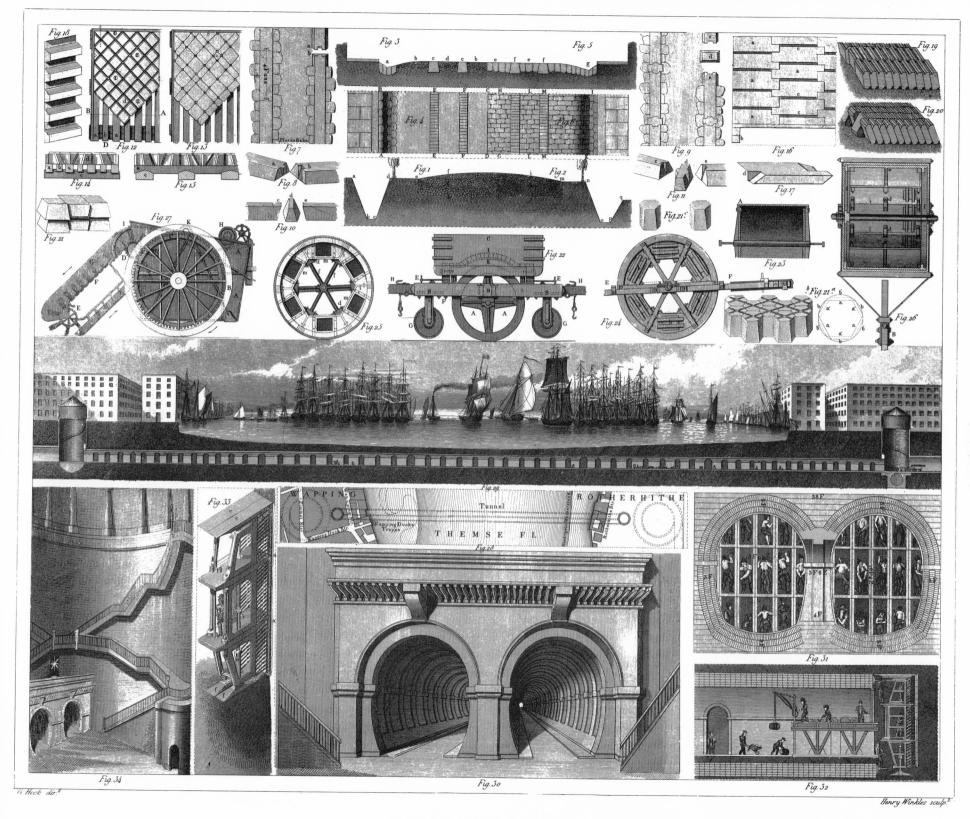

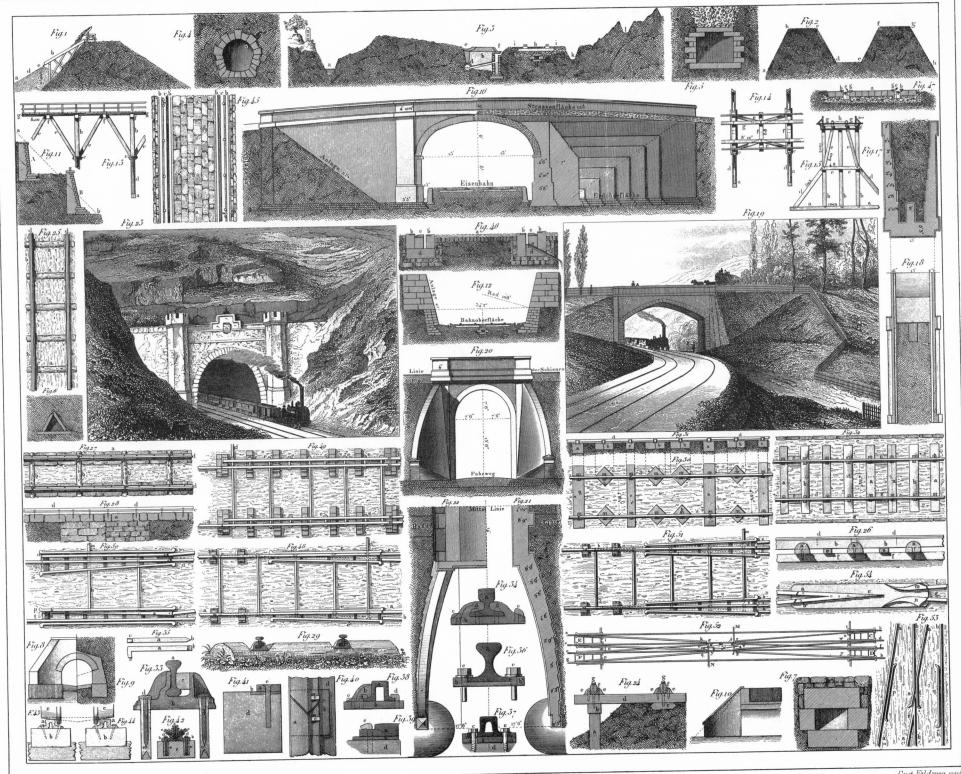

Gust, Feldroeg scul

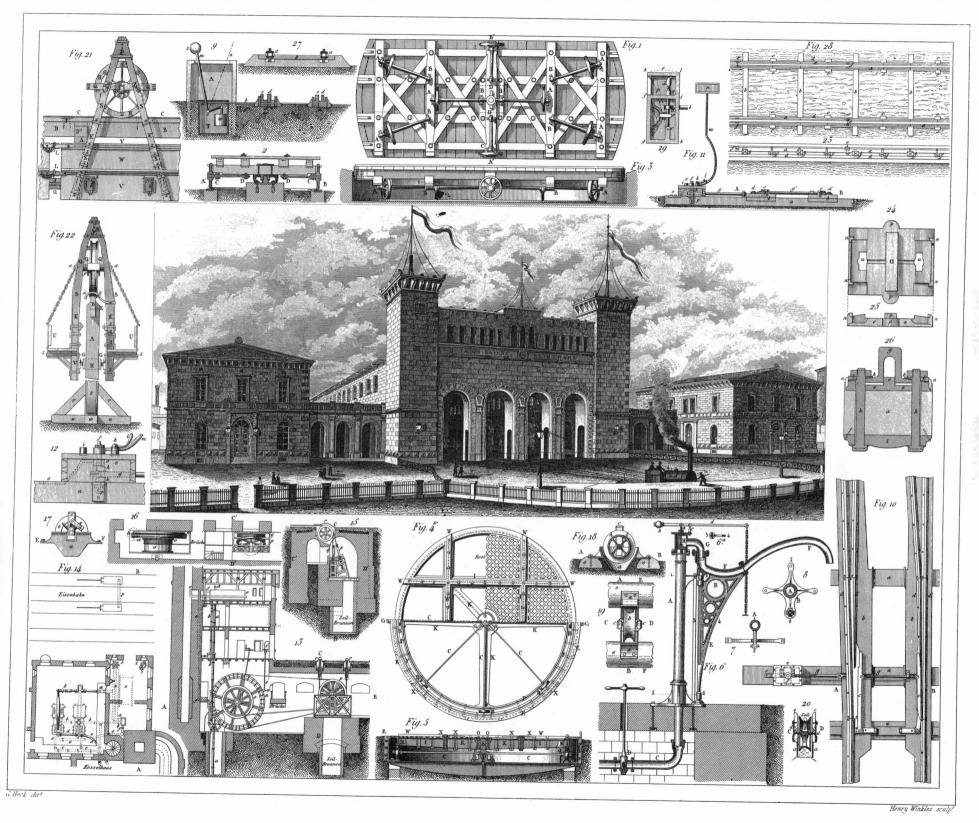

PLATE 468. RAILROAD CONSTRUCTION; LEIPSIC STATION

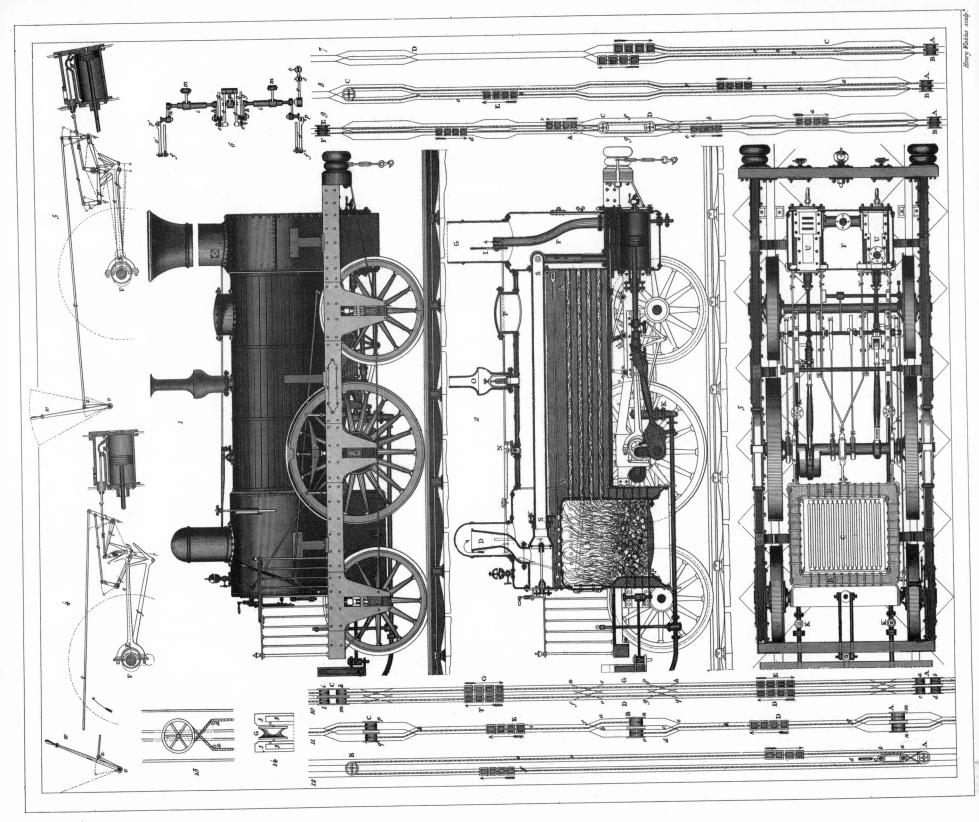

PLATE 469. MOTIVE POWER; CONSTRUCTION OF INCLINED PLANES

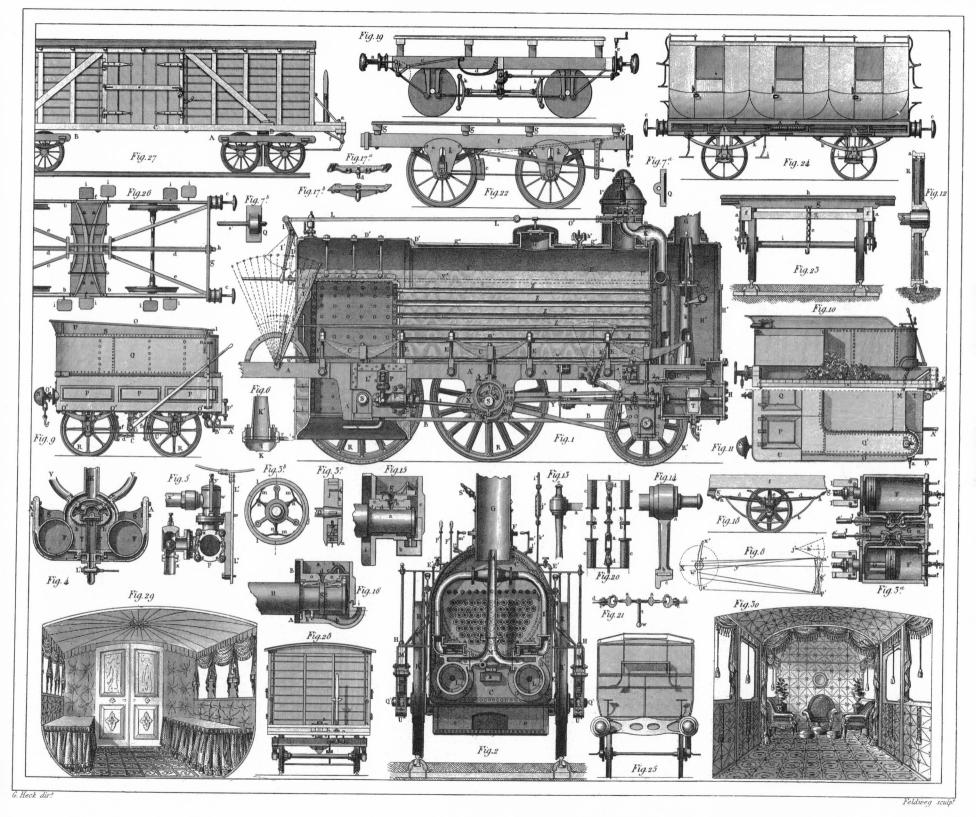

PLATE 470. CONSTRUCTION OF LOCOMOTIVES AND RAILWAY CARS

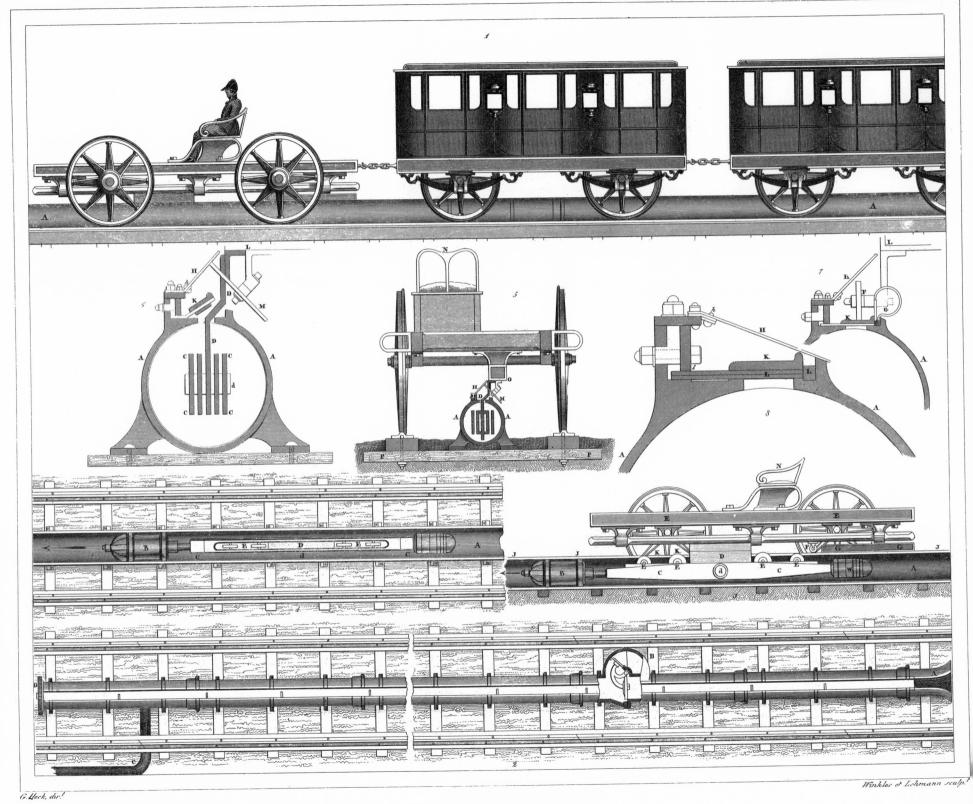

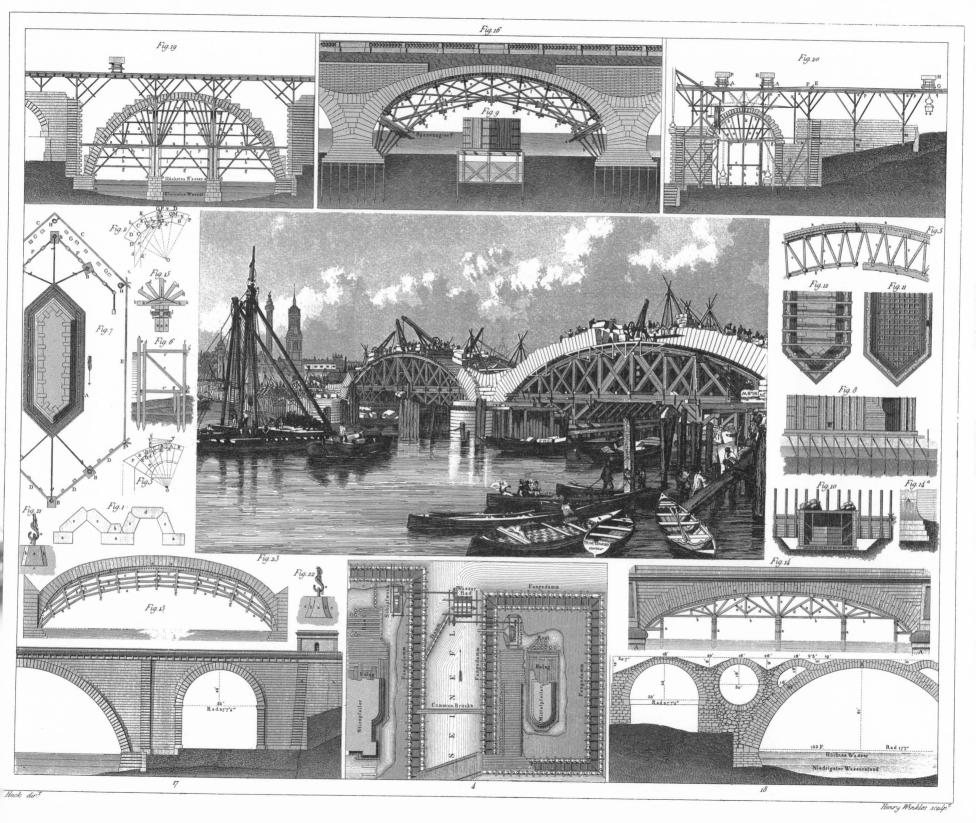

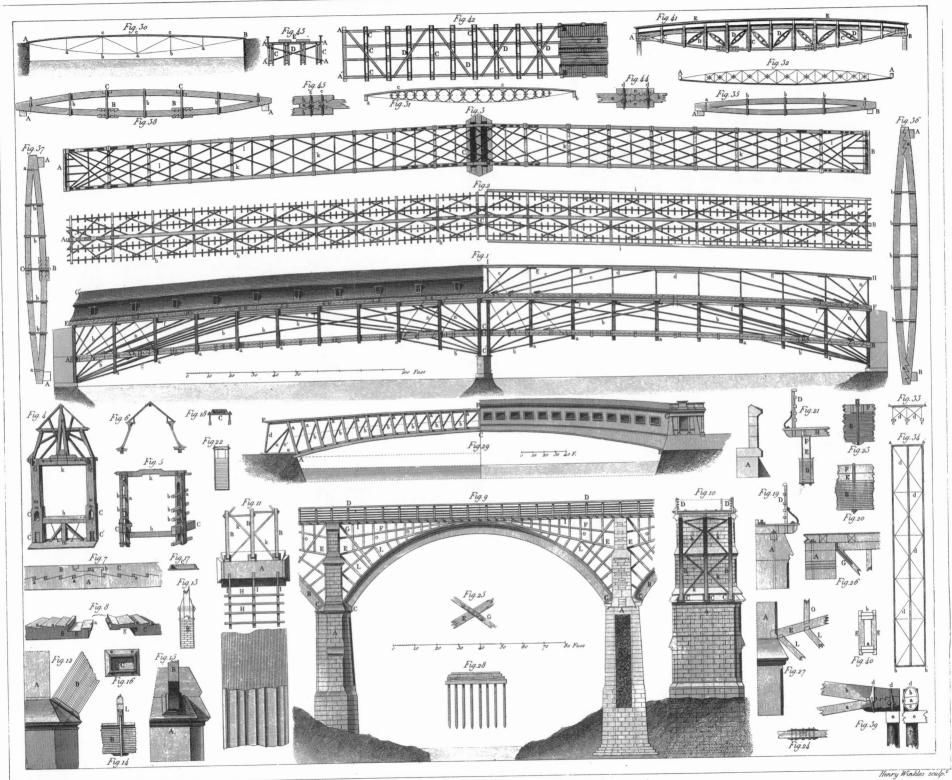

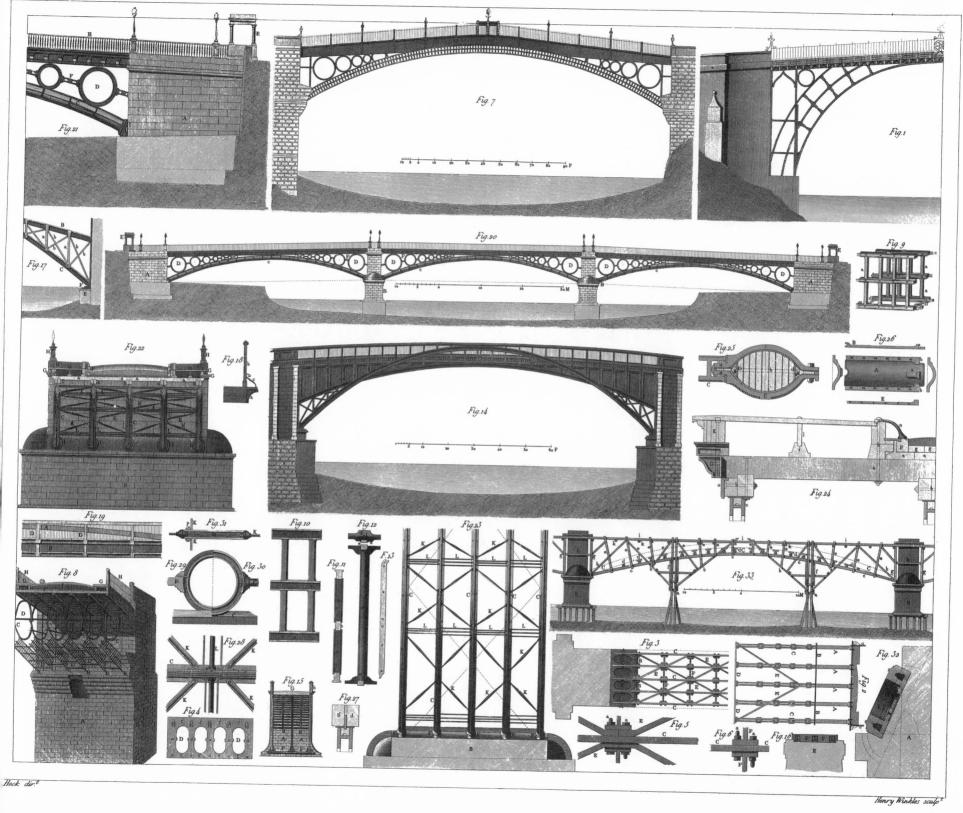

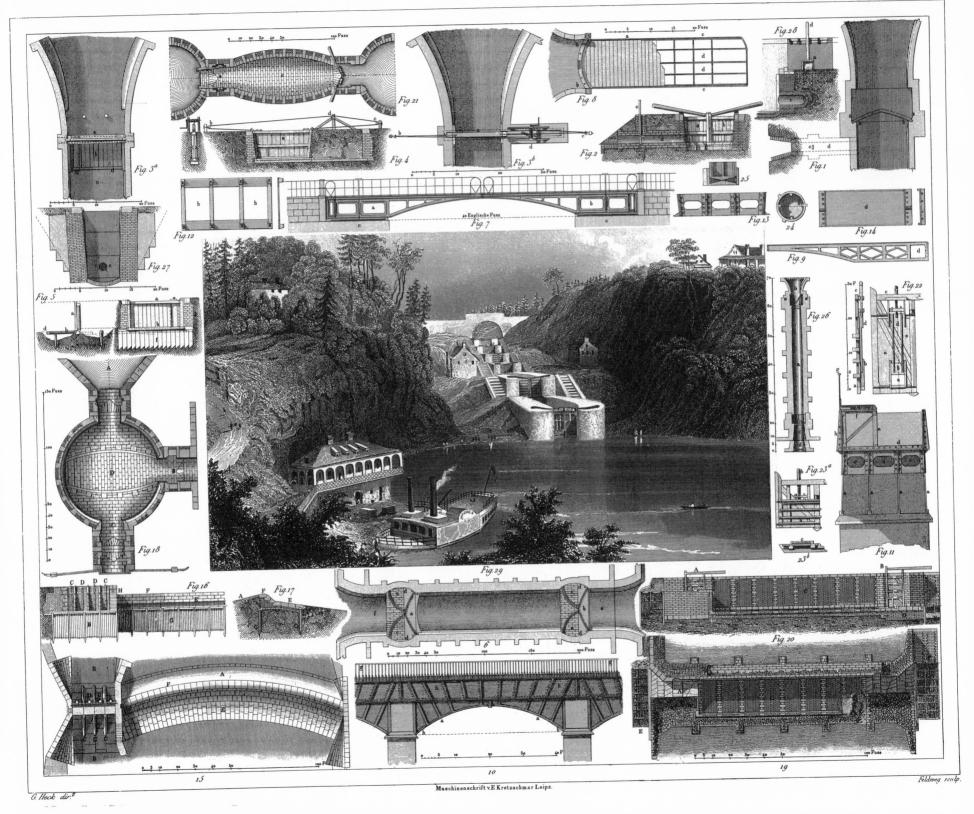

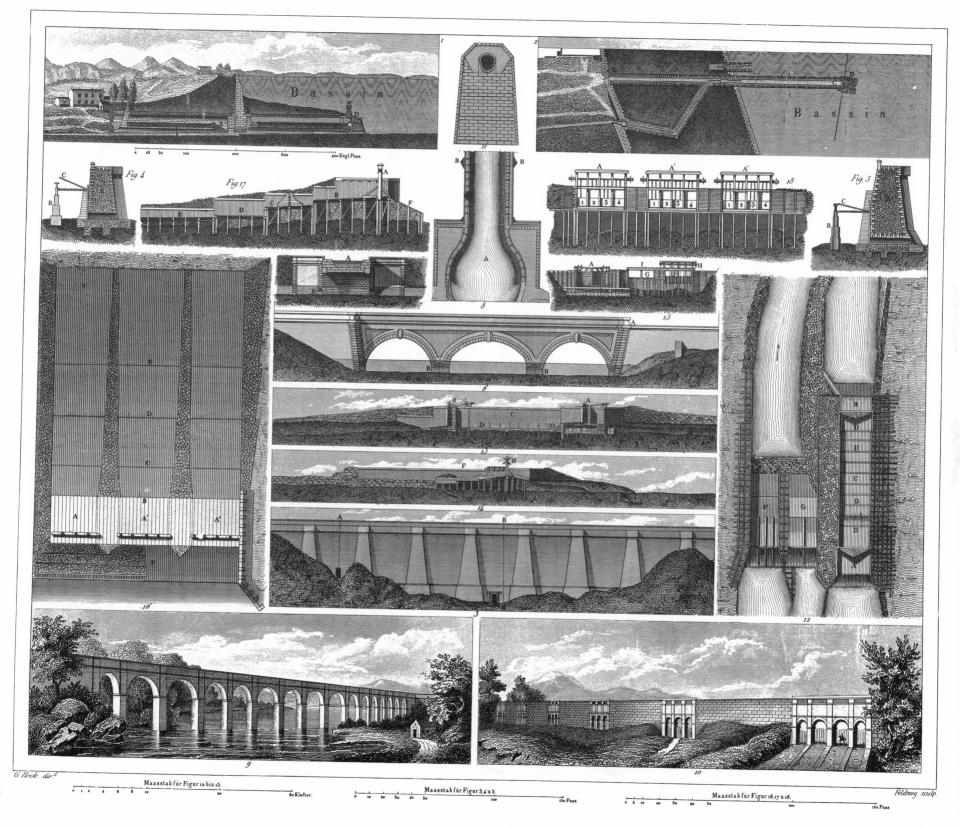

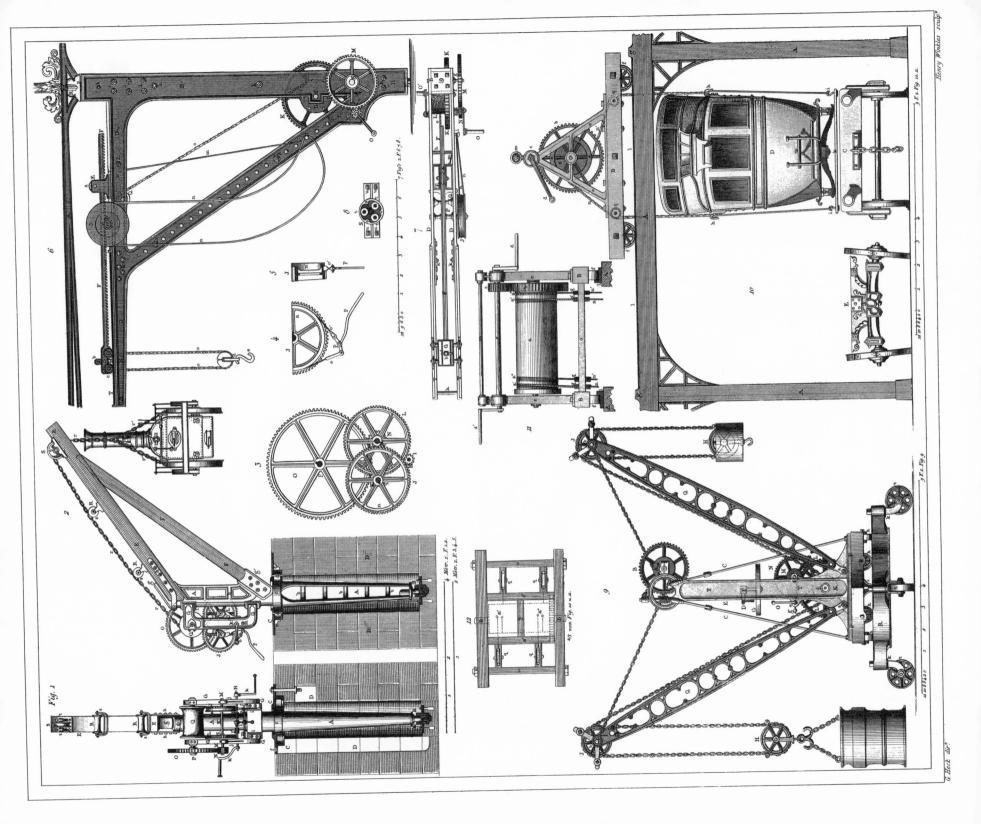

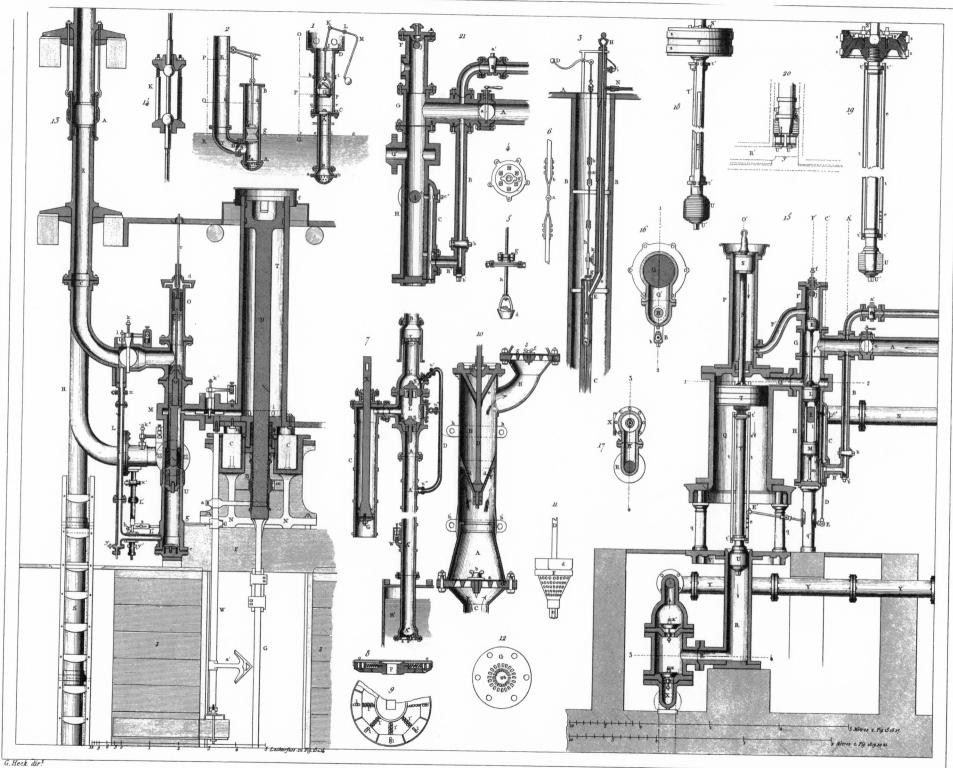

Henry Winkles sculp!

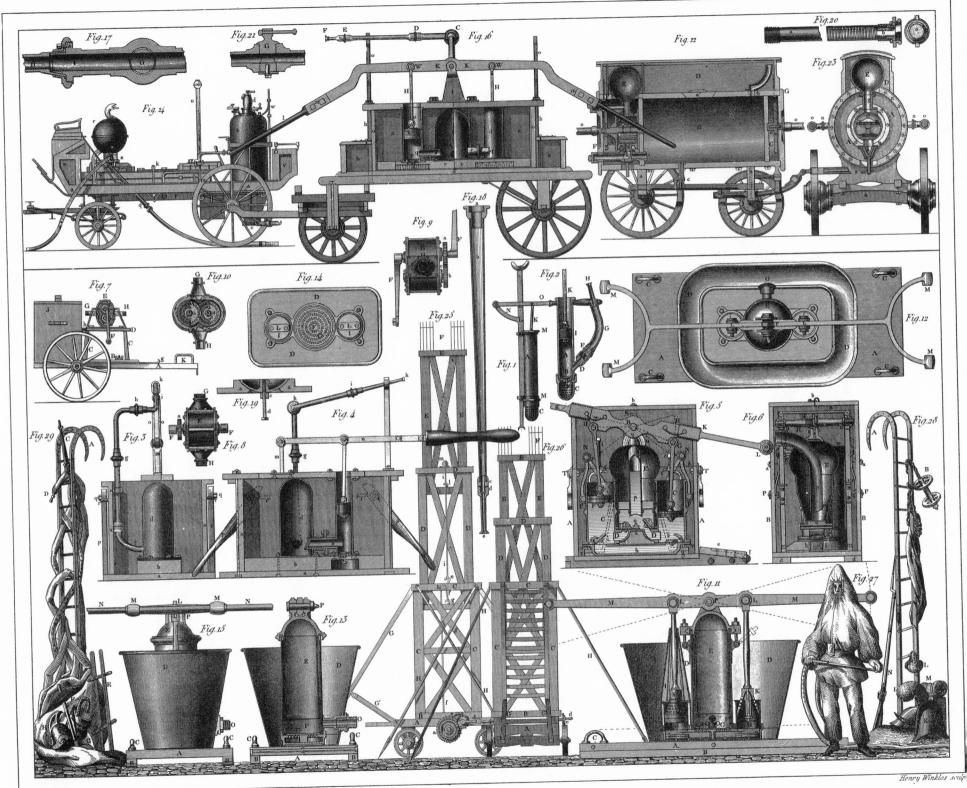

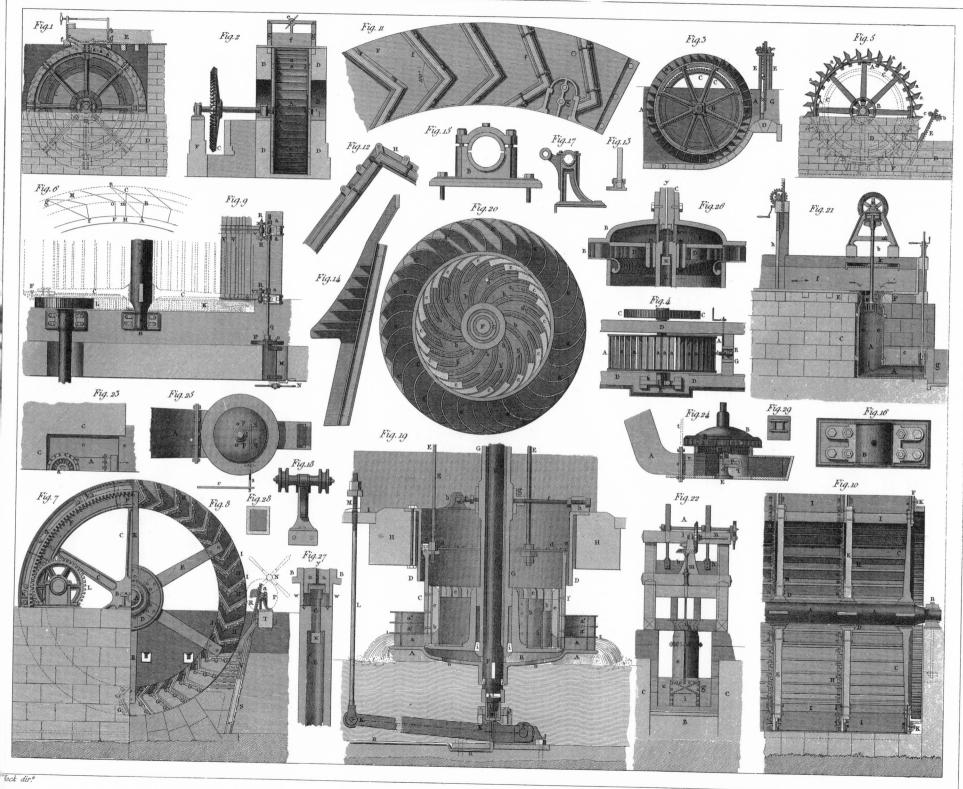

Henry Winkles sculp!

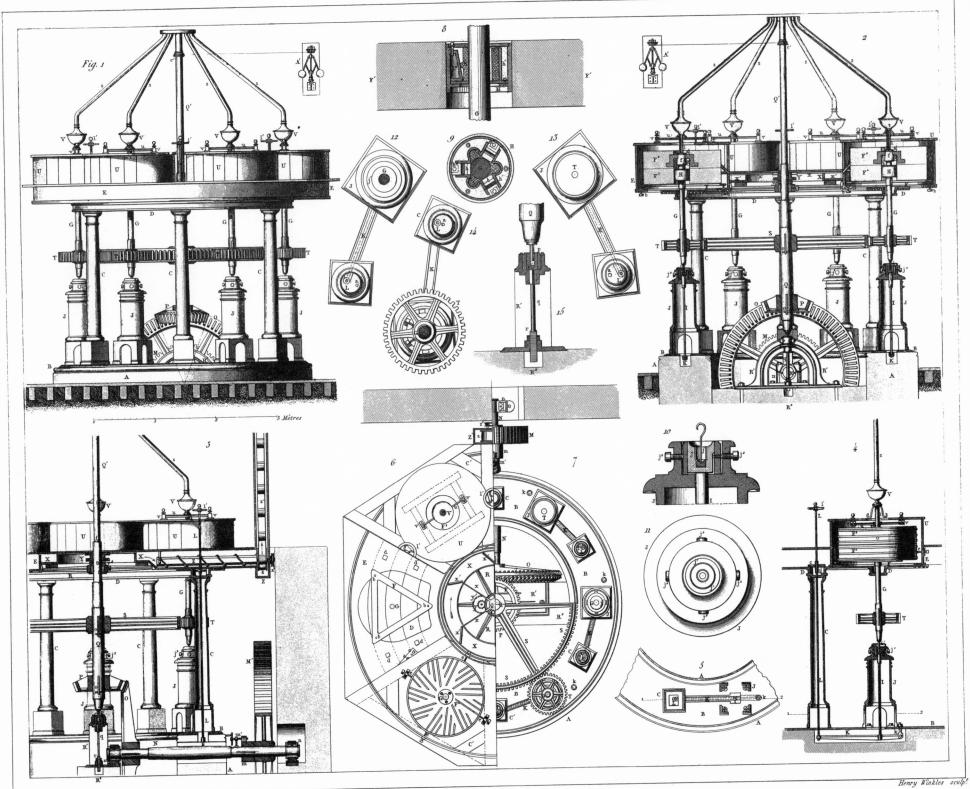

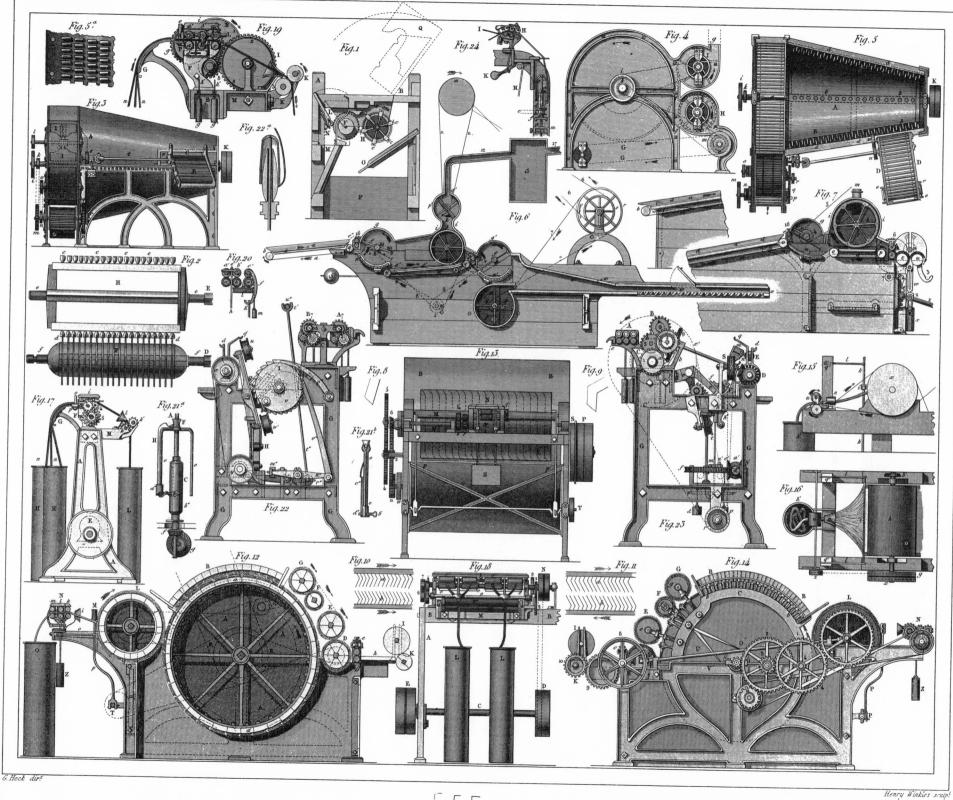

5,55

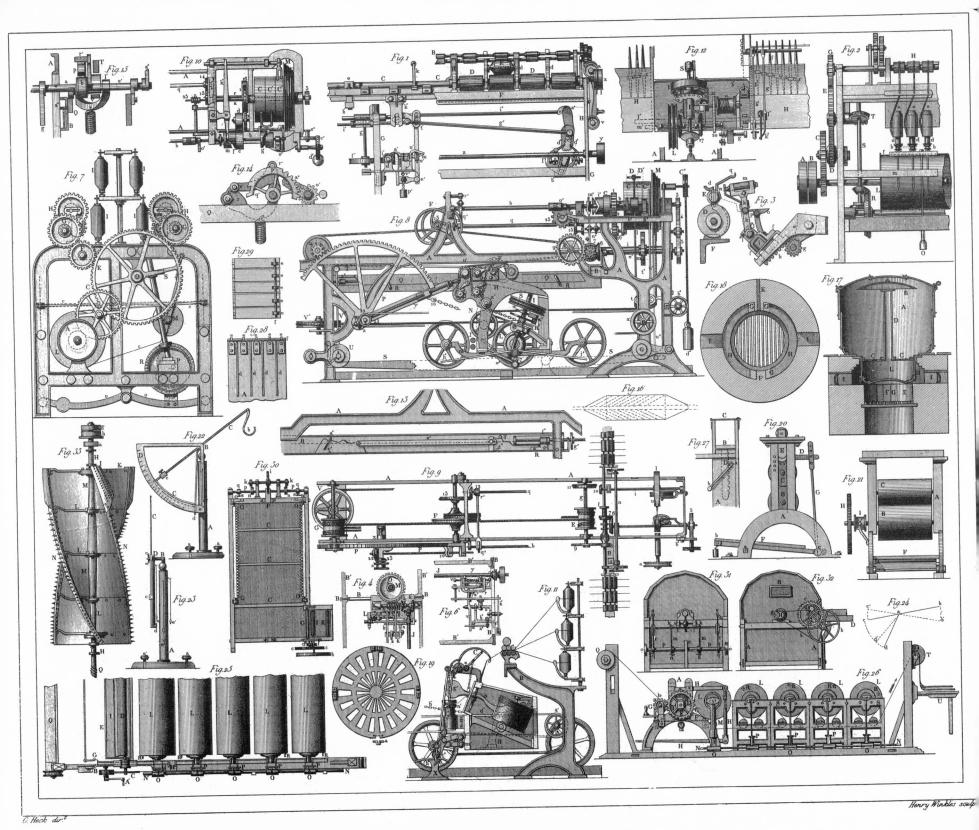

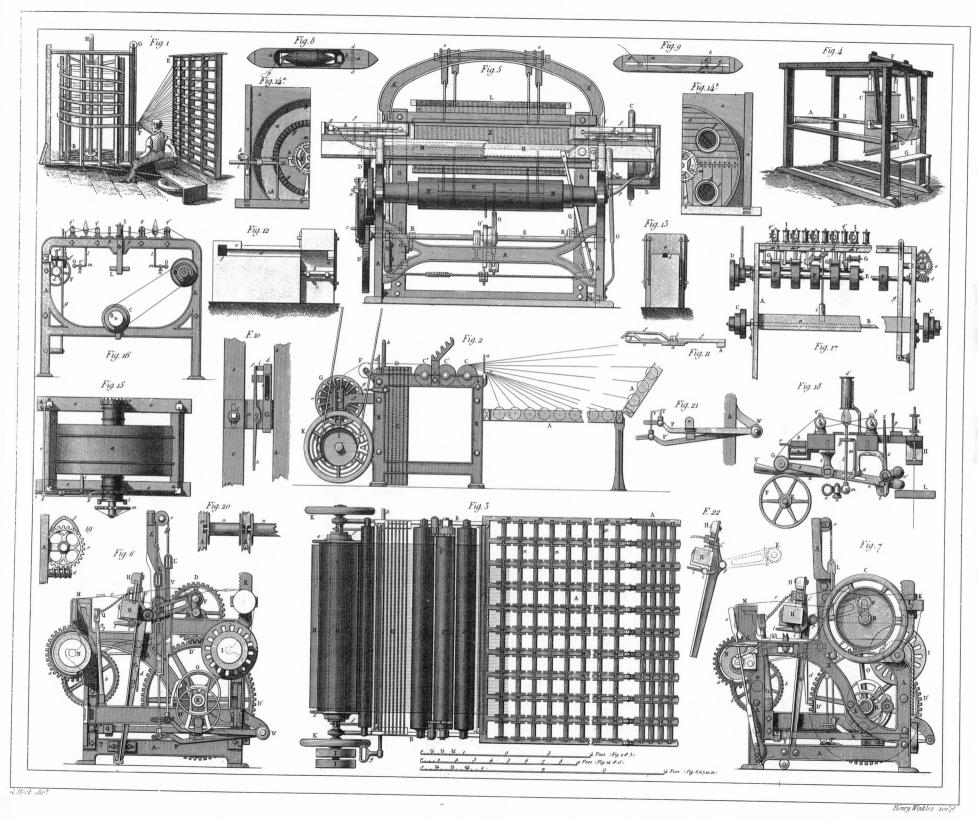

PLATE 484. WEAVING EQUIPMENT

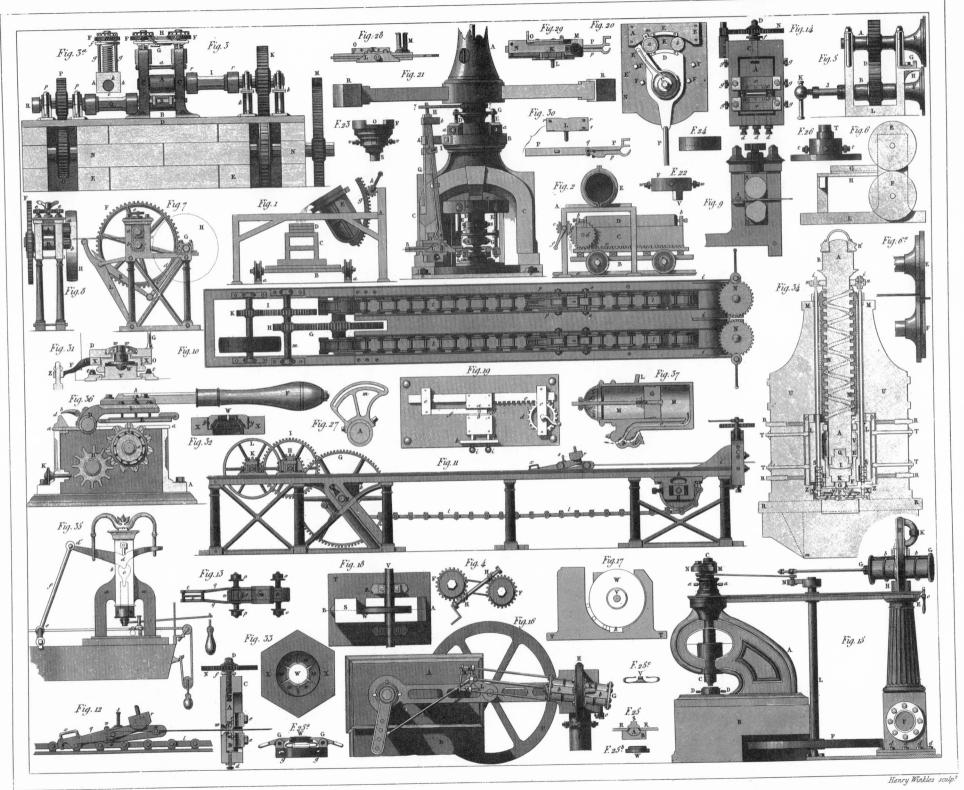

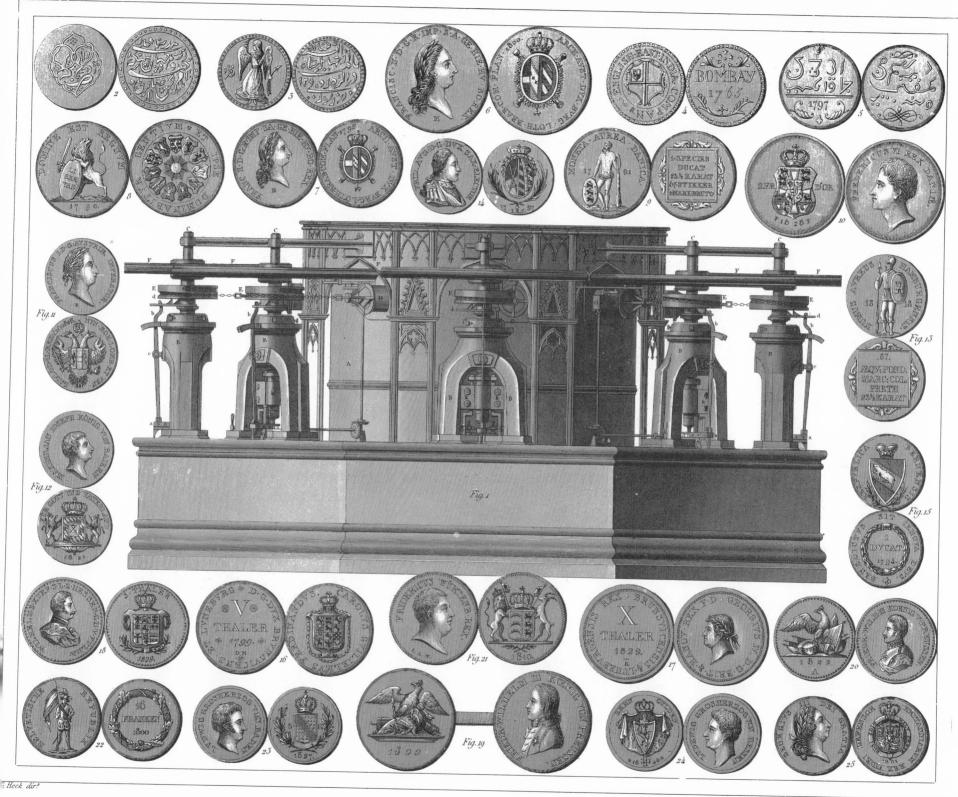

Henry Winkles sculp!

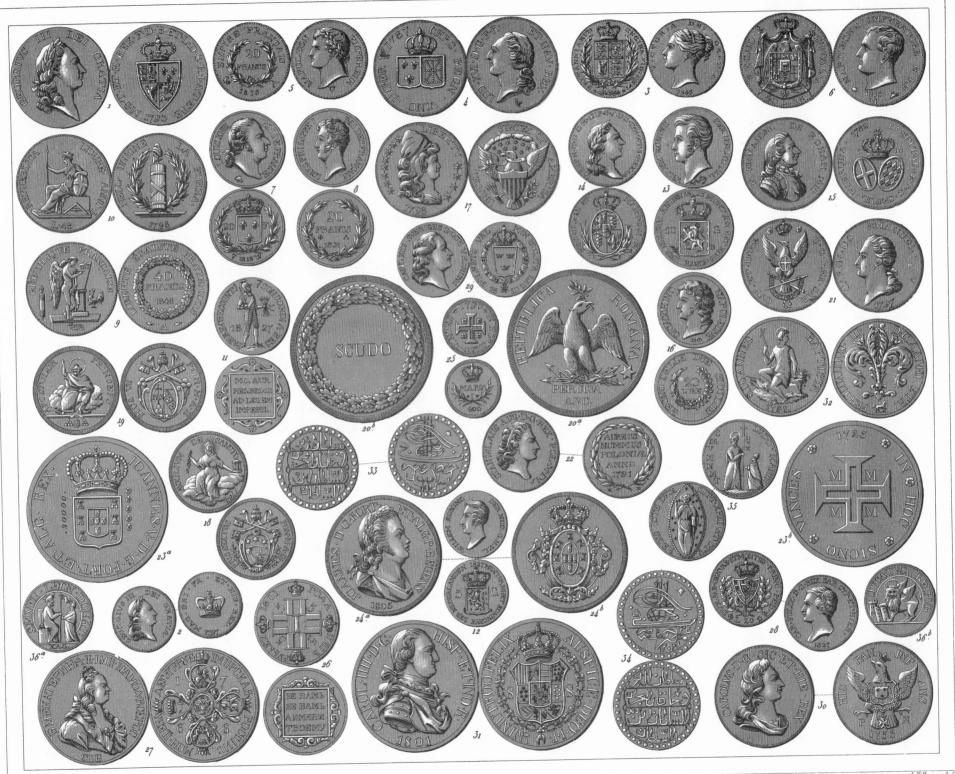

J. Keller scul

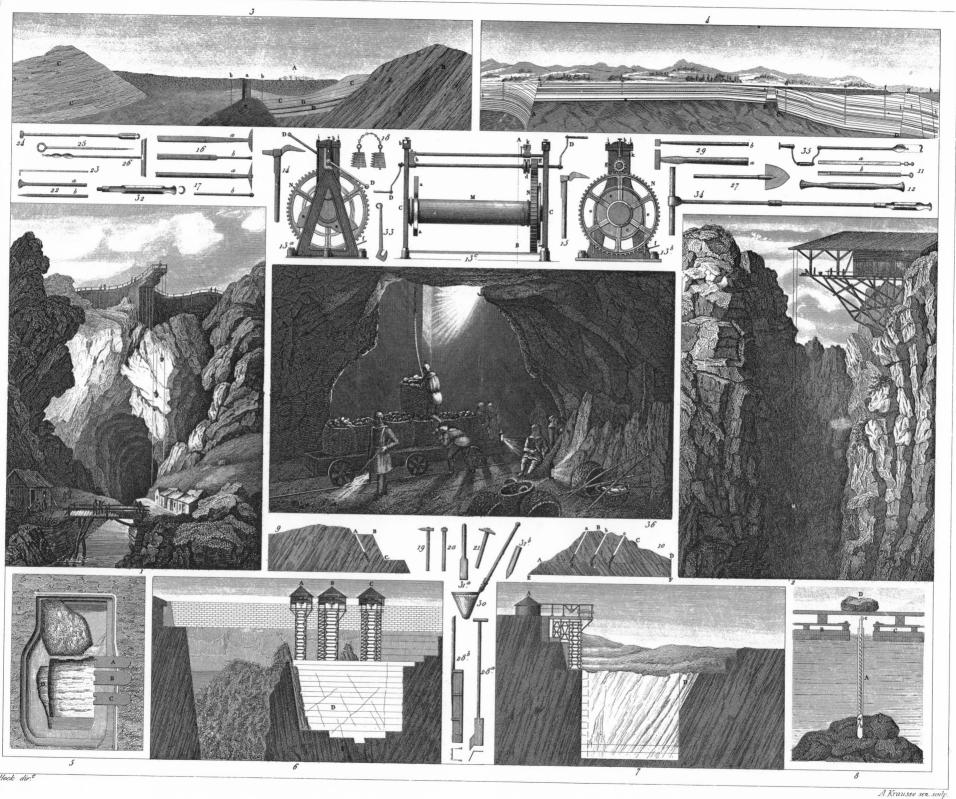

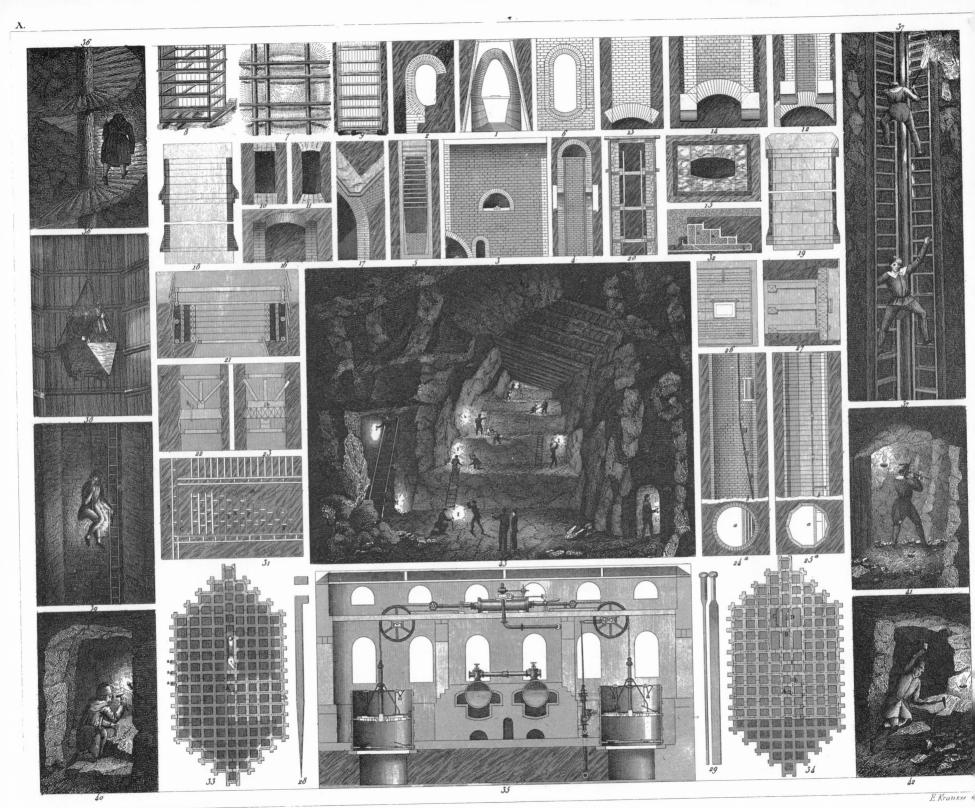

? Hook dir.t

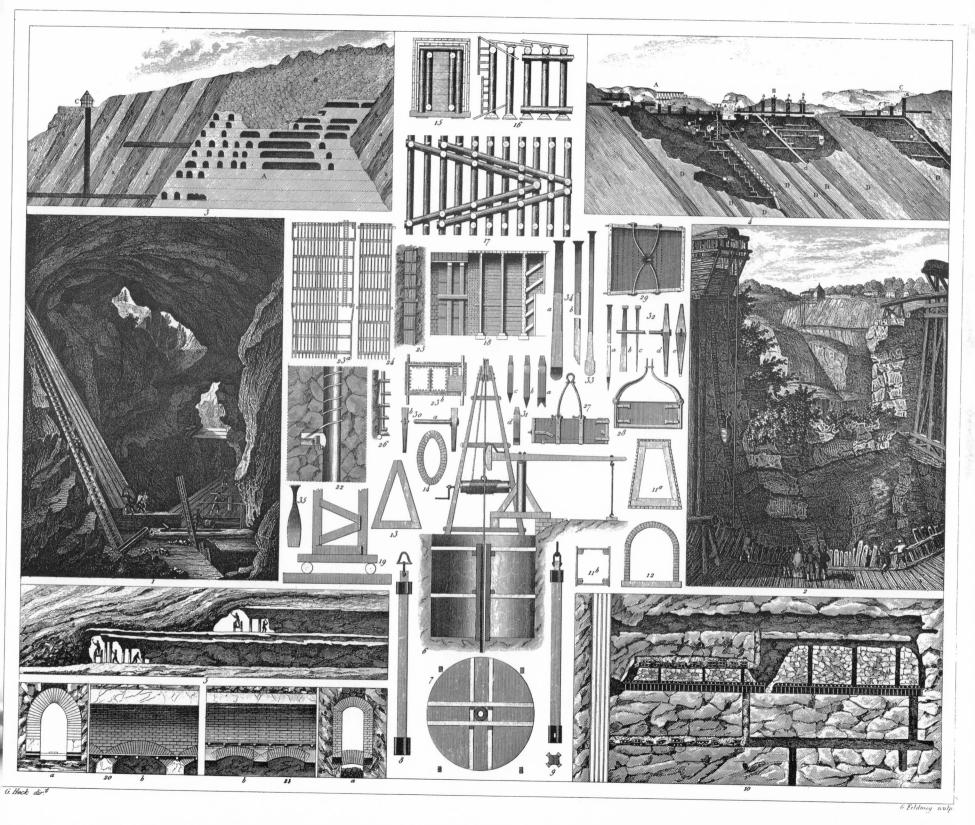

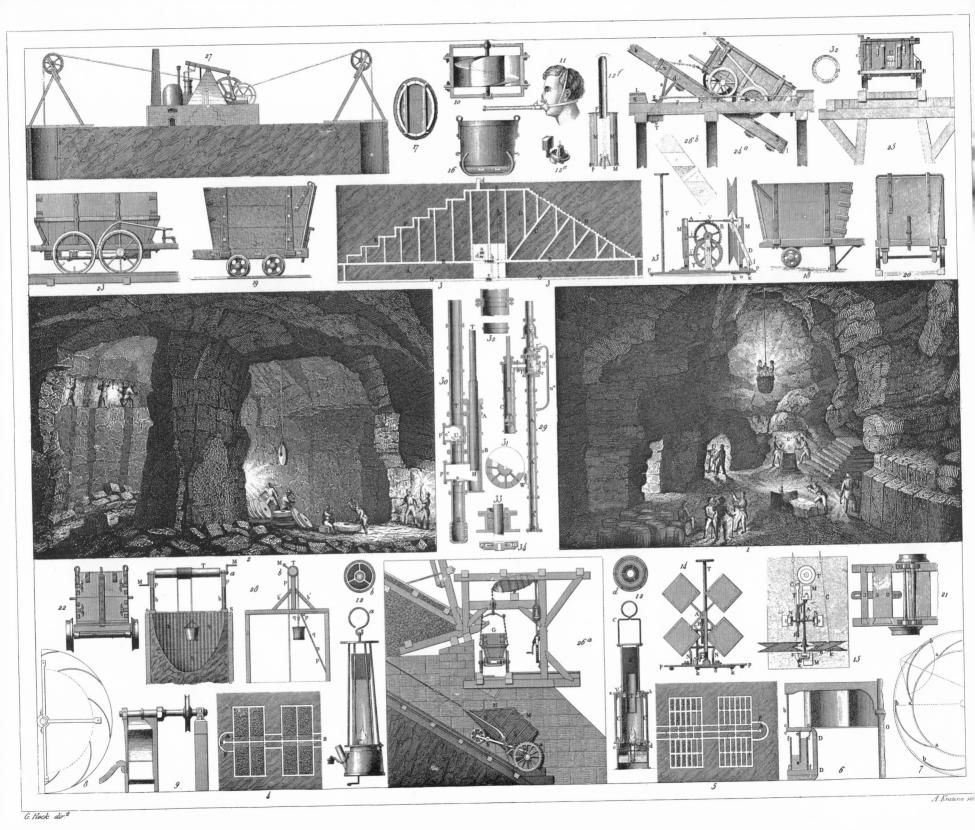

PLATE 491. MINING

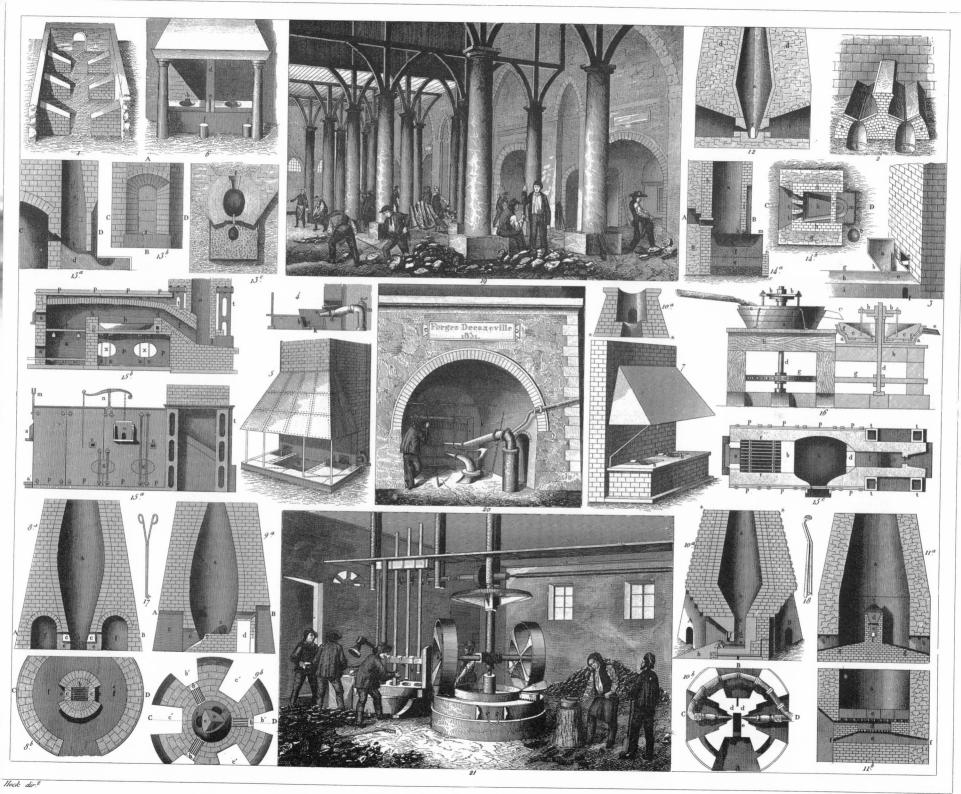

E. Krausse sculp.

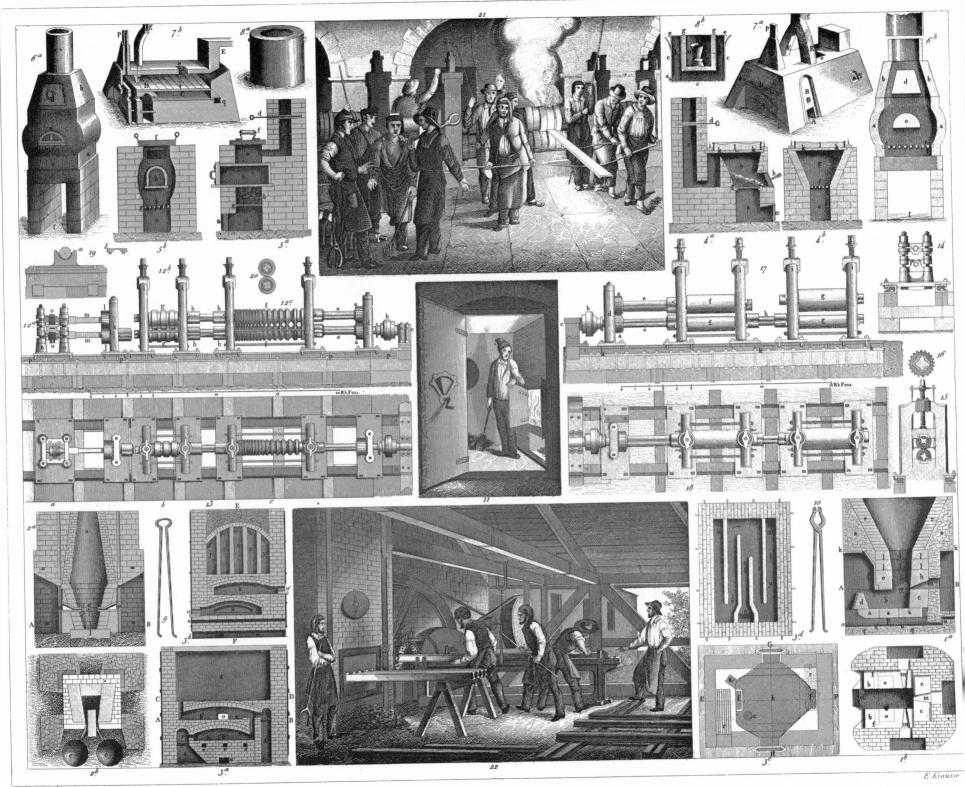

G. Heck dir.t

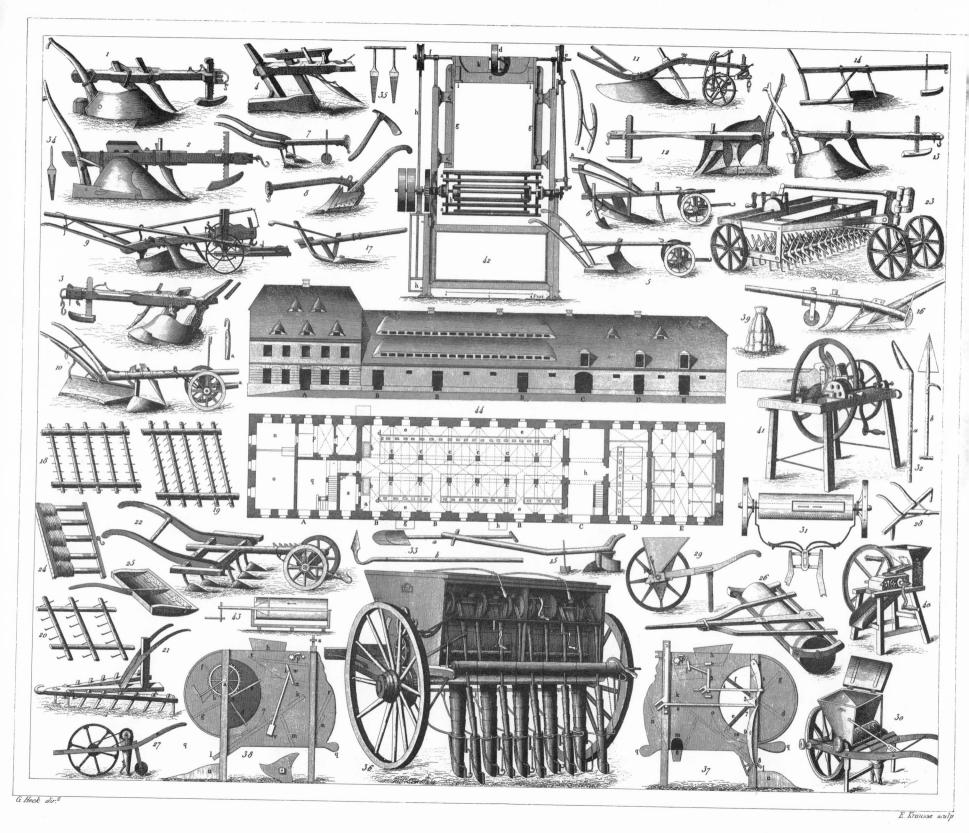

PLATE 494. AGRICULTURE

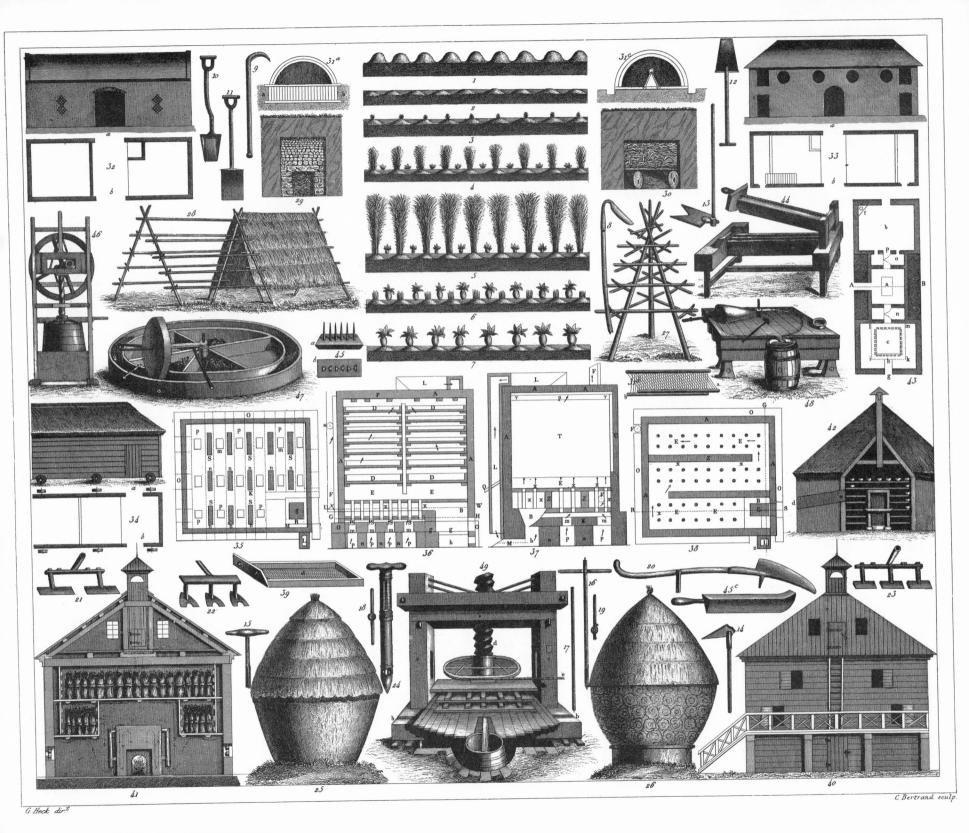

PLATE 495. AGRICULTURE

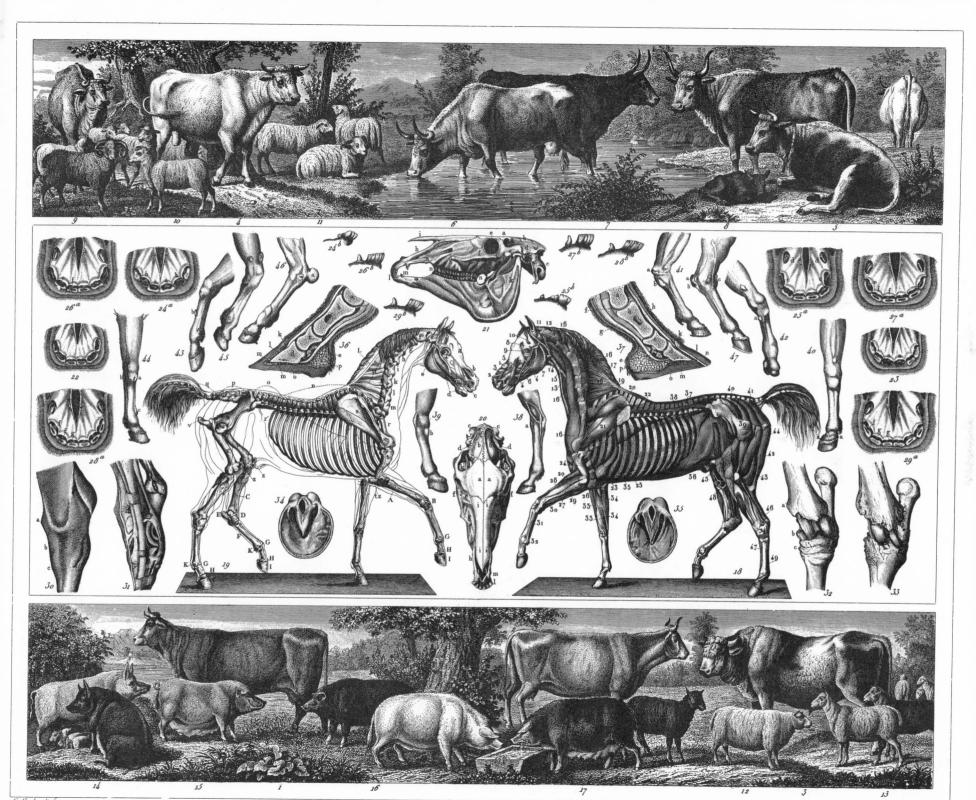

A. Krausse sculp.

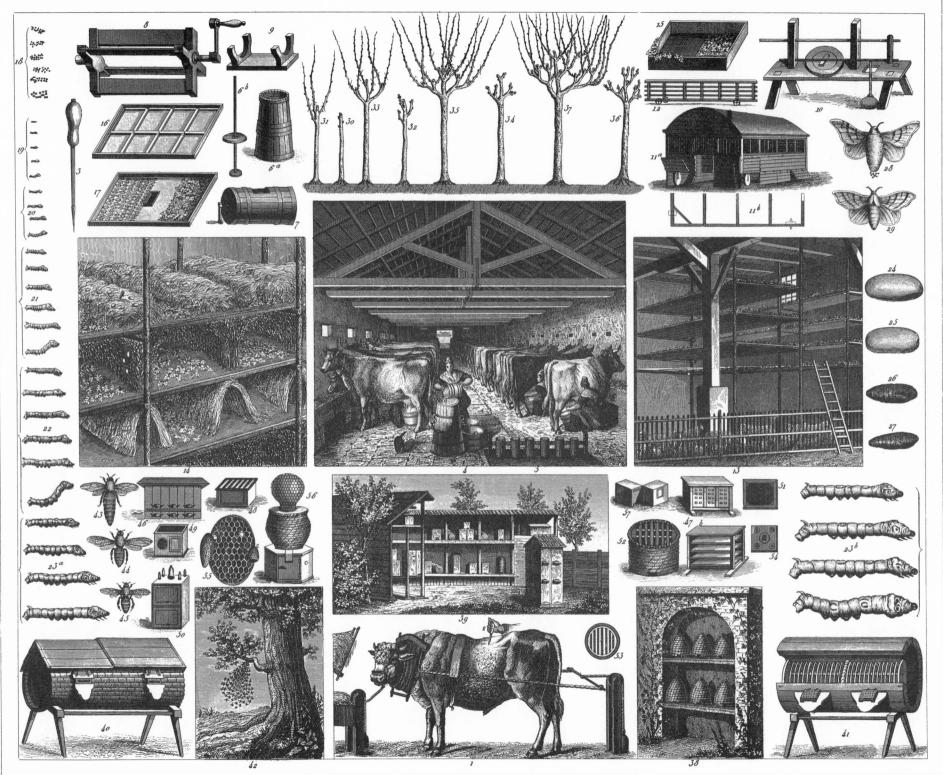

G. Heck dir.t

A Krause saulp

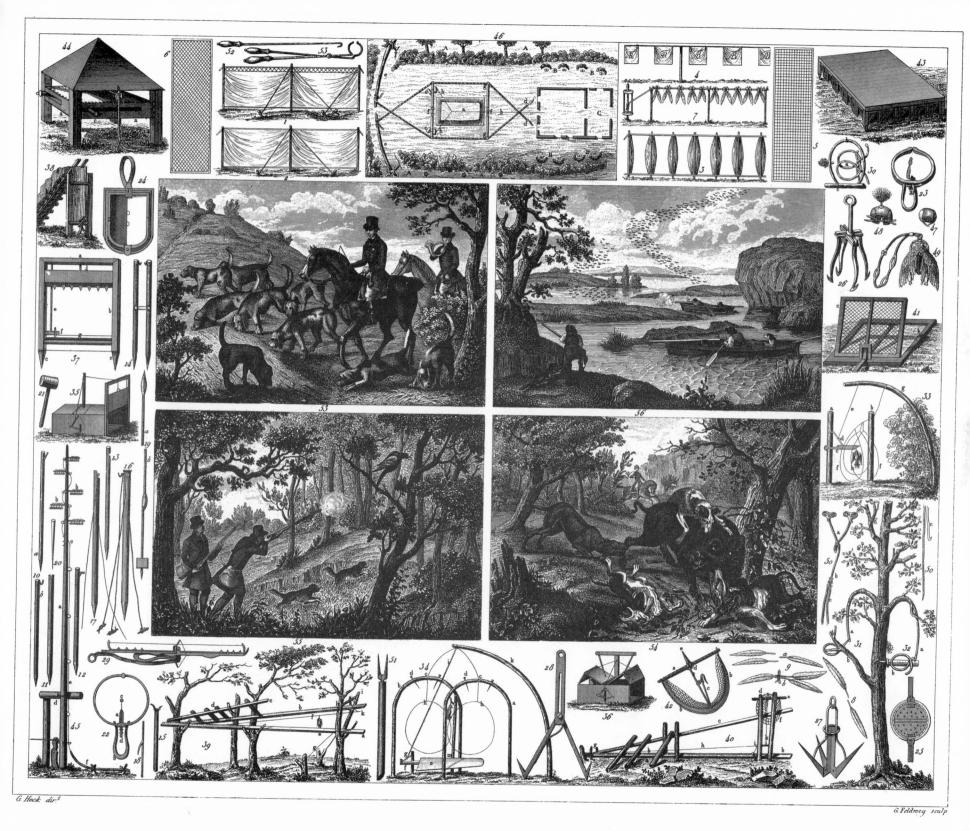

PLATE 498. HUNTING

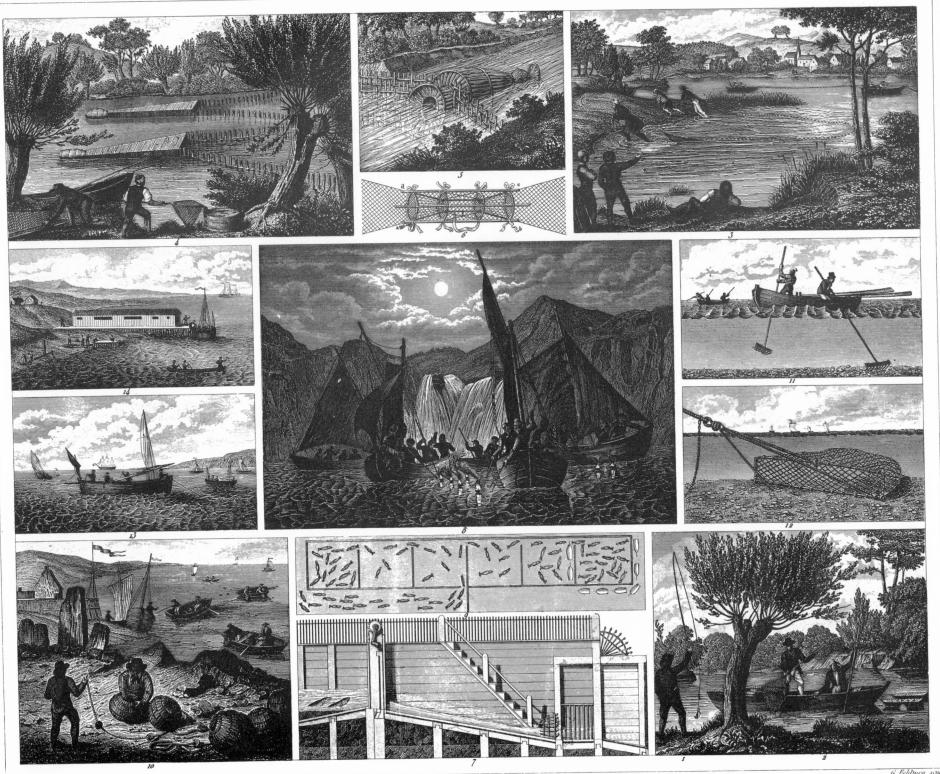

G. Heck dir.t

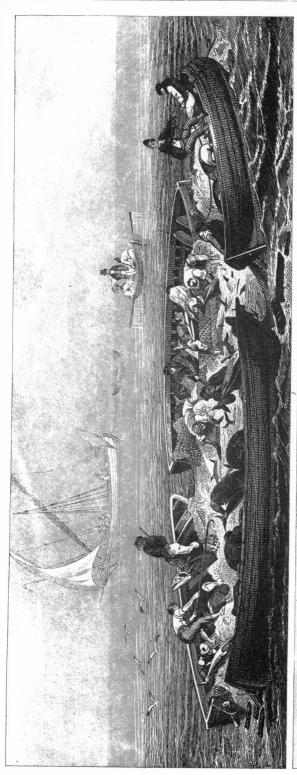

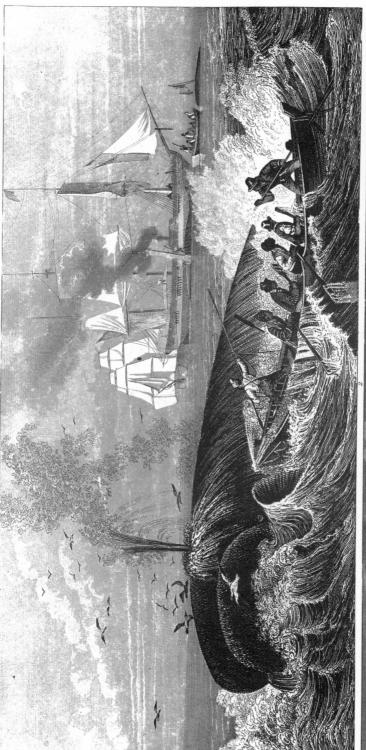

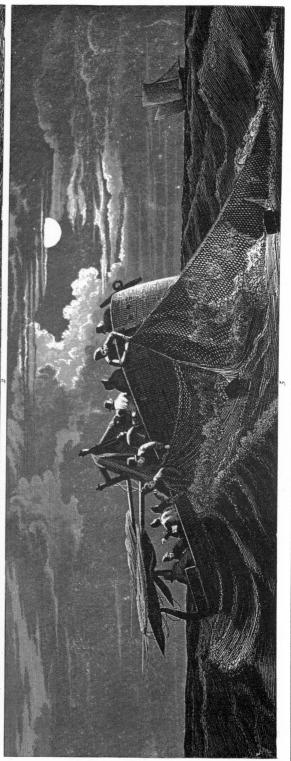